D0102746

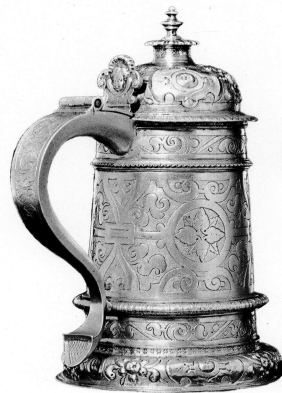

The Collector's Dictionary of the
Silver and Gold
of Great Britain and North America

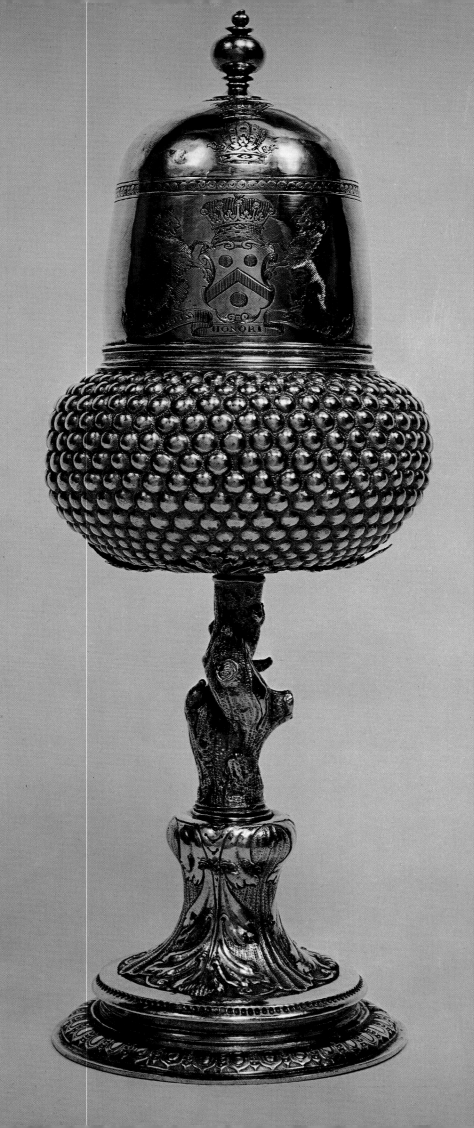

The Collector's Dictionary of the
Silver and Gold
of Great Britain and North America

by Michael Clayton

Country Life
London · New York · Sydney · Toronto

Frontispiece
Plate 1 The Stapleford Cup
An unmarked, gold cup, c. 1610.
Height 7¾ in. (18·8 cm.).
The earliest surviving piece of undoubtedly
English secular gold plate.
British Museum, London.

Published by
The Hamlyn Publishing Group Limited
London · New York · Sydney · Toronto
Hamlyn House, Feltham, Middlesex, England
© Copyright The Hamlyn Publishing Group
Limited 1971
ISBN 0 600 43063 4

Printed offset litho in Great Britain by
Jarrold & Sons Limited, Norwich

Reference
NK
7143
C55

Contents

4/17/72 cl

I have never before been asked to write an introduction to a dictionary, but this is not surprising since I have not hitherto known anyone rash enough to shoulder such a task. But since I both know the author of this work and indeed persuaded him that he was the man for the job, at the thought of which I had myself blenched when tentatively approached some ten years ago, I can surely do no less than congratulate him from the bottom of my heart on the successful completion of his labours and commend his book unreservedly to all lovers of English and American silver.

Michael Clayton is happily endowed with a natural enthusiasm for his subject coupled with driving energy, both of which have served him admirably in his task. This is no mere scissors and paste production. Once having taken the plunge he realised that, if his entries for the subjects to be discussed were to carry authority, he must search for facts, not only by studying the records of the past, but also by personal exploration of family strong-rooms up and down the British Isles as well as those of colleges, livery companies and other institutions. His horizon expanded with the realisation that the silver of Great Britain included by descent that produced in Britain's one-time Colonies across the Atlantic, and he set off in 1965 on a whirlwind tour of the principal collections of the United States. The result is that he sees early American silver as an important factor in studying the whole subject, and he therefore blends its history with the old country's productions to make many vital observations. Notice, among other points, how he comments, for instance, on the high incidence of 17th-century sugar boxes surviving in the eastern states of the Republic as opposed to Great Britain, or points the relationship of the American porringer to the undoubtedly misnamed English bleeding bowl, providing us, through his comparison with the covers of the rare skillet, with a clue to the obvious original function of these pieces.

Coupled with his personal inspection of so many pieces and quick eye for rare or seemingly unique examples is his appreciation of documentary evidence as an essential factor in revealing the true nature of some form not hitherto fully understood, or in tantalisingly introducing us to some item of which we seem to have no surviving example as yet recognised. My own favourite puzzle on this score is the entry in the Wakelin Ledgers for Manning Lethulier in 1743 'To 2 silver perrots for a Hammer Cloth'. This was only solved by a reference to Burke's *General Armoury*, which revealed the crest of the client as a parrot, and the realisation that these mysterious birds were coach trappings. While reading the proofs of this dictionary I derived much pleasure from the author's use of such sources and commend to its users the delightful, and to me hitherto unknown, lady seeking a second-hand inkstand, whose letter to a goldsmith in 1746 is quoted in the *Inkstand* entry. The reader can hunt for and be rewarded by the discovery of many other glimpses of the use and purpose of specific pieces and the matter-of-fact attitude of the day toward such pieces as functional plate to be listed, weighed, valued and bequeathed without fuss or ceremony.

This 'matter-of-factness' is indeed one of the dictionary's most important qualities. Too often, today, we are tempted by some highly coloured, glossy-covered volume on the arts into supposing that here at last we have discovered the definitive work on 'Korean Teapots of the 9th Century', 'Carved Whalebones from the Congo' or some such, only to find that it is merely a pretty picture-book designed chiefly, it seems, to display the skill of the photographer of the *objets trouvés* it contains. There is none of that here. This book is, as it should be, a mine of facts, a starting-point under any heading from which to explore all that is known or has been written about the subject in question. To this end the author has most sensibly and conveniently provided bibliographies to every entry other than purely definitive ones, and this I am sure will prove of lasting value for many years, even though of course more will come to be written on many features before long. His cross-referencing, too, seems painstakingly devised to resist any excuses for not being able to find the subject looked for, and his quick, nervous and even, at times, conversational handling of his material makes the entries eminently readable and entices one constantly to go on to the next. This is, I believe, one of the essential qualities of a good dictionary: to fascinate by what it tells and so to lure one on deeper into its alphabetically juxtaposed array of knowledge. It was, I think, E.V. Lucas, that rambling essayist of a half-century ago, who claimed his favourite bedside reading was the *Dictionary of National Biography* and wrote a charming essay on the A's or B's to demonstrate his claim. I have a strong suspicion that (if it doesn't grow too heavy) this new contribution to its subject will prove hard to put down for many an enthusiast.

Works of this kind must inevitably be judged to some extent, though by the judicious, not too quickly, by their illustrations. The competition between the author's desires and the pressures of economic production must indeed present a constant problem, but I believe that the blending here of photographs and line drawings is a satisfactory solution, and I am naturally paternally flattered that my daughter's efforts with the drawings were welcomed by my one-time pupil to illustrate his text.

We are now into the second century of the written word on our heritage of plate, since it was 1863 that Chaffers' *Hall Marks on Gold and Silver Plate* first appeared, to be followed about twenty years later by Cripps' *Old English Plate* and, after another roughly equal period, by Sir Charles Jackson's weighty tomes *An Illustrated History of English Plate*. Since then, over the last sixty years, many volumes, catalogues and articles on the subject have appeared.

It was high time that someone should attempt to digest the work of the past and reduce it to manageable proportions in easily accessible form, and this, I have no doubt has been remarkably accomplished here. I believe that before very long 'Clayton's Dictionary' will be referred to in the same breath as 'Jackson's History' as the two standard works on a vast subject which few have had the boldness to attempt.

A.G. Grimwade
London

Introduction

To attempt a wholly comprehensive account of all facets of wrought silver, during all time and in all places, would be almost certainly beyond the bounds of possibility. An account of the history of silver, even of one country, if wholly comprehensive, would today make a doubtful investment for any publisher. Narrowing the field still further to an approximate period only allowance must still be made for the appearance of new survivals or odd variations on a known theme. It is with these reservations that I venture to call this volume a Dictionary, well knowing how much more I shall learn as a result of new objects being called to my attention by future readers. To this I look forward.

The difficulty of classifying certain objects must be obvious. When does a sugar bowl become a small punch bowl, or even a slop basin? The answer must inevitably be the requirement of the user, which may differ from generation to generation, and from country to country. No detailed coverage of marks, which is a subject in itself, has even been attempted. Indeed, several new works on London and provincial marks are 'on the stocks' at the moment of writing.

I have endeavoured to illustrate rarer, rather than the better known pieces, but with a bias towards objects more generally surviving than a piece of such early date or rarity, that only one such remains. As a period, I have covered that of 1150 to 1880, with occasional excursions beyond these limits. As readers will be aware, the majority of surviving silver or gold objects are later than 1500 in date. Doubtful descriptions found in early inventories, but not so far certainly identified, have not been included.

It may be remarked that towards certain silversmiths such as Harache, Lamerie, Willaume, I have shown an undue amount of attention, certainly in so far as illustrations are concerned. This is owing to several reasons; the surviving quality and quantity of their output being the most obvious. There is also the attention drawn to them by museums and auctioneers who illustrate specimens of their work in catalogues as being examples of the best workmanship. Of those silversmiths who have had a specialist book devoted to them, I have given a short 'potted' biography; forthcoming works will expound this facet of collecting. One hopes that in due course someone will undertake biographies of silversmiths such as the Harache family, the Willaumes, George Wickes and others of their kind. In the case of certain selected (a most difficult task) American silversmiths, I have ventured upon their biographies myself.

By means of citing the specialist works or articles most relevant to the particular subject at the end of each section, I hope to have avoided placing my readers in a position I find maddening myself; namely failing to specify which of the works in the main bibliography will best enlarge upon the matter.

To single out individuals in acknowledging help, so far as information or photographs are concerned, would be invidious. It is perhaps better to say that I have been lucky enough never once to meet with a refusal of information or photographs the moment my needs and intentions were made clear, either in the British Isles, the United States, Canada or Russia. Public study collections have generally revealed some feature worthy of record, however small. The kindness and patience of their curators towards me has been beyond praise. Collectors themselves have often produced some interesting ideas, perhaps because they bring a breath of the outside world to the comparatively small group of specialists working with and upon this relatively small subject. Without the ungrudging assistance and generosity of the members of the silver departments of both Christie's and Sotheby's, it is doubtful if this book could have been so fully illustrated, even with the help of Elizabeth Grimwade, who is responsible for all the drawings. Besides the above-mentioned firms I must also make grateful acknowledgements to Evans Brothers Ltd. for permission to quote extracts from *An Introduction to English Silver* by Judith Banister; to Major-General H.D.W. Sitwell C.B., M.C., for the information in the chart Royal Goldsmiths and Jewellers; and to Gerald Taylor for permission to reproduce, with more recent addenda, the bibliography published in 1956 in his book *Silver through the Ages*.

I must also thank by name Messrs A.C. Cooper who are responsible, not only for taking the majority of the photographs, but for patiently searching their remarkable negative library for items photographed years before and for which the owners were sometimes able to supply only the scantiest information. My thanks should also be made here to Ruth Goodsir and to my wife, Georgina, for their patience in typing and retyping the manuscript, and finally to Arthur Grimwade, not only for reading the proofs, but also for teaching me all that I know of silver. Lastly, I should record my admiration of the patience of my publishers towards me.

Michael Clayton
Geneva

Inkstand
Maker's (or sponsor's) mark, AI,
probably that of Alexander Jackson.
Hall-mark for 1639.
Length 16½ in. (41·9 cm.)
Width 15½ in. (39·5 cm.)
Height 10¼ in. (26·1 cm.)
The inkstand, probably the finest
and largest of the 17th century,
is decorated in the manner of
Christian Van Vianen.

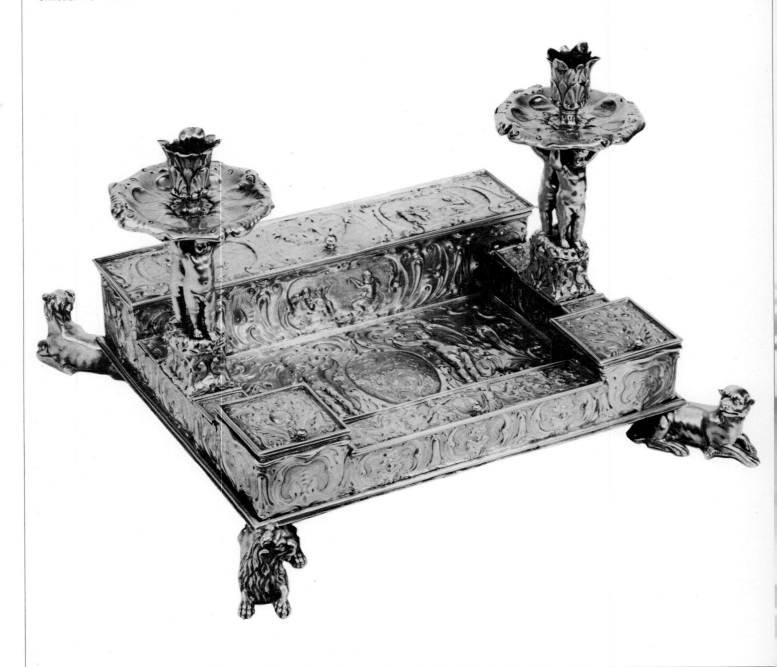

The Collector's Dictionary of the
Silver and Gold
of Great Britain and North America

Numbers in bold type refer to illustrations

Acanthus

Plant with fleshy, prickly leaves, reproduced in stylised form as decoration on Corinthian capitals and particularly on silver made about 1670–90, and during the Classical revival of 1770–1825.

Achilles Shield

Commissioned by the Prince Regent from John Flaxman, R.A. in 1818. The designs were taken from Book 18 of *The Iliad*, and an example in silver was ordered from Rundell, Bridge & Rundell and delivered in 1821. Another of the same date survives and a third was made in 1823. Rightly, Flaxman was extremely proud of these designs, which he first moulded in a general manner, then cast in plaster. He finally carved the plaster before making the mould from which the metal casting was made. The lengthy process probably accounts for the extraordinary quality of the finished product.
See also Flaxman, John; Rundell, Bridge & Rundell.

Adam, Robert (1728–92)

A series of designs for silver by both Robert and his brother James Adam, survive in the Sir John Soane Museum and can be seen in *Adam Drawings*, vol. xxv (**79**). There is, however, no proof that all these designs were accomplished, and in a number of cases they were indeed alternative designs. Extant are the candelabra made for Sir Watkin Williams Wynn in 1774 and now at Lloyd's, a pair of candlesticks made by S. & J. Crespell (**80**) and an Irish race cup executed by Daniel Smith & Robert Sharp in 1764. The Adam brothers created their own classical style, which attracted the following of many other designers and silversmiths, not least the great entrepreneur Matthew Boulton. It seems unlikely that the Adam brothers prepared many designs for plate after 1775. A considerable number of pieces of the Northumberland Dinner Service, part of which is now at the White House, Washington, appear to be from the designs of these brothers.

Other pieces which owe their inspiration to Adam designs, include large numbers of race cups and covers. It seems, however, that the only piece of gold plate in their style is the cup and cover made by Andrew Fogelberg in 1777 and engraved with the Arms of Clitherow, standing 12$\frac{5}{8}$ in. (32·1 cm.) high.
Bibliography
E.A. Jones, 'Adam Silver'. *Apollo*, vol. xxix, p. 55.
Robert Rowe, *Adam Silver*. Faber & Faber, 1965.
See also Boulton, Matthew.

Alloy

Probably derived from the French *à la loi* and known originally as 'allay', it refers to one of two processes. (i) A base metal mixed with a precious metal to harden it, improve its working qualities and modify its colour. (ii) A combination of different metals fused together, for example, brass and bronze.

Almanack

Among the many objects selected for embellishment in the late 17th century was a pocket almanack in the form of a scroll. A surviving example is found in a private collection and engraved 'James Webster. A Frendes Gift'. The cylinder containing the scroll and the winding spool is engraved with foliage in a style fashionable in the 1690s.

Alms Basin and Altar Dish

Not until after the Reformation in the 16th century did the silver alms dish appear as a normal church furnishing, although private chapels possessed them before this period. An early example of an alms basin is the one made in 1493, possibly to match a ewer found at Corpus Christi College, Oxford (**1**). One or two others were made during the reign of Edward VI from Recusant plate, as were a number of communion cups. One at St George's Chapel, Windsor, was made in 1548 and another at St Magnus, London Bridge, in 1524. It was not, however, until the reign of James I, with the reappearance of the private donor, that the alms basin and altar dish generally reappeared. Their dual purpose, both as alms basins and altar dishes was an added attraction. Amongst the Garter Service of Plate (seventeen pieces) at St George's Chapel, Windsor, which was supplied by Christian Van Vianen in 1637 and lost during the Civil War, were a set of three such basins. Whilst the earlier ones were plain, there was an increasing tendency, as the 17th century progressed, to decorate these pieces. The results were not always pleasing. St James', Piccadilly, London, possesses one of the finest basins made in 1683. Both Eton College (1662), and Norwich Cathedral (1665) have handsome examples of which the cross embossed in the bowl is the sole decoration and a number of finely embossed dishes were decorated by M. Houser, including those at Buckingham Palace (1664) and Auckland Castle (1661). The altar dish at Auckland Castle was intended for the private chapel of Dr John Cosin, appointed Bishop of Durham only months beforehand and a friend of the Master of the Jewel House. In 1706 Isaac Liger was commissioned by George Booth, 2nd Earl of Warrington, to make an alms dish for his chapel at Dunham Massey; the quality of the engraved deposition in the centre, signed by Simon Gribelin, after Caracci, is exactly what one would expect from such a combination of patron and engraver. Many an 18th-century, and earlier, alms plate is no more than a meat dish pressed into ecclesiastical service, sometimes with a handle added, or perhaps derived from a toilet service, as the superb silver-gilt example which is one of a pair made by Benjamin Pyne in 1698, now in the Victoria and Albert Museum (**3**). At Tabley Hall in Cheshire there is an alms box of *c.* 1677, whilst on the Channel Isle of Jersey, St Aubin's Church commissioned two collecting boxes of tankard form in 1750. Partly covered trays were also produced to avoid embarrassment to the alms-giver. A series of Coronation alms dishes, the perquisite of the Lord High Almoner, yet remain with their hereditary recipient's descendant. One of the most interesting alms dishes, and one of the largest pieces of Scottish provincial plate extant, is the Fithie Communion Plate (**2**) made in Dundee by Thomas Lyndsay and engraved with the date 1665 (Albert Institute, Dundee). A smaller dish, also the work of Thomas Lyndsay, engraved with the same date (1665) as well as the initials IH, a lily between, is in the Sheffield City Museum. St Ives, Cornwall, has an unusual collecting plate with a tubular handle to one side, made by John Babbage of Exeter in 1743; another, made by Gurney & Cook in 1747, is at Norwell, Nottinghamshire.
Bibliography
C.C. Oman, *English Church Plate*. Oxford University Press, 1957.
See also Dish; Ewer and Basin; Jug.

Altar Candlestick

Until the Reformation, only a single pair of candlesticks would have been placed upon the altar. Of these only bronze examples of English workmanship have survived. Apart from the Baroque form of baluster stem on a tripod base (**71**), and a pair of

1 Alms Basin
Maker's mark, a horseshoe.
Hall-mark for 1493.
Diam. 16¾ in. (42·53 cm.).
Corpus Christi College, Oxford.
The Arms of the See of Winchester
impaling Fox were probably added
after 1501.

2 Fithie Communion Plate
Maker's mark of Thomas Lyndsay.
Hall-mark for 1665, Dundee.
Diam. 19 in. (48·3 cm.).
Albert Institute, Dundee.
One of the largest pieces of
Communion plate made in Scotland.

3 Alms Basin
Silver-gilt, one of a pair.
Maker's mark of Benjamin Pyne.
Hall-mark for 1698.
Victoria and Albert Museum.
Engraved with the Arms of Sir
William Courtenay of Powderham
Castle. The chased ornament is
in the manner of Jean Lepautre
(1618–82).

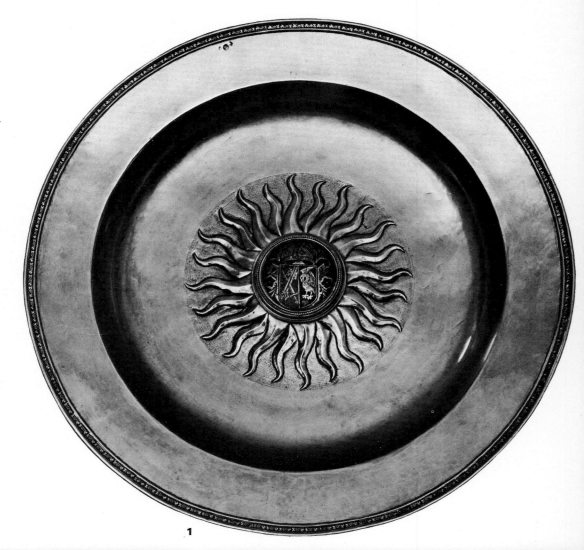

1

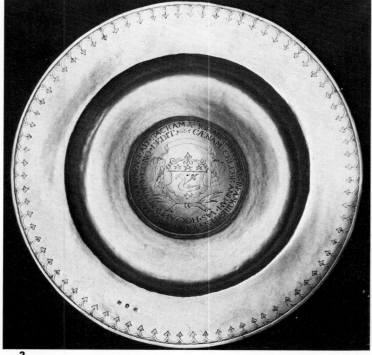

2

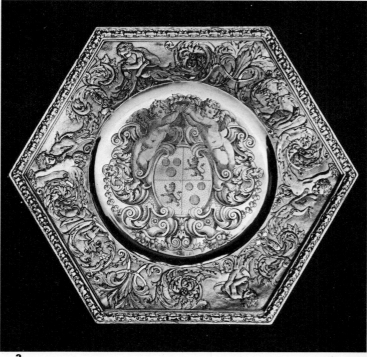

3

candlesticks at Rochester, also made in 1653, their large size is a feature which usually distinguishes them from normal secular examples. A pair executed by Denny & Bache in 1696, bearing the Royal Arms of King William III stand 37 in. (94·0 cm.) high, and are perhaps the tallest altar candlesticks known.

Bibliography
C.C. Oman, *The Gloucester Candlestick*. H.M.S.O.
See also Candlestick.

Altar Cross See Cross.

Altar Cruet

They consisted of two in number, one for wine (*vinum*), the other for water (*aqua*). Only two medieval examples have survived, one lacking a handle or spout is silver parcel-gilt. Their form may well have been similar to that of the ampullae. It might be expected that, as today, these should be associated with a stand. Thomas Beauchamp, Earl of Warwick, had a pair formed as angels. Mounted rock-crystal was an ideal medium for altar cruets, so far as distinguishing the contents was concerned. At St Peter Port Church, Guernsey, there is an altar cruet of parcel-gilt which is 6⅛ in. (15·6 cm.) high. It probably dates from *c.* 1530, the finial A (*aqua*) is a restoration. It *may* be English; certainly English flagons of approximately this form are known, but usually of a much later date. A number of Recusant cruets survive, in this case almost all have the letters A or V as a finial. Medieval examples seem to have more often had these letters engraved and enamelled on the flat top of the cover. As might be expected, a number of Canadian cruets survive. Langdon illustrates a pair made by Paul Lambert (1691–1749). Lambert seems to have received a large number of commissions for Canadian ecclesiastical plate.

Bibliography
C.C. Oman, *English Church Plate*. Oxford University Press, 1957.
J.E. Langdon, *Canadian Silversmiths, 1700–1900*. Toronto, 1966.
See also Recusant Plate.

Altar Dish See Alms Basin.

Altar, Portable

The obligation of a priest to say Mass at a hallowed table led, in early times, to the provision of small portable altars of wood or stone, sometimes silver-mounted. In the Musée de Cluny, Paris, there is an extremely fine example of a portable altar, probably English and dating from *c.* AD 1000, made of reddish marble with parcel-gilt mounts, the engraved figures being gilt on a white ground. Another can be seen at Durham. As churches with permanent altars became more common, so the need for such portable pieces decreased by the 12th century.

Altar Vase

Although a number of pieces have been pressed into service for this purpose, few are known to have been made solely for this purpose. An unmarked silver-gilt pair of altar vases engraved with the date 1680 are in the Walker Art Gallery, Liverpool, and a set of four dated 1725 are at Wardour Castle, Wiltshire.

Ambassadorial and Perquisite Plate

The custom of supporting the status of an ambassador, while representing his sovereign at a foreign Court, appears to date from the 16th century, when the records of the Jewel House show that considerable quantities of the sovereign's personal plate were issued on 'temporary' loan to those unable to supply their own sideboard. Almost invariably the Master of the Jewel House had enormous difficulty in ensuring its safe return. His problem was doubled when the great Officers of State (the Speaker of the House of Commons included) also managed to secure the grant of an issue of the sovereign's personal plate. The loan then assumed very expensive proportions, as they, unlike ambassadors, might hold their office for some years, whereas an ambassador usually went upon a special mission and returned within a stated number of months. Though the Jewel House might insist on the return of an equal quantity of weight (the basis of the issue) it proved difficult to secure the return of plate issued to a father and pledged or sold by a spendthrift son immediately upon his father's decease. To prove its Royal origin, the plate was engraved with the Royal Arms and if successfully, though illegally, retained for a long period, it was sometimes melted, refashioned and re-engraved with the same arms though the sovereign concerned may have been dead for some fifty years or more. By the 17th and 18th centuries the scale of issue to the different ranks of those entitled to the Royal Plate was cut and dried, but as this was done by weight and the Royal Treasury was so bereft of actual wrought plate, it was customary to issue a warrant for the purchase of so many thousand ounces of plate to be made up at the direction of the warranted. The bill resulting therefore depended upon how expensive a silversmith was patronised by the fortunate (though as an ambassador he was unpaid) recipient. Under King William III (1695–1702) plate valued at £102,843 13s 8d was issued, a figure which should be multiplied by at least six to give a comparison with the cost today of even the plainest workmanship. Eventually, the issue was based on a monetary scale until the cancellation of the custom in the 19th century. The 1st Duke of Wellington was the last to receive an issue on his appointment as Ambassador to the Congress of Verona. Not until 1839, however, was the issue of plate to the Speaker of the House of Commons disbarred by law.
See also Service.

American Silver

From the middle of the 17th century silversmiths were plying their trade on the American continent, in that region now comprising the eastern United States. The principal influence was that of Holland in the area of New York (New Amsterdam) and that of England elsewhere. Though extending over a much smaller area, the influence of the Netherlands was tenacious and both the silver forms and customary usage of the objects themselves lingered on into the early 19th century, in spite of, or perhaps because of, the Treaty of Westminster, whereby New Amsterdam passed into English sovereignty as early as 1674. The Dutch language survived well into the middle of the 18th century, although it was after the commencement of English rule that New York saw its hey-day as the entrepôt for furs, flour and milling. Piracy flourished, amongst the spoils being considerable quantities of bullion. In New England, Boston was by far the most flourishing of a not inconsiderable group of Atlantic coast ports, with a remarkably widely spread pattern of trade.

Surprisingly, no system of assaying and legal marking of silver was ever set up, except in Baltimore in 1814, though there had been attempts to establish by law an assay office in Philadelphia in 1753, and on several later occasions, the last being in 1770. In general, the quality of the silver was intended to emulate that of England (925 parts pure silver out of 1000, the balance being almost entirely of copper). Baltimore silver was slightly less fine, being similar to the old Scottish (and French) standard, and, theoretically, was intended to bear a town mark, assayer's mark and date-letter beside the mark of the maker, which, by 1700, seems to have been consistently used. Sometimes the word 'Sterling' (rarely 'Standard') is also found, but this is not common until 1860, when it became general to the whole nation. After 1850, the letters 'D', 'C' or 'Coin' or 'Pure Coin' are also found, indicating the source of the metal from which the object was fashioned. The United States coin standard in the 19th century was 900 parts pure silver with 100 parts alloy, that is slightly less pure silver than Sterling.

In the late 17th century a number of relatively wealthy settlers came from Europe bringing with them their fine furniture, silver and other family effects, and it would be quite incorrect to picture a society always struggling for its existence, as is so often portrayed in the days of the earliest settlers. Growing prosperity called for even more of these luxuries, which demand, in spite of considerable imports, sufficed to support a number of extremely capable silversmiths. The high quality of 17th- and 18th-century silver from the hands of such men as John Coney, Jacob Hurd and, earlier, Hull & Sanderson, to say nothing of Pieter Van Dyck and Gerrit Onckelbag, reflects their ability to compete with the silversmiths of Europe, specimens of whose work were continually arriving on that side of the Atlantic. Forms were adapted to the requirements of Colonial living. Only the engraving seldom matched the quality attained by silversmiths in London or Amsterdam. Otherwise, the visitor from Europe saw little in the houses of the well-to-do which was very different from that he might expect to find in his fatherland.

The Colonial porringer, a shallow cup with a pierced flat handle to one side, seems to have been a far more lasting form than its brother, the mis-named English bleeding bowl. The shallow, hemi-spherical, fluted and chased, two-handled bowls from the Dutch settlements, probably intended for punch or bishop, owe their form to the brandy bowl of the Netherlands, though they were larger and had handles like those of the English porringer. Beakers of the tall and elegant Dutch form did not, regrettably, survive much later than the middle of the 18th century. Forks were perhaps even rarer than in England. Oval sugar boxes made by Edward Winslow and also by John Coney, outnumber their English counterparts. Candlesticks and tea kettles are surprisingly rare. The Rococo style of decoration, except in rare instances, never caught the imagination of the 18th-century American. Bowls for punch, sugar or for use as slop basins were made to emulate the form of Chinese porcelain. A considerable trade in Chinese porcelain was carried on by the Spanish settlers and some of it was brought overland across the Panama Isthmus, finding its way north to the English Colonies, though the bulk of the eastern seaboard's trade was with Europe. Of such forms are the bowls made by Paul Revere.

By the end of the 18th century the Classical style was fashionable on both sides of the Atlantic and it is probably true to say that at this stage Philadelphia led the nation as the capital of elegance. The pierced galleries round the urn-shaped products of Philadelphia silver at this time are delightfully balanced with the otherwise largely undecorated form. In 1793 and 1798 Philadelphia suffered two disastrous outbreaks of yellow fever. Many fled to Baltimore, among them a number of silversmiths.

Thus was founded that city's early 19th-century pre-eminence in the world of fashion, and Philadelphia's decline was sealed when the national and political capital was removed to Washington.

Only very rarely found in England (and generally condemned as 'wrong' when it does appear) is the bellied jug following the form of the Liverpool pottery jug, which may in its turn derive from a group of small silver mugs of this outline seemingly peculiar only to Chester. By 1840, a search for different forms, including the adoption of, and dispensing with the French Empire style after the War of 1812, was a fashion led by President Monroe. The rather ugly, small, bombé beakers of c. 1815 instance this search which culminated in the production of grotesquely flamboyant objects, which foreign though they may be to today's taste, yet were the height of fashion at the time, and evidence of commercial and social success in houses on both sides of the Atlantic. The Centennial Exhibition of 1876 probably marked the nadir of taste, so far as functional design was concerned in the United States.

Throughout the 17th, 18th and early 19th centuries surprisingly little silver of any note, besides objects such as spoons for essential everyday use, seems to have emanated from what was to become known as 'The South'. The answer may lie in the close connections between the planters and Europe and the relative poverty of the remaining rural population. It is unlikely that the victorious Northern troops can be blamed.

See also Burt, Benjamin; Burt, John; Coney, John; Dummer, Jeremiah; Engraving; Hull, John; Hull & Sanderson; Hurd, Jacob; Kierstede, Cornelius; Myers, Myer; Revere, Paul; Richardson, Joseph; Sanderson, Robert; Syng, Philip, Junior; Ten Eyck Family; Van der Spiegel, Jacobus; Winslow, Edward.

Ampulla

Probably derived from the words *amb olla*, meaning a 'round pot'. The three holy oils were contained in flasks, often of similar form to altar cruets, and might in their turn, if of small size, be kept in a chrismatory of casket or trefoil form. No English medieval examples are known to exist, with the possible exception of the body of the gold dove amongst the Coronation Regalia which might have been used as an ampulla. As might be expected in a largely Catholic area, considerable numbers of French Canadian chrismatories and ampullae of 18th-century date survive. The gold ampulla (4), formerly a part of the Scottish Regalia, is engraved with the date 1633 (National Museum of Antiquities, Edinburgh); the form appears to be based on a Chinese porcelain original. So rare are early examples that the two, large, baluster-shaped vases belonging to the Cathedral of Ratisbon which date from c. 1290, should probably be mentioned, in that they may also be of a form made for secular use. One, $10\frac{5}{8}$ in. (27·1 cm.) high is engraved C.S. (*Chrisma Sanctum*), for the Catechism. The other, $9\frac{1}{2}$ in. (24·2 cm.) high, is engraved O.I. (*Oleum infirmorum*), for the sick.

See also Altar Cruet; Canadian Silver.

Andirons

'Item. One paire of awndirons, one firepanne and one paire of tonges'. So runs the inventory of the Fairfax family in 1594.

The central feature of any room in northern Europe is the fireplace and its embellishment has naturally been of the first consideration to its owner. In the days before the invention of central heating, the large fireplace was the general rule and thus of prime importance. This meant that some sort of support for large burning logs was desirable and for this iron rests, or fire-dogs, were provided. The tallest (and rarest) examples, over 20 in. (50·8 cm.) high, are more properly called 'andirons', they are usually accompanied by a pair of smaller fire-dogs. At various times andirons were decorated on the outward, visible side by the application of silver or brass, having on the inner side a slot to receive one end of the iron log-rest. Pokers, tongs, shovels and their rests were also mounted in, or made from, solid silver, though often with an iron core. Six sets remain at Ham House, Surrey, besides a hearth brush and two fire-pans for charcoal or ash. The fireplaces of the Royal Palaces and the houses of the great were more often than not so fitted, although no silver andirons earlier than Charles II's reign appear to have survived. Some of the earliest are those belonging to the Duke of Buccleuch, each surmounted by a figure, probably Cleopatra. Generally speaking these fire sets are seldom dated later than the first quarter of the 18th century, for once installed in a private house, most of these sets seem to have remained in the same fireplace ever since, unless removed of necessity. The metalwork of the dogs is often of only fairly thin sheet metal, though by the 1690s a tendency for cast finials becomes more apparent (5). A pair of extremely fine Elizabethan brass andirons survive at Hardwick Hall and several examples of fire-dogs in silver may be seen at Knole, Ham House, Hatfield, Burghley and in the English National Museums. A pair made in 1671 can be seen in the Museum of Fine Arts, Boston. The 1st Earl of Bristol records on December 31st, 1698 that he 'Paid Watt Compton for a pair of andirons and 2 little knobbs for tongs and shovel weighing 307–14 at 5/4*d*. £82:1:0.'. One of the finest pairs is that made by Philip Rollos in 1704, standing 26 in. (66·1 cm.) high (collection of the Duke of Portland); the scrolling bases incorporate a puffing cherub's mask and from the lobed vases above issue flames.

Bibliography

E.A. Jones, *The Gold and Silver of Windsor Castle*. Arden Press, 1911.
Sir C.J. Jackson, *An Illustrated History of English Plate*. Vols I and II, pp. 249, 275 and 883. 1911.
N.M. Penzer, 'The Royal Fire Dogs'. *Connoisseur*, June 1954.
N.M. Penzer, 'The Plate at Knole', part II. *Connoisseur*, April 1961.
J. Hartley Beckles, 'Fire Dogs'. *Connoisseur*, vol. XIX, pp. 151 and 227.
H.A. Tipping, 'Chimney Furniture at Ham House'. *Country Life*, vol XLVII, p. 448. 1920.

See also Bellows; Fire-irons.

Anthemion

Means 'flower' in Greek and describes a stylised motif representing the flower of the honeysuckle. This motif was widely used in Classical architecture.

Apostle Spoon See Spoon (Apostle Spoon).

Apple Corer

The handle was often formed as a cylinder, with a scoop attachment, crescent in section. One of the earliest to survive is dated 1683, and can be seen illustrated on Plate **60f**. This apple corer also has a pierced finial to the handle for use as a caster. The blade is generally too small for modern apples, but entirely adequate for the smaller varieties of about two hundred years ago. Fully marked examples are rare during the middle of the 18th century.

Arabesque

Fanciful stylised line ornament, usually symmetrical, of scrolling intertwining foliage.

Archery Prize See Arrow.

Argand, Aimé

A Swiss physician who came to England in 1783. His principal invention was an oil lamp, but his patent of 1784 was later revoked on a point of law. The main innovation he introduced was the self-consumption of the wick and soot by the channelling of air to both sides of the wick. Argand contacted Matthew Boulton and arranged for the lamps to be made, in the first instance, in London, and the wicks in Manchester. Olive oil was expensive, and it was difficult to purify the ideal Spermaceti oil. Some of these lamps incorporate Wedgwood plaques and cut-glass decoration. Some have shades fitted with glazed chintz. There are several examples in the Henry du Pont Museum, Winterthur.

In March 1790, George Washington wrote to Governeur Morris: 'I would thank you also for sending to me at the same time fourteen (of what I believe are called) Patent lamps, similar to those used at Mr. R. Morris's, but less costly, two or at most three guineas a piece, will fully answer my purposes. Along with these, but of a more ordinary sort (say at about one guinea each) I should be glad to receive a dozen other Patent lamps for the Hall, Entries, and Stairs of my house. These lamps, it is said, consume their own smoke, do no injury to furniture, give more light, and are cheaper than candles. Order a sufficiency of spare glasses and an abundance of wicks'. From a subsequent list, the fourteen can be identified as the boat- or tureen-shaped lamps in the fashionable elliptical form. Those for 'Hall, Entries, and Stairs' suggest the wall-bracket type (**504**).

Bibliography

Marie Kimball, *Furnishings at Monticello*.
K.C. Buhler, *Mount Vernon Silver*. 1957.

See also Oil Lamp; Sconce.

Argentiferous

Meaning 'yielding silver' and derived from the Latin for silver *argentum*, whence its symbols Ag and Æ, which are used by chemists and numismatists, respectively.

Argentine See Sheffield Plate.

Argyll (Argyle)

Generally accepted as being a container for gravy or sauce, the design incorporating some form of heat-preserving element. This is usually either hot water or a bar of heated iron. The credit for inventing the piece is usually given to one of the 18th-century Dukes of Argyll (created in 1701). As the earliest recorded seems to be that made by Fuller White, 1755–6, the 3rd Duke is the most likely candidate. Josiah Wedgwood advertised them as 'Gravy Cups' in 1774. Their greatest period of popularity was from 1765–1800, when they were made in silver, Sheffield plate and, of course, porcelain and earthenware.

There are four variations of the argyll:
(i) Those with an outer water-jacket, enclosing the gravy reservoir. They are usually filled with water at a point near the top of the handle, the spout (often with an interior grid) passing through the water-jacket (**6**). They are generally cylindrical or vase-shaped, though ovoid and baluster examples are known and even one of helmet form was made by Carter, Smith & Sharp in 1785. Most remarkable,

nd of a large size, being 14 in. (35·6 cm.) high, is hat made by Wakelin & Taylor in 1779 and pre-sented to the Queen's College, Oxford, by Lord Chesterfield. This is formed as a two-handled cup and cover and, having no spout, was probably in-ended for mulled wine or hot punch, rather than gravy, for which it would have been most awkward.

ii) Those having a vertical tube placed within the argyll and designed to hold a heated iron bar. The tube has a cover, usually reflecting in style the cover of the argyll proper, which in this type is more often than not vase-shaped. The spout may be either swan-necked or beak-like. Without the central tube, a number of these pieces have changed hands as 'individual coffee pots'.

iii) Similar to the above, but the inner compartment s conical and thus, though it could be used with ron, water was obviously intended as the heating medium by the maker.

iv) The two-section argyll. This, usually of baluster orm, has a lower section (about one-third of the total height) which is filled in most cases by a pro-ecting intake opposite the spout to which the handle is placed at right angles. This type appears relatively early (one of 1766 is recorded) and lasts nto the 19th century. Wedgwood was even making such 'Gravy Cups' with 'Water Pans' in cream-ware in 1774.

Presumably, such a steady demand for so long a period must have meant that the argyll was con-sidered a satisfactory design. Today, many would question its effectiveness.

Bibliography
G.B. Hughes, *Small Antique Silverware*. Batsford, 1957.
Harold Newman, 'Argylls, Silver and Ceramic'. *Con-noisseur*, February 1969.
G.B. Hughes, 'Silver Argylls'. *Country Life*, April 8th, 1952.

Arris

The sharp edge at the join of two plane or curved surfaces, much emphasised during the Classical revival.

Arrow

The revival of the sport of archery was probably at its greatest during the late 18th century, and it is at this time that most English silver arrows were made, though Musselburgh, Peebles and Scorton Arrows date from the 17th century. They were presented as prizes at competitions and they are often, but not always, inscribed, and seldom particularly accurate representations of the original.

Arrows, as well as bells, are recorded as race prizes in the 17th century and are often referred to as 'barbs'. A plain, cylindrical mug, made in Edinburgh in 1706, is engraved with the arms of that city and inscribed 'This was Gifted by the Town of Edr. to William Neilson Leale. Deanofgild of Edr. who Gain'd the silver Arowat Leith the 13 of June 1710'. A porringer of 1688 engraved with the Arms of Dakeyne on one side and the figure of an archer on the other is inscribed 'Charles Dakeyne, Capt. April 23 1690'. A silver horn, hall-marked 1786, is engraved with the Arms of William, 2nd Earl Fitzwilliam, and those of a Society of Archers which include those of the city of York. A silver quiver, in a private collection, was made in Birmingham in 1819–20, and may be associated with the Coronation ceremonies of George IV in Scotland. The following entry occurs in the *London General Evening Post, No. 2756* for Thursday–Saturday, August 3rd, 1751: 'The same Day, ac-cording to annual Custom, the Silver Arrow was

shot for at the Buts at Harrow on the Hill, by Twelve of the young Gentlemen educated at that School, which was won with Difficulty by Master Stanley. They were near five Hours contending for the Prize, owing to the Equality of the young Gentlemen, who got Nine each, Ten being the winning Number. There was as great a Concourse of People as was ever known on this Occasion'. This competition was begun in 1684 and was last held in 1771; competitors wore a special uniform on this occasion. Some of these arrows survive.

Musselburgh Arrow

Each winner of this small arrow himself presents a silver or gold medal with his name and the date en-graved upon it. These are kept in Archers' Hall, Edinburgh. The earliest is dated 1603, and an un-broken series survive from 1676. The Musselburgh Arrow is competed for by the Royal Company of Archers, the Queen's personal bodyguard in Scot-land. They alone are the only body of men allowed to compete for this arrow, and the arrows of Peebles, Edinburgh, Selkirk and Dalkeith. The arrow of Peebles is 17½ in. (44·5 cm.) long, and dates from *c.* 1628; the Edinburgh Arrow, with the maker's mark of Thomas Ker, is dated 1709 and is 27¼ in. (69·2 cm.) long; the Selkirk Arrow, dated 1660, is 11¾ in. (29·9 cm.) long, and that of Dalkeith, 1727 and 12½ in. (31·8 cm.) long. The Stirling Arrow has been lost since 1745 and was first recorded as being competed for in 1678. Three arrows (two of 17th-century date) survive at St Andrews, and another at Aberdeen.

Scorton Arrow

Made of silver, this arrow is 22 in. (55·9 cm.) long. It is said to have been presented by Elizabeth I to a group of archers at Oxford. At one time it was mis-laid, only to reappear about a century later, in the village of Scorton, near Richmond, Yorkshire. The first recorded contest for this arrow dates from 1673. Since then the competition has been held annually, within the county of York.

Archery Medals and Badges

Although the silver arrow has always held pride of place so far as the Royal Toxophilite Society prizes are concerned, a number of badges, some merely for identification, are known to exist. The largest, of Continental form, is the property of the Royal Toxophilite Society, and depicts an archer at the moment of drawing his bow. This is formed as a breastplate and was probably presented to the Finsbury Archers by Queen Catherine of Braganza, and is dated 1676 (now on loan to the Victoria and Albert Museum). Large numbers of small prize medals of many and varied forms were made as a result of the late 18th- and early 19th-century revival of the sport of archery. The same Society also has a ewer made by Paul Storr, inset with medals in the form of score cards. Small silver horns are not uncommon as archery prizes. That of 1822 given to 'The Bowmen of Walton le Dale' is curved and measures 10¼ in. (26·1 cm.) from lip to mouthpiece. At the turn of the century, firms such as Phipps & Robinson, seem to have specialised in such *outré* work. The drawn bow given by the Duchess of Northumberland to the Archers of Chevy Chase in 1793 was executed by this firm (**7**). The only pair of silver gauntlets, if such they be, are the product of Hester Bateman, made in 1783. Scottish participation in this sport has ever been more general and splendid collections of prize medals survive both at St Andrews and amongst the plate of the Royal Company of Archers.

Bibliography
G.A. Hansard, *The Book of Archery*. 1845. (Con-tains lists of Archery Societies and their prizes.)
A.J.S. Brook, 'An account of the Archery Medals ...

St. Andrews ... Aberdeen, etc.'. *Proceedings of the Society of Antiquaries of Scotland*, vol. XXVIII.
J.B. Paul, *The History of the Royal Company of Archers*. Edinburgh, 1875.
G. Bernard-Wood, '300 years of North-Country Bowmen'. *Country Life*, May 31st, 1962.

Ashet

Derived from the French *assiette*, this name, peculiar to Scotland, is given to the oval meat dish and serves to emphasise the particularly close links that existed for many years prior to the 19th century between Scotland and France. Examples of meat dishes made in Scotland are far less common than those from England.
See also Dish.

Asparagus Tongs

The earliest forms of the asparagus tongs have not survived, although Samuel Pepys, in the 17th cen-tury, records 'a hundred of Sparrowgrass'. In its earliest form, *c.* 1745, the asparagus tongs could be described as scissor-like, seldom more than ½ in. wide, with a corrugated ridge on the inside of one or both arms. The tongs were comparable in size to a pair of tailor's scissors. Later the arms widened and were often pierced. Miss Burdett purchased a pair made by Wakelin in 1771. In Victorian times the scissor form was replaced by a bow, often with a guide bracket. There is, of course, no reason why the early form should not also have been used as a meat server.

Assay

Pure gold is extremely heavy in proportion to its cubic volume and also very soft (malleable) and, if pure, is referred to as '24 carat'. Silver is not so malleable and approximately only half the weight of a piece of gold of similar cubic measurement.

Both are too soft to use in their pure form and must be hardened by the admixture of base metals, usually copper, though silver may be used with gold. If both silver and copper are added to gold it becomes pale and green in colour. If pure copper is added it becomes rich red in colour. The fact that a 50 per cent alloy of copper added to silver retains a silvery appearance can easily lead to fraud with-out protection. In general, the best proportions of gold and alloy are 22 parts pure gold to 2 parts alloy, but this can be varied so that 18, 15, 12 or 9 carats (or parts) are balanced by an alloy making up 24 parts. These balanced fractions of pure gold and alloys are legally used and obviously the less pure gold parts the cheaper the finished product. With silver only two standards are permitted in Great Britain, 925 parts out of 1000 as normal Sterling standard and 958·3 parts as the higher or Britannia standard. By the same measurement, 18 carat gold is the equivalent of 750 parts fine gold to 1000 (24 carats). For most of the English gold coinage and all since 1672, the fineness has never been below 22 carats (916·66 parts gold to the 1000).

In order to protect the buyer of gold and silver, a system of testing, or assaying, and checking the quality and standards of an object is necessary. This can be done by comparison (touch), weight, or chemical means. The first demands considerable visual skill as the object to be tested and a piece of known quality have both to be stroked across a piece of basanite, a hard flint-like slate, and the resulting streaks compared. In the second test, weight, small portions of the object to be assayed are scraped from each piece, wrapped in lead (lead and silver are also used to wrap gold) and heated in a bone-ash crucible. As the heat is applied the

4 Ampulla
Gold, made for Charles I.
Engraved with the date June 18th,
1633. Part of the Scottish Regalia
at the National Museum of
Antiquities, Edinburgh.

5 A Pair of Andirons
Maker's mark, PR, probably the
mark of Philip Rollos.
c. 1695.
Height 15 in. (38·1 cm.).

6 Argyll
Maker's mark of S. & J. Crespell.
Hall-mark for 1769.
Height 4½ in. (11·42 cm.).
The engraved arms are probably
those of Norbury.

7 Bow and Arrow
Maker's mark of T. Phipps &
E. Robinson.
Hall-mark for 1793.
Presented by the Duchess of
Northumberland to the Archers of
Chevy Chase in 1793.

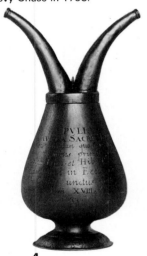

4

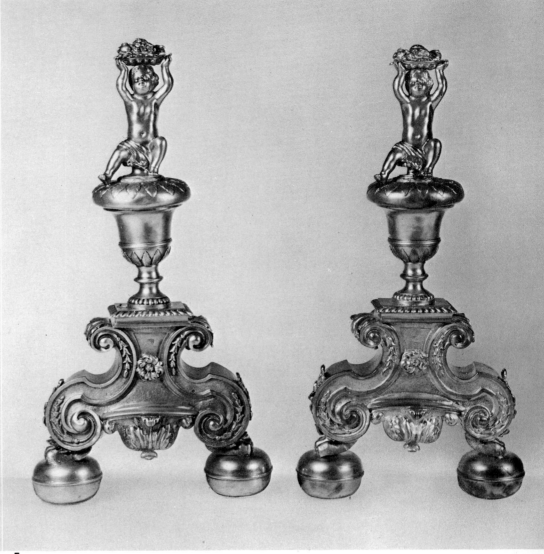

5

6

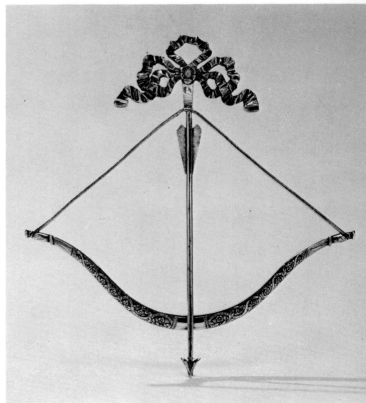

7

ead and other base metals oxidise and are ab-
orbed by the crucible, known as a 'cupel'; the
alance is then weighed and compared with the
weight of the original scrapings.

In the case of gold which is also wrapped in
ilver, a further process is required whereby the
ilver is finally removed by placing it in hot nitric
acid. This method was first recorded in 1495. If, on
completion of these tests, the gold or the silver
are found to be below the lowest permitted stan-
dards, the marks which would guarantee their
quality, 'hall-marks', as they are known, are with-
held and in practice the object under examination
crushed and returned to the maker. Samuel Pepys,
visiting the Mint on May 19th, 1663, records in his
diary for that day a detailed description of this
second method. The third is a simple method and
applicable only to silver, but requires some reason-
able idea of the quality of metal being tested.
This involves the dissolving of the weighed
scrapings, also known as 'diet', in nitric acid and the
addition of a standard solution of sodium chloride
common salt); at a certain point the cloudy
liquid clears and silver chloride is precipitated. A
comparison of the original weight of the silver
sample and the quantity of saline solution required
to do this, enables the fineness of the metal to be
assessed.

There are, of course, other methods of assay,
such as spectroscopic emission, but this is not
normally used by any of the assay offices except
under particular circumstances, such as the assay
of platinum.

Standards for the assaying of silver vary
throughout the world, but no standards for silver
other than Sterling and the Britannia standard are
permissible in Britain. In other countries, however,
different standards for plate-working are often
obtained. As in Britain, the silversmiths over the
centuries established, by trial and tradition, their
own standards, and gradually in most countries
these became legally authorised. Some are higher
than Sterling, others are as low as 800 parts per
1000.

For a list of towns with which town marks have
been associated and the approximate dates of their
activity see the chart below.

Aberdeen	1450—1880
Arbroath	1830—40
Banff	1680—1850
Birmingham	1773—present day
Barnstaple	1370—1730
Bristol	17th century—1800
Canongate	1600—1835
Chester	Early 15th century—1962
Cork	1660—1840
Dublin	1638—present day
Dundee	1550—1834
Edinburgh	1552—present day
Elgin	1700—1830
Exeter	16th century—1882
Galway	1640—1750
Glasgow	1681—1964
Greenock	1740—1825
Guernsey	1690—1750
Hull	1570—1710
Jersey	1760—1830
Kilkenny	1650—1700
King's Lynn	1600—1700
Leeds	1650—1800
Limerick	1700—1800
Lincoln	1420—1710
Liverpool	Late 17th century—1740
London	Late 14th century—present day
Montrose	1650—1820
Newcastle-upon-Tyne	15th century—1883
Norwich	1423—1701
Perth	1550—1850
Plymouth	1600—1700
Sheffield	1773—present day
Tain	1720—1800
Taunton	1640—1700
Wick	1780—1820
York	16th century—1856
	(no plate assayed 1713—78)
Youghal	1650—1720

Those in italic type are towns which devised and
maintained a recognised system of assay marks,
whether or not acknowledged as assay offices by
the Crown and Parliament.

The dates given are not necessarily the earliest
record of a goldsmith or silversmith working in the
city or town.

Bibliography
Wm. Babcock, *A Touchestone for Gold and Silver*.
1st Edition 1657.
W.J. Cripps, *Old English Plate*. 8th Edition, London,
1903.
J.H. Watson, *Ancient Trial Plates*. H.M.S.O., 1962.
Sir C.J. Jackson, *English Goldsmiths and Their
Marks*. 2nd Edition 1921, reprinted 1949.
See also Birmingham Assay Office; Diet and Diet
Box; Goldsmiths' Company; Hall-mark; Pyx, Trial
of; Spectroscopic Emission.

Astragal
Small, continuous, half-round moulding, often en-
riched with beading and other decoration. A smaller
version of the torus, and reverse of the scotia.

Auriferous
Meaning 'gold bearing' and derived from the Latin
for gold—*aurum*; symbols for gold are Au and A∨,
which are used by chemists and numismatists,
respectively.

Badges
Our forebears in the late 17th and early 18th cen-
turies seem to have been particularly addicted to
badges of office which in some cases differed little
in appearance to medals. Arm badges, sewn to the
upper arm of a jerkin, are sometimes as much as
6 in. (15·3 cm.) wide. The Admiralty Barge Badges
are of this size, decorated with an enamelled
anchor, and that for the cox was exceptional, being
a 16¼ in. (41·3 cm.) long breast badge. Of the
original forty-four Admiralty Barge Badges issued
in 1736, some twenty-four were sold in 1849, and
fifteen melted in 1853 to make long service medals.
Besides the Admiralty, City Livery Companies,
corporations, almshouses, great noblemen, Officers
of State (including the Sun Badge of the Yeomen of
the Guard) all furnished their retainers with silver
badges, besides other equipment in the same metal,
as part of their uniform. Badges for the King's Mes-
sengers are made of gilt, and are decorated with a
pendent greyhound. These Messengers were
holders of an office known to exist as early as 1454,
when there were but four, by 1641 their number had
multiplied tenfold. Today they still travel the world
on the Crown's business. The Royal Arms on these
badges are painted and certainly from 1689 on-
wards, were glass covered, that is until the Corona-
tion of Queen Victoria in 1837, after which the
badges were enamelled. These, however, were
worn as pendants hung from a ribbon. More in
accord with our own day are the arm badges of the
Sun Insurance Company, of which a number of
late 18th-century date survive, once worn by its
officers and also the porters, whose duty it was to
evacuate their building in the event of fire. Silver
was also used for Masonic badges. Archery and
school prize medals are other examples more
commonly seen.

From the earliest times, horse harness has been
enriched with metal ornament, sometimes enamel-
led. Earlier than the late 18th century, such objects
are very uncommon survivals. Considerable quan-
tities of heraldic badges, coats of arms and other
such harness or carriage ornament made in silver
(including buttons for footmen and grooms) have,
however, survived from the 19th century. An
enormous volume was also made in heavily
coated Sheffield plate or electroplate.
See also Breastplate and Gorget; Corporation and
Ceremonial Plate; Dogett, Thomas; Masonic
Badges and Jewels; Medal; Shoulder-belt Plate;
Theatre Ticket.

Baluster
A small pillar or column of varied outline, used in
describing metalwork, especially the stems of wine
cups, standing cups, communion cups and candle-
sticks for which this shape was particularly
favourable.

Bannock Rack
Triple-row variant of the toast rack, generally
Scottish. An example by Patrick Robertson of
Edinburgh, 1773, is in the Royal Scottish Museum.

Barding Needle
Such needles are extremely rare. The finger ring
handle is placed slightly above and beyond the
crescent section at one end of the needle (**60a**).
Presumably it was used to insert rolls of bacon into
a fowl or beneath the outer skin of a joint prior to
cooking.

Barnstaple
Besides a few larger pieces, such as the cup of *c.*
1550 made by Thomas Matthew (now lacking its
cover), belonging to Poughill Church, Cornwall,
considerable quantities of spoons, usually of fine
quality, but sometimes with coarsely finished,
large and clumsy finials, came from this town
during the 16th and 17th centuries. Silver was
mined nearby and a number of makers have been
identified and associated with this town; Peter
Quycke (Quick), John Peard or Peart, John Coton
and several others. The town mark, sometimes
'BARNVM' or a cypher, seems to have been a
matter of individual taste. The town badge was a
bird until 1624, when a grant of arms gave the
town a turret. Both marks have been found on
Barnstaple spoons.
See Spoon (Ceremonial Spoon).

Bartholomew Fair
A fair was held annually from 1133 to 1855 at West
Smithfield, London, for the last two weeks of
August, starting on the 24th day of the month. It
became normal practice for the more important
silversmiths to set up shop at the fair, which was
often patronised by the greatest in the land. Many
small, often shoddy, pieces of 17th-century silver
were probably brought here as a 'fairing'. A travel-
ling set of fine quality survives, engraved 'Bartholo-
mew Fairing sent by His Grace the Duke of Ormond

to Fridasweed Lady Stephen 1686'. What is thought to be the earliest surviving piece of American silver, a small, two-handled, shallow dish or saucer, made by Hull & Sanderson, c. 1650, is just such a 'fairing'. It bears the initials of a girl married in 1651.

Other 'fayers' were set up as the occasion demanded, sometimes without the required legal charter and documentation. Those times when the Thames froze solid in the heart of London, as recorded by Pepys and others, were quite sufficient as an excuse. A turned wood tumbler cup with silver rim inscribed 'Bought at ye Fayer upon ye Ice on ye River Thames in ye Greatt Frost January ye 26th 1683–4 for Priscilla Tavernor' has a maker's mark only, SP. Such pieces were exorbitantly expensive in comparison to their real worth. A soup ladle of 1732 in the Guildhall Museum, London, is engraved with an inscription relating to the Great Frost of 1739–40. A piece of glass of the Ravenscroft type with a silver rim also bears a 17th-century Frost Fair inscription. Such fairs were usually visited by the Wardens of the Goldsmiths' Company and their records bear ample proof of a series of fines thereafter imposed for sub-standard wares offered for sale.

Bibliography
W. Andrews, *Great Frosts and Frost Fairs*.
See also Travelling Canteen.

Basin See Ewer and Basin.

Basin, Liturgical
Reference is made under Ewer and Basin to the two basins bequeathed by Bishop Fox to Corpus Christi College, Oxford. Though no proof can be adduced it seems possible that these may have been intended for use at the altar, the water being poured from the one, into the other, over the celebrant's hands. Certainly a number of major foundations were known to possess such sets during the Middle Ages, York Minster having a pair of gold basins dating from about 1300.

Bibliography
C.C. Oman, *English Church Plate*. Oxford University Press, 1957.

Basin, Pudding
Oval in shape, occasionally circular, and formed just as a modern pie dish. Surviving examples are uncommon and seldom date earlier than 1750. A plate list of 1752 notes '2 basons to bake puddings in. 39.–0'.

Basin, Sugar See Sugar Bowl.

Basin, Wash See Bowl.

Basket, Bread or Dessert
The name is symptomatic of the individual's requirement of the piece. In the 18th century they were also known to be used as sewing baskets, although most of the entries in the Wakelin Ledgers of the 1770s refer to them as 'bread baskets'. The earliest known appears to be that of 1597 (**8**). Circular in shape, the decoration of this basket consists of pierced scalework and its very average quality is such as to incline one to believe that these were made in considerable numbers, but only a few rare examples have survived. One, dated 1602, is also known to exist. Another of 1641 (**9**), is pierced with cherubs' heads and scrolls and another, dated 1656, pierced with flowers, foliage and ovolos, also survives. However, it is not until the 1700s that baskets generally take the accepted oval form as illustrated on Plate **11**. John Hervey, 1st Earl of Bristol, writing on October 7th, 1696, describes a

basket he had bought as 'ye great silver chased baskett weighing 128 oz. 4 dwt.'. A similar one made by William Denny, c. 1700, is at present in the collection of the Duke of Portland. These baskets, still circular or oval at will, pierced and chased to represent basket-work soon came to have a D-loop handle on either side. A circular pair made by Lamerie in 1724 were in the collection of the Earl of Haddington. By 1730 the handle may be fixed and centrally placed (**13**), and shortly afterwards the swing handle appears (**12**). Pierced, foliate and geometrical ornament is seldom seen before 1735, but from this date onwards the variety in shape and decoration is endless and the sides tend to curve further outwards so that the base is of considerably smaller compass than the everted rim. There is a fine, large, circular basket executed by Thomas Farrer in 1725, some 12¾ in. (32·4 cm.) in diameter, in the Royal Collection, and a pair of oval, two-handled examples made by Paul de Lamerie in 1736 in the Farrer Collection, Ashmolean Museum, Oxford. In these later more elaborate examples the bowl is made of one piece of metal with cast feet and an applied rim (**14**). Comparatively rare are the shell-shaped baskets (**15**), appearing about 1740, with a rising scroll handle at one end. Two fine examples in this style also made by Lamerie and dated 1746 and 1748 are amongst the Farrer Collection, Ashmolean Museum, Oxford. By 1760 the quality of piercing had much improved and baskets had become far less massive. However, the use of small fly presses and the construction of the bowl from up to a dozen separate panels, each of different design, the joints between being concealed by a wirework ribbon, proved too severe a challenge for the handworker. At the same time, wirework baskets sometimes decorated with applied sprays of corn and foliage, encouraging the belief that such baskets were usually intended for bread or rolls, made their appearance even in Sheffield plate (**17**). Wirework was the cheapest form for such a basket, and in 1784 one cost £2 15s 0d. By 1775 the factory-made baskets had fairly ousted their competitors and the quality, in general, seems to have suffered as a result (**18**). American baskets appear to number only two. One made by D.C. Fueter of New York, c. 1755, is in the Museum of Fine Arts, Boston. The other is in the Metropolitan Museum of Art, New York. A plain, oval basket of 1781, with a handle to one side, is in the possession of Liverpool Corporation and appears to be extremely rare as it has a central division. Much smaller baskets, either circular or oval, were supplied in sets as part of the fittings of an epergne. Somewhat surprisingly the silver basket appears to be confined in general to Britain. This may explain the mystery of an English basket of 1764, now to be seen at the Henry du Pont Museum, Winterthur, for its marks have been carefully drilled out and those of a contemporary American maker substituted. At least one set of four baskets of late 18th-century date, having a handle at either end, is known.

Of different form is the oval basket of 1677, the property of the Council of the London Stock Exchange, which, like another oblong example made by Pierre Harache in 1686, may have been intended as a layette basket. Both are shallow, but would seem to follow the development of the basket rather than the tray (**10**). Variations are numerous at the turn of the 19th century, some examples having handles, others handleless (**20**) and some reverting to an earlier form (**19**). The Regency period expected something far grander than the late 18th century and accordingly produced baskets to suit this taste (**21**). A most remarkable basket is that made by Robert Hennell in 1850,

some 8¼ in. (21·0 cm.) long, which recently came to light. It has twelve internal nest-like divisions and was presumably intended for plovers' eggs or even spitted wheat-ears.

Bibliography
G.B. Hughes, 'Pierced Silver Table Baskets'. *Country Life*, November 10th, 1950.
See also Epergne.

Bateman, Hester (1709–94)
The daughter of Thomas and Ann Needham, who married John Bateman, a gold chain maker, on May 20th, 1732. They had four sons, John, Peter, William and Jonathan and two daughters, Letticia and Anne. By 1747 the Batemans had moved from Nixon's Square, St Giles, Cripplegate, to 107, Bunhill Row, just outside the City of London and almost opposite the Armoury House. In 1760 John Bateman died. His eldest son John had become free of the Goldsmiths' Company in 1751, but predeceased his mother in 1778, leaving a wife and three children named Thomas (a goldbeater), Peter and Hester. At the time of the elder John's death, his second son Peter was finishing an apprenticeship commenced in 1755; he survived until 1825.

Hester Bateman, Senior, entered her mark, a script H B, at the Goldsmiths' Hall in 1761 (a). Much of her earlier work was commissioned as 'outwork' by other silversmiths and retailers and on its receipt they overstruck the Bateman punch with their own. At first the family largely produced flatware, spoons and forks, but then the firm moved on to larger domestic objects. In 1769, Jonathan Bateman, Hester's youngest son, married Ann Dowling. In 1790 Hester Bateman retired, and her sons Peter and Jonathan, registered their joint mark (b), but when Jonathan died in 1791 his widow, Ann, registered a new mark in conjunction with her brother-in-law (c).

In 1800 they took into partnership Ann's second son, William, and registered his mark with theirs (d). In 1805 Ann retired and a new punch, the initials of Peter and William Bateman, was brought into use. Peter Bateman retired in 1815 leaving William in full command until 1839, when he in turn handed over the business to his son, another William.

a b c d

Some of the work of the Bateman family is illustrated on the following Plates: **322, 382, 393, 420, 492, 584, 625b, 656**.

Bibliography
David S. Shure, *Hester Bateman*. W.H. Allen, London, 1959.
See also Women Silversmiths.

Bath
Generally used as a colloquial 18th-century description for a wine cistern. But it is just possible that a bath in the modern sense was implied by the entry in the *British Gazetteer* of August 15th, 1724: 'Some days ago, Mr. Crispen, a silversmith of this city carried the fine silver bathing vessel (Made for the King of Portugal) to his Majesty at Kensington who was well pleased with so curious a Piece of Workmanship, which can scarcely be match'd in all Europe'. It weighed about 6,030 ounces and the last phrase might well discount its being another wine cistern.
See also Wine Cistern.

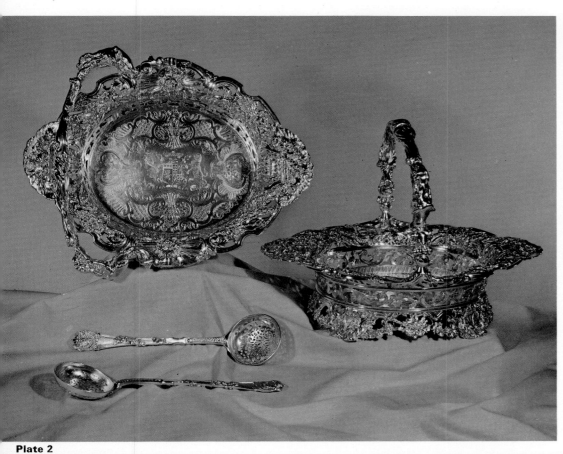

Plate 2

Plate 2 A Pair of Baskets with Associated Ladles
Maker's mark of Paul de Lamerie.
Hall-mark for 1737.
The baskets are 16 in. (40·6 cm.) wide.
The ladles are unmarked.
From the Woburn Abbey Collection, by kind permission of His Grace the Duke of Bedford.

Plate 3 A Set of Beakers and a Monteith
Maker's mark, IL in a heart with a fleur-de-lys below.
Hall-mark for 1688.
These thirteen beakers, together with the monteith, were presented to the Corporation of Newark-upon-Trent, Nottinghamshire, by Nicholas Sanderson.

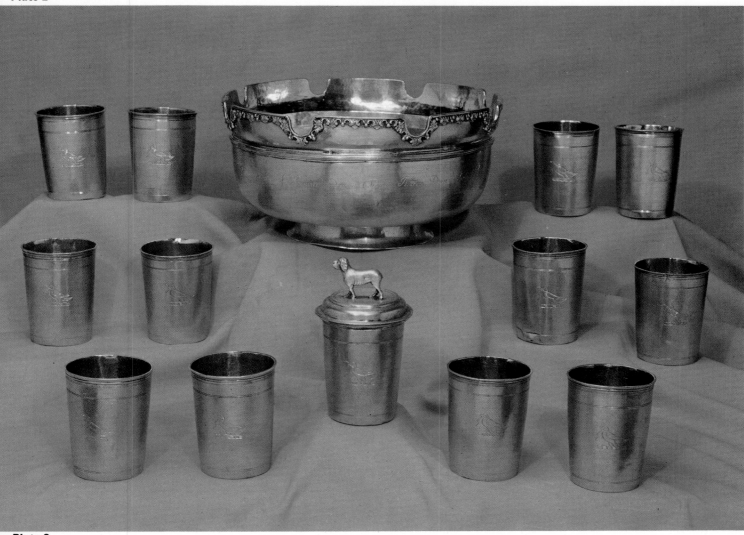

Plate 3

Plate 4 Sugar Box
Maker's mark of Edward Winslow of
Boston, Massachusetts,
c. 1700. Width $7\frac{1}{2}$ in. (19·1 cm.).
Henry du Pont Museum, Winterthur,
Delaware.

**Plate 5 Three American
Panelled Bowls**
The largest bowl bears the maker's
mark of Jacob Ten Eyck of New
York, *c.* 1730.
Diameter $7\frac{1}{2}$ in. (19·1 cm.).
The smallest bowl bears the maker's
mark, H.B. (possibly the mark of
Henricus Bolen of New York), *c.*
1690. The other, plain bowl of *c.*
1690 also bears the maker's mark,
H.B. Diameter $4\frac{1}{16}$ in. (10·3 cm.).
Henry du Pont Museum, Winterthur,
Delaware.

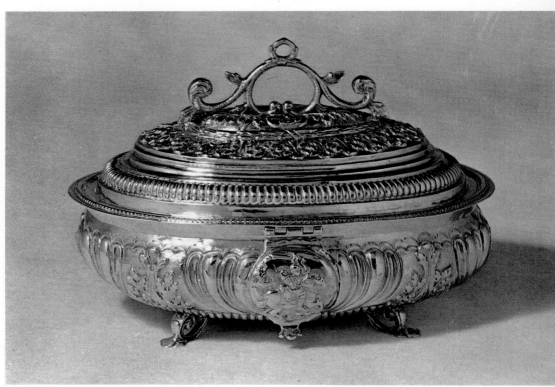

Plate 4

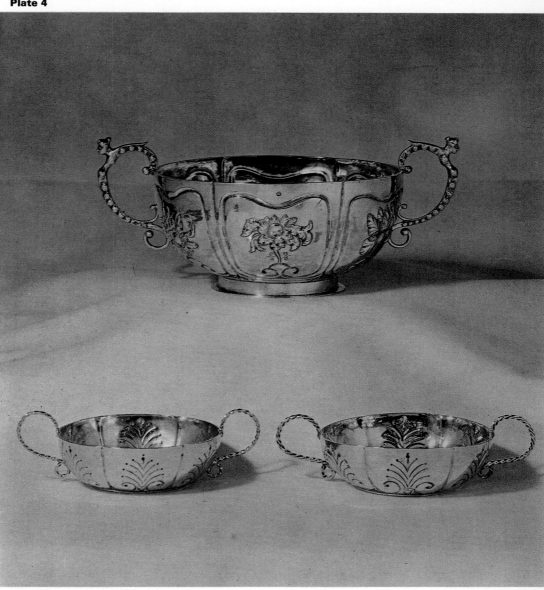

Plate 5

Baton, Field-Marshal's and Staff of Office

Silver- and gold-mounted staves of hardwood or ivory have been the badges of office for those holding great positions for many centuries. The more lengthy examples may be used as a staff (see Cane and Staff), the shorter ones are more correctly called 'batons', usually about two feet in length. Merton College, Oxford, possesses such a baton of about 1620, the badge of authority of one of its officers, the Steward of the Manor of Holywell. Those of an Office of State have the silver finials engraved with the Royal Arms at one end and those of the holder at the other. Batons of command, such as those depicted in portraits, seem usually to have been covered in leather or velvet, perhaps even enclosing a telescope. Though the first British commander to be appointed to the rank of field-marshal was the Earl of Orkney in 1736, the earliest English field-marshal's baton, of the now commonly accepted form, seems to be the fine, if garish, gold example given by the Prince Regent to the 1st Duke of Wellington in 1813, now at Apsley House. It was supplied by Rundell, Bridge & Rundell. The inspiration for its form, velvet covered, sprinkled with stars and surmounted by the figure of St George and the dragon, being the baton of Marshal Jourdan captured at Vittoria on June 21st of the same year (Collection of Her Majesty the Queen). At least three such batons were also awarded to Admirals of the Fleet in 1821. The finely worked staff of James Compton, 3rd Earl of Northampton, as Constable of the Tower of London from 1675–81, should probably also be mentioned under this heading.

See also Cane and Staff; Corporation and Ceremonial Plate.

Bay-leaf Garland

Worn as a crown by heroes or poets of Classical tradition, and used in stylised form to enrich torus mouldings, especially during the later years of the 17th century and the Neo-Classical revival.

Bead and Reel

Enrichment of astragal, or continuous half-round moulding, with alternate beads and reels; copied from Classical architecture.

Beaker

The earliest surviving beaker appears to be that preserved at Trinity Hall, Cambridge. Though it may not be English it has inspired many that are. The finial of its cover is missing, nevertheless the inside of the beaker bears an enamelled print with the arms of the donor, and founder of the college, William Bateman, Bishop of Norwich, who died in 1354. The Founder's Cup of Oriel College, Oxford, c. 1460, is also the subject of much controversy as to its origin. A silver-gilt beaker, which is in a private collection, is undoubtedly English as it bears the hall-mark for 1496; the 'horse nail' ribs applied to the sides are an interesting form of decoration also found on bronze mortars. The Founder's Cup and cover of Christ's College, Cambridge, dated 1507 (22), is another early survival of beaker form, though having a disproportionately large foot. There is another beaker of 1525 recorded, and a fine large example, again belonging to Christ's College, Cambridge, is encrusted with precious and semi-precious stones. Three fine beakers and covers survive from the late years of the 16th century. One, the Magdalen Cup of 1573 (24) is in the Manchester City Art Gallery; so called from the number of beakers of similar form depicted in late 15th- and 16th-century paintings of the washing of Christ's feet by Mary Magdalene. Another of 1584 is at Frecheville, Derbyshire, and a third, as fine as the first, has an associated cover. The 16th-century beaker generally has a wider, more spreading foot than its successors; it is, therefore, a form not capable of very great variety, but affords none the less great scope for the decorator (23), and it seems likely that at this time sets of beakers were made, as in later centuries. Those with a pronounced rib below the lip seem to have almost certainly been made as part of a set, being perhaps the 'bowl for wine (if not a whole nest)' referred to by William Harrison writing in the 1580s. An example of one such beaker, part of a set, belongs to Honington Church, Lincolnshire, and dates from 1577, whilst an actual set of nine made in 1615 are now to be found in the Kremlin, Moscow. A nest of four with their cover, dated 1664, are in the Hutchinson Bequest, Fogg Art Museum, Harvard University, Massachusetts (26). A number of perishes, particularly in Scotland, use beakers as communion cups, but from 1550 to 1660 the standard cup elsewhere within the British Isles has a bowl of beaker form. A set of seven made in 1654 for the Old Independent Church, Great Yarmouth, still survive. The Dutch influence is pronounced upon those emanating from Norwich and the surrounding districts. Trinity Hall, Cambridge, has a number of beakers known as 'tuns'. The earliest dates from 1690 and was probably inspired by the Founder's Cup of that college referred to above. Most late 17th-century beakers are considerably shorter than those of earlier date, and occasionally have a stand or cover (25 and 28). A particularly handsome beaker of 1701 was made by Benjamin Pyne and decorated with cut-card work; it forms part of the Douai Treasure, now preserved at St Edmund's College, Ware, Hertfordshire. At Oriel College, Oxford, are a number of beakers, each one having two scrollwork handles. The earliest is hall-marked 1677 and the handles appear to be contemporary. A remarkable nest of thirteen beakers, together with a monteith, made in 1688 was presented to the Corporation of Newark-upon-Trent, by Nicholas Sanderson (Colour Plate 3). The cover, common to all, is surmounted by his crest, a talbot. A nest of three, once at Hare Court, hall-marked 1697, measuring 4 in. (10.2 cm.), 4$\frac{1}{8}$ in. (10.5 cm.) and 4$\frac{1}{2}$ in. (11.5 cm.) high, were sold at Christie's on December 17th, 1930. Small travelling sets, usually designed for the use of one person, generally included a beaker, sometimes oval in shape (684 and 685). Some of these have lavished upon them the finest engraving that the late 17th century could produce. A pair in gold, one made by Benjamin Pyne in 1719, are in the collection of the Duke of Portland. Two other gold beakers, one dated 1685, the other 1697, with cover, were originally gifts given by the Turkey Company and valued at about £60. The Duke of Portland also has a pair of exceptionally fine beakers in the Régence style of c. 1705. A shaped, gold beaker, only 2$\frac{1}{2}$ in. (6.4 cm.) high was made in 1716 for Lady Margaret Cavendish Harley. It is engraved on one side with a view of the White Tower in the Tower of London, in which her grandfather was confined at the time; on the other side is inscribed the word 'Remember'. Harley was imprisoned on a charge of high treason, but was released in 1717. But for a coat of arms or crest and a moulded foot, 18th-century beakers are usually plain, and by 1775 even the moulded foot is seldom found. The Chester Gold Race Cup of 1774 is of beaker form. The sides, tapering inwards from the base, give a solid if inelegant effect. 19th-century nests of beakers are usually entirely contained within the lines of the largest and they therefore diminish in size and capacity.

Generally speaking, beakers do not seem to have been popular for secular use in Colonial America (27). There is, however, a superb example of 1685, by Cornelius Van de Burgh, in the Garvan Collection, Yale University Art Gallery, and one of the most remarkable pieces of American engraving, probably inspired by a political print, is that on a beaker by D.C. Fueter now in the Henry du Pont Museum, Winterthur (30). Though engraved with the date 1778, it may well have been made as early as 1755. By 1800, however, a particular form of sturdy beaker had made its appearance having sides at first vertical then tapering sharply towards the base. These are peculiar to the United States and are often called 'Julep cups'. E.A. Jones, in his study of American Church Plate, found 'no fewer than 577 silver beakers, over 56 of these being of American workmanship'. These latter often show considerable Dutch influence. The Congregational Church of Hampton, New Hampshire, has a set of eight plain beakers made by John Coney, which appear to have been purchased in 1713.

Double beakers forming a barrel are much less common. An Elizabethan example of 1572 does indeed survive in the Hermitage, Leningrad, but the majority are of late 18th-century date (29), a large number being made in Chester. They should not be confused with the very rare pairs of 17th-century tumbler cups that take the form of a dumb-bell.

Bibliography

C.C. Oman, *The English Silver in the Kremlin, 1557–1663*. 1961.
C.C. Oman, 'The Douay Treasure'. *Connoisseur*, August 1958.
C.C. Oman, 'Cambridge College Plate'. *Connoisseur*, April 1959.
A.G. Grimwade, 'A New List of Old English Gold Plate', part II. *Connoisseur*, August 1951.
Treasures of Cambridge Exhibition. Goldsmiths' Hall, 1959.

See also Cup; Goblet; Monteith; Travelling Canteen; Tumbler Cup; Tun; Vase.

Beef Machine

The Wakelin Ledgers (Victoria and Albert Museum) contain an entry in the year 1775 for the Duke of Chandos a 'beef machine' which, together with a cream ewer, weighed 16 ounces 5 pennyweights. No obviously recognisable object exists, but there is extant a pair of detachable brackets which could presumably be clamped to the side of a meat dish (in a private collection). Each bracket is furnished with a forked finial, the whole weighs 11 ounces 5 pennyweights and was made by Thomas Heming. At least three other pairs, one by the same maker, are also known. It is possible that these brackets are indeed the beef machine referred to, but the method of their use is conjectural. On the other hand, Sir Robert Burdett purchased at the same time a 'beef machine' and a 'beef skewer' on April 18th, 1772. Asheton Curzon did likewise a week beforehand, his skewer having a hole (probably a ring top). In 1774 Charles Bouchier purchased 'a chain and pin to a Beef Machine'.

Bee-hive See Honey Pot.

Beer or Ale Jug See Jug.

Bell

Gold, silver-gilt and silver have all been used as decoration for the shrines of the 9th to 12th-

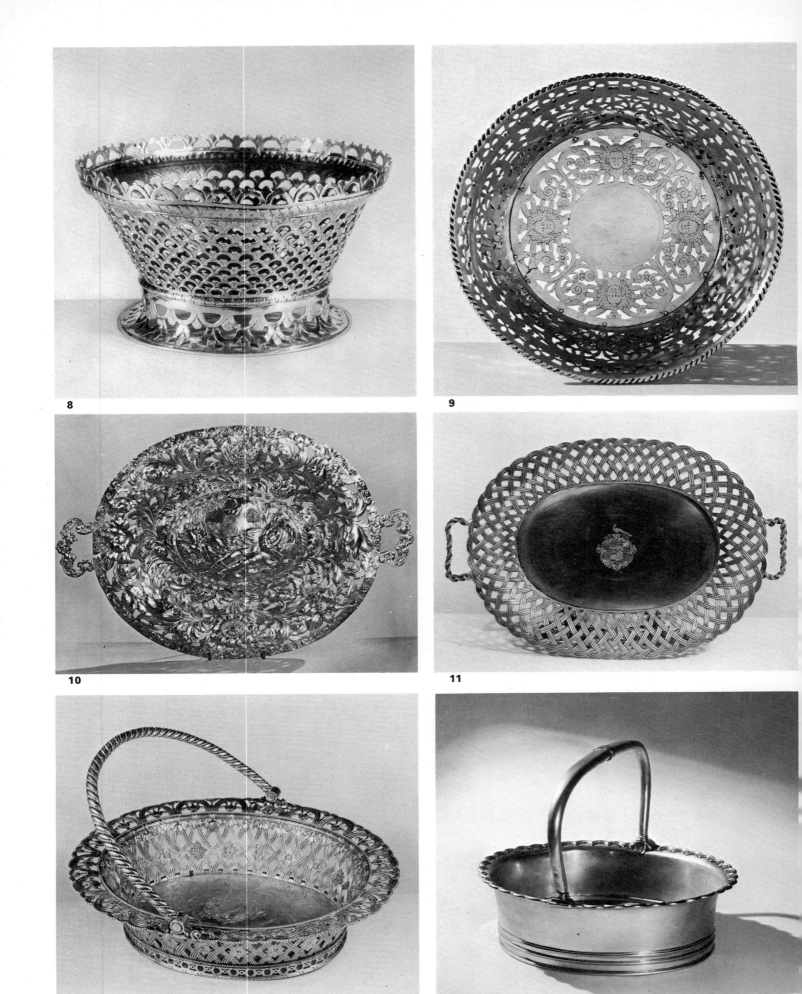

8

9

10

11

12

13

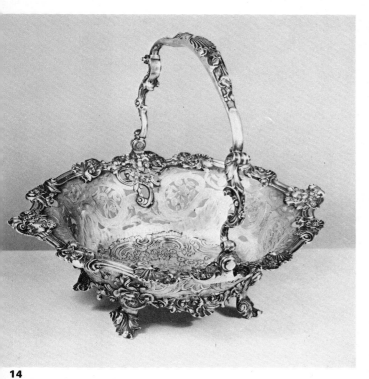

14

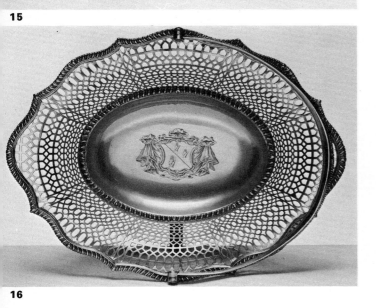

15

8 Basket
Maker's mark, a branch.
Hall-mark for 1597.
Diam. 8¼ in. (21·0 cm.).
Height 4¾ in. (12·1 cm.).
One of the earliest known baskets.

9 Basket
Maker's mark, PG with a rose below.
Hall-mark for 1641.
Diam. 10¼ in. (26·1 cm.).
Decorated with cherubs and scrolls.

10 Basket
Silver-gilt.
Maker's mark, TN and another.
Hall-mark for 1677.
Width 24 in. (61·0 cm.).
Council of the Stock Exchange.
The four feet were added at a
later date.

11 Basket
Silver-gilt, one of a pair.
Maker's mark of John Eckford.
Hall-mark for 1703.
Width 14½ in. (36·9 cm.).

12 Basket
Maker's mark of Paul de Lamerie.
Hall-mark for 1734.
Width 13¼ in. (33·7 cm.).
It has a swing handle.

13 Basket
Maker's mark of John Hamilton.
Hall-mark for 1736, Dublin.
Engraved with the Arms of Meade.
It has a fixed handle.

14 Basket
Maker's mark of Paul de Lamerie.
Hall-mark for 1746.
The bowl is made of one piece of
metal with an attached rim and
cast feet.

15 Basket
Maker's mark of Phillips Garden.
Hall-mark for 1750.
Width 15 in. (38·1 cm.).
Polesden Lacey.
Fashioned as a shell, one of the
most popular forms of the mid 18th
century.

16 Basket
Maker's mark of Edward Aldridge.
Hall-mark for 1759.
Width 15½ in. (39·4 cm.).
Engraved with the Arms of Adair.

17 Basket
Maker's mark of Parker & Wakelin.
Hall-mark for 1773.
Diam. 12¼ in. (31·2 cm.).
This was most probably a bread
basket.

18 Basket
Hall-mark for 1782.
A factory-made basket.

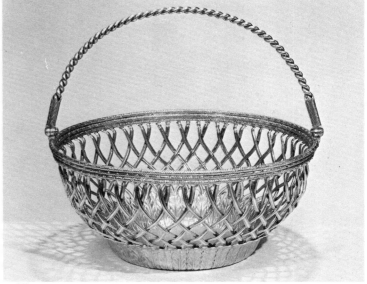

17

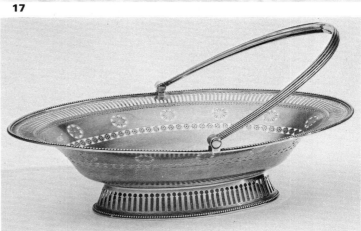

18

16

19 Basket
Maker's mark of Paul Storr.
Hall-mark for 1794.
Width 11¼ in. (28·7 cm.).
20 Basket
Maker's mark of W. &
P. Cunningham.
Hall-mark for 1801, Edinburgh.
Length 16¼ in. (41·3 cm.)
21 Basket
Silver-gilt, one of a set of four,
originally made with glass liners.
Maker's mark of Paul Storr.
Hall-mark for 1815.
Width 12¼ in. (31·2 cm.).

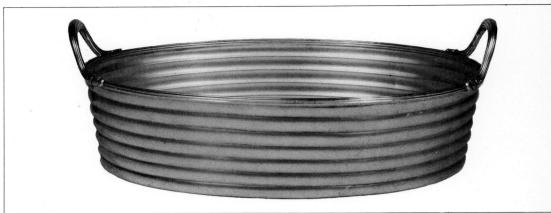

19

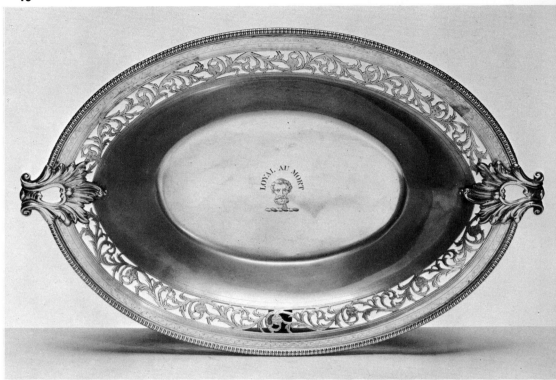

20

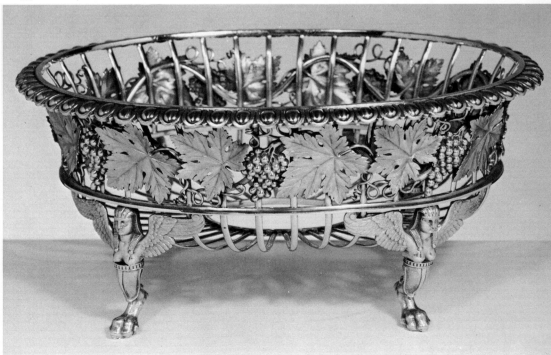

21

century bronzed iron bells, mostly associated with the Celtic Saints. These, however, are of an earlier date than those concerning us, which fall into four main categories. Small spherical bells are also found on children's rattles of the 18th and 19th centuries. Also spherical are the four pendent bells round the standing mazer of 1523 belonging to the Barber-Surgeons' Company to whom it was given by King Henry VIII. These are probably the earliest to survive.

Table Bell
These comparatively large bells are extremely rare. In form, they are identical to those belonging to an inkstand and it is only by their greater size that they can be distinguished from the inkstand bell. They usually date from the first half of the 18th century. An example is to be seen in the collection of the Duke of Portland, it dates from about 1690 and was made by Anthony Nelme. Robert Cecil, in his portrait of *c.* 1600, which hangs in the National Portrait Gallery, London, is depicted with just such a table bell beside him.

Inkstand Bell
In the days when the postal delivery was a much more occasional occurrence than it is today, it was imperative that a letter, once written, should be dispatched as soon as possible. This, together with the convenience it afforded of summoning a servant, was the reason that amongst the other accessories of the 18th-century inkstand was a bell (**32**). Usually this was centrally placed on the stand and also acted as a cover for a shallow well, in which were kept such things as seals and wafers. Usually the handle was of baluster form and occasionally it also formed a socket for a taper. Though not exempted from hall-marking, there is no doubt that almost half the surviving 18th-century bells are unmarked. Being separate pieces, and having a particular use apart from the inkstand to which they originally belong, many have been parted from their companion pieces. The Plaisterers' Company possess an unmarked example engraved with the date 1648, and the Goldsmiths' Company one of 1666 (**31** and Colour Plate 30). An inkstand bell belonging to the Royal College of Physicians is hall-marked 1636 and may be the earliest to survive, the Duke of Portland having another of 1637.

Coronation Bell
The canopy, which was held above the sovereign at his or her coronation by the representative Barons of the Cinque Ports, was embellished at the end of each 8 foot canopy pole by a silver bell. At every coronation such bells were made and one was the perquisite of each bearer. Three such bells made for the Coronations of 1714 (**33a**), 1761 (**33c**), and 1820 (**33d**) are in the Victoria and Albert Museum, another is amongst the silver at Lulworth Castle and is derived from the Coronation canopy of George II (**33b**). Another, converted to a table bell, is also in existence. Perhaps the earliest unmarked example is that engraved with a crown and the initials C R, probably standing for Charles II. A similar canopy also protected the consort. The number of bearers seems to have varied from six in 1661, 'under a canopy borne up by six silver staves, carried by Barons of the Cinque Ports, and little bells at every end', to perhaps as many as sixteen in 1820, though it is difficult to be sure that this latter figure refers only to one canopy. Froissart records the canopy of Henry IV as having gold bells (probably gilt) at each of the four corners. The Royal Mass Bell, made in Edinburgh in 1686 by Zacharius Mellinus, for use in the Chapel of Holyrood House by James VII of Scotland, whilst he was still Duke of York, also survives

in the possession of St Mary's Blairs, near Aberdeen, Scotland.

Race Bell
Two spherical bells, the usual form for a horse bell, still survive. One of silver-gilt dates from 1590, the other one is dated 1599. Both were awarded at Carlisle Races as prizes (**34**). Another pear-shaped bell of 1608–10 was given at Lanark and one of the two Paisley Bells is dated 1620. Others were also awarded at Chester (first in 1571), though none are known to survive, whilst a gold one was given at York in 1607. This custom giving rise to the phrase 'to bear away the bell'.

Bibliography
G.B. Hughes, *Small Antique Silverware*. Batsford, 1957.
G.B. Hughes, 'Silver table bells'. *Country Life*, December 20th, 1956.
Edward Perry, 'Gift Plate from Westminster Hall Coronation Banquets'. *Apollo*, June 1953.
J. Fairfax-Blakeborough, *Northern Turf History*. 1949.
A.J.S. Brook, 'The Silver Bell of Lanark'. *Proceedings of the Society of Antiquaries of Scotland*, p. 174, March 9th, 1891.
Joseph Strutt, *Sports and Pastimes of the People of England* (p. 33).
Hubert Fenwick, 'Silver for Huguenot and Catholic'. *Country Life*, April 25th, 1968.
See also Inkstand.

Bellows
Surviving examples are very rare. One, decorated with marquetry and silver-gilt mounts was probably made by Benjamin Pyne, *c.* 1680; it is in the Royal Collection at Windsor (**35**). Another, almost a duplicate by the same maker, though not of gilt, probably originated from Chobham Hall, Kent, and is now in the Ashmolean Museum, Oxford (**36**). Both bear the cypher of Charles II. Another pair at Ham House, Surrey, have one side totally encased in silver. In the same house a second pair (noted by Walpole) still survive, although the filigree mounts need not necessarily be English. There is a pair, bearing the Arms of Maitland and dating from about 1675, in the collection of Judge Untermyer. Numerous imitations of silver-mounted fire-irons, and so probably bellows, were made *c.* 1900.

See also Andirons; Fire-irons; Furniture.

Berain, Jean (1638–1711)
A French architect, designer and engraver; master of the late Baroque style of decoration, he exercised considerable influence on the Huguenot goldsmiths. Sheets of designs were issued by him in large quantities, together with more designs executed by Jean Lepautre (1618–82), and Paul Ducerceau (*c.* 1630–1713). These designs must have been imported into Great Britain in some numbers. Jean's brother Claude was also an artist of considerable merit.

Beresford Plate
The Beresford Plate originated with William Carr Beresford, born in 1768, son of the 1st Marquess of Waterford. Some one hundred and seventy-five pieces of silver and Sheffield plate came by descent into the hands of Harold Beresford Hope, who had married a Pole in 1910, was a diplomat. In 1917 he died, leaving this plate for the use of His Majesty's Legation, as it then was, in Poland. The Legation became an Embassy in 1918 and the plate was used in Warsaw until 1939, when it was necessarily left behind at the outbreak of the Second World War. By 1945 it had disappeared. In

the same year a few pieces were recovered, and eight more pieces in 1946, including two wine coolers. In 1956 a pair of candelabra and a meat dish were discovered in New York.

Thus, it may be assumed that much of the Beresford Plate, together with that of the old British Embassy in Constantinople and what survives from St Petersburg, is still extant.

Bibliography
'Where is the Beresford Plate?'. *Connoisseur*, April 1957.

Bermuda
Generally speaking, most articles of Bermudian silver are small, such as table silver and shoe buckles. However, of surviving Bermudian silver, at least two tankards made by Thomas Savage, are known today.

Bibliography
Erica Manning, 'Bermuda Silversmiths'. *Country Life*, February 27th, 1964.

Bezoar (stone)
A calculus or concretion found in the stomach of some animals, usually ruminants, formed of layers of animal matter deposited round some foreign substance. Bezoar stones were supposed to have antidotal and other medicinal properties; examples are known to have been mounted in silver or gold, and, if European, are usually of 16th- or 17th-century date.

Billet
May apply to one of three definitions: (i) a thumb piece on a tankard, flagon or ewer; (ii) Gothic moulding of short cylinders or squares at regular intervals; (iii) an ingot of metal.

Bird Cage
A number of hemispherical, wirework domes are known from the 1770s, decorated with applied swags of fruit and foliage, and of a size suitable to fit over a second-course dish. The purpose of these is uncertain, perhaps they were intended as a decorative cover to a prepared cold dish. There is a much larger example, on oblong plateau, some 17 in. (43·2 cm.) wide, which may also have been intended for the same purpose. On the other hand a bird or squirrel cage cannot be excluded. Neither can a 'surprise' at table, which was a favourite 18th-century affectation. The front of a cylindrical mug, which is dated 1778, is engraved with a canary-like bird beneath a scroll bearing the inscription '... PRISE BIRD ...' and beneath the foot 'C. Farrer at Edward the Black Prince, Kennington Lane'. There seems no justification for thinking this to have any connection with cockfighting, indeed the purpose of the inscription is unfortunately lost.

See also Collar.

Birmingham Assay Office
Largely due to the efforts of Matthew Boulton, one of Birmingham's most illustrious sons, an assay office was set up here by Act of Parliament in 1773. At the same time a similar office was set up at Sheffield. In each case their establishment was jealously resisted by the Goldsmiths' Company of London. Considering, however, the quantity of silver sent from Birmingham to Chester prior to this date, Chester being the nearest assay office, it is remarkable that the greater opposition did not come from the office most likely to lose much of its business. In the event, a great deal of work continued to be sent to be marked in Chester, the Birmingham hall-mark apparently implying, quite wrongly, a

22 Covered Beaker
Maker's mark, a fish.
Hall-mark for 1507.
Height 9½ in. (24·2 cm.).
Diam. at the base 4½ in. (11·5 cm.).
The Founder's Cup of Christ's
College, Cambridge, presented by
Margaret Beaufort, Countess of
Richmond and mother of Henry VII.
Decorated with the Tudor rose,
portcullis and marguerites in
allusion to the donor's name.

23 Beaker
Parcel-gilt.
Maker's mark, N R in monogram.
Hall-mark for 1591.
Height 7 in. (17·8 cm.).
St Giles Church, Cripplegate.
Engraved with the Arms of the
Vintners' Company.

24 Covered Beaker
Silver-gilt, also known as the
Magdalen Cup.
Maker's mark, M H in monogram.
Hall-mark for 1573.
Height 7¾ in. (19·7 cm.).
Manchester City Art Gallery.

25 Beaker
Maker's mark, T D, probably the
mark of Thomas Dare of Taunton.
c. 1645 (pricked 1646).
Height 3½ in. (9·0 cm.).

26 Beakers
A nest of four beakers and their
cover.
Hall-mark for 1664.
Hutchinson Bequest, Fogg Art
Museum.

27 Beaker
Maker's mark of Cornelius
Vanderburgh of New York.
c. 1685.

28 Covered Beaker
Silver-gilt.
Maker's mark, R H.
Hall-mark for 1686, London.
Carter Bequest, Ashmolean Museum.

29 Double Beaker
Maker's mark of John Rowbotham
& Co.
Hall-mark for 1775, Sheffield.
The two beakers form a barrel.

30 Beaker
Maker's mark of D. C. Fueter.
Height 3³⁄₁₆ in. (8·2 cm.).
Henry du Pont Museum.
The presentation inscription on
this American beaker is dated 1778.

22

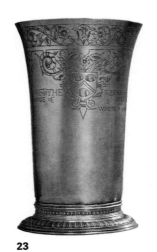

23

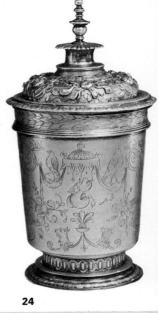

24

25

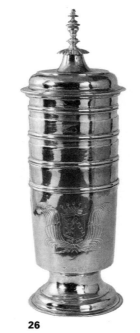

26

27

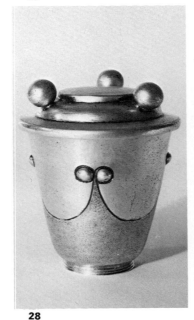

28

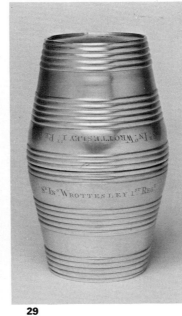

29

30

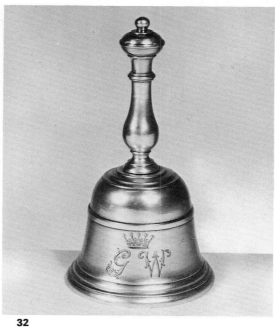

31 **32**

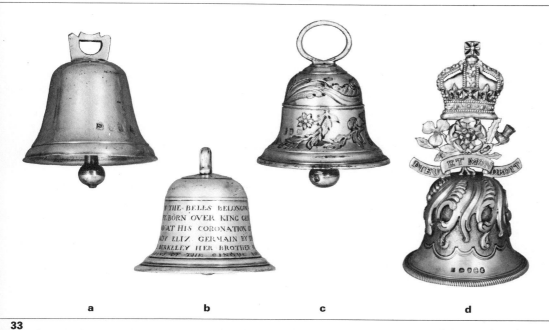

a b c d

33

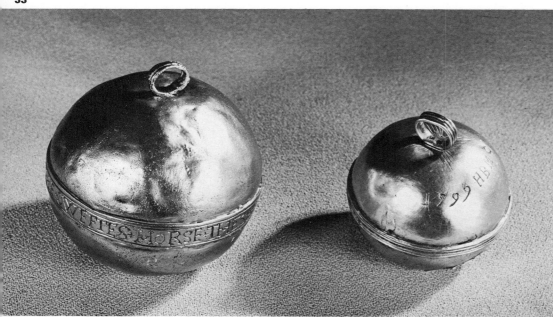

34

31 Bell

Maker's mark, WW.
Hall-mark for 1666.
This bell was originally presented by Sir Robert Vyner to the Goldsmiths' Company, London, in 1666. At a later date the bell was incorporated into an inkstand by Paul de Lamerie (1741).

32 Bell

Maker's mark of Peter Archambo.
Hall-mark for 1736.
Engraved with the initials of George Booth, 2nd Earl of Warrington.

33 Coronation Canopy Bells

a. Maker's mark of Francis Garthorne.
Hall-mark for 1714.
Victoria and Albert Museum.
One of the canopy bells used at the Coronation of George I.
b. Maker's mark of George Garthorne.
c. 1727.
One of the canopy bells used at the Coronation of George II.
c. Maker's mark of John Swift.
Hall-mark for 1761.
Victoria and Albert Museum.
One of the canopy bells used at the Coronation of George III.
d. Maker's mark of T. & J. Phipps.
Hall-mark for 1820.
Victoria and Albert Museum.
One of the canopy bells used at the Coronation of George IV.

34 Racing Bells

Right: unmarked but engraved with the date 1599.
Diam. 1¾ in. (4·5 cm.).
Left: unmarked, c. 1600.
Diam. 2 in. (5·1 cm.).
Carlisle Corporation.
Inscribed on the band around the centre 'THE SWEFTES HORSE THES BEL TO TAK FOR MI LADE DAKER SAKE'. The Lady Dacre referred to was probably the wife of William, Lord Dacre, who was governor of Carlisle during the reign of Queen Elizabeth.

lower class of goods to many prospective purchasers. The mark of the Birmingham Goldsmiths' Company, who were known as 'The Guardians of the Standard of Wrought Plate in Birmingham', was ordained to be an anchor.

 Birmingham mark on silver and gold

Today, the sheer quantity of pieces passing through this office to be assayed is almost unbelievable. It may be mentioned, as no one seems satisfactorily to have explained the choice of an anchor as the hall-mark, that while the committee were urging the original establishment of the Birmingham Assay Office, they used to meet at the Crown and Anchor Tavern in London. The Sheffield mark is a crown. The date-letter system uses twenty-five letters of the alphabet, excluding only J.

Having the advantage of rather more space than that of London, Birmingham deals with a vastly greater quantity of articles. These, if intended for sale in Great Britain, are sent for marking from all over the world. The bulk of the work, however, is of local manufacture for an ever-increasing number of pieces are sent from small working goldsmiths in the provinces. The office in some cases collects the goods to be assayed, unlike London where the manufacturer must send the parcel by his own messenger. On arrival this is checked (weighed, counted and docketed) and all work received is assayed and marked during the course of the same day. If, however, it arrives after 9.30 a.m. an extra charge is made. On the original docket, filled in by the manufacturer, the standard of the gold or silver is stated, but this is also given an approximate check to avoid wasting time on a full-scale assay should a typographical error have occurred. All articles must be complete. For example, a teapot without a lid would not be assayed. A sample of five grains in weight (0.003 ounces Troy being the absolute minimum) is then taken by means of scraping or clipping the piece. Once this is done, the object is removed for marking, and the sample for assay (gold by fire, silver by chemical means). Until the result of the assay is known and the piece found up to standard, it is not released to the manufacturer. If below standard, it is broken. When returned to the maker, a piece of gold or silver equal to the weight of that removed for assay is returned also. Both metals are weighed to the nearest 10,000th of a grain.

In Birmingham the chemical assay of silver is done by the Volhard Method, using ammonium thyocynate in solution and iron nitrate as an indicator. London uses sodium chloride, a process known as the Gay Lussac. Gold is assayed by fire at 1100 °C, using a cupel which absorbs the lead and other base metals which oxidise; its silver content is removed with nitric acid. This process can also be used for the assaying of silver, but the process is much slower in that the temperature must be lowered before removing the sample from the furnace, otherwise it will occlude, that is to split and absorb oxygen.

Failure to reach the standard does not mean that a manufacturer need be found guilty of fraud. Careless control of the temperature when melting bullion may produce a casting of a different quality in different places.

The assay office receives a continuous stream of persons wishing to register a maker's mark, and for this no charge is made. The punch must, however, be of a different form to any other so that no duplication may arise, and once registered the design is copyright, in any size. The assay office maintains its own tool-making staff, purely for making the enormous variety of jigs and punches required for the infinite number of different pieces sent for assay. These punches are only issued within the office against a signature, and the deposition of a name-tab by the workman concerned. All must be returned and placed under a triple lock each night before any of the staff leave.

The original office, set up in 1773, was open for two days a week on an upper floor of the King's Head Tavern in New Street, Birmingham. The inn sign is now the property of the Birmingham Assay Office. At the present day the office is open five days a week from 8.50 a.m. to 5 p.m.

An extremely valuable specialised contribution to our published knowledge of the Birmingham box-makers of the late 18th and 19th centuries is included in Eric Delieb's book *Silver Boxes*.

Bibliography
E. Delieb, *Silver Boxes*. Herbert Jenkins, 1968.
Sir C.J. Jackson, *English Goldsmiths and Their Marks*. 2nd Edition 1921, reprinted 1949.
Shirley Bury, 'Assay Silver at Birmingham'. *Country Life*, June 13th and June 20th, 1968.
See also Mazarine.

Bishop

'A sweet drink made of wine, oranges or lemons and sugar with mulled or spiced port'. Popular during the second quarter of the 18th century.

Black Jack

Leather-working was a craft carried out to a very high standard during the Middle Ages. Both tankards and jugs must have been amongst the more useful articles produced. It is only from the 17th century, however, that these so-called 'jacks' survive, some having been given the extra distinction of a silver rim. Leather bottles were also produced in imitation of both pilgrim flasks and the standard glass bottle of the day. Extra mounts, such as cartouches, are found on these leather bottles, but should be examined with care to ensure that they are contemporary with the remainder, for they are rarely hall-marked.

Bleeding Bowl

The earliest form is a shallow, straight-sided bowl, indistinguishable from the cover of a skillet, but by the end of the 17th century, the sides are convex and there is a distinct, narrow, undecorated rim. In England, a porringer implies a two-handled bowl, while in America, a shallow, single flat-handled bowl. Today, in England, it is this latter which is known as a bleeding bowl. However, opinion is divided as to their use, and the fact that they are, and always have been, known as 'porringers' in America supports the view that their use as a bleeding bowl was exceptional and it is likely that the American usage is more correct (**38**). English usage, however, leads us to discuss these shallow bowls under the heading of bleeding bowls, though as such they cannot have been very convenient. Their general form seldom changes, except as noted above, and, save for their marks, it is only by the piercing of the handle that they can be stylistically dated. The majority date from between 1625 and 1730 (**37**), though at least one, dated as early as 1623, is in a private collection; another in the Victoria and Albert Museum, is hall-marked 1638. An example from Norwich was made for a surgeon in 1689, but this does not constitute proof that he used it in his surgery. Very occasionally the bowls have graduated interiors and a few American examples are known to have covers (one such example by John Brevoort, New York, may be seen at the Montreal Museum of Fine Arts). On the rare occasions when the lid of a posset pot or skillet has survived and is compared with a bleeding bowl they are often found to be identical, a circumstance which leads one to wonder if this is how some originated (**515**). An unusual Scottish example made by Milne & Campbell, Glasgow, c. 1760, has a fluted leaf-like handle. A painting by Troost (1697–1750) shows a woman, after childbirth, eating from a porringer of this very form. The many and varied forms of pierced decoration of the handles of American examples were used by the late J.M. Phillips as chapter headings for his book mentioned below.

Bibliography
Ronald F. Michaelis, 'English Pewter Porringers', parts I, II, III and IV. *Apollo*, July, August, September and October 1949.
Ronald F. Michaelis, 'Back from the Dead'. *Apollo*, October 1950.
J.M. Phillips, *American Silver*. London 1949.
See also Porringer; Skillet.

Bodkin and Needle Case

These cases and the bodkin itself, were often made of silver and attached to a châtelaine. Examples in gold are also found and, like étuis, are often superbly decorated. The needle case is generally cylindrical and sometimes contains a compartment for a thimble. The bodkin may be found with the pierced end finished with a small scoop for use as an ear-pick (**60e**). 17th-century examples are club-shaped, the stem unscrewing to reveal a second case for the needles, the outside formed as four or more spools for thread. The bodkin is occasionally found pierced at both ends; one such example is the work of Joseph Richardson of Philadelphia, and can be seen in the Wadsworth Athenaeum.

Bolection

Generally a smooth moulding which projects before the face (that is higher) of the work decorated.

Bombé

An outward, convex curve. Used as a description of an object having a bulging curved outline. The term is most frequently found used in the descriptions of late 18th- and early 19th-century teapots but soup tureens, tankards and punch bowls may also be so described.

Book Binding

Prior to the Reformation, silver or parcel-gilt gem-set book covers for the Gospels and Epistles were part of the normal furnishings of any great ecclesiastical establishment, though seldom found elsewhere. No undoubted English examples have survived, excepting one of c. 1530, part of the Franks Bequest to the British Museum. Irish examples are, however, world famous. After 1540 these were slowly replaced by tooled, leather bound copies of the Bible and the Book of Common Prayer. Elizabeth I seems to have had copies fully bound in silver, to judge from their weight, a form general on the Continent almost to the present day. However, 17th-century England seems to have found an excuse for bringing a little colour into the Church by silver-mounting covers of coloured velvet or embroidered work. An example of c. 1630 appeared at Christie's in 1963. During the reign of Charles I, some extremely fine engraving and piercing was lavished upon these and other books of a devotional or valued character

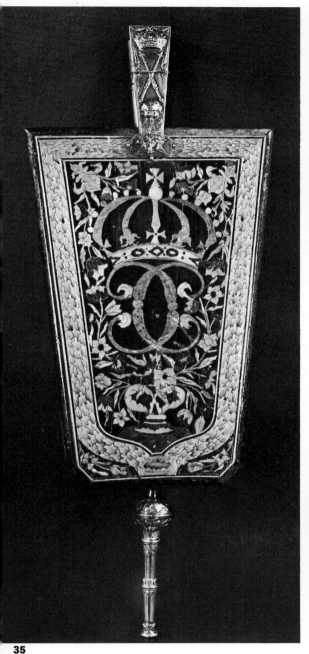

35

37

36

38

35 Bellows
Silver-gilt mounts and marquetry
decoration, also known as 'Nell
Gwyn's Bellows'.
Maker's mark, P crowned, probably
the mark of Benjamin Pyne.
c. 1680.

36 Bellows
Unmarked, *c.* 1680.
Height 29⅝ in. (75·3 cm.).
Ashmolean Museum.
Engraved with the Arms of Sir
Joseph Williamson, a friend of
Samuel Pepys.

37 Bleeding Bowl (Porringer)
Hall-mark for 1635.
Diam. 4⅜ in. (11·1 cm.).

38 Bleeding Bowl (Porringer)
Maker's mark, TM, probably the
mark of Thomas Milner of Boston.
c. 1725.
Diam. 5 in. (12·7 cm.).

(545b). Pepys writes in his diary on November 2nd, 1660: 'In the afternoon I went forth and saw some silver bosses put upon my new Bible which cost me 6s. 6d. the making, 7s. 6d. the silver which with 9s. 6d. the book comes, in all, to £1. 3. 6'. Afterwards he 'went with Mr. Cooke who made the bosses and Mr. Stephens, the silversmiths, to the Tavern'.

After 1710, with a few coarse exceptions in Scotland, the decoration was usually carried out wholly by the binder. A Canadian binding by Paul Morand, c. 1805, is in the Henry Birks Collection, Toronto.

Bibliography
J.F. Hayward, 'Silver Bindings from the Abbey Collection'. *Connoisseur*, October 1952.
C.C. Oman, *English Church Plate*. Oxford University Press, 1957.
J.E. Langdon, *Canadian Silversmiths, 1700–1900*. Toronto, 1966.

Boss Up

To beat up sheet metal from the back, moulding it roughly into its desired shape.

Bosun's Whistle

The 'Bote Swayne' is referred to as blowing his whistle as early as the beginning of the 16th century. Certainly, these were also worn by the Lords High Admiral of England, though none are known to survive. Most of those existing are dated from the 18th and 19th centuries and finely decorated with bright-cut engraving. The pipe is known as the 'gun', the barrel as the 'buoy' and the flat plate between them as the 'keel'. There is an early surviving example of 1763, with the maker's mark, I S. The wrongly oft-quoted portrait of an Elizabethan gentleman in the Ashmolean Museum, Oxford, does not in fact show him wearing a whistle, which would have been worn by the Lord High Admiral, but a combination wheel-lock spanner and screwdriver for use with a pistol.

Bibliography
Eric Delieb, *Bulletin*. Vol. III, nos. 3 and 4.

Bottle

In Elizabethan times the term 'flagon' meant a flask or a bottle of baluster form, usually furnished with a chain handle. Almost the only survivors of these are those now preserved in the Kremlin, Moscow, the earliest of which is a pair dated 1580, presented in 1604 to the Tzar Boris Godunov by Sir Thomas Smith, the English Ambassador to Russia. As the 17th century progressed, this particular form of object dies out and the name 'flagon' is transferred to the tall, cylindrical livery pots. Similarly, the flattened pear-shaped flasks, which in the early part of the century would have been called 'flagons', are referred to as 'pilgrim bottles'. Again, the earliest of these to survive is in the Kremlin, that of 1663 presented by the Earl of Carlisle to the Tzar of Russia in 1664.

See also Casting Bottle; Flagon or Livery Pot; Flask; Pilgrim Bottle.

Bottle Stand

These are extremely rare. Oval in section, the stand was designed to hold a bottle of flattened Chianti-flask form (that is, with rounded base). A hot-water jug, part of a shaving set, in the Ashmolean Museum, Oxford, has a base of similar form, probably for use with shaving water. In the same Museum is a bottle stand, engraved with the Arms of Veale, made by Augustin Courtauld in 1723 (**39**).

See also Jolly Boat; Wine Coaster.

Bottle Ticket See Wine Label.

Bougie Box See Taper Stand.

Boulton, Matthew (1728–1809)

He joined his father's firm at Snow Hill, Birmingham, as a silver stamper and piercer and later became a partner. The business was at first confined to the making of buttons, shoe buckles and cut-steel work, but on removing to Soho, a district nearby, they took into partnership a John Fothergill, a man with good foreign business connections. The new factory was opened in 1764 at a cost of £20,000 (a gigantic sum of money). Aiming at quality, allied to quantity, he was indefatigable in his search for rare objects to copy in Sheffield plate, ormolu and, after 1765, in silver (Fig. VIIb). The Duke of Northumberland helpfully made available many rare objects and Robert Adam freely tendered his advice. By 1770 Boulton was employing between seven and eight hundred artists and craftsmen in the factory at Soho. Due to the activity and perseverance of Boulton, an assay office was established at Birmingham in 1773, thus avoiding the necessity of all silver goods being sent to Chester for marking (**62**). Indirectly, his efforts led to the opening of the Sheffield Assay Office in the same year. From 1781 to 1809, the firm's title was Matthew Boulton & Plate Co.; from 1809 to 1834 it was known as M.R. Boulton, and from then until 1843 as the Soho Plate Co.

Bibliography
H.W. Dickinson, *Matthew Boulton*. 1937.
A. Westwood, *The Assay Office in Birmingham*. 1936.
Robert Rowe, *Adam Silver*. Faber & Faber, 1965.
W.A. Seaby and R.S. Hetherington, 'The Matthew Boulton Pattern Books'. *Apollo*, February and March 1950.
W.A. Seaby, 'A Letter Book of Boulton and Fothergill', parts I and II. *Apollo*, September and October 1951.
Shirley Bury, 'Assay Silver at Birmingham. Matthew Boulton and the Soho Manufactory'. *Country Life*, June 13th and June 20th, 1968.
See also Argand, Aimé.

Bourdaloue See Chamber Pot.

Bowl

Though the Halton Moor Bowl in the British Museum dates from immediately prior to the Norman Conquest of 1066, perhaps the earliest surviving bowl and cover, dated c. 1380 and of undoubted English provenance, is that formerly at Studley Church near Ripon, Yorkshire, and now in the Victoria and Albert Museum (**40**). The Studley Bowl is engraved with the alphabet in black-letter type, together with a contracted form of the word 'festeyinge' (feasting). This is probably a *collock* piece, 'collock' being the Old English for a pot or a bowl without a foot and was intended to be used by a child. This bowl is, therefore, of extreme rarity on a number of different counts. In 1653, Captain William Tyng of Boston died, leaving a 'colker bowl'. One can only presume as to its similarity in form to the Studley Bowl.

The original purpose of the bowl is most difficult to define. The only certainty is that it, unlike the basket, could hold both liquids or solids. Most of those surviving from the second half of the 17th century derive either from the cup form or from the basin (**42**). Examples, such as the one dated 1677, now in the Art Institute of Chicago, which has a broad shallow body, two handles and three ovoid feet, are obviously derived from the cup form. An-

other, with its cover, of 1668, is 10¼ in. (26·1cm. in diameter; the cover being reversible as it ha three scroll feet is also of cup form. The deepe examples derived from the basin, such as tha decorated with chinoiserie designs made in 168? and now in the Jackson Collection (Nationa Museum of Wales), were probably intended fo use as wash bowls. The three bowls describe above are large in size, but there are many others of every imaginable size and purpose; such ar bowls suitable for sweetmeats or fruit; chap bowl which were supplied with toilet services; spitting pots; chamber pots and mortars. Sugar bowls covered and uncovered, seem to grow large during the 18th century; some Scottish ones migh almost be intended as slop basins for tea. Silve slop bowls were advertised in the *Pennsylvani Packet*, November 6th, 1800, and as sets of te caddies and sugar bowls become more and mor prevalent as separate table appurtenances, so th slop bowl emerges in its own right. However, smal gatherings also demanded small punch bowls, an yet another use of the bowl is as a christening bowl one of 1743 is amongst the Farrer Collection Ashmolean Museum, Oxford. The great covere bowls possessed by some university colleges of th 17th century, one dated 1640 at King's College Cambridge, is 12 in. (30·5 cm.) in diameter, hav been called most extraordinary names on occasion usually on the strength of some early inventor (**41**). A bowl, made in 1677, now lacking its cove in Mrs Munro's Collection, Pasadena, California is traditionally recognised as an artichoke bowl! A little thought, however, suggests that all too ofte the name is attached to an object by the butler o the day, depending upon how he, not his master o the donor, chooses to use it and what he calls i One of the most attractive is that hall-marked 1679 12 in. (30·5 cm.) in width, with an almost flat, tripl scroll-footed cover, formerly the property of th Charity Commissioners of Withycombe Raleig Oval bowls, plain or fluted (**47**), for pies or pud dings are found dating from the early 18th century The standing cups, made to the order of Sir Franci Bacon from the matrices of the Great Seal in 157 are engraved with an inscription which refers t them as 'bowles' (Colour Plate 27). The parish o St Mary in the Marsh, Norwich, whose plate is no scattered, was possessed of a genuine alm 'bason' made by Whipham & Wright in 1765; ther are two 'wash basins' in the Royal Collection, on being 14¾ in. (37·5 cm.) in diameter, executed b John Bridge in 1832, and some unusual, simu lated lacquer-work bowls and covers made b Paul Storr in 1810 are extant (**48**). A covered, two handled bowl made in 1735 is the work of Paul d Lamerie and may well have been intended as small tureen for soup. It can be seen at the Sterling and Francine Clark Art Institute, Williamstown Massachusetts. An American type of two-handle bowl, showing signs of Dutch influence, and prob ably intended for punch, is known from a numbe of late 17th- and early 18th-century survivors, suc as the one made by Benjamin Wynkoop an loaned to the Smithsonian Institution, Washington D.C., by Mrs J.R. Hovey. A number of bowls an stands, some with handles, some with or withou covers, are known throughout the 18th centur (**44**). At least one example has always been know as a 'porridge bowl', but those of about 7½ in (19·1 cm.) in diameter and with covers, are prob ably rightly designated by Sir Charles Jackson a 'broth bowls' (**43** and **45**). An outstandingly fin example, c. 1735, on a three-legged stand with spirit lamp, decorated with applied masks an floral swags and with drop-ring handles wa

xhibited at the Golden Jubilee Exhibition of the British Antique Dealers Association at the Victoria and Albert Museum, London, in 1968. However, he original purpose for which the bowl and cover, made by Paul Storr in 1821, were intended is not certain (**49**).

Bibliography

.N. Pearce, 'New York's two-handled panelled ilver bowls'. *Antiques*, October 1961.

See also Casserole; Christening Bowl; Ecuelle; ont; Mazer; Monteith; Mortar; Pudding Dish; Punch Bowl; Quaich; Spitting Pot; Sugar Basin; Sugar Bowl; Toilet Service.

Bowl, Baptismal

n the Dunn Gardner Collection, sold at Christie's n 1902, there was a bowl 16 in. (40·7 cm.) in diameter, decorated with chinoiserie figures, hall-marked 1683. This was engraved beneath the foot 'This bason held the consecrated water, where-with was baptised May the 29. 1697. Elizabeth, the only daughter of Sir Thomas Poweil, of Broadway. art. by Elizabeth his first wife'. Besides this, a fair number of churches on both sides of the Atlantic possess bowls of various shapes and sizes which re or have been used for private or public baptism. Holy Trinity, Newport, Rhode Island, is remarkable n owning both an elliptical (1734) and a circular asin; they were both made by Daniel Russell. The rst might serve also as a jardinière and the second, deep hemispherical bowl with broad flanged lip, s of a form known also in pewter. It seems unlikely hat one church needed two baptismal basins, but here is no doubt that they were both intended for he same church and are so inscribed, but unfor-unately not with their intended purpose. A bowl with everted lip in the Farrer Collection, Ash-molean Museum, Oxford, by Francis Crump, 1743, would seem to be less doubtful in purpose. It is ngraved 'LAVA NOS A DEUS PECCATO/ DOMINE MISERICORS ET BENIGNE/ XTENDE NOBIS MISERICORDIAM UAM'.

See also Font.

Box

Boxes of various shapes and for many purposes ave been the necessity of every age (**52**). xamples in precious metals, or like the Dyneley Casket of *c.* 1620, of mounted alabaster, some-imes betray their real purpose if they retain their original lining. A dome-shaped, mother-of-pearl ox with unmarked silver mounts of about 1590 is n the Museum of Fine Arts, Boston. A particularly ine jewel casket is that of about 1660 (**50**) which ppeared at Sotheby's in 1966. Many 17th-century, nd later, toilet services are now represented only y the larger rectangular boxes converted for use s inkstands (**57**), for cigars or suchlike. Some must have been made specifically for jewellery **56**). Nevertheless, so large were some services hat one cannot help but wonder as to what use the original owner put all the different containers. Some are referred to in inventories as 'comb boxes' **53** and **54**). Sugar boxes were popular during the ate 17th and 18th centuries (**51** and **55**). 19th-century caskets are usually intended for the recep-ion of presentation scrolls of address. A shagreen-overed dispatch box of *c.* 1670, the silver mounts inely embossed with scrolling foliage and decor-ated with the monogram of Charles II, is in the Wallace Collection, London. Another of about the ame date is of wood, cut from the Boscobel Oak, with engraved silver mounts. One of the most interesting entries in the Garrard Ledgers is as ollows:

'*Asheton Curzon Esq*.

1772 Aug. 13 To Cash paid Mr. Wyatt the Architect	£2. 2. 0	
Dec. 16 To a fine Chased Sarcophagus with a Bas relief of figures on one side 195. 0. at 10/6	£102.12. 9	
To engraving a long inscription	9. 0	
To a red leather case	£1. 0. 0	
	£106. 3. 9'	

See also Caul (Cawl) and Stone Boxes; Counter and Score Boxes; Instrument Case; Knife Box; Seal Box; Snuff Box; Soap Box; Spice Box; Sugar Box; Tea Caddy; Tobacco Box; Toilet Service; Vinaigrette.

Box, Alms See Alms Basin.

Brand

Incredible though it may seem, silver brands were made for marking slaves, on the grounds that this metal, heated by burning spirits, was a more humane branding-tool. These are yet preserved at Wilberforce House Museum, Hull.

Brandy Saucepan See Saucepan.

Brazier

See Chafing Dish; Dish Cross; Incense Burner; Pastille Burner; Pipe Lighter; Tea Kettle.

Breastplate and Gorget

The use of silver for decorative and identification purposes is nothing new. Waits (see Corporation and Ceremonial Plate), barge masters and a whole variety of servants all wore badges. In general, however, these tended to be worn on the upper arm, so that the breastplate and gorget are usually particular marks of rank, distinction or achievement. One of the earliest breastplates is that sent by Charles II to the Queen Pamunkeys in Virginia, sometime after 1677 (Jamestown, Virginia). An Archery Society breastplate, engraved with the date 1676, survives, and is on loan to the Victoria and Albert Museum. A number of other medals of plaque form survive in both the United States and Canada. Two sets of these were made by D.C. Fueter in 1760 and 1764 for presentation by Sir William Johnson to Indian Chiefs when they signed peace treaties with the Kings of England. Similar medals were given at a later date by the President of the United States, a representative group of which may be seen in the Henry Ford Museum at Dearborn, Michigan. Both silver and silvered, base metal plaques of shaped or plain oval form, measuring approximately 6 in. by 4 in. (15·3 cm. by 10·2 cm.), called Potomac medals are known. These date from 1792, 1793 and 1795. Some of those made in 1793 and all of those made in 1795 are the work of Joseph Richardson, Junior, an assayer at the United States Mint from 1795. These medals are presumably the lineal descendants of those ordered in 1661 to be worn by all Indians visiting the American settlements.

The gorget was at first worn only by the military, not only by officers; originally a piece of armour worn round the neck, it survived as a badge of rank. The American Indian, however, appreciated it purely as decoration and a considerable business grew up so far as local American and Canadian silversmiths were concerned, in supplying trade goods of this form to the Indians, sometimes with further pendent plaques, ear-rings, arm bands and head bands *en suite*. A self-portrait of Zacharie Vincent in the Quebec Seminary, Quebec City, shows an outstanding example of this fashion. The gorget made by John Richardson of Philadelphia, in the collection of the Historical Society of Pennsyl-vania, is remarkable for its engraving of a seated Indian, the sun, a fire, a tree and a Quaker with a pipe of peace. It was probably made for the 'Friendly Society for Propagating Peace with the Indians by Pacific Measures', of which Richardson was a member. American military gorgets are rare. An example by Barent Ten Eyck of Albany, New York, *c.* 1755, held by the Heye Foundation, is engraved with the English Royal Arms. English examples of an earlier date than 1760 are un-common and when found are seldom fully hall-marked. The portrait of Tayadoneega, the Mohawk Chief, by Romney is interesting, as he is shown wearing an arm band and a military gorget. The latter, presented to him by King George III, still survives.

Bibliography

J. Paul Hudson, 'A Silver Badge for an Indian Queen'. *Virginia Cavalcade*, Autumn 1960.

Harold E. Gillingham, 'Early American Indian Medals'. *Antiques*, December 1924.

J.E. Langdon, *Canadian Silversmiths, 1700–1900* Toronto, 1966.

See also Badges; Jewish Ritual Silver; Shoulder-belt Plate.

Bright-cut Engraving

A form of faceted ornament made by the gouging out, by one stroke of the engraving tool, of a small portion of silver, leaving behind a burnished sur-face. A series of such strokes may be used to form a pattern of ornament. Such engraving was par-ticularly popular during the late 18th and early 19th centuries.

See also Silversmithing.

Britannia Metal

A leadless alloy of tin, copper and regulus of antimony. In appearance it resembles silver or polished pewter; it was used from about 1790 and well into the 19th century.

Britannia Standard

The Civil War in England resulted in the melting of most of the then existing plate for conversion to coin. The year 1660 brought the Restoration of Charles II and a vast demand for plate. This was only made possible by the reconversion of coin. Restoration fashion was such, however, that vastly more plate was made in silver than was per-haps originally melted and by 1690 this, combined with Stuart financial transactions, resulted in a desperate shortage of coin. Such coin as was not wholly melted was liable to clipping, there being no milled silver coin then issued. In 1697, in order to prevent 'the wicked and pernicious crime of clipping', the Government acted, raising the standard for wrought silver from 11 ounces 2 pennyweights (92·5 per cent) to 11 ounces 10 pennyweights (95·8 per cent) in each pound (Troy). New marks were to be struck: the maker's mark showed the first two letters of his surname; the mark of the Goldsmiths' Company, a lion's head erased; and a new standard mark, the figure of Britannia. A fresh date-letter series was also ordained. The resulting silver was, however, considerably softer and consequently wore less well than the old standard. However, this fact favoured those silversmiths who were adept at casting and may have speeded the introduction

39

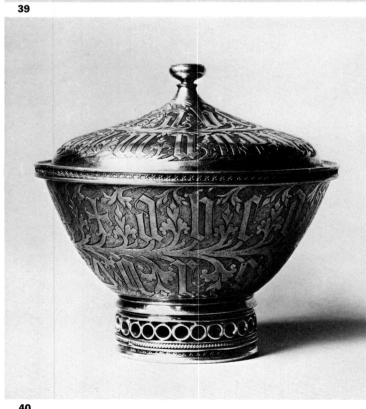

40

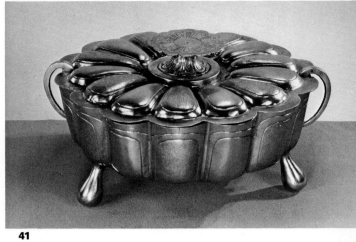

41

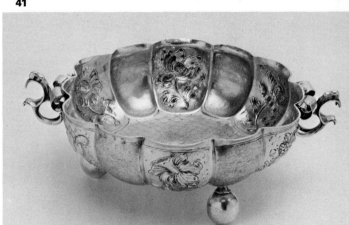

42

43

44

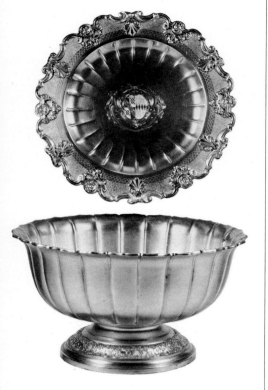

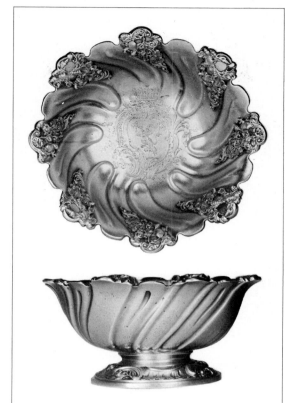

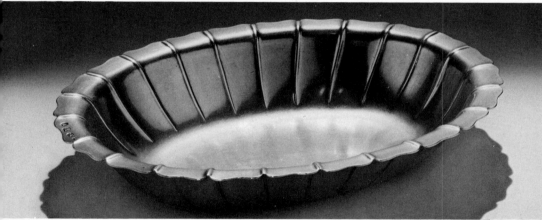

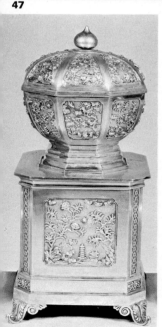

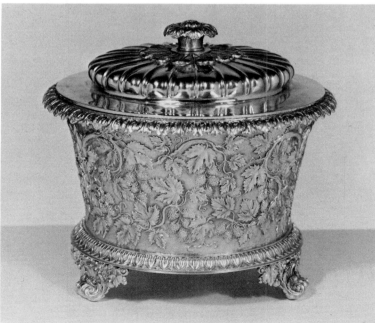

39 Bottle Stand
Maker's mark of Augustin Courtauld.
Hall-mark for 1723.
Ashmolean Museum.
Engraved with the Arms of Veale
impaling Young.

40 The Studley Bowl
Silver-gilt.
Unmarked, *c.* 1380.
Victoria and Albert Museum.
The bowl is engraved with the
alphabet in black-letter type.

41 Bowl and Cover
Maker's mark, R L with a trefoil
below.
Hall-mark for 1640.
Width 12 in. (30·5 cm.).
King's College, Cambridge.

42 Bowl
Maker's mark, A H.
Hall-mark for 1675.
Diam. 11 in. (28·0 cm.).
Overall width 14½ in. (36·9 cm.).

43 Bowl and Stand
Maker's mark of William Aytoun.
Hall-mark for 1733, Edinburgh.
Engraved with the Arms of Menzies
impaling Campbell.

44 Dessert Bowl
Maker's mark of William Fountain.
Hall-mark for 1801.
Designed to be used with a glass
liner.

45 Bowl and Stand
Maker's mark of Paul de Lamerie.
Bowl: hall-mark for 1725.
Diam. 8 in. (20·4 cm).
Stand (above): hall-mark for 1723.
Engraved with the Arms of Lady
Georgina Spencer. This was her
porridge bowl and stand.

46 Bowl
Silver-gilt.
Maker's mark of George Wickes.
Hall-mark for 1744.
Diam. 6½ in. (16·5 cm.).
Engraved with the Arms of Capel
for William Anne, 4th Earl of
Essex. There is another similar
bowl, but larger, by the same
maker at All Souls College, Oxford.

47 Oval Bowl
Maker's mark of William Lukin.
Hall-mark for 1726.
Width 12¾ in. (32·4 cm.).

48 Bowl and Stand
Silver-gilt, simulating lacquer-work,
one of a pair.
Maker's mark of Paul Storr.
Hall-mark for 1810.
Height 15 in. (38·1 cm.).
These are copies of an earlier
example made about 1720.

49 Bowl and Cover
Silver-gilt.
Maker's mark of Paul Storr.
Hall-mark for 1821.
Diam. 6½ in. (16·5 cm.).

of the latest French fashion. The new law had the desired effect as coin could no longer be used as bullion by silversmiths. By June 1st, 1720, aided by the acquisition of vast quantities of silver from the New World and a new milled coinage, the crisis was over and the law repealed, but a tax of 6d per ounce was imposed on wrought plate. It now became optional as to which standard a worker chose to use. Paul de Lamerie was one who continued in the higher standard until 1732 (see Lamerie, Paul de). It should be noted that these new marks applied only to silver. Gold made during this period continued to be struck with the Sterling marks.

See also Hall-mark.

Broth Bowl See Bowl.

Brush See Toilet Service.

Buckle
These, of every size, for shoes, belts, breeches (at the knee), hats and stocks were made in both silver and gold. They are rarely fully hall-marked until the end of the 18th century unless of an exceptionally large size. Often only the rim. is of precious metal, the tongue being made of steel. Most are extremely well made and only the difficulty of finding a present-day use for them keeps their price so low. An American gold buckle by Everadus Bogardus of New York, c. 1705, is amongst the collection of the New-York Historical Society. In *Adams Weekly Courant* (Chester), April 28th, 1767, an advertisement for the return of stolen goods read thus: '... and twenty-four pair of shoe-buckle rims, made by William Cox. Silversmith at London. mark'd W.C.'. The 1st Earl of Bristol purchased a pair of gold buckles from Charles Mather in 1714 for a total of £6 1s 10d. Buckles were not items of luxury, but necessities for use with the fashionable dress of the late 17th and 18th centuries.

Bugle See Trumpet.

Burnisher
A tool with a very hard, polished, working surface, of agate or dog's tooth, used for burnishing gold and silver.

Burt, Benjamin (1729–1805)
The youngest son of John Burt and Abigail Cheever, he worked in Boston, Massachusetts. He was probably apprenticed with his brothers Samuel and William. He was the maker of a number of good serviceable pieces of silver, including a fine tankard of 1769 in the Henry Ford Museum, Dearborn, Michigan, and another with a writhen finial to the cover, in the Harrington Collection. Benjamin Burt led the Boston goldsmiths at President George Washington's memorial procession, which was held in 1800.

Burt, John (c. 1692–1745)
He was apprenticed to John Coney. John Burt worked in Boston, Massachusetts. He was the maker of a number of pieces of plate for Harvard University, including those (amongst them a pair of candlesticks, exceptionally rare in Colonial silver) presented to Tutor Nicholas Sever. The inventory of Burt's estate includes a most valuable list of his goldsmithing tools. Other important pieces from his workshop are a pair of chafing dishes in the Art Institute of Chicago, a sugar bowl in the Museum of Fine Arts, Boston, and a rare hexafoil salver on a trumpet foot in the Harrington Collection.

Butter Boat
A set of twelve heavy butter boats, shaped somewhat like the bowl of a punch ladle with waved rim, made by Paul Crespin between 1757 and 1758, are amongst the collection of the Duke of Portland. Opposite the lip, the side of the bowl extends to form a downward scroll handle. Butter boats were presumably intended to hold melted butter and are on average some 3 in. (7·7 cm.) in overall length.

Butter Dish
It could best be described as a two-handled, covered bowl, usually on four feet and having a glass liner. These appear, often in Ireland, in the late 18th century (**58** and **59**). At first the pierced sides revealed the coloured glass, later only the cover and saucer stand were made of silver, the glass dish being cut and faceted. A superb example by Paul Storr is illustrated on Colour Plate **6**.
See also Escallop Shell.

Butter Knife
Appearing c. 1790, these are often found with green ivory or mother-of-pearl handles. Large services of table silver were also supplied with pairs, or more, *en suite*. The blade is of scimitar form and is developed at a later date for use as a fish knife. A number of Old English pattern, gilt examples of 1803 are in the collection of the Duke of Portland.

Butter Shell See Escallop Shell; Oyster Dish.

Butter Spade or Trowel
These had a triangular blade, each side about 2 in. (5·1 cm.) long, with turned, partly ivory or wooden, baluster handle. Due to their shape, they have obviously been used for many other purposes, besides cutting butter. They appear about 1770. Joseph Musgrave purchased a pair made by Wakelin in 1771, and the same firm supplied another client with a gold 'butter trowel' on a separate occasion.

Button
Buttons of silver, gold and Sheffield plate, not to mention pinchbeck, survive in sets of six, eight or more. They were made *en suite* with those for cuffs (link buttons) and other items of clothing, as demanded by the fashion of the day, and are consequently found in large numbers. Those made of metal were chased or engraved with a variety of designs, crests and badges. Silversmiths fashioned them by a series of special punches or stamps, and one such was amongst the workshop tools of Richard Conyers of Boston, Massachusetts, whose goods were appraised on April 4th, 1709. It was valued at £1 0s 0d, thus showing that such equipment was expensive to make and highly prized.

Cable
A moulding made to appear like twisted rope. It was cast, embossed or made of twisted wire.

Caddinet
They were first mentioned at the Coronation of Charles II (1660), but only two of these Continental importations appear to have survived. Both are now engraved with the Arms of William and Mary and are in the collection of the Earl of Lonsdale, on loan to the Victoria and Albert Museum. One is, however, hall-marked 1683 and has lion finials to the box covers. It must have been re-engraved to accompany a second, made in 1688 for the Coronation of the latter Monarchs. Each is formed as a rectangular salver with two covered boxes at

one end, for spices and eating utensils. They were placed in front of the Monarch and upon them each of his or her dishes were set in turn. The one made in 1688 is particularly noteworthy, being decorated with the Arms of England and Ireland, as used between February 13th and April 11th, 1689, the earlier, re-engraved caddinet has the full Arms of the three Kingdoms. With these are associated two pear-shaped 'cruet' jugs, each with the finial to the cover formed as a V, perhaps indicating that their purpose was to hold vinegar and not as being ecclesiastical pieces pressed into secular use.
Bibliography
C.C. Oman, 'Caddinets and a Forgotten Version of the Royal Arms'. *Burlington Magazine*, vol. C, pp 431–5, December 1958.

Caddy See Tea Caddy.

Caddy Spoon See Spoon (Caddy Spoon).

Cage-work
A form of decoration, probably of German inspiration, in which a sleeve of pierced, and usually chased, bird and foliate decoration encloses a plain inner section, sometimes gilt in contrast. Obviously the term may also be used of any object pierced and cage-like in appearance. However, the accepted application of this term is to those rare items, only about twenty-five of which are so far recorded, usually dating from between 1665 and 1680. These are mostly two-handled cups and covers, but there are also included in this group two tankards; the standing cup and cover given by Samuel Pepys to the Clothworkers' Company and the communion cup at Ashby-de-la-Zouch dated 1676.

Cake Basket See Basket, Bread or Dessert.

Calcutta See Forgery; Hamilton & Co., Calcutta.

Can See Mug.

Canadian Silver
Thanks to the researches of Mr John Langdon and others a great deal more is known of Canadian silversmiths and their marks than one would have dared hope.
Following close on the heels of the first French settlers in Quebec came a number of silversmiths of varying ability. Villain, Beaudry and Fezeret were all working prior to 1700 when the total population was less than 17,000. Lack of available native silver in the late 17th and early 18th centuries made heavy inroads on the coinage and reconversion of existing pieces of plate was perhaps even more usual in Canada than in Europe, where it became quite normal to send old plate against an order for a new piece. Until the coming of an English régime (the town of Halifax was founded in 1749 and Quebec was captured in 1759), the tendency was to follow the fashions from France and many of the pieces are of extremely high quality. As the settlers pioneered further westward, so the silversmiths followed, and amongst the pieces made were vast quantities of trade goods supplied as gifts or for sale to the Indians, both in Canada and the United States. These, when found, are often in excavated condition, having been buried along with their owners for a number of years. A very large proportion of the surviving larger pieces are those designed for ecclesiastical use, with the exception of spoons of which considerable numbers yet remain. As in American Silver, candlesticks are very rare, though one, by Paul Lambert of Quebec, c. 1700, is in the

Jewel Box
nmarked, *c.* 1660.
Vidth 7 in. (17·8 cm.).
Sugar Box
Maker's mark, I H with a fleur-de-lys
and two pellets below.
all-mark for 1672.
Vidth 6½ in. (16·5 cm.).

52 Jewel Casket
Walrus ivory with silver mounts.
Maker's mark of Katherine Mangy
of Hull.
c. 1680.
Length 3¾ in. (9·6 cm.).
Width 2⅛ in. (5·4 cm.).
Hull Museum.

53 Box
Maker's mark, B B.
Hall-mark for 1684.
Width 10¾ in. (27·3 cm.).
This was most probably a comb
box and part of a toilet service.

54 Comb Box
(A view of the top.)
Maker's mark of Pierre Harache.
Hall-mark for 1685.
Engraved by Simon Gribelin.

55 Sugar Box
Maker's mark, F V with a coronet
above, probably the mark of a
silversmith named Fuller.
Hall-mark for 1705, Exeter.
Width 6¼ in. (15·9 cm.).

50

53

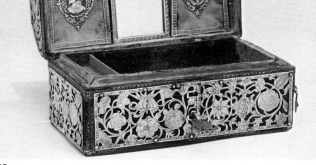

51

54

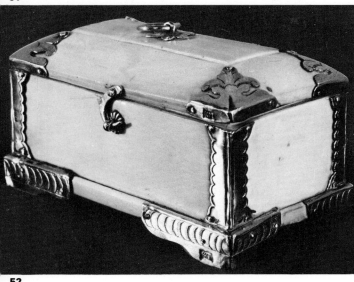

52

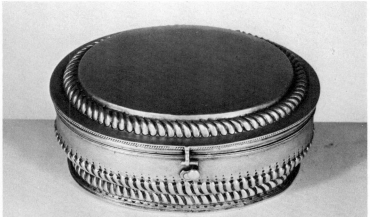

55

56 Box
Maker's mark of Paul de Lamerie.
Hall-mark for 1721.
Length 4⅜ in. (11·1 cm.).
Width 3½ in. (8·9 cm.).
Part of a toilet service, this box
was probably hinged at a later
date. It is interesting to note
that the mark of Lamerie overstrikes
the mark of another maker, possibly
that of Paul Crespin.

57 Comb Box
Maker's mark of Thomas Heming.
Hall-mark for 1758.
Width 9¾ in. (24·8 cm.).
Part of a toilet service.

58 Butter Dish
Maker's mark of Christopher Haines.
Hall-mark for 1785, Dublin.
National Museum of Ireland.

59 Butter Dish,
Cover and Stand
Maker's mark of John Emes.
Hall-mark for 1807.
Stand: diam. 7¾ in. (19·7 cm.).
Engraved with the Arms of Drax,
Erle and Sawbridge.

60 Kitchen Utensils
a. Barding needle, unmarked.
b. Mote spoon.
c. Sucket fork and spoon.
Hall-mark for 1691 (?).
d. Pastry cutter.
Maker's mark, AH in monogram.
Hall-mark for 1683.
e. Bodkin and ear-pick.
f. Apple corer with a caster in the
handle.
Maker's mark, probably MB.
Hall-mark for 1683.
g. Corkscrew.
c. 1770.

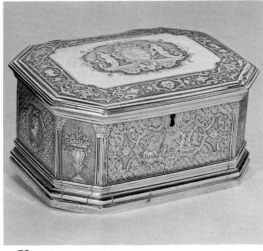

56

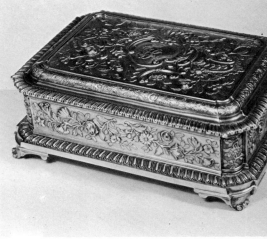

57

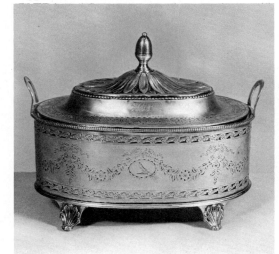

58

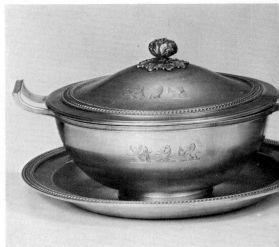

59

60

enry Birks Collection. In the same Collection is a lid silver mortar by the same maker. A tureen made
y Laurent Amiot, c. 1790, and a set of three bowls
ade by Hendery & Leslie in the late 19th century
e equally rare. The Jesuits gave rings engraved
th the initials IHS to the Indians on their baptism,
t early finger rings are rare. Few Canadian forks
e known to survive, but 18th-century examples
e even less numerous in the United States.
bliography

E. Langdon, *Canadian Silversmiths and Their arks, 1667–1867*. Stinehour Press, 1960.
E. Langdon, *Canadian Silversmiths, 1700–1900*. ronto, 1966.
A. Jones, *Transactions of the Royal Society of nada*. Series III, vol. XII, 1918 (Section II).
msay Traquair, *The Old Silver of Quebec*. acmillan, Toronto, 1940.
rs and Mackay, 'Master Goldsmiths and Silver-iths of Nova Scotia'. *The Antiquarian Club*, 1948.
he French in America 1520–1880'. *Exhibition talogue, Detroit Institute of Arts*, 1951.

ndelabrum

e Wardrobe Accounts of Edward III in 1324
ention 'VI Candelabr Argenti'; indeed this form
as common in all metals throughout the 14th,
th and 16th centuries. '1688. Nov. 5th Paid to Mr.
chard Hoar the goldsmith for a pair of branch
ndlesticks weighing 78 ounces 2 dwt. at 7s. 6d.
r ounce . . .', so records the diary of John Hervey,
t Earl of Bristol. As the same entry mentions
onces separately, this reference must surely be to
ndelabra as we know them today. Other than the
nford crystal and silver candelabrum of about
80 (see Candlestick) and a pair of three-light
amples with figure stems of c. 1675 in the Ash-
olean Museum, Oxford, the earliest marked
ndelabra appear to be a pair, each of three lights,
ted 1697 at Welbeck Abbey. A single example of
00 made in Dublin is known. In the Haddington
ollection were a pair of two-light branched
ndelabra and a single four-light branched
ample made by Pierre Platel in 1717, associated
th four candlesticks made by Paul de Lamerie in
24. The candelabra of the Haberdashers' Com-
ny, in its present form, is probably of 1720,
ough the stem is hall-marked 1714. A set of six
ndlesticks, each with two branches, were made
Paul de Lamerie in 1737 and are in the collection
the Duke of Bedford. Fig. **IVa** illustrates a
ndlestick with two-light branches. It is certain
at matching branches and stems are rare up to
'50 (**61**, **63** and **70**) and it is not until 1760 that
ey become more common (**66**). Nevertheless,
ere does exist at Ickworth the vast set of twelve
ade by Simon le Sage in 1758, and they are
markable in every respect. Prior to 1770 branches
r three lights (Fig. **VIIa**) are far less common than
r two, for example a pair made by James Paltro in
'57, which are in the Art Institute of Chicago.
til the third quarter of the 18th century, cande-
ra stems are usually only very slightly, if at all,
ger than the contemporary table candlestick. A
re exception is the splendid pair with four branches
ich are 29 in. (73·7 cm.) in height, of column
rm on a stepped square base. They were made by
omas Heming in 1765. By virtue of their being
rmally in two pieces, branches and stems have
quently become separated; sometimes later
ditions were made to a set of candlesticks with
hich the branches are *en suite*. Family division or
ater date often completed the mix-up. Branches
Sheffield plate were frequent additions to silver
cks during the last quarter of the 18th century
d during the 19th century the majority of cande-

labra were plated throughout. This is not to imply
that the silver candelabra was no longer made, but
the size of the finished object and the high duty to
be paid was not conducive to commissions for such
pieces in Sterling metal as that illustrated on Plate
62. Needless to say the great families, guided in
their taste by the Prince of Wales, continued none
the less to order pieces from Rundell, Bridge &
Rundell and examples of all styles are extant, in-
cluding a pair made by Benjamin Smith for the
Duke of Wellington in 1816 which are no less than
57 in. (144·8 cm.) high. Figs. **VIIIc**, **IXc** and **Xa**
illustrate the type of candelabrum commissioned by
Rundell, Bridge & Rundell. Colour Plate **7** illus-
trates a five-light, silver-gilt candelabrum made by
Paul Storr in 1817. The coming of the Romantic
era at the very end of the reign of George III paved
the way for decoration – over-decoration in the
opinion of many – for it embraced all known forms
and styles so that the description of a number of
combined centrepieces and candelabra is a
matter of some difficulty (**72**). A silver-gilt, nine-
light candelabrum made by Edward Farrell in 1824
stands some 35 in. (88·9 cm.) high. It weighs 1,144
ounces and is formed as Hercules atop a boulder
from which springs the many-headed Hydra he is
about to slay. A piece such as this is typical of the
collections of the Royal Dukes (sons of King
George III). This particular example, the property of
the Duke of York, was sold at Christie's on March
19th, 1827. It should not, however, be thought
that fine, balanced work was unknown during the
mid 19th century. At least some candelabra have
been converted to burn Colza oil at a later date, and
lamps of candlestick form are the lineal successors
of the candelabrum. A splendidly over-decorated
pair, designed for eight or nine lights, was made
by Tiffany's of New York, in the mid 19th century,
and is amongst the Morrison Gift to the Min-
neapolis Institute of Arts. This pair is an excellent
example of 'American Victoriana'.
Bibliography

J.F. Hayward, 'Candlesticks with figure stems'. *Connoisseur*, January 1963.
R.W. Symonds, 'Lighting the 18th century Home'. *Country Life Annual*, 1958.
A.G. Grimwade, 'Woburn Abbey and its Collections. The Silver'. *Apollo*, December 1965.
G.B. Hughes, 'Elaboration by Candlelight'. *Country Life*, October 7th, 1965.

Candlestick

Although Henry VIII is known to have possessed
four made of gold, enamelled in red and decorated
with his monogram, table candlesticks are extremely
rare survivals prior to the Restoration of 1660. This
is surprising when one considers their necessity
until the fairly recent past. The only Elizabethan
example is a rock-crystal and silver two-light
example called the Sanford Candlestick and
dated c. 1580, whose present whereabouts is a
mystery. A pair of silver-gilt and rock-crystal
candlesticks in the Philadelphia Museum of Art
bear the maker's mark only, P, and date from about
1610 (**65**). A wirework candlestick of 1615, on
three cupola feet, is in a private collection (**68**); two
other similar ones of 1618 survive, as does a pair of
c. 1630 (**64**). Jackson produces an engraving of
another type of this period, as having been in the
Meyrick Collection. An 18th-century reincarnation
is illustrated in Fig. **IVc**. A splendid silver-gilt pair of
1624 are amongst the English plate in the Kremlin,
but four plain candlesticks of 1637 are apparently
the earliest set in existence. They have wide, cir-
cular drip pans at the base of the stem, and each
stands on a broad, bell-shaped foot. This form

would appear to have survived until the Restoration
to judge from the large number of examples on
trumpet feet found in the Kremlin (dating c. 1663),
another pair of 1653 (**67**) and a few examples in
earthenware and pewter. Colour plate **9** illus-
trates a pair of candlesticks hall-marked in 1675. The
tentative revival of Gothic forms in ecclesias-
tical plate of the mid 17th century seems to have
spread to secular silver but slightly, and there is
little existing evidence to show this, only a type of
cluster column candlestick (**69** and Fig. **Ia**). The
Corporation of Hereford have cluster column
candlesticks which date from 1666. The earliest
known American candlesticks are of this type, and
are in the Garvan Collection, University of Yale,
they are also probably the finest of their kind (**74**).
Less than a dozen pairs of American cast candle-
sticks appear to have survived prior to the middle
of the 18th century. Surviving Canadian examples
are probably less than four in number. At Salisbury
Cathedral, the altar candlesticks of 1663 are
formed as two superimposed cluster columns with
a cushion between. By this time Dutch influence
was on the increase (Fig. **Ib**), and the pair of 1673
in the Farrer Collection, Ashmolean Museum,
Oxford, on four escallop feet represent this search
for a new style (**73**). It is strange that in a nation
very much influenced by architecture, it was not
until the early 1680s that the Doric column (Fig.
Id), or monument, candlestick appeared (**76**).
This also represents the last of the candlesticks
raised from sheet metal until the 1770s. The first
cast candlesticks appear in 1675, rather shorter
than their successors but of a now familiar form on
square or circular base and cast in three parts. A
pair, on a triangular foot, made by Pierre Harache
in 1696, is in a private collection. Figs. **Ic** and
IIIa are examples of cast candlesticks.

Not until the turn of the 18th century were the
column candlesticks fairly ousted. From now on
the variety is endless and the quality of some cast
examples quite remarkable. The smaller variety of
about 6 in. (15·3 cm.) high, continued to be made,
generally for use in toilet services (Fig. **Ie**). Those
intended for the table become slightly taller, about
7 in. (17·8 cm.) high (**75**), and an octagonal or
hexagonal foot of shallow domed form, sometimes
faceted, is fashionable during the first two decades
of the 18th century (Fig. **IIIb, c** and **d**). The type
with square moulded base, with cut corners and
sunken depressions at the foot of the plain
baluster stem dates from about 1720 (Fig. **IIIe**).
The form remains little changed, but towards the
middle of the century more and more decoration is
added and the candlestick grows still taller (Figs.
IVa, c and **Vb**). Shells, foliage and rock-work serve
as adjuncts to examples which are amongst the
fullest flights of the Rococo (**79**). Figs. **Va, c** and
VIb illustrate the variations of the Rococo style.
During the 1750s, a form of candlestick with
attenuated baluster stem, somewhat resembling
bamboo, makes its appearance, probably inspired
by the chinoiserie fashion of the day. These were
made in enormous quantities by specialist makers,
such as the Cafe family, Gould and Coker (Fig. **V**).
Very rarely, Irish examples are encountered, in
which the stem and base may be unscrewed, a
feature relatively common in brass candlesticks. A
plainer, more reserved form succeeded these in the
1750s, frequently with gadrooned decoration (Fig.
VIa).

It should be noted that candlesticks, usually on
triangular bases, with figure stems, either kneeling
or standing, had appeared during the last decade of
the 17th century (**82** and Fig. **II**). A pair by
Anthony Nelme of 1693 is in the collection

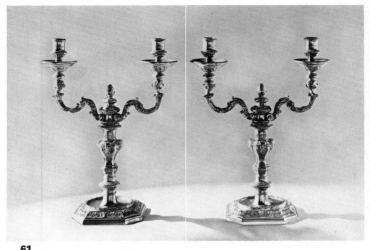

61

62

63

64

65

66

67

68

69

70

71

72

61 A Pair of Candelabra
Maker's mark of George Wickes.
Hall-mark for 1731.
Engraved with the crest and motto
of Frederick, Prince of Wales.

62 A Pair of Candelabra
Maker's mark of Matthew Boulton.
Hall-mark for 1809—12.
Height 24½ in. (62·3 cm.).
Branch span: 16½ in. (41·9 cm.).

63 A Pair of Candelabra
Maker's mark of Frederick Kandler.
Hall-mark for 1738.

64 A Pair of Candlesticks
Maker's mark, WR with an arçh
above, probably the mark of
William Rainbow.
c. 1630.

65 A Pair of Candlesticks
Silver-gilt and crystal.
Maker's mark, P within a shield.
c. 1610.
Philadelphia Museum of Art.

66 Candelabrum
One of a set of four.
Maker's mark of Thomas Pitts.
Hall-mark for 1759—60, London.
Overall height 16 in. (40·7 cm.).
Colonial Williamsburg, Virginia.

67 A Pair of Candlesticks
Maker's mark, AM, probably the
mark of Andrew Moore.
Hall-mark for 1653.
Height 6¾ in. (17·2 cm.).

68 Candlestick
Maker's mark, WC with an arrow
between.
Hall-mark for 1615.
Height 5 in. (12·7 cm.).

69 A Pair of Candlesticks
Maker's mark, B P with an escallop
below.
Hall-mark for 1670.
Height 8 in. (20·4 cm.).
Cluster column candlesticks
engraved with the Arms of
Chichester.

70 Candelabrum
Maker's mark of John Pero.
Hall-mark for 1733.
Height 7½ in. (19·1 cm.).
Engraved with the crest of Lascelles.

**71 A Pair of Altar
Candlesticks**
Maker's mark, hound sejant.
Hall-mark for 1653.
Staunton Harold.

72 Candelabrum
One of a pair.
Maker's mark of Robert Garrard.
Hall-mark for 1825.
Height 29 in. (73·7 cm.).
Applied with the Arms of William,
6th Duke of Devonshire.

39

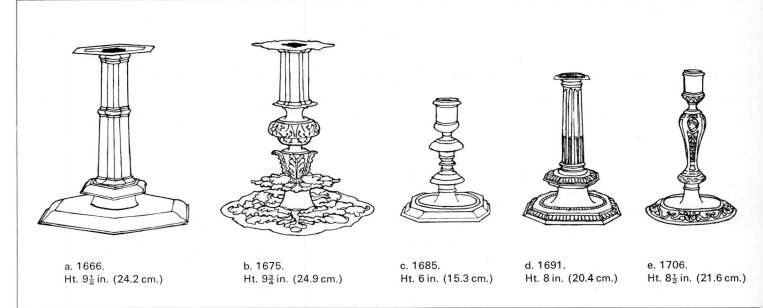

a. 1666.
Ht. 9½ in. (24.2 cm.)

b. 1675.
Ht. 9¾ in. (24.9 cm.)

c. 1685.
Ht. 6 in. (15.3 cm.)

d. 1691.
Ht. 8 in. (20.4 cm.)

e. 1706.
Ht. 8½ in. (21.6 cm.)

Fig. I

Fig. I
A group of candlesticks, 1666–1706. a. The influence of the Gothic revival is illustrated in this candlestick. b. An example of a cluster column candlestick. c. A cast candlestick on an octagonal base. d. A monument candlestick, showing the influence of the architectural Doric column. e. A candlestick which may have been part of a toilet service.

Fig. II
A figure-stemmed candlestick.

Fig. III
A group of candlesticks, 1707–38. a. A cast candlestick on a circular base. b. c. and d. Examples of early 18th-century table candlesticks, with octagonal and hexagonal feet, which were sometimes faceted. e. A candlestick with a square moulded base, cut corners and a sunken depression at the foot of the plain baluster stem.

Fig. IV
A group of candlesticks, 1737–40. a. The candlestick becomes taller towards the middle of the 18th century and the plain, baluster stem now becomes highly decorated. b. A French-inspired candlestick. The two-light branches illustrated above could be attached to a variety of sticks with the result that they often became separated from their original candlesticks. c. An 18th-century reincarnation of the early 17th-century wirework candlestick.

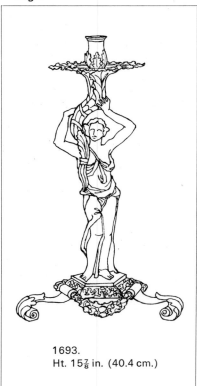

1693.
Ht. 15⅞ in. (40.4 cm.)

Fig. II

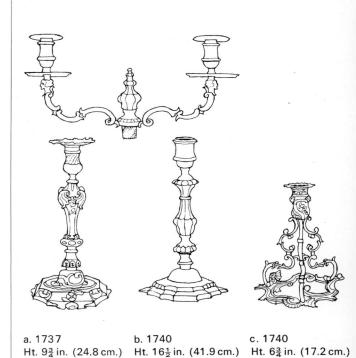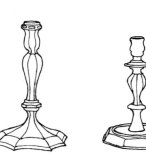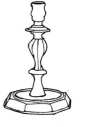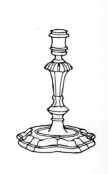

a. 1737
Ht. 9¾ in. (24.8 cm.)

b. 1740
Ht. 16½ in. (41.9 cm.)

c. 1740
Ht. 6¾ in. (17.2 cm.)

Fig. IV

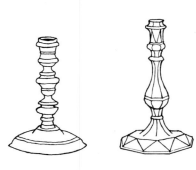

a. 1707.
Ht. 6 in. (15.3 cm.)

b. 1713.
Ht. 7¼ in. (18.4 cm.)

c. 1715
Ht. 7¼ in. (18.4 cm.)

d. 1725
Ht. 6⅛ in. (15.6 cm.)

e. 1738
Ht. 6⅞ in. (17.5 cm.)

Fig. III

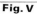

Fig. V
A group of candlesticks and branches, 1742–53. a. and c. Examples of highly decorated candlesticks, showing the fullest flights of the Rococo fashion. b. A table candlestick with decorated baluster stem and octagonal base. d. A figure-stemmed candlestick, showing the influence of Oriental fashion.
Fig. VI
A group of candlesticks, 1755–71. a. A plainer form of the attenuated baluster candlestick with gadrooned decoration. b. A highly decorated Rococo candlestick. c. and d. The column candlestick returns to favour during the middle of the 18th century. e. A figure-stemmed candlestick showing French influence. The three-light branches make its total height 22 in. (55·9 cm.).

a. 1742
Ht. 10¾ in. (27.3 cm.)

b. 1748
Ht. 13¼ in. (33.7 cm.)

c. 1750
Ht. 16 in. (40.7 cm.)

d. 1753
Ht. 11 in. (28.0 cm.)

Fig. V

a. 1755
Ht. 9⅞ in.
(25.1 cm.)

b. 1759
Ht. 11½ in.
(29.2 cm.)

c. 1760
Ht. 16 in.
(40.7 cm.)

d. 1770
Ht. 10¼ in.
(26.1 cm.)

e. 1771
Ht. 12⅒ in.
(30.8 cm.)

Fig. VI

73

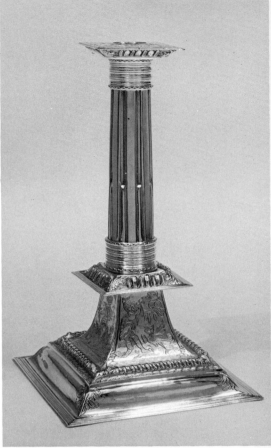

76

74

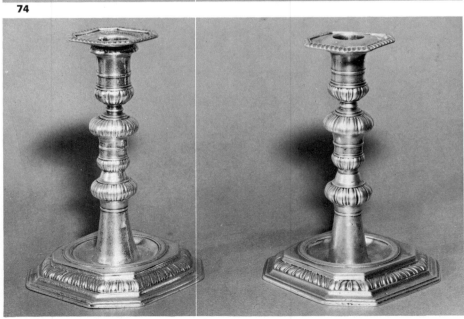

75

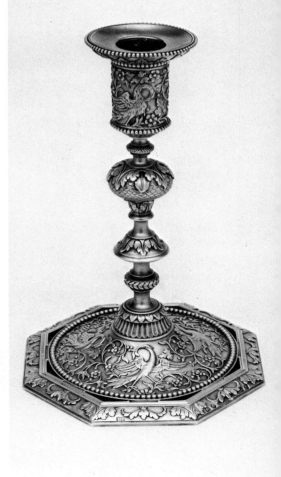

77

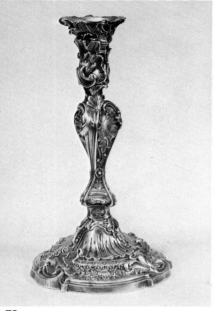

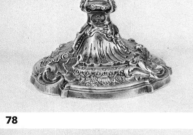

78

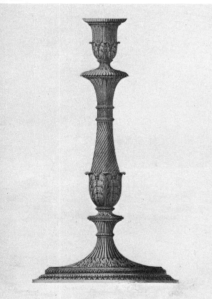

79

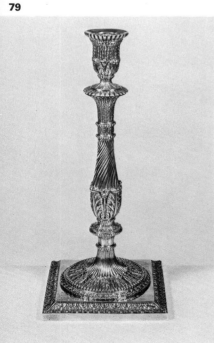

80

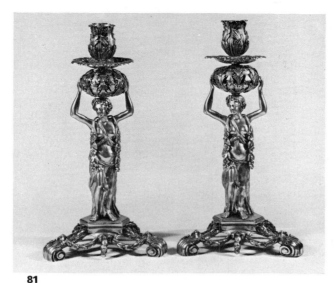

81

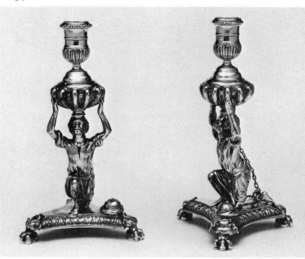

82

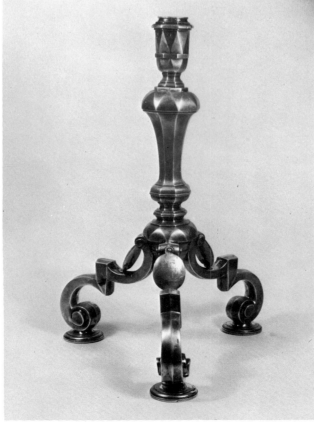

83

73 A Pair of Altar Candlesticks
Maker's mark, TI, probably the mark of Thomas Issod.
c. 1675.
Height 11 in. (28·0 cm.).
Church of the Holy Cross, Bedminster.

74 A Pair of Candlesticks
Maker's mark of Jeremiah Dummer of Boston.
c. 1675.
Yale University Art Gallery, Mabel Brady Garvan Collection.

75 Candlesticks
Two of a set of four table candle-sticks.
Maker's mark of Thomas Ker.
Hall-mark for 1700, Edinburgh.
Height 7 in. (17·8 cm.).
Engraved with the crest and motto of Hope.

76 Candlestick
Maker's mark of Cornelius Kierstede of New York.
c. 1690.
Gift of Robert L. Camman to the Metropolitan Museum of Art, New York.

77 Candlestick
One of a pair.
Maker's mark of Paul Storr.
Hall-mark for 1800.
Height 7 in. (17·8 cm.).
These were originally made to order for Fonthill Abbey and supplied by Vulliamy & Son.

78 Candlestick
One of a set of four Rococo candlesticks.
Maker's mark of James Shruder.
Hall-mark for 1740.
Height 10¼ in. (26·1 cm.).

79 Design for a Candlestick
An Adam design for a candlestick.
c. 1764 and taken from *Adam Drawings*, vol. XXV, nos 96, 97 and 98. Sir John Soane Museum.

80 Candlestick
One of a set of six, probably based on the design of James Adam (1764).
Maker's mark of S. & J. Crespell.
Hall-mark for 1769.
Height 14 in. (35·6 cm.).

81 A Pair of Candlesticks
Maker's mark of Thomas Heming.
Hall-mark for 1770.
Height 12¼ in. (31·1 cm.).
Arms of Arundell with Conquest in pretence.

82 A Pair of Candlesticks
Maker's mark of Anthony Nelme.
Hall-mark for 1697.
Height 8¾ in. (22·3 cm.).

83 Altar Candlestick
One of a pair.
Maker's mark of Gabriel Sleath.
Hall-mark for 1712.
Height 21¾ in. (55·3 cm.).
Bristol Cathedral.

of the Bank of England. From 1735 onwards, figure candlesticks made by the best makers of the day, reappear intermittently, usually of an Oriental form (**81** and Figs. **Va** and **d**). Such candlesticks of caryatid form were made in Sheffield plate from about 1755. Ernest Sieber made a pair of these in 1748, during his time as a silversmith in England, and after his return to the Netherlands in 1752, he made another pair from the same moulds which were marked in The Hague. An interesting, though very late and small example, made by William Elliot dated 1818, has the stem formed as a mandarin. Another pair, each formed as an Eleanor Cross, 1805, are illustrated in Fig. **IXb**. One of the latest of such flights of fancy are the Gothic pair made by George Fox in 1845, whose stems are formed as knights in armour. Small taipersticks, usually only miniature versions of the table candlesticks, are however found with figure stems of totally different form. A pair made by John Cafe in 1761 has the stem of one formed as a sailor, the other as a milkmaid; these are in the collection of the Duke of Portland. Examples formed as Harlequin are rather more common (see Candlestick, Taper).

The general use of detachable nozzles seems to be an innovation of the 1740s, perhaps because of the difficulty of cleaning wax from the more decorative examples. Such nozzles often reflect the shape of the candlestick base, but some of them are formed as expanded flowers (Fig. **Vd**). During the 17th and early 18th centuries, the sockets of candlesticks are sometimes pierced to allow for the stub of the candle to be levered out. The fine pair of 1624, referred to above, exhibit this feature as part of the original decoration and not as an afterthought adapted by the owner. French influence produced variations throughout the 18th century as illustrated in Figs. **IVb**, **VIe** and **VIIa**.

The column candlestick returns to favour in the 1760s (Fig. **VIc** and **d**); the Duke of Ancaster purchased '8 pair pillar candlesticks and nozzles weighing 202 oz' from Edward Wakelin in 1771. Most of this type have Corinthian capitals; a pair of 1761 with Doric capitals are most uncommon. It is possible that the pair of Sheffield plate candlesticks for which Horace Walpole paid two guineas in 1760 and described as 'quite pretty', were also of this form. The Adam taste demanded a more elegant stem to the candlestick (**79** and **80**), and a form of plain or partly fluted, tapering baluster, rising from a circular, reeded or beaded foot met this requirement. However, there were many variations as Fig. **VIIa**, **b**, **c** and **d** illustrates. The best examples are by John Schofield. By the early 19th century, heavily chased, foliate examples become more general once again (Figs. **IXa**, **c** and **Xc**). Overlapping both these styles is the plain telescopic candlestick, often of Sheffield plate, and plain of necessity, whose height might be altered at will. Makers such as Paul Storr would on occasion produce, probably to special order, a candlestick such as that illustrated on Plate **77**, the design for which was probably copied from a box-wood example made in France at the turn of the 17th century.

Two other varieties should be noted. Throughout the 18th century, albeit rarely, is found a form of dwarf candlestick having a base and socket of normal size, but lacking the usual stem between. These usually stand a mere 4 in. (10·2 cm). high, and are often called 'desk' candlesticks. They should probably be identified with those supplied to the Earl of Coventry in February 1775 by Wakelin 'To a pair of very low Chimney Candks.', and those illustrated in Fig. **XIa**, **b**, **c**, **d** and **e**. The other variety is of a size midway between the

table candlestick and the taperstick (Fig. **Vb**). These are usually c. 1770 in date. Once again Wakelin's account to Morgan Lewis of 1771 seems to provide the answer: 'To lining 2 pair silver, 2 pair plated and 2 Tea Candlesks with wood covered with green cloth'. The latter is a reference to the midway candlestick and to the filling of the base of such candlesticks with either wood, plaster or bitumen, generally referred to as 'loading', to ensure greater stability. Here, perhaps one should note the possession by Emmanuel College, Cambridge, of two candlesticks 3¾ in. (9·6 cm.) high with broad drip pans, hall-marked 1687, which are designed to screw into a desk or perhaps a pew in the College Chapel.

With a set of candlesticks there might be supplied a pair of snuffers with steel cutting edges for trimming the wicks, together with a stand of similar form to the candlesticks. Whereas the stand would usually be the work of the same candlestick-maker, the snuffers were produced by specialists. Surviving sets are rare, as it would appear that the demand for them died out by 1730, the snuffer tray replacing them. It is thus almost incredible that of the rare surviving American candlesticks, there should be a pair made by Cornelius Kierstede of about 1690, with just such a stand (**529**). The snuffers themselves have, regrettably, not survived. Amongst the Farrer Collection, Ashmolean Museum, Oxford, is a set of four candlesticks with snuffer stand made by Joseph Bird between 1701 and 1702. Bird appears to have been one of the principal candlestick makers of his day.

Throughout the period 1660–1730, altar candlesticks, if large, with pricket finials, continued to be made. They are considerably taller than the table candlestick, and the base is usually of an incurved triangular form, a type which survives on the Continent to a much later date (**71**). Perhaps the largest of such altar candlesticks are a pair made by Denny & Bache, dated 1696. These stand at 37 in. (94·0 cm.) high, and bear the Royal Arms of King William III (collection of the late Lord Fairhaven). An unusual pair is that on three scroll bracket feet, made by Gabriel Sleath in 1712, at Bristol Cathedral (**83**).

Bibliography
Silver Treasures from English Churches. Christie's, 1955.
G.B. Hughes, 'Old English Candlesticks', part I. *Apollo*, February, April 1953.
C.C. Oman, *The English Silver in the Kremlin.* 1961.
J.F. Hayward, 'Candlesticks with figure stems'. *Connoisseur*, January 1963.
Y.A. Fulwell, 'English Silver Candlesticks'. *Antique Collector*, December 1966.
C.R. Beard, 'Taipersticks. The Wright-Bemrose Collection'. *Connoisseur*, vol. LXXXVIII, p. 302.
C.C. Oman, *The Gloucester Candlestick.* H.M.S.O., 1958.
J.E. Langdon, *Canadian Silversmiths, 1700–1900.* Toronto, 1966.
G.B. Hughes, 'Candlesticks with a telescopic stem'. *Country Life*, April 18th, 1968.
See also Altar Candlestick; Candlestick Library; Chandelier; Chantrey, Francis; Nursery Candlestick.

Candlestick, Hand or Chamber

Bed-chamber candlesticks were designed for easy carrying, having a broad drip tray serving as the base and a finger ring, tongue-shaped or scroll handle to one side. Early examples of these hand candlesticks are extremely rare (**86**). One such rare example dated 1652 was sold in 1896 and again in 1903, but does not seem to have re-

appeared since. One wonders whether the combined snuffers, stand, extinguisher and chamber candlestick (**525**) was intended simply as the latter or as a combination set for a servant going the rounds of a large house and seeing to the upkeep of several dozen in daily use. Less than twenty such candlesticks prior to 1700 appear to have survived. Most of these early examples have pierced sockets to enable the stub of the candle to be levered out (**84** and **85**). Some examples dating from this time have their base resting upon stud feet. A rare pair by Philip Rollos of 1702, in the Clanwilliam Collection, has the handle formed as a crest; another at Colonial Williamsburg, Virginia, is triangular in shape and was made in 1733 (**88**). Besides a conical extinguisher, it also became the practice to fit a pair of snuffers through a slot in the stem of the socket (**87**). The tongue handle was superseded in the 1720s by a ring or rising scroll handle into which the conical extinguisher was slotted (**89**). From the mid 18th century onwards pairs of collapsible travelling candlesticks are found. Later, it became usual to protect the flame from draughts by a cylindrical glass shade, and this fitted into a pierced gallery round the base of the stem and was pierced to let an air supply reach the flame. For these particular forms the extinguisher has a long handle, rising from the finial and it often fits over a protuberance rising from the field of the pan. These candlesticks were made in large sets, for at least one was required by each person retiring to bed. An example made by Paul Storr in 1827 is in the collection of Earl Spencer (**90**). Its socket and baluster move, in a gimbal-like mounting, so as always to be vertical. Another of 1812 in the collection of the Duke of Devonshire, has a double steel clip fixed to the front and this facilitates its use at a table or writing desk. In January 1772, Baron D'Alvensleben purchased from Messrs Wakelin 'a doub. hand Candlestick' weighing almost 18 ounces; such a piece does not seem to have survived. One made by Joseph Lownes of Philadelphia, c. 1810, now in the Metropolitan Museum of Art, New York, is in the form of a pen tray, having a sloping triangular housing for the snuffers at one end, the socket in the centre and the conical extinguisher beyond.

Bibliography
G.B. Hughes, *Small Antique Silverware.* Batsford, 1957.
J.F. Hayward, 'Assheton-Bennett Collection'. *Connoisseur*, May 1956.
'Assheton-Bennett Collection'. *Manchester City Art Gallery Catalogue, 1965.*
A.G. Grimwade, 'Silver at Althorp', part II. *Connoisseur*, June 1962.
See also Pen Tray; Snuffer Scissors.

Candlestick, Library or Reading

These, probably inspired by Italian originals, have one or more branches whose height is adjustable on a vertical pole. The light is, at the same time, shielded from the eyes, yet magnified by a reflective shade of dished outline. The Duke of Chandos had one in the library at Cannons which was valued at £28 6s 3d in 1725, but fetched £47 at auction in 1747. An Irish example (**93**) is on loan from the Atha Collection to Kansas City Art Gallery. This, made by Joseph Walker in 1719 has two lights, as has that by Samuel Siervent, 1762 which is 19½ in. (49·6 cm.) high. Another in the Victoria and Albert Museum made by Jonathan Alleine in 1766, has two lights, each formed as a detachable hand candlestick, besides a conical extinguisher and two V rests for a pair of snuffers (now lacking). In 1772, a Sambrook Freeman

88

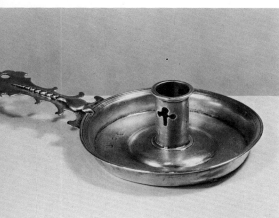

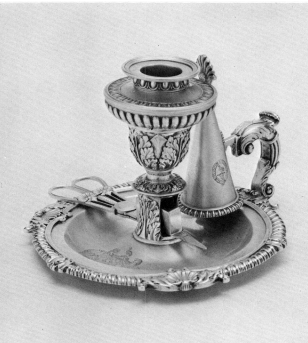

89

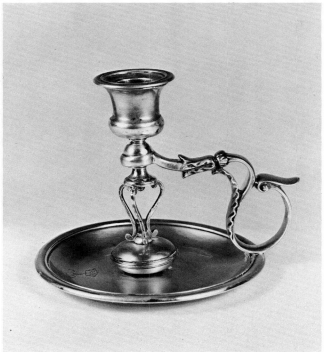

90

84 Hand Candlestick
Maker's mark, WS.
Hall-mark for 1686.

85 Hand Candlestick
Maker's mark, BB.
Hall-mark for 1686.
Diam. 5½ in. (14·0 cm.).

86 Hand Candlestick
Maker's mark, IW.
Hall-mark for 1693.
Height 2¾ in. (7·0 cm.).
Drip tray: width 3⅞ in. (9·9 cm.).
Sterling and Francine Clark Art
Institute.
Engraved with the Arms of Fortescue.

**87 A Pair of Hand
Candlesticks**
Silver-gilt.
Maker's mark of John Schofield.
Hall-mark for 1792.
Snuffers: maker's mark, WB.

88 Hand Candlestick
Maker's mark of Edward Pocock.
Hall-mark for 1733–4, London.
Height 2 in. (5·1 cm.).
Overall length 6½ in. (16·5 cm.).
Colonial Williamsburg, Virginia.

89 Hand Candlestick
Maker's mark of J. & W. Storey.
Hall-mark for 1808.

90 Hand Candlestick
Maker's mark of Paul Storr.
Hall-mark for 1827.

Fig. VII
A group of candlesticks, 1776–83.
a. A candlestick with three-light branches, making its total height 20 in. (50·8 cm.). d. A candlestick with two-light branches, making its total height 16½ in. (41·9 cm.). All four candlesticks illustrate the Adam style, with plain or fluted, tapering baluster stems.

Fig. VIII
A group of candlesticks, 1788–1800. a. A candlestick with three-light branches, making its total height 22 in. (55·9 cm.). c. A candlestick with six-light branches, making its total height 25½ in. (64·8 cm.). All three candlesticks illustrate how much taller such pieces were becoming at the end of the 18th century and how much they were inspired by the taste of the Prince of Wales and his followers.

a. 1776	b. 1777	c. 1779	d. 1783
Ht. 11⅔ in.	Ht. 11¼ in.	Ht. 11¼ in.	Ht. 10⁹⁄₁₀ in.
(29.6 cm.)	(28.6 cm.)	(28.6 cm.)	(27.8 cm.)

Fig. VII

a. 1788
Ht. 10½ in. (16.7 cm.)

b. 1789
Ht. 12 in. (30.5 cm.)

c. 1800
Ht. 19 in. (48.3 cm.)

Fig. VIII

Fig. IX
A group of candlesticks, 1802–
c. 1810. a. A highly chased and
foliate example with two-light
branches, making its total height
20 in. (50·8 cm.). b. One of a pair
of Eleanor Cross candlesticks. c. A
highly chased and foliate example
with three branches. d. A plainer
example.
Fig. X
A group of candlesticks, 1811–42.
a. A candelabrum with three
detachable branches, making its
total height 29 in. (73·7 cm.), of a
style inspired by the Prince of Wales
during the Romantic era. b. A
candlestick midway in size between
the table candlestick and the
taperstick. c. A highly chased and
foliate example.

a. 1802 b. 1805 c. 1808 d. *c.* 1810
Ht. 12$\frac{4}{5}$ in. (32.6 cm.) Ht. 2 in. (5.1 cm.) Total ht. 27 in. (68.6 cm.) Ht. 10 in. (25.4 cm.)

Fig. IX

a. 1811. Ht. 22$\frac{1}{10}$ in. (56.3 cm.) b. 1823. Ht. 9$\frac{1}{4}$ in. (23.5 cm.) c. 1842. Ht. 12$\frac{1}{2}$ in. (31.8 cm.)

Fig. X

bought 'a double branch and slider to a reading Candk' together with 'a tin shade painted and covered with green silk' (Garrard Ledgers, Victoria and Albert Museum). A similar candlestick supplied to Sir Robert Clayton had 'a pair of steel snuffers with silver bows for ye Reading Candk.'. On January 28th, 1668–9, Samuel Pepys records in his diary: 'Mr. Sheres hath, beyond his promise, not only got me a candlestick made me, after a form he remembers to have seen in Spain, for keeping the light from one's eyes, but he hath got it done in silver very neat . . .'.

Bibliography
C.H. Collins Baker and M.I. Baker, *James Brydges, 1st Duke of Chandos*. 1949.
See also Candelabrum.

Candlestick, Piano

A Victorian innovation was a dwarf candlestick, usually in pairs, with a single branch which could overhang the music rest, or indeed a mantelpiece. Uncommon and usually of electroplate when found, they are seldom beautiful or very practical.

Candlestick, Taper

The taper candlestick, or taperstick, as it is more generally known, follows in design the various forms of table candlestick and first appears about 1685. Two fine, early examples belong to the Corporation of Oxford, one made by Benjamin Pyne in 1690, the other by Edmund Proctor in 1701. The only exceptions to this design are those which formed part of an inkstand, either separately or as the handle of a bell or the cover of a wafer box. The latter are usually very similar in form to chamber candlesticks, with the exception that the extinguisher is often attached by means of a chain (**92**). The use of sealing wax for all letters created the need for a single taper holder upon the writing desk, therefore it is unlikely that pairs were often found in use together, although sold as such. The taper, in itself, was of small diameter and dwarf, desk or chimney candlesticks should not be confused with tapersticks. The Harlequin taperstick belongs to the late 1740s. Lord Delamere purchased one, which stood about $5\frac{1}{2}$ in. (14·0 cm.) high, in April 1759 at a cost of £2 14*s* 0*d*; however, it does not seem to have found favour in a larger size, though reproduced by Emes & Barnard in the 1820s. Tapersticks are also known as 'tobacco' and 'tea' candlesticks and die out in 1775, except as part of an inkstand, being succeeded by the wax-jack. In Exeter Museum, there is an interesting example bearing the London hall-marks of 1619. This stands upon a ring foot stamped with egg and dart decoration, from which spring three scroll brackets to support the pan and socket, the former having a flat, pierced handle to one side. At the other end of the scale is an amusing, silver-gilt pair formed as standing figures of mandarins and made by William Elliot in 1818. They stand 7 in. (17·8 cm.) high and could almost be considered as desk candlesticks. The Assheton-Bennett Gift to Manchester City Art Gallery includes a very complete range of tapersticks.
See also Taper Stand.

Candlestick, Travelling

Some of the earliest, which date from the 1740s, are formed as two hemispheres, having candle sockets which may be unscrewed, laid loose on either side of the central boss and the other hemisphere inverted and screwed into the first. One engraved with the crown and cypher of Queen Charlotte and hall-marked 1805 also has conical extinguishers which are dated 1807. This type,

however, is most frequently of late 19th-century date having been set as a favourite task for cadets at Woolwich. A variation of this theme is a Victorian oval example with folding sockets and scroll handles (**91**). Another type is club-shaped, the foot unscrewing and revealing a socket with a candle protected by the shaft of the club into which the socket is now attached, so that it serves as a stem. An example of 1798, some $5\frac{1}{2}$ in. (14·1 cm.) high, is in a private collection. An ingenious Sheffield plate example (Sheffield City Museum) forms not only a hand candlestick, but also a telescopic table candlestick.

Cane and Staff

Gold and silver mounts have been employed as decoration for the staffs and wands of gentlemen from early times. In the 16th century, the staff was usually of some exotic hardwood; in the 18th century, ebony, until 1750 when the malacca cane became fashionable as a 'dress' stick. The majority of the survivors are of the latter wood with gold or silver tops, often finely chased with a Classical scene and engraved with the owner's initials. The quality of this chasing and that of watch cases shows much affinity. Gentlemen holding the offices of Gold and Silver Sticks-in-Waiting to the sovereign had a particular form of staff in the respective metals, the tops bearing the Royal Arms and chased with a Régence decoration below. One of each of these may be seen in the collection of the late Lord Fairhaven at Anglesey Abbey. In the same collection is a gold-topped cane engraved G P R (perhaps for George, Prince Regent), appropriately chased with King John signing the Magna Carta. This also retains its outer case of metal, shagreen covered, a rare survival. Cane heads, enclosing vinaigrettes or forming the hilt to a sword blade encased in the cane itself, are not unknown, although early examples are rare. The Staff of the Mayor of Guildford is made of campeachy wood and has silver mounts engraved with the date 1565. In the London Museum is a silver-mounted black-thorn stick engraved 'Ralph Blundel June ye 1. 1679'. The Officers of State bore wands of office, varying in length but usually some 60 in. (152·4 cm.) long. On occasion, shorter batons were supplied, often with the Royal Arms at one end and those of the holder at the other. Porters and running footmen also bore large staves of up to 90 in. (228·6 cm.) long, of similar form to those of a parish beadle. St Edward's Gold Staff, 55 in. (139·7 cm.) long, is among the English Coronation Regalia, and could best be described as a sceptre rather than a staff, save for its iron ferrule.

Bibliography
Sir C.J. Jackson, *An Illustrated History of English Plate*. Vol. II, p. 919. 1911.
See also Baton, Field-Marshal's and Staff of Office; Corporation and Ceremonial Plate; Vinegar Stick.

Canongate

Canongate is now an integral part of Edinburgh, but in early times it was a separate Burgh. The Canongate mark is the crest of the Burgh, a stag's head charged between the antlers with a cross-crosslet fitchée. Silver bearing this mark is found but rarely, and on the earliest examples the stag is lodged (that is, recumbent). Usually, but not invariably, the cross-crosslet is omitted from the mark. It is doubtful if much silver, if any, emanated from Canongate after 1835.

Bibliography
Sir C.J. Jackson, *English Goldsmiths and Their Marks*. 2nd Edition 1921, reprinted 1949.
See also Edinburgh Assay Office.

Canopy Silver

A tankard of 1661 belonging to the Goldsmit[h] Company is engraved 'This Pott was made of [the] Silver of ye Canopie when King Charles ye 2nd w[as] crowned Aprill 23rd, 1662'. A chinoiserie porring[er] of 1685 is engraved 'Ex Regis Fulcro Regis Salu[...] and a further inscription detailing its use at '[the] Coronation of James II 23 of Aprill 1685'. A cano[py] pole dated 1820 (one of eight at the Coronation [of] 1821) was illustrated in the catalogue of [the] C.I.N.O.A. (La Confédération Internationale d[es] Négociants en Oeuvres d'art) Exhibition at t[he] Victoria and Albert Museum in 1962. Since [the] Coronation of King John on Ascension Day 119[...] the monarch and his consort have been escort[ed] by the Barons of the Cinque Ports, each holdin[g a] pole with a bell on its end, which supported [the] canopy. Thus, the silversmith had sixteen possi[ble] 8 ft. (244·0 cm.) poles to draw upon in 1757 wh[en] he made the punch bowl and ladle, now in [the] possession of the Corporation of Hastings.

Bibliography
Edward Perry, 'Gift plate from Westminster H[...] Coronation Banquets'. *Apollo*, June 1953.
See also Bell (Coronation Bell).

Canteen See Service; Travelling Canteen.

Carat and Weight

In so far as it concerns gold, the carat is not [an] absolute weight, merely a twenty-fourth part o[f a] unit. Each carat is divided into four grains and ea[ch] grain into four quarters. When referred to [in] relation to a diamond the carat equals 3·17 grai[ns]. Both silver and gold are measured in T R O Y weig[ht].

24 grains=1 pennyweight (dwt.).
20 dwt. =1 ounce (oz.).
12 oz. =1 pound (lb.).
1 grain =0·648 grammes.

Conversions
1 ounce Troy=1·097 ounces Avoirdupois=3[...] grammes.
1 pennyweight=0·05485 ounces Avoirdupoi[s=] 1·555 grammes.
1 gramme=0·03215 ounces Troy=0·643 dwt.
 To convert ounces Troy to ounces Avoirdup[ois] multiply by 1·0971.
 To convert ounces Avoirdupois to ounces Tr[oy] multiply by 0·9115.

Bibliography
Staton Abbey, *Goldsmiths and Silversmiths Han[d]book*. 1952.

Card Case

Tablet cases made their appearance in the 18[th] century, the tablet being of ivory and often t[he] whole was fitted as an étui. During the seco[nd] quarter of the 19th century the card case prop[er] made its appearance. Usually manufactured [in] Birmingham, it was generally chased with flow[ers] and foliage. One particular variety had a top[o]graphical subject on one or both sides, Winds[or] and Warwick Castles, Abbotsford and Newste[ad] Abbey being most popular. Besides those specia[lly] commissioned, Exeter Cathedral, Osborne a[nd] Buckingham Palace were somewhat more unusu[al].
See also Étui; Snuff Box.

Cartouche

Originally a scroll ornament like the Ionic volu[te,] derived from cut-paper or parchment scrolls, [it] developed into a tablet form, usually oval, w[ith] scrolled or ornate frame containing a coat of arm[s,] inscription or pictorial ornament.

Casket See Box.

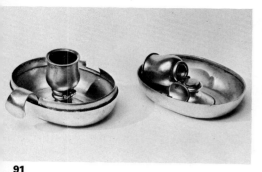

91

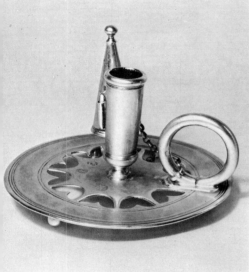

92

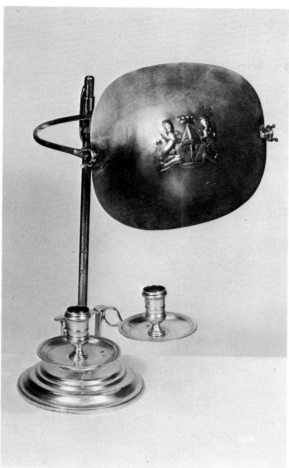

93

91 **A Pair of Travelling Candlesticks**
Maker's mark of Hamilton & Inches.
Hall-mark for 1902, Edinburgh.
Length 3½ in. (8·9 cm.).

92 **Taperstick**
Maker's mark of John Shepherd.
Hall-mark for 1699, London.
Ashmolean Museum.
This is of hand candlestick form.

93 **Library Candlesticks**
Maker's mark of Joseph Walker.
Hall-mark for 1719, Dublin.
Atha Collection, Kansas City
Art Gallery.

Fig. XI
A group of candlesticks, known as
dwarf or desk candlesticks, 1680–
1769.

a. 1680. Ht. 5¾ in. (14.6 cm.) b. 1704. Ht. 4½ in. (11.5 cm.)

c. 1767. Ht. 5⅜ in. (13.7 cm.) d. 1767. Ht. 5⅜ in. (13.7 cm.) e. 1769. Ht. 5 in. (12.7 cm.)

Fig. XI

Casserole

Derived from the French word descriptive of an open-mouthed pan, this form of stewpan (first noted about 1725) would not be detailed here, but under stewpan, were it not for the survival of at least one of four such two-handled circular pans, in this case with shallow domed cover. Its overall width is 9¾ in. (24·8 cm.) and it was made in 1795 by Robert Salmon. This is engraved 'Four of these Carosols and their covers are the produce of a present ... to Mrs. Siddons ...'.

See also Stewpan; Vegetable Dish.

Caster

The modern spelling is 'caster', the termination 'or' being a survival from the 18th century. The caster, be it for sugar or any other form of spice has taken many forms. The Elizabethan bell salt usually terminates in a caster, probably for pepper. A number of smaller 16th-century casters, some partly of rock-crystal, are probably the 'casting bottles' referred to in early inventories (**94**). If used for sugar, that is until the advent of modern milling machinery, the piercings had to be sufficiently large to permit the passage of the roughly pounded loaf sugar. Existing Elizabethan examples seem too finely pierced for this purpose (**95**, **96** and **97**). Blind casters, usually forming part of a set of three or more, are generally thought to have been for dry mustard. They are, however, seldom found surviving as parts of 17th-century sets; perhaps they were pierced later. One, the finial of the cover being detachable, was obviously designed for use with a long spoon; this dates from the 1740s. Between the Elizabethan bell salts and the cylindrical 'light-house' form (**99** and **101**), first known during the Cromwellian Commonwealth, nothing appears to have survived the holocaust of the Civil War. An example engraved with the date 1658 is one of the earliest on record (**98**). By the reign of Charles II the cylindrical form was more or less constant. Some of the earliest sets were the fluted examples of 1683, at the Queen's College, Oxford. Another, earlier, plain blind caster of 1669 is known, and an octagonal example with hinged cover of 1674 is still in an ancestral collection. A pair of 1672 now separated are both 5¼ in. (13·4 cm.) high, both bear the Arms of William, 2nd Earl of Dumfries. That in the Sterling and Francine Clark Art Institute is a blind caster. A set of three, large, square casters, also with hinged covers, made by John Edwards in 1701, is still at Petworth. Another rarity, both as a piece and because it is six-sided, is the caster in the Museum of Fine Arts, Boston, made by John Coney, c. 1715. By the first decade of the 18th century a change of form became apparent, plain or octagonal pear-shaped casters made their appearance (**104**), decorated according to the fashion of the moment with cast and applied cut-card work and straps (**103** and **106**). This naturally led to fine chasing and elaborate Rococo forms (**102** and **108**). The Classical vase shape is sometimes used for casters of the late 18th century. At the beginning of the century however, one man, Charles Adam, seems to have held almost a monopoly of their making, and by the end of the reign of George II, this specialist market was largely in the hands of Samuel Wood (**107**).

Since 1800 almost no new form of sugar caster is recorded, although large numbers of silver-mounted, cut-glass examples were made from 1780 onwards. The Victorians delighted in 'beautifying' old ones and copying anew, but little, if any, has been done to better a design basically perfected two hundred and fifty years ago. A pair of 1809 in the Royal Collection formed as owls are revivals of a German original. The trade name 'Warwick Cruet' probably derives from the set fitted with five casters made in 1715 by Anthony Nelme. All sets later in date than 1720 have almost certainly formed part of such a Warwick Cruet (**162**). The muffineer, appearing c. 1760, and usually only a smaller edition of the sugar caster, is probably intended for pepper, though it can be utilised for modern, finely ground sugar. The smallest casters of all are very uncommon, and were probably intended for use with an oil and vinegar frame, some of which have an extra ring to accommodate such a caster besides those for the bottle caps. A pair, made for the Percy family in 1681, each 3⅛ in. (8·0 cm.) high, are engraved G (possibly for ginger) and N (possibly for nutmeg). William Fitzhugh of Virginia ordered in 1689 'a Sett of Castors, that is to say for Sugar Pepper and Mustard'. The cover to a caster was at first flat-domed, later it became a pointed dome which could be fitted by means of a bezel, fitting tightly within the upper lip of the body. Lamerie used a circular bezel with octagonal casters. The cover could also be fitted by means of a deep sleeve-type bezel fitting over the outside of the upper part of the body (**100**) or by a bayonet joint, utilising two lugs attached to the cover and an interrupted rib round the lip of the body, this latter being the usual fitting until 1695. Of this form is a very rare Edinburgh example made by Thomas Yourston in 1684, now in a private collection in Canada. The hinged covers to the square casters of 1701, cited above, have overriding lugs to a moulded lip at the front. That of 1674 has a hook and eye type of fastening. Another set of square casters, c. 1720, are illustrated on Plate **105**.

Bibliography

W.W. Watts, *Catalogue of the Lee Collection*. 1936.
G.B. Hughes, 'Silver Casters and Cruets', parts I, II and III. *Apollo*, January, February, July 1954.
E.A. Jones, *The Plate of the Queen's College, Oxford*. 1938.
J.F. Hayward, *Huguenot Silver in England*. Faber & Faber, 1959.

See also Cruet; Epergne; Inkstand; Kitchen Pepper or Spice Dredger; Mustard Pot; Pepper Pot; Scent Flask.

Casting

Handles and other fittings to objects wrought in silver are often cast, generally in a sand (marl) mould, then chased up afterwards. This applies to every form of mount, including such sections as the Apostles on spoon finials; porringers (one of 1683 has the maker's mark, EN, on the handles whilst the body bears the mark, DC); the lion's mask and drop-ring handles on punch bowls; spouts for jugs and coffee pots and the swing handles and mounts of the finer quality baskets. Considerable portions of epergnes and wine cisterns were also cast. Throughout the first half of the 18th century and until the 19th century, with the exception of the cheaper variety stamped out in Sheffield and Birmingham, almost all candlesticks and candelabra were cast. Occasionally, later copies reveal the impressions of hall-marks struck on the originals from which a mould was made. The handles of the more important two-handled cups were also made by casting, usually in two halves; some finials were also fashioned in this way. During the 18th century it is quite common to find relatively unimportant mugs with cast handles of plain S scroll and, later, reversed S. Tankards on the other hand only seem to have been given such handles when more than ordinarily important. Particularly impressive are the dolphin handles on the gold cup of 1732 made by David Willaume f Frederick, Prince of Wales, as a gift from Sidn Godolphin, but never in fact presented, probal owing to Godolphin's death in that same year.

It is likely that specialist casting shops suppli the needs of most silversmiths from comme moulds. Lamerie was perhaps unique in makil most of his own castings. He, and others with similar clientele, did on occasion cast the arms of company or a certain patron, which were the applied to the commissioned piece. The Coac makers' Company have a flagon of c. 168 decorated with their cast coat of arms. In mal cases the arms themselves may be unscrewed an aid to cleaning, and this was doubly usef should the object have to be sold to a new own See also Silversmithing.

Casting Bottle

These are noted in a number of early inventori as being sometimes of appreciable dimensior six in the Jewel House of the Tower of Londc mentioned in the Inventory of 1649, actua weighed 198 ounces. The only survivors of casti bottles, as we know them, are quite small. Or in the Victoria and Albert Museum, of about 154 is of rock-crystal with silver-gilt mounts, yet or 5¼ in. (13·4 cm) high, others are even smaller. would seem likely that these were used sprinkling scented water, spice or pounce, espe ally when one considers how many of them we provided with devices which enabled them to suspended from chains.

See also Pounce Box.

Caudle

There were many varieties of this drink; the wh caudle, of oatmeal, spices and white wine; t brown, which substituted ale, dark wine or bran for the white wine and tea caudle which addition to the above ingredients also contain tea, eggs and spices, and was generally admini tered to pregnant women.

See also Cup, Caudle.

Caul (Cawl) and Stone Boxes

The birth of a child with a caul over its face h always been considered a good omen. Con memorative inscriptions on silver or gold boxes snuff-box size and form in which the caul is pr served record the few rare occasions on whic this occurred. An unmarked, gold example on part of the Noble Collection, chased to represe a hamper, is engraved 'The Honourable Willia Robert FitzGerald Second Son to James ai Emily Earl and Countess of Kildare was bo March the Second 1748/9 with the inclosed Ca on his Face' (**520e**). Another similar box, made Exeter, is amongst the collection of the Birmin ham Assay Office. At St John's College, Oxfoi is an ovoid box, the upper part made of glass wi the lower half of gold, containing a human ga stone (maker's mark only, F incuse). It bears th inscription 'This stone was taken from ye body Doctr John King, Lord Bishop of Londo Descended from ye Antient Kings of Devonshii who dyed ANNO 1621'. The box is 3 in. (7·7 cm in overall length and still preserves its origii shagreen case.

Cavetto

Quarter-round concave moulding.

Censer (Thurible)

The requirement of this piece of plate is that should allow for the slow and controlled burnii

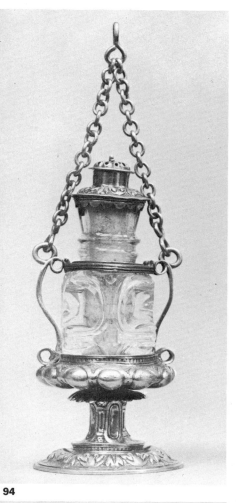

94 Caster
Unmarked, *c.* 1540.
Victoria and Albert Museum.
In the early inventories such casters were referred to as 'casting bottles'.

95 Caster
Hall-mark for 1563, London.
Victoria and Albert Museum.
Sir Charles Jackson calls this piece a 'rose-water sprinkler'.

96 Caster
Maker's mark, probably IF.
Hall-mark for 1577.
Height $4\frac{3}{8}$ in. (11·1 cm.).

97 Caster
Silver-gilt.
Unmarked but ascribed to a gold-smith whose mark is TYL.
c. 1610.
Height 3 in. (7·7 cm.).
Victoria and Albert Museum.

98 Caster
Unmarked, *c.* 1658.
Height $4\frac{1}{4}$ in. (10·8 cm.).

94

95

96

97

98

of incense and the escape of a steady stream of smoke. It is swung from pendent chains by an altar boy during the course of the Mass. At first spherical, by 1200 the upper half had attained some architectural form, and the Gothic taste generally favoured an architectural upper section finely pierced and chased. Only one English, silver-gilt example has survived from the Middle Ages; it is the magnificent Ramsey Abbey Censer of c. 1350, found with its associated parcel-gilt incense boat in 1850. It should be emphasised that this was probably a particularly fine censer even in its day. Colour Plate **13** illustrates both the Ramsey Abbey Censer and Incense Boat. The repair of the censers was an annual item in the accounts of any sacrist. It was he who was also responsible for the very large censers which swung in the main body of the church; many are known to have existed and, in fact, one is still in use at Cambridge.

Despite their mention in records, no Recusant censers seem to have survived prior to 1680 (**109**). That made for the Chapel Royal, Edinburgh, in 1686, is probably the earliest and finest. Early 18th-century examples tend to resemble sugar casters or be straightforward copies of Continental originals. That by Benjamin Pyne of 1708 (**110**), formerly in the Clifford Collection, resembles a sugar caster, whilst another by Laurent Amiot of Quebec, c. 1790, is a copy of a Continental censer (Henry Birks Collection).

Bibliography

C.C. Oman, *English Church Plate*. Oxford University Press, 1957.

J.E. Langdon, *Canadian Silversmiths, 1700–1900*. Toronto, 1966.

Hubert Fenwick, 'Silver for Huguenot and Catholic'. *Country Life*, April 25th, 1968.

See also Incense Boat; Pastille Burner; Perfume Burner; Recusant Plate.

Centrepiece See Epergne; Plateau, Table.

Chafing Dish

On January 10th, 1666, Samuel Pepys went to Mr Stokes and 'bespoke a silver chafing dish for warming plates'. One of these objects, of shallow bowl form with outward-curving scroll supports for plates and a handle to one side, can be seen in use in Hogarth's painting *The Entertainment* which can be dated between the years 1735 and 1758. Generally, they were used to keep only one plate warm, and this of silver or pewter, for the direct flame or heat of burning charcoal was too great for porcelain or pottery. Isaac Walton in *The Compleat Angler* (1653) recommended for the cooking of the chub: 'Let him then be boiled gently over a chafing dish with wood coles'. One dated 1686, formerly the property of Bishop Ken, is amongst the plate of Winchester College; another of 1685 is illustrated on Plate **111**. An Irish fluted bowl engraved with the date of 1673 (National Museum of Wales) is of chafing-dish form. A rare quadrangular example survives of c. 1675; it bears only the maker's mark, B. In 1697, John Hervey, 1st Earl of Bristol 'paid Mr. Chambers . . . for a chafin dish with a cawdle heater'. Some examples were interchangeable as kettle stands, these usually having two drop-ring handles to one side. In England the dish ring and dish cross seem to have taken over from the chafing dish by 1750, though a late example made by Emick Roemer, 1763, survives at Colonial Williamsburg, Virginia. American examples are more numerous, though still rare. A pair by John Burt of Boston, made about 1730, is in the collection of Phillip Hammerslough. Two pairs and a number of singles

by John Coney also survive, besides a pair made by Jacob Hurd. Often only size and strength of construction make them distinguishable from pipe lighters. An example by Boulton & Fothergill, Birmingham 1773–4, has the lamp mounted on gimbals, an idea used also by Paul Storr for a hand candlestick in the Earl Spencer's Collection (**90**). A pair of heaters made by Paul de Lamerie in 1728 as part of a dinner service, may have been intended for use with dishes or even saucepans, as was the one illustrated on Plate **493**.

See also Dish Cross; Pipe Lighter; Saucepan; Tea Kettle.

Chain

In medieval times it was the custom to wear plain or decorated chains, not only for the suspension of badges of office, but also as jewellery. These were of gold, silver or base metal. If of the former, the chain was a very welcome present, which could be either worn or cut down to realise cash and a pleasant conceit so far as both donor and recipient were concerned, in that neither were soiling their hands with ready money. More elaborate girdles of linked and decorated plaques were also made, often many feet longer than a mere waist belt, yet still a source of decoration or ready cash. Survivals are extremely rare from any country and seldom marked. The so-called 'Midside Maggie's Girdle' is a late survival; its clasp was probably made by Adam Allane of Edinburgh, c. 1610. The chain is now in two sections, one 28 in. (71·2 cm.) in length, the other 23¾ in. (59·4 cm.). Chains of the Orders of Chivalry are of a far more elaborate form and must be thought of as jewellery. This applies also to most mayoral regalia, though the gold chain of the Borough of Guildford (c. 1673) is utterly plain and cannot be dated with certainty. Equally impossible to date with certainty are the chains of the Corporation of Norwich, though they probably date from the 18th century. The splendid Lord Chief Justice of England's Collar of SS and knotted tassels belonging to Lord Ellenborough, was once worn by his predecessors, Lord Kenyon and Lord Mansfield, and reputedly also by Lord Chief Justice Jeffreys (1683–9).

Bibliography

A.J.S. Brook, 'Midside Maggie's Girdle'. *Proceedings of Society of Antiquaries of Scotland*, p.445, May 13th, 1889. Also vol. x, p.321.

C.K. Jenkins, 'Collars of SS. A Quest'. *Apollo*, March 1949.

See also Corporation and Ceremonial Plate.

Chalice

By definition a wine cup used at Mass. Similarly, although a 'communion cup' implies a vessel used in the English Reformed Churches, it may well resemble the Roman Catholic chalice in form. Normally accompanying the chalice would be the paten, a plate to hold the bread at Mass.

With the exception of the sovereign, the Church was almost the only client of any import to the goldsmith until the early 14th century. Nevertheless, changing fashion and the Reformation, besides normal wear and tear, have, so far as is known, left us few pieces of plate other than spoons, of earlier date than 1350. Of these surviving pieces, the majority are chalices, with or without patens, all unmarked and dateable by style alone. C.C. Oman in an exhaustive study on English Church Plate covers the years AD 597—1830, he deals with the whole subject, suggesting certain groupings by style. It should be mentioned that most of these surviving pieces come either from chance finds, tombs or, in a few cases, from

Scandinavian countries to which there must ha[ve] been quite a considerable export trade during t[he] early Middle Ages. As ordained by the Rubrics [a] chalice should have a bowl of sufficient capac[ity] for the wine, a foot large enough to enable it [to] stand firmly, and a stem with a knop to ensure [a] firm grip between the index, middle fingers a[nd] the thumb.

If the Trewhiddle Chalice, now in the Brit[ish] Museum, and dating from about AD 875 [is] accepted as English we have then a gap of thr[ee] centuries before the next piece appears, except[ing] only the two-handled Ardagh Chalice of the 1[0th] century, undoubtedly Irish although of Byzanti[ne] inspiration. In 1890 the tomb of Archbish[op] Hubert Walter at Canterbury was opened to rev[eal] a chalice and paten of exceptional quality, to whi[ch] the date of 1180 was ascribed. The quality [of] workmanship of most of these early pieces [is] extremely high, and it appears that price, n[ot] evolution, decreed the degree of ornamentati[on] (**112**). The Dolgelly Chalice (National Museum [of] Wales) is signed 'Nichol'us Me Fecit De He[re]fordie' and is of about 1270. Until 1320, the fo[ot] of the chalice is always circular, allowing t[he] chalice to roll when laid on its side to drain. Th[is] form was gradually replaced by a hexagonal foot [or] 'mullet' with incurved sides, a form which last[ed] well into the 15th century (**113**). The fluted [or] writhen knop now becomes lobed, often chas[ed] with angels' heads, lozenges or quatrefoil flowe[rs]. One panel of the foot is usually engraved with [a] crucifix and this type overlaps the introduction [of] the London hall-marking system. Three exampl[es] so marked are known; the earliest dated 1479 is [at] Nettlecombe in Somerset. About 1490 the poin[ts] of the incurved hexagonal foot tend to be giv[en] crescent or foliage finials. Frequently these proje[c]tions have been broken away at a later date. We[re] not surviving chalices so rare, there would doub[t]less be many more with inscriptions recording t[he] name of the donor, such as that of 1494 illustrat[ed] by Sir Charles Jackson in *An Illustrated History* [of] *English Plate*, p.340. Soon after 1500 the hexaf[oil] foot makes its appearance and this is the form [of] the gold chalice of Bishop Fox at Corpus Chri[sti] College, Oxford, and also the Oxburgh Chalice [of] 1518 shown on Plate **114**. Colour Plates **15**, [16] illustrate Bishop Fox's Chalice and Crozier; t[he] gold chalice is hall-marked 1507, and stands 6 [in.] (15·3 cm.) high. A variation on this form with [a] waved border to the foot appeared only a few yea[rs] before the advent of the Dissolution during t[he] reign of Henry VIII. As a result of this wholesa[le] plundering of churches and monasteries only abo[ut] eighty pre-Reformation English chalices surviv[e]. A blind-tooled, leather travelling case for a chalic[e] made c. 1400, survives in Hereford City Museu[m]. The form of English Recusant and Irish 17th- a[nd] 18th-century chalices are basically very similar, [as] Plate **115** illustrates.

Bibliography

C.C. Oman, *English Church Plate*. Oxford Un[i]versity Press, 1957.

J. Gilchrist, *Anglican Church Plate*. Connoisseu[r,] Michael Joseph, 1967.

J.J. Buckley, 'Some Irish Altar Plate'. *Royal Iri[sh] Academy*, 1943.

See also Communion Cup; Goblet; Paten.

Chalice Materials

The use of any material other than gold or silv[er] for chalices was forbidden during the early Midd[le] Ages. Pope Leo IV (AD 847) and the Council [of] Tribur (AD 897) issued prohibitions to this effe[ct]. These were again repeated in Spain at the Coun[cil]

Plate 6 Butter Cooler
A parcel-gilt butter cooler made by
Paul Storr.
Hall-mark for 1816.
Height 7½ in. (19·1 cm.).
Gibbs Collection, Nottingham
Castle Museum.

Plate 6

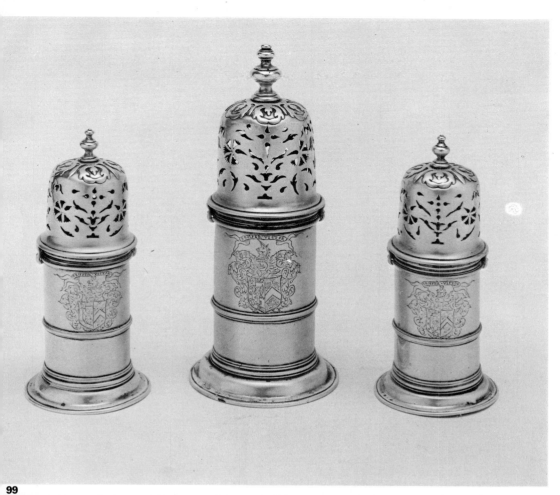

99

Plate 7 A Five-light Candelabrum
Maker's mark of Paul Storr.
Hall-mark for 1817, London.
Height 32½ in. (82·6 cm.).
The branches of this silver-gilt
candelabrum spring from an
acanthus vase, which is supported
by two griffins. Decorated with the
Royal Arms of George III and the
badge of George, Prince of Wales
(later George IV).
Collection of Her Majesty the
Queen.

99 Set of Casters
Maker's mark of Andrew Law.
Hall-mark for 1693, Edinburgh.
Height 7½ in. and 6 in. (19·1 cm.
and 15·3 cm.).
Engraved with the Arms of Ramsay
impaling Carstairs, for Sir John
Ramsay, 2nd Baronet of Whitehill.

100 Caster
Maker's mark of Pierre Harache.
Hall-mark for 1699.
The Goldsmiths' Company.

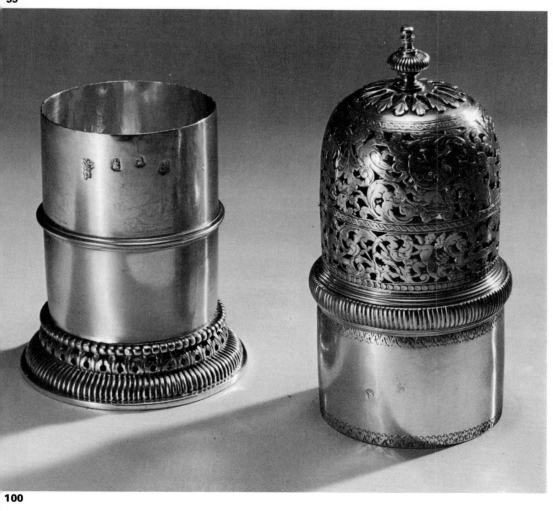

100

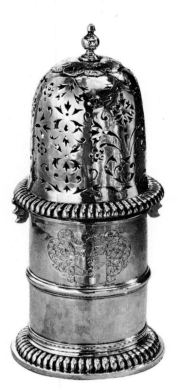

101 Caster
Maker's mark of Pieter Van Dyck.
c. 1695.
Yale University Art Gallery,
Mabel Brady Garvan Collection.

102 Casters and Stand
Maker's mark of Paul de Lamerie.
Hall-mark for 1723.
Ashmolean Museum.

103 Set of Casters
Hall-mark for 1708.

104 Caster
Maker's mark of Augustin Courtauld.
Hall-mark for 1726.
Height 8¼ in. (21·0 cm.).
Engraved with the Arms of
Chadwick.

105 Set of Square Casters
Unmarked, *c.* 1720.
Engraved with the crest of Elton
of Clevedon, Somerset.

106 Set of Casters
Silver-gilt.
Unmarked, *c.* 1700.

107 Casters
Left: maker's mark of Samuel Wood.
Hall-mark for 1749.
Height 7½ in. (19·1 cm.).
Right: maker's mark, ID over IM.
Hall-mark for 1770.
Height 6½ in. (16·6 cm.).

108 Casters
a. Maker's mark of Charles Kandler.
Hall-mark for 1727.
Height 6⅝ in. (16·9 cm.).
Engraved with the Arms of Thomas,
8th Duke of Norfolk.
b. One of a set of three casters.
Maker's mark of Herne & Butty.
Hall-mark for 1761.
Height 8½ in. (21·7 cm.).
Engraved with the Arms of Lascelles
and Challoner.
c. One of a pair of casters.
Maker's mark of David Willaume, Jr.
Hall-mark for 1741.
Height 6¾ in. (17·2 cm.).

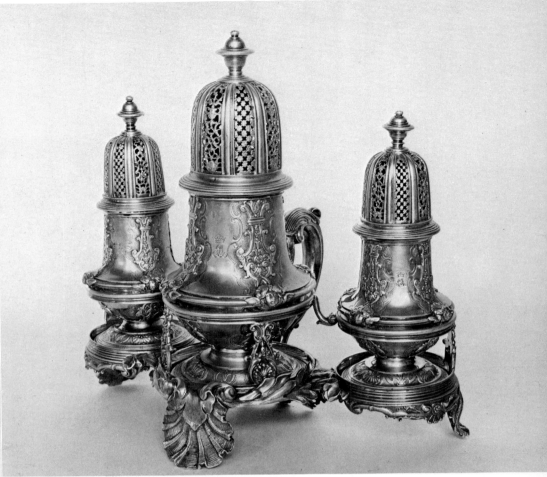

102

103

104

105

106

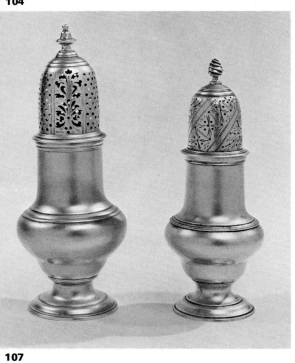

107

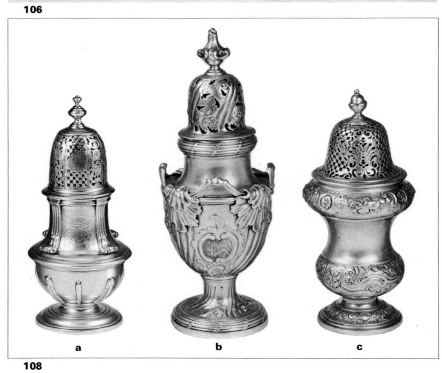

a b c

108

109 Censer
Unmarked, *c*. 1695.
Probably English.
Height 4⅞ in. (12·5 cm.).
It has a contemporary engraved weight beneath the foot.

110 Censer and Incense Boat
Censer: maker's mark of Benjamin Pyne.
Hall-mark for 1708.
Height 8⅞ in. (22·6 cm.).
Incense boat: maker's mark only of Benjamin Pyne.
Rat-tailed spoon: maker's mark, DV with a sun(?) above.
Examples of Recusant plate.

111 Chafing Dish
Maker's mark, IS with a pillar between.
Hall-mark for 1685, London.
Height 4¾ in. (12·1 cm.).
The Goldsmiths' Company.

112 Chalice
Unmarked, late 12th century.
St David's Cathedral, Wales.

113 The De Burgo-O'Malley Chalice
Silver-gilt.
Unmarked but the inscription is dated 1494.
Probably made in Galway.
Height 8 in. (20·4 cm.).
National Museum of Ireland.

114 The Oxburgh Chalice and Paten
Maker's mark, a fish.
Hall-mark for 1518.
Chalice: height 6 in. (15·3 cm.).
Paten: diam. 5¼ in. (13·4 cm.).

115 Chalice
Unmarked, *c*. 1640.
Height 6⅝ in. (16·9 cm.).
An example of Recusant plate.

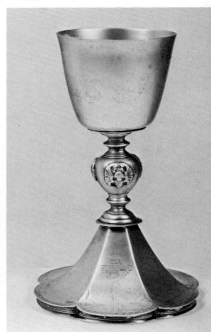

109

111

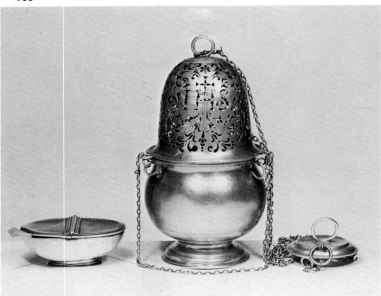

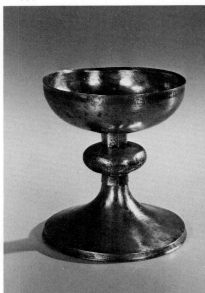

110

112

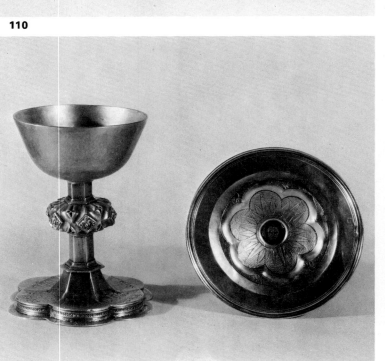

113

114

115

f Compostella (1058). The Council of West-
inster (1175) ordered 'that Chalices must be of
Gold or Silver', the only exception being the use of
ewter ones at the burial of priests in poorer
hurches. The use of wood and glass, presumably
ncluding crystal, was specifically banned. Later
xamples are known to have been made of base
etal, such as copper, and then gilt.

Chalice Spoon

y custom, water was added to the wine in the
halice. In the 13th and early 14th centuries a
poon was used for this purpose, but so far as is
nown none have survived, if indeed they were of
ny specific form. As with chalices they are made
f silver, silver-gilt, and in 1384 one gem-set
xample of gold, belonged to St George's Chapel,
Windsor.

Chamber Candlestick

ee Candlestick, Hand or Chamber.

Chamber Pot

he earliest to be made of silver appears to be that
ecorded in the household books of Queen
lizabeth I in 1575: 'A round basin and Ewer with
piss-pot of silvr. weighg. 57 oz.'. By 1598 the
hamber pot was common enough to be satirised
y John Marston. One of 1670, made in York by
Marmaduke Best and part of York Corporation
late, was illustrated on the cover of the *Antique
Collector* in October 1958. It differs but slightly in
orm from those of the present day. Other surviving
examples date from 1709, 1714 (made by Isaac
iger and illustrated on Plate **116**), 1716 (by
imon Pantin) and there were eight in the Foley
rey Collection sold in 1921 at Christie's. That
ney were made in solid gold as well as gilt is
lmost certain, for in 1672 a certain lady pawned
ne for £15 described as of gold, an otherwise
xcessive sum had it been mere silver-gilt. The
lver chamber pot probably died out with the
dvent of porcelain and stoneware on a large scale
uring the early 19th century. At least one or two
sually formed part of an issue of plate in the 18th
entury, and well into the 19th century a chamber
ot was part of the equipment of every dining room.
ord Molineaux purchased one weighing 26
unces 10 pennyweights from Messrs Wakelin in
772. Hogarth, an acute observer, includes one in
is painting *Midnight Modern Conversation* of
733, another is shown in the engraving of a
rinking bout on a great punch bowl made by
amerie, now in the Farrer Collection, Ashmolean
Museum, Oxford. Apparently unique is the two-
andled variation traditionally made for a member
f the York family by Robert Garrard in 1818,
or use in his coach when he was Mayor of Leeds
117). A later example, in a private collection, by
e same maker (1836) is of the normal form
hough smaller than usual. The bourdaloue makes
nly a rare appearance, even in porcelain. A note-
orthy example made in Sheffield plate, c. 1790,
s in the Sheffield City Museum.

Champlevé

namelling done by gouging out troughs from the
etal to be decorated, into which the frit is melted.
he surface is then ground flush and polished.

Chandelier

arly examples are numbered amongst the plate of
ueen Elizabeth I (Item 772 of the 1574 Inven-
ory), and another of c. 1630, once hanging in the
athedral of the Assumption, Moscow, was
elted down in 1812. These were more generally

known in the past as 'branches'; sometimes, as in
the Royal Inventory of 1721, the same word is con-
fusedly used to describe the branches of yet an-
other piece—the 'Aparn' (epergne)—which besides
baskets, casters and sauce boats, also had four
branches. The size, weight and cost of such
chandeliers or 'branches' meant that only the very
rich could afford them and this, added to the
physical problems of cleaning them, probably
contributed to their early disappearance. In the
Inventory of 1721 quoted above, two chandeliers,
one of twelve nozzles, the other of ten, are recorded
at St James's Palace; there were also another two
at Hampton Court, one with sixteen nozzles, an-
other with twelve. Windsor had only one, which
had six nozzles and weighed a mere 535 ounces
(**694**) as compared to the largest at Hampton
Court which tipped the scales at 1,931 ounces 10
pennyweights. Of all these Royal Chandeliers only
two still survive, the twelve-branched example at
Hampton Court made by George Garthorne and
that of ten branches made by Daniel Garnier for St
James's Palace and now at Colonial Williamsburg,
Virginia (**118**). Earlier than these is the example
dating from about 1670 in the Duke of Buccleuch's
Collection. A pair of Queen Anne examples by
John Boddington, 1710(?), are in private owner-
ship. Two, both dated 1734, made by Paul de
Lamerie, each with sixteen branches, hang in the
Kremlin. In 1752 the Fishmongers' Company
commissioned a chandelier, this with seventeen
branches is profusely decorated with seaweed and
dolphins and still adorns the Company's Hall (**119**).
In spite of their rarity, the list is by no means com-
plete, one of the latest being made by Robert
Garrard, c. 1835. Those designed by William Kent
and published by Vardy were executed in Hanover;
now at Anglesey Abbey in Cambridgeshire, these
chandeliers have handles at the lowest point to
facilitate their being pulled down, if required,
against a balanced counterweight.
Bibliography

W.W. Watts, 'Silver Chandeliers Made for George
II'. *Connoisseur*, vol. c, p. 232.
E.A. Jones, *The Old English Plate of the Emperor of
Russia*. 1909.
See also Jewish Ritual Silver; Nursery Candle-
stick.

Channel Islands

Although silversmiths such as Thomas Morin of
Jersey were working during the first quarter of the
17th century, it was not until the 18th century that
the products of the Channel Islands, excepting
perhaps spoons, became sufficiently numerous to
be collected. Silver was in fact mined in Sark
between 1835 and 1845, and a tea and coffee
service (whereabouts unknown) was made to
promote this scheme.

The mint established during the Civil War at
Trinity in Jersey coined shillings, half-crowns and
Jacobuses (20s. pieces). These, however, bear no
distinguishing mint mark. However, the Royalist
sympathies of the islanders probably ensured that
a large quantity of plate was melted for the king's
cause. Surviving early ecclesiastical plate, if
marked, is usually from London. The majority of
pieces of Channel Islands silver bears makers'
marks only—the standard was ordained to be that
of England in 1771—with the occasional addition
of a J for Jersey and a number of other marks
peculiar to particular silversmiths. Huguenot
émigrés tended to use French-type marks.

Initials engraved on silver from the islands are
unusual in that they generally represent a Chris-
tian name and surname by three letters rather than

two. Thus, John Langlois would appear as JLG
rather than JL. Other than spoons, plate from these
islands is usually represented by christening cups,
beakers, wine cups and occasional larger pieces
such as two-handled cups (but without covers), a
few candlesticks, coffee pots, teapots, salvers,
mugs and even a snuffer stand. Pieces such as a
militia sword hilt and a shoulder belt by Jacques
Quesnel are rare survivals. The spoons follow the
development of their English counterparts almost
without exception. Any form of decoration is most
unusual on Channel Islands silver. The christening
cups are remarkable for the difference between
those of Guernsey and Jersey. Both have two
handles, but those from Jersey are wide (about
4 in.) and shallow, whereas Guernsey cups are
only about 3 in. wide and 2½ in. deep. Guernsey
cups almost invariably have a rim foot.

A number of the rarities enumerated above are
from the workshop of Guillaume Henry of
Guernsey. He was also the maker of the rarest
piece of all, an ovoid hot-milk pot, besides two
very unusual covered sugar bowls of almost
spherical form. Perhaps the largest piece known is
the two-handled punch bowl dating from about
1700, which bears a maker's mark RB of Huguenot
type.

The decline of silversmithing in the Channel
Islands towards the end of the 18th century is
emphasised by the increasing importation of
London-made, Guernsey-type christening cups,
upon which the Channel Islands wholesalers over-
struck their own marks. A few of these pieces are
by Hester Bateman, and some also bear the rare
drawback mark of 1784/85.

A good representative collection of Channel
Islands silver may be seen at the Société Jersaisie
Museum.
Bibliography

Richard H. Mayne, *Old Channel Islands Silver*.
1969.

Chantrey, Francis (1781–1841)

A leading sculptor occasionally commissioned by
Rundell, Bridge & Rundell. Born in Sheffield, he
left his considerable fortune to the Royal Academy
of Arts for the 'purchase of Fine Art of the highest
merit . . . executed in Great Britain'. Traditionally,
he prepared a design for table candlesticks for
Messrs Gainsford & Nicholson of Sheffield in 1812.
These are of caryatid form, the female figure sup-
porting on her head the candle socket; her feet rest
on four out-turned acanthus leaves, the whole on
a concave, square plinth.

Chap Bowl or Cup

A small bowl or pair of bowls, covered or un-
covered, used to hold lotions and preparations for
the cheeks. They are sometimes found with stands.
Equally usable as tea cups but usually they form
part of a toilet service.
See also Toilet Service.

Chasing

The art of decorating metal by hammering, and
so raising it or driving it to one side, that a pattern
is produced either in relief or incuse without the
loss of any of the metal. In this latter respect it is the
very opposite of engraving.

In the late 17th century, embossed chasing in
high relief was the fashion; by the early 18th
century, plain almost undecorated silver had
returned to favour to be followed in the 1740s by
a period of highly skilled chased decoration which
largely coincided with the Rococo period.

It is not always easy to tell the difference

116

117

118

116 Chamber Pot
Maker's mark of Isaac Liger.
Hall-mark for 1714.
Diam. 6¾ in. (17·2 cm.).
Engraved with the Arms of George
Booth, 2nd Earl of Warrington.

**117 Travelling Chamber Pot
and Cover**
Maker's mark, probably of Robert
Garrard.
Hall-mark for 1818.
Diam. 9¼ in. (23·5 cm.).
Engraved with the Arms of Richard
York of Wighill Park, Yorkshire.
Traditionally used by an ancestor
of the York family when he held
office as Mayor of Leeds.

118 Chandelier
Maker's mark of Daniel Garnier.
c. 1695.
Overall height 27 in. (68·6 cm.).
Overall width 33 in. (83·9 cm.).
Colonial Williamsburg, Virginia.
Listed in the Royal Inventory of
1721 as 'one 10 nozelld Branch
730.0.0' and 'At St. James's in
the Lodgings'.

119 Chandelier
Hall-mark for 1752.
Height 46½ in. (118·1 cm.).
This seventeen-branched chandelier
is known from the records of the
Fishmongers' Company, to whom it
belongs, to have been obtained from
William Gould, a specialist
candlestick maker.

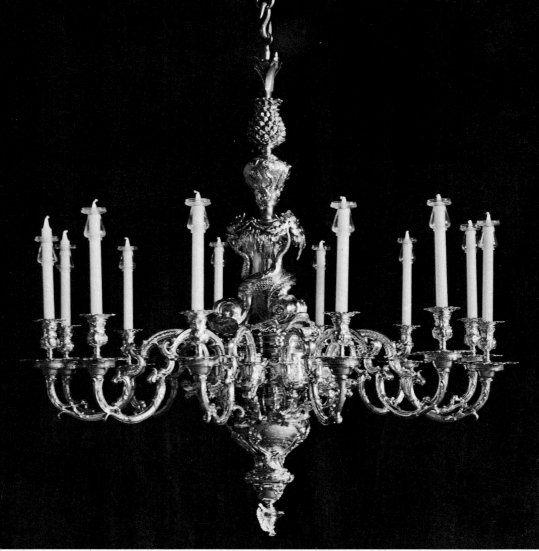

119

between chasing of the mid 18th century and good work of the late 19th century, both on an article manufactured about 1740. Sometimes the hallmarks may have been applied after the chaser had completed his work, in this case they will carry through the ornament. Unfortunately, a skilled workman, having the intent to deceive, could on occasion work so accurately as to make this test inconclusive. As a generalisation, it is true to say that the assymetrical decoration of the 18th century has an ease and flow seldom achieved by later imitators. Country silversmiths, in particular in Ireland, produced chased ornaments of comparatively coarse workmanship, but with a definite 'style' of its own and equally difficult to imitate. Chiselling solid metal, though allied to engraving, was usually required only for large castings of figures and it is symptomatic that a casting fresh from the mould is described as having to be 'chased up' not chiselled up, before sale.
See also Bright-cut Engraving; Engraving; Silversmithing.

Châtelaine

From the Middle Ages, until quite recently, it has been the custom for the mistress of the house to carry a clip hooked to her belt. Attached to the clip by means of chains were scissors, bodkin, pomander, étui, keys and any other small item, such as a notebook, necessary in the day-to-day running of a house. The majority of those surviving are dated later than 1740. Very rarely are they made in gold, quite frequently in silver (the only mark usually being on the belt hook) and most commonly in pinchbeck. See Colour Plate **12**.
See also Pomander.

Cheese Dish See Toasted-cheese Dish.

Cheese Scoop

Those with relatively heavy gauge handles, sometimes of ivory, and blades of crescent section generally date from the late 18th and 19th centuries. Patent examples had a thumbpiece mechanism to expel the cheese from the scoop. They should not be confused with apple corers or marrow scoops which are smaller, though the latter may well have been pressed into service as cheese scoops on many occasions.

Cheese Stand

These are extremely rare in silver, and take one of two forms, either a cradle or a waiter on a central foot. One of the earliest examples extant is of waiter form, and was made by Pierre Harache in 1689; its exceptional strength and weight are two of the principal reasons for its being thought to have been made specifically for this purpose (**120**). Another of 1727 is also known. It is 16¼ in. (41·3 cm.) in diameter, and the centre is engraved with a monogram. Both 1689 and 1727 being Coronation years and both these stands having belonged to the same family, the possibility of their having some connection with the actual ceremonies should be considered. They could very well have been used as bearers for the crown.

The earliest known piece to survive with contemporary documentation is the pair made by Edward Wakelin in 1760 for the 9th Earl of Exeter: 'June 30. 1760. To 2 Cheese plates 89. 4. at 9/—. £40. 3. 0'. These are 13 in. (33·1 cm.) in diameter and have no moulded border to the rim. The cradle form supposes the use of a large cheese to be placed on its side, and of the two surviving examples, one was in fact once used as a jardinière. It was made by Edward Wakelin in 1760

and supplied to the 9th Earl of Exeter on 'August 20 1760. To a pierced cheese plate 66. 19. 11/2d. £37. 7. 6.'. It is now in the Victoria and Albert Museum. The other, dated four years later, is illustrated on Plate **121**.
See also Coronation Plate.

Chess Set

Surprisingly, only about three early examples of this ancient game are so far known to exist, the pieces of the two sides, silver and silver-gilt respectively. One set, unmarked, dates from c. 1670 (**122**), another is hall-marked 1816 (**123**) and a third bears the mark of Fuller White, c. 1750.

Chester Assay Office

The earliest record of a goldsmith in Chester is in the first quarter of the 13th century. Coin was, however, minted here during the Dark Ages. The fact that Cheshire is a County Palatine under the Earls of Chester may explain why there was no mention of the city, when in 1423 touches were appointed to be used by other towns. Written evidence survives of the existence of a Goldsmiths' Guild in Chester. The first Royal Charter was that issued by James II in 1685–6. Prior to this date no other mark, but that of the maker, appears to have been struck on plate of Chester manufacture. The hallmarks ordained for use by the assay master were the coat of arms and crest of Chester, besides a date-letter, thus making, with the maker's mark, four punches in all. As with other provincial assay offices the Act of 1696 disenfranchised the Chester Assay Office, and it was not until 1701 that it was re-established. The number of letters of the alphabet used as date-letters seems to have varied from cycle to cycle. The communion cup of Llanferres, Flintshire, has the maker's mark of Richard Richardson only, and a presentation inscription dated 1699. This is interesting as it was made and marked when the Chester Assay Office had no legal standing, and was thus not submitted for assay. The new town mark of 1701 was the Arms of Chester impaling those of the Earl of Chester. On the reverse of the 1701 copper plate is struck another mark, three plumes collared by a coronet. This, though known to have been used on a trefid spoon, is thought to have been the mark struck on Welsh mined silver, which was usually dispatched direct to London during the first half of the 18th century. Copper plates, struck with the makers' marks, are preserved and it was only in 1962 that the office was finally closed, almost all its work being, by that time, of Birmingham manufacture. The families of Pemberton and Richardson each supplied several generations of Chester goldsmiths during the 17th and 18th centuries. Though rare, early pieces of Chester silver are usually larger and more important than those products of 1720 onwards, such as tumbler cups, spoons and other small wares.

a 1686-96

b 1701-79 c 1779-1962

Bibliography
T.S. Ball, 'Ancient Chester Goldsmiths and their work'. *Connoisseur*, vol. LXXXIX, p. 291.
T.S. Ball, 'Some Chester Civic Treasures'. *Con-*

noisseur, vol. XC, p. 387 and vol. XCI, p. 98.
T.S. Ball, *Church Plate of the City of Chester*. 1907
Maurice H. Ridgeway, *Chester Goldsmiths*
Sherratt, 1968.

China Trade Silver

Recent research by J.D. Kernan seems to confirm that the Chinese, always expert copyists, produced an appreciable quantity of silver in the Anglo American style. Most of the pieces so far known are thought to originate in the East, c. 1800, and bear marks simulating those struck by the Goldsmiths' Company of London. There is, however, every chance that earlier pieces may also survive Occasionally a Chinese character is found in conjunction with a maker's mark of European type.

Bibliography
J.D. Kernan, 'China Trade Silver: Checklists fo Collectors'. *Connoisseur*, vol. 160, November 1965
See also Hamilton & Co., Calcutta.

Chinoiserie

The rage for things Oriental seems to overcome the English every so often. At first it seems only to have touched the world of the silversmith with the mounting in silver of porcelain from the Eas marvels then to be equated with 'gryphons' eggs nautilus shells and coconuts. However, during the last half of the 17th century a more pervasive win began to blow; though at first felt on the Continen England also felt it by 1670. Chinese lacquer materials and porcelains arrived in increasin numbers and a vogue for copying the forms of porcelain in silver, such as ginger jars and vase was supplemented by chasing a wide range of European forms with scenes supposedly representing Chinamen, birds and Chinese landscapes. mattered not that neither chaser, client, nor pur chaser could tell the difference between the Turkis or Oriental scenes depicted. Most interesting is the similarity of the chased decoration on all this work C.C. Dauterman suggests a single *atelier* (work shop) producing this decoration, to whom differen makers sent their work; it was not after all unusua to employ an outsider as an engraver and, to the casual glance, this chasing more resembles en graving. He records twenty-three makers for fift pieces all dating from between the years 1678 an 1688, twenty of them from 1683 to 1684. An alter native may be a retailer, specialising in this fashion who commissioned the chaser to decorate thos pieces he considered suitable and had bough especially for his stock. These dates are no arbitrary, but much earlier or later hall-marke pieces reflect the tendency of all men to wish to b fashionable. For example, there exists a piece o Cromwellian Commonwealth silver, decorated thirty years after its being made, with chinoiseri designs, and on occasion chinoiserie pieces re placed a piece lost from a set, such as a toile service. Sources for this work are difficult to trace but the English translation of John Nieuhoff account of his voyage as part of a Dutch East Ind Company Embassy to the Emperor of Chin appeared in 1669, and does seem to have bee used for some of these designs. Monteiths, ging jars, mugs, porringers, tankards, salvers and all th various pieces comprising toilet services were s decorated. Very occasionally, provincial silver wa 'improved' in the same way, but the porringer fro Newcastle upon Tyne of c. 1690 (private collec tion) is of extreme interest. Rarest of all are th gold chocolate cup with cover, reversible to form stand, made by Ralph Leek, c. 1685, in th collection of Lord Derby, and also gold, an u marked, small, two-handled cup and cover o

bout 1685. Irish silver with chinoiserie decoration
excessively rare. A porringer by John Segar of
ublin, 1685–7, bearing the Arms of Sir John
Vynne may be cited.

About 1750, the Chinese fashion returned again
nd this time the chasers excelled themselves, pro-
ucing brilliantly modelled repoussé figures, which
overed the surfaces of coffee pots, tea caddies
nd peered from behind swirling, engraved,
ococo cartouches. Epergnes with Chinese roofs
nd pendent bells are amongst the more extrava-
ant fancies; a pair of candlesticks made by Phillips
arden in 1756 carry it to excess. Meanwhile,
hippendale designed mahogany chairs, painted
o look like bamboo and the commonest form of
id 18th-century candlestick is also inspired by
he bamboo.

Once again the wheel turned and returned, only
artially this time. The Prince Regent (later George
V) and his friends turned to the East for inspiration
or the Pavilion at Brighton and similar architectural
xtravaganzas. Paul Storr made a number of pieces,
n imitation of lacquer-work, decorated with cast
hiselled panels of Chinese figures and foliage in
elief. These include two covered bowls and
ands, one bowl being the original of c. 1710, the
emainder by Storr, 1810, and an octagonal sugar
owl of 1812. There is also an unmarked bowl,
over and stand so decorated in Her Majesty the
ueen's Collection. This form of decoration is also
nown on a few pieces of 17th- and early 18th-
entury date; a snuff box in the Victoria and Albert
useum and a number of small, two-handled,
ctafoil bowls, about 2½ in. (6·4 cm.) in diameter,
esides a large tankard and cover. It is possible that
ese, almost all of which are gilt, are Batavian in
rigin, and some were hall-marked on importation.

ibliography
.C. Dauterman, 'Dream Pictures of Cathay'. *The
Metropolitan Museum of Art Bulletin*, Summer
964.
ugh Honour, *Chinoiserie, The Vision of Cathay*.
ohn Irwin, 'Origins of the "Oriental Style" in
nglish Decorative Art'. *Burlington Magazine*,
pril 1955.
.A. Jones, *Old English Gold Plate*. 1907.

Chocolate Pot

ke coffee, chocolate was introduced into England
uring the period of the Cromwellian Common-
ealth. The *Publick Advertiser*, Tuesday, June
6th–22nd, 1657, advertises 'an excellent West
dia drink called chocolate'. The earliest chocolate
ot known, however, is one made by George
arthorne of 1685. In New England a William
eay owned one in 1690, which he called a
ocolato pot'. John Coney made one for Mrs
arah Tailer in 1701. From the first it seems to have
een apparent that approximately the same form
ould do admirably for both the chocolate and
offee pot, always allowing for the fact that the
diment of chocolate was to be savoured and not
voided as with coffee and tea. To this end, the
d of a chocolate pot was given a small hinged or
deways sliding finial, through which the stirrer
molinet) could be twirled immediately before
ouring. It was not until the 1820s, when Van
outen managed to extract much more of the
ocoa fat, that the comparatively thin chocolate
e know today was made possible. Two varieties
f the chocolate pot should be noted at the very
utset. The vase-shaped, probably of Oriental
spiration, extremely rare and seldom dated later
an 1700, frequently partly fluted, was found not
nly in London (examples of 1685 and 1688) but
so in Leeds (**124**), Chester, Exeter, Newcastle

and America. This vase-shaped chocolate pot has
a shallow-domed cover and a detachable cap
finial, as found on early tea caddies. The other
variety (**125**, **126**, **127** and **128**), probably an
importation from France, has a pivoted finial to the
cover. It is either pear-shaped and plain, like that
made by John Coney, Boston, c. 1720, or variously
decorated, as one by Peter Oliver, Boston, c. 1715,
which is fluted. Occasionally this variety stood on
three scroll or lion feet, as that by Benjamin Bradford,
1697, or Nathaniel Locke, 1708 (**130**). A particu-
larly fine example on three hoof feet made by Pierre
Harache in 1703, has the pivoted finial and, most
unusual, a bayonet joint to hold cover and body
together. By 1705, the tapering, cylindrical form
of the contemporary coffee pot had taken over;
there are at least two American examples made by
Edward Winslow which are of this form. One is
illustrated on Colour Plate **17**. From this time
onwards, coffee and chocolate pots developed
side by side, identical apart from the aperture in the
lid (**129**). Whilst coffee pots are constantly made
throughout the 18th century, this is not so with
chocolate pots or teapots. An example executed by
Paul Crespin in 1738, with a molinet, may be seen
in the Ashmolean Museum, Oxford. It is engraved
'This Chocolate pot was given by Lionel Earl of
Dysart to the Honbe Mrs. Tollemache April 29th
1791'. About 1745, however, a pear-shaped jug,
now referred to as a hot-water jug, appears and
survives until 1755. It may be that this also did
duty for chocolate, as it undoubtedly still does in a
number of houses today, having always been thus
used within living memory. Yet the number of
entries in the Garrard Ledgers in the 1750s for
'Turky Coffee Pots' may in fact refer to this particular
form. At least one later example of 1774 still
retains its original molinet with pierced silver
flanges. This, like the Irish chocolate pot made by
Ralph Woodhouse of Dublin about 1740, is of the
French pear-shaped variety. The Irish example is of
great rarity, some 10 in. (25·4 cm.) in height. It
has a turned baluster handle to one side and may
well have been ordered as a direct copy of a French
original.

Bibliography
G.B. Hughes, 'Silver Pots for Chocolate'. *Country
Life*, October 20th, 1960.
See also Jug; Molinet.

Chrismatory See Ampulla.

Ciborium

A vessel of chalice-like form, with broader,
shallower bowl and cover, in which the bread for
the Holy Sacrament is consecrated. Recusant
examples survive.
Bibliography
C.C. Oman, *English Church Plate*. Oxford Univer-
sity Press, 1957.

Cigarillo Holder

The earliest so far recorded, though only partly
hall-marked, bears a date-letter which appears to
be London, 1831. This is 4⅝ in. (11·8 cm.) long
and engine turned. It extends by means of
diminishing telescopic sections to a total length of
12⅜ in. (31·5 cm.). The earliest record of the word
'cigarette' appears in 1842, though no factory
specialising in their production seems to have been
in operation until 1857.

Claddagh Ring

In the Claddagh district of County Galway, and on
occasion elsewhere in Ireland, plain gold wedding
rings formed as two hands holding a heart and

surmounted by a crown were fashionable during
the 17th and 18th centuries. They generally bear a
maker's mark only and usually this belongs to a
Galway worker. Similar rings were advertised as
being available by 18th-century Colonial American
goldsmiths.
See also Ring.

Claret Jug

Generally indistinguishable from the ale jugs of the
18th century, unless of exceptional form, as
those made by Thomas Heming in 1777 (**131**).
Covered jugs return to fashion in the 1830s (**133**),
concurrently with the rise in popularity of frosted-
glass (**132**). Generally speaking, the 19th-century
claret jug is made of silver-gilt, and embodies
grapes and vine foliage in the decoration. A patent
device by which, on gripping the handle the lid
might be opened, is found during this period.
Later the ovoid form reigns supreme.
See also Jug.

Cleaning

To judge from numerous entries in the Ledgers of
George Wickes, and his successors during the
18th century, Crocus Martis (at 1s the box) and
'plate skins' were recommended as the most
advisable cleaning materials of the day. When past
cleaning at home, plate was taken to the silver-
smith to be 'boyled and burnished'.
Silver
Pieces used continually need little more than
washing in soap (or a detergent) and water, rinsing
thoroughly and drying with a soft cloth, chamois
leather or rubbing with the palm of the hand.
Salt corrodes silver badly, therefore silver salt
cellars and their spoons should be emptied after
use and well washed. Glass liners often conceal
the salt that has slipped between the liner and its
casing; gilt salts are safe until the gilding becomes
worn. Corrosion is best dealt with by a silversmith,
but jewellers' rouge is effective in less severe cases.
Ornament should be cleaned with ammonia and
french chalk, lightly brushed in the crevices if there
are intricate surfaces, and then rubbed with a soft
cloth. Certain new liquid cleaners have been
marketed and are safe if the directions are strictly
followed and the silver *well rinsed* and dried; they
combine the advantages of quickness and avoidance
of abrasion. Most piped and natural water contains
chlorine, which discolours silver; silver should
never be left wet. Stored silver should be wrapped
in acid-free tissue paper, kept in baize or plastic
bags.
Silver-gilt
Paul de Lamerie's instructions cannot be bettered:
'Clean it now and then with only warm water and
soap with a sponge, and then wash it with cleane
water, and dry it very well with a soft Linnen Cloth,
and keep it in a dry place for the damp will spoil it'.
Never use any abrasive or brush.
Gold
Wash in a weak solution of liquid ammonia or
other detergent and polish with a soft cloth. Gold
is much softer than silver and needs very gentle
handling.
Bibliography
H.J. Plenderleith, *The Conservation of Antiquities
and Works of Art, Treatment, Repair and Restora-
tion*. 1956.

Clock and Watch

In July 1967 there appeared at Christie's a hitherto
unrecorded piece of English Royal Plate, which
though altered in the 18th century is clearly
identifiable as the combined clock and salt cellar

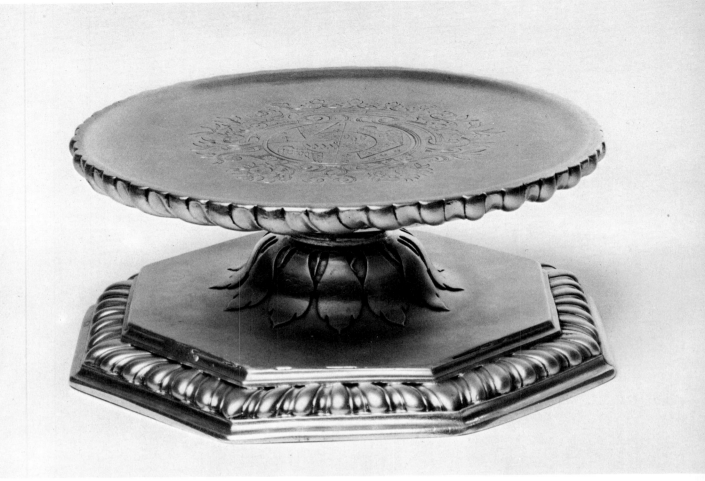

120

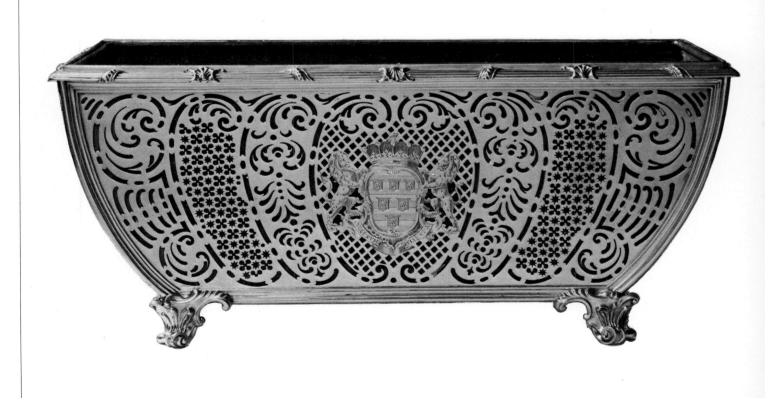

121

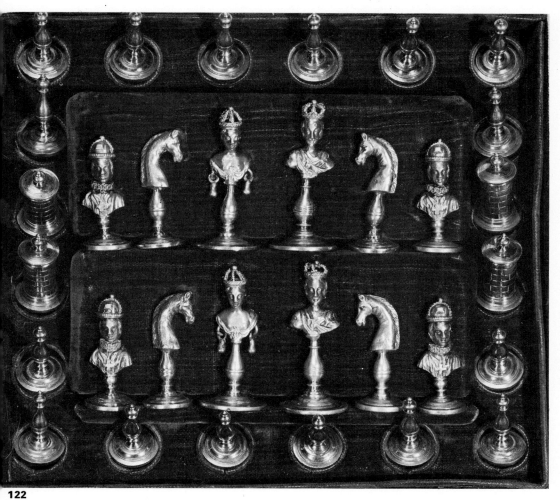

122

120 Cheese Stand (?)
Silver-gilt.
Maker's mark of Pierre Harache.
Hall-mark for 1689.
Engraved with the Arms of Charles,
6th Duke of Somerset.

121 Cheese Stand
Maker's mark of Parker & Wakelin.
Hall-mark for 1764.
Length 14¼ in. (36·2 cm.).
Engraved with the Arms of
Brownlow, 9th Earl of Exeter.
One of the two extant examples
known of the cradle form cheese
stand.

122 Chess Set
Silver-gilt and white silver.
Unmarked, *c.* 1670.
The kings: height 3 in. (7·7 cm.).
Victoria and Albert Museum.
The kings and queens of this set
are busts of King Charles I and
his Queen, Henrietta Maria. The
contemporary case is lined with
crimson velvet and mounted in
silver.

123 Chess Set
Silver-gilt and white silver.
Maker's mark of Edward Farrell.
Hall-mark for 1816.

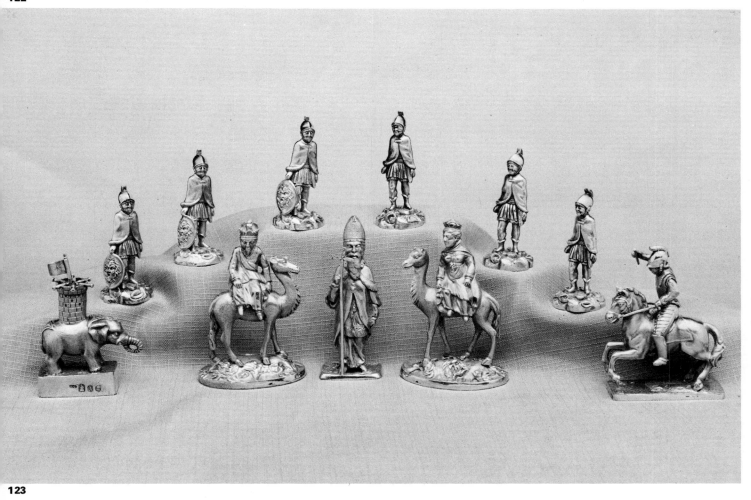

123

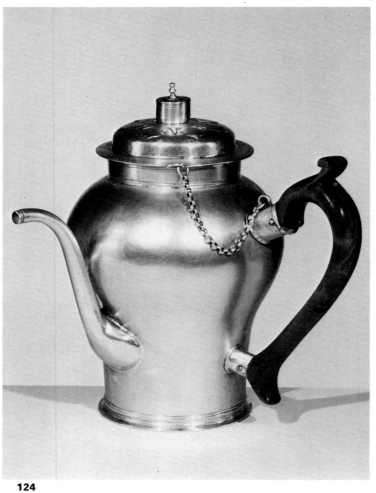

124

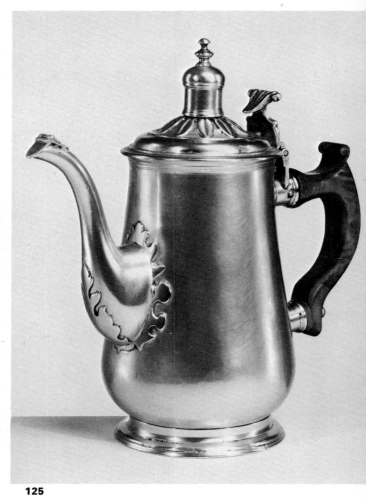

125

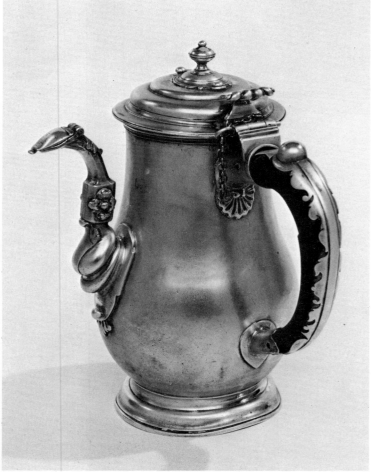

126

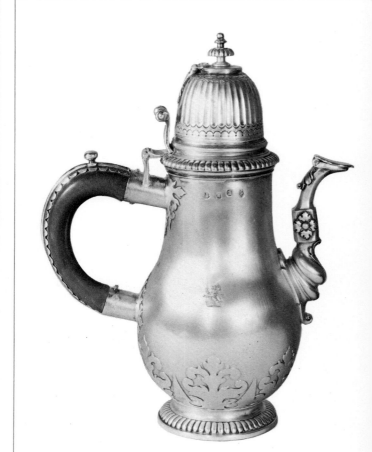

127

124 Chocolate Pot
Maker's mark of R. Williamson of Leeds.
c. 1695.
Height 7½ in. (19·1 cm.).
125 Chocolate Pot
Maker's mark of Joseph Walker.
Hall-mark for 1699, Dublin.
Height 9½ in. (24·2 cm.).
126 Chocolate Pot
Maker's mark of William Lukin.
Hall-mark for 1701.
Height 8¾ in. (22·3 cm.).
127 Chocolate Pot
Maker's mark of Thomas Corbett.
Hall-mark for 1703.
Height 11 in. (28·0 cm.).
128 Chocolate Pot
Maker's mark of Pierre Platel.
Hall-mark for 1705.
Height 8⅝ in. (21·9 cm.).
Assheton-Bennett Collection.
129 Chocolate Pot
Maker's mark of William Denny.
Hall-mark for 1705.
Height 10 in. (25·4 cm.).
130 Chocolate Pot
Maker's mark of Nathaniel Locke.
Hall-mark for 1708.
Height 9½ in. (24·2 cm.).

128

129 130

131 A Pair of Claret Jugs
Parcel-gilt.
Maker's mark of Thomas Heming.
Hall-mark for 1777.
Height 11 in. (28·0 cm.).

132 Claret Jug
Silver-gilt and frosted-glass, one
of a pair.
Maker's mark of Paul Storr.
Hall-mark for 1838.
Height 10¼ in. (26·1 cm.).

133 Claret Jug
Maker's mark of John Bridge.
Hall-mark for 1833.
Height 11½ in. (29·2 cm.).
Another identical jug was made by
Joseph Taylor in 1835. The one
illustrated was a gift from
William IV to Lord Ducie in 1834.

131

132

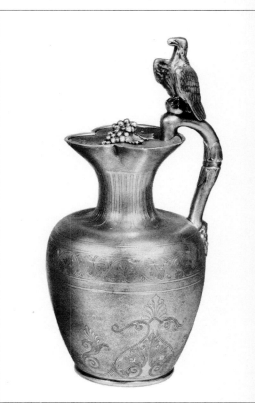

133

entioned four times in the Royal Inventories ?tween the years 1550 and 1597. Made of silver-t, enriched with enamel, cameos and semi->cious stones, the design could well be English, rhaps inspired by Holbein. Few people can never ve seen a silver watch case. Very few, however, ve seen a silver clock case. Odd though this is, e number of clock cases of English silver can rhaps be numbered on the fingers of one hand, ough a quantity with wooden frames, heavily crusted with silver are known. Even these, how-er, are uncommon, and it may be that the un-itability of a metal requiring constant polishing is apparent to the maker of an instrument whose curacy depended on its steady treatment. Two ocks made by John Paulet of London, c. 1710, e known to exist, one being in the Winthrop llection at the Fogg Art Museum, Harvard iversity, Massachusetts, the other in the Victoria d Albert Museum. Each has considerable silver rts. A clock made by James Newton, c. 1740, s mounts bearing the Sterling lion only, the work John Pollock. A splendid Rococo silver-unted clock is that presented to Mrs Strangeways rner in 1740 by Lady Archibald Hamilton. It is pported by the figure of Minerva seated upon a ashell, with a balustrade to the front. Another, most as fine, is that by John Ellicott, c. 1755. In ither case do the mounts appear to be marked. e famous clock made for King William III by omas Tompion at a cost of £1,500 has a case of ony and silver. It was part of the perquisites of e Groom of the Stole, the Earl of Romney, and s come by descent to the present owner, Lord ostyn.

For a watch, however, a silver case and even me was far more common from the late 17th to th centuries, and differed in no way from gold amples, with the exception that the finest 1bossed 'pair' cases display evidence of the creased malleability of gold. Though not com-1lsory, at certain periods most watch cases are ll-marked; this, however, is no guarantee of the te of the movement it now encloses. Very large arriage watches' of similar form to the fob watch re given similar cases, plain within and often ghly decorated and/or embossed without. A re case is one made by Pitts & Preedy in 1795, which the silver-gilt mounts of the clock, in-uding two free-standing figures, are fully hall-arked. Perhaps the earliest unquestioned sur-vor is that in the Victoria and Albert Museum ade by David Bouquet, who died in 1665. The 1allest spring-striking clock known, made by 1omas Tompion, has silver mounts (Scudamore ollection). A silver watch made by Joseph indmills for William III, c. 1690, has enamelied oving dials (Ilbert Collection, now in the British useum). George Michael Moser, a German-wiss, was considered the best chaser in London uring the 1740s. Although he specialised in watch ises (some of his designs survive in the Victoria d Albert Museum), he probably also undertook her work. To him may be attributed many of the est Rococo cases.

bliography
an Lloyd, 'The Collector's Dictionary of Clocks'. puntry Life, 1964.
ark Girouard, 'English Art and the Rococo', part . Country Life, February 3rd, 1966.

loisonné

1amelling done by first melting the frit into spaces :fined by wire soldered to the surface about to be :corated; principally an Oriental technique but uch used during the early Middle Ages.

Close-plate

Refers to polished steel, dipped in tin with a foil of silver applied and burnished. By this process, rust tended to appear relatively soon. Nevertheless, it was commonly used for buckles, knife blades, skewers, cheese scoops, bits, spurs and other articles of steel or iron. The whole surface to be plated is first made smooth, then dipped in sal-ammoniac and then into molten tin, the sal-ammoniac serving as a flux. A thin foil of silver of the correct size is laid on and pressed evenly and smoothly over the surface. A hot soldering-iron passed over the foil serves to melt the tin, which acts as a solder between the iron and the silver, after which the piece is burnished. Though known in early times, this process was particularly used during the 18th and early 19th centuries until superseded by cheaper, though less satisfactory, methods.

Bibliography
G.B.Hughes, 'The Art of Close-Plating'. *Country Life*, December 19th, 1968.
Edward Wenham, *Old Sheffield Plate*. 1955.
See also Sheffield Plate.

Cobbler Tube

Cobbler is defined by the *Oxford English Dictionary* as 'a drink made of wine, sugar, lemon, and pounded ice, and imbibed through a straw'. Perhaps the only recognised example of such a 'straw' is that, now in the Montreal Museum of Fine Arts, $6\frac{1}{4}$ in. (15·9 cm.) long and engraved 'John Scott Esqr. to Major John Coffin, Chas Town [sic] 1782. PIGNUS AMICITIAE'. This is almost certainly American. The scroll-shaped tube, closed and pierced at one end with a hook to one side, usually of American manufacture, and often called a 'feeding' tube, is probably a variation of this 'straw'.

Cockfighting Spur

John Moore advertised on his trade card, c. 1750: 'My Silver Spurs and Cock Spurs are marked with the two first letters of my name and all steel spurs with my Sir [sic] name at length'. These cock-fighting spurs are illustrated on the trade card as being a plain ring, from one side of which projects a long downward-curving spike some four times the diameter of the ring in length. They were attached by leather thongs to the leg of the bird. A case of steel examples and a single silver one may be seen at St Fagan's Castle, National Folk Museum of Wales. A two-handled cup in a Los Angeles private collection has engraved, on either side, cockfighting scenes and two winning in-scriptions by the bird 'Red Spartan', one dated 1770, the other 1771. It is $5\frac{7}{8}$ in. (15·0 cm.) high and hall-marked 1766. A number of spurs are to be seen in the collection of the Birmingham Assay Office and it is likely that many were manufactured in that city.

See also Bird Cage; Hawking and Cockfighting; Tumbler Cup.

Coconut Cup

As early as 1259 a coconut-shell formed into a cup is mentioned at Durham, but outside the Universities of Oxford and Cambridge and another at Eton, early silver-mounted coconut cups are rare. New College, Oxford, has two 15th-century examples and another of 1584. One of about 1450 is in the Lee of Fareham Collection in Toronto. Oriel College, Oxford, has one of about 1490 and there is another of early 16th-century date at the Queen's College, Oxford. At Cambridge, Gonville and Caius College has two 15th-century examples and Corpus

Christi College another. St Augustine's College, Canterbury, has a restored example of c. 1500. The Ironmongers' Company has one of about 1510 and there is another dated 1518 at the Vintners' Hall. The fashion for these cups, originally thought to be endowed with magical qualities, declined after the Tudor period, only to be revived c. 1770, and declared popular presumably due to their 'Gothick' associations. An interesting example of the 17th century is that from Hull made by Edward Mangy, c. 1670, now in the Royal Scottish Museum, Edinburgh.
See also Mounted-pieces.

Coffee Biggin

A cylindrical form of coffee pot with strainer, lip spout, legged stand and lamp. Generally of late 18th- and early 19th-century date, it was pro-bably originally designed to be conveniently packed and used when travelling. Large numbers were made by John Emes and later Emes & Barnard. The coffee biggin takes its name from its inventor George Biggin, described as 'quite a virtuoso'. By 1829 Charles Fox had invented a coffee percolator, 9 in. (22·9 cm.) high, formed as a compressed spherical teapot, for which it might equally well serve, which had an additional fitting of cylin-drical form with two filters and a diaphragm similar to the Continental *cafés filtres*.

Coffee Pot

Coffee appeared in England prior to the Civil War and one, if not indeed the first, coffee house was opened in 1652, and by 1700 there were over four hundred in London alone. The earliest recorded American coffee house was one set up in Boston in 1670. The earliest known coffee pot (**134**) now in the Victoria and Albert Museum, dates from 1681; probably made by George Garthorne, it is of a large size, being $9\frac{3}{4}$ in. (24·8 cm.) high. This coffee pot is of a tapering, cylindrical form, with incurved conical cover. It much resembles the vast teapot of 1670 in the same Museum. The form is perhaps copied from a Near Eastern original. Another, also by Garthorne, made in 1689, with the crown and monogram of William and Mary, is in the Royal Collection. Though the handle may be at right angles to the spout (Figs. **XIIa, d** and **XIIIa**) and, on occasion, of turned baluster form (Fig. **XIIb**), this tapering, cylindrical shape persists, being greatly refined over the years and sometimes made octagonal (Figs. **XIIIb, c, d** and **XIVa**). The hinge pin of the cover may be detachable to assist cleaning and until 1710 a thumbpiece may also be provided. At the turn of the century, and later in the provinces (**135**), the vogue for cut-card decoration also found expression on coffee pots, both at the junctions of the handle and spout and, occasionally, down the back of the handle (Figs. **XIIa, b, c** and **XIIIa**). One example by William Charnelhouse, dated 1704, has a spigot tap instead of a spout (Fig. **XIIc**). The earliest Scottish coffee pot so far known is octagonal, made by Colin McKenzie of Edinburgh in 1713. A number of spouts have hinged flaps closing them, a feature more common on those which are hand-raised rather than cast, the so-called 'duck's head' terminal is the successor to these (**136**). By 1730 the base of the body begins to curve out slightly over the moulded rim of the foot and it is this form, with its shallow, domed cover, which first appears chased in the Rococo taste. Figs. **XIVb, d** and **XVb** illustrate this de-velopment. The handle at right angles to the spout has now vanished and the pear-shaped body comes into fashion about 1740 (**137**). In time, the body becomes more waisted, and by 1760 the so-

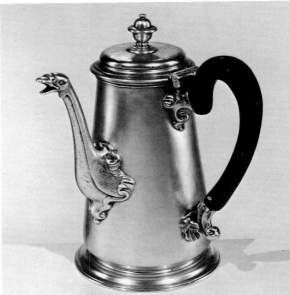

136

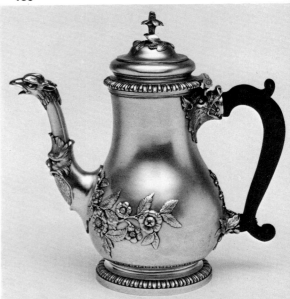

134 Coffee Pot
Maker's mark of George Garthorne.
Hall-mark for 1681.
Height 9¾ in. (24·8 cm.).
Victoria and Albert Museum.
Engraved with the Arms of Sterne.
One of the earliest known coffee
pots.

135 Coffee Pot
Maker's mark of Isaac Cookson.
Hall-mark for 1728, Newcastle.
Height 9½ in. (24·2 cm.).

136 Coffee Pot
Maker's mark of Paul de Lamerie.
Hall-mark for 1734.
Height 8¼ in. (21·0 cm.).

137 Coffee Pot
Maker's mark of Henry Haynes.
Hall-mark for 1748.
Engraved with the Arms of Ridge,
Sussex.

138 Coffee Pot
Maker's mark of A. Graham.
Hall-mark for 1762, Glasgow.

137

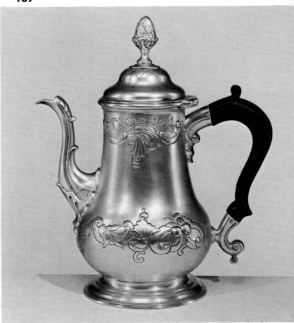

135

138

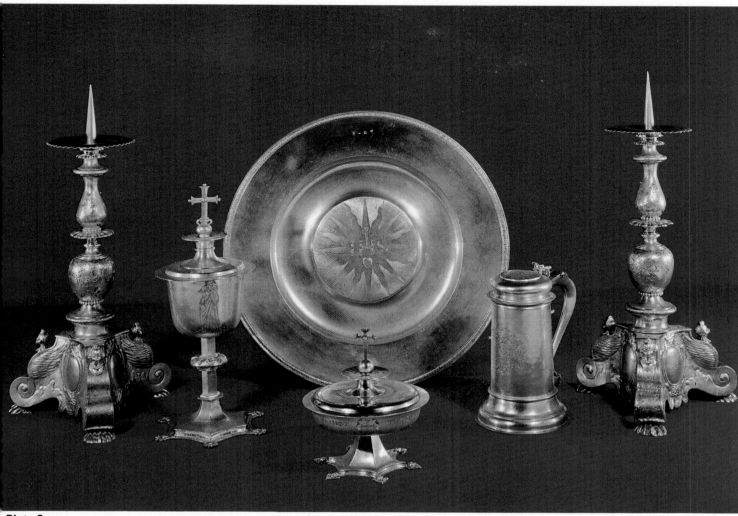

Plate 8

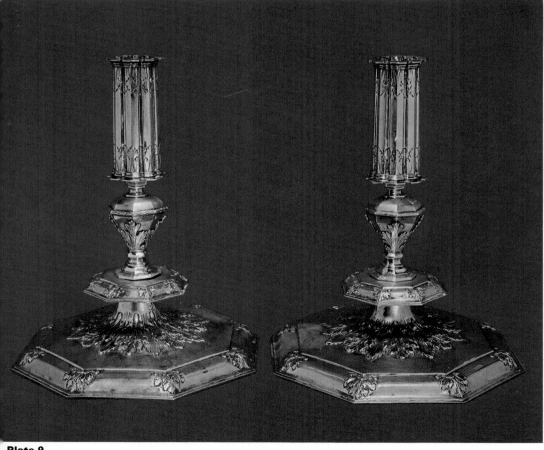

Plate 9

Plate 8 **Part of the Staunton Harold Chapel Plate**
The chalice bears the maker's mark, R.B.
Hall-mark for 1640.
The rest of this High Church plate, excepting some unmarked pieces, bears the maker's mark of a hound sejant and hall-marks for 1654.
Courtesy of the National Trust (on loan to the Victoria and Albert Museum, London).

Plate 9 **A Pair of Candlesticks**
Silver-gilt candlesticks bearing the maker's mark, I.B.
Hall-mark for 1675.
Height 13¾ in. (35·0 cm.).
They were presented to Harthill Church, Yorkshire, by the 2nd Duke of Leeds.

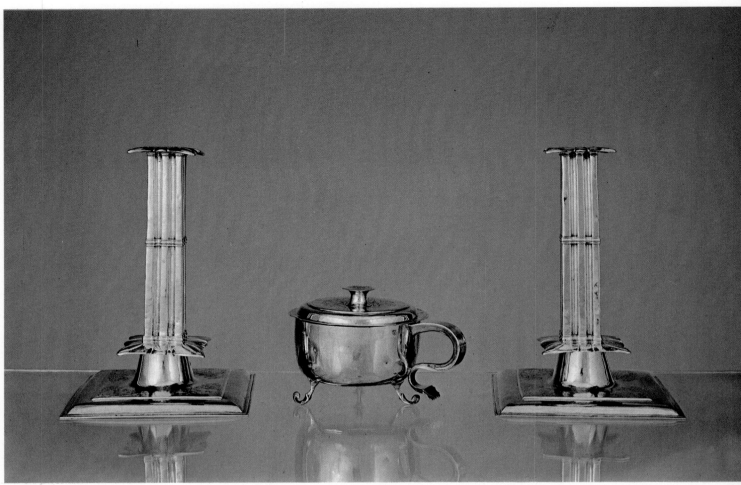

Plate 10

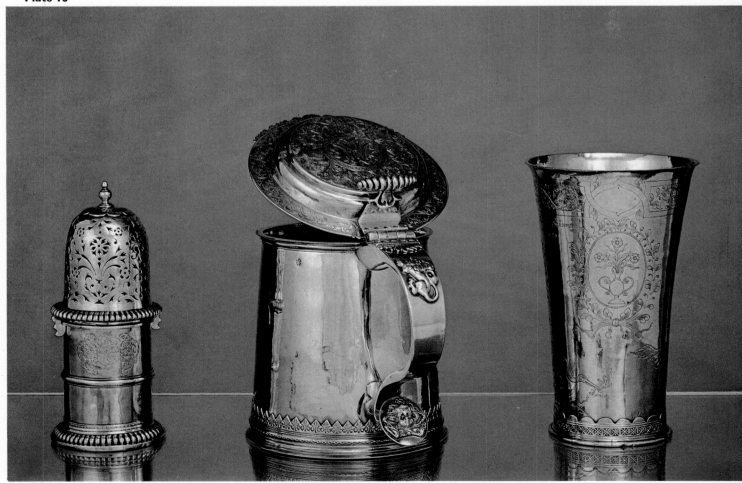

Plate 11

Fig. XII

a. 1700
Ht. 8¾ in. (22.4 cm.)

b. 1702
Ht. 8¾ in. (22.4 cm.)

c. 1704
Ht. 9¾ in. (24.8 cm.)

d. 1709
Ht. 9½ in. (24.2 cm.)

Fig. XIII

a. 1710
Ht. 10½ in. (26.7 cm.)

b. 1713
Ht. 9½ in. (24.2 cm.)

c. 1714
Ht. 9⅞ in. (25.1 cm.)

d. 1719
Ht. 9⅖ in. (23.9 cm.)

Fig. XIV

a. 1720
Ht. 9½ in. (24.2 cm.)

b. 1731
Ht. 8½ in. (21.6 cm.)

c. 1734
Ht. 9 in. (22.9 cm.)

d. 1739
Ht. 8½ in. (21.6 cm.)

Fig. XV

a. 1754
Ht. 7⅝ in. (19.4 cm.)

b. 1767
Ht. 10¾ in. (27.3 cm.)

c. 1767
Ht. 11½ in. (29.2 cm.)

d. 1767
Ht. 8⅜ in. (21.3 cm.)

Fig. XVI

a. 1771. Ht. 13¾ in. (35.0 cm.)

b. 1820. Ht. 11 in. (28.0 cm.)

c. 1829. Ht. 12 in. (30.5 cm.)

Plate 10 A Pair of Cluster Column Candlesticks and Skillet
The candlesticks bear the maker's mark of Jeremiah Dummer of Boston, Massachusetts, *c.* 1685. Height 10¾ in. (27·3 cm.). Engraved with the Arms of Jeffries, Usher, Clarke and Everard or Lidgett. The skillet bears the maker's mark of William Rouse of Boston, Massachusetts, *c.* 1675. Yale University Art Gallery.

Plate 11 Caster, Tankard and Beaker
The caster bears the maker's mark of Pieter Van Dyck of New York, *c.* 1700. Height 7¾ in. (19·7 cm.). Mabel Brady Garvan Collection. The tankard bears the maker's mark of Jacobus Van der Spiegel of New York. Height 7⅜ in. (18·8 cm.). Gift of the late Francis P. Garvan, Mrs Garvan and Spotwood D. Bowers. The Sanderson Beaker bears the maker's mark, CV over B within a heart. Height 8 in. (20·4 cm.). Mabel Brady Garvan Collection. All three pieces are in the Yale University Art Gallery.

Fig. XII
A group of tapering, cylindrical coffee-pots, 1700–9. a. A coffee pot with the handle at right angles to the spout, a conical cover and cut-card decoration. b. A coffee pot with a turned baluster handle at right angles to the spout and cut-card decoration. c. A coffee pot made by William Charnelhouse, decorated with cut-card work and having a spigot tap. d. A plain coffee pot with the handle at right angles to the spout.

Fig. XIII
a. A pear-shaped coffee pot with a hinged cover to the spout and cut-card decoration. b. An octagonal coffee pot. c. An octagonal coffee pot with a duck's head terminal to the spout. d. A plain, tapering, cylindrical coffee pot.

Fig. XIV
a. An octagonal coffee pot of tapering, cylindrical form with the handle at right angles to the spout. b. and d. Two pear-shaped coffee pots in the Rococo style. c. A plain, slightly tapering, coffee pot with an almost flat cover.

Fig. XV
a. and d. Two pear-shaped 'Turky' coffee pots with lip spouts. b. A coffee pot with the base of the bottom of the pot curving out slightly over a moulded rim foot, in the Rococo style. c. A 'dropped bottom' coffee pot again in the Rococo style.

Fig. XVI
A group of coffee pots, 1771–1829, in the style of the Classical revival. a. A coffee pot of vase form. b. and c. Two combined coffee pots and hot-water jugs.

called 'dropped bottom' appears (Fig. **XVc**), the capacity of the pot was thus increased considerably. *The Pennsylvania Journal*, December 15th, 1763, advertised 'Single and double belly'd coffee pots'. From 1710 onwards, the handle was usually of double scroll form (**138**). The numerous entries in the Garrard Ledgers during the 1750s for 'Turky' coffee pots may refer to the so-called pear-shaped, 'hot-water jugs' (Fig. **XVa** and **d**), whose lip spouts would be far better suited to pouring Turkish coffee than that of the normal form of coffee pot with its spout springing from half-way, or even lower, down the body. A particularly fine example made by Lamerie in 1747 has the finial to the cover formed as a butterfly and the spout as a spray of (coffee?) foliage. The vase form of the Classical revival lent itself to the coffee pot, and many variations were produced on this particular theme from 1770 onwards (Fig. **XVIa**). By 1780 the sale of combined tea and coffee services was becoming more usual. Coffee pots were probably also being used as hot-water jugs for tea. By 1800 the hot-water jug of the tea service resembles the circular teapot from the base to the shoulder, but has an elongated neck above the shoulder (Fig. **XVIb** and **c**). This form is usually found with a heater and stand, and its use for coffee would seem to have become secondary.

Bibliography
G. Scott Thomson, *Life in a Noble Household* (pp. 167–9). Jonathan Cape, 1950.
See also Chocolate Pot; Jug.

Coffee Urn See Tea Urn.

Coffin Handle
A New England variant of the usual Old English pattern handle for table silver of 1780–1820.

Coffin Plate
This might almost be described as furniture. Understandably rare, for normally it was buried with the coffin; very few pieces are known in silver, they are more often made of brass or lead. One piece, looted from a tomb during the American Civil War, was part of the silver fittings supplied by William Waddill in 1770 for the coffin of Governor Norborne of Virginia (Colonial Williamsburg, Virginia). One from an English Royal coffin also survives.

Coin
In early times (at an earlier period than the one with which we are dealing) the coiner and silversmith were often the very same man, and known as a 'moneyer'. However, there are the following exceptions. During the Civil War in England (1642–9) a number of towns and castles under siege, notably Newark, struck their own coin. In some cases this was done by using wrought plate, and stamping upon it a number (X for ten pennies). In Colonial America between 1652 and 1662, Hull & Sanderson, who entered into a special partnership for this very purpose, were commissioned to strike one shilling coins (known as Bay Shillings) together with sixpences and threepenny pieces. At first stamped N.E. for New England; later, to prevent clipping, the coins were surrounded by a double ring. The first 'Tree' issue bore a crudely executed willow. From 1662, their products bear a representation of an oak tree, still dated 1652, but with a twopenny piece dated 1662. In 1663 the pine tree replaced the oak on the three larger denominations, but the 'authorisation' date of 1652 was still struck. Hull received one of every twenty coins struck.

'Pine Tree' shilling. Museum of Fine Arts, Boston.

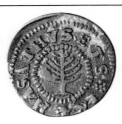

In 1787, Ephraim Brasher of New York issued a gold doubloon (value about $16·00) of which six are known, and on which he placed his maker's mark. The United States Mint was established at Philadelphia in 1792. In England, shortage of silver during the Napoleonic Wars compelled the authorities to countenance the use of Spanish dollars, and in 1804 the duty-mark or sovereign's head, normally struck on silver, was also struck upon the dollars to indicate such official recognition.
Bibliography
Philip Nelson, 'The Early Coinage of America (1584–1774)'. *Connoisseur*, vol. XXIX, p. 238.

Colander See Orange Strainer.

Collar
So far, one of the earliest surviving dog collars appears to be that having serpentine, wire-moulded borders, engraved at the hinge and clasp with acanthus foliage and bearing a maker's mark, TF, also known on a late 17th-century communion cup. The collar is further decorated with four applied chrysanthemum-like studs and two inscriptions, the earlier 'My Lord Monthermers his dog' (private collection). However, most of the surviving silver collars, usually with rolled border, date from the middle of the 18th century. These are often engraved with the name of the dog for whom they were intended, being frequently given as prizes for greyhounds. In the 17th century, however, they were also undoubtedly made for Negro pages or slaves. A portrait of James Drummond, 2nd Duke of Perth, painted *c*. 1700 and now hanging in the National Portrait Gallery, Edinburgh, illustrates one such collared Negro. To judge from a number of extremely small examples, often furnished with a silver padlock, they must also have been made for monkeys. The Garrard Ledgers note their being supplied in 1751 'to a dog Collar', and in 1759 to the Earl of Mansfield 'to a silver collar and padlock'. Paul Revere invoiced 'a silver squirrel chain' though he mentions no collar or padlock. A three-link chain with swivel eyes, some 10⅛ in. (25·7 cm.) in length, was probably intended for a couple of hounds. It is hall-marked 1834 and the central link is engraved 'GYD HELFA CAERGYBI Wm Bulkley Hughes Comptr 1835'. (With the Hunt of Holyhead, Anglesey.)
See also Bird Cage; Monteith.

Collecting Box
So far as is known, only one dating from 1677 has survived, at Tabley, Cheshire. It is of cylindrical form and decorated with rudimentary cut-card work. St Aubin's Church, Jersey, commissioned two, of tankard form, in 1750.

Collock Piece See Bowl.

Comb
The tendency of the sharp tines to scratch the head may account for the unpopularity of silver combs, hence even those used purely as decoration for a lady's hair are surprisingly rare. An unmarked example survives at Mount Vernon, and another

engraved with foliage, also of about 1780, exhibited at the Montreal Museum of Fine A[rts]. One of 1813 is in an English private collection. T[he] large boxes in toilet services of the late 17th a[nd] early 18th centuries are sometimes referred to [as] 'combe boxes' in inventories of the period. Silv[er]mounted, tortoiseshell combs were the gen[eral] form from the late 17th century onwards.

Communion Bowl
These, peculiar to the Channel Islands, seem [to] have been the most popular form of commun[ion] vessel on these islands until 1640. Flagons to h[old] the wine were not common, instead bowls w[ere] used, or shallow cups on feet, preserving the fo[rm] of the bowl though with baluster stem. Howev[er] after 1660, the communion cup was usually on[ly a] locally made variation on an English original.

Communion Cup
Though vast quantities (estimated to be about n[?] tons) of plate were appropriated by Henry VIII [at] the time of the Dissolution, and during the reign [of] Edward VI, a great number of churches contriv[ed] to keep more than the one chalice that the Spe[cial] Commissioners were prepared to leave th[em]. Others sold plate and refurnished their church[es]. More plate was 'lost' at this time than ever bef[ore]. The wiser churchwardens converted their chali[ces] to communion cups, a convenient nomenclat[ure] for the Anglican form of sacramental cup, tho[ugh] many priests were still prepared to celebrate [the] Mass of both the Anglican and Roman Cath[olic] Churches. The conversion was often at the rate [of] two chalices to one cup. Pieces made during [the] ecclesiastical Gothic revival of the mid 17th cent[ury] resemble the medieval Roman Catholic chal[ice]. The restoration of the Roman Catholic faith un[der] Mary Tudor did not last long enough to allow [for] the refurbishing of the churches with plate. To[day] only about eighty pre-Reformation silver chal[ices] survive. Lichfield and Peterborough were tw[o of] the relatively few churches which were loote[d of] their plate during the Civil War (1642–9) an[d it] seems that the main offenders for such actions w[ere] Cromwellians. The earliest true communion [cup] known to survive is at St Lawrence, Jersey, an[d] hall-marked 1548, the year in which the cup w[as] restored to the laity. Its form combined reasona[ble] capacity with plainness (**139**). There does, ho[w]ever, seem to have been no directive as to w[hat] form would be most suitable as a communion c[up] but there was a general feeling that it had [to] be different from the normal run of cups; capa[city] was of secondary importance, in that the gre[at] quantity of wine would be held in a flagon (Fi[g]. **XVII**). A number of secular pieces were then, [and] later, pressed into service for the use of the Chu[rch] (Fig. **XIX**). It was not, however, until the access[ion] of Elizabeth I that, under the leadership of Ar[ch]bishop Parker, the provision of communion c[ups] at each and every church became a pressing is[sue] and from 1564 they invariably appear with a pa[ten] cover. A number of local silversmiths must h[ave] been kept very busy as this was done diocese [by] diocese. London silversmiths, however, secu[red] large commissions (**140** and **142c**). Needless [to] say there were exceptions, and it is notewo[rthy] that, whereas the Edward VI cups, of wh[ich] eighteen survive, were made regardless of expe[nse] (in the hope of being permitted to keep someth[ing] rather than lose all to the Crown), the Elizabet[han] examples had to be paid for if they and t[heir] 'fashion' cost more than the break-up value of [the] original chalice. This consequently resulted i[n a] number of poor-quality objects. Norfolk paris[hes]

hich from 1565 were ordering their new plate om Norwich rather than London, usually ob- ned pieces of excellent quality and frequently tter than the products of the Capital. This, how- er, cannot be said of many provincial centres 41, 142a and b). Once the Church of England as firmly established, the chances of finer plate ing acquired increased (Fig. **XVIII**). By the gn of Charles I, complete services of altar plate, ps, flagons, alms basins and patens were given the Church. That for St George's Chapel, indsor, by Christian Van Vianen being of seven- en pieces was finished in 1637, yet melted thin a decade thanks to the Civil War. The Crom- llian Commonwealth did not prevent the supply plate, though more was probably made for High nglican private chapels, such as Chobham Hall, nt, or Staunton Harold, Leicestershire, 1653 olour Plate **8**), than for individual churches. uch plate of this latter sort was formed in the le of the Gothic revival.

During all this time the development of clesiastical and secular plate had run parallel 43 and 144) and it was not until about 1690 that e new fashions of the Huguenot silversmiths gan to deviate from the more conservative quirements of the Church (**145**). The cup and ver made by John Chartier in 1699 (Christ- urch, Oxford) is exceptional, in that most com- union cups of the 18th century are singularly inspired. A silver-gilt communion service com- sing a flagon, an oval dish and a pair of com- union cups with paten covers, all made by Paul Lamerie in 1717, survive in the collection of the ke of Brunswick. He also made a good deal of e communion plate given by Mrs Strangeways orner to the parishes of which she was patroness. th rare and splendid exceptions, most 18th- ntury Church plate can only be described as inspired (**146**). At a later date, Paul Storr and hn Bridge did, however, contribute something wards the betterment of these standards during e early 19th century and to A.W. Pugin may most be accredited the 'Gothick' revival in urch plate. Rare pieces are the gilt knives, one th scabbard, one with a box, at Melbury Samp- rd and Abbotsbury, both given by Mrs Strange- ays Horner in about 1755. The Communion ate of Scotland and Ireland, also includes a mber of varieties, thanks mainly to their being de in the provinces. A peculiarly Scottish com- union cup was of the tazza form, though a few e London made. In general it is true to say that some time or other almost every form of bowl s been used, in the churches of the United ngdom, as a vessel for Communion. Miniature ts of cup, paten and phial for the administration Communion to the sick are rare prior to 1820 t increasingly less so thereafter (**147**). A number churches in the United States also possess fine rvices of Communion plate, the gifts of William or Queen Anne; similar gifts were also made to urches and chapels in Canada.

bliography
e the large bibliography for specialist works Diocesan or County plate.
St George Spendlove, 'The Mohawk Silver'. nnoisseur, vol. cxxvi, 1950.
G.G. Ramsey, 'Treasure of the House of Bruns- ck'. Connoisseur, August 1952.
J. Buckley, 'Some Irish Altar Plate'. Royal Society Antiquarians of Ireland, 1943.
Burns, Old Scottish Communion plate. Edin- rgh, 1892.
Gilchrist, Anglican Church Plate. Connoisseur/ ichael Joseph, 1967.

C.C. Oman, *English Church Plate*. Oxford University Press, 1957.
Maurice H. Ridgeway, *Chester Goldsmiths*. Sherrat, 1968.
Neville Connell, 'Church Plate in Barbados'. *Connoisseur*, August 1954.
See also Beaker; Chalice; Goblet; Paten.

Coney, John (1655–1722)

In about 1634 at the age of six, his father was brought from Lincolnshire to Boston, Massachusetts. The boy was apprenticed to John Milom, a cooper. He married Elizabeth Nash of Boston in 1654 and they had thirteen children; John, the silversmith being the eldest, born January 5th, 1655. It seems that John may have been apprenticed to either Jeremiah Dummer or John Hull, the latter being the more likely, though this is not proven. He married three times, having twelve children, most of whom died in infancy.

His earliest surviving piece of work is a two-handled caudle cup and cover presented to the First Parish Church of Concord, Massachusetts, on April 6th, 1676 and now in the Garvan Collection, Yale University Art Gallery. At that time he can have been but a few months out of his apprenticeship. This was the starting-point, and from this date until his death in 1722, he continued to ply his trade. More plate fashioned by him survives than by any other New England silversmith of his generation.

The surviving silver made by Coney almost covers the whole field of American Colonial silverwork. During the early period, his mark usually incorporates a fleur-de-lys and his initials (a), but after about 1700 he appears to have adopted a rebus, using a coney (rabbit) instead of the fleur-de-lys (b). He also employed two further small marks (c) and (d), often in conjunction with one of the larger punches. These, when so used, are often on the bezel of the cover of the object.

a b c d

Amongst the more important surviving pieces of his workmanship may be mentioned what is probably his only known inkstand of the 18th century of about 1710 (Metropolitan Museum of Art, New York), the monteith of *c.* 1720 (Roosevelt Collection) and another of about 1715 in the Garvan Collection, Yale University Art Gallery, a chocolate pot of the rarest 'ginger jar' form, made about 1700 (Museum of Fine Arts, Boston) and the two-handled Stoughton Cup and Cover presented to Harvard University by William Stoughton in 1701 (**203**). A pair of bulbous mugs of about 1695 should not be forgotten. The Minneapolis Institute of Arts possesses a spout cup of about 1710 (**570**) and a very rare circular dinner plate of about 1695, both are his work. By him also survive a number of casters and at least two pairs of candlesticks, extremely rare in Colonial silver. The Currier Gallery of Art holds a sugar box of his making. Plates **360** and **586** and Colour Plate **18** serve to illustrate the scope of John Coney's work.
Bibliography
H.F. Clarke, *John Coney, Silversmith*. (This work includes a detailed list of all pieces, then known, by Coney.) 1932.

Coral See Rattle; Teething Stick.

Cordial

A medicine, food or beverage which invigorates the heart and stimulates the circulation—a pungent

alcoholic beverage. Referred to especially in the 17th and 18th centuries as an after-dinner drink and frequently taken by Parson Woodford.
Bibliography
Parson Woodford, *Diary of a Country Parson*.

Cordial Frame

A frame, usually of late 18th-century date, used to retain small glass decanters, containing amongst other things, cordials; such frames are the ancestor of the spirit tantalus.

Cordial Pot

A vessel for containing cordial. Normally understood to be small glass decanters which were used for this purpose and more often than not square in section.

Amongst Her Majesty the Queen's Collection is a silver-gilt ewer and cover by Francis Garthorne, *c.* 1695, some 7 in. (17·8 cm.) high, with a long, curved spout and harp-shaped handle. In many respects it resembles in outline the argyll of the 1780s. This and two or three small, gourd-shaped, covered vessels of Chinese wine-pot form, having sometimes curved spouts, and with makers' marks of the late 17th century, are thought, often being gilt, to have been used for cordial. They may have a plain rim foot or three scroll feet, and are usually about 4½ in. (11·5 cm.) high. Conversely, the known consumption of tea at the period and the rarity of teapots makes one wonder whether these were not in fact designed as trial pieces, however impractical those with solid silver handles may have proved to be when filled with a hot beverage. See also Teapot.

Cork Goldsmiths' Guild

The quantity and importance of silver produced at Cork, together with the continuous attempts of its goldsmiths to obtain the right to an assay office throughout the 18th and early 19th centuries, is the sole reason for its non-inclusion under Provincial Goldsmiths (Irish). During the early 17th century, silver was mined near Youghal, County Cork, by Richard Boyle, 1st Earl of Cork, from mines, which he leased in 1631 for a rent of 'a fair bason and ewer, four dozen of silver plates and eight great silver candlesticks'. The Society of Goldsmiths of the City of Cork was incorporated to include members of most of the other crafts of the city in 1656. A number of the goldsmiths during the late 17th and 18th centuries would also appear to have been either political or religious refugees from the Continent. In all probability such was Anthony Semirot, the maker of a fine, plain, cylindrical coffee pot of about 1715. Their influence on the products of Cork workshops was considerable. The Great Mace of Cork, by Robert Goble, dated 1696, is now in the Victoria and Albert Museum, and both castle and ship marks are clearly visible on the head. The earliest form of town mark is based upon its arms, a ship between two castles, though the former is frequently omitted. It was not uncommon for this mark to be struck with separate punches for ship and castles. Early in the 18th century, the use of this mark was discontinued, and the word 'Sterling' or 'Starling', variously spelt, was substituted. Such a mark may well have been felt to offer the public some remedy under the Common Law, even though no official assay of Cork productions took place, with the rare exception of certain larger pieces which were sent to Dublin. No date-letter system was ever instituted and by 1825 Cork, with other provincial centres, sent its wares to Dublin for assay. A gold freedom box by William Reynolds of Cork, engraved with the Arms of Cork, was

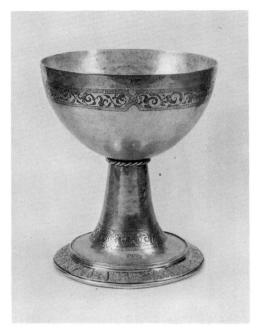

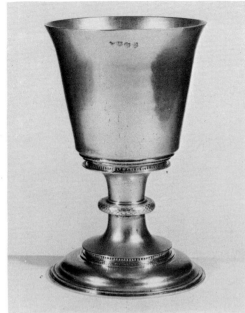

140

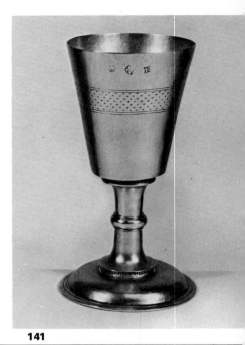

141

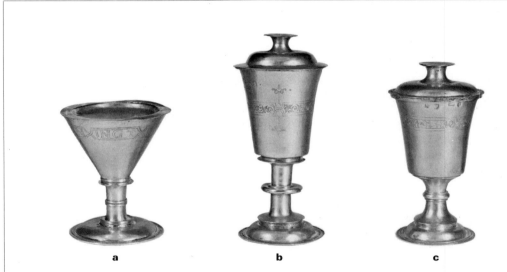

a b c

142

139 Communion Cup
Maker's mark, IW in monogram.
Dated between the years 1520–50.
Height 7½ in. (19·1 cm.).
St Petroc Church, Bodmin, Cornwall.
One of the earliest true communion
cups.

140 Communion Cup
Maker's mark, a hand and coronet.
Hall-mark for 1553.
Height 9 in. (22·9 cm.).

141 Communion Cup
Maker's mark of George Kitchen.
Hall-mark for 1568, York.
Height 6 in. (15·3 cm.).

142 Communion Cups
a. Unmarked, *c.* 1570.
Height 4¾ in. (12·1 cm.).
b. Maker's mark of Lawrence
Stratford of Dorchester. *c.* 1574.
Height 7¾ in. (19·7 cm.).
c. Hall-mark for 1568, London.
Height 6⅞ in. (17·5 cm.).

**143 Communion Cup
and Cover**
Silver-gilt.
Hall-mark for 1683.
Victoria and Albert Museum.
The property of St James'
Church, Piccadilly.

144 Communion Cup
Maker's mark, A Y.
Hall-mark for 1684.
Height 6 in. (15·3 cm.).

145 Communion Cup
Maker's mark of John Oliver.
Hall-mark for 1692, York.

**146 Communion Cup
or Flagon**
Maker's mark of Richard Richardson.
Hall-mark for 1742, Chester.
With a lip to each side, this cup
is presumed to have been used in
place of a flagon to pour the wine
into smaller vessels.

147 Communion Set
Hall-mark for 1823, London.
Victoria and Albert Museum.
This type of set was used to
administer communion to the sick.

143

144

145

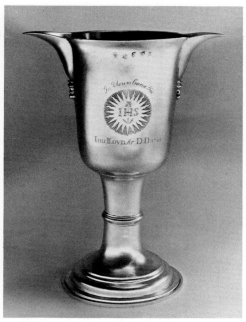
146

147

Fig. XVII
Communion cup at St Margaret's, Westminster. Hall-mark for 1551, London.
Fig. XVIII
Communion cup and paten at Beddgelert, North Wales. Hall-mark for 1610, London.
Fig. XIX
Communion cup at Marston Church, Oxfordshire. *c.* 1450, height $5\frac{7}{8}$ in. (15·0 cm.).

Fig. XVII **Fig. XVIII** **Fig. XIX**

given to Admiral Lord Rodney in 1782, now in the National Maritime Museum, Greenwich. Others by Reynolds of 1761 and 1764 are extant. The Sterling mark was confusedly also used in Limerick, Chester, Liverpool and Plymouth and in the United States by the middle of the 18th century. Amongst the Jackson Collection (on loan to the National Museum of Wales) may be seen a splendid porringer and cover made by Charles Bekegle, c. 1695. An earlier example by Richard Smart, c. 1675, was formerly in the Beaumont Collection. Almost the whole range of silversmiths' products seem to have been produced here at some time, even such large pieces as a pair of soup tureens by Terry & Williams, c. 1800.

Bibliography

Sir C.J. Jackson, *English Goldsmiths and Their Marks*. 2nd Edition 1921, reprinted 1949.

See also Irish Silver.

Corkscrew (Bottle Screw)

The form of this piece of essential equipment has not changed over the years. Basically of T-shape, the cross bar may be removable to form a socket into which the screw may be fitted. 17th-century examples sometimes incorporated the owner's seal or a tobacco stopper. As cork does not seem to have supplanted waxed linen, wrapped around wooden plugs for use as bottle stoppers, until the second half of the 17th century, these above mentioned are the earliest bottle screws likely to be found. Though the most convenient form is the ring, into which the screw folds when not in use, a seemingly endless succession of variations were made during the 18th and 19th centuries. Almost all metals were used for the mounts, only the screw being invariably of steel (**60g**). Birmingham Trade Catalogues illustrate a large number, the grander examples having a brush within the silver handle (the T-shaped variety) to clear the neck of the bottle prior to decanting.

Bibliography

C.R. Beard, 'Corkscrews'. *Connoisseur*, vol. LXXXIV, pp. 28 *et seq.*
H. René d'Allemagne, *Le Musée Le Secq des Tournelles à Rouen*. 1924.

Coronation Plate

Though Charles I was in considerable financial difficulties before the outbreak of the Civil War and disposed of at least one crown and a sceptre in 1643, the English Regalia, including a crown of wirework (filigree) reputedly King Alfred's, survived almost entire until 1649, though had the Commons not been at first baulked by the Lords, most of the English Regalia would have been destroyed in 1644. On August 9th, 1649, it was ordered that the Regalia be delivered to the 'trustees for the sale of the goods of the late king, who are to cause the same to be totally broken, and that they melt down all the gold and silver, and sell the jewels to the best advantage of the Commonwealth'. This was carried out all too thoroughly and it would appear that only the body of the eagle forming the Coronation Ampulla and the Anointing Spoon survived, the former almost entirely, the latter largely reworked, for use at the Coronation of Charles II. The bill for their replacement in 1661 by Sir Robert Vyner being some £32,000 or almost fifteen times the figure realised in 1649. Amongst the plate now preserved with the Regalia is an Elizabeth I salt cellar, this, however, would appear to have been supplied with the new plate in 1661, and to have no previous royal history. The Scottish Regalia is of earlier date in that the gold crown, which was refashioned by James Mossman, c.

1540, yet retains the arches of its predecessor (Colour Plate **19**). Likewise the silver-gilt sceptre which was given by Pope Alexander VI in 1494 was refashioned by Adam Leys of Edinburgh in 1536. The so-called 'Lord High Treasurer's Mace' may also date from the first half of the 16th century. The gold Scottish Ampulla (National Museum of Antiquities, Edinburgh) is engraved with the date 1633. Until the Coronation of George IV in 1820 it was the custom for certain of the hereditary Officers of State, such as the Earl Marshal, the Chief Butler, the King's Champion, the mayors of certain cities and others, to claim a piece of plate as their fee for services rendered at a coronation and the ensuing banquet. In certain cases this was gold; certainly the plate demanded by the Earl Marshal, some of which survives from the Coronations of 1727, 1761 and 1822, and the King's Champion, was of gold. Two goblets of 1660, now re-engraved with the Arms of William and Mary, survive in the Royal Collection, and, having come from the plate of one of the Howards, these may just possibly have some connection with the Coronation of Charles II. They are, however, only silver-gilt. A number of later pieces of such plate have certainly survived, including the caddinets used at the Coronation Banquet of William and Mary (1689), though one is of earlier date (1683). The cup and cover claimed by the Mayor of Oxford in 1761 as his fee for the office of Under Butler is also extant.

Bibliography

A.J.S. Brook, *Proceedings of the Society of Antiquaries of Scotland*, vol. XXIV.
H. Farnham Burke, *Coronation Book of King Edward VII*.
John Dart, *Westmonasterium*.
Cyril Davenport, *The English Regalia*.
Domestic State Papers of Henry VIII.
Captain H. Taprell Dorling, D.S.O., R.N. ('Taffrail'), *Ribbons and Medals*.
Sir John Ferne, *The Glory of Generosity*.
Ian Finlay, *Scottish Gold and Silverwork*. 1956.
Martin Holmes, F.S.A., 'The Crowns of England'. *Archaeologia*, vol. LXXXV; *The Crown Jewels*, (official pamphlet on sale at the Tower of London).
E.A. Jones, *Old English Gold Plate*. 1907.
William Jones, *Crowns and Coronations*; *Finger Ring Lore*.
L. Wickham Legge, *English Coronation Records*.
Nicholls, *The Progresses of Queen Elizabeth*.
Sir Francis Palgrave, *The Ancient Kalendars and Inventories of the Treasury of His Majesty's Exchequer*.
A.D. Purdey-Cust, *Coronations in England*.
Records of the Jewel Office, the Lord Chamberlain's Office and Mint.
Royal Calendars and Wardrobe Accounts.
P. Schramm, *A History of the English Coronation*.
Robert M. Shipley (President: Gemological Institute of America), *Famous Diamonds of the World*.
H.D.W. Sitwell, *The Crown Jewels*.
John Speed, *The Historie of Great Britaine*.
W.H. St John Hope, 'The King's Coronation Ornaments'. *The Ancestor*, vols. I and II.
Alistair and Henrietta Tayler, *The Stuart Papers at Windsor*.
Arthur Taylor, *The Glory of Regality*.
Professor and Mary Tout, *Chapters in Medieval Administrative History*.
Sir Edward Twining, *The English Regalia and Crown Jewels in The Tower of London*.
Sir George Younghusband, *The Jewel House*.
Sir George Younghusband and Cyril Davenport, *The Crown Jewels of England*.

See also Caddinet; Spoon (Coronation Spoon).

Coronet

It may be that early coronets survive, but th continued refitting to the heads of new owners meant that the vast majority have been altered of all recognition to their original form. One 18th-century date and some by Paul Storr known to exist. John Hervey, 1st Earl of Bris records his paying Louis Cuny £14 'for my Ea Coronet' on October 19th, 1714. Coronets vary detail according to the rank of the wearer. ermine border and velvet lining is the remnant the medieval Cap of Maintenance. The illustrat shows their heraldic representation.
See also Heraldry.

Duke
strawberry leaves

Marquess
strawberry leaves with two balls

Earl
five balls

Viscount
nine balls

Baron
four ball

Corporation and Ceremonial Plate

Almost without exception the survival of many the earliest pieces of English silver may be at buted to their remaining in the possession of guil colleges or corporations and these latter are possessors of a marvellous variety of obje Maces, staves, Swords of State, oars, chains office and waits' badges comprise the bulk of su plate (**592**), but besides these, certain pieces the table also survive, a number of which referred to elsewhere under their particular descr tion. York Corporation possesses a gold goblet 1672 and a silver chamber pot; Oxford a g porringer of 1680; Guildford and Norwich C porations each have superb ewers and basi Probably the most important civic collections those of London, Bristol, Norwich, Portsmouth a York. Great civic occasions when these pieces brought out are still impressive, but possibly no much as in the 16th century when Cardi Wolsey proceeded in state 'with silver pillars a poleaxes borne before him'.

Mace

These may be divided into three types. Sergea Maces, by virtue of which a sergeant was e powered to arrest and restrain wrongdoers wit the boundaries of the borough, and Great Ma borne before a mayor as a symbol of his author The latter in general developed from one of former, when the corporation in question had m than one sergeant; but by the mid 16th centur might be bought 'for dignity' or, as in the seco half of the 17th century, be a gift from a lo magnate, by which time the office of mace-bea had been created as a separate entity. The origi form was that of a battle mace (**148a**) w flanged head. By the late 15th century there wa general tendency for the pommel to be so enlarg and decorated with the Royal Arms or those of Lord of the Borough, that the mace was car reversed. During the next century, the arms w often surmounted by a coronet, and the flan degenerated into mere brackets before finally appearing (**148b** and c, and **151**). Nevertheles number of 16th- and 17th-century copies w made of earlier examples (**149**). Some five hund Sergeants' Maces survive, ranging in date from 15th century to the present day, but only about hundred of the Great Maces are still extant, an

se the earliest is of the 17th century (**150b**). at of the city of Edinburgh was made in 1617 by orge Robertson. Of those ordered under the mwellian Commonwealth, to be made solely Thomas Maunday or to his pattern, a number ve survived. The mace at Congleton, Cheshire, ed 1651, is practically unaltered but for the loss its acorn finial (Colour Plate **21**), likewise that Marlborough, dated 1652 and illustrated on te **150a**. Early in the 18th century, Benjamin ne departed from the accepted form of shaft to duce a baluster-type mace, such as the one at nchester, made in 1722, 63 in. (160·1 cm.) in gth, and Gravesend (1714). The maces at aumaris each contain, in the head, a beaker of ped outline, whilst those of Evesham (1619) formed so that each bowl may be used as a ing cup. At Hull, one of the Sergeants' Maces ains the Arms of the Commonwealth engraved the reverse of the Royal Arms, which may be ily called into use by means of a bayonet joint. The third type may be called Faculty Maces, and those of university faculties, Courts of Session d that of the House of Commons. In each case ir existence being also a symbol of authority. at of the Faculty of Common Law of St Andrews iversity, Scotland, being the earliest (1438) and bably of Scottish manufacture. In the Ash- lean Museum, Oxford, may be seen the maces the Faculty of Law (c. 1575) and those of dicine and Arts Faculties (c. 1610). The mace the Commons of Ireland was made in 1675; en the Commons were dissolved in 1801 it was uired by a descendant of the last Speaker, d Oriel, and finally became the property of the nk of Ireland in 1937. That of Glasgow Uni- sity was in use by 1469, but 'mendit and gmentit' in 1590.

As an example of the way in which pieces of icial plate became private possessions, it is rth noting that on April 4th, 1672, a warrant is ued for the delivery to Roger Harsnet, he being e of King Charles' 'Sergeants at Arms' of the d Mace, 'in regard of His Extraordinary service ng Imployed by the Right honorable the Lord mmissioners of His Majestie's Treasurie in ching in His Majestie's Revenue'. The mace of van, Ulster, made by John Hamilton of Dublin 1723 cost £70 when given by Theophilus ments on June 29th, 1724 to the town. It ntually reverted to the family of the donor during 19th century, and when sold by them in 1967 the Ulster Museum, the price at auction was 500.

liography

.S. Brook, 'The Maces of Scotland'. *Proceedings the Society of Antiquaries of Scotland*. Enlarged d reprinted, Neill & Co., 1893.

. Hughes, 'The Story of English Maces'. *Country e*, August 8th, 1952.

yor's Chain

most all are of 19th-century date, other than that the City of London, which is a collar of SS of d and enamel, the gift of Sir John Alen in 1545, ugh perhaps itself earlier, and another of 1570 Kingston upon Hull. At Guildford, the Mayor's dge and chain presented by the High Steward, hur Onslow, in 1673 are of gold.

liography

. Jenkins, 'Collars of SS. A Quest'. *Apollo*, rch 1949.

e also Chain.

far the earliest reference is in a letter dated 1459 d addressed to John Paston, 'On Moneday last Crowmere was the ore and bokys of regystre of

the Amrelte takeyn a wey from my Lord Scalys men. He seyth, per Deum Sanctum, as we sey here, he schal be amrel or he schal ly there by'. These oars may be intended as representations of steering rather than rowing oars. Like maces, there are varieties. Great Oars borne as maces before the mayor (**152**), one of the finest being that of the Admiralty of the Cinque Ports at Dover; another of Boston, Lincolnshire, made by Benjamin Pyne, c. 1725, having been alienated, was repurchased by Boston Corporation a hundred years later. The broad blade allows ample space for decoration. Water Bailiffs' Oars (**665**) were carried like Ser- geants' Maces as a symbol of their authority in the port or river in question. Sometimes the crown un- screws to reveal a miniature oar. About a dozen of the former and rather more of the latter survive. One of the oars from Saltash is dated 1623. The silver Oar of the Admiralty Court probably dates from 1660, the loom or shaft was restored in 1798. The Oar of Boston, Massachusetts was made by Jacob Hurd, Boston, c. 1720. These should not be confused with the small model oars made as prizes during the 19th century for Fleet and other rowing competitions.

Bibliography

G.B. Hughes, 'Silver Oar of the Admiralty'. *Country Life*, April 10th, 1958.

'Oar Maces of Admiralty'. *Exhibition Catalogue*, National Maritime Museum, 1966.

Judith Banister, 'The Right to Bear a Silver Oar'. *Country Life*, June 16th, 1966.

Joan Woolcombe, 'The Silver Oar of Admiralty'. *Antique Dealer and Collectors' Guide*, June 1966.

Stave of Office

Beadles, whether as the servants of corporation, court or parish are usually furnished with a staff of office as a symbol of their authority. The word 'verger' being derived from the Latin *virger*, meaning 'verg-bearer', he being similarly equip- ped. In general the staff is a black hardwood pole with a silver head, the latter may take various forms. Sometimes the staff is decorated with one or more silver bands and is generally 5 to 7 feet long. Their constant use has resulted in all but a few being of 17th-century, and later, date. 16th-century ex- amples survive in the possession of the University of Oxford. Porters and running footmen employed by the rich and powerful might also be similarly equipped.

See also Baton, Field-Marshal's and Staff of Office; Tipstaff.

Sword of State

The symbol of certain jurisdiction derived from the Crown. There are less than fifty such swords extant, the possessions of some thirty-one cities and towns. Both Bristol and Lincoln possess 14th- century examples of actual fighting swords with embellished hilts (**593**). In all cases the sword is borne point uppermost in the absence of the sovereign and sheathed. Yarmouth alone bears it unsheathed in time of war. Only those cities and towns having a Royal Charter should bear Royal Arms upon the sword or scabbard. The latest of the Bristol swords has silver mounts made by Peter Werritzer in 1752; the silver alone weighing 201 ounces 13 pennyweights when supplied. Occasion- ally the swordbearer wears the Cap of Mainten- ance, though few of these caps have survived (**592**).

Trowel

The cult of the ceremonial silver trowel for the laying of foundation stones, reached its height during the later 19th century. Examples earlier than 1825 are uncommon, and when found usually plain. Two of 1806 and 1807, both silver-gilt, and

made in Dublin, are in the collection of the Duke of Bedford at Woburn.

Wait's Chain

The original watchmen of a medieval city seem, in time, to have become converted to a band of minstrels and provided with livery and instruments. Each wore a badge with the arms of the corporation and also a chain or collar. Fine examples of these latter remain at Exeter (c. 1500) and Norwich (c. 1550). There are others at Bristol, King's Lynn, York and Beverley and in the Victoria and Albert Museum.

Bibliography

Jewitt and Hope, *Corporation Plate and Insignia of Office*. Vols. I and II. Bemrose & Sons, 1895.

C.G.E. Blunt, 'The Corporation Plate of the City of Portsmouth'. *Apollo*, July 1926.

A.E. Preston, *Abingdon Corporation Plate*. Oxford University Press, 1958.

M.J. Groombridge, N.D., *Chester. Charters, Plate and Insignia*.

E.A. Blaxhill, *Colchester Borough Regalia*. 1950.

C.C. Oman, 'Guide to Regalia and Plate of the City of Norwich'. *Connoisseur*, April and May 1964.

C.H. Ashdown, *Corporation Plate of City of St Albans*. 1949.

Insignia and Plate of the City of Westminster. Cambridge University Press, 1931.

C.C. Oman, 'The Plate of Guildford'. *Apollo*, September 1948.

Corporation Plate Exhibition. Goldsmiths' Hall, August 1952.

G.B. Hughes, 'The Story of English Maces'. *Country Life*, August 8th, 1952.

A.G. Grimwade, 'Shrewsbury and Boston Plate'. *Apollo*, October 1951.

Ian Finlay, 'Scottish Ceremonial Plate'. *Apollo*, January 1956.

Leonard Willoughby, 'Norwich Corporation Plate'. *Connoisseur*, vol. XVII, p. 183.

Leonard Willoughby, 'Chester Corporation Plate'. *Connoisseur*, vol. XVII, p. 183.

Leonard Willoughby, 'The City of Bath'. *Con- noisseur*, vol. XX, p. 23.

Leonard Willoughby, 'The City of Hereford'. *Connoisseur*, vol. XXII, p. 15.

Leonard Willoughby, 'The City and County of Bristol'. *Connoisseur*, vol. XXIII, p. 71 and p. 147.

Leonard Willoughby, 'The City and County of York'. *Connoisseur*, vol. XXIV, p. 3 and p. 137.

Leonard Willoughby, 'The Town of Portsmouth'. *Connoisseur*, vol. XXV, p. 131 and vol. XXVIII, p. 15.

Leonard Willoughby, 'The City of Liverpool'. *Con- noisseur*, vol. XXVII, p. 79 and vol. XXXIV, p. 39.

Anon., 'The Silver Plate of the City of Hull'. *Con- noisseur*, vol. XXXVIII, p. 77.

G.C. MacLean, 'The Mansion House Plate'. *Con- noisseur*, vol. XXXIV, p. 139.

See also Oyster Gauge; Theatre Ticket; Tipstaff.

Counter and Score Boxes

From the 16th century there survive, though rarely earlier than 1650, a surprising number of small, cylindrical boxes with cap covers, some having pierced sides and sometimes similarly pierced ends; in a number of cases these still contain up to as many as thirty thin silver discs, often finely stamped with the portraits of the Kings and Queens of England (sometimes duplicated). One in the Victoria and Albert Museum is contemporary with the thirty-nine Elizabethan sixpences it contains. Their survival is not surprising when one considers the almost universal interest in games of chance. Much rarer is a circular score box, in this case the work of Samuel Pemberton, probably intended for pool or whist, and made in 1799. The top is

148 Corporation Maces

a. A German steel fighting mace.
Dating from the 15th century.
b. Parcel-gilt.
Unmarked, dating from the late
15th century.
Length 16¼ in. (41·3 cm.).
Southampton Corporation.
c. The Wilton Mace.
Maker's mark, IG, but signed 'Ri
Grafton fecit'.
Inscribed with the date 1639.
Length 24½ in. (62·3 cm.).
Wilton Corporation.
The arches with orb and cross
are later additions.

149 The Morpeth Mace

Parcel-gilt.
Unmarked but inscribed with the
date 1604.
Length 26½ in. (67·3 cm.).
Morpeth Corporation.

150 Corporation Maces

a. A Commonwealth mace.
Silver-gilt.
Maker's mark of Tobias Coleman.
Hall-mark for 1652 (altered in 1660).
Length 41 in. (104·1 cm.).
Marlborough Corporation.
Inscribed 'the freedom of England
by God's blessing restored'.
b. One of a pair.
Unmarked, c. 1680.
Length 44½ in. (113·1 cm.).
Newcastle-under-Lyme Corporation.
On the tail, the badge of the town
and the crest and Arms of the donor,
William Leveson Gower of Trentham.

151 The Albrighton Mace

(Detail of the head.)
Unmarked, c. 1660.
Length 30½ in. (77·5 cm.).
Albrighton Corporation.

152 Oar Mace

Parcel-gilt.
Maker's mark of Edward Aldridge.
Hall-mark for 1748.
Rochester Corporation.
The Mayor of Rochester holds the
title of Admiral of the Medway,
of which this oar is the symbol.

148

149

a

b

150

151

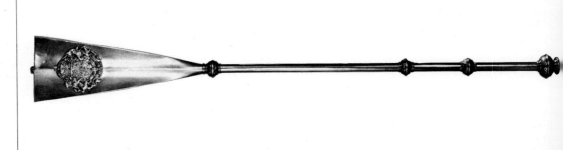

152

ngraved with the numbers up to ten and has a moveable pointer. Some $1\frac{1}{8}$ in. (2·9 cm.) in diameter, it was probably intended to contain ounters also (Birmingham Assay Office Museum).

ibliography
'oyle's Games Improved. London, 1790.

ourtauld Family

he Courtaulds are one of several Huguenot amilies whose first few generations became and emained silversmiths in the City of London during he 18th century.

Between the years 1687 and 1689 Augustin ourtauld the Elder arrived in London, eventually ecoming a cooper but apprenticing two of his ns, Augustin II and Peter, to Simon Pantin in 701 and 1705, respectively. Peter died in 1729, ut though he registered a mark, no surviving work y him is known to exist. Augustin II registered his ark in 1708 (a). The greater part of his work is ell designed, but unexceptional as compared to at of Paul de Lamerie (**104** and **162**). Augustin's terling mark (b) was entered in 1729 with another (c), of script form, in 1739. The tea table ated 1742, a fine example of an inkstand of 731 with bell and wax cylinder, both now in the remlin, and the table salt of 1730, which he preented to the Corporation of London in 1741, are erhaps the most unusual products of his workhop (**440**).

 a b c

His son, Samuel, was apprenticed to his father in 734, and continued to work for him once his pprenticeship was complete. Samuel did not, in ct, register his marks (d) and (e) until 1746, when e seems to have taken over his father's business,

 d e

emaining at the same premises (Chandos Street) ntil the latter's death in 1751. Understandably, amuel Courtauld was much influenced by the ococo style, none the less a number of finely proortioned, plain pieces came from his hand, among hem a most interesting inkstand with a sliding rawer beneath, now in the Farrer Collection, shmolean Museum, Oxford. Perhaps his finest vork, of which only a few pieces survive, is the oilet service made for a Russian client in 1763.

When Samuel died in 1765, his widow, Louisa erina Courtauld, registered her own mark (f), and n 1768 took George Cowles, soon to become her ephew, into partnership. Their joint mark (g) was sed while the partnership lasted until 1777 when owles was replaced by Louisa's son, Samuel ourtauld II. Mother and son registered a joint nark (h). This partnership only lasted three years nd in 1780 the family business came to an end.

 f g 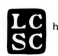 h

Whether the second Samuel was, in fact, trained s a goldsmith is a debatable question. Even as ate as 1940 it was mistakenly thought that a large umber of silver toys were the work of Augustine ourtauld; this was due to the misreading of the othic maker's mark of David Clayton.

ibliography
.A. Courtauld and E.A. Jones, Silver wrought by the Courtauld Family. 1940.
John Hayward, The Courtauld Silver.

Cox, James (d. 1788)

He was known to have been working as a clock- and automata-maker by 1760, when he established his business at 103 Shoe Lane, London. He held an exhibition of his work at Spring Gardens, and in 1772 and 1774 published catalogues of his automata. Much of his work went to the Oriental market, principally to China. Indeed, there was a Cox Museum at Zehol. However, his principal claim to fame is that he was the first to employ the principle of a change in atmospheric pressure or temperature to provide the motive force for a clock mechanism. Between the years 1783 and 1787 Messrs Jaquet Droz et Leschot of Geneva supplied striking watches to J. Cox & Son at Canton. After Cox's death in 1788, his son continued the business, but appears to have gone bankrupt and the firm was reconstituted as Cox & Beale. Again in 1792 it failed leaving debts of £4,570, probably because by this time, although they had acquired a reputation for supplying their Chinese clients with goods at very high prices, they could seldom undertake and guarantee their repair. From the hand of James Cox himself, are found a number of superb gold cage-work étuis and other luxury 'toys', such as the telescope, which, when extended, is 14 in. (35·6 cm.) long, with a watch at one end, now in the Rolex Collection, Geneva. It would not be surprising to find some connection between G.M. Moser, the chaser, and James Cox. See also Moser, George Michael.

Cream Boat

Cream boats are identical in every detail, but for size, to sauce boats. They became highly fashionable, in particular during the reign of George II. They declined in popularity, however, later in the century, though a pair dated 1797 has been noted bearing a contemporary inscription linking them to a coffee house, from this it may reasonably be assumed that they were intended to hold cream. Initially, during the latter part of the 18th century, they are marked beneath the body and after that period, beneath the lip. Examples marked beside the handle are suspect as being converted from pap boats by the addition of a handle and feet.

Bibliography
G.B. Hughes, 'Georgian Milk and Cream Jugs'. Apollo, June 1956.
See also Pap Boat.

Cream Jug

Although it is recorded that the Chinese took warm milk with their tea, in the 1650s, it does not appear that this was the custom in Europe for some time yet. No earlier examples of 'milk potts' than the reign of Queen Anne (1702–14) are recorded (**153**), and the taking of *cream* with tea was apparently regarded by some as a novelty, even as late as 1780. As a number of early services include a small jug, it would seem that this was for milk and when used for cream it was with dessert rather than tea. Small pieces are often an excuse for delightful flights of fancy on the part of their makers and this is more than usually so of cream jugs. Their variety is infinite. Generally speaking, however, a covered jug was designed for hot milk. The earliest cream jugs, were plain, pear-shaped, and sometimes octagonal, usually on a rim foot, but increasingly frequently on three hoof or scroll feet, especially from 1735 onwards (**156b** and **154b**). An ovoid variety of c. 1720, also popular in Scotland, on three scroll feet is the last of the 'milk potts' and at this date the helmet shape, common to the larger varieties of jug, appears (**155c**). This, with its broad lip, is eminently suited to the slow pouring necessary with cream. At first cream jugs were generally cast, and examples such as the one formed as a nautilus shell on a crouching dragon base (**154c**), opened the doors for a wonderful variety of cast, applied and chased forms. In Ireland, where chasing was always greatly favoured, the most usual form was a simple helmet-shaped body on three lion's mask and paw feet. This allowed the chaser vast scope (**154**, **155**, **156**, **157**, **158** and **159**). Examples with covered lip spouts are rare and were probably intended for use with a cover. That by Adrian Bancker, New York, c. 1740, now in the Metropolitan Museum of Art, New York, may, however, never have possessed a cover.

Bibliography
G.B. Hughes, 'Georgian Milk and Cream Jugs'. Apollo, June 1956.
C.C. Oman, 'English Silver Milk Jugs in the 18th Century'. Apollo, July 1931.
G. Norman-Wilcox, English Silver Cream-jugs of the 18th century. Munro Collection, 1952.
G.B. Hughes, 'Georgian Silver Milk Jugs'. Country Life, September 15th, 1955.
See also Hot-milk Jug or Pot.

Cream Jug, Cow

Originally a Dutch inspiration, most, if not all, known English examples are by John Schuppe, who entered his mark in 1753, and may well have been a Dutchman himself (**160**). His mark is rarely found on any other piece, though a taperstick and one or two other pieces made by him are known to exist, including a pair of small shell-like bowls, each on three escallop feet.

Bibliography
C.C. Oman, 'English Silver Cow Milk Jugs'. Apollo, vol. xv, p. 42.
G.B. Hughes, 'Silver Cow Milk-jugs'. Country Life, January 7th, 1954.

Cream Pail

The cream pail, which was formed as a hooped bucket with a swing handle, first appears about 1730, frequently bearing the mark of Aymé Videau. Early examples have vertical sides, later the sides taper and the handles may be pierced. By 1770 they give way to the all-pervading urn- or vase-shaped pail, sometimes pierced and with a glass liner. On close examination, early examples are often found to be matted between the hooped bands. George Washington recorded in 1784 the prices of plated examples to be had from Birmingham and Sheffield: 'Cream-pails & Basons, various patterns. Cream-pails 16/– Basons 18/–'.

Cream Skimmer

As with so' many culinary utensils, examples in silver are not unknown. Cream skimmers are usually circular, slightly concave sheets of silver, sometimes pierced on one side, and found dating from the 1750s. The handle may be of ring form on the larger examples, but more usually it is a turned, wooden baluster, fitting into a socket. In Scotland, with occasional English examples, a sickle-shaped variety appears in the late 18th century. These are not crumb scoops. Amongst the plate acquired by the 1st Earl of Bristol from the estate of his uncle, Baptist May, was '1 skimmer' (Diary, May 7th, 1697). A fine example of the larger disc form was made by John Emes in 1797, 10 in. (25·4 cm.) in diameter. In the collection of the Duke of Devonshire are a skimmer and a ladle made by Eliza Godfrey in 1748, both engraved 'Confectioner'.

153　Cream Jug
Gold.
Maker's mark of David Willaume.
Hall-mark for 1705.
Height 3½ in. (8·9 cm.).

154　Cream Jugs
a. Maker's mark of John Garner.
Hall-mark for 1739.
Height 3½ in. (8·9 cm.).
b. A nine-sided jug.
Maker's mark of Edith Fletcher.
Hall-mark for 1729.
Height 3⅛ in. (8·0 cm.).
c. A shell-shaped jug.
Unmarked, c. 1725.
Height 3½ in. (8·9 cm.).

155　Cream Jugs
a. Maker's mark of Paul de Lamerie.
Hall-mark for 1731.
b. Hall-mark for 1790, Dublin.
National Museum of Ireland.
c. Unmarked, c. 1730.

156　Cream Jugs
a. Maker's mark of Paul de Lamerie.
Hall-mark for 1742.
b. Maker's mark of William Fleming.
Hall-mark for 1742, London.
c. Silver-gilt.
Marker's mark of Peter Archambo.
Hall-mark for 1733.

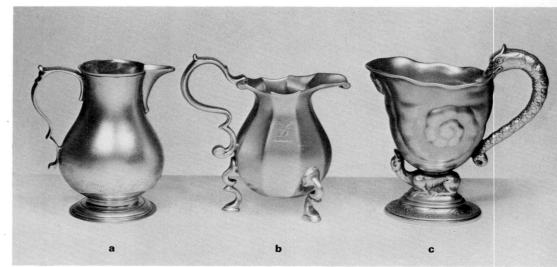

a　　　　　b　　　　　c

154

a　　　　　b　　　　　c

155

153

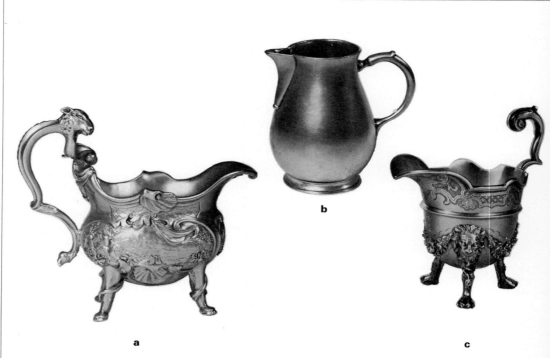

a　　　　　b　　　　　c

156

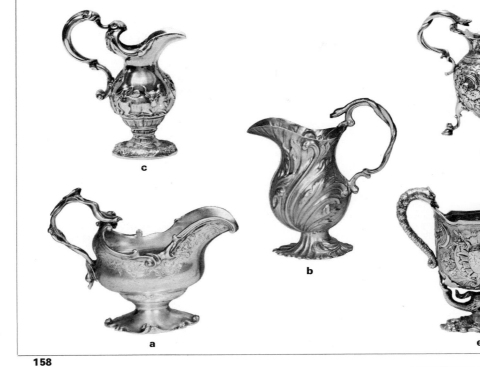

158

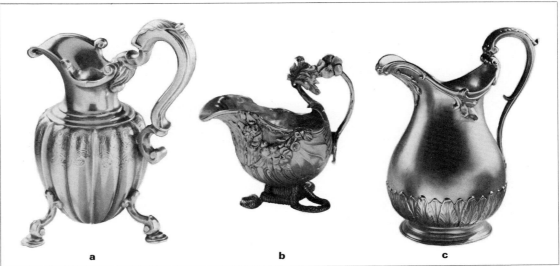

159

157 b

157 a

160

Crest

Heraldic badge originally worn on the helmet as identification when the visor was closed. Often engraved on small silver objects when space or cost prevented the use of a full coat of arms.

Cresting

A medieval ornament, usually foliate and regular, placed along the top of horizontal surfaces.

Crocket

A medieval ornament, like cresting, along the steep, sloping surfaces of pinnacles and finials.

Cross

During the Middle Ages, enormous numbers of crosses both pectoral (for suspension round the neck) and rosary, must have been made in both silver and gold. Of these, 18th-century examples, both from Ireland and Canada, are extant. Few, if any, of undoubted English provenance have survived. The same must also apply, to a lesser extent, to processional crosses for which base metal was often used. One of these, though of a later era, was made for Catherine of Braganza, Queen of Charles II: it is dated 1664 (Palacis das Necessidades, Lisbon). A Canadian specimen, made by Pierre Latour, dated c. 1790, is amongst the Henry Birks Collection. So far as is known, no altar cross was made between the accession of Elizabeth I and the death of George IV, except for use in Recusant chapels, and surprisingly none of these latter appear to have survived. The cross present on the altar at the Coronation of Charles I (1625) was later claimed to have been a part of the Coronation Regalia.

Bibliography
C.C. Oman, *English Church Plate*. Oxford University Press, 1957.
J.E. Langdon, *Canadian Silversmiths, 1700–1900*. Toronto, 1966.
See also Dish Cross; Rosary.

Crozier

From the word *croce* meaning 'crook'. Other than the St Kieran Crozier dated c. 1150, and two other Irish examples of similar date and form, very few of the great pieces of British Church plate of the Middle Ages have survived the ravages of time, royal rapacity and the pendulum of fashion. Doubtless many croziers (pastoral crooks) have been consigned to the melting-pot together with reliquary chasses, morses and those many other splendid adjuncts of the Roman Catholic Church. One magnificent silver-gilt crozier to survive is that given by Bishop Fox to the College he founded, Corpus Christi College, Oxford. It is $71\frac{1}{4}$ in. (181·0 cm.) long and dates from between the years 1487 and 1501 (Colour Plate **15**). Another, even finer, is that of William of Wykeham, Bishop of Winchester, at New College, Oxford (Colour Plate **14**). New College also preserves his mitre. The crozier made for Limerick in 1418, at the instigation of Bishop Conor O'Dea, is also associated with a mitre of the same year made by Thomas O'Carryd. The mitre and parcel-gilt crozier of Bishop Wren (**161**) are also extant, dating from c. 1660 they were probably made for the funeral rites of Matthew Wren, Bishop of Ely, who died in 1667 (Pembroke College, Cambridge).

Bibliography
J.T. Fowler, 'On the use of the terms Crozier, Pastoral Staff and Cross'. *Archaeologia*, vol. LII.
John Hunt, 'The Limerick Mitre and Cross'. *Archaeologia*, vol. LX, p. 465.
See also Mitre.

Cruet

These may be of several forms. Those designed for two bottles only are oil and vinegar frames, and derive from ecclesiastical plate. The article for which the name 'cruet' is generally applied, is fitted with two silver-mounted glass bottles or ewers and three silver casters. The Warwick Cruet of 1715, though it has five silver casters, was long thought to be the earliest prototype of the cruet (Earl of Warwick's Collection). However, earlier specimens of c. 1707 are known. The frame of the early cruet is usually cinquefoil in plan, though examples from Dublin tend to deviate from this pattern, especially with regard to the differing levels of the base plate (**162**). The retaining frame proper is of moulded wirework and has a central handle in all but a few very early examples. There is usually a cartouche to one side. A rare variation, of superb quality, perhaps originally part of a surtout de table, is the frame for three casters only made by Lamerie in 1735, in the Farrer Collection, Ashmolean Museum, Oxford (**102**). Provincial examples, such as the one made by William Beilby of Newcastle in 1743, now in the Art Institute of Chicago, or that by Coline Allan of Aberdeen, c. 1740, are rare. The pair of enormous cruets, formerly the property of the Grocers' Company, are remarkable, not only for their size—$18\frac{1}{4}$ in. (46·4 cm.) high—but also for the fact that the vase-shaped casters are still composed entirely of silver, because during the period in which they were made (by Robert Piercey in 1782) it had become fashionable to have the casters as well as the oil and vinegar bottles made of cut-glass. The pierced, domed covers were, naturally, still of silver. Very often the frame was of a circular gallery type, finely pierced with a decorative rim. By the end of the century, the boat shape, common to so many silver designs, was not unusual (**163**). Some of the finest of this form are by Parker & Wakelin and John Schofield (**388**). Of the latter's work the cruet made in 1789, amongst the C.D. Rotch Bequest to the Victoria and Albert Museum, is one of the finest to be found. An undated frame design for a cruet of this type, together with a plan, is annotated with the contents of the bottles and vases: 'Oil, Soy, Mustard, Lemon, Vinegar, Ketchup, Pepper and Cayan'. By 1800, the oval cruet frame, now with any number of smaller additional bottles and vases, served to combine the original cruet frame with the more recently introduced soy-frame. At least one pair of the latter survive, with escallop-shell bases and dolphin handles made by Wakelin & Taylor in 1787. During the second quarter of the 18th century, almost 70 per cent of these 'Warwick Cruets' bear the mark of Samuel Wood. In general, the 19th century saw a gradual reduction in size of the cruet frame (**164**). An interesting, modern, full-sized cruet frame made by Leslie Durbin in 1940, was exhibited at Goldsmiths' Hall in 1951.

See also Altar Cruet; Epergne; Mustard Pot; Oil and Vinegar Frame; Warwick Cruet; Soy-frame.

Cucumber Slice

A flat, rectangle of ivory with a handle at one end and a diagonal opening occupied by a silver blade in the centre. First appearing in the 1770s, they were made spasmodically throughout the 19th century. Wakelin invoiced Lord Waldegrave in 1771 'to mending a cucumber slice'.

Cup See also Beaker; Tumbler Cup.

Cup Bearer

One of the great Offices of State in medieval times, and one which often became hereditary to one family. The Cup Bearer was not necessarily also the taster to the sovereign. A portrait, now in the National Gallery of Scotland, of Sir David Murray, 1st Viscount Stormont, Cup Bearer to James VI of Scotland and I of England (**165**), is particularly interesting as it shows an almost identical cup to an unmarked example, now in the Victoria and Albert Museum, which is engraved inside the bottom of the bowl. This cup is, of course, earlier in type than the date of the painting, which encourages the supposition that it is an accurate representation of the one used by Stormont.

Cup, Bridal

Prior to the Reformation it was the custom to give to the bride and groom immediately following the marriage ceremony a cup or mazer of wine in which small cakes had been soaked. A number of churches kept a special cup for this purpose.

Cup, Caudle

It seems to be generally accepted that this description should apply to a two-handled cup of baluster (shaped) form, with or without cover. The most common examples were made between 1650 and 1690 (one such example of 1646 appeared in 1961), with occasional later survivals, especially of a larger size (**169** and **171**). As, however, caudle, a broth, was generally administered to women after childbirth or to convalescents, the caudle cup proper must be of relatively small size (**167**); its successor, the porringer, was larger, but was probably used for the same purpose. The spout cup, which may be of either form, though usually the latter but with the addition of a spout, was devised to aid the drinking of any liquid on whose surface some of the ingredients were likely to float. John Hervey, 1st Earl of Bristol, records his purchase of December 7th, 1697 of 'a chafin dish with a cawdle heater'. One of the finest two-handled cups and covers of this form is gilt, twelve-sided and dated from 1652. This has a 'skirt' foot, whereas smaller examples are generally footless. At this early date one occasionally finds a spire-like finial to the cover as on standing cups of the period. An extremely rare type, half caudle cup, half porringer, once in the W.R. Hearst Collection, is of compressed spherical and almost lobate form, and retains its original stand of tazza form. Such stands were usual with pieces of any importance (**168**). Another caudle cup of normal outline, also with its stand, was presented to Ionas Shish, the King's Master Shipwright on the occasion of the launching of the 'Royall Charles' in 1668. John Evelyn records his favourable opinion of Shish in his diary on March 3rd, 1668. One very rare variant on this theme is illustrated on Plate **170**. A second, can best be described as having a 'dropped bottom' and resting on three goose feet, the cover decorated with a goose finial: this is hall-marked 1672 and is in a private collection. One of the earliest surviving race cups is a small caudle cup won at Asby Maske in 1669, it was made by William Robinson of Newcastle. Even in the 18th century, cups and tankards of considerable size were still supplied with stands as prizes at all manner of competitions. Lesser examples of caudle cups had covers reversible to form stands, having spool-shaped finials or, less often, three outward-turned scrolls. This latter is however, more usually found on a porringer (**166**).

See also Caudle; Porringer.

Cup, Chocolate

Usually of Chinese porcelain during the late 17th and early 18th centuries. A set of six silver-gilt saucers and their retaining frames made by Isaac Liger in 1713, survive and are engraved 'Theas si

162

**1 Bishop Wren's Crozier
and Mitre**
Crozier: parcel-gilt.
Unmarked, *c.* 1660.
Length 5 ft. 10¼ in. (178·6 cm.).
Mitre: unmarked, *c.* 1660.
Height 11¾ in. (29·9 cm.).
Pembroke College, Cambridge.

162 Cruet
Maker's mark of Augustin Courtauld.
Hall-mark for 1725.
Frame: width 8½ in. (21·6 cm.) at the
back; 5 in. (12·7 cm.) at the
front.
Large caster: height 7 in. (17·8 cm.).
Small caster: height 5¼ in. (13·4 cm.).

163 Cruet
Glass bottles with silver mounts.
Maker's mark of Paul Storr.
Hall-mark for 1803.

164 Cruet
A stand with mustard and ginger
jars.
Maker's mark of Rebecca Emes &
Edward Barnard.
Hall-mark for 1809, London.
Tray: length 8 in. (20·4 cm.).
Jars: height 3¾ in. (9·6 cm.).
Art Institute of Chicago.

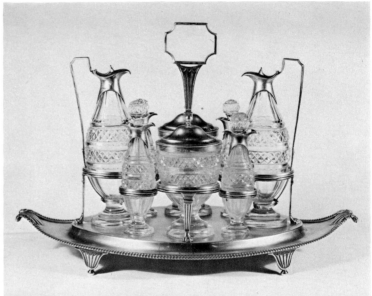

163

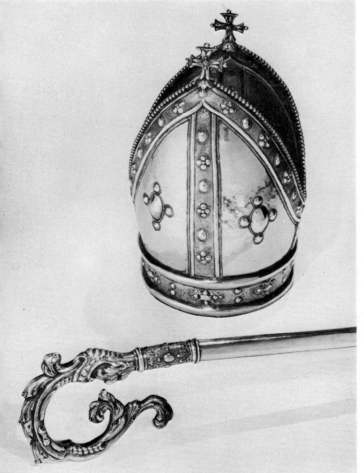

161

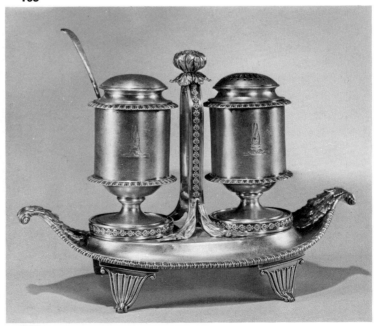

164

165 Portrait of a Cup Bearer
Portrait of Sir David Murray, 1st
Viscount Stormont (d. 1631).
Artist unknown.
26½ in. × 22 in. (67·3 cm. × 55·9 cm.).
National Gallery of Scotland.
Murray was cup bearer to James VI
of Scotland. Note the finger lost in
an affray in 1588. There is an
almost identical cup in the Victoria
and Albert Museum, unmarked but
engraved with the initials IC and
MN.

166 Caudle Cup and Cover
c. 1660.
Engraved with the Arms of Walpole.

167 Caudle Cup
Maker's mark, HN with a bird and
a branch below.
Hall-mark for 1661.
Height 2⅛ in. (5·5 cm.).

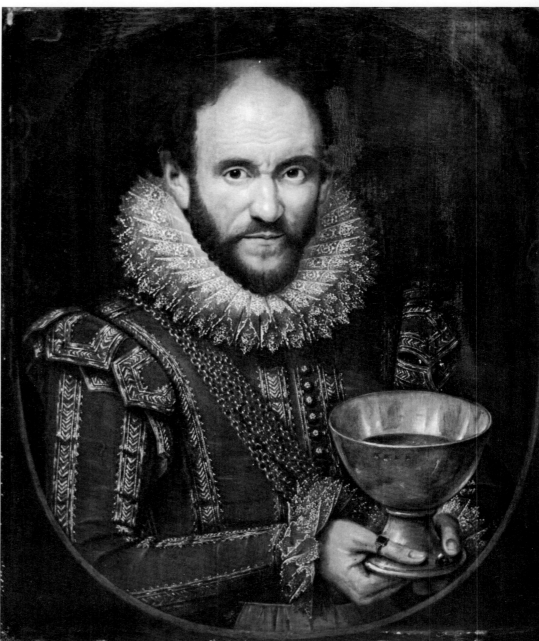

165

166

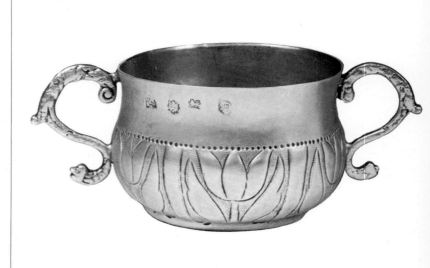

167

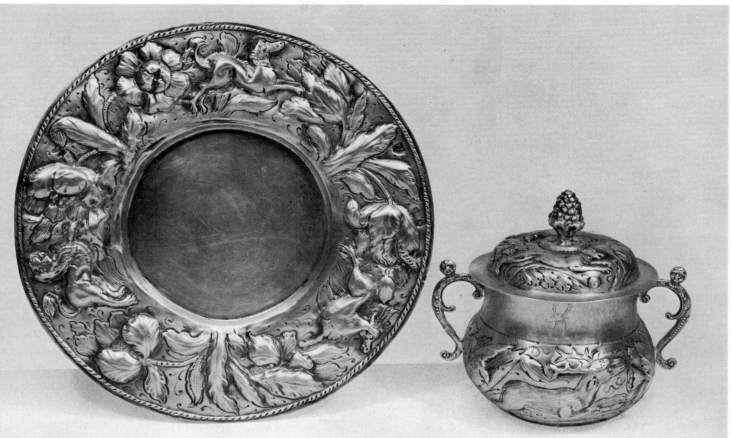

168

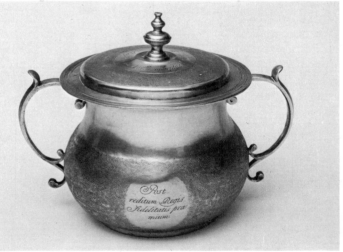

169

**168 Caudle Cup,
Cover and Stand**
Maker's mark, B D.
Hall-mark for 1669.
169 Caudle Cup and Cover
Silver-gilt.
Maker's mark, TH in monogram.
Hall-mark for 1670.
Inscribed with sentiments regarding
the Restoration of Charles II.
170 Caudle Cup and Cover
Maker's mark, WH.
Hall-mark for 1673.
Height 9 in. (22·9 cm.).
171 Caudle Cup and Cover
Maker's mark of Timothy Blackwood.
Hall-mark for 1679, Dublin.
Height 9 in. (22·9 cm.).
The base is chased with an
expanded rose.

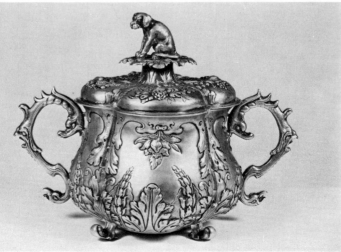

170 **171**

frames, six silver saucers and six Cheany [Chinese] Chocolet cups was given me . . . November 1713'. The advent of European porcelain cups and saucers rendered this form in silver archaic by 1735. A set of four silver-gilt trembleuses (stands for chocolate or tea cups) were made for Peter Burrell by Augustin Courtauld in 1728. Could these be the very same that Messrs Wakelin charged for in July 1775: 'Peter Burrell Esq. to mending a Chocolate frame very much broke 4/–'? A picture by J.E. Liotard, dated 1745, and entitled *The Chocolate Maid* actually shows a trembleuse in use. A pair of gold chocolate cups of almost inverted-bell form were made from a collection of mourning rings by John Chartier in about 1700; one engraved 'Mortvis Libamur', the other 'Manibus Sacrum', and they have been known as such from the early 18th century. A larger gold cup, engraved with chinoiserie decoration, was made by Ralph Leek, c. 1685, and is in the collection of the Earl of Derby. It may have been intended for chocolate; it also has a cover reversible to form a saucer.

Bibliography
E.A. Jones, *Old English Gold Plate*. 1907.
S.A. Courtauld and E.A. Jones, *Silver wrought by the Courtauld Family*. 1940.
A.G. Grimwade, 'A New List of Old English Gold Plate'. *Connoisseur*, May, August and October 1951.
G. Schiedlavsky, *Tee-Kaffe, Schokelade*. Munich, 1961.
See also Tea Cup and Stand or Saucer.

Cup, Custard

From the 17th century onwards, a number of small, single-handled cups have survived, two with covers made in Dublin, c. 1695, were in the Mango Collection (*Connoisseur*, vol. LVIII). Some may have belonged to toilet or travelling services. The custard cup in silver is extremely rare. Far more common is their survival in glass. A silver-gilt pair of stands, each fitted with such cups is in the Royal Collection, made by Phillip Rundell in 1821, and each cup having a detachable liner and spoon. See also Cup, Thistle.

Cup, Dram See Stirrup Cup.

Cup, Julep

A description often applied to a small, cylindrical beaker if of American origin. Better known as a 'dram' or 'stirrup' cup.
See also Beaker.

Cup, Ox-eye

Generally plain, with two circular handles, these are also known as 'tuns' at Magdalen College, Oxford, and 'plates' at the Queen's College, Oxford. A pair made in 1698, of elongated form, now at Eton College, are known as 'strangers cups', being used to regale guests and visitors. The earliest known ox-eye cup is dated 1616. It belongs to the Mercers' Company, having been originally given to Trinity Hospital, Greenwich, by Thomas, Earl of Arundel, the 'Great Collector' (Fig. **XXa**). The Clothworkers' Company possesses an ox-eye cup of 1657, and the Raynsford Cup at Lincoln's Inn, dated 1677, is also of this form. Surprisingly, the Cambridge colleges possess none. At Balliol, Oxford, the records of 1642 reveal that they were also known as 'Zegadine' cups. The largest set, made in 1677, consists of eleven such cups, originally twelve, belonging to the Queen's College, Oxford. Possibly the only other 17th-century set of cups—although of quite different form—is that comprising seven (once eight) small, two-handled cups of

about 1657, the maker's mark, hound sejant. They are amongst the plate at Winchester College, and are only 3¾ in. (9·6 cm.) in diameter. Of much later date were the set of twelve two-handled cups and covers made by Nicholas Clausen, 1719, to the order of King George I, now scattered amongst various collections, including that of Her Majesty the Queen. There are three other ox-eye cups amongst the plate at Merton College, Oxford, and this by no means completes the list, to which may be added a silver-mounted coconut of this form, made during the early 17th century.

Light though they would be, one must conclude that it is this form of cup which is referred to in the following order, in an undated letter of c. 1550, and not the shallow, two-eared saucers commonly found during the reign of Charles I: 'Sir, I must . . . desire you to cause to be made for a friend of mine twelve drinking pots of silver, each of 6 ounces weight, and twelve round trenchers of silver, also of 6 ounces the piece; all of which I pray you let be well and clean wrought, and of the best fashion. The pots would be with two ears each pot, and without cover, fashioned as ye know our English beer and ale pots be'. (*Tudor Family Portrait*, by Barbara Winchester, pp. 146–7.)

Bibliography
E.A. Jones, *The Plate of the Queen's College, Oxford*. 1938.
E.A. Jones, *The Plate of Merton College, Oxford*. 1938.

Cup, Spout See Spout Cup.

Cup, Standing (and Cover)

Basically only two forms of medieval ceremonial standing cup are known. This statement cannot unfortunately be based on proven knowledge, but is governed rather by the small number of actual survivors. The so-called 'King John Cup' at King's Lynn is the earliest (1350) and remarkable for its weight, enamelled decoration and quality (Colour Plate **22**). The bowl may be described as of inverted-bell shape, as are the Anathema Cup of 1481 at Pembroke College, Cambridge, and the Richmond Cup of the Armourers' and Braziers' Company (**173**). Also of this form are the Warden's Grace Cup at New College, Oxford, and a particularly early example, similarly unmarked, in the Birmingham City Art Gallery. The Chinese porcelain stem cup of the 15th century may also have some unrecorded influence on this form of standing cup. However, the Foundress's Cup of Christ's College, Cambridge, dated c. 1440, is of somewhat different form, though closely related to those of Marston Church, Oxford, made c. 1450 (Fig. **XIX**); the standing cup of Lacock, Wiltshire (**172**); another at the Museum of Fine Arts, Boston; the magnificent cup of 1449, the gift of Sir Thomas Leigh to the Mercers' Company (Colour Plate **25**) and the Kimpton Bowl at the Victoria and Albert Museum. All the standing cups described above, fall into the category of the bell-shaped form.

The second type of standing cup is best described as having a font-shaped bowl, probably derived from a mazer and surviving examples date from the first quarter of the 16th century. Corpus Christi College, Oxford, has a particularly fine example of 1515 (**175**), though the plain lines of the Cressener Cup (1503) belonging to the Goldsmiths' Company, demonstrates that the taste of the day was by no means always for highly embossed work. The Campion Cup of 1500 in the Victoria and Albert Museum is the earliest known marked example to survive. The number of font cups engraved in English or Latin, with inscriptions such as 'Gyre

God Thakes for all' (1511, at Deane, Hampshi or 'Soli Deo Honor et Gloria' on the Campion C with its extraordinary, heavy gauge walls to bowl, and the Wymeswold Cup of 1512, enco ages the belief that the larger examples may ha been originally designed for use as grace cu (See Tazza.) Another is engraved 'This is the Co mvnion Covp'. The Charlecote Cup of 1524 o came to public notice in 1945 (**174**), whilst Welford Cup (Northamptonshire) of 1518 v excavated, while digging a fence-post hole, recently as January 1968. What is perhaps earliest surviving piece of Exeter plate made Richard Hilliard, c. 1560, is also of this form.

Also under this heading come the silver-mount coconut cups, which were an extremely popu form throughout this period. By 1525, Rena sance forms and decoration began to appe though the font cup survived as a suitable fo for presentation to conservative bodies such corporations, colleges and guilds (**177**). T Boleyn Cup of 1535 at Cirencester (**176**) may cited as a new form in England, though w reservation as to certain features. Another Co tinental introduction, probably German, was thistle-shaped bowl generally on a bracket baluster stem (**178** and **184**). The great Bow Cup of 1554 belonging to the Goldsmiths' Co pany is also of this form. During the latter part the century, a shallow 'champagne goblet' fo appeared. An extremely rare Scottish example silver-gilt with rock-crystal stem is the Methu Cup of the mid 16th century, now in the L Angeles County Museum (Colour Plate **2** Larger examples have a cover, such as the Hutt Cup, 1589 (**183**) and one made in 1568, now Kenilworth Church, once the property of Rob Dudley, Earl of Leicester. One of the largest is Vice-Chancellor's Cup of Cambridge Univers made in 1592, 17½ in. (44·5 cm.) in height. (S Tazza.) A rarer type has a deep, egg-shaped bo and these were usually provided with a co (**182**). Other forms are gourd cups (**181**) which only ten are known to survive, the Be Cup of 1570 being one of the finest, now in t Jackson Collection (National Museum of Wales melon cups—there is one dated 1563 in the In Temple (**179**)—and acorn-shaped cups. Of t last form are the Westbury Cup (1585) in Museum of Fine Arts, Boston, and the unmark gold example of c. 1610 from Stapleford, Leicest shire, now in the British Museum (Colour Pl **1**). At this time there also appear cups of mount ostrich eggs and shells (**180**). (See Mounte pieces.) During the 1590s the steeple cup makes appearance together with a group of piec executed with applied foliate wirework. Two these cups have a maker's mark, TYL, both a dated 1611 and another is unmarked (**187** a **188**).

During the middle years of the 17th centu there appears a plainer form with a cylindrical bov often matted and with a baluster stem (**190**) a occasionally an attempt at a new style (**189**). Aft the Restoration, a number of standing cups we made, but the fashion was fast changing to th two-handled variety. However, the Royal Oak C of 1676 belonging to the Barber-Surgeor Company (**191**), some few others decorated wi chinoiserie engraving, or gadrooning (**192**), we made during this period. The cup and cover mac by Thomas Bolton of Dublin in 1695 for prese tation by Sir Joseph Williamson to Dublin Co poration is no less than 28½ in. (72·4 cm.) height. The famous gold cup by Anthony Nelme 1729 perpetuates the form of the standing cup in

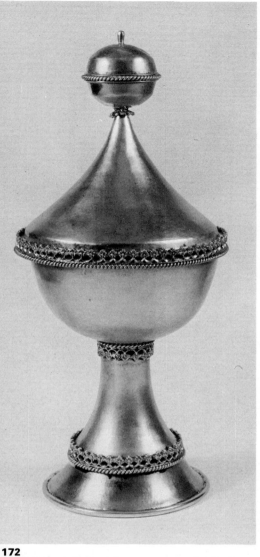

172

173

172 Standing Cup and Cover
Parcel-gilt.
Unmarked, *c*. 1450.
Height 13¾ in. (35·0 cm.).
Lacock Church, Wiltshire.
The nearest parallel is the
Founder's Cup of Christ's College,
Cambridge, which can be dated
1440 by reason of the arms it bears.
173 The Richmond Cup
Silver-gilt standing cup and cover.
Maker's mark, a wreath.
Late 15th century.
Height 12½ in. (31·8 cm.).
Presented to the Armourers' and
Braziers' Company by John
Richmond, who was Master of the
Company from 1547–8.
174 The Charlecote Cup
Hall-mark for 1524.
A font-shaped cup.
175 Standing Cup and Cover
Maker's mark is illegible.
Hall-mark for 1515.
Height 7¾ in. (19·7 cm.).
Corpus Christi College, Oxford.

174

175

176 The Boleyn Cup
Silver-gilt standing cup and cover.
Maker's mark, a group of three
flowers.
Hall-mark for 1535.
Height 12⅜ in. (31·5 cm.).
Cirencester Church, Gloustershire.
The falcon badge is the particular
device of Queen Anne Boleyn.

177 Standing Cup
Maker's mark, M, probably the mark
of Thomas Matthew of Barnstaple.
c. 1550.
Height 7⅞ in. (20·0 cm.).
Poughill Church, Cornwall.
This cup once had a cover,
now lost.

178 Standing Cup and Cover
Maker's mark, R D in monogram,
probably the mark of Robert Danbe.
Hall-mark for 1553.
Height 12 in. (30·5 cm.).
The Armourers' and Braziers'
Company.

179 Standing Cup and Cover
Silver-gilt.
Maker's mark, HW with two pellets
in quatrefoil.
Hall-mark for 1563.
Height 10½ in. (26·7 cm.).
The Honourable Society of the
Inner Temple.
The marks, which are now
undecipherable, were recorded by
W.J. Cripps in 1878.

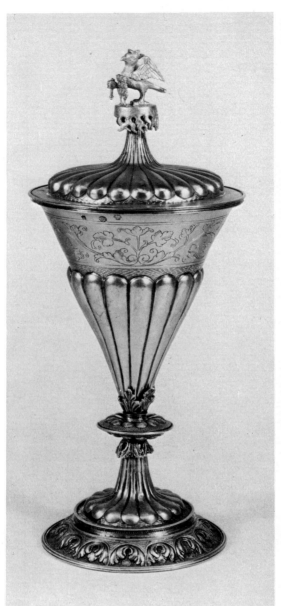

176

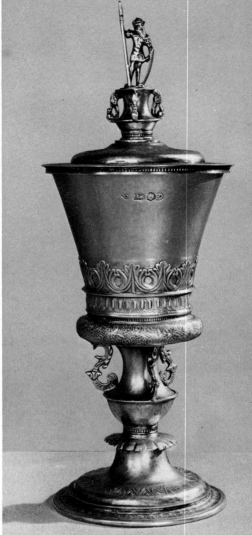

178

177

179

180

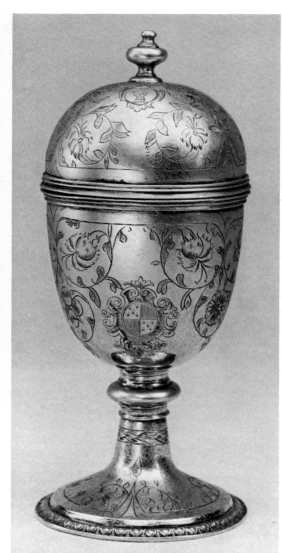

182

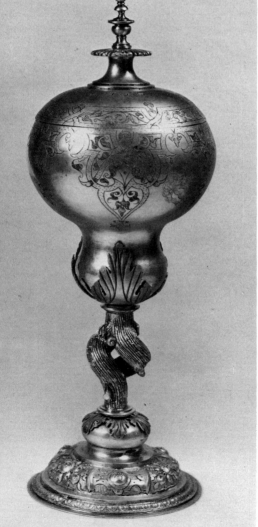

181

183

180 The Glynne Cup
Silver-gilt standing cup.
Hall-mark for 1579.
Victoria and Albert Museum.
Originally the body of this cup
was probably a nautilus shell.

181 The Wilbraham Cup
Silver-gilt standing cup and cover.
Maker's mark, SB.
Hall-mark for 1585.
Height 11½ in. (29·2 cm.).
Engraved with the Arms of
Wilbraham of Woodhey.

182 Standing Cup and Cover
Silver-gilt.
Maker's mark, a helm.
Hall-mark for 1585.
Height 6⅜ in. (16·2 cm.).
Assheton-Bennett Collection.
The Arms are possibly those
of Stanhope.

183 The Hutton Cup
Silver-gilt standing cup and cover.
Maker's mark, IS in monogram,
probably the mark of John Speilman
or Spilman.
Hall-mark for 1589.
Height 13⅜ in. (34·0 cm.).
Traditionally the gift of Queen
Elizabeth to Elizabeth Bowes on
the occasion of her wedding in
1592.

**184 The Great Seal
of Ireland Cup**
Silver-gilt standing cup and cover.
Maker's mark, HL conjoined and a
star below.
Hall-mark for 1592.
Height 19⅝ in. (49·9 cm.).

185 Standing Cup
Silver-gilt.
Maker's mark, RH, probably the
mark of Richard Hilliard of Exeter.
c. 1560.
Height 5 in. (12·7 cm.).
Birmingham City Art Gallery.
The centre is engraved with the
initials GD and a hart's head
between.

186 Standing Cup and Cover
Maker's mark, AB in monogram.
Hall-mark for 1611.

187 Standing Cup and Cover
Silver-gilt and rock-crystal.
Unmarked, *c.* 1610.
Height 11¼ in. (28·6 cm.).
Tong Parish Church, Shropshire.

188 Standing Cup and Cover
Silver-gilt.
Maker's mark, TYL.
Hall-mark for 1611.
Height 18⅝ in. (47·3 cm.).
Victoria and Albert Museum.

189 Standing Cup and Cover
Maker's mark, WW with a fleur-de-
lys below.
Hall-mark for 1666.
Height 9¾ in. (24·8 cm.).
Engraved with the Arms of Ley.

190 Standing Cup and Cover
Maker's mark, WH with a cherub's
head below.
Hall-mark for 1669.
Height 15¼ in. (38·8 cm.).
The Honourable Society of Gray's
Inn. Engraved with the
contemporary Arms of Pagitt and
Gray's Inn and an inscription
recording that the cup was a gift
of Justinian Pagitt.

191 The Royal Oak Cup
Parcel-gilt standing cup and cover.
Maker's mark, RM, probably the
mark of Richard Morrell.
Height 16½ in. (41·9 cm.).
The gift of Charles II to the
Barber-Surgeons' Company in 1676.

192 Standing Cup and Cover
Silver-gilt.
Maker's mark, WI with a mullet
below.
Hall-mark for 1686.
Height 20⅝ in. (52·4 cm.).
Engraved with the Arms of Savile.
The inscription records that this
cup was presented to Newark-on-
Trent by the Honourable Henry
Savile in 1687.

193 Standing Cup and Cover
Silver-gilt.
Maker's mark of Benjamin Pyne.
Hall-mark for 1705.
Height 22½ in. (57·2 cm.).
Surmounted by the crest and Arms
of the Pewterers' Company and
inscribed 'The guift of Mr. Samuell
Jackson Augt. ye 9th 1705'.

184

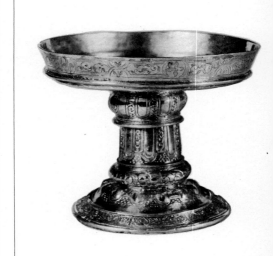

185

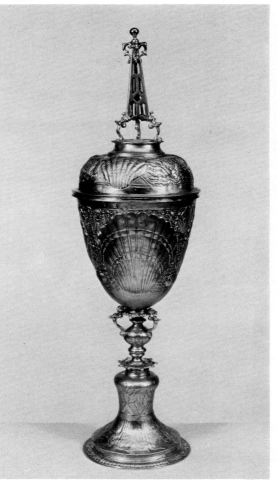

186

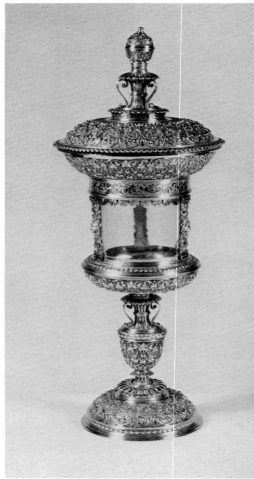

187

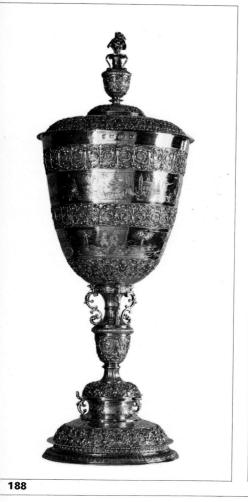

188

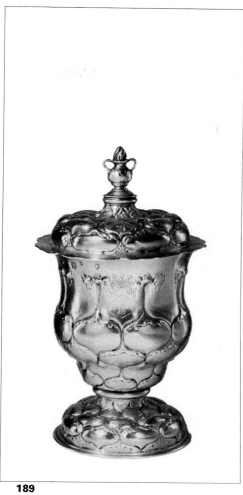

189

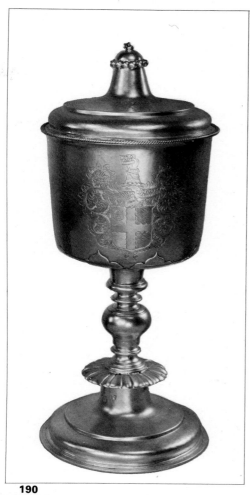

190

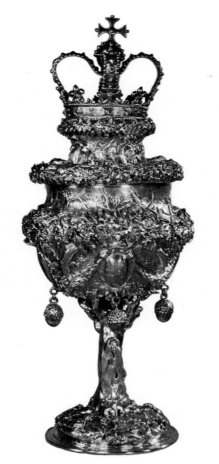

191

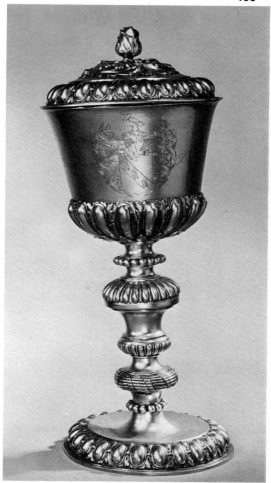

192

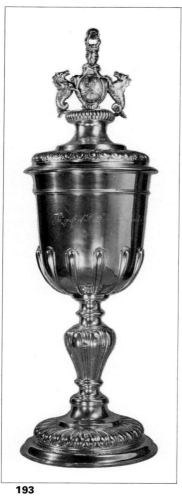

193

the 18th century, so do the Advice Cup made by Benjamin Pyne in 1705 and another by the same maker made in the same year for the Pewterers' Company (**193**).

Bibliography

N.M. Penzer, 'Howard Grace Cup and Early Date letter Cycles'. *Connoisseur*, vol cxvii, 1946. (Also a letter in reply in vol. cxviii from Commander G.E.P. How.)

N.M. Penzer, 'The King's Lynn Cup'. *Connoisseur*, vol. cxviii, 1946.

C.G.E. Blunt, 'An English Covered Cup of 1514'. *Connoisseur*, vol. cxviii, 1946.

Herbert Maryon, 'The King John Cup at King's Lynn'. *Connoisseur*, February 1953.

C.C. Oman, 'The Charlecote Cup'. *Apollo*, November 1945.

N.M. Penzer, 'Tudor "Font-shaped" Cups', parts I, II and III. *Apollo*, December 1957, February and March 1958.

N.M. Penzer, 'The Steeple Cup'. *Apollo*, April 1960.

See also Beaker; Cup Bearer; Mounted-pieces; Screw-thread; Tazza; Tumbler Cup.

Cup, Steeple

This type is distinguished by its egg-shaped bowl, trumpet foot and, above all, by the pierced three- or four-sided steeple as the finial to the cover. Often the finial is missing and frequently the entire cover has been lost. Of sixteen examples in the Kremlin, only four are complete. Frequently chased with strapwork and foliage, a number exhibit shells, dolphins and barrels. The earliest, of about one hundred and fifty so far recorded, was made in 1599. The steeple itself usually rises from bracket supports (**186**) and is often surmounted by a figure finial. Steeple cups continued to be made up to the time of the Civil War and could be anything up to three feet tall, that at St Ives, Cornwall, presented to the Borough in 1640 being no less than 33 in. (83·9 cm.) high. They appear to be a peculiarly English form of cup, and to mark the period when foreign influence on English silver was at its lowest ebb since the early 16th century. It should, however, be noted that this type of finial was used at an earlier date and in fact a gold steeple cup was presented to Elizabeth I in 1573 and another to James I in 1608 by the Inner and Middle Temple Societies. A gourd-shaped bowl and, very rarely, a globe-shaped bowl are also found to the steeple cup; of the latter, only eight are known. A very tall steeple-like cover survives into the first years of the reign of Charles II, soon developing into a concave cone. The cup made in 1604 from the Great Seal of Ireland of Queen Elizabeth I is of this form and a set of three (a pair and one larger) dated 1611 is in a private collection.

Bibliography

N.M. Penzer, 'The Steeple Cup', parts I, II, III, IV, V and VI. *Apollo*, December 1959, April, June, October and December 1960 and July 1964.

N.M. Penzer, 'The Pickering Cup', parts I and II. *Apollo*, February and March 1960.

N.M. Penzer, *An Index of English Silver Steeple Cups*. Society of Silver Collectors, 1965.

Cup, Stirrup See Stirrup Cup.

Cup, Tasting

'Cups of assay' were known in the Middle Ages, and these were important pieces of plate. Any standing cup and cover might be called a tasting cup. The small cups of baluster form with a scroll handle to one side, or stirrup cups, may also be known as such, for surely such is the function of any cup. Tasting cups have also been called tea cups, but this is rather less likely, at least until one is found with the original wickering, or some other insulation, to its handle.

Cup, Tea (and Stand)

See Tea Cup and Stand or Saucer.

Cup, Thistle

Perhaps the earliest cup having a thistle-shaped bowl is the Richmond Cup, the property of the Armourers' and Braziers' Company, London. Once dated *c.* 1500 its medieval form may possibly be a survival of a date as late as 1545 (**173**). Many variations on this theme commence in the 16th century and, though the bowl is generally of obvious thistle form (**178** and **184**), it is also probably correct to consider the great Bowes Cup (1554) of the Goldsmiths' Company as one of this type. During the later 17th century, however, a number of small mugs were made, principally in Scotland, usually having the lower part of the body decorated with applied flutes. One or two very heavy, plain examples of larger size were made in London. Many of the Scottish examples of the thistle cup are very small indeed and often bear only a maker's mark.

See also Cup, Chocolate; Cup, Custard; Mug.

Cup, Two-handled

Appearing during the 16th century and progressing through many different forms—ox-eye cup, caudle cup, porringer and the imposing two-handled cup and cover. The symbol of stability during the 18th century, the two-handled cup, usually with cover, reaches its largest size about 1775. From this date it declines both in size and importance, with but a brief revival in the shape of the Trafalgar Vase designed by John Flaxman and those awarded to naval commanders during the Napoleonic Wars. Two-handled coconut and serpentine cups with silver mounts are found intermittently throughout the period. By far the earliest two-handled cup known is that of 1533 at Corpus Christi College, Oxford. In form and decoration it is purely Renaissance. Another very similar cup at Corpus Christi College, Cambridge, dates from 1555, though it has a cover of 1531 (**194**). There is also a similar but later copy dated 1570. The same form, though plain, reappears in the ox-eye cup of 1616 belonging to the Mercers' Company (see Cup, Ox-eye), though having a much lower foot (Fig. **XXa**). This form is preserved, though with the addition of a cover, in a twelve-sided example of 1649. By this date, however, the cast caryatid figure handle, popular during the next thirty years, is about to replace the plain ring or flattened wire handle. A very rare type of two-handled cup is the plain, cylindrical variety with flat cover and stud finial of Puritanical sternness of which an example of 1653 exists. During the Cromwellian Commonwealth, shallow, covered bowls decorated with stylised foliage on a matted ground make very rare appearances (**195**), and it is from this period that the caudle cup dates (see Cup, Caudle). The earliest caudle cup usually has a cover with flat, spool-shaped finial, so that it may be reversed to form a stand (**166** and Fig. **XXIIb**). Alternatively, the cover may have three scroll feet (Fig. **XXIa**). The two-handled cup with straight sides, sometimes lobed (Fig. **XXb** and **c**), rapidly grows deeper and is known as a porringer, but does not become pre-eminent until the 1670s (**196** and Fig. **XXIa** and **b**). It is doubtful if one can be historically correct in defining these two types of cup as one for caudle, and the other for pottage (not porridge); in each case the small examples, usually without a cover, have certainly lent their name to the large ceremonial version (**197**). In 1649 the Inventory the Royal Jewel House reads: 'One Gold potting and cover P. oz. 15½ oz valued at 3£ 6s 8d per 51. 13. 4.'.

From the Restoration in 1660, these cups we decorated with embossed flowers and foliag lions, unicorns and other beasts (Fig. **XXIb**) bei incorporated amongst the foliage (**168**). Betwe the years 1665 and 1680 a form of cage-wo decoration is found on a small group of abo twenty cylindrical cups, which often stand on thr ball or shell feet. These rarely bear any mark oth than that of the maker. That of Colerne Church Wiltshire (**199**) is even more remarkable in posse sing a salver or presentoire, though one must adm this was usual with the more important caudle cu and porringers (**197**) and not unknown with t most important early 18th-century cups and cove

A most uncommon form is that in which t cylindrical sides of the cup taper inwards towar the lip. Such a one, made by Andrew Moore, *c.*167 having a serpent ring handle to the cover, amongst the Carter Bequest in the Ashmole Museum, Oxford (Fig. **XXc**). Related to the lat is a strange cup, presented by Queen Anne Captain Robert Fairfax for his part in the taking Gibraltar in 1704. It was probably the work of Isa Liger, is hall-marked 1705 and has carya handles and a serpent ring handle to the cover. fine, plain gilt cup of 1707, now in the Brit Museum, was presented to Sir John Leake, w commanded the same expedition.

No mention has yet been made of the gristly cartilaginous style of ornament, introduced i England by Christian Van Vianen, sometime after arrival in 1630 at the behest of Charles I. Piec directly influenced by him are excessively rare they were probably the first to be sent to melting-pot during the Civil War. A small gold c and cover of about 1665, with this style decoration, survives, and Vianen's influence is occasionally apparent as late as 1680, though th is probably due to the long residence of the exil Court in his native land, the Netherlands.

As early as 1680, cut-card decoration begins make its appearance at the junction of the foot a body of the cup (**202**). During the last decade the century, but very rarely, a detachable cut-ca calyx is found. Normally it was soldered (**201**). For the general run, the lower part of t body and cover is embossed with a calyx acanthus foliage (**204**), the handles being of pla scroll form and the finial to the cover an openwo foliate bud. Perhaps the finest example, though n the largest, is the porringer made by Daniel Garni *c.* 1680, at the Queen's College, Oxford (Colo Plate 33). In the 1680s a number of porringe were decorated with chinoiserie engraving, whi enjoyed a short-lived vogue (**200**). Another for of decoration reappeared, also for a very sh period, this was the plain, matted ground. It remarkable because of its use on a couple of cu by two different makers, both hall-marked 1685 a made for Sir Herbert Croft. They stand on feet, foretaste of those to come, though they have cove of out-moded form.

Provincial centres, usually some few yea behind the Metropolis, produced numbers of sm cups, such as the one from Taunton (**198**). By t late 1690s partial fluting tended to repla acanthus decoration (Fig. **XXIc**), and an emboss border of ropework round the body was usua combined with a band of stamped orname immediately above and below (**206**). This rop band or rib reflects a rapidly approaching chang

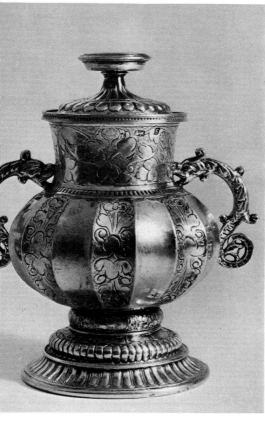

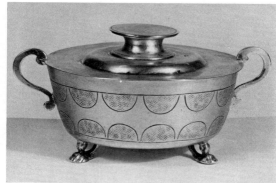

195

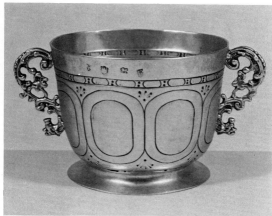

196

194 Two-handled Cup and Cover
Silver-gilt.
Hall-mark for 1555, the cover 1531.
Height 6 in. (15·3 cm.).
Corpus Christi College, Cambridge.
There is another similar cup of 1533 at Corpus Christi College, Oxford.

195 Two-handled Cup and Cover
Maker's mark of Thomas Maundy.
Hall-mark for 1638.
Diam. 4¼ in. (10·8 cm.).

196 Two-handled Cup
Maker's mark, IH in monogram.
Hall-mark for 1652.
Height 3¾ in. (9·6 cm.).

197 Two-handled Cup and Salver
A caudle cup and silver-gilt salver.
Maker's mark, IH in monogram.
Cup: hall-mark for 1657.
Height 5 in. (12·7 cm.).
Salver: hall-mark for 1656.
Diam. 12 in. (30·5 cm.).
Engraved with the Arms of Thomas Wenman (1596–1665).

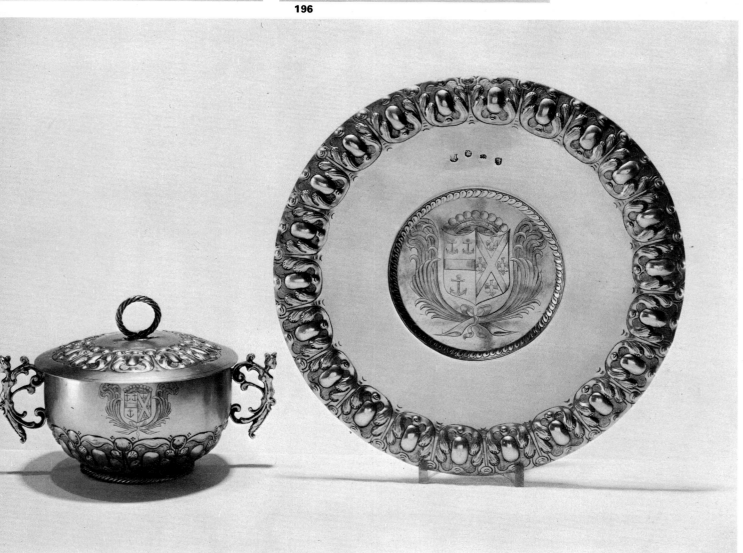

due to the influence of the Huguenot goldsmiths. They introduced the French type of cup and cover, with cast hollow handles and applied strapwork, cast and chased with Régence ornament (**205** and **207**), which was soon, perforce, imitated by English makers. From this date the two-handled cup tends more and more to become a piece of ceremonial plate and as such was frequently given as a race prize (Fig. **XXIIa** and **b**). The small individual examples without feet grow less common in England, though they were still made in the Channel Islands for use as christening cups. The latest of all were made in London, c. 1780, and overstruck by Channel Island retailers, who presumably could not compete with London silversmiths by way of price. One large two-handled cup and cover of c. 1735 is known to have been made in the Channel Islands (**211**). The number of American two-handled cups to survive is relatively small; perhaps the finest of those made in the 17th century is that given to Harvard University in 1701 (**203**). This was made by John Coney, c. 1695.

Very rarely, and then most frequently on those of Scottish manufacture, do small stud thumbpieces survive on early 18th-century cups (Fig. **XXIIa**). By the reign of George I, a series of magnificent cups and covers were being produced in London and, as far as gold examples are concerned, the next reign saw equally fine products from Edinburgh. To date, only one cup having a bowl of oval section seems to be recorded, this being made by Pierre Platel in 1707. Particularly handsome is the gold race cup made by Pierre Harache, Junior, in 1705. This, formerly in the Noble Collection, was originally given by Queen Anne as the Queen's Cup, Richmond, Yorkshire, in 1706. It is 6 in. (15·3 cm.) high, and at the time of making cost £122 14s 3d.

Due to their imagination, silversmiths such as Rollos, Lamerie and others (**208, 210** and **213**), probably did not require any assistance from the designers of the day. However, at least one cup was made in gold from a design by William Kent (**212**) and later in the century the enormous influence of the Adam brothers was brought to bear directly upon silver (Fig. **XXIIIa** and **b**). Books such as Vardy's *Some Designs of Mr. Inigo Jones and Mr. William Kent*, 1744, inspired both patrons and craftsmen. At least two large two-handled race cups are known to have been made, one as early as 1764, from an Adam design now preserved in the Sir John Soane Museum, London. Another such cup, illustrated on Plate **214**, shows the unfortunate results of silversmiths not fully understanding the principles of Adam decoration. To judge from Plate **215**, one was fully conversant with the fashion two years later. Throughout the 18th century a number of cups were made as race prizes, generally speaking, relatively plain at first, especially in the case of gold examples (**209**). On the other hand not all gold cups are plain, as Fig. **XXIIc** illustrates. Pairs of cups are by no means unusual, but there is a suite of three, two 8½ in. (21·6 cm.) high, the third 11¼ in. (28·6 cm.) high, all made by Anthony Nelme between the years 1713 and 1715. Nicholas Clausen made a set of twelve for King George I in 1719; this set is now scattered. The Classical style of the Adam brothers invaded almost every form of decoration, and cups and covers were no exception. However, only one piece is known in gold, a race cup of 1777 by Andrew Fogelberg, some 12⅝ in. (32·1 cm.) high. The so-called 'Trafalgar Vase' was produced during the early years of the 19th century; designed by John Flaxman, some sixty-six in all were made and presented between the years 1804 and 1809 (**216**).

The Warwick Vase (**218**), caught the imagination of Regency England, and its form was used, not only singly, but in large sets, for use as wine coolers or any other purpose which an owner might desire (Fig. **XXIIIb**). From 1830 the cup tended to lose its handles and suffer from the Victorian desire to over-decorate. The Ascot Gold Cup of 1908 (**217**) shows at least an attempt, influenced by the Art Nouveau style, to return towards greater simplicity.

An offshoot to the two-handled cup which never blossomed and may have been originally inspired by a Continental example, is the shallow two-handled bowl and cover on a high foot. There is one in the collection of the Duke of Devonshire, dating from about 1665, by the maker whose mark, a hound sejant, is almost a guarantee of exceptional quality. There is a gold cup of pineapple lobed form by the same maker at Exeter College, Oxford, and another, similar, in a private collection; both date from the 1650s.

See also Cage-work; Flaxman, John; Gold, Objects wrought in; Lloyd's Patriotic Fund; Meth Cup; Mounted-pieces; Race Prizes; Sillabub Pot; Theocritus Cup.

Cup, Wager

Probably of German inspiration, only a small number from the 17th century have survived. The Vintners' Company possesses one of about 1680, formed as the figure of a woman holding aloft a pivoted bowl. To win the wager it was necessary to drain both before setting the cup down again. In 1827 the Company commissioned a number of replicas and the vast majority of those extant are of this date. A Dublin example of 1706 is in the Victoria and Albert Museum.

Cup, Wine

Dr Vaughan, in his book of 1602 entitled *Fifteen Directions for Health*, declared that 'The cups whereof you drinke should be of silver, or silver and gilt'. Comparatively few small cups seem to have survived from the last quarter of the 16th century, though considerably more exist from the early years of the 17th century. It would thus seem that the wine cup or goblet (also known as a 'quaffing cup') was relatively new to the Elizabethans, otherwise there is no reason why more should not have survived. Often these cups follow the general outline of their larger brethren, though seldom with a cover, and a number owe their form solely to Continental influences. They are hardly ever more than 8 in. (20·4 cm.) in height, and more usually stand about 5 in. (12·7 cm.) high. Five main types are recognisable:

(i) Shallow, nearly hemispherical bowl, slender baluster stem, trumpet or cymbal-shaped foot.

(ii) Ovoid bowl, stem and foot similar to the above.

(iii) Bell-shaped bowl, stem and foot similar to the above. (A pair of 1636 were formerly in the Harewood Collection; another pair, 1627, from Barnard's Inn, are in the Birmingham City Art Gallery.)

(iv) Octagonal, tapering, straight-sided bowl, slender baluster stem with applied open brackets below the bowl, foot as above, usually circular, occasionally octagonal.

(v) Plain beaker-shaped bowl, thick baluster stem, trumpet foot with convex border dating from 1625 to 1660.

The first is equally well described as of champagne-glass form, some have plain bowls, some are chased with a graduated network of squares probably derived from the decoration of Venetian glassware of the day. The fourth type is usually

decorated on each of its sides with a single flowe[r] on a matted ground and, as in all cases, the lip left plain. The fifth type is one of the most satis[-] factory designs, relying entirely on its line, usuall[y] quite plain but for either a coat of arms or a[n] inscription, or both. These latter are often o[f] greater capacity than the foregoing types, an[d] thus suitable as communion cups. One at Stew[-] keley, Buckinghamshire, dated 1654, was pu[r-] chased for just such a purpose in 1671 for the su[m] of £2. The coming of glass into fashion and i[ts] comparatively easier supply, ousted the silve[r] wine cup from the table by the second half of th[e] 17th century. A wine cup of 1672, with flute[d] lobate sides, in the Museum of Fine Arts, Bosto[n,] may be either a survival of this form or it was in[-] tended to be used as a communion cup for the sic[k] though there is no particular evidence for this latt[er] surmise. An example of the first type, but with a[n] extraordinarily elongated, baluster stem of 1611, [is] the property of St Mary's College, St Andrew[s,] Scotland. The cup (1629) from which Kin[g] Charles I received his last Communion on Janua[ry] 30th, 1648, now in the collection of the Duke [of] Portland, is an unusually heavy example of the thi[rd] type. A remarkable, late survival of the secon[d] type is a cup by Cornelius Wynkoop of New Yo[rk] c. 1730. Those of the best quality had their bow[ls] raised from one piece of silver, less importa[nt] examples were seamed with a dovetail joint.

Bibliography
A.G. Grimwade, 'Silver and Glass Cups; A com[-] parison'. *Connoisseur*, February 1953.
Sir C.J. Jackson, *An Illustrated History of Englis[h] Plate*. 1911.
G.B. Hughes, 'When wine was drunk from silve[r]' *Country Life*, November 1965.
C.C. Oman, 'The Plate of the City Companies [of] York'. *Connoisseur*, 1967.
See also Chalice; Communion Cup; Goble[t;] Jewish Ritual Silver; Provincial Goldsmit[hs] (English).

Cut-card Work

A type of decoration intended to enhance th[e] object, it was particularly popular in the late 17[th] and early 18th centuries. A sheet of silve[r,] generally pierced with foliage, sometimes wi[th] added beadwork stems, though otherwise u[n]decorated, was applied by means of solder to th[e] object, either as a calyx round the body or as [a] border (**202**). It seems to have been most oft[en] used by the more proficient goldsmiths from 167[0] onwards, and only on rare occasions is th[e] decoration detachable (**201**). The application [of] chased foliage, scroll straps and palm leaves [is] sometimes, though wrongly, termed cut-card wo[rk.] Cut-card work is in fact fashioned and appli[ed] separately. A particularly fine pair of two-handl[ed] cups and covers of c. 1695, 4⅜ in. (11·1 cm.) hig[h,] the maker's mark, FSS with a crown above, sho[ws] this work at its finest; the same may be said of th[e] engraved decoration. These are now at Temp[le] Newsam House, Leeds.

See also Silversmithing.

Cutlery

Other than silver handles for knives and forks, t[he] study of the development of knife blades and ste[el] pronged forks is a subject in itself. It may, howev[er,] be pointed out that the Sheffield makers, who[se] records survive from 1614, seldom used their ow[n] names as registered marks but frequently those [of] foreign towns and countries as they felt incline[d] so long as no duplication was involved. Certa[in] earlier records also survive from the 16th centu[ry]

ig. XX

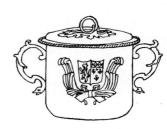

a. 1616. Ht. 8½ in. (21.6 cm.) b. 1667. Ht. 7¾ in. (19.7 cm.) c. 1668. Ht. 6 in. (15.3 cm.)

ig. XXI

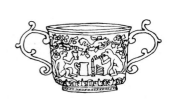

a. 1676. Ht. 4½ in. (11.5 cm.) b. *c.* 1690. Ht. 4½ in. (11.5 cm.) c. 1702. Ht. 10 in. (25.4 cm.)

ig. XXII

a. 1709. Ht. 10¾ in. (27.3 cm.) b. 1735. Ht. 7½ in. (19.1 cm.) c. 1757. Ht. 7 in. (17.8 cm.)

ig. XXIII

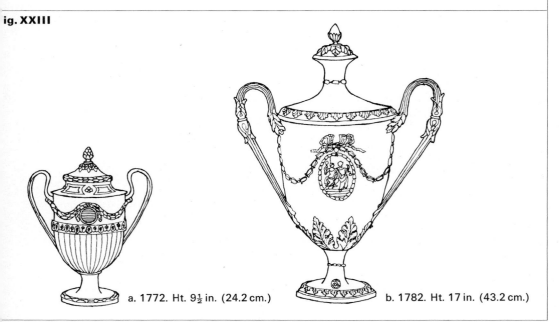

a. 1772. Ht. 9½ in. (24.2 cm.) b. 1782. Ht. 17 in. (43.2 cm.)

Fig. XX
A group of two-handled cups, 1616–68. a. An ox-eye cup of 1616. b. and c. Two covered two-handled cups with straight sides.
Fig. XXI
A group of two-handled cups, 1676–1702. a. A two-handled cup with straight sides and a reversible cover with three scroll feet. b. A straight-sided, two-handled cup highly ornate after the style of the Restoration. c. The cup becomes taller and fluting replaces acanthus decoration.
Fig. XXII
A group of two-handled cups, 1709–57. a. Two-handled cups tend to become more and more pieces of ceremonial plate. b. A caudle cup with two handles, the cover has a flat, spool-shaped finial which when reversed forms a plate. c. A gold, highly decorated, two-handled cup.
Fig. XXIII
Two-handled cups of 1772 and 1782. Both show the influence of the Adam brothers and their Classical style.

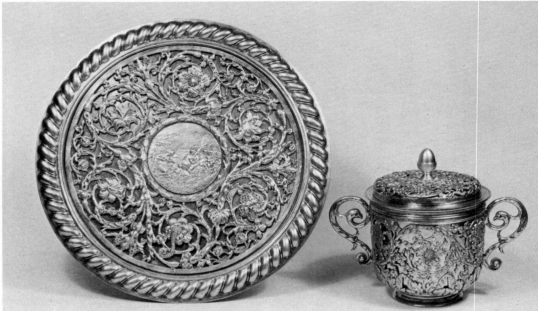

199

198 Two-handled Cup
Silver-gilt.
Maker's mark of T (Thomas?)
Dare of Taunton.
c. 1680.
Height 3⅛ in. (8·0 cm.).

199 Two-handled Cup and Salver
Maker's mark, G F.
c. 1680.
Cup: height 5⅛ in. (13·0 cm.).
Salver: diam. 9¾ in. (24·8 cm.).
Colerne Church, Wiltshire.

200 Two-handled Cup and Cover
Maker's mark, a goose in a dotted circle.
Hall-mark for 1686.
Height 7½ in. (19·1 cm.).
Engraved with the Arms of Smyth or Smith of County Durham or York.

201 Two-handled Cup and Cover
Maker's mark of Pierre Harache.
Hall-mark for 1691.
Height 5¼ in. (13·4 cm.).
Decorated with *detachable* cut-card casing.

202 Two-handled Cup and Cover
Maker's mark, B B, probably the mark of Benjamin Bathurst.
Hall-mark for 1692.
Height 7⅝ in. (19·4 cm.).
Normanton Church, Yorkshire.

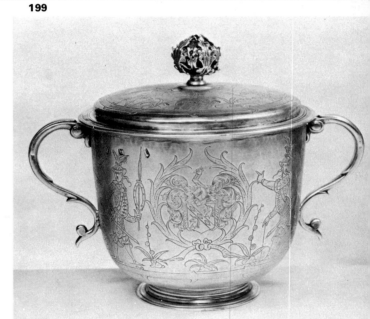

200

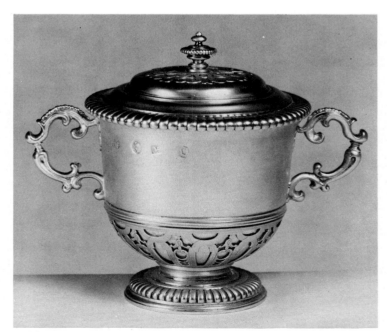

201

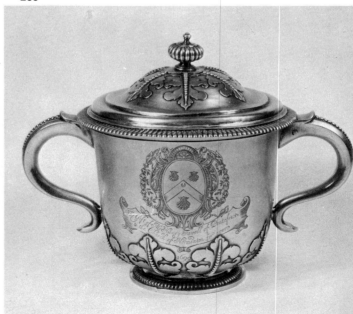

202

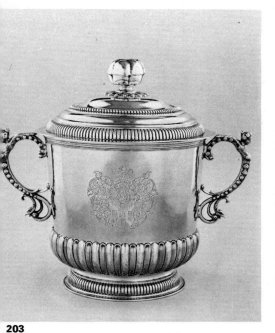

203

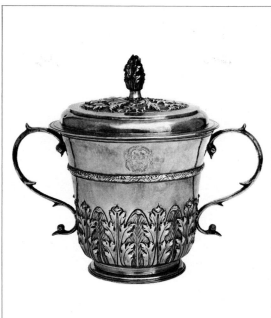

204

203 Two-handled Cup and Cover
Maker's mark of John Coney of Boston.
c. 1695.
Height 10¼ in. (26·1 cm.).
Fogg Art Museum.
Engraved with the Arms of Stoughton.
The gift of the Honourable W. Stoughton to Harvard College in 1701.

204 Two-handled Cup and Cover
Maker's mark of Joseph Walker.
Hall-mark for 1696, Dublin.
National Museum of Ireland.

205 Two-handled Cup and Cover
Maker's mark of Pierre Platel.
Hall-mark for 1702.

206 Two-handled Cup and Cover
Maker's mark of John Carnaby.
Hall-mark for 1702, Newcastle.
Height 11 in. (28·0 cm.).

207 Two-handled Cup and Cover
Maker's mark of Thomas Bolton.
Hall-mark for 1708, Dublin.
Height 10 in. (25·4 cm.).
Assheton-Bennett Collection.

208 Two-handled Cup and Cover
Silver-gilt, one of a pair.
Maker's mark of Philip Rollos.
Hall-mark for 1714, London.
Engraved with the cypher and Royal Arms of George I.

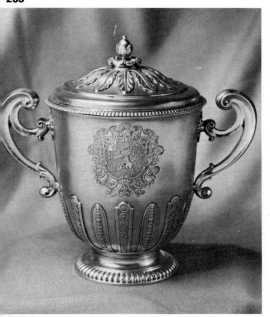

205

206

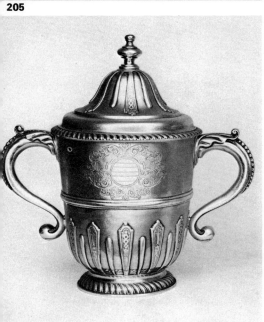

207

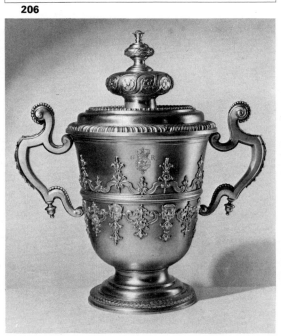

208

209 Two-handled Cup
Gold.
Maker's mark, CC or GG with a
crown above.
Hall-mark for 1725.
Height 4 in. (10·2 cm.).
Overall width 6¼ in. (15·9 cm.).
Inscribed 'won at York ye 5 of
August 1725 by Cuthbert Routh
Esq''.

**210 Two-handled Cup
and Cover**
Maker's mark of Paul de Lamerie.
Hall-mark for 1732.
Height 12¾ in. (32·4 cm.).
Engraved with the Arms of Strode
impaling Caulfield.
A very early example of the
Rococo style.

**211 Two-handled Cup
and Cover**
Maker's mark, IG, of the Channel
Islands.
c. 1735.
Height 12½ in. (31·8 cm.).
Engraved with the Arms of Selwyn
impaling Moore.
Possibly one of the largest pieces
of plate made in Jersey.

**212 Two-handled Cup
and Cover**
Gold.
Unmarked, c. 1735.
From a design by William Kent,
the original designs and the cup's
shagreen case are still in existence.

209

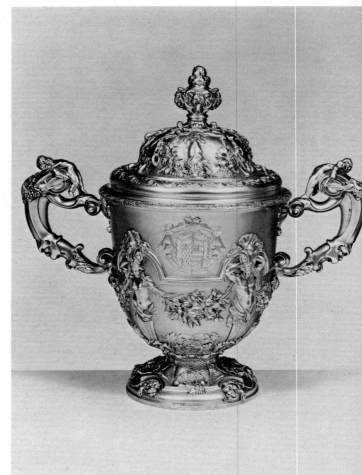

210

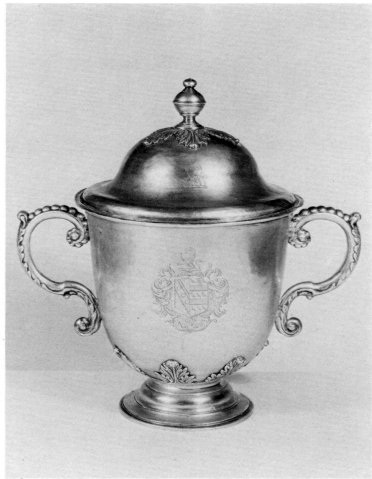

211

212

213

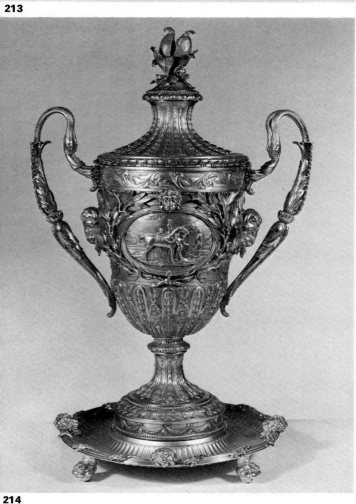

214

215

**213 Two-handled Cup
and Cover**
Silver-gilt.
Maker's mark of J. Berthelot.
Hall-mark for 1751.
Crest and Arms of Warburton, on
the reverse the Arms of Grosvenor.
**214 Two-handled Cup
and Cover**
Maker's mark of W. Holmes &
M. Dumee.
Hall-mark for 1774.
Height 21¾ in. (55·3 cm.).
The bezel is signed 'Willm Moore.
fecit Paternoster row London'.
**215 Two-handled Cup
and Cover**
Silver-gilt.
Maker's mark of William Holmes.
Hall-mark for 1776.
Height 18¾ in. (47·7 cm.).
Walker Art Gallery.

216 The Trafalgar Vase
Maker's mark of Benjamin Smith.
Hall-mark for 1808.
217 The Ascot Gold Cup
Hall-mark for 1908.
Height 16¾ in. (42·6 cm.).
218 The Warwick Vase
Maker's mark of Paul Storr.
Hall-mark for 1812.

216

217

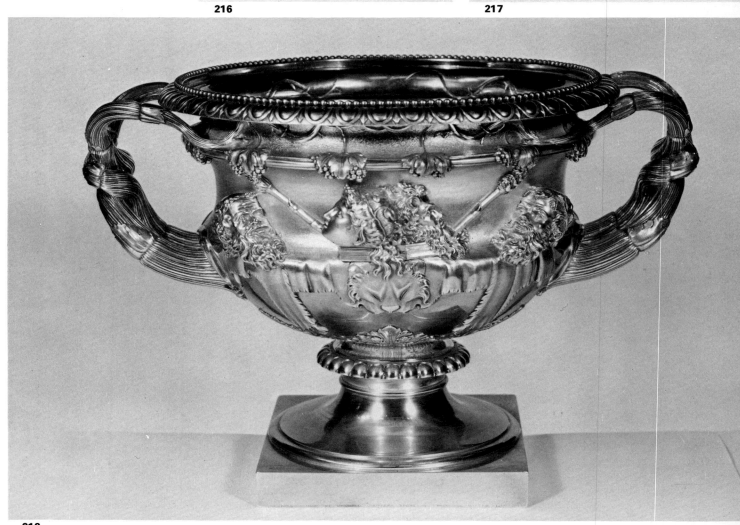

218

ver knife handles, during the late 17th century, ere of tapering, cylindrical form with flat tops; ey are infrequently fully marked. The few surviv- sets of knives, forks and spoons of Queen ne's reign have handles that are usually attribu- to a specialist maker. The pistol-handled knife, ginally cast in two halves and very plain, in time comes more decorative and by the 1760s relies gely for its strength on the composition with ich the handle is filled, rather than the gauge of tal. Not until the early 19th century, was the avier gauge metal reintroduced and only then th the plainer, reeded handles. Examples of tlery are illustrated in Figs. **XXIV**, **XXV** and **XVII**.

liography

E. Leader, *History of the Company of Cutlers in llamshire*. Vols I and II, 1905.

arles Welch, *History of the Cutlers' Company*.

A. Jones, 'Old Sheffield Cutlers' Marks'. *Apollo*, l. XXI, p. 193.

ma Recta

ulding with section of two opposed curves, the per concave.

ma Reversa

ulding with section of two opposed curves, the ver concave.

amascene

inlay metal, usually steel or copper, with either ld or silver, or both; the gold and silver was aten into undercut grooves. The word derives m Damascus, where the technique was much ctised on swords and gun-barrels.

canter Stand See Jolly Boat; Wine Coaster.

Lamerie, Paul See Lamerie, Paul de.

esign and Decoration

hould not be thought that the silversmiths of any riod have been wholly dependent upon their own aginations, however fertile, for the variety of their sign. The influence of architecture and painting s been considerable, and with the invention of nting in the 16th century, complete pattern oks, more often than not German, were available d widely used by silversmiths. In England, how- er, the tendency, judging from the comparatively v surviving pieces, was for the ornament to be ed and the form adapted. During the reign of een Elizabeth I, a balance was usually struck tween decorated and plain surfaces, but during early Stuart period larger pieces became, all o often, grossly over-decorated. The fullest hts of Renaissance fancy do not seem to have en carried out to their extreme as they were on Continent, though a number of pieces of graving were taken directly from Renaissance signs, such as the *Labours of Hercules* by inrich Aldegraver on the dessert (spice) plates 1567, now in the Fowler Collection, Los geles. Interestingly, these designs were also graved by a known artist, Pieter Maas, and it ems likely that, in England, such work was often ried out by religious exiles. The history of igious persecution on the Continent is almost ntinuous and by this means England secured an host unbroken supply of artists seeking religious eration and suitable working conditions. Their ming was a mixed blessing. Native craftsmen, ough their guilds and companies, set up guished cries at the competition. On the other nd, their presence raised the standard of English

decorative art over the years, with a comparative lapse during the period 1615–30 when English craftsmen seem to have been left to their own, somewhat unimaginative, devices, supplemented by a slight Portuguese influence. One such refugee was Christian Van Vianen, although the influence of his work was probably little felt, except amongst the finest craftsmen, and the Civil War ensured the destruction of almost all the work he executed for King Charles I and his Court. A tentative attempt at a Gothic revival so far as ecclesiastical plate was concerned seems to have been short-lived. The flagons of 1663 and 1669 at Pembroke College, Cambridge, illustrate this fashion, as does the plate from Staunton Harold (Colour Plate **8**).

With the exception of a few pieces, chased with matted panels containing a reserved design of stylised flowers and foliage (**226**), the Cromwellian Commonwealth period of 1649–60 shows little originality in design or decoration. A rose water dish of 1656, a number of small porringers of the shallow bowl form and a very few tankards are amongst the rare survivors thus decorated. Even this restrained work seems to have been ex- ceptional.

Following the Restoration of 1660, the influence of their long exile in the Low Countries, upon both King and Court, became immediately apparent. Richly decorated objects of every sort abounded. Not only silver for the table, but furniture also, was made in silver and silver-gilt. Piercing and em- bossed foliage became most popular, but fine engraving was extremely rare. The new fashion may have suited the English silversmiths, who lost no time in making up for what were probably the lean years of the previous decade.

However, the wave of anti-Huguenot persecu- tion following the Revocation of the Edict of Nantes in 1685, brought a further influx of refugees. The commissions they gathered for their French-style products dismayed yet another generation of English silversmiths, who, since 1660, had been largely influenced by Dutch taste. It is, however, seldom that supply can channel demand and the English workmen, having in some cases even used their marks on pieces patently not of their own making, soon realised the way in which the wind was blowing. Men such as Pierre Harache, David Willaume, Pierre Platel (**205**) and other first- generation Huguenots led the new fashion, closely followed by their sons and nephews, who in turn introduced the Rococo style of decoration (**210**), which developed after 1730 together with the Palladian style. It is interesting to note the almost complete lack of true Baroque influence in English art as a whole during the late 17th century, save in the engraving of cartouches; Dutch and pseudo- Chinese decoration on the other hand, made by no means unimportant appearances.

During the 18th century, designs for silver were on occasion prepared by the leading draughtsmen of the day and, as is usual in such cases, they were often before their time. H.F. Gravelot and G.M. Moser wielded great influence so far as the spread of the Rococo was concerned. Many connoisseurs faced by the gold cup of c. 1730, designed by William Kent, would date it thirty years later (**212**). Kent was the inaugurator of the belief that an architect designed not only houses, but also their contents. He was also the cornerstone of the Pal- ladian movement, the cult which emulated the styles and art of the early Italians and in particular Palladio. The publication in 1753 of Wood's *Baalbek and Palmyra* opened the floodgates of a new Classical revival. The Adam brothers were only the first of many, and some of their designs for

plate, dating from 1764 onwards, survive in the Sir John Soane Museum, London. The style they introduced held the field for about thirty years. The great London firms of the early 19th century, such as Rundell, Bridge & Rundell; Hunt & Roskell, and Garrard, commissioned designs from Flaxman, Stothard, Pistrucci and many more. An example was set them by Matthew Boulton in Birmingham, who from 1770 had accepted the designs of others, and even Wakelin had commissioned Wyatt in 1772 to design a small memorial sarcophagus for Asheton Curzon. The firm of Elkington & Co., Birmingham, championed that city once again in the 1840s, co-ordinating both design and manu- facture. The influence of the Society of Arts and Henry Cole now began to be felt. Until that time, it is perhaps true to say that objects for daily use were seldom subjected to the over-decoration lavished by every generation on pieces for display. The over-emphasis on naturalism during the 1840s now began to give way to a revival of the Renaissance style, a form which embraced almost all types of classical decoration, including on occasion a number of unfortunate marriages.

Throughout the middle of the 19th century, the desire for figures and groups in silver was so constant as to call forth a very large number of superlative pieces. Unfortunately, however, the vast majority of products were factory-made and maximum decoration at minimum price seems, all too often, to have been the client's only require- ment, although Sir Walter Scott observed that 'the profusion of ornament is not good taste'. Towards the end of the century, the work of Alfred Gilbert— reminiscent in some cases of the Van Vianens'— and William Morris's ideas, put into practice by C.R. Ashbee (1863–1942), along with those of the Art Nouveau style, tended towards the production of individuality in style and design. The smaller workshops, such as those of Omar Ramsden and Harold Stabler, coped best with these individual tastes, thus leaving the larger firms seemingly devoid of much original thought and inspiration.

Bibliography

M.G. Fales, 'English Design Sources of American Silver'. *Antiques*, January 1950.

Oman and Rosas, 'Portuguese Influence upon English Silver'. *Apollo*, June 1950.

A.G. Grimwade, 'Period Ornament in English Silver'. *Apollo*, September, October and November 1952, March and May 1953 and November 1954.

Mark Girouard, 'English Art and The Rococco', part III. *Country Life*, February 3rd, 1966.

Patricia Wardle, *Victorian Silver*. Herbert Jenkins, 1963.

Shirley Bury, 'Connoisseur Period Guide'. *Con- noisseur*, 1958.

Society of Arts, Catalogues. Exhibitions 1847, 1848 and 1849.

The Great Exhibition, Catalogue, 1851.

F. Townshend, 'Irish Silver: Decoration and Re- decoration'. *Irish Georgian Society*, vol. VIII, no. 1.

Robert Rowe, *Adam Silver*. Faber & Faber, 1965.

Shirley Bury, 'The Arts and Crafts Experiment. The Silverwork of C.R. Ashbee'. *Victoria and Albert Museum Bulletin*, January 1967.

C.C. Dauterman, 'Dream Pictures of Cathay'. *Metropolitan Museum of Art Bulletin*. Summer 1964.

See also Chinoiserie; Ramsden, Omar.

Dessert Service

From early times the use of gold or silver-gilt for dessert ware seems to have been preferred (Colour Plate **23**). It should be remembered that an object that is now gilt, may not always have been so.

One of the most splendid and earliest undoubted dessert services still extant, must be that supplied by Daniel Smith & Robert Sharp to the Duke of Portland in 1764. It comprises four fruit and foliage baskets, sixteen leaf-shaped dishes with applied mulberries, strawberries, currants and other fruit decoration, all chiselled in the round and finely modelled. Also belonging to this service are four tree and insect candelabra, each of three lights, made by John Cafe in 1762, together with several dozen plates. A number of other such services survive unbroken (**219**). It is usually the decoration, and its generally being gilt, that distinguishes the intended purpose of the service, unless documentary evidence (as with ambassadorial plate) can be produced. Rundell, Bridge & Rundell produced vast quantities of silver-gilt plate in an age when it was even more fashionable to gild than usual (**220** and **231**). The addition of a set of wine coasters to a dessert service was quite usual during the first decade of the 19th century. One of the last of such services commissioned on a grand scale was that designed by William Burgess (1827–81) for the Marquess of Bute as a wedding present for his friend, G.E. Sneyd. Made by Barkentin & Krall in 1880, part is silver, part gilt and both enamelled; it also included a multi-branched centrepiece and is now in the Victoria and Albert Museum. Special services of table silver consisting of an equal number of knives, dessert spoons and forks were supplied from the late 18th century, the handles of the knives might on occasion have been made of agate or Scottish jasper. As time went on, pieces such as ice spades and sugar sifters were also added to the dessert service.
See also Mounted-pieces.

Dessert Stand

These are known from Elizabethan inventories, though it seems that none have survived. A few James I examples are extant, such as that of 1616 in the Fitzwilliam Museum, Cambridge, another of 1617 (**221**), and others of 1619 (**222** and **225**). It should be emphasised that to describe the articles illustrated as dessert stands is arbitrary. For a shallow dish on a central foot, having either pierced or chased decoration, or both, would seem most suited to dessert or pastries (**224**). By 1635, those surviving tend to have simple, punched, beaded decoration (**223**), occasionally having a Catherine-wheel like appearance. A very rare pair, dated 1638, is amongst the Jackson Collection (on loan to the National Museum of Wales); even a set of four is still extant. Plate **226** illustrates the typical decoration of the Cromwellian Commonwealth period; this form survives until the end of the century. Probably the 'sweetmeat stand' purchased by Prince Rupert on April 29th, 1670 was in fact of this form (**230**). The use of these stands as salvers, and as stands for the more imposing caudle cups, during the last half of the century, means that classification is somewhat difficult if the cup has been lost (**197**). Two American pieces, one a footed salver by Timothy Dwight, the other a plate by John Coney, each engraved, c. 1690, by what appears to be the same hand, encourages the belief that these may have formed part of a dessert service (Museum of Fine Arts, Boston). By 1700, the form seems to have been replaced by the fluted, shallow, round or oval dish with scalloped rim, the earliest so far recorded being made in 1697 and known colloquially as a 'strawberry dish'. This form was obviously derived from an Oriental porcelain original and it is also referred to in the Wickes Ledgers as a 'sallad dish' (**228**). Amongst the finest of these is that by Paul de Lamerie, 1725,

now in the Museum of Fine Arts, Boston, each scrolling out-turn of its rim springs alternately from a mask or foliate cartouche (**229**). Setting aside the epergne and the basket, the true dessert stand does not, with rare exceptions (**227**), return until the opening years of the 19th century, when it became increasingly popular, often in sets of two or four as supporters to a centrepiece (**233**). Numbers of earlier plates and dishes were given high feet at this time, and most examples bearing hall-marks of around 1800 are suspect. Amongst the Birmingham Civic Plate is the Holte of Aston Hall Dish; this combines a little of every type, being of shallow concave/convex section, circular, chased with swirling fluting and on a low rim foot; some 16½ in. (41·9 cm.) in diameter, it is hall-marked 1671, with the maker's mark, WW. Another from the same service also survives.
See also Epergne; Salad Dish; Salver; Strawberry Dish; Tazza.

Diaper Work

A trellis-like surface of ornament consisting of a regular network of shapes, sometimes squares or lozenges.

Diet and Diet-box

As with the Officers of the Royal Mint, the assay masters at each of the assay offices are required to keep a very small representative quantity, a diet, of each pound of wrought plate. This is placed in a diet-box under several locks and keys held by the different officers of the assay office. Annually, the diet is assayed as a check upon the activities of the assay master himself during the previous year. The assayers at Birmingham and Sheffield are under oath to assay only such pieces as already bear the mark of their maker, and to place in the diet-box only metal from work which they have passed as being standard.
See also Assay; Pyx, Trial of.

Dish

Any large circular or oval piece of plate with a centre of shallow bowl form may be called a dish but if the centre be over 1½ in. (3·8 cm.) below the rim it may be more correctly described as a basin and if the diameter is less than 10 in. (25·4 cm.) and the piece is circular, it is said to be a plate. This stated, there will always remain a number of pieces which might fall into at least any two of the three categories, or there may be some which might have been specifically intended to hold such objects as sauce boats or soup tureens. With rare exceptions, such as those intended for dessert, which are often of silver-gilt, any decoration is confined to the rim upon which the crest or coat of arms is also engraved. Were this not so, the use of knives and forks, except with silver blades and prongs, would most certainly soon ruin the central decoration. Dishes which have survived from the 17th century, and these are rare (**231**), have a broad rim often with turned, reeded border and are usually circular. Fifteen made between the years 1581 and 1601 formed part of the dinner service of Sir Christopher Harris; it was buried on Dartmoor during the Civil War and afterwards recovered by the family. Initially with reeded moulding (**235**), by the 18th century the meat dish ('ashet' in Scotland, from the French *assiette*) if oval, or second-course dish, if circular and about 12 in. (30·5 cm.) in diameter, will have a heavily gadrooned lip and a somewhat narrower border. Many varieties of a shaped outline followed, including the octagon (**234** and **236**), and a number of earlier services were brought up to date by altering the border. This action was

illegal, for it probably involved the addition Sterling metal borders to the remainder, which s bore the Britannia standard marks. A number such altered services survive. By the mid 18 century, many minor varieties of the shape moulded and/or gadrooned border were in use a the ubiquitous shell often decorated the angl especially those dishes made by the leadi makers of the day (**237**). It should not be f gotten that soup tureens of the day were genera provided with a stand (as were sauce tureens fr about 1760). So-called 'meat dishes', either o or circular, with decoration somewhat above normal quality, are likely to have been intend as such, though not to the exclusion of any ot use. In June 1772 Wakelin invoiced the Duke Ancaster for 'sinking 4 sauceboat plates comport dishes'; such are the vagaries of fashi An average dinner service would include basi seventy-two plates (see Plate (ii)), appro mately twelve oval dishes in the following ove sizes, four at 12 in. (30·5 cm.), two at 13¼ (33·7 cm.), two at 15¼ in. (38·8 cm.), two at 17 (43·2 cm.), one each at 18 in. (45·8 cm.) and in. (50·8 cm.) and four circular second-cou dishes about 12 in. (30·5 cm.) in diameter. A extra pieces would be at the discretion of the bu and perhaps be added over the years (**232**). Fr 1770 onwards a change of the earlier fashion led reed-and-tie and beaded rims, and narrow b ders; this meant the compression of any engrav coat of arms into a small space between rim and the shoulder of the dish. From 1740 at le one dish with a detachable pierced strainer, kno as a 'mazarine' (occasionally circular), would supplied with each service; this type of dish w intended to hold such food as boiled fish. V rarely towards the end of the century a long, n row fish dish may also be found in the din service and the so-called 'venison dish' w broadly ribbed base and gravy reservoir at one e appears during the Regency period, one such d is illustrated at the top of Plate 232. Plates, d rings, dish crosses and finally hot-water stands, t last usually of Sheffield plate, are also associat with dishes. In the case of the venison dish, a h water compartment is part and parcel of the who A favourite shell, foliage and gadrooned pattern the early 19th century is illustrated on Plate 23

As stated above, the early 17th-century dish rare and, its survival, though due in one or tw cases to its safe burial during the Civil War, is m often, thanks to its having been given to a chu as an alms basin. A number of ewers and basins the mid 17th century were clearly of dual purpo at least in so far as the basin was concerned, a especially when one considers its original purpo according to the stock list of the retailer. Gr dishes, chased and decorated with a variety motifs, were a feature of the sideboard until early 18th century. Large American dishes a extremely uncommon. A set of three (one large a two smaller) made by J.W. Forbes of New York in the Sterling and Francine Clark Art Institu Williamstown, Massachusetts, and date from abo 1810. They have heavily gadrooned borders (**23**

Plate 12 Châtelaine
A George II gold châtelaine with the maker's mark, ST crowned.
Hall-mark for 1728.

219

**Plate 13 The Ramsey Abbey
Censer and Incense Boat**
The silver-gilt censer is unmarked,
c. 1350.
Height 10¾ in. (27·3 cm.).
The parcel-gilt incense boat is also
unmarked, *c.* 1350.
Length 11¼ in. (28·6 cm.).
Both these pieces were discovered
while the bed of Whittlesea Mere,
Cambridge, was being drained in
1850. One half of the incense boat
lid opens on a hinge. The ram's
head terminal is a rebus on Ramsey
Abbey. Victoria and Albert Museum,
London.

219 Dessert Dishes
Silver-gilt, part of a dessert
service.
Maker's mark of J. Wakelin &
W. Taylor.
Hall-mark for 1787.
Square dish: 8⅝ in. (22·0 cm.).
square.
Plate: diam. 9⅜ in. (23·8 cm.).
Oval dish: width 11 in. (28·0 cm.).
Circular dish: diam. 8½ in. (21·6
cm.).

220 Dessert Service
Part of a dessert service which
consists of six circular plates
and a pair of cream jugs.
Maker's mark of Joseph Taylor.
Dishes: hall-mark for 1836.
Diam. 6⅛ in. (15·6 cm.).
Cream boat: hall-mark for 1840.
Engraved with the crest of
Lowther.

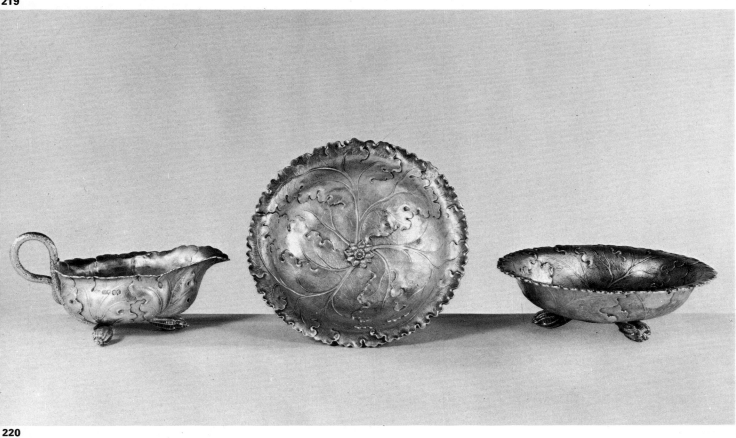

220

221 Dessert Stand
Maker's mark, probably T.C.
Hall-mark for 1617.
Diam. 8½ in. (21·6 cm.).
Witham Church, Essex.
Engraved with the Arms of Banks.
It has a central spreading foot.
222 Dessert Stand
Maker's mark, CB in monogram.
Hall-mark for 1619.
Diam. 9 in. (22·9 cm.).
Engraved with the Arms of Machell.
223 Dessert Stand
Maker's mark of Thomas Maundy.
Hall-mark for 1638.
Diam. 9½ in. (24·2 cm.).
224 Dessert Stand
Maker's mark, CB.
Hall-mark for 1631, London.
Diam. 11¾ in. (29·9 cm.).
225 Dessert Stand
Maker's mark, probably B S.
Hall-mark for 1619.
Diam. 12½ in. (31·8 cm.).
The Honourable Society of the
Middle Temple.

221

222

223

224

225

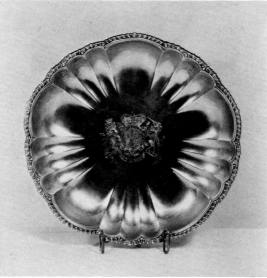

226 **Dessert Stand**
Maker's mark, a bird with a branch of leaves in its beak.
Hall-mark for 1650.
Diam. 8 in. (20·4 cm.).
Laugharne Church, Carmarthenshire.
The initials are those of William Thomas, Bishop of St David's and Worcester, and his wife, Blanche.

227 **Dessert Stand**
Silver-gilt, one of a set of four.
Maker's mark of either William Cripps or William Caldecott.
Hall-mark for 1761.
Diam. 10 in. (25·4 cm.).
Engraved with the Royal Arms.

228 **Dessert Stand**
Maker's mark of Richard Bayley.
Hall-mark for 1719.
Diam. $6\frac{7}{8}$ in. (17·5 cm.).
Engraved with the Arms of Crosse impaling Jodrell.

229 **Dessert Stand**
One of a set of four.
Maker's mark of John le Sage.
Hall-mark for 1742.
Diam. $6\frac{7}{8}$ in. (17·5 cm.).
Part of a surtout supplied by the Jewel Office and engraved with the Royal Arms of George II.

230 **Dessert Stand**
Maker's mark of Benjamin Bathurst.
Hall-mark for 1694.
Diam. $8\frac{1}{4}$ in. (21·0 cm.).

226

227

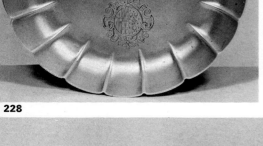

228

229

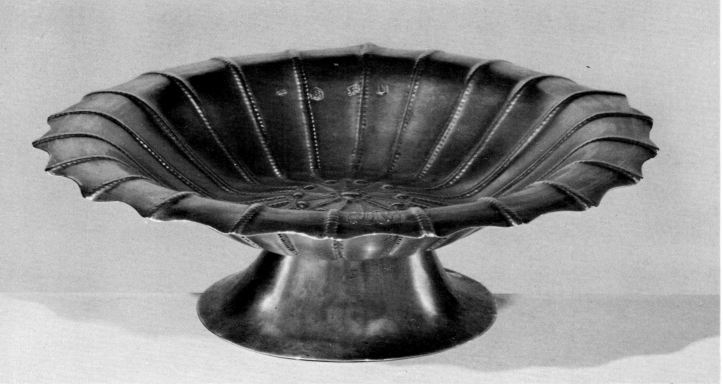

230

231 Dish
Maker's mark, RS with a heart and two pellets below.
Hall-mark for 1631.
Diam. 17¼ in. (43·8 cm.).
Engraved with the Arms of Twysden.

232 Dinner Service
An early 19th-century dinner service.

233 A Pair of Dessert Stands
Silver-gilt.
Maker's mark of Paul Storr.
Dishes: hall-mark for 1814.
Diam. 14 in. (35·6 cm.).
Stands: hall-mark for 1816.

234 Set of Four Dishes
Maker's mark of David Willaume.
Hall-mark for 1725.

235 Dish
Maker's mark almost obliterated.
Hall-mark for 1684.
Width 16½ in. (42·0 cm.).
Engraved with the cypher and Arms of Patrick, 3rd Earl of Strathmore and the Arms of Lyon.

236 A Shaped Dish
One of a pair.
Maker's mark of Peter Archambo.
Hall-mark for 1738.
Width 16 in. (40·7 cm.).
Engraved with the Arms of George Booth, 2nd Earl of Warrington.

237 Dish
Maker's mark of Paul de Lamerie.
Hall-mark for 1741.
Width 17¼ in. (43·8 cm.).
Engraved with the Arms of Bridge, Dorset.

238 Dish
One of a suite of three.
Maker's mark of Paul Storr.
Hall-mark for 1811.
Width 17 in. (43·2 cm.).
Engraved with the Arms of Richard Butter and those of Baron Caher.

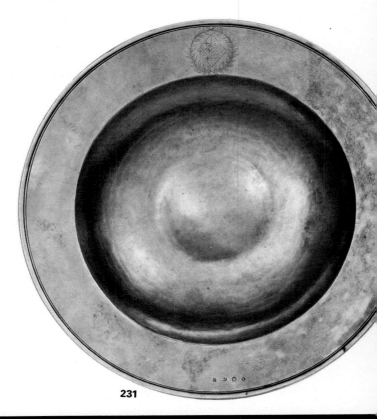

231

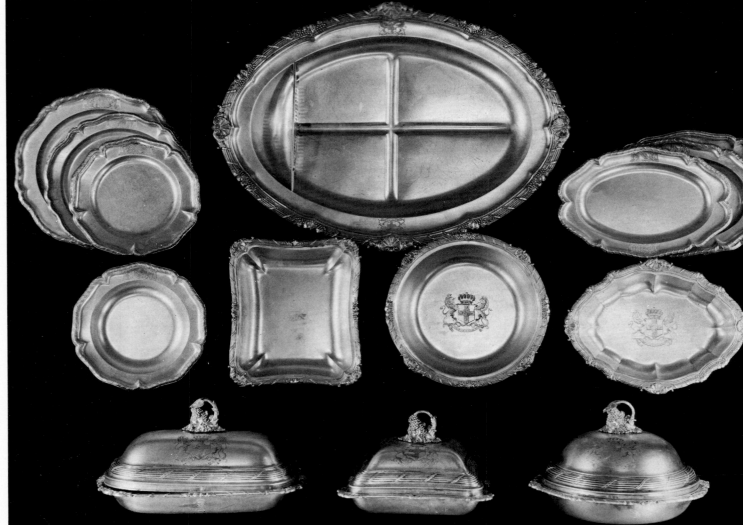

232

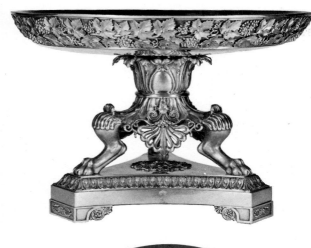

235

236

237

238

111

On October 29th, 1770 the Wakelin Ledgers record that the Hon. Charles Pelham was supplied with:

'23 Oval. 10 Round Dishes.
4 Pointed Compote Do. [probably cushion-shaped]
7 dozen of Plates.
2 Fish Plates. [probably mazarines]
6 Large and 6 smaller Sauceboats.
12 Plates [stands] for do.
12 Threaded sauce spoons.
12 Fine Salts and Spoons. [with twenty-four blue glasses]
2 Large and 2 small fine Terrines. Linings & Dishes.
4 Fine Ice pails'.

See also Alms Basin and Altar Dish; Casserole; Ewer and Basin; Mazarine; Plate (ii); Pudding Dish; Salad Dish; Salver; Saucer; Sideboard Plate; Stewpan; Supper Service; Sweetmeat Dish; Vegetable Dish; Voider.

Dish Cover

Silver examples dated earlier than 1800 are uncommon, whatever their size, though by no means unknown. With the introduction of Sheffield plate enormous quantities were made and this perhaps presented an opportunity to melt and refashion an equal weight of unappreciated silver. Some of the earliest silver covers to survive are richly chased with lambrequins and foliage (**240**) but, in general, they are plain and embellished only with a coat of arms or crest. The finials may take the form of a crest or ring handle. Covers for circular dishes seem to have been more usual than for oval ones, that is until the coming of the entrée dish proper (**241**). It is likely, that what we today call a second-course dish, originally performed the function of an entrée dish and would thus explain their provision. Very rarely openwork covers are found, decorated with applied flowers and foliage, these probably appeared with the dessert. Large examples are extremely rare and were originally associated with a mirror plateau. In general, they date from about 1770. A set of four, fluted, circular dishes made by Magdalene Feline in 1750 and a further pair *en suite* made by Thomas Heming in 1771, each with a cover, are amongst the Royal Collection. In certain dinner services, particularly in complete services made by such silversmiths as Lamerie or Godfrey, a two-handled circular bowl, with a wide flange and domed cover is found, but they are rare; so too are the circular mazarines. An example made by William Cripps in 1754 is 14½ in. (36·9 cm.) in overall width.

See also Entrée Dish and Stand.

Dish Cross (Table Cross)

The dish cross had adjustable sliding legs, with arms equally adjustable about a central heater. It was capable of accepting almost any size of dish or bowl and in the days when kitchens and dining rooms were often far apart it must have been a necessity in many a home. Dish crosses first appear in the 1730s as successors to the dish ring and seem to have died out by the end of the century when they were replaced by hot-water stands (often of Sheffield plate) or even a hot-water reservoir in the dish itself. One of the most interesting is a cross made by Paul Crespin in 1738 with alternative triple- or single-wick burners to the lamp, from the lower half of which, on three different levels, obtrude the three arms. These are each slotted to engage with a geared brass column within the base of the lamp so that on pulling or pushing one leg the others either advance or retract at the same time. Another, almost identical,

by James Shruder is illustrated on Plate **242**. Another example in the Manchester City Art Gallery, dated 1750, has secondary supports half-way along each arm, these being of fixed extent, but it has no heater. American examples are very rare and it is remarkable that one of the few dish rings and also a dish cross should have both been made by Myer Myers. Both are now in the Garvan Collection, Yale University Art Gallery. Another dish cross maker's mark, IS, is in the Henry Ford Museum, Dearborn, Michigan. English provincial dish crosses are equally rare. One of 1786 by Joseph Whalley is known from Chester and there is also a Scottish example, some 13 in. (33·1 cm.) in overall width, by Coline Allan of Aberdeen, *c.* 1750. A dish cross, executed by Matthew Boulton of Birmingham in 1774, has slots of uncertain purpose on the upper face of the sliding terminals. The Rev. Mr Cornwallis (Dean of Canterbury) purchased 'a French plate dish cross' from Messrs Wakelin in 1773. In 1784 George Washington copied out details of price lists for plated wares from Birmingham and Sheffield: 'Dish Crosses. Ditto Dr. & with & without bearers. with lamp and bearer 44/– with lamp and no bearer 40/– without lamp and with bearer 40/– without lamp & bearers 36/– each'.

Bibliography

G.B. Hughes, 'Keeping Georgian Food Hot'. *Country Life*, December 26th, 1968.

See also Chafing Dish.

Dish Ring

The dish ring seems to have been somewhat uncommon in England at any period. By virtue of its fixed shape it could only be used as the support for dishes of the same size and none are known with heaters. It may be that it is derived from the brazier of the latter part of the 17th century; the earliest surviving examples date from the reign of William III, but almost certainly the dish ring was superseded by the adjustable dish cross before the middle of the 18th century (**243**). A dish ring made by Paul de Lamerie in 1745 is a late survival, as is that made by Richard Richardson, Chester, in 1738. The so-called 'Irish potato' rings are in fact only a later form of dish ring (*c.* 1765) and as examples are extant, in at least one case with a pierced silver cover, there is no doubt that some of these were designed to support a wooden bowl. At first the top and bottom rims of the spool-shaped sides are of equal diameter (**244a**). Later the top is narrower than the base (**244b and c**). The sides are pierced and chased with a variety of ornament and the form appears to have been popular in Ireland between the years 1750 and 1820. A very rare American example by Myer Myers, the sides pierced but otherwise undecorated, is amongst the Garvan Collection, Yale University Art Gallery. About 1810 Messrs Watson & Bradbury produced in Sheffield an ingenious collapsible variety.

Bibliography

M.S.D. Westropp, 'Irish Silver Dish Rings'. *Connoisseur*, vol. XCVIII, p.213.

See also Flagon Ring.

Dish Stand See Entrée Dish and Stand.

Dish Wedge

In form these are self-explanatory. They may be of openwork and, on occasion, are finely decorated. Generally the upper edge is serrated in order to grip the rim beneath a plate or dish. They usually date from between the years 1750 and 1850 and are found in pairs. Their size varies.

Dogett, Thomas (d. 1721)

Actor and joint manager of Drury Lane Theatr He initiated an annual race for six watermen to held on or conveniently near August 1st in hono of the accession of George I to the throne. In 171 posters announced '. . . There will be given by M Dogett an Orange Livery with a badge represen ing Liberty to be rowed for by six watermen th are out of their time within the year past. They a to row from London Bridge to Chelsea.' Th funds he left are now administered by the Fis mongers' Company. The badge is of silver, en bossed with the White Horse of Hanover and th word 'Liberty'.

Douter

Of scissor form, easily confused at first sight wi sugar nippers, but the douter can be distinguishe by the absolutely flat surface of the plates at th end of either arm. A short-lived form, general dating from about 1725, they were more probab designed to deal with the wick of a kettle lam rather than that of a candle.

See also Extinguisher; Snuffer Scissors; Sug Nipper.

Drawback Mark See Hall-mark.

Dredger

The dredging box is recorded in inventories of th mid 17th century. Other than one early example caster form, probably of the Cromwellian Commo wealth period, none previous to the reign Charles II seems to have survived. It may be co rect to refer to the so-called 'kitchen pepper' or t pounce pot of an inkstand as a dredger. In Fe ruary 1666, Pepys 'did carry home a sil drudger . . .'.

See also Caster; Inkstand.

Dressing Weight See Plummit; Toilet Service

Drum See Kettle Drum.

Dual Purpose Items

This heading encompasses a great variety of form For example, combined knives and forks, one ti being of blade form, are known in many sizes they were made to suit individual requiremen Such were the gold knife and fork made for Lo Nelson after the loss of his arm, the sewing instr ment with ivory handle made by Joseph Willmo of Birmingham in 1820, some 12½ in. (31·8 cm long and now in the collection of the Birmingha Assay Office. Early folding spoons, the bo detachable from the tines of the fork which pass through lugs on the back of the bowl, are rare English silver and usually come from travelling se Continental examples on the other hand are qu common, even of 17th-century date. Measurir spoons with a bowl of different size at either er were usually amongst the fittings of toilet servic of the 19th century. Under this heading may mentioned communion cups, whose covers a reversible to form a paten on a central foot. Al porringers and caudle cups which had simil covers, though of shallow bowl form, so that th may be used either to eat from or to provide a ty of stand for the main body of the cup. Cover sugar bowls of the second quarter of the 18 century are also found with reversible cove which might be variously used as a spoon, tra saucer or stand at the whim of the owner. A pla communion cup made by Richardson of Chest in 1742 has a lip spout to each side, presumab for the dual purpose of cup and flagon.

239 **Set of Three Meat Dishes**
Maker's mark of John W. Forbes of New York.
c. 1810.
Large dish: width 18 in. (45·8 cm.).
Smaller dishes: width 14 in. (35·6 cm.).
Sterling and Francine Clark Art Institute.
Engraved with a crest of a demi-unicorn.

240 **Dish Cover**
Unmarked, *c.* 1725.

241 **Oval Dish Cover**
One of a suite of three.
Maker's mark of Edward Farnell.
Hall-mark for 1820.
Overall length 20 in. (50·8 cm.).
With the applied Arms of Sir Jacob Astley, 5th Baronet.

239

240

241

113

242 Dish Cross
Maker's mark of James Shruder.
Hall-mark for 1739.
Another similar example made by
Paul Crespin is at Petworth, Sussex.
243 Dish Ring
Unmarked, *c*. 1735.
Victoria and Albert Museum.
244 Dish Rings
a. Maker's mark of John Hamilton.
c. 1745.
b. Maker's mark of William
Townsend.
c. 1770.
c. Maker's mark of John Lloyd.
c. 1770.
All three rings were made in Dublin
and are in the National Museum of
Ireland.

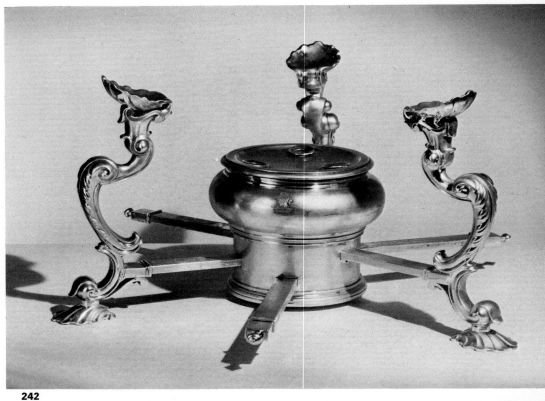

242

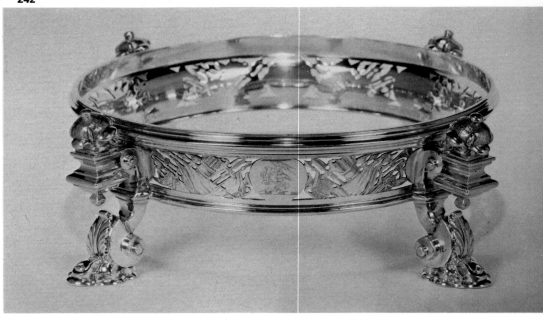

243

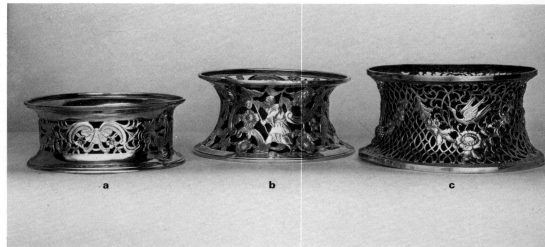

a b c

244

Dublin Assay Office

[To] have seen only part of the collection of gold and [sil]verware in the National Museum of Ireland is to [re]alise that the Irish were highly skilled in gold-[sm]ithing from very early times. Goldsmiths are [re]corded in Dublin throughout the Middle Ages. [W]hen first the Dublin goldsmiths were incor-[po]rated is not known. However, by 1555 they [ap]plied to the Dublin Corporation to have a true [co]py of the enrolment of their Charter exemplified, [th]e original having perished by fire. In 1605 the [Ci]ty Council decreed that all plate was to be [m]arked and assayed before sale; the marks were to [be] a lion, a harp and a castle. No piece bearing [th]ese marks is known to exist. In 1637 the Dublin [Go]ldsmiths petitioned Charles I for a Royal [C]harter and obtained one of the largest and fullest [of] such documents on record. This prescribed a [kin]g's mark, a harp crowned (a), and a maker's [m]ark, and gave search powers throughout Ireland. [Pr]esumably because the Wardens were to be held [re]sponsible for any defaults, a date-letter system [w]as also instituted, but after the first forty years [se]ems to have become almost haphazard. In 1730 [th]e Hibernia mark was added to show that a duty [of] 6d per ounce had been paid, but this was not [le]gally enjoined on the Company until 1752 (this [m]ark, though similar, should not be confused with [th]at of the Britannia standard which was never [co]mpulsory in Ireland) (b). This duty was never [re]pealed but on its reimposition in England, and [af]ter the Union of 1800, the sovereign's head mark [w]as also added in 1807, thus reducing the figure [of] Hibernia to the status of a Dublin town mark. [Th]e duty was finally repealed in 1890. From 1731 [th]e date-letters run in sequence, using twenty-[fo]ur letters of the alphabet (excepting I and V).

a b

Various standards of gold have been permitted [in] Ireland, and owing to the relatively large number [of] Dublin-made gold snuff and presentation boxes [in] existence, it is worth noting that 22 carat [st]andard, the only standard permitted until 1784, [is] stamped with these figures: 22 carats with the [fig]ures and a plume of feathers; 18 carats with the [fig]ures and a unicorn's head. The remaining marks [fo]r 15, 12 and 9 carats, allowed since 1854, have [no] particular symbols.

The amount of information available relative to [th]e later history of the Dublin Goldsmiths' Com-[pa]ny is remarkably full and comprehensive.
Bibliography
Sir C.J. Jackson, *English Goldsmiths and Their Marks*. 2nd Edition 1921, reprinted 1949.

Dummer, Jeremiah (1645–1718)

[H]e worked in Boston, Massachusetts, and was [ap]prenticed to Hull & Sanderson in 1659. A gold-[sm]ith and merchant, he engraved the plates for the [fir]st paper money for Connecticut. A considerable [qu]antity of silver made by him survives, showing [e]normous variety. It includes a standing salt (one [of] three known) in the Museum of Fine Arts, [B]oston, and a spout cup and cover in the same [M]useum. He also made a fine tankard displaying [th]e cut-card decoration with which he is accredited [as] having introduced to the American Colonies, it [is] now in the Phillips Academy, Andover, Massa-[ch]usetts. A pair of cluster column candlesticks, c. [16]85, and an interesting two-handled bowl, [w]hich he made at a slightly later date, are both in [Ya]le University Art Gallery. One of his apprentices [w]as probably Edward Winslow (1669–1753).

Duty-dodgers

The temptation to all silversmiths to avoid the duty of 6d per ounce levied on plate manufactured between the years 1719 and 1758, by removing the marks from a small piece of previously marked plate and applying them to the base of such objects as casters, sauce boats, coffee pots and two-handed cups, seems to have been irresistible to most, even such silversmiths as Paul de Lamerie. The duty was, by the standard of the day, no small amount, and since most of the marks were almost contemporary with the piece to which they were applied, the duty-dodging was almost impossible to detect without removing the base of the object in question.

By sharply striking the base of a suspected duty-dodger with a hammer and punch, a check test of sorts can be made. If a small pimple is raised on the inside of the piece, then the base is probably solid right through. If no pimple appears, a double bottom may be suspected, though this can only be proved by removing the base when the addition will fall clear (**245**). A faultlessly soldered double bottom with no air space between might react as a perfectly legal piece. The striking of a maker's mark, once clearly and three times double struck, could also give the impression of legal hall-marks.
Bibliography
Commander G.E.P. How, 'An Anomaly of Modern Hall-Marking'. *Connoisseur*, vol. CXXIV, 1949.
See also Forgery.

E.A. F-S. (Ernst August. Fidei-Kommis)

The inventory mark of Ernst Augustus, first King of Hanover, and engraved on the back or the base of all the Cumberland Plate. Thus, the provenance of pieces bearing the English Royal Arms and so engraved may be identified. A set of twelve cups and covers made by Nicholas Clausen in 1719, now scattered, once formed part of this collection. In Roman Law *Fidei Commissum* (to faith en-trusted) is a bequest which a person made by begging his heir or legatee to transfer something on to a third person. King George III also decreed an especial system of differentiating the coats of arms of Princes of the Blood. The label, usually proper only to the eldest son of an armigerous family, was to be borne by all, but undifferenced only in the case of the Prince of Wales. It may also be appropriate to mention the existence of a two-handled oval tray made by Scott & Smith in 1803, presented to Sir William and Lady Gomm by some of the children of King George III and engraved with their initials.
GA George Augustus, Prince of Wales.
As Augustus, Duke of Sussex.
Aff Adolphus Frederick, Duke of Cambridge.
As Augusta Sophia.
Eh Elizabeth
M Mary.
S Sophia.
Aa Amelia.

Eared, Two-

A description of which the exact 16th-century connotation seems open to doubt. The 17th-century, shallow, saucer dishes with two, flat, escallop handles are referred to in present-day English usage as 'two-eared'. In the United States, however, the small 17th-century dram cups or wine tasters (fairings), having plain S-scroll handles not unlike the profile of an ear, are so called. This seems to be another case of 'bleeding bowl' versus 'porringer'.
See also Cup, Ox-eye; Cup, Two-handled; Stirrup Cup.

Ear-pick

A small cup-shaped depression, usually found as a terminal to a tooth-pick or a bodkin. Generally found as single items during the 17th century, they form one of the pieces of an étui during the 18th century.
See also Étui.

Ear-trumpet

Silver examples are not unknown. The form is in no way peculiar, and survivors are usually of 19th century date. Messrs Wakelin evidently had at least one deaf client (or a surgeon) for they supplied Richard Bull in the 1770s with at least three 'hearing trumpets' weighing about $7\frac{1}{2}$ ounces each. In the Sheffield City Museum is a telescopic ear-trumpet stamped W.B. Pirie, 352 Strand. This, of Sheffield plate, must date from c. 1820.
See also Horn.

Echinus

A quarter-round moulding, on occasion enriched with egg and dart ornament.

Ecuelle

Originally based on a French design, there are few ecuelles which survive, probably less than twenty English examples and as few Canadian and American. One of the earliest known English ecuelles is that made by Daniel Garnier, $6\frac{1}{2}$ in. (16·5 cm.) in diameter, whose cover, magnificently decorated with cut-card work, is engraved with a contemporary monogram and the date 1694. This was formerly in the Noble Collection. They were often fashioned by Huguenot makers for the most important personages of their time, whose taste might be expected to be for things French. No Canadian examples are known with either covers or pierced handles. The form of the ecuelle is a shallow, circular bowl with flat handles to each side and with a domed cover (**246**); the name may also be associated with the finely made, two-handled, shallow, circular bowl with flat handles to each side have normal vertical scroll handles and are of uncertain purpose, but perhaps they were used as broth bowls (**247**). They are occasionally found throughout the first seventy years of the 18th century and at least one example from Ireland (Jackson Collection, National Museum of Wales) survives. One of the finest ecuelles is that made by Thomas Farren in 1729, now at the Museum of Fine Arts, Boston. Another at Pollock House, Glasgow, dates from 1718 and its maker was David Willaume. The only recorded pair, made by Isaac Liger in 1726, were originally commissioned by George Booth, Earl of Warrington, and are now in the Ashmolean Museum, Oxford. Whether it is justifiable to associate the Scottish quaich, early examples of that form being similar in size, with the ecuelle is a matter of debate.
Bibliography
J.E. Langdon, *Canadian Silversmiths, 1700–1900*. Toronto, 1966.
See also Bowl; Quaich.

Edinburgh Assay Office

Silver was worked in Edinburgh from early times. As early as 1485 a deacon and searcher were appointed, it being ordained that all plate should bear the maker's mark, the deacon's mark and that of the town. The silver was to be 11 out of 12 parts fine, a slightly lower standard than English silver. In 1687, the Edinburgh goldsmiths were granted a Charter by James VII of Scotland (James II of England) granting them powers to search through-out Scotland. At this time there would seem to have

245 Duty-dodger
Showing how a plate from a
correctly marked piece is transposed
into the base of another in order
to avoid paying the necessary duty.
This particular transposed mark
is dated 1769.

246 Ecuelle
Maker's mark of James Shruder.
Hall-mark for 1738.
Engraved with the Arms of Dawkins
impaling Colyear.

247 Ecuelle
Silver-gilt.
Maker's mark is illegible.
Hall-mark for 1762.
Stand by Thomas Heming.

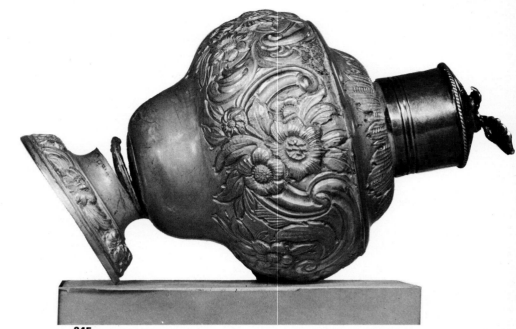

245

246

247

en records of goldsmiths in Glasgow, Aberdeen, rth, Inverness, Ayr, Banff and Montrose besides ose of Edinburgh. The Edinburgh town mark is, d always has been since 1485, the Arms of inburgh, a triple-towered castle (a). The deacon's ark was also his maker's mark and as he was en- ed to produce silver at the same time as he held ice his mark may appear struck twice on either le of the castle. In 1681 it was also agreed to stitute a date-letter system and substitute an say master's mark for that of the deacon. In 1759 s was discontinued and the thistle mark ostituted (b).

(a) Edinburgh mark on silver and gold

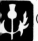

(b) Mark on all Scottish sterling silver after 1759

Since the Act of 1696 was passed by the English irliament before the Union, and did not therefore ply to Scotland, the first Parliamentary Act ative to the two kingdoms was that of 1720, en lowering the permitted standard in England the Sterling standard of 11 ounces 2 penny- eights resulted in raising that of Scotland by 2 nnyweights. There is thus no Scottish Britannia indard for 1697–1720. By the same Act a duty 6d per ounce was imposed on all manufactured imported plate. In 1757, because the duty was o difficult to collect, it was repealed and an nual licence substituted, but in 1784 the duty as reimposed and in 1797 doubled. By 1804 the ty had risen to 1s 3d per ounce and 1s 6d by 17, at which rate it remained until abolished in 90. Under the Parliamentary Act of 1836 the pervision of goldsmithing in Scotland, with the ception of Glasgow and an area forty miles in dius round that city, was subject to the incor- ration of goldsmiths of the city of Edinburgh. In 64 the Glasgow Assay Office ceased to function. e identification of Edinburgh makers is relatively sy from as early as 1525 because the well- eserved minute books of the goldsmiths have en kept up to date.

bliography

r C.J. Jackson, *English Goldsmiths and Their arks*. 2nd Edition 1921, reprinted 1949.

e also Canongate.

Iinburgh Silver

e distance between London and Edinburgh fore the days of railways, added to a long- inding Scottish connection with the Continent, d a history of war between Scotland and igland, ensured considerable differences in itional styles. As in the north-east of England, :otland was also influenced by Scandinavia.

During the Middle Ages a number of large and iportant pieces of silver were made in Edinburgh. ' Scottish gold was the basin, of gallon capacity, iade in Edenborough . . . by a Scotsman' and isented, filled with gold coins, to the King of ance by the Regent Morton.

James VI, in 1603, travelled south with his ourt, to become James I of England, leaving the :ots a poorer people. From this time onwards, the ndency was, on the whole, to manufacture taller pieces, often copied from wooden or ver-mounted originals such as quaichs and izers. Large pieces of ornamental plate are rare irvivals in early Scottish silver. Spoons, thistle- aped mugs, candlesticks, casters and, very casionally, relatively plain punch bowls and two-

handled cups are the rule until the end of the 17th century. After the Union with England in 1707, prosperity increased and, in spite of the '15 and '45 Rebellions, a number of important pieces began to appear such as gold cups and two gold teapots of 1736 and 1737 made by James Kerr (Colour Plate **39**), besides other items such as coffee pots. The Scottish teapot is usually of spherical form, with flush cover, on a high, moulded, circular foot and with a straight, tapering spout. It is associated with a shallow cream or milk boat, often almost the size of a sauce boat. Frequently the shoulder of the teapot, and often the everted lip of both cream boat and sugar bowl, were chased with stylised foliage. A particular form of ovoid urn on three feet was peculiar to Scotland. From 1750 the English influence became more and more obvious, helped by the building of new Turnpike roads, though it is not until 1763 that the earliest Scottish soup tureen, so far known, appears. Generally speaking, the quality of all Scottish silver is very high. Numerous American and Canadian makers struck marks closely allied to those of various places in Scotland, a tribute perhaps to the export trade of the day, or, more likely, the traditionalist outlook of the expatriate Scottish client.

Bibliography

I. Finlay, *Scottish Gold and Silver Work*. 1958.
T. Burns, *Old Scottish Communion Plate*. 1892.
See also Mazer; Mines, Gold and Silver; Spoon.

Egg Boiler

Amongst the many and varied 'aids to Gentility' produced by silversmiths, the egg boiler seems to be the most practical. Usually of oval, hemi- spherical or cylindrical form, on openwork feet, with a lamp between; the eggs were held in a wirework frame within the body, the top of which was covered by two hinged flaps and from which protruded a ring handle, sometimes framing an hour glass (**248**). Usually they catered for four or six eggs to be boiled at the same time and in general such pieces date from about 1790. A silver- gilt example was once in the collection of the Marquess of Exeter at Burghley. Gilding on such pieces is generally reserved for the insides of the egg cups and spoons, with which such boilers were sometimes also fitted.

Egg and Dart, Egg and Tongue

Ornament used for mouldings, most popular in the 16th and 19th centuries; arrowhead or tongue-like detail alternates with ovolo.

Egg Frame and Egg Cup

On February 3rd, 1690 Lady Hervey wrote: 'Dear Cosen donn gave me a sillver ege thing worth ten ginnes'. So far the earliest recorded surviving egg- cup frame, holding ten egg cups, is that dated 1740 and made for George Booth, 2nd Earl of Warring- ton (**249**). Another, of basket form, holding six egg cups, dates from 1770 and is at Harewood House. This form was soon overtaken by an openwork wire frame holding any number of cups, generally not less than four nor more than eight; such frames also allowed for the egg spoons. The bowl of the spoon was at first of pear, later of concave shield shape (**250**). On occasion a central salt cellar, sometimes of glass, was incorporated into the frame. The varieties of such pieces are in- finite, perhaps because of the growing competition that the workers of hand-wrought plate were experiencing from the manufactories of Birming- ham and Sheffield. Some firms might in the course of a few years produce as many as fifty or sixty different patterns to suit all tastes and every

imaginable breakfast table.

Bibliography

G.B. Hughes, 'Stands for Georgian Egg-cups'. *Country Life*, November 21st, 1968.

Electroplating

Metallic salts split up and 'ionize' when dissolved in water, forming positively charged metal 'ions' (atoms with excess positive electrical charges) and negatively charged 'ions', the solution remaining electrically neutral. On the passage of a direct electric current through the solution, the metal ions are attracted to the negative plate or cathode when the excess electrical charge is neutralised. Under suitable conditions the metal atoms so formed cohere to each other and to the cathode to form a compact and adherent metallic coating. The metal content of the solution is kept constant by the use of positive plates or anodes of the metal being deposited, which dissolve, thus supplying fresh metal ions. Therefore, to electroplate an object it must act as the cathode. Hollow-wares such as a jug or coffee pot never 'take' so heavy a deposit on the interior as the exterior unless the anode is actually placed within it.

For many years during the early part of the 19th century, chemists had been working towards the electrical deposition of gold or silver on a base metal, usually copper. The Galvanic Goblet of 1814 being an isolated example of a process which did not at that time prove commercially practical. By the mid 1830s success seemed near, due to the strenuous efforts of Elkington & Co. of Birming- ham. In March 1840 John Wright took out a patent; the basis of his research had, perhaps, been Scheele's *Chemical Essay*. In September of the same year he entered into partnership with Elkington. A series of further patents were taken out by this firm who bought out the patents of out- siders in order to improve their own process. Once silvered or gilt, the object was hammered all over to secure the adhesion of the coating and later burnished, usually by hand. The firm also entered into agreements with a number of outsiders as to the manufacture of plated articles under licence. By the Great Exhibition of 1851 the process was well established and although the process of electrogilding was applauded as being beneficial to the health of those employed (the expectation of life of those employed upon mercury-gilding being considerably reduced by the poisonous fumes), it was felt that electrosilvering was best reserved for *objets d'art* as opposed to domestic pieces. The Victorian passion for realism was given great impetus from the fact that actual ferns, leaves and even small animals could be, and were, electro- plated. Electroplating also served the faker and the forger, who could now cover up solder marks and other faults in old silver.

While Sterling silver is used in the making of Sheffield plate, 925 parts pure silver and 75 parts of alloy, usually copper, electroplating requires the use of pure silver. This fact, therefore, allows for a chemical test to be made if there is any doubt as to an object being either one or the other. Nitric acid, slightly diluted with distilled water, when applied to the surface of Sterling standard metal will change its colour to blue. On the other hand, if no change takes place then the silver is pure and the object has been electroplated.

Bibliography

G.B. Hughes, 'Identifying of old Sheffield Plate'. *Country Life*, April 10th, 1969.

See also Sheffield Plate.

Embossing See Chasing; Silversmithing.

248 Egg Boiler
Maker's mark of John Edwards.
Hall-mark for 1802.

249 Egg Frame and Egg Cups
Maker's mark of Peter Archambo.
Hall-mark for 1740.
Engraved with the initials of
George Booth, 2nd Earl of
Warrington.

**250 Egg Frame, Egg Cups
and Spoons**
Maker's mark of Paul Storr.
Hall-mark for 1813.

249

248

250

...amelling

...sically this may be said to be the art of applying ...hin coating of glass to a metal, which, when ...ated to a high temperature, melts and fuses with ...e metal.

...Cloisonné enamelling, or enclosing enamels of ...ferent colours between slightly raised outlines ...gold wire, was a process used by the Ancient ...eeks. The Celts and Saxons in Britain gouged ...signs in the metal and filled this sunken area ...th enamel, leaving a raised champlevé ground ...tween. By 1500, led by the Penicaud family, a ...w process of painting in enamel, usually on a ...pper ground, was being practised at Limoges. ...ring the last half of the 18th century multitudes ...small boxes, dishes and candlesticks were pro- ...ced at Battersea and Bilston in Staffordshire, ...e designs being eventually printed rather than ...nd drawn. Plique-à-jour is a process of enamel- ...g between metal filigree and is most commonly ...ed for jewellery, allowing the light to penetrate ...m both sides.

...Amongst the Jones Collection (Victoria and ...bert Museum) are a set of four table candlesticks ...d a pair of tea candlesticks, each of column form ...a square base, decorated with swirling silver ...d pale blue enamelled fluting and with stamped ...ollwork. These are probably from the Birming- ...m manufactory of Matthew Boulton, c. 1770.

Bibliography
...nneth F. Bates, *Enamelling*. World Publishing, New York, 1951.

...graving

...e art of inscribing or sculpting in metal is as ...cient as the use of metal; to engrave is to cut ...ay with the aid of a graver or scorper, as ...posed to chasing, in which the metal is pushed ...one side. In common usage, engraving on silver ...considered a most attractive aid to decoration or ...commemorate the gift of the piece, or for the ...plication of either a coat of arms or crest and ...otto to indicate its possessor. A peculiarity of ...ottish engraving is the tendency to engrave the ...otto, if any, above the crest rather than under- ...ath it as in England (**252** and **506**). Initials were ...o engraved to indicate events, such as marriages, ...nerally that of the surname on top, those of the ...ristian names below in a triangular form: 'taken ...t of the House of Mr. Edward Eastham who ...eps the Fighting Cocks Inn in New York, a silver ...art Tankard, marked on the handle $^E_{ES}$ engraved, ...e silversmiths Mark is $^{WK}_B$ Punch'd, and a cypher ...the lid ES'.

...From the first this was a separate art, though the ...orkshop of a goldsmith might well employ a full- ...e engraver. As soon as the arrival of printing ...de it possible, the market was supplied, usually ...m Germany, later from Holland, with a series of ...sign books upon which engravers of all ...untries drew heavily, though making any adjust- ...nts they felt necessary (**251**). Very few names ...engravers have come down to us from the 16th ...17th centuries, as few ever signed their work. It ...uld, for instance, be interesting to know the ...me of the man responsible for the lion, birds, ...erub and flowers on the waiter dated 1691 at ...rrington Church, Wiltshire. Even the superbly ...graved top of King William III's silver table at ...ndsor (**290**) bears only the initials R.H.S. Simon ...ibelin (1661–1733) (**253**), Benjamin Rhodes ...graver to Richard Hoare, the founder of ...are's Bank), James Sympson (who did on ...casion sign his work) were all working at the ...rn of the 18th century. A fine carriage watch

made by Jeremie Gregorie of c. 1680, in the Victoria and Albert Museum, has a sea fight engraved on the back and is signed P. Hallam. I. King signed a ewer and basin of 1685 and a cup of 1689 at St John's College, Oxford. An oval tobacco box, engraved with drinking and smoking utensils, made c. 1690 incorporates the initials IC, perhaps as a signature. William Hogarth was apprenticed to Ellis Gamble, an engraver in 1712, and may have done work for Lamerie between the years 1718 and 1735 (**255**). Of great interest and rarity, if not of the finest quality, is the communion plate of Henley, Suffolk. The chalice, paten and flagon are each engraved with a different scene from the Passion of Our Lord. All three pieces were made by Edward Pocock in 1728. A gold tobacco box made by Humphrey Payne in 1742 (Farrer Collection, Ashmolean Museum, Oxford) has a lengthy inscription signed J. Ellis. The author of the engraving on the fish trowel of 1741 made by Lamerie is unknown (**256**). Certainly there must have been many other engravers, such as J. Teas- dale, who signed an extravagant Rococo engraving on a salver dated 1763, which is amongst the Courtauld Loan to the National Gallery of Rhodesia. One suspects, however, that the English and American engravers suffered from a lack of inventiveness and their clients' preference was governed by either the taste of their fathers or of the Continent. At least some American engravers, including the following: Nathaniel Hurd, James Smither, Joseph Leddel and J.D. Stout, signed some of their work; the first, a tea urn dated 1774 now in the Kansas City Museum, the second a tankard in the Henry Ford Museum, Dearborn, Michigan, the fourth engraved a monteith made by Daniel Henchman. The Garvan Collection, Yale University Art Gallery, contains a gold freedom box of 1784, made by Samuel Johnson of New York and signed 'Maverick Sct.' (P.R. Maverick, an engraver from New York). Amongst several pieces of finely engraved American silver should be noted a tankard made by William Vilant of Philadelphia, brilliantly engraved by Joseph Leddel, with what might almost be supposed to be Jacobite sym- bolism, dated 1750. Archibald Burden engraved a small number of prize medals for attachment to silver arrows awarded at St Andrews University Archery Club between the years 1718 and 1721. Phillip Jacques de Loutherbourg came to England from Alsace in 1771. He may be the author of the superbly engraved decoration on a teapot made in 1772 now at Williamstown, Massachusetts, and also a tea caddy of the same year (present where- abouts unknown). The quality of the work on these pieces is such as to raise the question of their being acid-etched, rather than engraved, a practice that became fairly widespread during the mid 19th century. In 1789 Joseph Cooke advertised in Philadelphia 'The Initials of any Person's name, in a cypher, engraved after the famous Lockington's London Patent cypher-book'.

Various styles of engraving follow the fashion- able decoration of the day, so far as the leaders of the profession were concerned (**254**), although a considerable time lag might be expected in the provinces and the Colonies. James Shruder designed his own trade card in about 1739, but employed J. Warburton to engrave the plate for him. On some occasions, such as the remaking of plate for colleges which had, out of financial necessity, sent earlier pieces to be melted, rub- bings of the original engraving are known to have been supplied to the newly commissioned silver- smith to be exactly reproduced upon the new plate. These rubbings were sometimes of an out-moded

style, being a century old or more, thus causing some confusion to the uninitiated examining an otherwise unmarked piece. On many occasions an existing piece of an engraver's work was sent to a silversmith to copy when making new plate. This accounts for coats of arms in cartouches of an earlier style upon pieces of a later date. This lapse, for obvious reasons of heraldic correctness, is seldom more than one generation.

To the casual observer the difference between fine chasing and engraving is not at first obvious. In general the Victorian mania for the 'improvement' of anything with a plain surface, such as coffee pots and salvers, was carried out by chasers rather than engravers, probably because it was thought to give a 'richer' effect than engraving. None the less, a great deal of the latter was done, often of a very high standard and, surprisingly, on electroplated articles.

An engraved silver table top of c. 1690 at Chatsworth, Derbyshire, is signed 'B. Gentot in. fecit' (1658–c. 1700) but was probably engraved in France as the engraver was a friend of Jean Tijou, for whose book on ironwork he engraved the plates. During the late 1680s, Tijou was employed at Chatsworth and so might have gained the com- mission for Gentot. From the late 18th century, fulsome inscriptions on pieces of presentation plate became more and more common (**257**).

Bibliography
Samuel Sympson, *A New Book of Cyphers*. 1726.
Simon Gribelin, *A Book of Ornaments usefull to All Artists*. 1700.
Day Book of Benjamin Rhodes 1693/1697. (In the possession of Hoare's Bank.)
Livre d'Estampes de Simon Gribelin, fait Relié a Londres 1722. British Museum Print Room, 1859/6/25.
J.F. Hayward, *Huguenot Silver in England*. Faber & Faber, 1959.
C.C. Oman, 'English Engravers on Plate', parts I, II, III and IV. *Apollo*, May, June, July and November 1957.
K.C. Buhler, 'Some Engraved American Silver'. *Antiques*, November and December 1945.
Montague Weekley, 'Thomas Bewick and a Hunts- man's Salver'. *Country Life*, March 7th, 1968.
See also Furniture; Gribelin, Simon; Heraldry; Hogarth, William; King, I.; Leddel, Joseph; Maverick, P.R.; Stout, J.D.; Sympson, Joseph; Tea Caddy; Teasdale, J.

Entrée Dish and Stand

Today the accepted form is either oblong or oval and with a cover; smaller and deeper, cylindrical dishes without covers being for a *soufflé*. In both cases these are derivations from the chafing dish of the 17th and 18th centuries, which was sometimes two-handled and provided with a dish ring and, on occasions, with a spirit lamp. From these chafing dishes the individual diner might eat directly or balance a separate plate on the dish ring. During the middle of the 18th century, the dish cross made its appearance, fulfilling the same purpose as the dish ring. By 1770, probably owing to a growing tendency to eat privately and with fewer servants in attendance, the entrée dish with cover makes its appearance in sets, usually of four (**258**). During the early 19th century, the heating method is either by spirit lamp, charcoal or hot iron, but this is enclosed within a stand of similar form to the dish it supports, having a handle at either end. Finally, a variant designed to be filled with hot water makes its appearance. In each case it is unusual to find the stands of silver; Sheffield plate and later electro- plate are the rule (**261**). Some exceptionally fine

251 Engraving
On a pax.
Galway engraving, c. 1635.

252 Engraving
On a seal box made for the High
Chancellor of Scotland.
Edinburgh engraving of 1604.
Royal Scottish Museum.

253 Engraving
On a circular charger made by
Pierre Harache in 1700.
Diam. 24 in. (61·0 cm.).
The engraving is possibly the
work of Simon Gribelin. The Arms
of Bathurst impaling Apsley.

251

252

253

54 Engraving
the centre of a wine cistern
made by Paul de Lamerie in 1719.
The Arms of John, 1st Earl of
Gower (1694–1754).

55 Engraving
On the Walpole Salver made by
Paul de Lamerie in 1728. The
engraving is possibly the work
of William Hogarth.
Victoria and Albert Museum.

256 Engraving and Piercing
On a fish trowel made by Paul de
Lamerie in 1741.
Farrer Collection.

257 Engraving
On a two-handled tray made by
Crouch & Hannam in 1802.

254

256

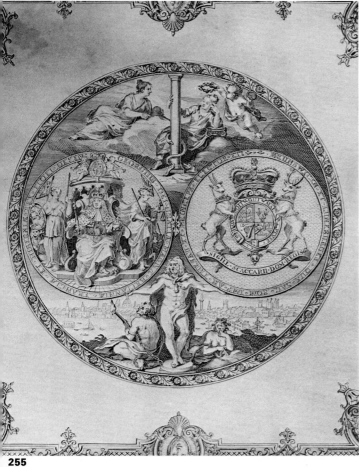

255

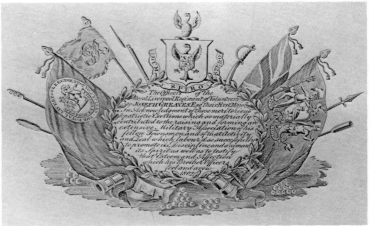

257

silver-gilt examples with ivory, scroll handles were made for the Duke of Northumberland by Phillip Rundell in 1823. Oval, they are 18¼ in. (46·4 cm.) in overall width and made *en suite* with a dinner service designed by Adam. Dishes of cushion shape were seldom provided with covers, and these appear to have been referred to in inventories of the 1740s as 'compot' dishes and in the Wakelin Ledgers for Charles Dunbar Esq. in 1771 as '4 Pincushion Compote Dishes'. More than almost any other piece, the entrée dish has, perhaps, more exceptions to the general rule, so far as the form and contemporary usage of these pieces of plate is concerned (**259**). Today they are frequently used to hold vegetables, at the table. Some particularly large, but otherwise identical examples at Althorp are referred to in the plate lists as 'Flank Dishes'. Others with deep, non-reversible covers were probably intended for game or fowl (**260**). Fan- or crescent-shaped covered dishes are usually survivors from a circular 'supper-set' which generally included a central circular dish. Reversible openwork stands and lamps, for either oval or circular dishes, generally date from the last quarter of the 18th century. The finial to the cover of an entrée dish was, on occasion, formed as the crest of the owner.

See also Casserole; Dessert Service; Supper Service; Toasted-cheese Dish; Vegetable Dish.

Epaulette

A good deal of uniform equipment must have been made in Sheffield plate, if not in silver or gold. However, the pair of epaulettes dated *c*. 1795, in the Sheffield City Museum, are noteworthy.

Epergne (Epargne, Epaunge, Machine)

Never particularly good at languages, the spelling of 'epergne' defeated many an English clerk making an invoice or inventory during the 18th century, and the final description 'machine' was often his answer (**262**). This table centre, generally on four feet, and at first of heavy gauge metal, occurs from the 1730s onwards, though there appears to be a reference to the branches of an 'Aparn' in the 1721 Inventory of the Royal Plate. It seems to have originally been designed to support a central shallow bowl and four or more circular dishes, each at the end of a branch (**263**). In addition, further branches for candles and a bracket at either end to accommodate two sets of three casters were optional. Lamerie's bill of 1721 to the Honourable George Treby invoices for 'a fyne polished surtout cruette frame, casters, branches and saucers' and '2 doble salts for ye surtout'. The Newdegate Centrepiece made by Paul de Lamerie in 1743, now in the Victoria and Albert Museum, is an example of the first variation; that, by the same maker, now in the Hermitage, Leningrad, illustrates the uttermost development of the epergne. Lamerie might almost be claimed as the originator of this design in silver, one was made by him, and survives, for each year from 1733 to 1736. Further branches might be added to take candle sockets (**266**), or small pendent sweetmeat baskets (rarely fully hallmarked) or even escallop-shaped dishes (one made by Eliza Godfrey in 1755 is illustrated on Plate **265**). The dishes (oval ones, as opposed to circular, are very uncommon) might unscrew or rest free in a retaining ring frame. Complete examples of such surtouts de table are very rare survivals. One made in 1731 by David Willaume and Anne Tanqueray, bearing the Arms of Cholmley Turner of Kirkleatham, Yorkshire, appeared at Sotheby's in 1963. It had six casters and a cover to the centre bowl, besides two pairs of oil and vinegar frames and

interchangeable candle sockets and sweetmeat dishes. A particularly interesting example, though considerably altered, is that in the Collection of Her Majesty the Queen, made by George Wickes in 1746 to a design by William Kent published by John Vardy in 1744. This has a 'plateau' stand, as has the example in the Hermitage, Leningrad, of 1741. Another 'fantastic' creation, also in the Royal Collection, is that made by Augustin Courtauld in 1741, in this case an exercise in shellwork. Yet another in the Collection of Her Majesty the Queen is illustrated on Colour Plate **20**, a silver-gilt epergne (centrepiece) made in 1741. The maker's mark is that of Paul Crespin, but in all probability this epergne was fashioned by Nicholas Sprimont. It should be made quite clear that though all epergnes were used on occasions as centrepieces, by no means all centrepieces may be described as epergnes (**264** and **269**). A number of examples with bells and canopies were made in the Chinese Rococo manner (**267**). The form changes radically by 1800 (**270** and **271**), only to reappear as an ideal vehicle for the Victorian desire for realism (**272**). From 1770 extra pieces, in the same manner, often incorporating cut-glass are found *en suite* with the epergne. During the second half of the 18th century, Thomas Pitts, succeeded by his son, William, seems to have specialised in epergnes and finely pierced basket-work. An example of this firm's work, dated 1798–1802 stands, with extra pieces, on its own silver plateau (**269**). A rare Irish combined epergne and cruet frame, of approximately boat form, on four castors, made in Dublin in 1787, is in the Victoria and Albert Museum. Equally unusual is the one which has a base of rectangular galleried form, with an oval two-handled basket above, made by Robert Williams of Dublin in 1780. Even rarer is the Scottish epergne. An example made by Lothian & Robertson of Edinburgh in 1760, follows the Rococo form, popular in England ten years previously (Parke-Bernet Galleries, New York, 1968). Particularly interesting because of its wirework construction is the five-branched epergne made by Roberts Cadman & Co. of Sheffield in 1798, now in the Sheffield City Museum.

Bibliography

E.A. Jones, *The Gold and Silver of Windsor Castle*. Arden Press, 1911.

J.F. Hayward, 'A ''Surtoute'' designed by William Kent'. *Connoisseur*, March 1959.

Edith Gaines, 'Powell, Potts, Pitts—The T.P. Epergnes'. *Antiques*, April 1965.

G.B. Hughes, 'Silver Epergnes'. *Country Life*, May 19th, 1955.

See also Cruet; Plateau, Table.

Escallop Shell

The shell, one of numerous motifs, was popular with almost all designers, and those of the early 16th and 17th centuries were no exception. The escallop-shell form was used on many items and in particular was useful for the lids of spice boxes. Though probably made in some quantity, no early 17th-century dishes of shell form appear to have survived, excepting a ewer and basin of dolphin and shell form. Two sets of three are known, both probably made by Samuel Hood in 1675, one however bears a Sterling mark whose registration perished in the fire at the Goldsmiths' Hall in 1682. A pair at the Bank of England is hall-marked 1694. The shell-form dish returned to favour during the reign of George I, Lamerie being one of the most prolific makers of the heavy, cast, realistic variety; from then onwards to 1830 they were turned out in large numbers, though often of stylised form and of

thin material. A fine set of six, only one with the maker's mark of Peter Archambo, were made 1729 and form part of the Assheton-Bennett G to Manchester City Art Gallery. An interesting con temporary use is specified in the Garrard Ledger 'John Trevor Esq. 1740. To 5 Scollops for Oyste 16 oz. 5 dwts. at 6/1d. per oz. £4. 19. 2.'. A ra American example is one made by Daniel You Charleston (d. 1750). Four escallop dishes for part of an epergne made by Eliza Godfrey in 175 now in the Art Institute of Chicago (**265**).

Bibliography

Commander G.E.P. How, *Notes on Silver, no.* 1945.

G.B. Hughes, 'The Escallop Shell in Silver'. *Count Life*, November 6th, 1969.

Étui (Etwee)

Another word of French origin, thus many a silve smith in the 18th century was by no means su how to spell it. One trade card illustrates the objec but calls it a 'tweezer'. Essentially, however, th latter is correct for the étui is a case in which keep small objects safe. It was usual for a lady have one, pendent to a châtelaine (containin perhaps a note card, pencil, scissors, a miniatu spoon, bodkin or tweezers); the hinged cov retained by a press-button catch. A silver examp of *c*. 1750, incorporates a telescope, adjusted sliding the cover up and down its sleeve and wi shutters at either end to cover the two lenses. T instruments are placed round the hollow centre. gentleman would tend to have a plain, u decorated case, often covered with shagreen a without a pendent ring. His might contain instru ments, a measure, pencil or, if a doctor or surgeo a set of razor-like knives for blood letting. Larg cases of similar form were made to hold surveyo instruments and sets of shaving razors. A pa ticularly fine pair of cases for the latter, in silver-g and enamel, survive. Gold, enamelled and jewelle étuis are not uncommon. The best English example were made by toymakers such as James Cox. T majority of gold ones are Continental; in Engla as with snuff boxes, large numbers were made pinchbeck.

Ewer and Basin

These were among the most important pieces medieval plate and only relegated to the sideboa on the introduction of the fork in the 17th centur The basin with its attendant ewer, seldom regarde as inseparable by the Tudors, was essential, due the fact that the diner found it continuous necessary to wash his food-covered hands, usual with scented water. Though the ewer of 'Helm Fation' was known in 1520, the earliest type basically of a tapering, cylindrical form, based on circular foot and usually with a cover. The spout attached to the body for its whole length and ru from base to lip; the flattened cover often bears enamelled medallion similar to that decorating t central boss of the basin. Both will have decorate bands occupying roughly an equivalent area to th left undecorated. One of the earliest surviving pa is dated 1545 and is at Corpus Christi Colleg Cambridge (**273**). The sister College at Oxford pr serves the earliest basin, dated 1493, whilst the is a fine pair of 1562 at Winchester. Guildfo Corporation possesses a similar ewer. The mediev word laire or the French word, *laver*, may applied to either or both the ewer and basin.

The next type is the vase-shaped ewer (**274**). general it has a narrow neck, the body of shap outline; the handle is usually formed as a caryat figure or writhing beast. A variant, with long cur

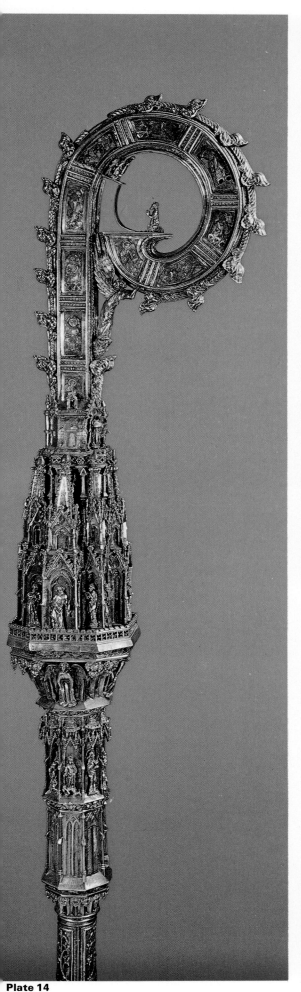

Plate 14

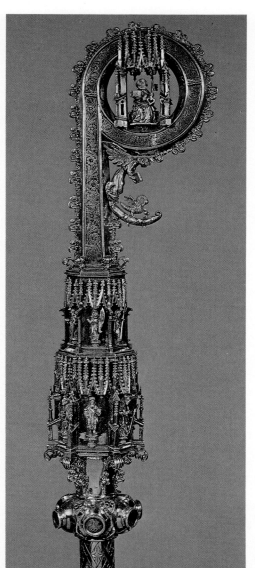

Plate 15

Plate 16

Plate 14 William of Wykeham's Crozier
Silver-gilt and enamel crozier of the second half of the 14th century. Presented to New College, Oxford, in 1403.

Plate 15 Bishop Fox's Crozier
An unmarked silver-gilt and enamel (niello) crozier, *c.* 1490.
Length 71¼ in. (181·0 cm.).
The figure within the crook is that of St Peter.
Corpus Christi College, Oxford.

Plate 16 Bishop Fox's Chalice
Gold.
Maker's mark, a lily.
Hall-mark for 1507.
Height 6 in. (15·3 cm.).
Corpus Christi College, Oxford.

123

Plate 17 Chocolate Pot
Maker's mark of Edward Winslow of
Boston, Massachusetts, c. 1720.
Height 9¼ in. (23·2 cm.).
Metropolitan Museum of Art, New
York, bequest of A.T. Clearwater, 1933.
Plate 18 Monteith
Maker's mark of John Coney of
Boston, Massachusetts, c. 1700.
Diameter 11 in. (28·0 cm.).
Engraved with the Arms of Colman.
Yale University Art Gallery,
Mabel Brady Garvan Collection.

Plate 17

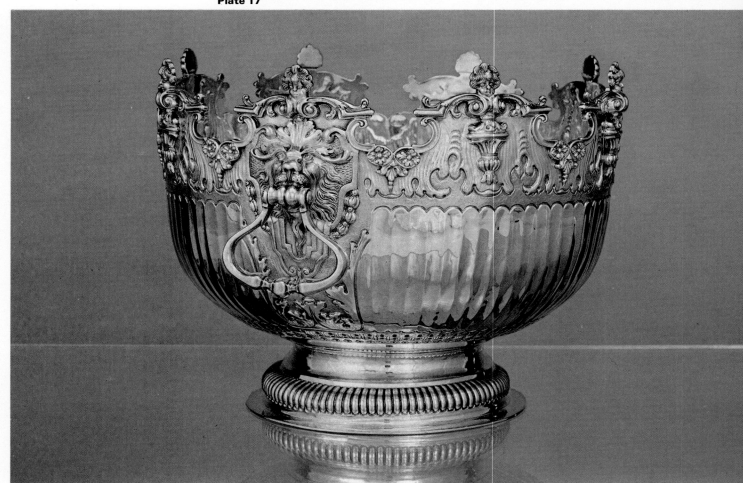

Plate 18

258

259

260

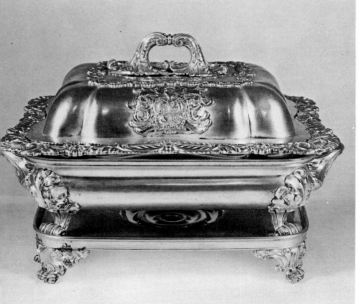

261

**258 Entrée Dishes
and Covers**
Maker's mark of Frederick Kandler.
Dishes: hall-mark for 1758.
Covers: hall-mark for 1769.
Engraved with the Arms of Meynell
quartering Poyntz and Littleton
impaling Booth.

259 Entrée Dish and Cover
Maker's mark of Boulton &
Fothergill.
Hall-mark for 1777, Birmingham.

260 Entrée Dish and Cover
Maker's mark of Paul Storr.
Hall-mark for 1799.
Diam. $9\frac{1}{2}$ in. (24·2 cm.).

261 Entrée Dish and Cover
One of a set of four; silver-plated
stand and heater.
Maker's mark of Edward Farrell.
Hall-mark for 1820.
Width $12\frac{1}{2}$ in. (31·8 cm.).
Applied with the Arms of Sir Jacob
Astley, 5th Baronet.

262 Epergne
Maker's mark of Paul Crespin.
Hall-mark for 1742.
Height 8¾ in. (22·3 cm.).
Width 14¾ in. (37·5 cm.).
Engraved with the Arms of Thomas
Watson-Wentworth, Earl of Malton.

263 Epergne
Maker's mark of Parker & Wakelin.
c. 1750.
Engraved with the badge of the
Prince of Wales.

264 Epergne
Maker's mark of J. Parker &
E. Wakelin.
c. 1760.
Height 20 in. (102·9 cm.).
Museum of Fine Arts, Boston.
Applied with the Arms of Powlet,
Dukes of Bolton, for Charles, 5th
Duke of Bolton. Unfortunately the
1760 Ledger of the firm has not
survived.

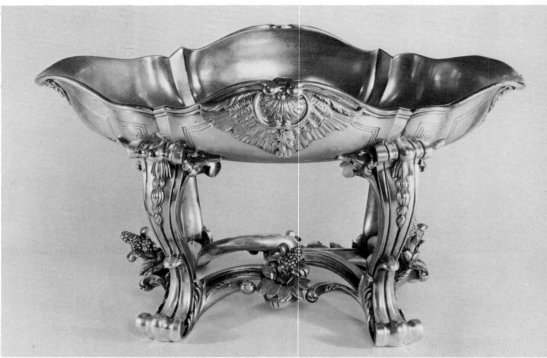

262

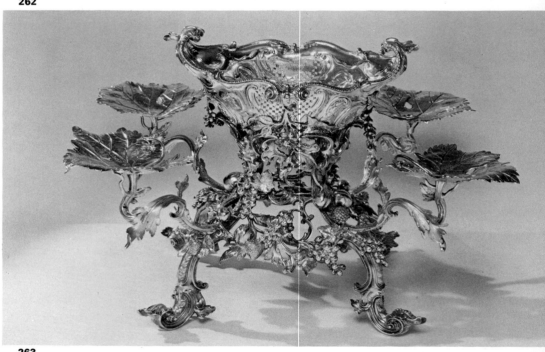

263

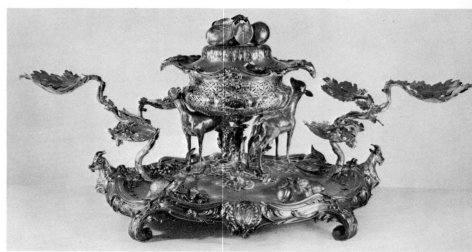

264

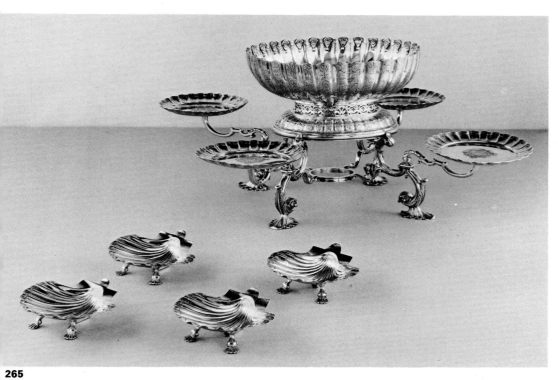

265

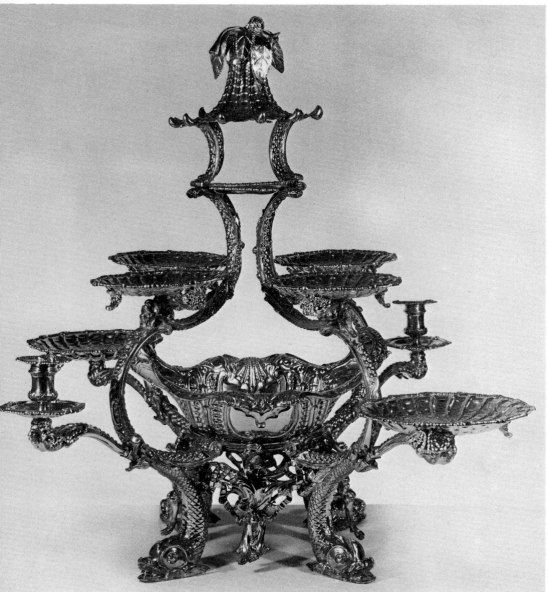

266

265　Epergne
Maker's mark of Eliza Godfrey.
Hall-mark for 1755, London.
Central bowl: height 5 in. (12·7 cm.).
Stand: 10 in. (25·4 cm.) square,
at the base.
Art Institute of Chicago.
It has alternative branches (not
shown) which fit into the sleeves
beneath the shell dishes.

266　Epergne
Maker's mark of Thomas Heming.
Hall-mark for 1753.
Height 24¾ in. (62·9 cm.).
Engraved with the Arms of Grenville
quartering Temple, Nugent and
another with Nugent in pretence.
With interchangeable candle sockets
and dishes to the lower branches.

267 A Chinoiserie Epergne
Maker's mark of Thomas Pitts.
Hall-mark for 1762.
Height 23¾ in. (60·4 cm.).

268 Centrepiece
Silver-gilt.
Maker's mark of J. Wakelin &
R. Garrard.
Hall-mark for 1797.
Width 15¼ in. (38·8 cm.).

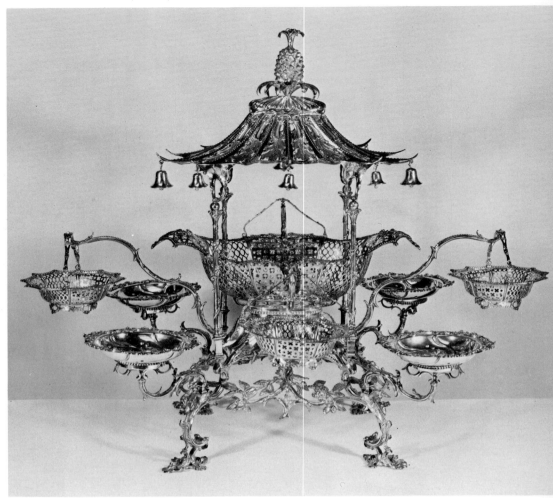

267

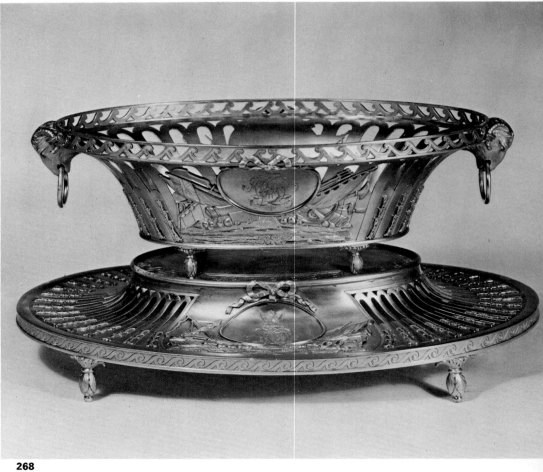

268

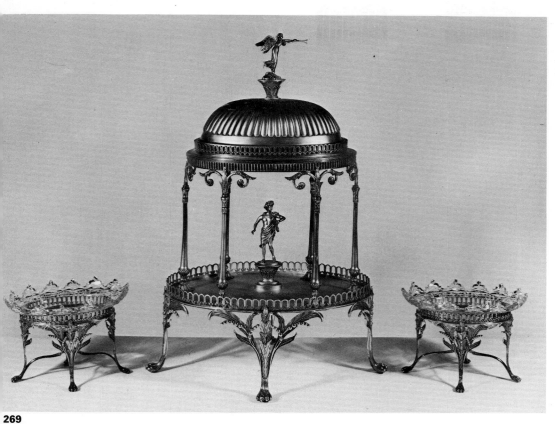

269

269 Centrepiece
Maker's mark of W. Pitts & J. Preedy.
Hall-mark for 1799.
Height 21¼ in. (54·0 cm.).

270 Centrepiece
Maker's mark of Digby Scott &
Benjamin Smith.
Hall-mark for 1806.
Height 22½ in. (57·2 cm.).
Engraved with the Arms of Richard,
1st Earl Howe.

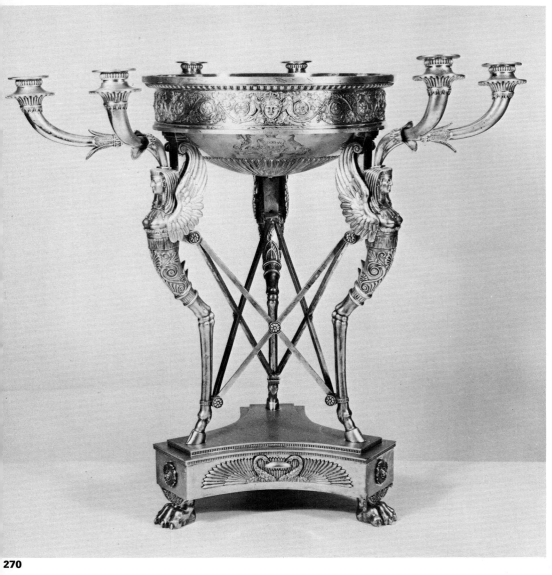

270

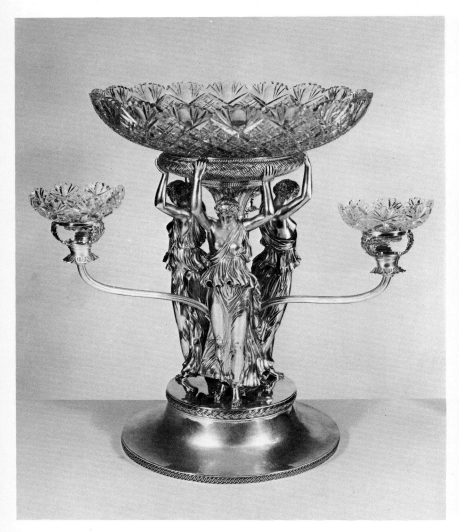

272

271 Centrepiece
With cut-glass bowls.
Maker's mark of Paul Storr.
Hall-mark for 1809.
Height 20 in. (50·8 cm.).

272 Centrepiece
With cut-, engraved and frosted-glass bowls and candle shades.
Maker's mark of Robinson, Edkins & Ashton.
Hall-mark for 1838, Birmingham.
Height 20 in. (50·8 cm.).

273 Ewer and Basin
Maker's mark, a queen's head.
Hall-mark for 1545.
Ewer: height 8⅝ in. (22·0 cm.).
Basin: diam. 18 in. (45·8 cm.):
Corpus Christi College, Cambridge.
Applied with the Arms of Christchurch, Canterbury, impaling those of Archbishop Parker.

273

274

275

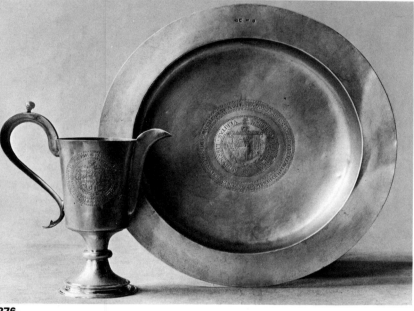

276

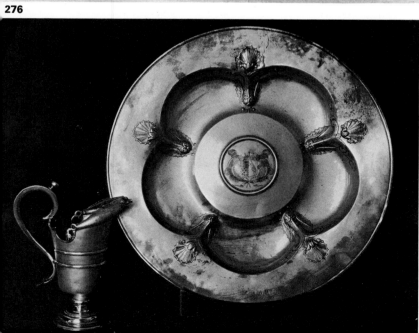

277

278

274 Ewer and Basin
Maker's mark, IN.
Hall-mark for 1592.

275 Ewer and Basin
Maker's mark, TF conjoined.
Hall-mark for 1618.
Ewer: height 14¾ in. (37·5 cm.).
Basin: diam. 16¾ in. (42·6 cm.).

276 Ewer and Basin
Maker's mark, SV, probably the
mark of Walter Shute.
Hall-mark for 1632.
The engraved arms are copied
from an earlier piece.

277 Ewer and Basin
Maker's mark, TB in monogram
within a shield.
Hall-mark for 1638.
Ewer: height 11¾ in. (29·9 cm.).
Basin: diam. 23¼ in. (59·1 cm.).
The ewer has an unusual triple
spout.

**278 The Howard Ewer
and Basin**
Silver-gilt.
Maker's mark, IV and a star below.
Hall-mark for 1617.
They were presented to the
Corporation of Norwich in 1663.

spout may have been inspired by Chinese porcelain, but almost certainly came by way of the Continent to England, from Portugal. Amongst the earliest of this form is the Wyndham Ewer of 1554, though perhaps the finest is that made in 1567, engraved with Old Testament scenes in the style of Pieter Maas, and amongst the Ruxton Love Loan to the Metropolitan Museum of Art, New York. The agate and silver-gilt ewer (1580) and basin (1581) in the collection of the Duke of Rutland illustrate to what degree these were inspired by Italian or Flemish silversmiths. The basin was perhaps made in Antwerp, imported and marked in England. A particularly large example is that of 1604 in the Museum of Fine Arts, Boston. Large numbers of ewers and basins were probably made in Nuremberg, Germany, and marked in England on importation, those at Norwich made in 1617 may well, among many other pieces, be a case in point (**278**). These, of which considerable numbers have survived, are often finely decorated with masks, strapwork, fruit and Classical or Biblical scenes. Such is the ewer and basin of 1618 belonging to the Middle Temple, which is entirely Portuguese in inspiration. The demand for them, however, induced a supply which included a number of very mediocre specimens such as that illustrated on Plate **275**.

The invariable rejection which seems to follow any excess is now clearly indicated by the arrival, during the reign of Charles I, of a third type, usually quite plain and of beaker form, often with a rib round the body (**277**) and of this type the ewer, dated 1610, at Eton College is exceptionally early. One of the finest, of this early Stuart type, is the pair (**276**) probably made by Walter Shute in 1632, in the Cassell Collection, brilliantly engraved with a coat of arms copied from the original piece which this ewer and basin obviously replaced. The ewer is also noteworthy in that a spherical button thumbpiece projects from the top of the handle, a feature found on a number of handles at this date; similar handles being supplied for ewers, flagons and jugs by specialist makers. The form extends through the Cromwellian Commonwealth period to the reign of Charles II, when the long lip spout (similar to that on the earliest type) becomes a mere indentation on the lip and the handle, once S-shaped, becomes harp-shaped. An exception to the rule is the fine gilt ewer with a long body spout and harp-shaped handle, made in 1671, bearing the Arms of Mary Stewart, Duchess of Richmond, now in the Art Institute of Chicago. Occasional covered examples are found. That in the Royal Collection has the maker's mark only of Francis Garthorne (the rare punch in which his name is spelt out in full). Charles II's marriage to Catherine of Braganza brought but a slight Portuguese influence of which the lobed, so-called 'Belton' dishes are an example. At the end of the 17th century the helmet form, sometimes with rising terminal figure handles, was revived by the Huguenots (**279**). The set bearing the applied Arms of Anson, made by Lamerie in 1726, weigh no less than 500 ounces. On occasion the basin is oval, probably made as part of a shaving or toilet set, as indeed were most, being of the bowl rather than shallow-dish form, such as those made by Daniel Garnier in 1697 for James, 1st Duke of Montrose. This type terminates in the Rococo example of 1742 made by Paul de Lamerie, belonging to the Goldsmiths' Hall. However, the finest Rococo example of all is that by George Wickes, c. 1740, having a ewer of vase form, the basin bearing medallion heads, perhaps of the twelve Caesars; another such ewer and basin, probably by the same maker, though unmarked, are

illustrated by Sir Charles Jackson on pp. 298 and 585 of his *An Illustrated History of English Plate*. Examples in the Classical style made by Phillip Rundell in 1822 are now in the Royal Collection. During the reign of George IV the taste for massive plate is exemplified by Plate **280**. From the Restoration onward a few small examples are found with the ewer approximately 6 in. (15·3 cm.) high and the basin of deeper bowl form. These probably all originate in toilet services long dispersed. A gold example made by Pierre Platel in 1701 is amongst the collection of the Duke of Devonshire (Colour Plate **29**). A particularly magnificent ewer and basin, 27½ in. (69·9 cm.) in diameter, were made by John le Sage in 1725 for Sir Michael Newton of Barrscourt. An even larger suite were those made in Dublin by John Humphreys in 1693 for the Viceroy, Lord Sidney; these are gilt and engraved with the Arms of Sidney. An extremely interesting, but very ugly, ewer is the silver-mounted, rock-crystal example made by George Heriot of Edinburgh (1568–85). Traditionally this ewer, 9½ in. (24·2 cm.) high, was presented to the Regent of Scotland, John, 1st Earl of Mar, by Queen Elizabeth I, but whether for use at or to mark the baptism of one of his children is uncertain. Some of the latest ewers and basins are those made for Jewish ceremonial use.

Bibliography
C.C. Oman, *English Silver in the Kremlin*. 1961.
J.F. Hayward, 'The Mannerist Goldsmiths', part IV. *Connoisseur*, January 1967.
See also Alms Basin; Dish; Jewish Ritual Silver; Jug; Shaving Set.

Exeter Assay Office

Though not mentioned in the Statute of 1423, it would seem probable that goldsmiths were working in Exeter from an early period. In fact it is likely that a Royal Charter, now lost, could have been their only justification for existing during the 16th and 17th centuries, from which period a quantity of Exeter-marked plate has survived, including a font cup by Richard Hilliard, made c. 1560 (see Cup, Standing). A considerable amount of the work of silversmiths of Barnstaple, Plymouth and the neighbouring towns came to Exeter. At this period the Exeter mark was a crowned or uncrowned X (a). The Parliamentary Act of 1697 did not stop the working of silver in the West Country (the Eddystone Salt was made after this date), but immediately it became possible, in 1701, an official assay office was set up. The Act provided that the Arms of Exeter, a triple-towered castle (c), should become the hall-mark. Some Exeter silver of this early 18th-century period is second only to the finest London work. In 1777 Exeter discontinued the use of the leopard's-head mark and by 1850 the assay office was so little utilised that its closure in 1883 was no surprise. To judge from the records the remarkable thing is that it survived for so long, for in 1773 the then assay master admitted that 'he had never received instructions from any man living how to assay'! An interesting aspect on local customs comes to light when one considers Exeter and West Country silver. During the 16th and 17th centuries most makers in this area spelt their names in full on a piece of silver of their own making. Although this custom originated in the West Country, American Colonial silversmiths often emulated this practice.

a b c. 1690 c

Bibliography
Sir C.J. Jackson, *English Goldsmiths and The Marks*. 2nd Edition 1921, reprinted 1949.
See also Provincial Goldsmiths (English).

Extinguisher (Podkin)

The commonest form is conical, usually retained with its accompanying hand candlestick by means of a lug to one side fitting into a slot provided on the candlestick. A later form, for use with candles which have the tall glass, draught excluder, has a long wire stem extending from the top of the cone, usually with a ball or ring finial. This sometimes fits over a conical projection on the saucer of the candlestick. Another form is a tube with trumpet-like mouthpiece, though these were more often used to extinguish spirit lamps beneath kettles.
See also Douter; Snuffer Scissors.

Eye-bath

Made in silver, usually as part of the fittings of a toilet service in the 19th century, the form is unchanged to this day. An example engraved WI with the maker's mark only, I.P., is in a private collection and dates from about 1800. Reversible Continental examples are known for use as a salt cellar or egg cup, one bowl being oval the other circular. An eye-bath in gold made by T. & J. Phipps in 1820 was in the Noble Collection.

Fairing See Bartholomew Fair.

Fakes

Fortunately very few real fake objects, made with the deliberate intent to deceive, lie in wait for the collector of English silver. The fake was normally based upon an earlier form. Plate **281** shows two standing bowls which are the product of one of the best metalworkers of the late 19th century, Marcey, who possessed considerable knowledge and ability. Pieces such as these, and fine gold and silver-mounted medieval sword hilts, have found their way not only into private, but also into public collections. Plate **282** shows an object which purports to be an Elizabethan tankard of 1569; the cylindrical neck and cover clearly bear the full London hall-marks for that year and it was made from a communion cup and paten cover, the remainder, however, is entirely 19th century.
See also Duty-dodgers; Forgery.

Fan Handle

During the 16th and 17th centuries these were not uncommon but silver examples seem to have completely disappeared during the 18th century, with the result that they are extremely rare today. One, 16th-century date, designed by Hans Holbein is now in the Schatzkammer at Munich. Other than this example, one must rely on contemporary portraits. One such portrait of Mary Cornwallis by George Gower (d. 1596) is in the Manchester City Art Gallery; it shows her holding a fan with a silver-gilt handle engraved with her arms. The fan itself appears to be of ostrich feathers.
See also Holbein, Hans.

Feather-edge

A form of bright-cut engraving, giving the effect the name describes. It was usually applied to table silver. Feather-edge was most popular from 1770 to 1790 but could easily be applied at a later date.

Feeding or Strainer Tube

Scroll shaped, closed and pierced at one end and with a hook fixed half-way down its length, the

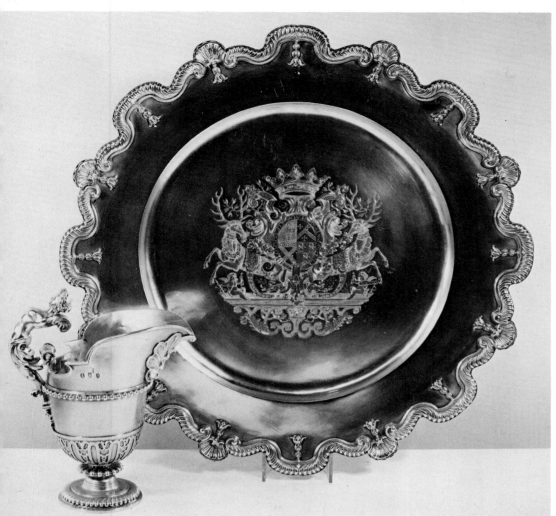

279

280

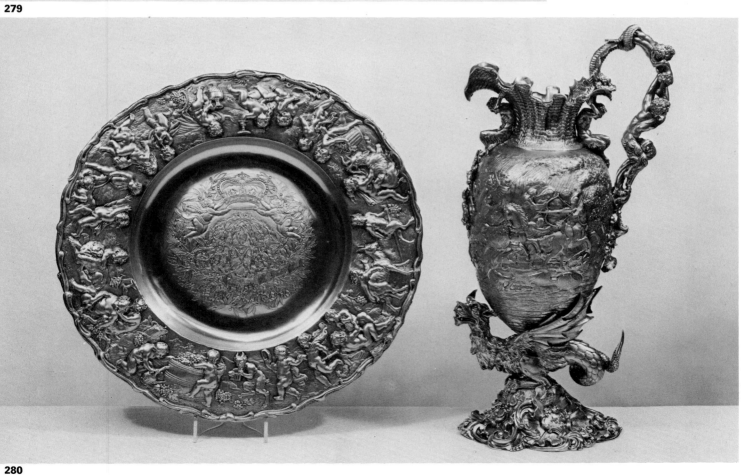

279 Ewer and Basin
Maker's mark of Pierre Harache.
Hall-mark for 1697.
Ewer: height 12 in. (30·5 cm.).
Basin: diam. 26 in. (66·1 cm.).

280 Ewer and Basin
Silver-gilt.
Ewer: one of a pair.
Maker's mark of Edward Farrell.
Hall-mark for 1824.
Height 23 in. (58·5 cm.).
Basin: one of a pair.
Maker's mark of E. Farrell.
Hall-mark for 1825.
Diam. 19 in. (48·3 cm.).

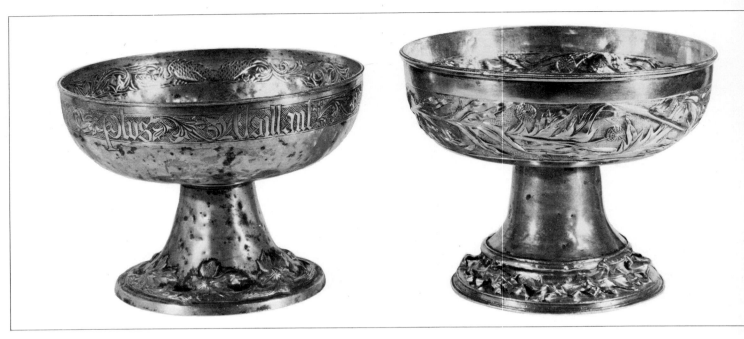

281 Fakes
Two cups, supposedly of *c.*
1500, were in fact made by
L. Marcey about 1900.

282 Fake
The upper beaker-shaped section
of this Elizabethan tankard was
probably made from a communion
cup of 1569. The remainder,
however, is of 19th-century date.

282

eding tubes were most probably more commonly nown as 'cobbler tubes', though they could be sed for any other liquid or semi-liquid food. They enerally date from c. 1800 and are of American anufacture.

ee also Cobbler Tube.

estoon

decoration which was frequently used on plate, incipally in the 16th century and during the Neoassical revival of the 19th century. It basically nsisted of a garland of fruit or flowers, suspended om each end and also sometimes in the middle, us making a balanced motif.

gure See Statuette and Model.

iligree

most an art form in itself; the openwork panels of crolling silver or gold, beads and wirework being rmed in geometric or foliate ornament. These anels were made into boxes, trays, candlesticks, iniature frames, and even occasionally knife andles. This work seems to have caught the nagination of all Europe during the late 17th ntury, though used at an earlier date. Unrtunately, by their very nature, filigree objects ldom incorporate any flat surface large enough r the striking of a mark. Origin is therefore almost ways based on the style and a matter of opinion **20**). Filigree-work was produced in almost every ontinental country and is perhaps best documented in Scandinavia. A comb box with filigreeork, and part of a toilet service, formerly in the alifax Collection, is probably English, c. 1680. In e Noble Collection there is a small cylindrical atch box of great rarity made by William Clark of lasgow, c. 1695. A notebook cover of about 1650 ith applied panels of filigree is illustrated on Plate **45b**.

By the early 18th century the demand for this ork seems to have receded. Pieces of later date e usually Oriental, enormous quantities being ought back from India during the 19th century, hen the taste for it was revived. A pair of silver igree-mounted bellows, which were noted by Valpole, still survive at Ham House, Surrey.

illet

arrow flat band, often between two mouldings.

inial

n architectural description of an ornament placed oon the apex of a roof. Used also for that on the over of a cup and the end of the stem of a spoon.

ire-dog See Andirons.

ire-irons (Poker, Shovel, Tongs, etc.)

he Chimney Furniture's of plate, for Iron's now uite out of date', so wrote John Evelyn in The ady's Dressing Room in 1690. Though he was erhaps being satirical, this was, in many cases, ue from the Restoration period onwards. In a umber of places such as Ham House, Burghley nd Knole, such pieces, usually of iron, either artly or entirely silver-covered, remain as witness this change of fashion. Indeed, there is a set of x such fire-irons at Ham House. There is also a ctangular ash-pan with silver mounts of about e same date, together with a hearth brush and a lver-mounted iron pole fire-screen. Bellows ecorated with marquetry and/or silver also surve. A pair of bellows, perhaps the earliest, can so be seen at Ham House. It is worth noting at a number of imitations, if not outright for-

geries, exist. Such fake pieces were normally made about 1900.

Bibliography

C.C.Oman, 'Sir Joseph Williamson'. Apollo, November 1953.

H.A.Tipping, 'Chimney Furniture at Ham House'. Country Life, vol. XLVII, p.448, 1920.

See also Andirons; Bellows.

Fish Dish See Mazarine.

Fish Dryer See Mazarine.

Fish Server or Pudding Trowel

The middle of the 18th century saw the introduction of a number of novelties, whereas previously the tendency had been to experiment and 'make do' with objects designed originally for other purposes. Amongst these novelties was the 'Pudding Trowle', such as the one supplied to the Earl of Kildare by Messrs Wakelin in 1745 (Wakelin Ledgers). The 'trowle' normally consisted of a triangular blade, which was pierced and sawn to various designs; that this should also be used for fish as well as pudding soon became obvious and by the 1770s, when it was suddenly fashionable to eat whitebait, a large number were not only fishshaped in outline but also pierced and chased to represent one. The earliest George II trowels usually have solid silver handles and there is one such example in the Farrer Collection, Ashmolean Museum, Oxford, made by Paul de Lamerie in 1741. Later, turned and stained ivory handles became the rule. By the 19th century a fish slice was supplied with almost every service of table silver (flatware) and the handles naturally were of the same pattern as the rest of the plate. A quite exceptional fish slice and fork are those having blades pierced and shaped as fins, made by George Adams in 1850, now in the Victoria and Albert Museum.

See also Trowel.

Flagon or Livery Pot

The word 'flagon' in the late 16th century was used to describe a container of baluster or bottle form with chain handles and with a detachable stopper. Nearly all survivors are now in the Kremlin, Moscow, a pair dated 1580, another two pairs dated 1606 and 1619 respectively; most are at least 18 in. (45·8 cm.) high. Like much postReformation plate, the dividing line between secular and ecclesiastical was very slight, that is until the end of the 17th century. Many of the 'Livery Potts', which we today refer to as 'flagons' (in 1619 they were known as 'stoops'), were first made for secular use and only presented to the Church at a later date. One, of 1609, with curved spout, at Hadley Monken, was not presented until 1619. Those formerly at Westwell, Kent (1594 and 1597), did not come to the parish until 1630. The earliest surviving livery pot appears to be the pearshaped form on a trumpet foot dated 1572 at Wells Cathedral, Somerset. A yet more elongated pair of 1577 are at Cirencester, besides a pair at Minster, Cornwall, dated 1588 (**285a**); another of 1606 survives at Holy Trinity, Hull. Others are preserved in the Kremlin (the small variety will be found referred to under Tankard). Best known because the form survived into the 19th century, is probably the cylindrical type; a fine pair made in 1598 are at Corpus Christi College, Oxford. These were sometimes chased or engraved with the conventional ornament of the day (**284**) and the lipped variety appears contemporaneously. St John's College, Oxford, has pairs of pear-shaped examples dated

1605 and 1633. Not until c. 1640 does the use of the word 'flagon' become general. The superb Thirkleby cylindrical pair of 1646 are now split, one at Temple Newsham, Leeds, one in the Victoria and Albert Museum, London (**285b**). A remarkable pear-shaped variety with straight or curved spout of Elizabethan form reappears between the years 1605 and 1620 (**283**). The 'feathered' flagons made for the Coronation of Charles II (1661) seem to owe their decoration to memories of their predecessors (**287**). After the Restoration, the cylindrical flagon may be plain (**286**), or decorated with large acanthus flowers and foliage. By 1670 the jug shape, otherwise unfamiliar until the middle of the 18th century, begins to appear, though rarely as a secular form. None the less, Paul de Lamerie was still producing the plain, cylindrical flagon in 1727 as were other makers, even as late as 1768 (**288**). Several variations on the theme of the contemporary wine jug (seldom however with a spout) were produced in the first quarter of the century. Other than size, there is little difference between the flagons made for Durham Cathedral by Butty & Dumee in 1766 and the secular hot-water jug of that day. In fact, in a number of churches, the flagons are no more than hot-water jugs. The awkward lines of the otherwise superbly fashioned flagons made by Paul Storr, were in turn surpassed by the Gothic extravaganza of A.W. Pugin, all too often so diluted by the goldsmith as to be almost unrecognisable.

Bibliography

C.C.Oman, The English Silver in the Kremlin. 1961.

J.Gilchrist, Anglican Church Plate. Connoisseur/ Michael Joseph, 1967.

A.J.Collins, Inventory of the Jewels and Plate of Elizabeth I.

See also Haunch Pot; Pilgrim Bottle; Water Pot.

Flagon Ring

Chester Parish Church (St Mary-without-theWalls, Handbridge) possesses a flagon and flagon ring, which were purchased through Thomas Robinson of Chester in 1712. The flagon was made by N. Locke of London, but Robinson made the ring to accompany it. The ring is formed as a rim 9¾ in. (24·8 cm.) in diameter, having three legs joined to a lower ring, the total height is 2¼ in. (5·7 cm.). It bears Chester marks for the same year.

Bibliography

T.S.Ball, Church Plate of the City of Chester. 1907.

Maurice H. Ridgeway, Chester Goldsmiths. Sherratt, 1968.

See also Dish Ring.

Flask

Late 19th-century spirit flasks are by no means rare, being made, on occasion, of silver and glass and usually having a detachable lower half for use as a cup. Their popularity is probably due to the rediscovery of the pleasures of hunting at the turn of the 18th century. Earlier than 1800 flasks are rare. A silver-gilt example made by J. Cuthbert of Dublin and engraved with the cypher of William III must date from about 1690, when that Monarch was himself in Ireland (the royal cypher not being used on ambassadorial plate). A Scottish flask, 8 in. (20·4 cm.) in height, was made by Lothian & Robertson of Edinburgh in 1751; this flask has a detachable oval beaker forming the base and is fitted with a screw-cap. Another, without a cup, was made by Hester Bateman in 1785. Messrs Wakelin supplied George Rice with 'a brandy flask' in 1758 and Sir William St Quintin with another in 1771. An unmarked flask, the gift of Lady Harley to 'Jno. Morley Esq. at Halstead in Essex. 1720.', is of

283

284

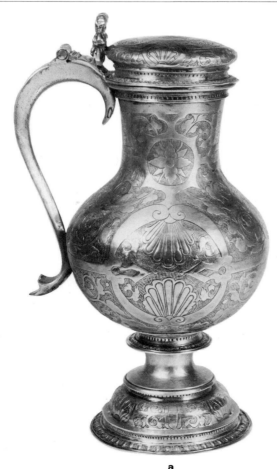

a

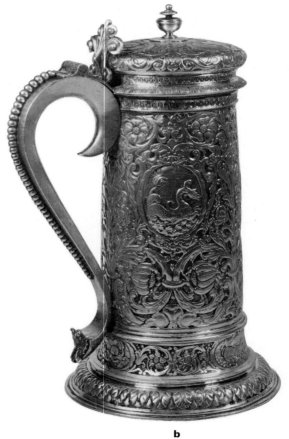

b

285

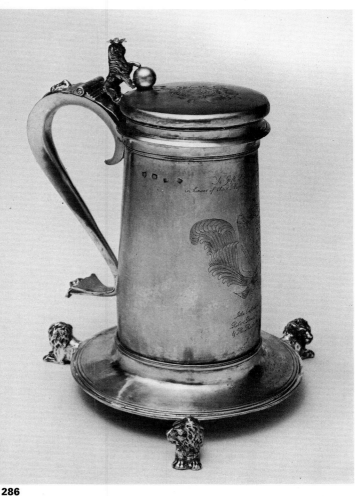

283 Flagon
Maker's mark, IA with two pellets
above.
Hall-mark for 1606.
Tong Parish Church, Shropshire.
284 Flagon
Silver-gilt.
Maker's mark, IA.
Hall-mark for 1607.
285 Flagons
a. Silver-gilt, one of a pair.
Maker's mark, HC with a hand and
a hammer between.
Hall-mark for 1588.
Height 11¼ in. (28·6 cm.).
Minster Church, Cornwall.
b. One of a pair.
Maker's mark, hound sejant.
Hall-mark for 1646.
Height 10 in. (25·4 cm.).
Once at Thirkleby Church,
Yorkshire, one now at Temple
Newsham, Leeds, the other in the
Victoria and Albert Museum.
Arms of Tyssen (Francis), a London
merchant.

286 Flagon
Maker's mark, IS with a rosette
below.
Hall-mark for 1663.
Height 14 in. (35·6 cm.).
Engraved with the Arms of the City
of Norwich and an inscription which
records its being presented on the
occasion of Charles II's visit to the
city.
287 Flagon
One of a pair.
Maker's mark of Charles Shelley.
Hall-mark for 1664.
Height 20¼ in. (51·5 cm.).
A 'feathered' flagon part of the
Coronation Plate. The cover is
chased with a monogram, D L,
possibly for Lionel Sackville, Duke
of Dorset.
288 Flagon
Hall-mark for 1768.
Height 14¼ in. (36·2 cm.).
Engraved with the Arms of Crawley.

286

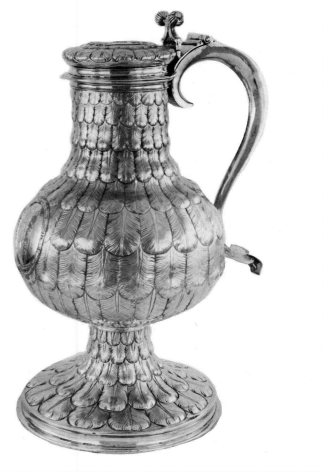

287

288

137

particular interest in that the screw stopper may be reversed to extract the neck plug.

Bibliography

Commander G.E.P. How, *Notes on Silver, no. 3.* 1943.

David S. Shure, *Hester Bateman*. W.H. Allen, London 1959.

See also Casting Bottle; Pilgrim Bottle.

Flaxman, John, R.A. (1756–1834)

A painter and designer, he obtained the Silver Medal of the Royal Academy in 1770. John Flaxman was responsible for a number of important designs produced for Rundell, Bridge & Rundell including the Trafalgar Vase (**216**), the Shield of Achilles commissioned in 1818 and two candelabra of 1809 in the Royal Collection, besides the National Cup made for George IV in 1824. The design for this latter, having the figures of St George, St Andrew and St Patrick, together with the national emblem, is in the Victoria and Albert Museum. The same Museum contains a number of other drawings executed by Flaxman under the commission of Rundell, Bridge & Rundell. A tea service engraved 'Designed by John Flaxman for his esteemed friend and generous patron Josiah Wedgwood 1784', though known to have been made, is untraced. Flaxman worked for Wedgwood from 1775 to 1787.

Bibliography

E.A. Jones, *The Gold and Silver of Windsor Castle*. Arden Press, 1911.

See also Achilles Shield; Rundell, Bridge & Rundell.

Fluting

Half-round parallel channels, vertical, oblique or curved, derived from Classical architecture, and usually embossed on plate. It serves to add rigidity to a flat surface.

Font

In general, originally designed for royal use, that used for the christening of Prince Arthur at Winchester in 1486 was sent from Canterbury, but this particular font seems to have perished by 1550, so that Queen Mary I ordered another to be made. She never had cause to use it, and this, perhaps last used in 1633, disappeared with the rest of the Royal Plate during the Civil War. A replacement, now amongst the Regalia, was ordered in 1660. Queen Elizabeth I replaced a brass font looted from the Chapel of Holyrood House by one of gold weighing 333 ounces. A general feeling, backed by a Royal Command in 1560, against private baptism relaxed only slightly in the 18th century, when a small number of bowls, some large enough to occupy the whole font, others little more than sugar basins, came to be numbered amongst the plate of various churches. A gold font, surrounded by the figures of Faith, Hope and Charity was made by Paul Storr in 1797 for the christening of the then Duke of Portland's heir. A final example made in 1840 is amongst the Royal Plate at Windsor.

Bibliography

J.G. Davies, *The Architectural Setting of Baptism*. Barrie & Rockcliff, 1962.

See also Bowl, Christening.

Forgery

Any precious object is bound to be imitated, and from early times the protection of the public from forgers has been the concern of the Government. Since 1300 the Government has exercised its control through the Worshipful Company of Goldsmiths (see Hall-mark). Conviction could involve severe penalties during the 16th century. The pillory and the severing of an ear being the punishment for a minor forgery offence, in addition to a substantial fine.

There are three main ways of forging hall-marks. One, by using false punches; two, by making a casting of the marks on a genuine article; three, by electrotyping. The use of false punches, when of brass, is usually detectable by the softer outline in the details of the punch. When of steel it is more difficult to detect but usually some small detail reveals the fraud. Cast marks often have a granulated appearance and the metal seldom has any spring in it, besides which, if used for a set of anything, say forks or spoons, the position of each mark on each piece will be absolutely identical. Electrotyped marks are fortunately rare but can be detected with modern aids, such as the spectroscope. The transposed hall-marks are genuine marks, cut from a piece of old plate and inserted in a new piece, this is done for three reasons. One, to pass off sub-standard metal as standard; two, to make false antiquities out of modern articles (**282**) and three, to dodge the duty on silver, this last was more common practice between 1719 and 1758 when many pieces, such as casters, sauce boats and cups, are particularly suspect.

The addition of silver or base metal to a hall-marked article is, following the Act of 1844, illegal. Thus the selling of a piece, such as a tankard converted to a jug by the addition of an unmarked lip, is an offence. In other words the purpose of the piece has been altered and this is also illegal. Previously, however, this was not so and in February 1758, Peter Burrell paid his goldsmiths 2s 'to beating a lip out of a cann [mug] & altering & cover' (Garrard Ledgers, vol. 2). The refashioning of dinner plates in the 18th century usually involved the substitution of new borders, at the same time retaining the original marks especially when of Britannia standard, this practice is self-evident condemnation. Chasing or embossing added at a later date is not, of course, an offence. The Goldsmiths' Company has a large documentary collection of such illegal pieces and will submit any doubtful piece to the Antique Plate Committee which meets under its auspices. One other method of forgery is the making of an object in base metal and then gilding or silvering it, so as to give the impression, even if not advertised as such, that the whole is of bullion. A fine font cup of latten, now in the Victoria and Albert Museum, dating from *c.* 1510, retains traces of gilding and would have been considered illegal by Wardens of the Goldsmiths' Company of that day, although it bears no marks.

Bibliography

Commander G.E.P. How, 'Electroplating. Antique Silver'. *Connoisseur*, vol. CXXIV, 1949.

Commander G.E.P. How, 'Repairs and Restorations to Antique Silver'. *Apollo*, September 1950.

Commander G.E.P. How, 'Vandalism'. *Apollo*, October 1950.

C.C. Oman, 'The False Plate of Mediaeval England'. *Apollo*, March 1952.

Judith Banister, 'Forgers, Furbishers and Duty Dodgers'. *Apollo*, October 1961.

Judith Banister, *An Introduction to Old English Silver*. Evans Brothers, 1965.

Spurious Antique Plate. Goldsmiths' Company.

See also Duty-dodgers; Fakes.

Fork

Credit for the introduction of the fork to Europe is given to the Italians. The English, whose taste seems to have changed little over the centuries, regarded the use of such things, at best, as foppis Foreigners visiting this country, as late as the rei of Charles II, remarked upon the lack of su delicacy, as was common practice on the Con nent. The English continued to eat from the end the knife blade, but naturally there were exceptio The earliest English fork recorded is that of 163 with two prongs, in the Victoria and Albe Museum. That the nobility used them at an earl date is unquestionable. Lady Hungerford used fork for green ginger in 1523. Queen Elizabeth was possessor in 1574 of twelve spoons a 'XII fforks of silver and guilt, thre of them Broke These same ones also appear, unbroken, in 1550 and 1559 Royal Inventories. More often th not, these early forks would seem to have been su plied as a single item with a spoon, though in 16 'Belted Will Howard' of Nawath ordered a set ten. The stem of the fork emulated the form of t spoon. Three prongs appear in the 1680s and fc prongs, as a general rule, by the 1760s, though t four-pronged variety were known as early as 167 Early forks being difficult to come by, forgeries ma from early spoons are regrettably quite frequen found and great care should be exercised wh deciding on such a purchase, unless the forks from an undoubted source. Until *c.* 1770 the tin of early three- and four-pronged forks are usua round in section. American and Canadian forks a very rare indeed. There is a pair in the Museum Fine Arts, Boston, of about 1715. Scottish forks also uncommon from the 18th century. Two thre pronged examples from Aberdeen, *c.* 1710, recer appeared. By the middle of the 18th century it b came common to have knives and forks with st blades and two or three prongs. The silver handl were generally of pistol form, the early ones cast two halves, the later ones stamped out of th sheet and filled with a composition core. The latter, especially those of Sheffield make, havi the minimum amount of silver, are frequently very poor condition and whereas the early hand usually outlasted the steel fittings, the la examples, if subjected to damp, frequently bu and can seldom be re-used. Such handles, unle of 19th-century date rarely have more than t Sterling or Britannia standard mark together wi that of the maker. Specialist fork-makers known, Robson's *London Commercial Directo* of 1821 lists Francis Higgins as a 'Silver Fc manufacturer'. Fig.**XXIV** shows some of the stag in the development of the fork from the 15th to t 19th century.

Combined forks and spoons, generally fro travelling sets, are found during the late 17 century. An example made by Jesse Knip (166 1722) of New York, exists, another by Johann N is in the Museum of Art, Philadelphia. They are al known as 'succade' or 'sucket' forks. During th last half of the 18th century a large fork suitable f serving makes its appearance. Wakelin suppli one weighing 4 ounces to Peter Burrell on Ap 14th, 1774 at a cost of £1 13s 0d. Examples havir five or more prongs were probably intended f use with a salad.

Bibliography

G.B. Hughes, 'Evolution of the Silver table-for *Country Life*, September 24th, 1959.

See also Toasting Fork; Travelling Canteen.

Fountain Pen (and other pens)

One of the earliest recorded is that referred to Constantijn Huygens, Secretary and Paymaster King William III, on June 2nd, 1690: 'I returned her [Lady Golstein] a gold pen belonging to t Queen, which I had repaired'. Fountain pens a

entioned on a number of silversmiths' trade cards roughout the 18th century. Wickes & Wakelin upplied one in 1757 to Asheton Curzon at a cost f £2 10s 0d. In January 1758 Mr Colebrooke urchased a gold one from the same firm for the entical sum. A silver quill pen presented in 1789, s exhibited at St Fagan's, National Folk Museum of ales. Jno. Schaffer advertised his patent 'peno-raph or writing instrument' in 1826 as holding ough ink for ten to twelve hours writing. He also plies that King George IV had already purchased e.

ox Mask See Stirrup Cup.

reedom Box See Seal Box.

ret

repetitive pattern made up of straight lines inter-cting at right angles, derived from Classical reek architecture and much used during the assical revival; also called 'key pattern' and eander'.

rosted Silver

film of pure silver left on the surface of a piece ter the copper-silver alloy has been heated and pped in hot, dilute, sulphuric acid (all 'silver' ntains some base metal to render it suitable for shioning). This frosted surface makes a very fective background to highly polished details, hether white or gilt and was an extremely pular form of decoration between 1800 and 50.

unnel See Wine Funnel.

rniture

e richness of the furnishing of the houses of the eat during the 16th century entitles one to sup-se that a fair number of pieces were in existence corated entirely, or in part, with precious metals. England, however, most furniture was plain. enry VIII, none the less, possessed in 1520 a ver-plated mounting block and this survived at st into the reign of Queen Elizabeth I. Even rlier, in 1508, a silver-plated weaving stool was nongst the trousseau ordered for the Princess Mary hen her marriage to the future Charles V was a riously considered proposition. In 1619 'a ding table covered all over with silver plate in-aven' is recorded; this, and many others, pro-bly went into the melting pot as a result of the anges of fashion or the Civil War. However, the tal reaction of the late 17th century to the plain-ss of the Puritan régime led to the return of the e of silver for chairs, tables, beds, mirror sur-unds (**289**), torchères (gueridons), fire-dogs, le screens and indeed anything that could be hanced, either by being wholly encased or em-llished with silver. A pair of 'scriptors' at Ham use, Surrey, since 1679, are particularly rare. hilst much more must have been made little of s furniture has survived, the best-known pieces ing either at Knole House in Kent (the table 80, the gueridons 1676) or Ham House. In the llection of Her Majesty the Queen there is a le presented to William III by the Corporation of ndon, c. 1690 (**290**), and another smaller ample of about 1670 given by the citizens of ndon to Charles II. A wooden table, the top of ver superbly engraved by B. Gentot, is in the llection of the Duke of Devonshire and dates m c. 1695. There is also a much later tea table ted 1742 in the collection of the Duke of Port-d, whilst that made by Augustin Courtauld in

the same year is now in Moscow. The throne and footstool in the Hermitage, Leningrad, were made by Nicholas Clausen in 1731 – 'a magnificent Silver Chair of State, adorn'd with an Imperial Crown, and a Spread Eagle, etc., gilt with Gold, made here for the Throne of the Empress of *Russia*, was finished's this Month. The Work cost near as much as the Metal, which weigh's 1900 Ounces', *Gentleman's Magazine*, July 31st, 1732 (vol. II, p.875). The great silver bed made by John Cooqus in 1674 for 'Madame Guinne' (Nell Gwynn) demanded 2,265 ounces of metal; it has perished but the bill sur-vives and has been published. Contrary to the general rule, those rare tables made for tea kettles are of solid silver, sometimes with an iron core. A Sheffield plate table of about 1825 is in the Sheffield City Museum and another, of single pedestal form, is in a private collection. In the Metropolitan Museum of Art, New York, are a table, mirror and pair of gueridons of c. 1715, silver-mounted in the fashion of thirty-five years previous to this approximate date. A small number of pieces of furniture of the mid 18th century, with applied silver handles and coats of arms, either cast or en-graved, have also survived, including a tub wine cooler with silver in place of the usual copper or brass bands. A bracket clock the work of James Newton has silver mounts made by John Pollock, each bearing the maker's mark and lion passant only. The Museum of Fine Arts, Boston, has a particularly large 'dressing glass' of 1692 which seems more likely to be a single item rather than part of a toilet set. Silver coffin furnishings of 1770, for which the bills still survive, are preserved at Colonial Williamsburg, Virginia. A small number of carved pine mantelpieces, of the third quarter of the 18th century, are known, applied with either silver or silvered embellishments, or both, such as masks, swags or Classical medallions.
Bibliography
P.A.S. Phillips, 'John Cooqus, Silversmith'. *The Antiquaries Journal*, July 1934.
N.M. Penzer, 'The Plate at Knole', part I. *Connois-seur*, March 1961.
John Hayward, 'Silver Furniture', parts I, II, III and IV. *Apollo*, March, April, May and June 1958.
E.A. Jones, *The Old English Plate of the Emperor of Russia*. 1909.
A.G. Grimwade, 'Peter the Great's Throne'. *Con-noisseur*,
E.A. Jones, 'The Maker of Nell Gwyn's Silver Bed-stead'. *Apollo*, vol. XXXVI, p.11.
C.C. Oman, 'An XVIIIth Century Record of Silver Furniture at Windsor Castle'. *Connoisseur*, vol. XCIV, p. 300.
See also Andirons; Bellows; Chandelier; Tea Table; Tray; Vase.

Gadroon
One of a set of convex curves or arcs joined at their extremities to form a decorative pattern, used in ornamenting plate. Chiefly used in the plural, 'gad-roons', hence 'gadrooned'. Such a pattern was usually applied to borders.

Galvanic Goblet
This charming piece made by Paul Storr in 1814 is in the Collection of Her Majesty the Queen, and appears to have pre-dated the introduction of electro-gilding by twenty-six years. The advent of electroplating is usually attributed to Arthur Smee in 1840, when it was immediately adopted by Elkington & Co., Birmingham.
Bibliography
Connoisseur New Guide. 1962 (Plate 54b).
See also Electroplating.

Garnish
Variously spelled throughout the Middle Ages, this word was used as late as the 17th century when a 'garnyessh' of plate (or pewter) referred to the display of silver upon the sideboard. It was often thought to refer to sets of dishes, and indeed it does, but not solely. In 1470, the Goldsmiths' Company paid £1 17s 6d 'for a garnish to two dozen of pewter vessels to serve the Company'. See also Service; Sideboard Plate.

Garniture See Ginger Jar; Vase.

Garrard Ledgers (Wakelin Ledgers)
Numbering forty-two in all, they span the years from 1735 to 1820 and fall into several groups. The Private Clients' Accounts (starting 1735). The Workmen's Ledger (starting 1766). The S. & J. Crespell Books (1778–1806) and a number of Day Books. The first two volumes, which cover the years 1735–47, have been retained by Messrs Garrards, the lineal descendants of the firm founded by George Wickes, who seems to have commenced his own business in Panton Street, London, on June 23rd, 1735. Barring these two volumes the rest may be consulted at the Victoria and Albert Museum Library. In 1747 Wickes took into partnership one Edward Wakelin; the next partner was John Parker, who joined the firm as an apprentice in 1751. By 1776, John Wakelin (Edward's son) and William Taylor were in com-mand, but by 1792 Taylor disappears, John Wakelin then taking Robert Garrard into partner-ship in his place.
From 1792, the firm remained, until the present century, in the hands of Robert Garrard's descen-dants, becoming eventually the Crown Jewellers and Goldsmiths. The ledgers form perhaps the most complete set of goldsmiths' business records extant and are a mine of information for the student. Some belonging to the firm of Messrs Barnard & Co. also survive. Original costs and owners' names may, on occasion, be identified with an existing piece by the aid of the ledgers, which may specify the original weight, date and maker of that piece.

Garter, Order of the
Founded c. 1348 by Edward II, this is the premier Order of Chivalry of Great Britain and the oldest in Europe. Perhaps the earliest surviving piece of the Order's regalia is the buckle (now with an 18th-century strap) in the collection of the late Lord Fairhaven, coarsely engraved with the Arms of the Emperor Maximilian, who was elected to the Order in 1489. Badges and jewels of the Order are not within the scope of this work. Suffice it to say that the George and the Lesser George both con-sisted of an enamelled figure of St George fighting the dragon. The George worn suspended from the collar, the Lesser George worn on the right hip and suspended from a dark blue sash. The Lesser George of gold or silver-gilt, originally belonging to Thomas Howard, Earl of Arundel (the great collector), was given to Elias Ashmole (founder of the Ashmolean Museum, Oxford) by Thomas Howard, Duke of Norfolk, in recognition of Ashmole's book *Institutes*, the history of the Order, and it may be mentioned since it can be seen in that Museum, whose silver collection is second to none. That belonging to the unfortunate Thomas Went-worth, Earl of Strafford, who was executed in 1641, is now in the Victoria and Albert Museum. It is finely enamelled and dates from c. 1640.
Bibliography
E. Ashmole, 'Order of the Garter'. *Connoisseur*, May 1953.

289 Mirror

Unmarked, c. 1690.
Height 7 ft. 6 in. (228·6 cm.).
A gift to William III from the
City of London.

290 Table

Maker's mark of Andrew Moore.
c. 1690.
Height 33¼ in. (84·5 cm.).
Table top: 29×48 in. (73·7×
142·2 cm.).
The table has a wood and iron
frame. The table top is engraved
with the Royal Arms and the
emblems of the four Kingdoms
(including France). The engraving
is signed with the initials H R in
monogram.

Fig. XXIV

A group of forks showing their
development during the 17th, 18th
and early 19th centuries. Approxi-
mately 6½–7⅔ in. (16·5–19·4 cm.)
long.

289

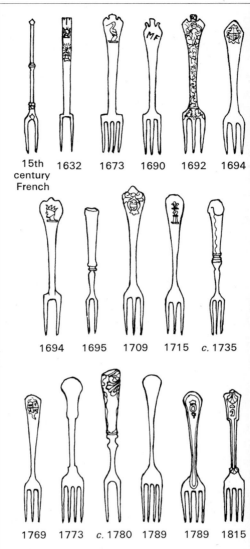

15th century French 1632 1673 1690 1692 1694

1694 1695 1709 1715 c. 1735

1769 1773 c. 1780 1789 1789 1815

Fig. XXIV

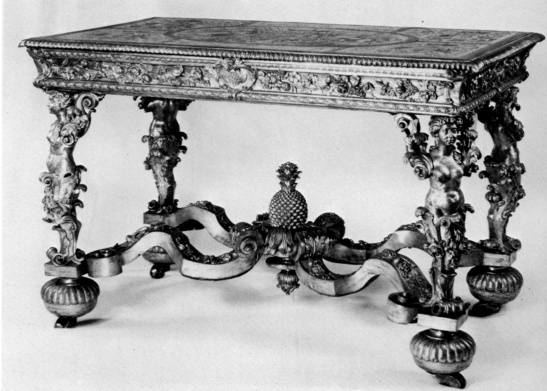

290

...auntlet

...pair was made by Hester Bateman in 1783, pre-...mably for some ceremonial occasion. Perhaps ...r a Lady-in-Waiting or indeed even for Queen ...arlotte, as one of these gauntlets is embossed ...th a portrait medallion of the Queen herself and ...e other with one of George III. The popularity of ...chery at this date was widespread and so the need ...r wrist guards should not be overlooked, for this ...ay well be the very reason why gauntlets became ...asonably fashionable during the later 18th ...ntury.

...bliography
...vid Shure, *Hester Bateman*. W.H. Allen, 1959.
...e also Wristband.

...rman Silver (Nickel Silver)

...probably originated in China, and by 1820 ...ward Thomason of Birmingham was attempting ...analyse it. However, it was Samuel Roberts of ...effield, working in Berlin in 1830, who first ...oduced it commercially. The metal (an alloy of ...ckel, copper and zinc) was at first brittle. In 1836 ...improved version was introduced known as ...rgentine'. This latter eventually ousted copper ...mpletely, as a basis for Sheffield plating, being ...its turn replaced by the electro-plating process ...mmenced by Elkington & Co., Birmingham.

...nger Jar

...is not likely that any of the so-called 'ginger ...s' could ever have been intended for actual use. ...e of the earliest recorded is that made by one, ...N (possibly the mark of Richard Neale), in 1658, ...me 14⅝ in. (37·2 cm.) high, chased with fruit and ...iage. Most of those surviving are in fact more ...osely allied to furniture, forming part of the ...rnitures introduced at the Restoration for ...coration of the mantelpiece and imitating ...inese porcelain originals. They are generally ...hly chased and decorated with masks, foliage ...d applied swags, the covers with foliage finials ...d pendent swags (**291**). At least one pair, with ...associated pair of stands, exist, they are ...corated with chinoiserie ornament; another pair ...ted 1685, similarly decorated but larger, 13¾ in. ...5·0 cm.) high, is in the collection of the Duke ...Rutland. The growing interest with which the ...d World' regarded the Orient probably accounts ...these great pieces of plate, often of compara-...ely thin metal, being named after objects of ...aller size but of similar form. They are rarely ...nd after 1700. In 1687 the Earl of Devonshire ...rchased 'a greate jarr, 2 flower potts, 4 little ...rs a bottle with a spoon'. The Dutch artist P.G. ...n Roestraeten was particularly fond of showing ...ch pieces in his still-life paintings and possibly ...pt one as a studio 'prop'. Certainly he spent a ...od deal of his career working in England. Oddly ...ough the present Duke of Devonshire has an ...ample of Van Roestraeten's work; in this case, ...e principal silver object depicted is a wine ...tern.
...e also Vase.

...asgow Assay Office

... October 14th, 1536 the Archbishop of Glasgow ...'Seal of Cause' concurring with the Town ...uncil incorporated a Guild of Hammermen. A ...nute book survives for the period 1616–1717. ...e Glasgow mark is the Burgh Arms—an oak tree, ...ird in the branches, the trunk surmounted by a ...mon and at the sinister fess point, a hand bell. ...complicated mark has caused a number of ...ieties in the punches (**703**). In 1681, at the ...ne time as in Edinburgh, a date-letter system

was introduced but seems to have been discontinued in 1710, not to be reintroduced until 1819, when by Act of Parliament the Glasgow Assay Office was formally instituted, being empowered to assay and mark all plate made in the city and forty miles around. During the interval, letters E, F, O and S were struck, the latter perhaps for 'Sterling' or 'Standard', the others as date-letters. The standard mark decreed is interesting, as being a lion rampant (possibly the Lion of Scotland) unlike that of any other British assay office, though it appears slightly earlier in conjunction with one or two makers' marks. In 1836 Glasgow's precedence over other Scottish provincial offices was ratified by law, though unjustified by history. The assay office was finally abolished in 1964.

Silver of Glasgow making during the 17th and 18th centuries is less common than that of Edinburgh, and larger articles, such as teapots, with the city's mark, are extremely rare.
Bibliography
Sir C.J. Jackson, *English Goldsmiths and Their Marks*. 2nd Edition 1921, reprinted 1949.
See also Provincial Goldsmiths (Scottish).

Glasses See Spectacles.

Goblet

A capacity of half a pint or more may, as a rule of thumb, be used as the deciding factor in describing a secular cup on a stem and foot as either a goblet or a wine cup (**292**). A goblet at Gatcombe, Isle of Wight, is dated 1540, another belonging to St Margaret Pattens, London, is dated 1551 (**293**) and the Boleyn Cup of 1535 at Cirencester (**176**) were all originally made as secular pieces, and because they are not grand enough to qualify as standing cups they are therefore known as goblets. Goblets usually have deep bowls, but this is not a hard and fast rule, as these three above cases show, each having a V-shaped bowl. However, the silver wine cup or goblet of the 16th and 17th centuries (**294**, **295**, **296**, **297** and **298**) seems to have fallen from favour with the coming of glass into general use after the Restoration of 1660. The 'Gothick' revival of the 1760s and the consequent return to favour of the coconut cup seems to have encouraged the silversmiths to produce a version of the goblet in silver, often in pairs, and though the shape varied by the 1820s (**299**) it is to these wine cups that the phrase 'a bumper of . . .' referred. Volume 4 of the Garrard Ledgers has entries as follows:
Dean of Winchester. 1772. May 7.
To 2 Goblets. 15–18 at 5/9
To making & gilding insides. 58/–
Mr. Hayes. 1775. June 8.
To 2 rummers with Water Leaves. 21–7 at 8/6
To gilding the insides. 14/– each.
Bibliography
A.G. Grimwade, 'Silver and Glass Cups'. *Connoisseur*, May 1953.
See also Beaker; Chalice; Communion Cup; Cup, Wine.

Gold, Hall-marks for

From 1300 the standard for gold was 19¼ carats pure gold to 24. As for silver, the leopard's head was the only assay mark. In 1363 the maker's mark was also required to be struck and in 1578 the date-letter was added. In 1477 the standard was reduced to 18 carats but in 1575 it was raised to 22 carats.

In 1544 the lion passant replaced the leopard's head as the standard mark. In 1798 the 18 carat standard was reintroduced, in addition to the existing standard of 22 carat. The crown mark was used in place of the lion passant, the latter remaining the distinguishing mark for 22 carat gold until 1844, when the crown was then used for both, and the lion passant finally discarded, (a) and (b). In 1854, the additional lower standards of 15, 12 and 9 carats were introduced. From 1854 onwards figure marks, including the standards, were also struck (that is, 0·75=18 carat). The figure marks for 14 carat (c) and 9 carat (d) are illustrated below. It must, therefore, be obvious that the standard marks for silver and gold are common to both until 1798, with the exception of the Britannia standard period for silver (1697–1720), when different marks were introduced for silver alone.
See also Carat; Weight.

 a b

 c d

Gold Metal

This metal resists all forms of atmospheric attack; it does not oxidize when heated in air beyond its melting point and is in fact inert to most chemicals. Gold has been mined in almost every country in the world at some time or another. It can be found in four different forms. Alluvial gold, which is derived by using water to break down gold-bearing, stratified rock; gold found in the quartz veins of sedimentary or igneous rock; blanket gold found in the pebble river-beds of South and West Africa and fourthly, gold which can be extracted during the smelting of copper, nickel, lead and zinc. By processes of washing, which vary in efficiency, the gold may be separated from the ore, or by the process of cyanidation, when the crushed ore is roasted and treated with a weak solution of sodium cyanide, thus dissolving the gold, which is later precipitated by the use of zinc. This latter is an extremely thorough process producing a metal 80 to 90 per cent pure. It can then be further refined by passing chlorine through the molten metal, the base metals form a surface of chlorides which may be skimmed off leaving a metal of 99·6 to 99·7 per cent purity. It is then possible to further refine this to 99·99 per cent pure gold.

Though the principal use of gold from antiquity to the present time has been as currency, its use as jewellery and other useful objects has been almost as important. It is, however, far too soft a metal to be used in its pure state, but it has the remarkable quality that, even when alloyed with large proportions of base metals (silver being one), to a large degree, it still retains its colour and resistance to tarnish. The degree of alloy is referred to in proportion of 1/24th part of a carat—24 carats being pure gold. Its melting point varies according to the type and quantity of the alloy.
Bibliography
Staton Abbey, *The Goldsmiths and Silversmiths Handbook*. 1952.

Gold, Objects Wrought in

Although the Regent Morton presented the King of France with a gallon basin made of 'natural gold' and in spite of the large number of pieces of solid gold plate, both ecclesiastical and secular, recorded in inventories prior to the Civil War (James I was presented with a gold standish weighing 35

291 Ginger Jar and Cover
Maker's mark, probably I H.
Hall-mark for 1680.
Height 14¾ in. (37·5 cm.).
292 Goblet
Silver-gilt.
Hall-mark for 1529.
Height 8⅜ in. (21·3 cm.).
Victoria and Albert Museum.
293 Goblet
Silver-gilt.
Maker's mark, a head erased.
Hall-mark for 1545.
Height 8 in. (20·4 cm.).
St Margaret Pattens, London.
**294 The Maria
Corbett Goblet**
Maker's mark, IN in monogram.
Hall-mark for 1587.
Height 5½ in. (14·0 cm.).
The Goldsmiths' Company.

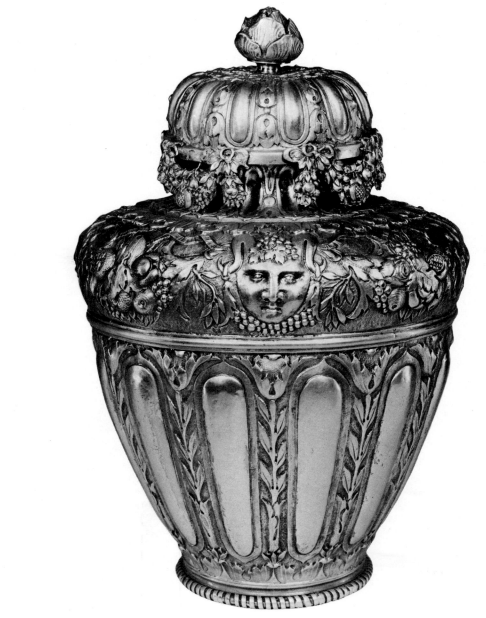

291

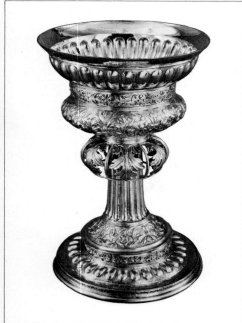

292

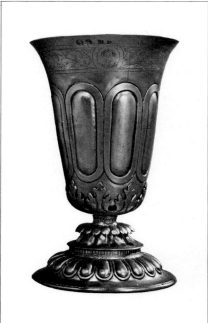

293

294

inces in 1620), gold does not seem to have been nearly so often used after the Restoration. Accepting only pieces of plate and excluding freedom boxes, snuff boxes, medals, coins, mayoral chains and jewellery (**355**), there are now some eighty remaining examples of an earlier date than 1821. Of these, only about seven can with any certainty be said to antedate the Cromwellian Commonwealth period of 1653–60, excepting always the Royal Gold Cup of the Kings of England and France, whose provenance is undecided, like that of the King John Cup (silver not gold) at King's Lynn (Colour Plate **22**). These are the chalice and paten of 1507 at Corpus Christi College, Oxford (Colour Plate **16**); the Crown of Scotland, partly fashioned c. 1540 (Colour Plate **19**); an originally secular acorn cup of about 1610 from Stapleford, Leicestershire, now in the British Museum (Colour Plate **1**); a chalice and paten of c. 1620 at Clare College, Cambridge; the gold Scottish ampulla of about 1630 and a multifoil porringer and cover at Exeter College, Oxford, dated c. 1655, and given to the College in the 1660s by Geo. Hall, Bishop of Chester. This porringer is of almost Gothic form, executed by the same maker (hound rampant) as the remarkable communion plate at Staunton Harold (Colour Plate **8**). There is also a second example, somewhat similar, in a private collection, perhaps five years earlier in date by the same maker. A very small cup and cover at Boston in the style of Van Vianen may also antedate the Restoration of 1660 and perhaps one of the two gold communion cups amongst the Communion plate of the Regalia. The remaining later pieces cover a very broad range of the goldsmith's art and include a wine cup, 8⅝ in. (21·9 cm.) high, made by Marmaduke Best of York in 1672; a superb small ewer and basin of 1701 by Pierre Platel (Colour Plate **29**); a buckle by Everadus Bogardus of New York, c. 1720; cups and covers, one by Lamerie of 1717, another by William Gilrist of Edinburgh, 1752 (in the Metropolitan Museum of Art, New York); Communion plate; spoons; beakers; a pepper pot (**394**); chocolate cups; tumbler cups; wine coolers (**722**); a font; teapots—three in all—two made in Edinburgh (Colour Plate **39**) and one made for William Beckford in London in 1785 and bearing the drawback mark, and even two pap boats. A number of pieces, commonly salvers, were also made from collections of gold snuff boxes, being usually engraved with the same arms as were on the originals. One such, by Paul Storr, 1813, is in the collection of the Duke of Devonshire. Gold cups were also given by the sovereign on the occasion of his or her coronation to the Chief Butlers of England and sometimes those of Ireland also. The vast majority of gold pieces are of London manufacture (**299**). Though recorded, the gold cup, valued at £106, and made in New York for presentation to Governor Fletcher in 1693, does not appear to have survived. On a number of occasions during the 18th century the Garrard Ledgers record the acceptance of solid gold pieces in part payment for new plate, generally at a rate of £3 15s 0d an ounce, while it was sold at £4 1s 0d an ounce.

Bibliography
E.A. Jones, *Old English Gold Plate*. 1907.
G. Grimwade, 'A New List of Old English Gold Plate'. *Connoisseur*, May, August and October 1951.
G.G.R., 'Gabriel Wirgman's Unrecorded mark'. *Connoisseur*, April 1957.
Peter J. Bohan, *American Gold, 1700–1860*. Yale University Art Gallery, 1963.
Edward Perry, 'Gift Plate from Westminster Hall

Coronation Banquets'. *Apollo*, June 1953.
E.A. Jones, 'The Gold Chalice of Welshpool'. *Cymmrodorion Society*, vol. XLIV, 1935.
C.C. Oman, *English Church Plate*. Oxford University Press, 1957.
Norman Gask, 'A Gold Charles II Pocket Cutlery Set and Three Gold Trefid Spoons'. *Apollo*, August 1949.
'The Lockhart Cup'. *Art Institute of Chicago Quarterly*, vol. LII, no. 2, April 1958.
L. Willoughby, 'Marquess Camden's Collection'. *Connoisseur*, vol. XXI, p. 239.
See also Cup, Chocolate; Holbein, Hans; Mines, Gold and Silver; Race Prizes; Teapot.

Goldsmiths' Company (London Assay Office)

The history of the Worshipful Company of Goldsmiths and that of the London Assay Office are inextricably intertwined, in that only those practising the 'mystery' could well be expected to have the knowledge to keep it secure. A guild of Goldsmiths is recorded in London as early as 1180, but not until 1327 did they obtain a Royal Charter from Edward III. This Charter conferred certain rights, but in return called for certain services and from thenceforth, with a number of reincorporations and confirmations, the Guild has been responsible for the quality of the wares sold by its members. This Guild was also responsible in early times for punishing offenders; this they sometimes did to their own advantage, for in 1452 a German, Lyas, was fined 'a gilt cup of 24 oz.' for having sold a piece of sub-standard gold. As may be expected, the Goldsmiths' Company came to blows, both legal and sometimes physical, with other companies, in particular the Cutlers', whose habit it was to furbish the handles of their products with precious metals. King Henry IV being a wise man passed this difficult question to the unfortunate Lord Mayor of the City with instructions to report immediately. The result was a re-issue of the original Charter of 1327. In 1462 the Goldsmiths' Company also obtained the right, and duty, to search out, assay and regulate the working of gold and silver throughout the realm. This raised problems with provincial workers, who objected to being supervised by Londoners and even more to paying the expenses of their visitations, with the obvious result that by the late 16th century and indeed, until after the Restoration, a good deal of plate was being sold unmarked, though during the unsettled period of 1640–58, production was as a whole largely curtailed. However, by 1675 this evasion had reached such proportions that a special order was issued by the Company to register not only the makers of large pieces, but also the manufacturers of watch cases, sword hilts and other small items. The copper plates on which these marks were struck are preserved, but unfortunately not the 'vellum Key'. After April 1697, however, the records are almost complete. The standard marks for both gold and silver are illustrated below.

Sterling silver marked in England. Minimum silver content 92·5%

Britannia silver mark. Minimum silver content 95·84%

London mark on sterling silver and gold

London mark on Britannia silver

22–carat gold marked in England. Minimum gold content 91·66%

18–carat gold marked in England. Minimum gold content 75%

14–carat gold mark. Minimum gold content 58.5%

9–carat gold mark. Minimum gold content 37·5%

Bibliography
Prideaux, *A History of the Worshipful Company of Goldsmiths*.
See also Assay; Hall-mark; Pyx, Trial of.

Golf Club

A golf club, the property of the Royal and Ancient Golf Club of St Andrews, now hung about with a plenitude of silver balls (presented by successive captains when 'playing themselves in'), was probably made in the 18th century and seems likely to be a lone survivor of a type originally more common, bearing in mind the Scots' love of prize silver arrows and guns. Although made comparatively recently in 1889, the Aughnacloy Putter is a particularly well-made piece, of ivory and ebony with silver-gilt (the gilding intentionally removed) and enamelled mounts. It well deserves mention for besides this, it is the oldest Irish prize golf club. Some 38 in. (96·6 cm.) long, it is said to have been copied from a Continental original.

Bibliography
T.C.H. Dickson, 'Ireland's Oldest Golf Trophy'. *Country Life*, January 30th, 1964.

Gorget See Breastplate and Gorget.

Green, Ward & Green

Of Ludgate Street, London, they were probably retailers who were supplied by Benjamin Smith and others. The Wellington Shield at Apsley House bears their signature, though made by Smith and designed by Thomas Stothard, R.A.

Gribelin, Simon (1661–1733)

An engraver and designer, born at Blois in France, he came to England about 1680 according to Horace Walpole. The engraved decoration of a number of pieces of plate may be assigned to him with some certainty. These include a salver on a central foot of c. 1695, in the Burrell Collection, Glasgow, a print of which is included in his book of designs; and two others at Chatsworth, Derbyshire. Besides these, other pieces have been ascribed to him on the grounds of similarity of style. A superb ewer and basin, the property of St John's College, Cambridge, made by Samuel Wastell in 1717 and the gift of Sir Thomas Wentworth to the College, are engraved with the Arms of the College and those of Wentworth within a splendid mantling almost certainly of Gribelin's work. He signed the engraved *Deposition* (after Caracci) on the alms dish made in 1706 by Isaac Liger for George Booth and a circular charger of 1700 (**253**). The comb box made by Pierre Harache (**54**) once at Burghley House, is from a toilet service almost certainly decorated by him. The basin from this set is now at Luton Hoo, Bedfordshire.

Bibliography
C.C. Oman, 'English Engravers on Plate. Simon Gribelin'. *Apollo*, June 1957.

Livre d'Estampes de Simon Gribelin, fait Relié a Londres 1722. British Museum Print Room, 1859/6/25.

J.F. Hayward, *Huguenot Silver in England*. Faber & Faber, 1959.

See also Engraving.

Griddle

Almost every variety of domestic plate was at some time made in silver. In most cases this was probably to answer the foible of the original owner. By about 1800 this tendency seems to have reached its height, perhaps influenced by a growing interest in foreign habits. The silver griddle was probably the short-lived successor to the dish cross and most examples seem to date from about the turn of the 18th century. One dated 1820 allows some of the gravy to be recovered and poured over the grilled food when served (**300**).

See also Toasting Fork.

Grotesque

A decoration, often in relief, with human and animal forms fantastically interwoven with foliage and scrolls. This design was derived from Roman murals, where bizarre, exaggerated or distorted forms prevailed, from which grew the auricular and cartilaginous styles.

Hall-mark

Hall-marking was first introduced by statute on September 26th, 1300 during the reign of Edward I and has continued in London to this day. The primary purpose is to guarantee the purity of gold or silver articles. However, this sytem serves also to protect the antique-buying public against forgeries, as almost complete records have been kept of all marks struck in London and a number of other provincial centres. Despite the loss of some records, the continuous nature of the system enables them to be reconstructed with some certainty.

Originally the mark of a leopard's head was ordained for both gold and silver and in 1363 the makers were also required to strike their marks, having first registered them at the Goldsmiths' Hall, London. In 1478 a system of date-lettering was introduced, using, in London at least, only twenty letters of the alphabet, and changed each St Dunstan's Day (May 19th), so that the Warden of the day could be identified if the quality of any plate passed as up to standard should ever be questioned at a later date. In 1544 the lion passant mark was added as an easily recognisable guarantee that the silver was up to Sterling standard. From 1784 to 1890 the sovereign's head was also struck to denote the payment of the excise duty then in force.

In 1660, to commemorate the Restoration of King Charles II on May 29th of that year, the Goldsmiths' Company decided to change the date-letter to that day, rather than May 19th.

Generally speaking, one might expect to find *at least* four marks on the majority of silver and gold articles:

(i) *The maker's mark*, in early times a device, later his initials and between the years 1696 and 1720 the two first letters of his surname. *Both the latter are now legal.* All too often today the so-called 'maker's mark' would be more correctly called a 'sponsor's mark', this anomaly not often arising during previous centuries.

(ii) *The hall-mark*, that is the mark struck by the assay office where the quality of the metal was verified. Each assay office struck its own distinctive identifying mark. The leopard's head, crowned or uncrowned, often referred to as the London hall-mark, is in fact the King's (Queen's) mark, and was enjoined in the statute of 1363 as such. Besides London, it is also struck at English provincial assay offices, but not in Scotland or Ireland. The crown was dispensed with in 1820 upon the accession of King George IV.

(iii) *A date-letter*, this not for the convenience of collectors of old silver, but to identify the assay master responsible for passing the piece. For should the quality of the metal, on which he had permitted the marks to be struck, ever be called in question at a later date he would have to answer for it. This date-letter is changed annually, on different dates by different offices. At certain offices variations of this system (see Edinburgh Assay Office) have been practised and Dublin, during the latter half of the 18th century, frequently omitted the date-letter altogether. For identification purposes the shape of the shield is of almost equal importance as the letter it contains.

(iv) Besides these marks there should also be a *Sterling mark*, a lion passant, which was apparently introduced in 1544 when the coinage was greatly debased. For the first six years (until 1549) the lion's head was crowned.

In order to defeat the purposes of those clipping the edges or even melting coin wholesale and fashioning silver articles by these illegal methods, the standard was raised above that of the coin between the years 1697 and 1720 (see Assay). The mark of Britannia was substituted for the Sterling lion and, for the London mark, a lion's head erased at the shoulders was ordained. The Sterling standard was restored on the perfectio amongst other things, of milled-edged coi Throughout this period gold continued to struck with the Sterling standard marks. modern assay of old pieces of Britannia standa frequently falls short by as much as 10 parts, th is, 940 instead of 950 (see Britannia Standard).

In 1784 a further mark was introduced indicate that a duty of 6*d* per ounce had been pa at the time of assay. This mark was to be t sovereign's head in profile. As this was not con menced until December 1st, 1784 and the Lond date-letter is changed upon May 29th (the date the election of the Warden of the Company), can be seen that a quantity of silver bearing t date-letter for 1784 may yet carry no duty ma This mark was also introduced in the provinc assay offices; in Dublin after 1800 (the date of t Union) and in Glasgow not until 1819 (on elevation to an assay city). During the first tv years, 1784–5, the mark is struck incuse opposed to intaglio (cameo). In Sheffield, and occasions in Birmingham, the king's head w struck twice in 1797 to denote the doubling of t duty, but this practice seems to have died a natu death. The duty eventually reached 1*s* 6*d* ounce and was not repealed until 1890.

At one time or another any combination of the marks may have been struck. The human being fallible and also venal. Generally speaking, t conduct of the assay offices throughout the cer turies has been of the highest standard, but exce tions to these standard practices become mo general as one looks further back in time. Fr

Monarchs of England		Enactments
Edward I	1272–1307	1300. A leopard's head. The King's mark ordained to struck on all plate.
Edward II	1307–1327	
Edward III	1327–1377	1363. The maker ordered to strike his mark or device.
Richard II	1377–1399	
Henry IV	1399–1413	
Henry V	1413–1422	
Henry VI	1422–1461	
Edward IV	1461–1483	1478. A date-letter system instituted in London. To changed each May 19th.
Edward V	1483–1483	
Richard III	1483–1485	
Henry VII	1485–1509	
Henry VIII	1509–1547	1544. A lion passant (Sterling) mark ordained.
Edward VI	1547–1553	
Mary I	1553–1558	
Elizabeth I	1558–1603	
James I	1603–1625	
Charles I	1625–1649	
Commonwealth	1649–1660	
Charles II	1660–1685	Date-letter to be changed each May 29th.
James II	1685–1689	
William & Mary	1689–1695	
William III	1695–1702	Britannia standard 1697–1720.
Anne	1702–1714	
George I	1714–1727	Sterling standard restored 1720.
George II	1727–1760	
George III	1760–1820	Sovereign's head duty mark (incuse) and drawback ma (incuse), 1784.
Regency	1811–1820	Sovereign's head duty mark (in cameo) 1786–1890.
George IV	1820–1830	Leopard's head uncrowned 1821.
William IV	1830–1837	
Victoria	1837–1901	Duty mark ceased 1890.
Edward VII	1901–1910	
George V	1910–1936	Jubilee mark. Two sovereigns in profile 1933–5.
Edward VIII	1936–1936	
George VI	1936–1952	
Elizabeth II	1952–	Coronation mark. Sovereign's head in profile, 1952–3.

uently, provincial makers struck no more than their own mark, if that, and a special (or royal) commission seems to have been considered ample justification for dispensing with an assay at the office concerned, this was so even in London. Though to please clients, and perhaps also confuse any searcher, the maker concerned often struck his mark once clearly and then double, in three separate places to give the impression that the piece had been submitted for assay. The sovereign's head has also been struck from 1933 to 1935 to celebrate the Silver Jubilee of King George V and Queen Mary and again in 1953 to commemorate the Coronation of Queen Elizabeth II.

It is thought that prior to 1478 a system of date-letters may have been intended, this has been occasioned by the discovery of a number of leopard's head marks on mid 15th-century spoons having a letter in place of the tongue. These may be date-letters, or even the initials of the warden of the day, either of which would serve to identify the official responsible, should a marked piece be found to be sub-standard or otherwise faulty at a later date.

(b) *Drawback mark*. From December 1st, 1784 to July 24th, 1785 an *incuse* mark of Britannia was struck on all plate intended for export, to indicate the repayment of duty already charged on the assaying of the piece. In time this practice was discontinued owing to the damage it caused to a piece of finished plate and to the export trade by the delay it occasioned. Probably the best-known example of this extremely rare mark is that on the gold teapot and stand of 1785 made for William Beckford, perhaps a dozen other pieces so marked are recorded, including a pair of cream jugs. Also known bearing this mark are a salver of 1785 by James Young and a number of Channel Islands christening cups.

For some detail of the day to day working of an assay office, see Birmingham Assay Office. For the parliamentary enactments concerning hall-marks, see the chart on p. 144.

See also Assay; Duty-dodgers; Forgery; Gold, hall-marks for; Goldsmiths' Company; Imported Plate.

Hall-marking, Exemptions from

The Plate Offences Act of 1738 (An Act for the better Preventing of Frauds and Abuses in Gold and Silver Wares) exempted a considerable number of minor articles from assay. Amongst them were: thimbles, stone-set jewellery, book clasps, very small Nutmeg Graters, Rims of Snuff Boxes, whereof Top or Bottoms are made of Shell or Stone, Sliding Pencils, Toothpick Cases, Tweezer Cases, Pencil Cases, Needle Cases, any Filigree Work, and Mounts, Screws or Stoppers to Stone or Glass Bottles or Phials, any small or slight Ornaments put to Amber or other Eggs or Urns, or any Gold or Silver Vessel, Plate or Manufacture of Gold or Silver so richly engraved, carved or chased, or set with Jewels or other Stones, as not to admit of an Assay to be taken of, or a Mark to be struck thereon, without damaging, prejudicing, defacing the same, or such other Things as by reason of the smallness or thinness thereof are not capable of receiving the Marks herein before mentioned or any of them, and not weighing Tenpenny Weights of Gold or Silver each'.

The Duty Act of 1748 was passed with the express intention of continuing these exemptions, but it was so imprecisely worded that by 1790, it was thought to be in need of improvement, when further exemptions were added to the list: 'Tippings, Swages, or Mounts or any of them not weighing

ten Penny-weights of silver each'. The next sections of the 1790 Act relate to the exemptions of wares weighing under 5 pennyweights each, but excludes the following from exemption, and these are but a few: 'Necks, Collars and Tops for Castors, Cruets or Glasses, appertaining to any Sort of Stands or Frames, Bottle Tickets, Shoe Clasps, Patch Boxes, Salt Spoons, Salt Shovels, Salt Ladles, Tea Spoons, Tea Strainers, Caddy Ladles, and Pieces to Garnish Cabinets, or Knife Cases, or Tea Chests, Bridles, or Stands or Frames'.

Generally speaking, therefore, it may be said that from 1738 to 1784 (and in effect up to 1790) wares weighing 10 pennyweights or less might be unmarked, after that date, and up to the present day, wares of less than 5 pennyweights are exempt, though they may of course be sent for marking should the manufacturer desire it. Prior to 1738, a number of small articles are found unmarked, but in general the tendency of the silversmith seems to have been towards the marking of his wares, if only because his clients were conditioned by long experience to expect some sort of marking as a guarantee of the object's quality.

Larger pieces of unmarked plate are found in considerable quantities and this may be due to a variety of reasons—a straightforward attempt to deceive; a special (perhaps royal) order; possible damage to detail if marked or the piece having become separated from a set, say a ginger jar from a garniture of vases or a box from a toilet set, though this latter explanation is the least feasible, having no validity whatsoever either in law or custom. The Act of 1575 implied that only plate intended for public sale need be marked.

In the 17th century at least, the Royalists appreciated the existence of unmarked plate, for those engaged in raising money for Charles I after the Battle of Edgehill (1642) were prepared to accept unmarked plate at 8*d* an ounce less than that offered for fully marked objects.

Hamilton & Co., Calcutta

A firm of silversmiths and jewellers established in Calcutta, India, by Robert Hamilton in 1808. The firm probably had considerable ties with Scotland. A number of their products can be identified by eye alone, for example, the pairs of cylindrical pepper and salt casters, each on a trumpet foot. Expert copying of English work was undertaken to meet the demands of expatriates on the Indian subcontinent. Their marks included H & Co., an elephant, the letter A (registered in London in 1810) and an incuse stamp with the name Hamilton & Co., Calcutta, round the word Jewellers. Messrs Pittar & Co. (inaccurately referred to by Sir Charles Jackson as Pillar & Co.) were also of Calcutta. Both firms are now defunct.

Hamlet, Thomas (c. 1775–1849)

He was an early 19th-century silversmith and jeweller of Sydney Alley, London. Pieces bearing his name (struck incuse) are invariably of high quality. A ewer and basin bearing the maker's mark, his name struck in full, were given by George IV to the King of Hanover. Hamlet was the natural son of Sir Francis Dashwood (d. 1781) and became an assistant with Francis Lambert to one, Clark of Exeter Change, London, whose business was 'toymaker' (cutlery, bronzes, clocks and watches, jewellery and silver). Hamlet and Lambert set up their own business in 1800 in St Martin's Court, London. Later, Hamlet opened his own silver and jewellery business which was to be highly successful for the next forty years, thanks to his

influential connections. However, he was financially ruined by unfortunate speculation and was declared bankrupt in 1842. He died in 1849, a pensioner in the Charterhouse, London. It is unlikely that his mark on a piece indicates more than his retailing it, as is the case with Rundell, Bridge & Rundell.
Bibliography
Wm. Chaffers, *Gilda Aurifabrorum*. 6th Edition, 1899.

Hand Candlestick
See Candlestick, Hand or Chamber.

Handle
Whips, sticks, canes and fans all came within the territory of the goldsmith and silversmith. With rare exceptions, such as the Guildford Mayoral Cane of 1565, most surviving mounted examples are of late 17th-century or more recent date. Mid 18th-century examples are often superbly decorated with chased ornament and, no less fine, is the bright-cut ornament popular during the last decades of that century. Gold cane mounts are generally fully marked. The dividing line between a jeweller's and goldsmith's work in these cases, is often difficult to determine.
See also Cane and Staff; Casting.

Handwarmer (Calefactory)
Ecclesiastical examples dating from the Middle Ages are recorded but none survive. They were probably of a similar form to a sponge box, with pierced sides and cover, but contained hot charcoal. On the Continent foot-warmers of 18th-century date are known and there is no reason why they should not have been made in England, especially for use in carriages or churches.

Hanoverian Pattern
This is a convenient term for describing those spoons and forks, whose stems turn upwards at their ends, and which were produced almost entirely between the years 1710 and 1775. This period encompasses the reigns of the first two Hanoverian monarchs (1714–60) with a slight overlap at either end.

Hanukah Lamp See Jewish Ritual Silver.

Harache, Pierre
A Protestant émigré from France, perhaps he came from the town of Rouen. On July 21st, 1682 he was made a Freeman of the Goldsmiths' Company and in 1687 a Liveryman. His earliest work so far recorded appears to be the pair of candlesticks made in 1683, now in the collection of Earl Spencer. His son 'Peeter' Harache entered his mark at the Goldsmiths' Hall on October 25th, 1698. Simon Gribelin, the engraver, worked for Pierre Harache. Plates **54**, **100**, **120**, **201**, **253**, **279**, **580** and **712** illustrate the calibre of his work, and serve to emphasise his prolific and varied output.
Bibliography
Judith Banister, 'The First Huguenot Silversmith'. *Country Life*, June 10th, 1965.

Haunch Pot
Their shape and purpose remain a mystery, unless the tankards of baluster form, popular in the late 16th century, are to be identified as such. For the Royal Inventories state that some nineteen were given by Queen Elizabeth I as New Year's gifts in 1562, weighing in the main between 17 and 20 ounces, with one of $11\frac{1}{4}$ ounces.
See also Flagon or Livery Pot; Tankard.

295 Goblet
Maker's mark, I B with an annulet between and pellets below.
Hall-mark for 1601.
Height 7 in. (17·8 cm.).

296 Goblet
Maker's mark, possibly A P with a fleur-de-lys.
Dating from the first half of the 17th century.
Height 5 in. (12·7 cm.).
This goblet possibly emanates from East Anglia.

297 Goblets
a. Maker's mark, G S with a shepherd's crook between.
Hall-mark for 1654.
Height 3⅛ in. (8·0 cm.).
b. Silver-gilt.
Maker's mark, R W, probably the mark of Ralph Warren.
Hall-mark for 1614.
Height 7½ in. (19·1 cm.).
c. Silver-gilt.
Maker's mark, C G.
Hall-mark for 1603.
Height 5 in. (12·7 cm.).
Victoria and Albert Museum.

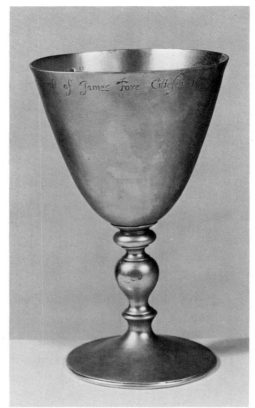

295

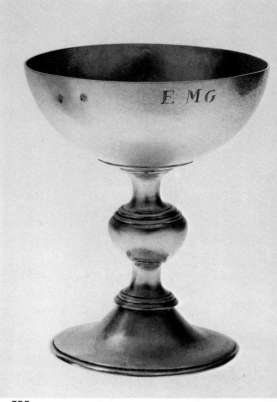

296

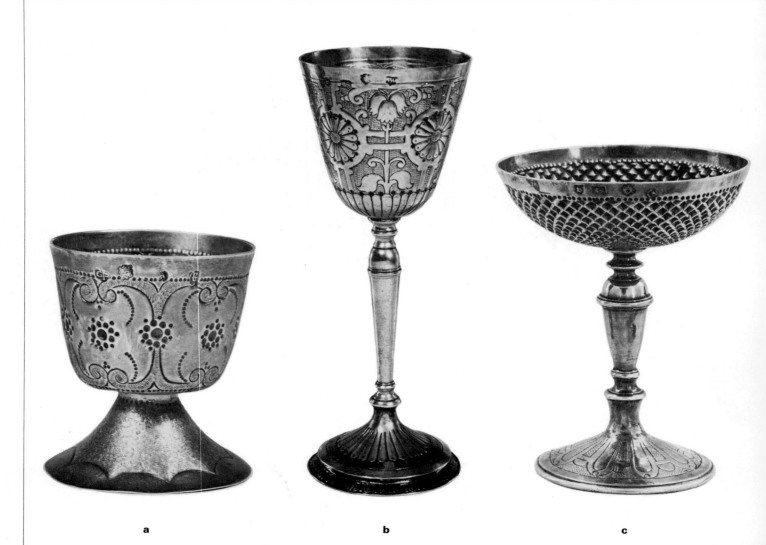

a b c

297

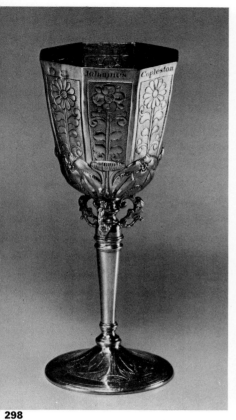

298

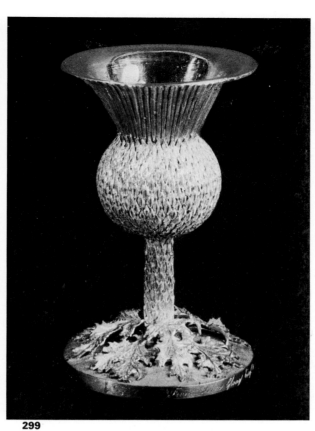

299

298 Goblet
Silver-gilt.
Maker's mark, F B.
Hall-mark for 1616.
Height 7½ in. (19·1 cm.).
The Goldsmiths' Company.

299 Goblet
Gold.
Hall-mark for 1824.
Height 3¾ in. (9·6 cm.).
A thistle-shaped goblet.

300 Griddle
Maker's mark of S. Whitford.
Hall-mark for 1820.
Each rib is concave in section and leads, via a hole, to the gutter across one end. Juices are thus gathered and can be poured over the meat when served.

300

Hawking and Cockfighting

Neither hawking nor cockfighting is yet defunct, although cockfighting is now illegal. Silver hawking prizes or equipment are very rare. A large cup of globe form was presented to Colonel Thornton at Barton Mills, Norfolk, on June 23rd, 1781 by the 'Confederate Hawks' headed by the Earl of Orford. The cup is supported on three hawk head and claw feet, the stretcher between has jesses and bells and the whole surmounted by a stooping hawk and its prey. Made by J. Wakelin & Wm. Taylor, it is 15 in. (38·1 cm.) high. Another, made by Storey & Elliott in 1809, has the finial to the cover formed as a cockerel. Cockfighting prizes often take the form of one or more tumbler cups, sometimes engraved with a suitable inscription; in one case, the engraving depicts a fighting cock triumphant over the fallen body of his late opponent. In Cheshire, these are still sometimes called 'cocking bowls'.
See also Bird Cage; Cockfighting Spur; Tumbler Cup.

Heraldry

A subject on its own, but in so far as it concerns silver, it must be obvious that without the use of enamel colour (sometimes colour constitutes the only major difference between two similar coats of arms), some other means of delineation is necessary. This is done by a system of different hatched (engraved) backgrounds, as shown on the chart on p. 153. Coronets, suitable to the different ranks of the peerage, are each engraved in a particular manner; supporters, crests and mottoes as applicable. In Scotland the motto, if any, is usually engraved above the crest, elsewhere beneath. This system was at first loosely applied during the late 17th century, when the colours or tinctures were rarely attempted, if indeed there was ever any uniform agreement on the method of their engraving. In time, set patterns became rigidly observed and the history of pieces can often be traced by their study, with the following provisos:
(i) A piece of silver might be re-engraved at a later date or bear a second coat of arms within an earlier cartouche.
(ii) Engraving in an earlier style may be copied on to a later object, either to preserve the memory of of an earlier piece or out of sheer laziness.
(iii) Provincial engravers, and this includes Americans, were sometimes the authors of archaic workmanship and occasionally ignorant of the purpose of that which they were undertaking.
(iv) Crests are seldom common to less than two or three families, coats of arms to one only. It follows that certain identification of the original provenance of a piece is difficult, even with both crest and motto. Occasionally, engraved initials may assist but without documentary evidence it is unwise to be too dogmatic as to provenance.
Very few surviving examples illustrate what may have been relatively common practice, that of striking a coat of arms from a die rather than engraving each piece separately, thus avoiding considerable expense. A dish bearing the Arms of William Twysden, c. 1610, is appropriated in this manner.
Bibliography
J. Fairbairn, Crests of Great Britain and Ireland. T. Jack, Edinburgh.
Sir Bernard Burke, Peerage, Baronetage and Knightage.
Moncreiffe and Porringer, Simple Heraldry Cheerfully illustrated. 1953.
J.H. Parker, A Glossary of Heraldry. Oxford, 1847.
Sir Bernard Burke, The General Armoury. 1884.

J.W. Papworth, An ordinary of British Armorials. See also Engraving.

Hob-nob

The term means to drink, one person to another. Thus pairs of waiters are occasionally referred to as such in 18th-century inventories. The glasses were presumably handed to each drinker on similar waiters. Wakelin supplied the Rev. Mr Neil on August 15th, 1772 with 'a pair of Hob-Nob Waiters' weighing nearly 29 ounces.

Hogarth, William (1697–1764)

Hogarth was apprenticed in 1712 to Ellis Gamble, an engraver. In the British Museum there survives proof of his work in an engraving signed W.H and with the date 1716. Perhaps he engraved for Paul de Lamerie between the years 1718 and 1735, certainly not later. He has for many years been accredited with having engraved the Walpole Salver made by Paul de Lamerie in 1727. Little unshakable evidence can, however, be adduced in support of this theory, reasonable though it is. He also signed the trade card of Peter de la Fontaine, c. 1740 (Heal's book on London Trade Cards, Plate 21). Many of his paintings show him to have been a most acute observer of objects and their specific use. The Entertainment in the Sir John Soane Museum, shows a chafing dish being used. The Marriage Contract illustrates a tea kettle on a tripod stand and in A Conversation Piece, formerly in the Cook Collection, there is a large square salver and a chandelier (694).
Bibliography
Anne Forrester, 'Hogarth as an engraver on Silver'. Connoisseur, February 1963.
C.C. Oman, 'English Engravers on Plate. Joseph Sympson & Wm. Hogarth'. Apollo, July 1957.
J.F. Hayward, Huguenot Silver in England. Faber & Faber, 1959.
See also Engraving.

Holbein, Hans (c. 1497–1543)

A painter and designer, he came to England at the request of Henry VIII in 1526. Amongst his drawings are designs for silver which may or may not have been manufactured. A fan handle, now in the Munich Schatzkammer, is thought to be of his invention. The Newmarket Gold Cup of 1887 is a replica in 18 carat gold made by J. Garrard from one of Holbein's designs and stands some 15 in. (38·1 cm.) high. The Boleyn Cup of 1535 (Cirencester Church) is the earliest so far known in the new style initiated by Holbein, though in fact this particular cup was inspired by a design of Hans Brosamer (176). The Seymour Cup, made in 1536, of which but a working drawing now survives, may well be his handiwork (Ashmolean Museum, Oxford).
See also Hour Glass.

Holy Water Stoup

Called in medieval times a 'stock' and sometimes, recently, miscalled bénetier. It seems unlikely that only one was ever manufactured in England, nevertheless, the only surviving example is one made by Joseph Barbut in 1719, now in the Ashmolean Museum, Oxford, and it is of superb quality. As Barbut is registered as a spoon maker it is unlikely that he was responsible for this piece, but in fact stood sponsor for a Huguenot (301).

Honey Pot

Formed as a skep bee-hive, this attractive design is uncommon. Originally, c. 1790, the upper third formed the lid with a ring or bee finial (302), later

the whole skep formed the lid to a glass vess which stood upon a matching dish (303). The sk of 1820 has sides more vertical than its predece sors, and a domed cover.
See also Sugar Vase.

Hookah

It was also known as a 'hubble-bubble'. Design to allow tobacco smoke to be drawn through wat and so cooled before reaching the lips of t smoker. Two extremely rare examples bear t London hall-marks for 1790; each has a silver-g fire bowl and cover, with decorative masks pe dent from chains while the bell-shaped wat reservoir forming the base is of cut-glass (304 These were almost certainly made to spec order, but there is no reason why less splend examples should not have been included among the many and varied articles made in Engla during the 18th century specifically directed at t Turkish (Oriental) market.
See also Pipe, Tobacco.

Horn

Amongst the earliest surviving pieces of secul plate are silver-mounted horns used for drinkin summons, or as tokens of the tenure of la (cornage); as late as the 18th century, horns we used to call factory hands to work. An Anglo-Sax example was excavated at Taplow in Buckingha shire in 1887. The Wassail-horn of about 134 belonging to the Queen's College, Oxford, h a cover of a somewhat later date; another, plain horn and cover belongs to Corpus Christi Colleg Oxford; it has an interesting finial formed as t head of a man, perhaps Edward III, and dates fro about 1347, when it was presented by Jo Goldcarne. This cover terminated in four silver-g acorns, which are now lost, they were intended form a rebus on the donor's name. William Care dying in 1406, bequeathed 'a horn with cover silver and gilt in which I was accustomed to dri on the Feast of the Nativity of Our Lord'. That Christ's Hospital, Horsham, Sussex, can be date c. 1490. A number of others survive, including extremely fine, ivory hunting horn of c. 1340, know as the Bruce Horn, which has two survivin original, enamelled, silver mounts decorated w hunting subjects. Attached to this large horn is much-decayed baldric, bearing fourteen bosse each with an enamelled coat of arms. Traditional this horn of tenure belonged to the Seymo family as Bailiffs and Keepers of the Forest Savernake and thence to the Bruces, Marquess of Ailesbury. Other horns of tenure are those of t Honour of Tutbury, the Pusey Horn of c. 14 (Victoria and Albert Museum) and the Horn Leys. Particularly interesting, both because of th place of manufacture and the fact that they ha remained in the same family who commission them, are two horns, one of which is engrave ' . . . THES HORNS TO BE GARNISHED CHESTERFIELD IN THE [YEAR] OF OU LORD 1574'. The Dayrell Horn, silver-tipped a engraved with the date 1692, was given to t Dayrells of Lillingstone Dayrell as Purlieu hunte Some 20 in. (50·8 cm.) long, it is made of ox-ho straightened by heating (now on loan to t Victoria and Albert Museum). Silver horns we popular as archery prizes during the early 19 century. A very few large powder horns of t 18th and 19th centuries were silver-mounted. Canadian example is in the New Brunswi Museum. Also of 19th-century date is a large o horn mounted as a drinking cup, the gilt mou hall-marked 1803, and the two feet springing fro

Plate 19

Plate 19 The Crown of Scotland
Made of Scottish gold set with diamonds, pearls, semiprecious stones and blue enamel.
Maker's mark of John Mossman of Edinburgh, *c.* 1540, with later additions.
Diameter 8 in. (20·4 cm.).

Plate 20 Centrepiece
Of silver-gilt with the maker's mark of Paul Crespin. However, it seems likely that it was in fact fashioned by Nicholas Sprimont.
Hall-mark for 1741.
Height 27 in. (68·6 cm.).
Collection of Her Majesty the Queen.

Plate 21 The Congleton Mace
A silver-gilt Commonwealth mace with the maker's mark, IV and a pellet below.
Hall-mark for 1651.
Length 41¼ in. (104·8 cm.).
The Corporation of Congleton, Cheshire.

Plate 20

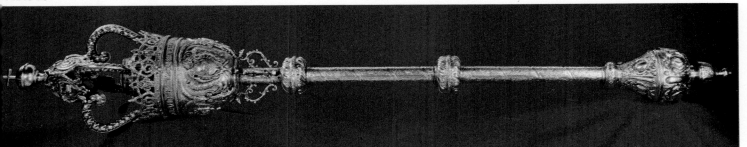

Plate 21

Plate 22 The King John's Cup
An unmarked, silver-gilt and
enamel, 14th-century cup.
Height 15 in. (38·1 cm.).
The stem and bowl are attached to
each other by an ingeniously simple
bayonet joint. The cup is remarkably
heavy.
The Corporation of King's Lynn,
Norfolk.

**Plate 23 Cup and Cover
and Dessert Dish**
The cup and cover are of silver-gilt
with the maker's mark, R.E.WE.
Hall-mark for 1808, London.
Overall height 11 in. (28·0 cm.).
The dessert dish is of silver-gilt, one
of a pair.
Maker's mark of John Angell.
Hall-mark for 1829, London.
Diameter 9¾ in. (24·8 cm.).

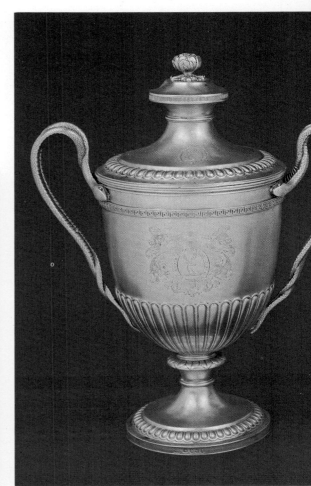

Plate 23

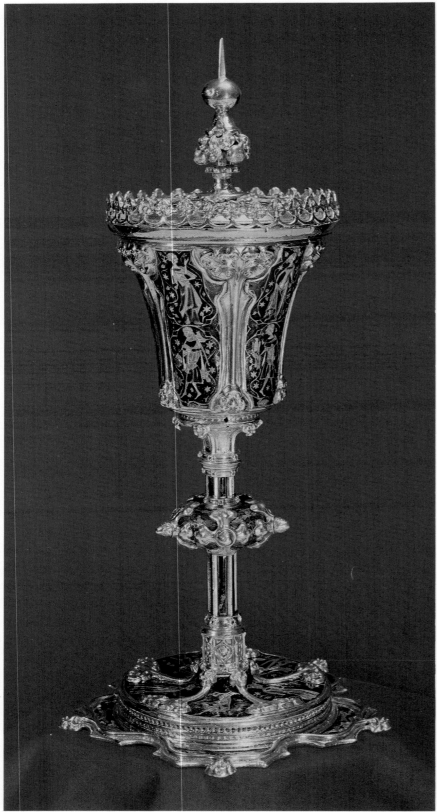

Plate 22

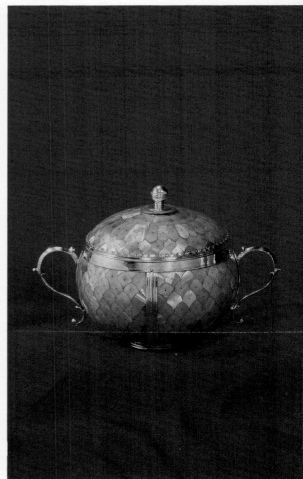

Plate 24

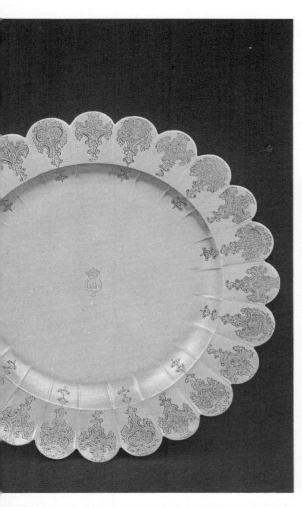

Plate 24 Cup and Basin
An unmarked, two-handled, mother-
of-pearl cup and cover, c. 1660.
A mother-of-pearl and silver-gilt
basin with the maker's mark, a
slipped trefoil.
Hall-mark for 1621.
Victoria and Albert Museum,
London.

Plate 25 The Leigh Cup
A silver-gilt and enamel cup with
the maker's mark, SW in monogram.
Hall-mark for 1499.
Height 16 in. (40·7 cm.).
Bequeathed by Sir Thomas Leigh
in his will of 1571 to the Mercers'
Company.
The Mercers' Company, London.

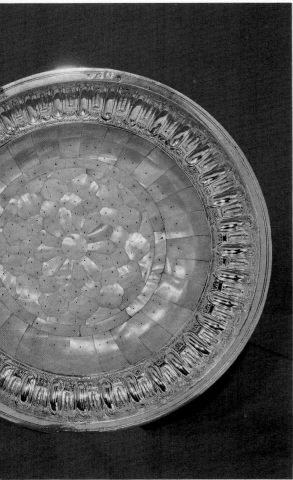

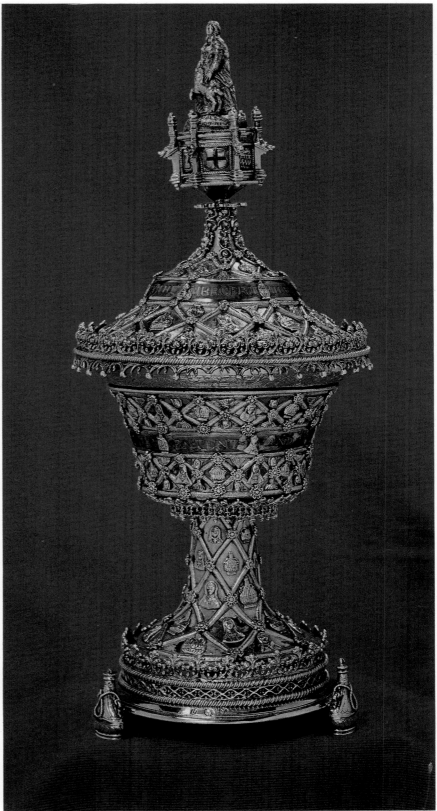

Plate 25

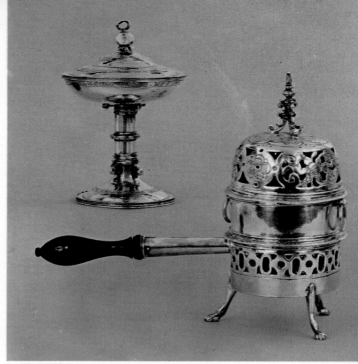

Plate 26 The Methuen Cup and a Perfume Burner
The Scottish silver-gilt and rock-crystal Methuen Cup of the mid 16th century, bearing the maker's mark, VH.
Height 7 in. (17·8 cm.).
The perfume burner bears the maker's mark, T.I.
Hall-mark for 1628.
Height 8¾ in. (22·3 cm.).
Gifts of William Randolph Hearst to the Los Angeles County Museum of Art.

Plate 27 The Bacon Cup
A silver-gilt standing cup with the maker's mark, a bird.
Hall-mark for 1574.
Height 11½ in. (29·2 cm.).
Engraved 'A THYRDE BOWLE MADE OF THE GREATE SEALE OF ENGLANDE...'.
British Museum, London.

Plate 27 Plate 26

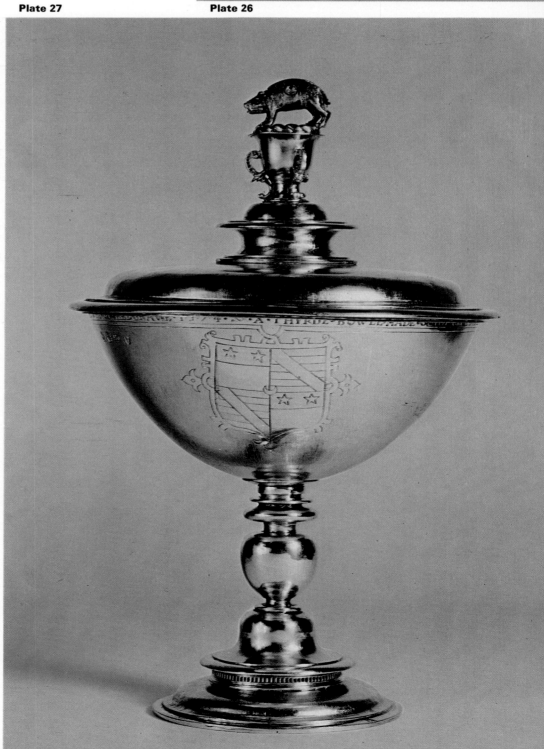

COLOURS

Azure blue	*Gules* red	*Vert* green	*Sable* black	*Purpure* purple

METALS

Or gold	*Argent* silver

FURS

Ermine
white field with black tails

Erminois
gold field with black tails

Ermines or **Pean**
black field with
white tails

black field with
gold tails

CORONETS

Duke
strawberry leaves

Marquess
strawberry leaves with two balls

Earl
five balls

Viscount
nine balls

Baron
four balls

Heraldry The system of engravings conventionally used on silver and gold to indicate heraldic colours, metals, furs and coronets

301

302

301 Holy Water Stoup
Maker's mark of Joseph Barbut.
Hall-mark for 1719.
Height 10 in. (25·4 cm.).
Carter Bequest, Ashmolean
Museum.

302 Honey Pot
Maker's mark of John Emes.
Hall-mark for 1802.
Height 5¼ in. (13·4 cm.).
In the shape of a beehive with
a bee and rose as the finial.

303 Honey Pot and Cover
Silver-gilt mounts and cut-glass.
Maker's mark of John Emes.
Hall-mark for 1807.
Overall height 6½ in. (16·5 cm.).

304 Hubble-bubbles
a. Maker's mark, IA.
Hall-mark for 1790.
Overall height 9¼ in. (23·5 cm.).
b. Maker's mark, IA and KD.
Hall-mark for 1790.
Overall height 14 in. (35·6 cm.).

303

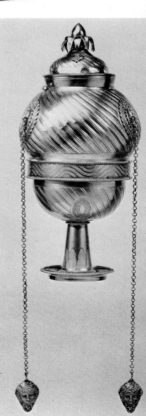

304 a

304 b

-masks, perhaps made from a record-breaking
ast or as an agricultural prize.

●liography

A. Jones, *Old Plate of the Cambridge Colleges*.
mbridge University Press.

A. Jones, *The Plate of the Queen's College,
ford*. 1938.

C. Moffatt, *Old Oxford Plate*. Archibald Con-
ble & Co. Ltd.

d Halsbury, *Laws of England*. Vol. XXIV, p. 340,
12.

C. Oman, 'English Medieval Drinking Horns'.
nnoisseur, vol. CXIII, p. 20.

M. Penzer, 'Christ's Hospital Plate', part I.
ollo, July 1960.

ter Stone, 'Some Famous Drinking Horns in
tain', part I. *Apollo*, April and May 1961.

. Langdon, *Canadian Silversmiths, 1700–1900*.
ronto, 1966.

e also Arrow (Archery Medals and Badges);
unted-pieces; Trumpet.

rn Book

lat, oblong, sheet of horn intended for the use
children. Generally inscribed on one side with
Lord's Prayer, and on the other with the
habet or numbers. Very occasionally found with
er borders. One such example, engraved 1682,
d five others noted by Tuer, are all that have been
orded to date. None are hall-marked.

●liography

V. Tuer, *The History of the Horn Book*. 1897.

e also Bowl.

t-water Stand

th the advent of Sheffield plate as a commercial
●position, the added advantage of individual
te warmers became a practical consideration.
or to this, chafing dishes and perhaps dish
●sses may have been used by the individual
urmet. By the creation of circular or oval, shal-
w, covered pans designed to contain hot water,
a bar of hot iron, which could be placed beneath
silver plates and dishes, to whose form they
re moulded, food might be kept hot whilst in the
ing room, and more important on its way from
kitchen. Only very rarely are examples entirely
silver found, as in the case of one made by
njamin Smith in 1806, now in the Royal Collec-
n. In most cases the warmer was fitted with two
p-ring handles and a flush, hinged trap at the lip,
abling it to be filled with hot water. Entrée dishes
d other large dishes were generally provided with
rit heaters or hot-iron bars rather than water-
kets, with the exception of the venison dish,
ich seems to have been almost invariably made
th a water-jacket, probably owing to its uneven
derside.

e also Chafing Dish; Dish Cross.

ur Glass

ough mentioned in the Royal Inventories of
nry VIII, no undoubted English silver-mounted
ur glass of the 16th or 17th century is known to
ve survived. One example, now in the Museum of
e Arts, Boston, whose provenance is unknown,
t of predominantly Germanic inspiration, has
en the subject of an article which implies that as
is of such ingenious form it could well be
cribed to Hans Holbein. Certainly there was a
sign executed by him in 1545 for a combined
ur glass, clock and salt and presented as a New
ar's gift to Henry VIII. John Cooqus charged
ll Gwynn 2s 6d 'for ye mending of ye goold
wer glasse' in 1674. A few small hour glasses
the late 18th and early 19th centuries survive.

Bibliography

L.G.G. Ramsay, 'A Holbein Hour-glass?'. *Con-
noisseur*, October 1954.

N.M. Penzer, 'The History of the Tudor Jewel
House', part II. *Apollo*, June 1956.

Hubble-bubble See Hookah.

Hull, John (1624–83)

He was born at Market Harborough, Leicestershire,
in 1624 and arrived at Boston, Massachusetts, in
November 1635 with his parents and a half-
brother, who had already served five years of his
apprenticeship (usually seven) to James Fearne, a
London goldsmith. John Hull, however, did not
commence to learn the trade of silversmith until he
was nineteen or twenty years of age, when he
started to work with his half-brother. Hull left a diary
from which we gather that he was also concerned
in other ventures. In 1652 he was appointed to coin
new money (the Pine Tree shillings and sixpences)
to replace the old clipped, and often debased,
coinage then in circulation in Massachusetts. It was
to be 'to the sterling standard for fineness', and for
this task he 'chose my friend, Robert Sanderson, to
be my partner'. In 1659 he took apprentices,
'Jeremie [sic] Dummer' (1645–1718) and Samuel
Paddy.

See also Hull & Sanderson; Sanderson, Robert.

Hull, Kingston upon

No mention is made of Hull in the Act of 1423,
when appointed towns were given touches of their
own, and no trace has been found of any charter for
a goldsmiths' company's incorporation in that town.
During the late 16th and early 17th centuries the
town mark used seems to have been the letter H, at
first engraved by Peter Carlill (free in 1556) to-
gether with his own mark; later stamped by silver-
smiths, such as James Watson (free in 1582), the
maker also striking his own mark. By about 1620,
however, the Arms of Hull had been adopted, three
ducal coronets in pale. The working of plate seems
to have died out towards the very end of the 17th
century and surviving pieces are rare, Abraham
Barachin being the only goldsmith to obtain his
freedom after the introduction of the Britannia
standard in 1697. Perhaps the rarest piece of Hull
silver is a skillet and cover made by James Birkby,
c. 1660, in a private collection. Less than one hun-
dred and fifty pieces of Hull silver are at present
known. These include a tankard of York (Scan-
dinavian) form made by Thomas Hebden and a
number of pieces made by Edward and Katherine
Mangy (members of the same family, who were
important York silversmiths).

Bibliography

C.C. Oman, 'Goldsmiths of Kingston upon Hull'.
Connoisseur, December 1951.

R.A. Alec-Smith, 'Silver bearing the Hull Assay
Mark'. *Apollo*, September 1951.

*Exhibition of Silver made by the Goldsmiths of
Kingston upon Hull*. 1951.

Hull & Sanderson

Though not the earliest silversmith known to have
gone to the American Colonies, John Hull (1624–
83) was born at Market Harborough, Leicester-
shire, and was taken to America at the age of ten,
together with his half-brother, then nearly out of
his apprenticeship to James Fearne. He then, as he
records in his diary, 'fell to learning (by the help of
my brother) and to practising the trade of a gold-
smith'. Robert Sanderson (1608–93) was also
born in England and apprenticed in 1623 to William
Rawlins in London for nine years (two years

longer than usual). Six years after completing his
apprenticeship, Sanderson emigrated to America,
first to Hampton and later to Watertown, Massa-
chusetts.

In 1652, Hull records his being chosen to mint
coin 'to the sterling standard for fineness' (these
were the famous Pine Tree shillings) 'and I chose
my friend, Robert Sanderson, to be my partner, to
which the Court consented'. Hull, later becoming
one of Boston's richest and most respected citizens,
received one out of every twenty coins minted. On
the strength of a small dram cup made by Hull &
Sanderson (Garvan Collection, Yale University Art
Gallery) yet bearing the maiden initials of Ruth
Brewster, who was married in 1651, the late J.M.
Phillips advanced the theory that they were already
partners as silversmiths before being empowered
to set up a mint. This seems quite reasonable. A
number of pieces survive with the marks of one or
other of the partners, besides those bearing their
joint marks, of which the earliest recorded is the
beaker pricked with the date 1659 and 'The Boston
Church'. In 1659, 'Jeremie Dummer' was bound
apprentice to Hull and was later to become the
author of a number of important surviving pieces
(**729**).

See also Coin; Sanderson, Robert.

Hurd, Jacob (c. 1702–58)

He worked in Boston, Massachusetts. Perhaps an
apprentice to John Edwards, of whose estate he
was one of the appraisers, Jacob Hurd was a
prolific silversmith, over three hundred pieces of
his work survive, including the gold snuff box in
the Museum of Fine Arts, Boston. Equally rare is the
Oar of Admiralty, now the property of the
Massachusetts Historical Society. By him also is
one of the earliest of the very few extant American
kettles, still owned by the family for whom it was
made. There is a particularly fine two-handled cup
and cover in the Museum of Fine Arts, Boston,
and he made a pair of casters, now in the Hammer-
slough Collection. Besides these pieces he was
known to have turned his hand to sword hilts or
anything else which required to be fashioned in
silver.

Bibliography

*Jacob Hurd and His Sons, Nathaniel and Benjamin,
Silversmiths*. Privately printed, 1939.

Hurling Ball

Hurling is a game, often very rough, that resembles
hockey. It has long been the national game of Ire-
land, and a version is still sometimes played in the
west of England, mainly on Shrove Tuesday. During
alterations at Newton Ferrers, near Callington,
Cornwall, in the 1920s, a silver encased ball, some
2 in. (5·1 cm.) in diameter, was discovered. It is
engraved in a 17th-century script 'Play fare bee
merry and wise that of your sport no harm arise.
God Save The King'. It would seem that the squire
of the village gave a new ball each year, he becom-
ing entitled to the old one.

Bibliography

F.H. Cripps-Day, 'Hurling to the Country'. *Con-
noisseur*, vol. LXXVII, p. 97.

See also Bell (Race Bell).

Ice-pail or Bucket See Wine Cooler.

Imported Plate

There seems little doubt that at all times a certain
quantity of foreign silver has been imported into
England for sale, being assayed and hall-marked
on arrival. This was certainly the case during the
late 16th and early 17th centuries. Some of the

surviving pieces also bear their original foreign marks. It was not until 1844 that it became legal to import plate made prior to 1800 without any formalities, later work still having to be assayed on entry, although no special mark for such plate was ordained until 1876.

Bibliography

C.C. Oman, 'A Rare Hall-marking Anomaly'. *Connoisseur*, vol. CXXI, 1948.

Incense Boat

Its title is sufficient to describe its form. The one medieval example, illustrated on Colour Plate **13**, is known as the Ramsey Abbey Incense Boat and dates from *c.* 1350; one half of the cover of the boat-shaped bowl is hinged to allow access (Victoria and Albert Museum). Usually a spoon, perhaps chained, accompanied the boat. Incense dishes and bowls are frequently mentioned in inventories; Recusant plate includes a number of incense boats. Those surviving are generally uninspired and often on a somewhat taller foot than medieval examples; one of 1742 is at Corby Castle, Cumberland. Medieval and 16th-century inventories often describe them as a 'shippe'. A considerable number of these pieces are to be found in Canada and, as might be expected, of French Canadian silver. The incense boat from the Chapel Royal, Edinburgh, made for James II, together with its accompanying censer, is London-made, whereas the bell from the same altar service is by Zacharius Mellinus of Edinburgh, 1686.

Bibliography

C.C. Oman, *English Church Plate*. Oxford University Press, 1957.

J.E. Langdon, *Canadian Silversmiths, 1700–1900*. Toronto, 1966.

Hubert Fenwick, 'Silver for Huguenot and Catholic'. *Country Life*, April 25th, 1968.

See also Censer; Nef.

Incense Burner

See Censer; Hookah; Pastille Burner; Perfume Burner.

Incuse

It literally means to impress by stamping. During the years 1784 and 1785 the duty mark struck at the assay offices was of this type. That is to say, the profile of King George III was struck deeper into the metal than the surrounding outline of the punch. Certain makers struck marks of this type but such marks were liable to damage, being 'proud' of the face of the punch. The drawback mark was also of this form.

See also Hall-mark.

Indian Peace Medal See Breastplate and Gorget.

Indian Trade Silver

A very considerable business, based on barter, was built up in silver goods, such as head bands, arm bands, gorgets, ear-rings, brooches and even cradle ornaments, which were exchanged for furs and other natural products of both Canada and the United States during the course of the 18th and early 19th centuries.

Bibliography

J.E. Langdon, *Canadian Silversmiths, 1700–1900*. Toronto, 1966.

A. Woodward, 'Highlights on Indian Trade Silver'. *Antiques*, June 1945.

Ingot

A block of metal cast into a shape and of a weight convenient for bulk handling and processing.

Inkhorn

During the Middle Ages and up to the 16th century at least, the normal container for ink was a horn. As more learned to write, so the need for an inkstand, or 'standish' as it was also called, became more obvious, though doubtless the itinerant scribe was still fully employed by the majority of people. See also Penner.

Inkstand (Standish)

In 1626 the Royal Plate included, amongst others, 'a silver standish with a drawer, box and dust box [pounce box]'. In 1620 the Countess of Oxford presented King James I with one of gold. However, existing early examples are comparatively rare. A casket of rectangular form and hall-marked 1610 has been so much repaired that it may be debatable as to whether it was originally designed as a standish (**305**). Other than this and a defective example of 1615, the earliest known surviving example, now in the Museum of Fine Arts, Boston, dates from 1630 (**306**). It has a container for ink, sand (also known as 'pounce', the powder of gum sandarach, which served to 'fix' the ink on absorbent paper or parchment) and a small wafer box. There are three other pre-Civil War examples of 1638 and 1639. Most important is that of 1639, shown on p. 10, having two candle-holders and numerous compartments and measuring 16½ in. (41·9 cm.) wide. It stands on four lion couchant feet and is wholly decorated in the manner of Van Vianen. The coats of arms it now bears are of early 18th-century date. The maker's, or more probably sponsor's, mark is probably that of Alexander Jackson.

The standish of the mid 17th century is of rectangular casket form (**307a**). That of 1652, formerly in the collection of the Earl of Haddington, has suffered alterations to the lid. One of 1662 in the Duke of Portland's collection is particularly fine. One of the largest inkstands known of this type was made by Paul de Lamerie in 1733, it is 15 in. (38·1 cm.) wide and originally it belonged to Sir Robert Walpole, now in the collection of the Bank of England (**310**). The earliest American inkstand was made by John Coney, now in the Metropolitan Museum of Art, New York, of triangular form, on three lion feet, with a central ring handle reminiscent of a cruet frame. The next type is salver-like, oblong and fitted with three or more silver bottles for ink, cleaning shot and pounce, sometimes with a sliding drawer beneath (**308**) or, as the superb silver-gilt example in the Ilchester Collection made by Simon Pantin in 1705 and fitted with a bell. Plate **307b** illustrates another inkstand of this form made by Anthony Nelme in 1703. A vertical tube is occasionally found, generally behind the central fitting, it was probably intended to hold a stick of sealing wax, a quill or a loose taper. An example of 1731 made by Augustin Courtauld, now in the Kremlin, Moscow, illustrates this feature; it also has a sliding drawer beneath, a feature retained by his son, Samuel, for an inkstand of 1748, now in the Farrer Collection, Ashmolean Museum, Oxford. Amongst the finest Rococo examples is one made by Peter Archambo in 1739, once in the Foley-Grey Collection, and another by John Edwards of 1744, chiselled with eagles wings, dolphins and scroll-work, bearing the Arms of Neeld, 16½ in. (41·9 cm.) wide. By 1740 oval examples appear, similarly fitted, sometimes with a taperstick or bell, or a combination of both (see Bell). Many other variations are extant (**309**, **311** and **318**). Small examples with a baluster handle to one side were probably designed for ladies and are not found much later than 1730. In 1760 a form with pierced, galleried sides appears, and this partial return to the

earlier casket form of base carries on into the 1[?] century, with many variations (**312**). The bott[?] are now frequently of cut-glass with silver mou[?] (**313**). Very occasionally an oil lamp of antic[?] form is added to the stand, especially between [?] years 1800 and 1830. Very large examples w[?] still made in the late 18th century, probably for [?] in the library (**314**). Globe inkstands appeared [?] 1790 and an ingenious combined inkstand a[?] candlestick made by Obadiah Rich of Boston m[?] date from *c.* 1830. Perhaps the most famous of [?] is the inkstand by Philip Syng, made in 1752 [?] the Pennsylvania Assembly and used by the s[?] natories to the Declaration of Independence. Ea[?] 19th-century inkstands reflect the demand of [?] day for massive plate (**315**, **316**, **317** and **319b**)[?]

A letter written by Elizabeth Purefoy shows t[?] times do not change very much!

'ffor Mr. Stafford Briscoe. Goldsmith at the Gold[?] Ballon by the corner of ffriday Street in Cheapsi[?] London.

<div align="right">Shalstone
Decemb'r the 17th 17[?]</div>

Mr. Bruce,

You advertise you have second hand inkstan[?] to sell. I want one about 5 inches wide by 8 inch[?] long, one whole side of it is to lay pens in, and [?] other side has three places, one of them for the [?] Viall, another for the wafers, and another for [?] sand, if you have any such thing at second hand [?] mee know, & what it is an ounce, & how muc[?] weighs. I do also want a soop dish of a fashiona[?] make & a couple of strong square waiters abou[?] inches square; if you have any second hand thi[?] of this sort let mee know the Price and weight [?] them & then you shall have my answer who am [?]

<div align="right">Your humble servt.
E.P.</div>

P.S. In August 1743 I lodged at Mr. Longley's o[?] against the Grange Inne in Carey Street by Lincol[?] Inne and bought severall things of you. And let m[?] know the price and weight of a small sized seco[?] hand bread basket when you have it'.

An early portrait by J.M. Wright of Sir Ro[?] L'Estrange (1616–1704) shows the type of sta[?] dish with cylindrical tube referred to abo[?] (National Portrait Gallery, London). A fine inksta[?] in the old style was that made by Leslie G. Dur[?] in 1944 to commemorate the 250th Anniversary [?] the founding of the Bank of England (**319a**).

Bibliography

E.A. Jones, 'An Historic Silver Inkstand'. *C[?] noisseur*, vol. XCVIII, p. 140.

The Antique Collector, April 1955.

Inkstand, Globe

The fashion, which spanned the years 1770–18[?] for the inkstand formed as a library globe seems [?] have been short-lived, possibly due to its u[?] suitability as a form for this purpose. They are ra[?] and, when found, very often of silver-gilt. Jo[?] Robins appears to have specialised in maki[?] these (**320**). Lord Melbourne purchased one fr[?] Messrs Parker & Wakelin in 1771. This was e[?] ceptionally heavy (59 ounces 15 pennyweigh[?] and cost £29 2s 6d. It included '2 glass boxes' a[?] the following year he required 'an inkglass to [?] Globe stand'.

Inkstand, Travelling

A non-spill ink pot, the cover screwing down up[?] a cork washer, is found from the 18th to mid 1[?] centuries, usually forming part of a travelling d[?] or a toilet service and taking the place of the 17[?] century penner.

See also Penner.

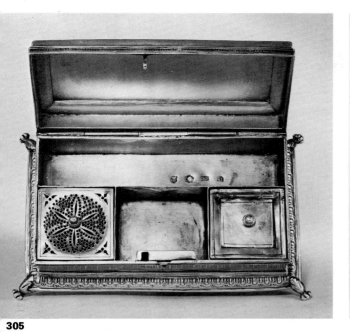

305

306

305 Inkstand
Maker's mark, BT between two
staves in saltire.
Hall-mark for 1610.
306 Inkstand
Maker's mark of William Rainbow.
Hall-mark for 1630.
Height 5¼ in. (13·4 cm.).
Museum of Fine Arts, Boston.
307 Inkstands
a. Maker's mark of John Ruslen.
c. 1669.
Width 6½ in. (16·5 cm.).
Engraved with the Arms of Pullen.
b. Maker's mark of Anthony Nelme.
Hall-mark for 1703.
Width 11½ in. (29·2 cm.).

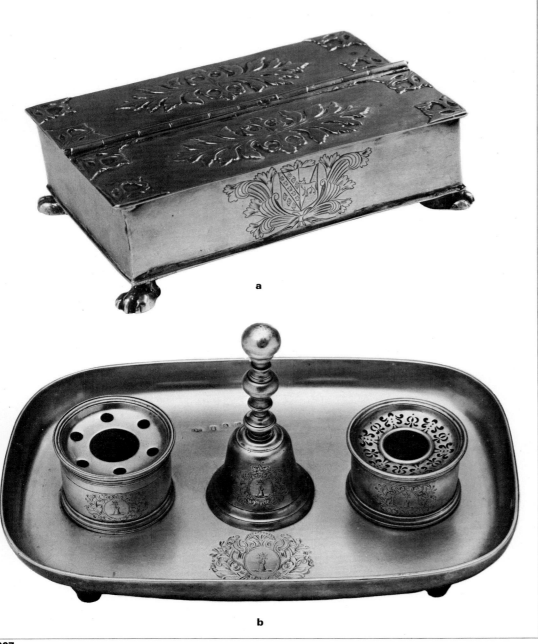

a

b

307

308 Inkstand
Maker's mark of Anthony Nelme.
Hall-mark for 1717.
Length 6¼ in. (15·9 cm.).
Width 2⅞ in. (7·3 cm.).
Assheton-Bennett Collection.

309 Inkstand
Maker's mark of Anthony Nelme.
Hall-mark for 1718.
Carter Bequest, Ashmolean
Museum.

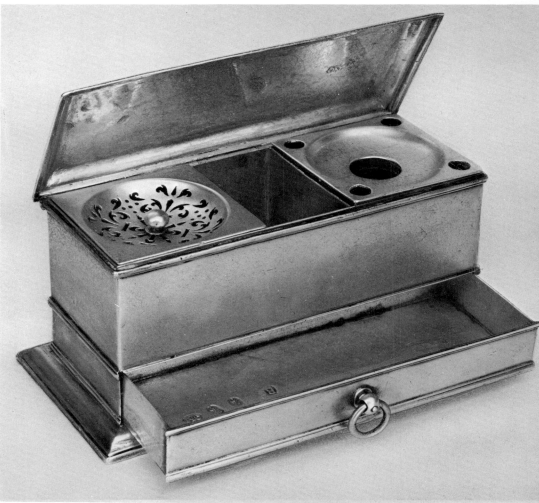

308

309

310

310 The Burrell Inkstand
Maker's mark of Paul de Lamerie.
Hall-mark for 1733.
Length 15 in. (38·1 cm.).
Width 7⅜ in. (18·8 cm.).
The Bank of England.
Engraved with the Arms of Walpole
and the monograms of Burrell and
Walpole.

311 Inkstand
Maker's mark of Benjamin Pyne.
Hall-mark for 1752.
Width 9¼ in. (23·5 cm.).

312 Inkstand
Silver-gilt.
Maker's mark of Wakelin & Taylor.
Hall-mark for 1790.
Overall length 13½ in. (34·3 cm.).

311

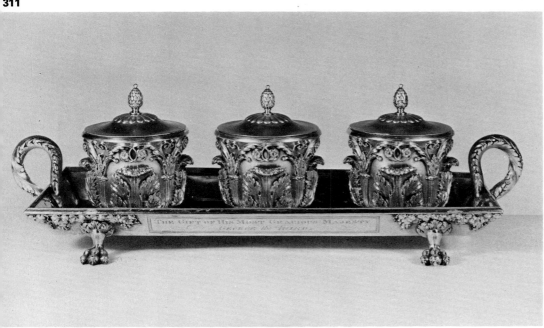

312

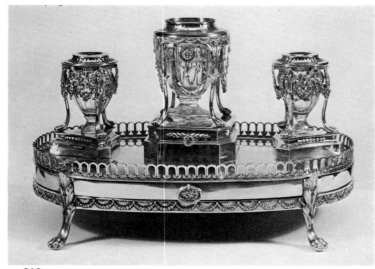

313

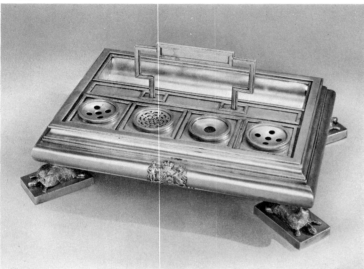

314

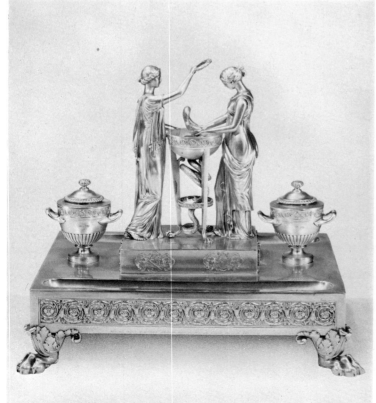

315

313 Inkstand
Silver-gilt.
Maker's mark of W. Pitts & J. Preedy.
Hall-mark for 1794.
Width 14½ in. (36·9 cm.).
Note the drawer in the base.
314 The Fitzwilliam Inkstand
Maker's mark of John Parker.
Hall-mark for 1802.
Length 16½ in. (41·9 cm.).
Width 11½ in. (29·2 cm.).
315 Inkstand
Maker's mark of Paul Storr.
Hall-mark for 1817.
Width 12½ in. (31·8 cm.).
Engraved with the Arms of Cooper.
316 Inkstand
Silver-gilt.
Maker's mark of Phillip Rundell.
Hall-mark for 1821.
Height 28½ in. (72·4 cm.).
The Royal Arms are engraved
beneath, in reverse, in order to
reflect on the upper surface of the
plinth.
317 Inkstand
Maker's mark of Harvey Lewis of
Philadelphia who was working
c. 1811–22.
Height 3⁷⁄₁₆ in. (8·8 cm.).
Yale University Art Gallery,
Mabel Brady Garvan Collection.

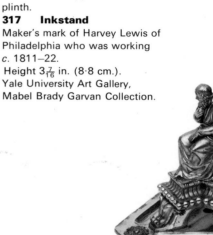

316

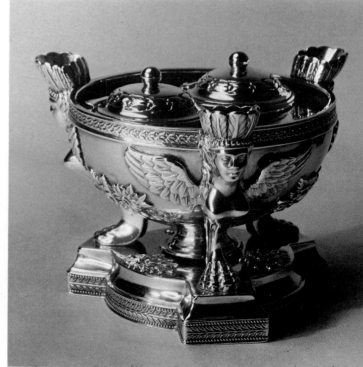

317

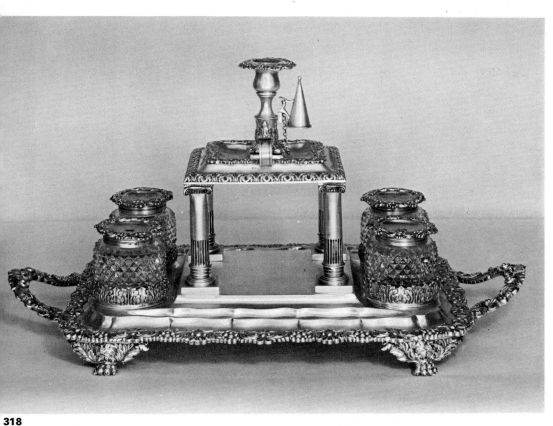

318

319 a

319 b

318 Inkstand
Maker's mark of John Angell.
Hall-mark for 1821.
Width 11 in. (28·0 cm.).
319 Inkstands
a. Parcel-gilt.
Maker's mark of Leslie Durbin.
Hall-mark for 1944.
Length 17¼ in. (43·8 cm.).
Commissioned to mark the 250th
Anniversary of the Bank of England.
b. Maker's mark of E. & J. Barnard.
Hall-mark for 1838.
320 Globe Inkstand
Maker's mark of John Robins.
Hall-mark for 1798.
Height 7½ in. (19·1 cm.).

320

Inkstand, Treasury

The treasury inkstand (also known as the 'ambassador' inkstand) takes its name from those issued to the Treasury in 1686, three of which still survive, although the form is, in fact, much earlier. Usually, but not always, they are double-lidded, rectangular, with a central handle and on four claw feet. Their issue was authorised on September 13th, 1686 when the Master of the Jewel House was ordered to provide 'one silver standish for the use of the King: twelve single standishes, 100 ounces each, for the use of the Lords of the Council together with a like number of candlesticks and pairs of snuffers'. Eight inkstands of similar form and date remain with the Privy Council, but these have foliate feet. Later examples based upon the original design vary in several different ways (**310**). One of 1761, made by Parker & Wakelin, has a cover divided into four sections, one pierced for quills, thus ensuring that the whole of one side need not be opened at the same time.

Bibliography
Lord Chamberlain's Accounts. P.R.O. (ref. LC 5/108 fol. 95).
See also Bell (Inkstand Bell); Inkhorn; Oil Lamp; Penner; Taperstick.

Instrument

Considerable quantities of medical instruments and utensils survive in silver. Also made in silver, though more often found in base metals, were navigational, astronomical, drawing and other instruments, such as scales. The majority of these latter are of Continental origin. Proven English examples are rare, such as the sextant at the National Maritime Museum made c. 1820. Two silver-encased microscopes executed by George Adams of Fleet Street, London, survive in the Science Museum, South Kensington, and the Museum of Science, Oxford. The latter appears to be that made by Adams for King George III in 1761 and the same Museum also houses a protractor made by Kirkby, dated 1765 and engraved with the initials of Queen Charlotte (1744–1818). An armillary sphere of c. 1700 made by Rowley; a telescope of c. 1725 and a number of silver- or gold-mounted loadstones of 16th- and 17th-century date are in the same Museum. The ease and clarity with which silver might be engraved undoubtedly encouraged its use by instrument-makers and the number of pieces, in which the dials are of silver inlaid in a brass frame, is considerable. Very few such pieces are hall-marked. Two silver astrolabes of late 17th-century date made by R. Glynne are in the collection of the Duke of Devonshire. At least one gold-mounted compass of 1788, made either by John Pottinger or John Phillip, is known to exist. A silver Universal Equatorial Dial by R. Glynne, 168 mm. in diameter and dating from c. 1730, also survives.

Bibliography
Kathleen Higgins, 'An Elizabethan Quadrant Dial in Silver'. Connoisseur, vol. cxxv, 1950.
Eric Delieb, 'Medical Silver'. Apollo, June 1961.

Instrument Case

Perhaps the earliest, certainly the finest to survive (there is another of brass in the Victoria and Albert Museum) is that belonging to the Barber-Surgeons' Company, now happily once again their property (**425**). This hangs from silver chains, is of silver-gilt and enamel and bears the Arms of the Company and those of Henry VII and applied with the figures of SS Cosmo and Damian, the patron saints of doctors, together with those of St Catherine and St John (the first three models are so far unknown on any other piece of English silver, although spoons

having St Catherine finials are recorded in medieval inventories and wills). Unmarked, it must date from c. 1515. It also retains its original carrying case of incised cuir-bouilli. Other cases, such as those for sets of razors, spectacles and geometrical instruments are found with increasing regularity from the 1740s onwards; 17th-century examples are rare, excepting those cases for travelling knives, forks and personal canteens. At least two shagreen-covered cases for surgeons' instruments, each about 6 in. (15·3 cm.) long, with a sliding drawer at one end, and silver mounts, survive from c. 1680. One even retains its lancets, forceps, tongue depressor, scissors, scraper for the teeth, spatula, measuring spoon and also a director (a guiding device, used when probing for bullets), not to mention a 'caustic' holder.

Bibliography
W.W. Watts, Catalogue of the Lee Collection. 1936.
See also Razor Case.

Irish Silver

A number of magnificent, Celtic, ecclesiastical pieces in gold, silver and enamel survive from the 8th to the 12th centuries, of which one of the most well known is the Ardagh Chalice (National Museum of Ireland, Dublin). Practically nothing survives from the turbulent four centuries that follow, until the re-establishment of the Dublin Goldsmiths' Company in 1637 (q.v.). Only a few spoons are known from this time, other pieces of domestic plate surviving solely from the post-Cromwellian period. Nevertheless, Irish silver styles begin, from the mid 17th century, to reflect closely the economic and political position of the country. Until the 1720s, Irish silver is very similar to that of London, both in style and quality. In some ways it is even more English than the latter, as Huguenot influence had not yet reached Ireland. On the other hand Irish silver can show more Williamite-Dutch influence, for example the toilet service made by John Phillips, c. 1680, or in the cut-card work on the splendid, great, silver-gilt ewer and dish made by John Humphreys of Dublin in 1693 for Lord Sidney, the Lord-Lieutenant of Ireland. Some articles are commoner in Ireland than in England, for example the small Ming porcelain-shaped bowls emulated in silver.

As the 18th century progresses, Irish silver grows more independent in character, but less fine in finish. The reason for this probably lies in the fact that the Anglo-Irish aristocracy, which at first controlled the wealth of the country, was largely made up of absentee landlords who bought their plate in London, an earlier example is the Great Seal of Ireland Cup, which was made in London in 1592 (Ulster Museum, Belfast). They also required their Irish-made plate at least to match that which was London bought. Only gradually did a less splendid, but Irish-orientated, middle class grow up, whose tastes were bucolic and less exacting. There are of course finely finished Irish pieces dating from this period, but they are the exception. Many pieces were decorated with a naturalised version of Huguenot-Dutch flat chasing. At first, flowing scrolls predominated, gradually to be replaced after the mid 18th century by more floriate patterns of higher relief. Typically Irish shapes began to be evolved, such as the famous dish rings and later, in the 1780s, pointed-handled flatware. Both these forms are hardly ever found in other countries, though the pointed-handled spoon seems to have been an immediate export success to the newly emancipated Colonies of America. The period from 1780 to 1800, when the Union with England took place, was one of great prosperity in Ireland. New

designs were evolved, especially the bright-[cut] patterns, which, when newly finished, glitter [like] cut-glass chandeliers. From 1800 onwards, [the] Union killed Dublin as a capital city and practica[lly] destroyed its flourishing silver trade. English a[nd] Irish styles again approached each other, thou[gh] the process seems to have been a two-way one, [as] traditional, rich, Irish surface decoration appea[led] to Regency and Victorian England. 'Famine' silv[er] is all the more striking in Ireland where poverty w[as] at its worst from the 1840s onwards. These hea[vy] pieces, two or three times the normal weight, w[ere] made for wealthy merchant families for whom sta[g-] nating commerce had closed other sources [of] investment; a tragic commentary on the tim[es.] National styles again developed from c. 1890, n[ow] based on Celtic patterns in the wake of the Gae[lic] revival. Some of these pieces are original a[nd] extremely interesting.

Ecclesiastical Plate

Considerable quantities of Irish chalices have s[ur-] vived from the 15th century onwards, notwi[th-] standing the proscription of the Catholic faith o[ver] a large part of the period. Most are understanda[bly] unmarked. The subject remains to be studied, [but] there do seem to be local stylistic variations, dra[w-] ing, in the later period, on styles current in north[ern] France and Rome, where the seminaries for Ir[ish] and English priests were then located.

Bibliography
Marks
M.S. Dudley Westropp, chapter on Ireland [in]
Sir C.J. Jackson's English Goldsmiths and Th[eir]
Marks. 2nd Edition 1921, reprinted 1949.
John Hunt, 'Redating some important Irish silv[er.']
Connoisseur, March 1961.
M.S. Dudley Westropp, 'The Cork Goldsmiths [...]
...' Cork Historical and Archaeological Soci[ety]
Journal, vol. xxxi, pp. 8–13, 1926.
M.S. Dudley Westropp, 'The Goldsmiths [of]
Limerick'. North Munster Antique Journal, vo[l.]
pp. 159–62, 1936–9.
Styles (Domestic Plate)
Francis Townshend, 'Irish Silver Sugar Tong[s.']
Country Life, June 11th, 1964
Francis Townshend, 'Irish silver Cream Jug[s.']
Country Life, September 23rd, 1965.
Francis Townshend, 'Irish Documents in silv[er.']
Country Life, June 9th, 1966.
Francis Townshend, 'Irish silver: decoration a[nd]
redecoration'. Bulletin of Irish Georgian Socie[ty,]
pp. 10–38. January–March 1965.
Francis Townshend, 'Silver for Wine in Ireland', pa[rts]
I, II and III. Country Life, June 15th, 1967, Ju[ne]
29th, 1967 and September 21st, 1967.
Ecclesiastical
J.J. Buckley, Some Irish Altar Plate. Dublin, 194[]
John Hunt, The Limerick Mitre and Crozier. Dub[lin]
Catalogues
Victoria and Albert Museum, Irish Silver. (Sm[all]
Picture Book, no. 46.)
Ulster Museum, Historical Silver in Ulster. Belfa[st]
1956.
See also Cork Goldsmiths' Guild; Dublin Ass[ay]
Office; Limerick; New Geneva.

Jardinière

It is difficult to be absolutely certain as to the [in-] tended use of certain oval bowls, some as much [as] 15 in. (38·1 cm.) long, with vertical or semi-verti[cal] sides, found towards the end of the 18th centu[ry.] The upper border is often scalloped like a monte[ith] sometimes in the form of the Classical 'wa[ve] pattern', in which latter case it was probably [in-] tended as a verrière (for cooling glasses). Usua[lly] these bowls have a mask and ring handle at eit[her]

d. They are very rare and are as frequently found
·de in Sheffield plate as they are in silver. Their
·sumed use for holding flowers is arrived at by their
·sociation with porcelain examples. A pair made by
·nry Greenaway in 1774 is amongst the collec-
·n of the Duke of Portland. As early as 1687 the
·rl of Devonshire purchased 'a great jarr, 2 flower
·tts, 4 little jarrs of silver', but these were pro-
·bly a *garniture de cheminée* and of ginger-jar
·m.
·e also Monteith.

·wish Ritual Silver

·with the Recusant Catholics, the Orthodox
·wish rite has required the commissioning of
·ecial pieces of silver. By the tacit approval of
·mwell in 1656 and later, the Corporation of the
·y of London (323), the Jewish community has
·ne from strength to strength and the present
·nagogue of Bevis Marks was consecrated as early
·the year 1701. There, and at the Jewish Museum,
· preserved a remarkable collection of bells for
· Scroll of the Law, Hanukah lamps, scroll
·unts (321), lavers and ewers. Other than those
·de by Abraham de Oliveyra, the majority of
·ces are the work of well-known silversmiths
·th no particular Jewish connection. A Sabbath
·np made by Hester Bateman in 1781 exists, and
·one of only five such lamps known (322). A
·rticularly fine Hanukah lamp made by John
·slen in 1709 was lent to the exhibition of Anglo-
·wish Art in 1955 by a private collector.
The major pieces of Jewish ritual silver are as
·lows:
·ron Box. A receptacle for the citron used at the
·stival of Tabernacles.
·nukah Lamp. The eight-branched candelabrum
·mmemorating the exploits of the Maccabees.
·ually formed as a back plate with an oil
·ervoir below and to the front.
·ddush Cup. The silver wine goblet used in the
·nctification ceremony.
·vers and Ewers. Used by descendants of Aaron
· wash their hands before pronouncing
·nediction.
·e Pointer. Used by the reader when reading from
· Scroll of the Law.
·monim (also called Finials). Silver bells which
·orn the Scroll of the Law. Placed upon the top
·ndles of the rollers, which may also be of silver,
·on which the Scroll is wound. When it is carried
·s usually covered.
·e Spice Box. Used at the Habdalah ceremony at
· conclusion of the Sabbath.
·liography
·. Grimwade and Others, *Treasures of a London*
·mple.
·. Grimwade, 'Anglo-Jewish Silver'. *Jewish*
·storical Society, vol. XVIII. Taylor's Foreign
·ss, 1951.
·. Grimwade, 'The Ritual Silver of Bevis Marks
·nagogue', parts I and II. *Apollo*, April and May
·50.
·are Judaica. Zagayski Collection'. *Parke-Bernet*
·talogue, March 18th and 19th, 1964.
·W. Rosenbaum, 'Myer Myers, Goldsmith'. *The*
·wish Publication Society of America, 1954.
·e also Lord Mayor's Dishes and Cups; Myers,
·yer.

·int Handle

·so known as 'leg-of-mutton holders', these 19th-
·ntury additions to the table enabled a firmer grip
· be taken of the joint by slipping a silver-mounted,
·ory handle over the bone and fixing it by means
· a thumbscrew.

Jolly Boat

One of the most attractive forms of double coasters
(325), the jolly boat, formed as a boat, is often
engraved across its stern with its name, and runs
on four castor feet fixed to the base. A red,
lacquer example with silver mounts dated 1801 is
in the National Maritime Museum, Greenwich
(324). One of the finest is that dated 1821 in the
collection of the late Lord Fairhaven, $17\frac{1}{2}$ in. (44·5
cm.) in overall length, fitted with three, graduated,
glass decanters; it is, however, designed more as
the hull of a frigate than a mere jolly boat.
See also Bottle Stand; Wine Coaster.

Jug

The earliest jugs to survive are those now, or at one
time, associated with basins and known as 'ewers'.
A few Elizabethan bulbous tankards may also be
considered as having served a double purpose both
as jugs and drinking vessels. Flagons of cylindrical
form are rare survivals as secular plate but they do
exist, and were frequently given, at a later date, to
the Church. Though clumsy, they must be con-
sidered as a form of jug. The livery pots dated 1594,
1595, 1604 and 1610 in the Kremlin, Moscow, are
very similar to the bulbous tankard form, though
each is on a high foot (the Collection also includes
one of these, dated 1571, which is on a low moulded
foot). There are also a number of flagons extant
which are in fact referred to in early inventories as
livery 'potts'. Contemporary with these was the
continued production of ewers and basins and two
pairs of vast bombé water pots of 1604 and 1615,
which also survive amongst the plate in the Kremlin.
It seems likely that these may have once formed
part of the English Royal Plate. By the time of the
Restoration in 1660, the demand for ewers and
basins was decreasing, with the exception of those
patrons who required massive sideboard plate. On
the other hand, jugs for use at table for wine or ale
make their appearance. A pair of c. 1650 in the Van
Vianen style are now in the Rijksmuseum, Amster-
dam (326), and are known to have been made in
England. Such jugs were supplied to cope with all
the vagaries of fashion, for use with toilet services
as shaving bowls (328), and for beverages, with or
without covers (327a). A pair made by Isaac Liger
in 1704 has finials to the lip extensions of the
cover. From Ireland came oddly attractive variations,
such as that made by David King in 1706 (340). It
should be remembered that any use which may be
considered apposite today, might have been so in
the 17th and 18th centuries. Generally speaking,
the handles of these jugs are polished and well
finished, which implies that they were not
intended to be wickered and therefore not intended
to hold anything more than a warm liquid (331).
The superb pair with cut-card ornament made by
Pierre Harache in 1697, in the collection of the
Earl of Warwick, are of very unusual bottle form
and may well have formed part of a toilet service.
Fluting and strapwork ornament were frequently
applied to the finest examples, which were usually
supplied in pairs, sometimes having the handles
engraved A and B for ale and beer. By 1725 the
covered jug tends to die out, excepting always
those intended to hold chocolate or coffee. In
general, the jug of the 18th century tends to be
relatively plain when singly made and not as part
of a set of any description. Odd forms inspired by
pottery originals, such as those from Nottingham,
tend to be of the first half of the 18th century (327b,
329, 330, 332, 334 and 335). From 1730 onwards,
the plain, pear-shaped form, sometimes of very
considerable size, is most usual, though the helmet
ewer with its attendant basin survives as sideboard

plate. With the impact of the designs produced by
the Adam brothers during the 1760s and the con-
sequent emphasis on Classical forms, of which the
ewer was in the van (337), a number of magnificent
though perhaps over-decorated pieces were pro-
duced (333 and 336). Matthew Boulton in
Birmingham produced a peculiarly elegant variation
which is illustrated as Plates 40, 41 and 42 in
Adam Silver by Robert Rowe. A remarkably re-
strained pair of claret jugs, of 'Grecian' inspiration,
is illustrated on Plate 131. These are the work of
Thomas Heming, goldsmith to Queen Charlotte,
and the one man who might be expected at that
time to have flown in the face of the relatively over-
decorated Adam Classicism. At the same time as
these larger pieces were being produced, an
infinite variety of cream jugs in miniature, but other-
wise frequently identical to the larger examples,
were being manufactured. Catholic Recusant wine
and water cruets might also take this form. Only
capacity, and sometimes decoration, can give any
clue as to the original purpose for which a par-
ticular jug was designed. A set of four, made by
Anthony Nelme in 1728, now at Eton College, are
exceptional. In the National Museum of Wales, is a
jug made by Joseph Smith, c. 1710, bearing the
Arms of Powell of Nanteos and with an engraved
inscription stating it to have been made from Welsh
silver extracted from the mines of Bwlch Yr
Eskerhir. During the 19th century, American jugs
often intended to hold iced water were made in
large numbers, often of great size. One, the work of
Baldwin Gardiner, in the collection of the New-York
Historical Society, dates from 1833 and is 17 in.
(43·2 cm.) high. Seldom found in English silver is
the Liverpool jug which became popular with
American silversmiths c. 1800. It follows the form of
the cream-ware porcelain original. English examples
of this form are so rare in silver that they are usually
condemned, quite wrongly, out of hand. One made
by Paul Revere in 1804 is in the Henry du Pont
Museum, Winterthur. It is probably worth noting
at this point that Wakelin supplied H.A. Fellowes on
June 21st, 1773 with '2 antique beer-jugs'.

By the 1820s the so-called 'claret jug', some-
times of frosted-glass with silver or silver-gilt
mounts and of pear shape, has developed and by
the middle of the 19th century the form is ovoid,
perhaps an intentional harking back to the
Elizabethan ewer, then regarded as Gothic and so
fashionable.

Bibliography
Robert Rowe, *Adam Silver*. Faber & Faber, 1965.
C.C. Oman, *English Silver in the Kremlin*. 1961.
See also Claret Jug; Cream Boat; Cream Jug; Ewer
and Basin; Flagon or Livery Pot; Jug (Pot), Hot-
milk; Meth Cup; Shaving Set; Water Pot.

Jug (Pot), Hot-milk

During the early years of the 18th century small
covered jugs of baluster form appear, with wood or
ivory handles and with lip spouts (338a, 339 and
340). These are often associated with some of the
earliest tea services and were probably intended to
hold hot milk, which was then served with the tea.
By 1730 another form, ovoid and on three feet,
makes its appearance (338b) and is soon copied
in Scotland. Both varieties are found with detach-
able or hinged lids, but seem to disappear by 1745
when the cream jug reigns supreme, probably re-
flecting a change in the tea-drinking habits of the
gentry. Occasionally, however, extra large cream
jugs of Classical form and with covers are found in
the 1780s, and these may have been used to hold
hot milk.
See also Cordial Pot; Cream Jug; Jug.

321 Jewish Ritual Silver
A Rimonim or finial for the
Scroll of Law.
322 Sabbath Lamp
Maker's mark of Hester Bateman.
Hall-mark for 1781.
Height 35½ in. (90·2 cm.).
323 Lord Mayor's Dish
Maker's mark of Robert Hill.
Hall-mark for 1719.
Width 24 in. (61·0 cm.).
A gift of the Bevis Marks
Synagogue.

321

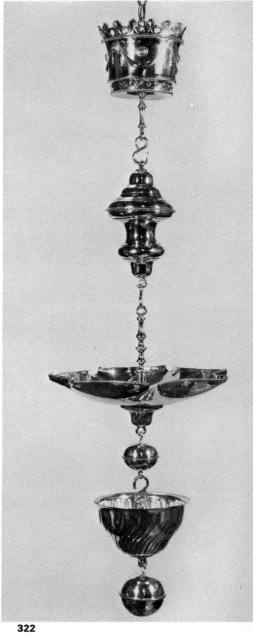

322

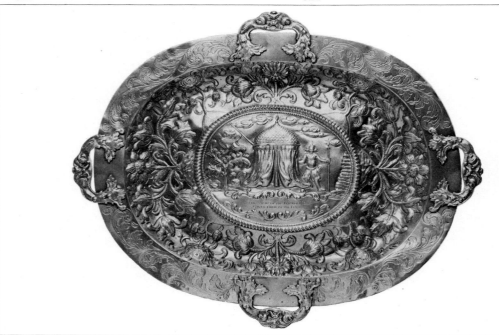

323

324

324 Jolly Boat
Silver-mounted, red-lacquered
papier-mâché.
Maker's mark, G D.
Hall-mark for 1801.
National Maritime Museum,
Greenwich.

**325 A Pair of
Double Wine Coasters**
Maker's mark of John Schofield.
Hall-mark for 1793.
Length 13¾ in. (35·0 cm.).
Engraved with the Arms of Adair
impaling Thomas.

325

326 A Pair of Covered Jugs
Maker's mark on one only, IC with a
pellet above and fleur-de-lys below.
c. 1650.
Height 11¼ in. (28·6 cm.).
Engraved with the Arms of
Bridgeman.
Fashioned in the Van Vianen style.

327 Jugs
a. Maker's mark of Charles Shelley.
Hall-mark for 1666.
Height 8½ in. (21·6 cm.).
b. Maker's mark of David Willaume.
Hall-mark for 1724.
Height 7¼ in. (18·4 cm.).

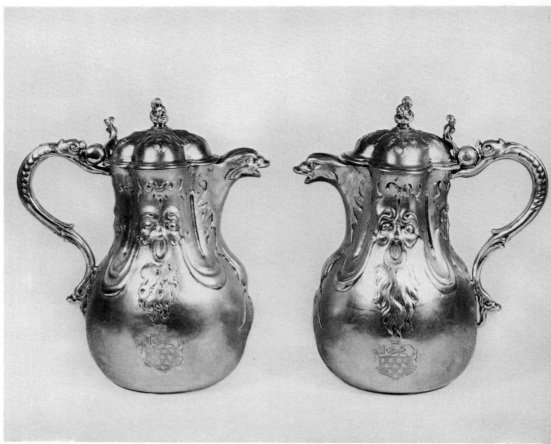

326

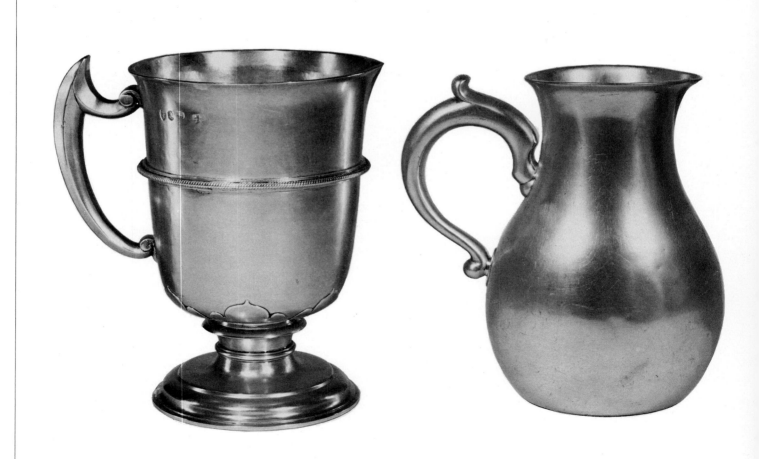

a

b

327

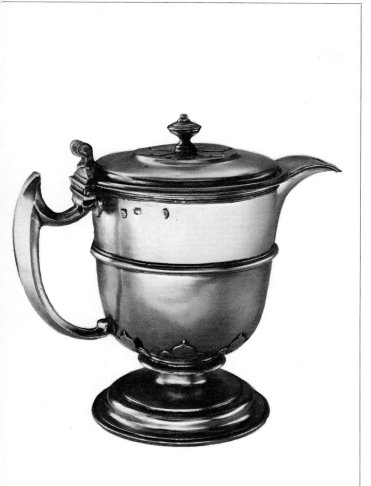

328

329

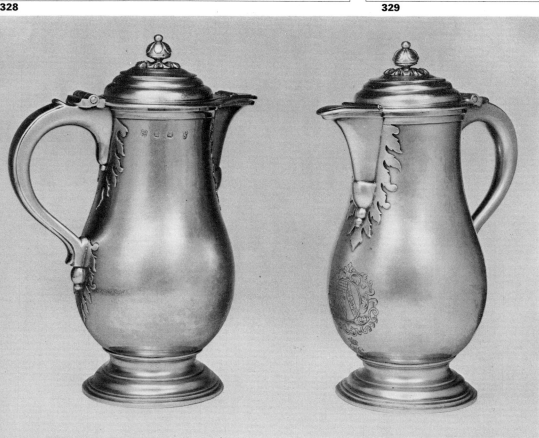

330

328 Covered Jug
Silver-gilt.
Maker's mark, RM.
Hall-mark for 1671.
Height 8 in. (20·4 cm.).

329 A 'Mead' Jug
Maker's mark of Ralph Walley
of Chester.
c. 1690.
Height 7 in. (17·8 cm.).

330 A Pair of Covered Jugs
Maker's mark of Robert Cooper.
Hall-mark for 1705.
Height 9¾ in. (24·8 cm.).
Engraved with the Arms of Pleydell
impaling Ernle and the monogram
and coronet of Baroness Burdet-
Coutts.

331 Covered Jug
Maker's mark of Simon Pantin.
Hall-mark for 1708.
Height 12¼ in. (31·1 cm.).
Engraved with the Arms of Crosse.
Possibly the finest of its kind.

332 Jug
Maker's mark of John Elston.
Hall-mark for 1714, Exeter.
Height 8¼ in. (21·0 cm.).
Engraved with the Arms of Sanford
of Nynehead Court.

333 A Pair of Covered Jugs
Maker's mark of Charles Kandler.
Hall-mark for 1733.
Height 10⅝ in. (27·0 cm.).
Engraved with the Arms of John,
2nd Earl of Breadalbane (1662–
1752).

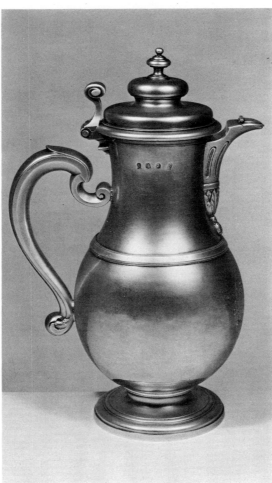

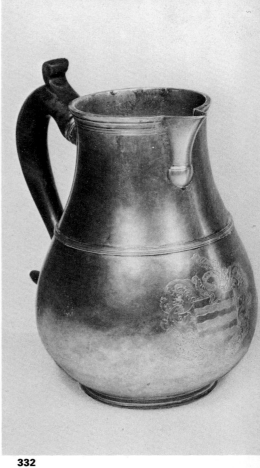

331

332

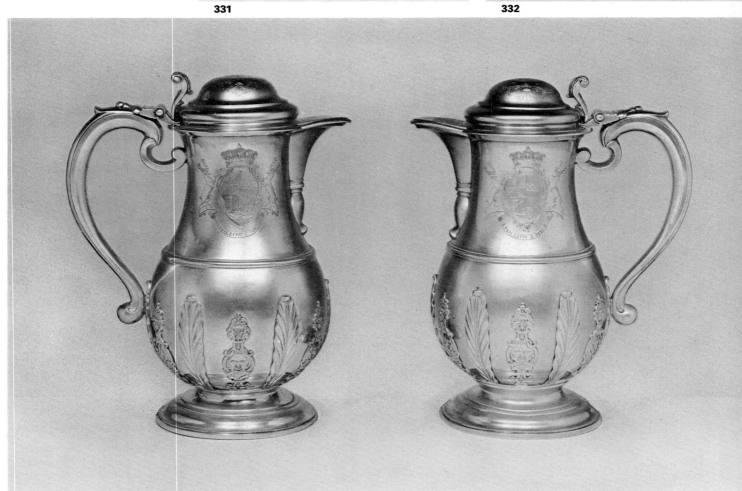

333

334

334 Beer Jug
Maker's mark of Benjamin Branker
of Liverpool.
c. 1735.
Height 6¾ in. (17·2 cm.).

335 Jug
No maker's mark.
Hall-mark for 1740, Newcastle.
Height 7⅛ in. (18·1 cm.).
Engraved with the Arms of Browne,
Doxford Hall, Northumberland.

336 Ewer
Maker's mark of Paul de Lamerie.
Hall-mark for 1742.
Height 18½ in. (47·0 cm.).
Applied with the Arms of Coote
impaling Newport for Algernon,
6th Earl of Mountrath.

337 Covered Jug
Maker's mark of Wakelin & Garrard.
Hall-mark for 1778.
Height 13 in. (33·1 cm.).
The handle was once perhaps
wickered.

335

336

337

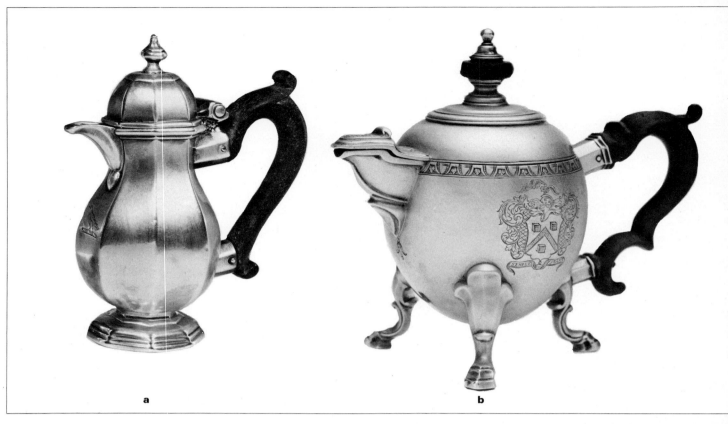

a b

338 Hot-milk Jugs or Pots
a. Maker's mark of Simon Pantin.
c. 1710.
Height 4¾ in. (12·1 cm.).
b. Maker's mark, G H, probably the
mark of George Hardy of Guernsey.
c. 1740.
Height 4½ in. (11·5 cm.).
The cover is detachable.

339 Hot-milk Jug or Pot
Maker's mark of Jonathan Madden.
Hall-mark for 1702.
Height 5½ in. (14·0 cm.).
Ashmolean Museum.

340 Hot-milk Jug or Pot
Maker's mark of David King.
Hall-mark for 1706, Dublin.
Height 7¾ in. (19·7 cm.).

339

340

g, Hot-water (or other hot liquids)

judge from the catalogues of present-day
:tion sales, one might think that there was some
tification in calling a number of pear-shaped,
vered jugs of the 1740s and 1750s hot-water
s. In fact, they seem more likely to have been
signed as 'Turkey Coffee potts' or even as
ocolate pots; most were probably originally
pplied with stands and their own lamps. Doubt-
s, as with so much else, different owners
ught of divers uses, but the considerable number
tea kettles surviving from this date seems to
clude the theory that these jugs were produced
narily to hold hot water (**341** and **342**).
By the 1770s occasional tea services are found
companied by jugs *en suite* with the teapot;
se jugs may have been intended as alternatives
the true coffee pot which was still being pro-
:ed (**343**). During the next twenty years the
questionable coffee pot disappears with few
:eptions and by the turn of the century the dual-
pose hot-water jug and coffee pot reigns
reme, but for the occasional coffee biggin.
ver-handled examples of the early form were
ost certainly wickered or leather covered when
: supplied.

lep Cup See Beaker.

nt, William (*c.* 1685–1748)
architect and a designer, his most important
wn surviving design for precious metal is that
blished in 1744 by John Vardy in *Designs of
go Jones and William Kent*—'A Gold Cup for
derick Prince of Wales'. This cup was later
en to Colonel Pelham (**212**), and must be
ed *c.* 1735, it still survives in a private collection.
ne five other similar examples are known, usually
silver-gilt and with finials to the covers which
fer from the Prince of Wales' feathers on the
ginal gold cup. One of these made by John
ift in 1769 is in the Bristol City Museum, another
in. (35·6 cm.) high, made by Thomas Heming in
32, is in the Royal Collection.
oliography
. Hayward, 'The Pelham Gold Cup'. *Con-
sseur*, July 1969.

ttle See Tea Kettle.

ttle Drum
October 13th, 1759 Messrs Wakelin were
ployed by the Prince of Wales 'to taking two
tle-drums to pieces. Poll. ye drums & steel
rk' (Garrard Ledgers, vol. 2). Those presented
the Household Cavalry by King George III were
de by P.A. & W. Bateman in 1804.

erstede, Cornelius (1675–1757)
tle is known of his early career, but he was per-
os apprenticed to Jesse Kip (1660–1722).
erstede worked in New York and was the author
a fine, pear-shaped kettle with an elaborate
out, now unfortunately lacking its stand and
ip. The extremely rare and fine pair of monument
ndlesticks, together with a snuffer stand of the
tical type, now in the Metropolitan Museum of
, New York, are also of his work and show con-
erable Batavian-Dutch influence. In the same
llection is a fine, two-handled, 'panelled' bowl
ne 10 in. (25·4 cm.) in diameter, dating from
: first years of the 18th century.

ng, I.
ate 17th-century engraver who signed a ewer
d basin of 1685 and a silver-gilt, two-handled

porringer of 1689 ('I. KING SCU^tp'), both are at
St John's College, Oxford.
See also Engraving.

Kitchen Pepper or Spice Dredger
An almost unique, small caster engraved with the
date 1658 (**98**), and two others of 1681, seem to
be the earliest form of *small* caster to have survived
prior to 1715, with the exception of the upper
section of Elizabethan and Jacobean bell salts.
The 18th-century form is cylindrical with a scroll,
ribbon-like handle to one side, on spreading,
moulded foot and frequently octagonal during the
years 1705–25 (**344**). The shallow-domed cover
might be secured by friction only (when worn this
could be disastrous), or alternatively a bayonet
joint, and it usually had a baluster finial. Over-
lapping, but surviving until the 1740s, is the
baluster form with shallow-domed cover, some-
times without a finial (**345**). These forms are, of
course, also found in pewter, but it is likely that
the names 'kitchen pepper' or 'spice dredger'
came through their association with flour dredgers
rather than their common use in the kitchen;
pounce (see Inkstand) or wig powder being a more
likely use for such an object in precious metal. The
smaller-sized, baluster casters of normal form are in-
frequently found throughout the century and they
were probably all intended for use with oil and
vinegar frames, some of which have an extra ring
frame to accommodate such a caster, besides
those for the bottle caps. Particularly fine examples
of the early 18th-century form are amongst the
plate of the Queen's College, Oxford, and a fine
octagonal American example made by Jacob
Hurd of Boston, *c.* 1720, is in the Sterling and
Francine Clark Art Institute, Williamstown, Massa-
chusetts, one of twelve that have been made by him which are
known to survive (**346**). Another made by John
Hastier of New York, *c.* 1730, is of elegant form
and is in the Cleveland Museum of Art. It is worth
noting '2 pepper box punches' as being amongst
the inventory of John Coney's tools.
Bibliography
G.B. Hughes, 'Silver Spice Dredgers'. *Country Life*,
September 28th, 1951.
See also Caster; Pepper Pot; Wig Powderer.

Knife
In medieval days the knife was a piece of personal
equipment. The introduction of a spoon and/or
combined fork led to each piece being decorated
en suite; gold, silver, pewter, bone, rock-crystal,
all were used for the hafts of such pieces. The steel
blades varied in shape, but usually bore a cutler's
mark, that of the London Cutlers' Company, being
struck from 1607 onwards, was an incuse dagger.
A set of six or more knives were normally kept in a
'canteen' or 'stock'. Late in the reign of Charles II
travelling knives and forks tended to become more
uniform, having tapering, cylindrical handles with
flat ends; at the turn of the century, sets with the
handles in the shape of pistol butts made their
appearance. The knives with handles of cast silver
have survived because of their solidity, but in
general the high price of silver encouraged their
manufacture in a lighter gauge metal. Fig. **XXV**
illustrates a range of knives dating from 1692 to
1815. By 1760 variations of all sorts were being
produced in Sheffield and elsewhere, generally
these had handles, largely of a resinous composi-
tion, with only the thinnest of silver surfaces.
Subjected to hard usage and damp, these knives,
especially those with steel blades, have suffered
severely, and a set of this late type is rarely found in
fine condition. Dessert knives with silver blades

(often made by Moses Brent) occasionally with
hard stone handles and often gilt, appear *c.* 1785
(see Mounted-pieces). The early 19th century saw
the introduction of straight, tapering handles
decorated *en suite* with the table service with
which they were to appear. Pen-knives with silver
handles, sometimes with leather-covered pocket
cases, are found from the 18th century onwards,
until the quill pen became obsolete. From the same
period folding fruit knives with silver blades also
survive.
Bibliography
Major C.T.P. Bailey, *Knives and Forks*. Medici
Society, 1927
J.F. Hayward, 'The Howard E. Smith Collection of
Cutlery'. *Connoisseur*, November 1954.
G.B. Hughes, 'Old Silver Knives'. *Country Life*,
February 17th, 1950.
H. Raymond Singleton, *A Chronology of Cutlery*.
Sheffield City Museums, 1966.
See also Knife Box; Mounted-pieces.

Knife Box
17th-century and early 18th-century examples are
of wood, covered with shagreen. The form is usually
rectangular in plan, with a hinged, forward-
sloping lid lifting to reveal slotted compartments
for spoons, forks, and a marrow scoop, besides the
knives. Generally they have a handle on either
side. Smaller examples are almost semicircular in
plan. There are also examples of knife boxes made
in mahogany, satinwood or with a tortoiseshell
veneer or decorated in marquetry, usually with
silver feet, handles and cartouches. An example
made in Pontypool 'Japan-ware' (tin-enamelled)
and another in Compagnie des Indes porcelain are
known. One made by Peter and Ann Bateman of
1797 is illustrated by David Shure in his book
Hester Bateman. Liverpool Corporation possesses
three, graduated, silver-mounted pairs of *c.* 1770.
All too often the inside has been removed to con-
vert the case to a stationery box. 18th-century
accounts and inventories sometimes refer to them
as 'table' or 'dessert' cases 'lyned with green velvet
and lac'd with gold' or even as a 'two or three dozen
shaped case'. This implies that the larger examples
allowed for both table and dessert spoons and
forks as well as knives. Boxes of similar form are
also found fitted with sets of razors, a strop and
scissors.

Knitting Needle Case
At least one example, hall-marked in 1829 at
Newcastle, survives. This case is of cylindrical
form, with a slot down one side to reveal the con-
tents and a detachable cap at one end to allow for
the removal of the knitting needles. This particular
case is 11 in. (28·0 cm.) long, and still retains a
number of its ivory needles.

Knop
A bulbous projection on a shaft, pillar, the stem of
a cup or chalice. Also a term used of a spoon finial.

Krater
A Greek vessel, of vase shape, with two handles.

Ladle, Punch or Toddy
With the advent of the silver monteith and the
punch bowl, besides those made in pottery, glass
or pewter during the last decades of the 17th cen-
tury, there also came into being a form of ladle. The
earliest type is a small, shallow, oval cup with a
ring handle to one side, similar in form to a French
wine taster. These are very rare; one of 1698 is
known to survive. In general, the accepted form is

341 Hot-water Jug or Pot
Maker's mark of George Wickes.
Hall-mark for 1745.
Engraved with the Arms of Elton.

342 Hot-water Jug or Pot
Maker's mark of S. & J. Crespell.
Hall-mark for 1768.
Height 9¼ in. (23·5 cm.).
Engraved with the Arms of Keppel.

343 Hot-water Jug or Pot
Maker's mark of William Holmes &
Michael Dumee.
Hall-mark for 1773.
Height 13½ in. (34·3 cm.).

342

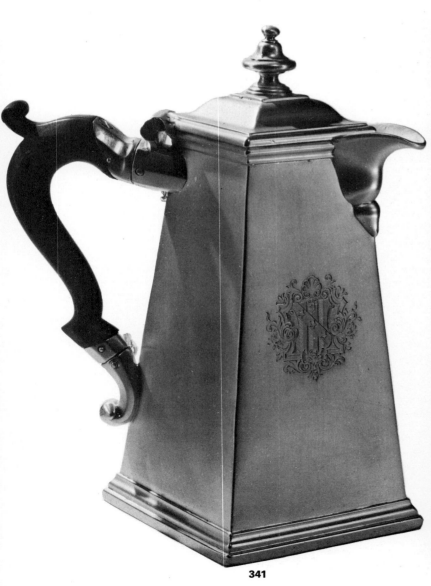

341

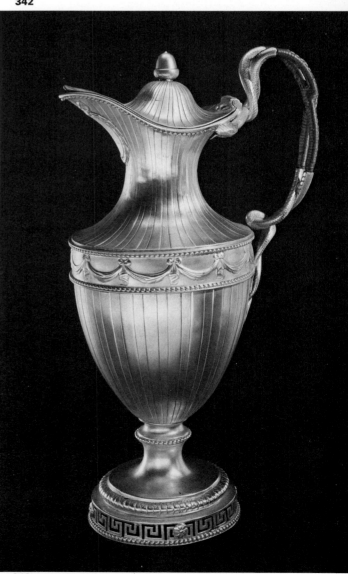

343

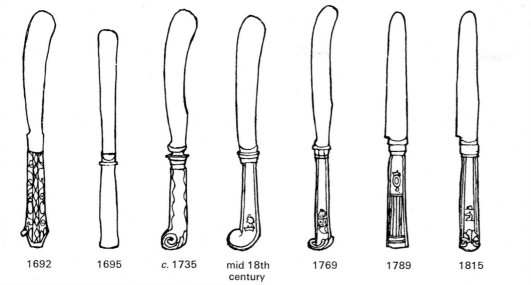

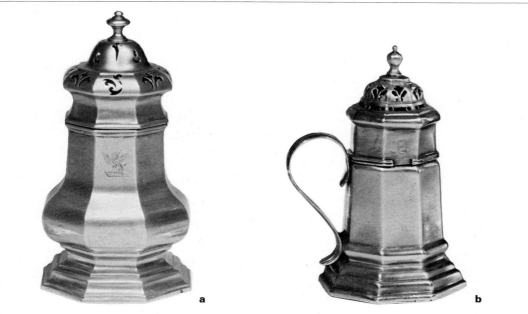

| 1692 | 1695 | c. 1735 | mid 18th century | 1769 | 1789 | 1815 |

Fig. XXV

Fig. XXV
A group of knives, 1692–1815.
Approximately 8–9 in. (20·4–22·9 cm.) long.

344 Kitchen Peppers
a. Maker's mark of Edward Wood.
Hall-mark for 1723.
Height 5 in. (12·7 cm.).
b. Maker's mark of Glover Johnson.
Hall-mark for 1708.
Height 3½ in. (8·9 cm.).

345 Kitchen Pepper
Maker's mark of David King.
Hall-mark for 1715, Dublin.
Height 3⅛ in. (8·0 cm.).
Victoria and Albert Museum.

346 Kitchen Pepper
Maker's mark of Joseph Hurd
of Boston.
c. 1720.
Height 3¾ in. (9·6 cm.).
Sterling and Francine Clark Art
Institute.

344

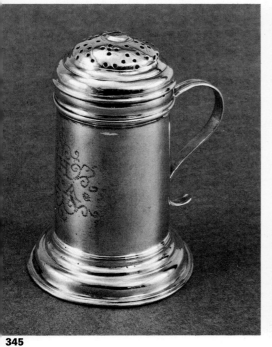

345 346

173

at first a plain, circular or ovoid bowl with a turned wooden or tubular silver handle at right angles to the axis of the bowl and joining it at about 45 degrees elevation. By 1740 this gives way to a variety of shaped bowls and by 1760 the twisted, whalebone handle becomes usual, together with a smaller, and thinner, bowl, frequently only partly marked and often unmarked. Seashells and coconuts were also used for the bowls. Very small, plain, circular, silver bowls of about 1 in. (2·6 cm.) in diameter, still retaining the whalebone handles at a very steep angle, are for toddy. These usually bear Scottish hall-marks of 19th-century date. The evolution of the ladle described above reflects the growing tendency to drink less bulky and more alcoholic liquors from smaller containers. Mid 18th-century examples are sometimes made from, or more frequently have inserted into them, a coin of William and Mary or Queen Anne, perhaps as an indication of Jacobite sympathies. It was not unusual to gild a silver shilling to resemble a golden guinea!

Bibliography
G.B. Hughes, 'Silver Punch Ladles'. *Country Life*, November 17th, 1950.

Ladle, Sauce, Soup, Sugar and Cream

Reference to ladles for soup are found from an early date, but the form as we today understand it, dates from about 1720. Lamerie supplied '4 ladles or ragoos spoons' weighing 27 ounces 10 pennyweights to George Treby in 1721. Prior to this, the large spoons (ragout spoons, today known as 'basting spoons') with tubular handles and deep, oblong bowls, probably served the office of ladles. The earliest and rarest form of true ladle is that with a pear-shaped bowl and curved, tubular handle terminating in a bird or beast's head. These ladles seem to be most often associated with tureens made by such fashionable silversmiths as Lamerie and Wickes. Smaller examples, *en suite*, were for use with sauce boats and sauce tureens. The later ladles, *en suite* with services of table silver, are not uncommon from 1760 onwards; some of the earliest being of Onslow pattern, a handle form better suited to ladles than spoons and forks. Ladles with wood or whalebone handles are for punch or more alcoholic liquors. From about 1770 onwards small ladles, sometimes with pierced bowls (sifters), are found. These are for use with sets of tea caddies and sugar bowls. Cream ladles were made *en suite* for use with cream pails. Occasionally, the stem of the ladle incorporates a small hook by which the ladle might be hung from the handle of the vase-shaped tea caddy of *c.* 1760.

Bibliography
Leonard Willoughby, 'Chester Corporation Plate'. *Connoisseur*, vol. XVIII, p.163.

Lamerie, Paul de (1688–1751)

Born on April 9th, 1688 and baptised at Bois Le Duc ('s Hertogenbosch) in the Low Countries, he was brought to England by his parents in 1689. By 1691 his father was tenant of a house in Berwick Street, St James', London, but within ten years the family was in financial difficulties, his father receiving a Crown pension of 2s 6d per day. In 1703 both he and his father were endenizened. On August 6th, 1703, Paul de Lamerie was made apprentice to 'Peter Plattell, Citizen and Goldsmith of London' for the term of seven years. Platel (the usual spelling) had his workshop in Pall Mall. On February 5th, 1712 Lamerie recorded his first mark (a), and he is described as a silversmith of 'Windmill Street'. In February 1716 he married

Louisa Julliot, who bore him two sons and four daughters. Both sons and one daughter died while still young. On March 17th, 1732 he entered a Sterling standard mark for the first time (b), having until 1732 consistently worked in the higher and softer Britannia standard metal, though no longer obligatory after 1720. On June 27th, 1739 he entered another mark (c), and in the same year moved to Gerrard Street, where he died on August 1st, 1751, directing in his will that all plate 'in hand' be finished and then sold by auction.

a b c

Unlike most silversmiths Lamerie often made his own moulds, from which he cast handles, finials and other applied decorations. As a result these are often a distinguishing mark of his handiwork. Lamerie's second mark (b) has often in the past been confused with that of his master, Pierre Platel. The latter's mark for the Britannia standard being the first two letters of his surname, there is no pellet between. In the case of Lamerie, the pellet is present to show the mark to be that associated with the lower (Sterling) standard, being the initial letters of his Christian and surnames. In the collection of the Earl of Haddington were a pair of candelabra with two-light branches and a four-light branched example made by Platel in 1717; associated with these were a set of four candlesticks made by Lamerie in 1724. An interesting case of transferred allegiance!

Some of Lamerie's actual work and the original invoices for it are known to have survived, this is most rare for few makers kept such complete records. Between the years 1721 and 1725 the Honourable George Treby ordered a considerable quantity of plate from Lamerie, including the well-known 'Treby' toilet service now in the Ashmolean Museum, Oxford. Invoices for this and 'a fyne polished surtout cruette frame, casters, branches and saucers' besides '2 doble salts for ye surtoute' remain with the family of the original owner. A pair of 'middle size waiters' made in 1749 for Admiral Hawke survive and so does their invoice. Lamerie's work is illustrated on the following Plates: **12**, **14**, **45**, **56**, **102**, **136**, **155a**, **210**, **237**, **254**, **255**, **256**, **310**, **336**, **348**, **417**, **468**, **477**, **511**, **512**, **513**, **527a**, **547**, **563**, **618**, **631**, **636**, **687** and **714**.

Bibliography
P.A.S. Phillips, *Paul de Lamerie*. Batsford, 1935.
'Paul de Lamerie'. *Exhibition Catalogue, Museum of Fine Arts, Houston*. 1956.
Judith Banister, 'A link with Paul de Lamerie'. *Apollo*, March 1961.
E.A. Jones, 'One of Paul de Lamerie's Chefs d'œuvres in the Winter Palace, St. Petersburg'. *Connoisseur*, vol. XXIII, p.53.
'Paul de Lamerie'. *Exhibition Catalogue, Sterling and Francine Clark Art Institute, Williamstown*. 1953.

Lamp, Sabbath

Two such are known to have been made in England by Abraham de Oliveyra in 1726 and 1734; another made by William Spackman in 1722 and one of 1813 is the work of Samuel Hennell. A number made in Canada are also extant; they are generally of rather coarse workmanship. A Sabbath lamp made by Hester Bateman in 1781 is the latest addition to this group (**322**).
See also Jewish Ritual Silver; Oil Lamp.

Lantern

One made of Sheffield plate is now in the Sh[...] field City Museum and dates from *c.* 1795. It [...] 6¼ in. (15·9 cm.) high, has five long, narrow sid[...] and one broad side with a reeded handle at [...] back. Sheffield plate, and occasionally silver, w[...] also employed for carriage lamps and harn[...] furniture.

Latten (Latoun)

A medieval form of brass; by the 17th century [...] average proportions for latten were as follow[...] copper, 72·915 per cent; zinc 25·01 per ce[...] iron 1·985 per cent. During the Middle Ages[...] number of pieces made of this metal seem to ha[...] been silvered with the express intent to decei[...] Spoons, and occasionally larger pieces, are fou[...] thus made, though there is no proof that t[...] silvering was applied by the maker of the piece [...] indeed at the same time. A font cup in the Victo[...] and Albert Museum is an oft-quoted examp[...] Early examples of latten pieces still survive; [...] Pershore Censer, whose pinnacle is dated *c.* 115[...] and the St David's Crozier, *c.* 1200, the lat[...] originally gilt, are two such survivals.

Leddel, Joseph (working 1750)

An American engraver who advertised as [...] pewterer, adding that 'He also Engraves on Ste[...] Iron, Gold, Silver, Copper, Brass, Pewter, Ivory [...] Turtle-shell in a neat Manner, and reasonably'. [...] signed the apparently Jacobite engraving on [...] tankard made by W. Vilant of Philadelphia, dati[...] it 1750. It also appears to bear the initials [...] Leddel's wife.
See also Engraving.

Lemon Squeezer

Equally correctly designated a lime squeezer; [...] principle on which it operates is the same as th[...] of a nutcracker. These squeezers are usually [...] hardwood with silver mounts, but examples [...] ivory are known. Most date from the late 18[...] century. One of ivory is in the Royal Collection, it[...] the work of Phipps & Robinson and dated 180[...] Examples are also known from Edinburgh.
See also Orange Strainer.

Letter Frame or Rack

Somewhat similar to the toast rack but genera[...] taller and of cage form, these appear in the 178[...] The grids are close together and joined at the to[...]

Library or Reading Candlestick

See Candlestick, Library.

Limerick

The names of more than twenty Limerick gol[...] smiths were registered in Dublin following t[...] Parliamentary Act of 1784 and up to the year 182[...] by which time their individuality as goldsmiths w[...] finally lost. Bright-cut flatware emanating fro[...] this town frequently includes a fleur-de-lys as p[...] of the decoration. This is also struck as an incu[...] mark, as is the word 'Sterling', though this latt[...] is by no means invariable. Occasionally, a crown[...] harp mark is found, presumably a fraudule[...] attempt to suggest that the piece had indeed be[...] sent to Dublin for assay as was required by law[...] See also Irish Silver; Mitre; Provincial Goldsmit[...] (Irish).

Lip Spout

A short spout as on a jug (occasionally covered) [...] opposed to the long, elegant spout of the coffee [...] chocolate pot.

...very Pot See Flagon or Livery Pot.

...oyd's Patriotic Fund (1803–9)
...e Patriotic Fund was established on July 20th, ...03 by merchants, underwriters and other sub-...ibers to Lloyd's, the insurance brokers. It was ...olved 'That to Animate the efforts of our ...fenders by sea and land it is expedient to raise ...the patriotism of the community at large, a suit-...le fund for their comfort and relief . . . and of ...nting pecuniary rewards, or honourable badges ... distinction, for successful exertions of valour or ...erit'. The awards took the form of swords of ...nour (fifty-six to the value of £100 each, thirty-...o to the value of £50 each and fifteen to the value ...£30 each), together with silver vases, some with ...nths, of which sixty-six were presented between ...e years 1804 and 1809. The total cost of these ...ards was £21,274. The swords, having gilt ...unts, were made by Richard Teed of Lancaster ...urt, The Strand, London. The vases, designed by ...hn Flaxman, were supplied by Rundell & Bridge, ...d some at least, were made by Paul Storr and ...njamin Smith (**216**). It seems likely that the ...nths were added to emphasise the fact that the ...cipient had served at the Battle of Trafalgar. Two ...the plinths, which were made for Nelson's ...nily, have additional tritons at the angles.
...liography
...rren R. Dawson, *Nelson Collection at Lloyd's.* ...yd's, 1932.
...ptain H.T.A. Bosanquet, *The Naval Officers ...ord.* H.M.S.O., 1955.
...e also Sword Hilt and Gun Furniture.

...rd Mayor's Dishes and Cups
...om 1679 to 1779 it became the custom for ...rtain of the religious communities of the City of ...ndon to make an annual presentation to the Lord ...yor by way of a *douceur* (**323**). The French and ...tch Protestant Churches did this, as did the ...wish Community. Originally the Jewish gift took ...e form of a silver dish, together with a purse ...ntaining about £50, and/or sweetmeats, later a ...ver (**466**), or a two-handled cup. Eleven of these ...nated pieces are known to have survived, the ...liest fully marked example dates from 1697, ...ough an unmarked dish in the Walker Art ...llery, Liverpool, may antedate this. The earliest ...e being embossed with Britannia trampling the ...ottish Jacobite rebels.
...liography
... Cecil Roth, *Connoisseur*, May 1935.

...ace
...e Corporation and Ceremonial Plate; Tipstaff.

...achine
... word sometimes used in 18th-century inven-...ies or invoices to describe such pieces as ...ergnes or centrepieces. The word frequently ...pears in the Garrard Ledgers, when the clerk was ...viously at a loss as to the correct designation of ...e piece.

...aker
...or to the late 17th century, the identification of ...articular London maker, by means of his mark ...on a piece of silver or gold, is only possible ...en chance has also preserved the original in-...ice or some other contemporary record. This is ...e to the unfortunate loss by fire of the earlier ...cords of the London Goldsmiths' Company. In ...rtain provincial cities, such as Chester and York, ...d also in Edinburgh, earlier records have sur-

vived. This means that many thousands of silver-smiths are recorded, some with whom no known surviving pieces can be associated. Sir Charles Jackson's great work *English Goldsmiths and Their Marks* lists a vast number of these marks and their corresponding identities where known. A forthcoming work by Mr Arthur Grimwade will enormously enlarge our knowledge of London goldsmiths, and since the publication of Sir Charles Jackson's book a great deal of research has been carried out by many people into the marks of most of the provincial makers. Some of these will in due course be published. Mr Stephen Ensko of the United States and Mr John E. Langdon of Canada have undertaken this task for their respective countries. For these reasons, it must be apparent that to attempt such a study in a work of this nature would not be feasible. In the few cases, however, where a specialist biography of a maker or family of silversmiths has already been pub-lished, a short résumé of their respective marks has been included, as most such works tend to be both rare and expensive.
Bibliography
Sir C.J. Jackson, *English Goldsmiths and Their Marks.* 2nd Edition 1921, reprinted 1949.
W.J. Cripps, *Old English Plate – Makers and Marks.* Various editions.
William Chaffers, *Hall Marks on gold and silver plate.* Various editions.
S.G.C. Ensko, *American Silversmiths and their Marks 1650–1850.*
John E. Langdon, *Canadian Silversmiths, 1700–1900.* Toronto, 1966.

Mannheim Gold
Pinchbeck alloy of copper, zinc and tin.

Map Case
A single, plain, rectangular example, intended to contain a folded map, is known, made by Louis Boudo of Charleston, Carolina, *c.* 1825. Now in the Metropolitan Museum of Art, New York, it was presented to General Lafayette by the State of Carolina in March 1825.

Marrow Scoop
Regrettably the habit of eating marrow (marrow bone) and toast received what appears to have been a death blow during the rationing of 1940–52. The marrow scoop, with its two, grooved channels of unequal width, sometimes reversed, the waist sometimes faceted, otherwise rarely decorated, seems to have come into use during the early 18th century. Originally supplied as one with a dozen knives, spoons and forks, thus implying communal use, but by the end of the 18th century and during the last, marrow spoons are found in sets, some-times with only one scoop. 18th-century knife boxes generally allow for one such between the rows for table and dessert cutlery.
See also Marrow Spoon.

Marrow Spoon
The predecessor of the marrow scoop is the mar-row spoon, a spoon of normal type with the stem formed as a scoop. The earliest so far recorded is of 1692. The rat-tailed bowl is generally finely engraved, and this is so constant a feature, to-gether with traces of gilding, that it seems likely that they formed part of a travelling set. If this is so, it implies that the marrow spoon was also in con-stant use in the home and it is therefore surprising that but few, early, plain examples are known. Up to the reign of Queen Anne they frequently bear only a maker's mark, after which time they become

quite common and are fully marked. At least one three-pronged marrow fork survives. It bears the maker's mark only and is dated *c.* 1670.

Masonic Badges and Jewels
Some of the earliest of these are triumphs of fine engraving upon badges pierced with the symbols of Masonry. Sometimes these also name the Lodge to which the original owner belonged, or for which they were made. Examples earlier in date than 1750 are rare. Large numbers of such jewels and badges were made by Thomas Harper, who was working in Fleet Street by 1784, though it was not until 1790 that he registered his better known mark. Probably the finest collection of Masonic Regalia is that at the Freemasons' Hall, London. A group of 18th- and 19th-century Masonic medals are illustrated on Plate **347**.

Matting
Also known as 'pinking'; this is a form of decora-tion made by a myriad of small punched indenta-tions on the surface of metal and popular throughout the 17th and 18th centuries as a background for burnished decoration. Perhaps the earliest surviving example is that on the Win-chester College Cup of 1632.
See also Chasing.

Maverick, P. R. (1755–1811)
'Maverick Sct' was the signature used by the engraver, Peter Rushton Maverick of New York on an oval, gold freedom box made by Samuel Johnson. When Baron von Steuben was pre-sented with the Freedom of the City of New York, on October 11th, 1784, he was also pre-sented with this freedom box.

Mazarine
Surviving examples were obviously intended for use as a 'double-bottom' to a meat dish of normal form, to act as strainers, so they were pierced. The fact that the Duke of Buckingham was robbed of no less than 'Seven Mazarine Plates, one Mazarine Plate of a smaller size' amongst other valuables in February 1673, inclines one to think that the present use of the word, which describes a pierced, oval or circular strainer to fit within a dish, is of a slightly more recent transposition. John Kersey in his *Dictionary* of 1708 defines mazarines as 'Little dishes to be set in the middle of a larger dish, for the setting out of Ragoos, or Fricassies, also a sort of small tarts fill'd with sweetmeats'. By the middle of the 18th century, however, the strainer dish (**348**), was certainly intended for fish, as witness a superb, silver-gilt, oval pair of 1762 made by George Hunter, pierced and engraved to represent a net full of fish, now in the Royal Collec-tion. Circular mazarines are considerably rarer. A particularly interesting example is that executed by Boulton & Fothergill of Birmingham, marked in Chester in 1770, and having two handles, now in the Birmingham Assay Office. In at least one in-ventory of the 18th century, such a dish is referred to as a 'Fish Dryer'. However, the elongated fish dish, found on the Continent, seems to be almost unknown in English silver. From 1780 onwards, mazarines were also made in Sheffield plate, the use of fly presses overcoming the difficulty pre-sented when the piercings were made by hand-saws and the copper core exposed.
Bibliography
N.M. Penzer, 'What is a Mazarine?'. *Apollo*, April 1955.
G.B. Hughes, 'The Mazarine for Elegance'. *Country Life*, March 14th, 1968.

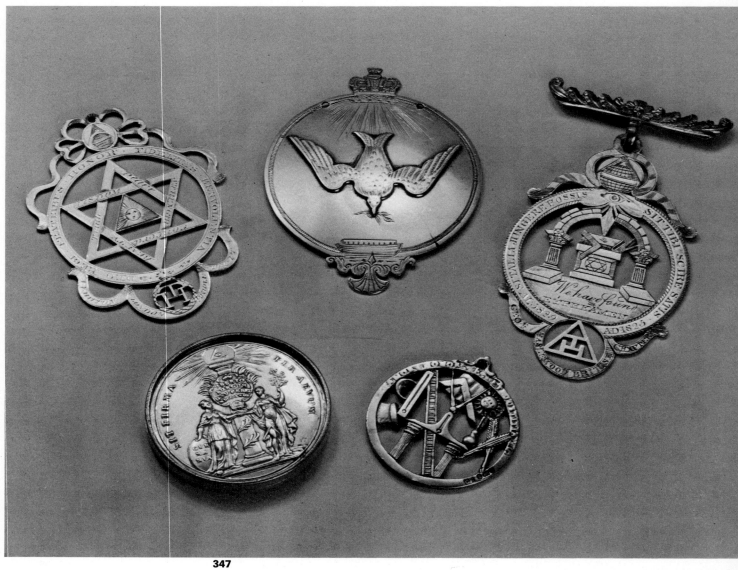

347

**347 A Group of
Masonic Medals**
Of 18th- and 19th-century date.
348 Mazarine
Maker's mark of Paul de Lamerie.
Hall-mark for 1745.
Width 18⅞ in. (48·0 cm.).
Engraved with the Arms of Parker.

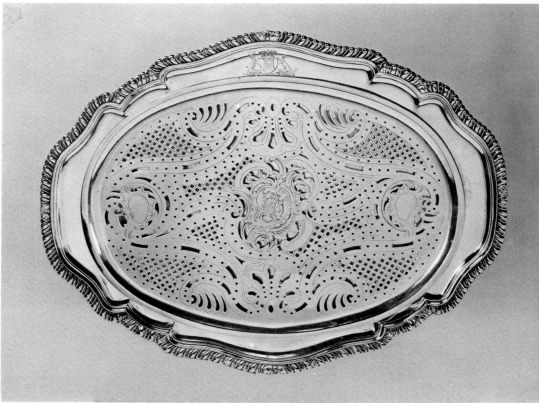

348

...zer

...ese drinking bowls, generally made of maple ...ood, usually with gold, silver-gilt or silver rims ...nd) and feet, probably derive their name from ... German word *másá*, meaning a spot, in ...erence to the spotted grain of the wood. The ...aller examples were used cupped in one hand, ... larger required the use of both. Since Sir ...arles Jackson published his works in the early ...t of this century, a number of other examples ...e appeared, though less than eighty are known ... survive of many hundreds made during the ...ddle Ages. His divisions are, however, still ...osite. (i) Those of the 14th to early 15th cen-...es with, generally, deep bowls and plain, shal-...w bands of silver. The centres with 'prints' ...plied decorated silver discs) of various subjects. ... From about 1450 to 1540. Shallow bowls with ...characteristic bands frequently engraved (Fig. **VI**), and with plain, moulded or rayed ...ged 'prints'. (iii) The Elizabethan mazer of simi-...form to the above but whose foot and lip are ...nnected by metal straps.

...Originally almost all mounted mazers were pro-...ed with covers, similarly mounted to the bowl, ... it must be emphasised that the vast majority of ...zers, were probably unmounted as they were in ...y use by all classes of people. Perhaps the most ...resting group of mazers, including some of the ...liest, are those preserved at Harbledown Hos-...al, Kent, and St John's Hospital, Canterbury ...9). One of these, of early 14th-century date, has ...'print' illustrating one of the scenes in the almost ...endary life of Guy, Earl of Warwick (**350**). Few ...he mazers belonging to group (i) have retained ...ir original foot, but it should be noted that a ...iety of the later groups have tall feet and these ... known (in contemporary documents) as ...nding mazers'. That known as the Three Kings ...zer of about 1490, has a detachable foot allow-...its use as a normal mazer or a standing cup ...4). Probably the most intriguing, besides being ... of the earliest, dating from about 1380, is the ...ous Swan Mazer belonging to Corpus Christi ...llege, Cambridge (**352**). In this case the central ...nt' is replaced by a swan modelled on top of a ...low column. This latter is pierced at the base and ...ntains a second column which acts as a siphon ...t the mazer is overfilled by the greedy. In which ...se the contents are automatically emptied over ... drinker's lap! The Rokewode Mazer (late 14th ...ntury) now in the Victoria and Albert Museum, is ...graved 'HOLD YOWRE TUNGE AND SEY ... BEST AND LET YOWRE NEYGHBORE ...TTE IN REST. HOE SO LUSTYTH GOD TO ...ESE LET HYS NEYGHBORE LYVE IN ...E'. Also in the Victoria and Albert Museum ...the Cromwell (second half of the 15th century), ...alker (*c.* 1480) and the Whitgift (1508) Mazers, ...last on loan. Somewhat unusual is the 'print' ...the Creation in the bowl of an early 15th-...ntury mazer in the Burrell Collection, Glasgow. ...n Gardner of Bury left 'J maser with iij feet ...ver and gilt' in his will of 1506, while in 1528 ...rdinal Wolsey gave to his College of Ipswich ...m oone standing Masar withe a cover and foote ...ar and gilte standing upon iij Lyons'. The Bute ... Bannatyne Mazer is of predominantly 16th-...tury date, yet it has an earlier (*c.* 1315), ...bossed gilt and enamelled 'print' at the centre, ...ion surrounded by six enamelled coats of arms ... Scottish families, and with a later cover of ...ved, sperm whale ivory (**351**). It is the subject of ...ch learned controversy as is the Watson Mazer, ...o claimed to be Scottish. The latter is also mainly ...16th-century date. Generally speaking the Scot-

...tish examples are considerably more elegant than their English opposite numbers, often because of their attractive, high, trumpet foot, though they are, in general, of later (16th century) date. The silver-gilt Galloway Mazer is outstanding (**353**). The St Mary's Mazer, the work of Alexander Auchinleck, made between the years 1552 and 1562 is the earliest fully marked piece of Edinburgh silver. The Fergusson Mazer has particularly fine marks though no date-letter; it is, however, engraved amongst other things with the date 1576. On February 27th, 1660, Samuel Pepys visited King Edward VI's Almshouses, Saffron Walden, Essex, and records that 'They brought me a draft of their drink in a brown bowl, tipt with silver, which I drank off, and at the bottom was a picture of the Virgin with the Child in her arms, done in silver'. This piece, hall-marked 1507, was sold by the Trustees of the Almshouses in 1929 for £2,900.

Bibliography

Sir C.J. Jackson, *An Illustrated History of English Plate*. Vol. II, pp. 596–647, 1911. (An exceptionally detailed survey.)
Commander G.E.P. How, 'Scottish Standing Mazers'. *Proceedings of the Society of Antiquaries of Scotland*, vol. LXVIII, session 1933–4.
E.H. Pinto, 'Mazers and their Woods'. *Connoisseur*, vol. CXXIII, 1949.
Richard, Lord Braybrooke, *The History of Audley End and Saffron Walden*. 1836.
Ian Finlay, *Scottish Gold and Silver Work*. 1956.
See also Bowl; Cup, Bridal; Mounted-pieces; Scottish Silver.

Meander See Fret.

Meat Dish See Dish.

Medal

This is a subject in its own right, for it comprises commemorative medals, military decorations and awards for archery and scholastic achievement. Whilst the former have an adequate literature of their own, archery and school prizes could form the subject of a specialist collection and Masonic badges should not be overlooked in this connection. Examples of Masonic badges are uncommon earlier than 1745. The gold medal of breast-badge form given to Vice-Admiral Penn by the Parliament of 1653 is a remarkable survival (**355**).

See also Arrow (Archery Medals and Badges); Badges; Breastplate and Gorget; Coin; Corporation and Ceremonial Plate; Masonic Badges and Jewels; Theatre Ticket; Volunteer.

Memorial Urn and Casket

One of the earliest known memorial urns is a fine silver-gilt example, some $5\frac{1}{2}$ in. (14·0 cm.) high, with oval medallions, intended to contain the locks of the deceased Edward Synge and made by Butty & Dumee in 1772. An exceptional gold memorial urn, $4\frac{1}{2}$ in. (11·5 cm.) high, the work of Cornelius Bland, 1780, still retains its original fitted shagreen case; it is of ovoid form, decorated in the Adam manner, and engraved with a coat of arms. In the National Army Museum, Sandhurst, is an example of casket shape engraved in memory of Lieutenant-Colonel T. Lloyd, killed at Nievelle, 1813. Extremely rare is the American example in gold made in 1800 to enclose a lock of George Washington's hair. Probably the work of Paul Revere, it was presented to the Grand Lodge of Massachusetts, and is, in fact, still preserved by that same Lodge.

Bibliography

M.G. Fales, 'An American golden Urn'. *Antiques*, vol. LXXXI, no. 2, February 1962.

Meth Cup (Methyr or Mead Cup)

One example only is known in silver. It is square and has two handles, made by Richard Williams of Dublin in 1772 and now in the Untermyer Collection, New York. Examples made of wood, with silver mounts, are not unknown and sometimes these cups have three handles. It must be remembered that the drinking of mead (fermented honey and water) was in no way confined to Ireland or even to the Celtic fringe of Britain. However, there seems to be little justification for calling an extremely rare jug made in Chester, *c.* 1690, a 'Mead Jug' in spite of the fact that the handle is at right angles to the spout (**329**).

Mines, Gold and Silver (Great Britain)

Little or no gold has been mined commercially in the British Isles since the Middle Ages. As a metal it is found in Wales, Cornwall, the Lake District, Scotland and parts of Ireland. In 1287 King Edward I had a bar of Irish gold inventoried as being amongst his treasure. Only from Wales has there been any production at all during this century. Traditionally the sovereign's wedding ring is made of Welsh gold. The richest vein is that in mid-Wales at Dolaucothi, there is another nearby mine at Pumpsaint. Northwards in Merioneth, gold has been mined at Rhinog, Vigra, Llanuwchlyn and Clogan. At Dolaucothi, Roman workings have been found one hundred and fifty feet below ground level. Mining here seems to have died out after the English invasion under Edward I, but was revived by Queen Elizabeth I who claimed all the mineral rights and brought in German experts to continue the work. Later the rights were leased to patentees, who owed tithe to the Crown, but had licence to divide their holdings and sell shares. They were known as 'The Governor, Assistants and Commonalty of the Mines Royal'; William, Earl of Pembroke, was appointed Governor. Amongst those who later held the lease was Sir Hugh Middleton, the great London goldsmith. Under King Charles I, another leaseholder, Mr Bushell, was even allowed to set up a mint at Aberystwyth, Cardiganshire, ostensibly to pay his labourers. Until 1693, this custom caused much unrest as the landowners were not permitted to work their own mineral veins. However, in 1693, partly because it was no longer profitable, the Crown gave way, though it still claimed the mineral rights to all unenclosed land. This, in a country where miles of moorland could not be physically enclosed, still left considerable grounds for dispute. The mining of gold did in fact lapse until the late 1930s, when there was a temporary but short-lived revival.

Silver, much more readily accessible and to be found in far greater quantities, has been mined in the Mendip Hills since Roman times (see Provincial Goldsmiths), the area around Barnstaple and throughout Wales (see Jug); it is found in varying quantities in most of the mountain masses of the British Isles (see Cork). In 1684, the Flintshire (North Wales) lead mines of Sir Roger Mostyn were noted as having 'silver but so little yt it seems the play is not worth the candle'. None the less, the Crown decided, *c.* 1694, to grant a Charter to the Gadlys lead mines (for which it charged a fee) and by 1700 these were being operated. Pennant states that between 1704 and 1744 not less than 430,604 ounces of silver were extracted from this mine, but the re-established mint at Chester had already been closed in 1698, and so their produce had to be carried directly to London. Pennant also states that 'Queen Anne and her successor [George I] commanded that all specie coined from the silver should be struck with the plume of

349 The Harbledown Mazers
Of late 13th- and 14th-century date.
350 'Print' of the Guy of Warwick Mazer
c. 1320.
Sir Guy, Earl of Warwick, slays the dragon and so saves the lion which 'went before Gye pleying'.

349

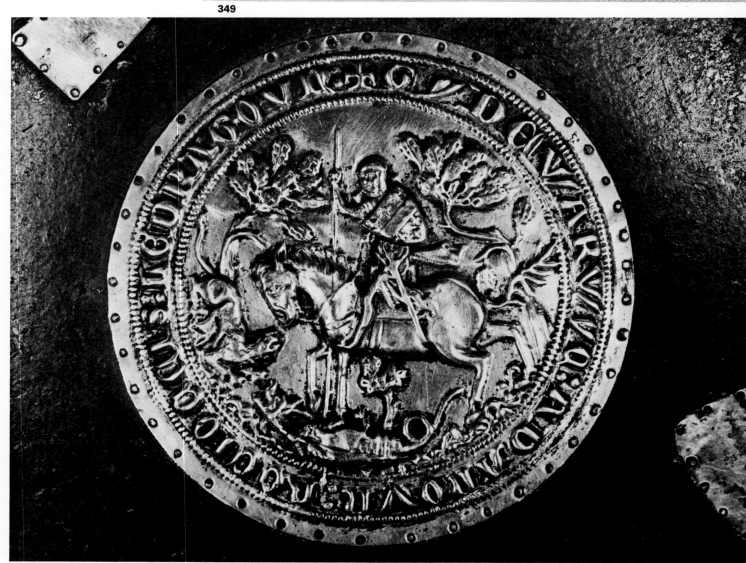

350

351

352

351 The Bannatyne Mazer
'Print': *c.* 1314–18.
Diam. 5 in. (12·7 cm.).
Bowl and mounts: 16th century.
On loan to the National Museum of
Antiquities, Edinburgh.
The mazer has a cover of carved
whalebone.

352 The Swan Mazer
Silver-gilt mounts.
Late 14th century.
Corpus Christi College, Cambridge.
So named because of the swan
resting on a pillar in the centre of
the bowl.

Fig. XXVI
A portion of the band of the
Warwick Mazer. Hall-mark for 1534.

353 The Galloway Mazer
Maker's mark of James Gray of
Edinburgh.
Engraved 1569.
Height 8¼ in. (21·0 cm.).
Diam. 8¾ in. (22·3 cm.).

**354 The Three Kings
Standing Mazer**
c. 1490.
Corpus Christi College, Cambridge.
The lip band is inscribed 'Jaspar
Melchior Balthasar'. The 'print'
is enamelled with a squirrel sitting
on the back of a fish.

Fig. XXVI

353

354

feathers, as a mark of its having been the production of the Principality'. The same directions had apparently been given by Sir Hugh Middleton for the Cardiganshire mines, and in 1637 Charles I had ordered the same device as a mint mark for coins of Welsh silver struck at Aberystwyth. A most puzzling trefid spoon of about 1690, bearing this mark (three plumes collared by a coronet) and the Arms of the city of Chester, is recorded and the mark is also struck on the reverse of the 1701 copper plate of the Chester Assay Office.

Of Scottish gold mines and their produce, there are a number of stories. In 1125 David I of Scotland decreed that 'a tenth of all gold found in Fife and Fothrif be granted to the Church of the Holy Trinity at Dunfermline'. It is also said that at his marriage to Mary of Guise, James V of Scotland set before each guest a covered cup filled with 'bonnet pieces' of Crawford gold, saying that this unusual dessert consisted of 'the finest fruits' of a barren moor. Gold was also mined for a short time at Winlocke-Head (Wanlock Head) by George Bowes, who was agent to Queen Elizabeth I of England. However, shortly after his first report to the Sovereign he was killed in a mining accident and the secret of the mine died with him. In 1567 Cornelius de Vois and Nicholas Hilliard (the miniaturist) were granted a licence from the Regent Morton to work all Scottish mines, but this proved financially unsuccessful. The Crawford-Muir mines, however, continued to produce a worthwhile yield, and it was probably from this source that John Mossman obtained 113 ounces of the metal for the crowns of James V and his Queen, together with other pieces. Abraham Grey got 'a good quantity of naturall gold' from the Wanlock Head area, enough to make 'a very faire deep bason' of gallon capacity, which, filled to the brim with gold unicorns (coins) was presented to the King of France by the Regent Morton, saying: 'My Lord, behold this bason and all that therein is: it is naturall gold, gotton within this kingdom of Scotland . . . [made] . . . at Edenborough, in Cannegate Streete; it was made by a Scottsman'.

King James VI, upon his accession to the throne of England, proposed a doubtful scheme whereby English gentlemen should finance the Scottish mines, in return for the honour of a knighthood as a 'Knight of the Golden Mynes or the Golden Knight'. During the middle of the 19th century gold was also found in Sutherland. A silver punch ladle of 1720 was made from silver mined at Alva (Royal Company of Archers).

Bibliography
T. Pennant, *The History of the Parishes of Whiteford and Holywell*. 1796.
E. Inglis-Jones, *Peacocks in Paradise*. Faber & Faber, 1960.
Maurice H. Ridgeway, *Chester Goldsmiths*. Sherratt, 1968.

Mirror See Furniture; Toilet Service.

Mitre

Usually an object more closely associated with the jeweller's craft than that of the goldsmith; none the less an unmarked silver example, c. 1660, together with a crozier at Pembroke College, Cambridge, are thought to have been made as part of the funeral array of Matthew Wren, Bishop of Ely (**161**). Anglican Bishops did not at that time wear mitres. The Limerick Mitre was made by Thomas O'Carryd at the order of Bishop Conor O'Dea in 1418. That of William of Wykeham at New College, Oxford, is of late 14th-century date, largely reconstructed in 1907 and again in 1929. Little remains of another mitre which is amongst the plate of All Souls College, Oxford.

Bibliography
John Hunt, *The Limerick Mitre and Crozier*.
W.H. St John Hope, 'The Episcopal Ornaments of William of Wykeham and William of Waynfleet'. *Archaeologia*, vol. LX, pp. 472 *et seq*.
The Treasures of New College, Oxford. (A Guide, N.D.)
Joan Evans, *A History of Jewellery*. 1953.

Modern Silver

During the last quarter of the 19th century, a movement orientated towards original design gained impetus. This, in direct opposition to the general taste of the day which dictated that the main criterion, and so the price demanded, of an excellent piece of silver, was a maximum amount of workmanship and technique, not a balanced design. These 'new men', C.R. Ashbee, Alfred Gilbert, Omar Ramsden and others, produced an 'Art Nouveau' which may not yet be wholly acceptable to us fifty years later, but which marked an attempt to return to individuality of style. In their turn, they were succeeded by Leslie Durbin, a pupil of Omar Ramsden (**319a**), Arthur Gaskin, R.Y. Gleadowe, Harold Stabler, Gerald Benney and a considerable number of other designers and/or silversmiths. Most of their productions are extremely well made and, of necessity, are relatively costly. The difficulty experienced in forming a collection of such pieces is symptomatic of their growing popularity. Too much credit cannot be given to anyone who can design and make a piece both practical and handsome, which is no mere imitation of something produced for the same purpose by generations of silversmiths in previous centuries.

Bibliography
Modern British Silver. Goldsmiths' Hall, August 1951.
Queen Charlotte's Loan Exhibition. Seaford House (Items 1–50), 1929.

Molinet

Also known as a 'swizzle-stick' or 'stirrer', this was usually made of wood and projected through an aperture in the lid of a chocolate pot in order to stir the liquid immediately before serving (see Chocolate Pot). At least one example survives, with a late, pear-shaped pot of 1774, it has four, finely pierced, silver flanges to the wooden rod. Another, made by John le Sage in 1739, has an ivory handle which may in fact be a replacement.

Monstrance

An open or transparent vessel of gold or silver in which the Host (the consecrated bread, signifying the body of Christ) may be exposed. Often similar in form to a reliquary in which sacred relics are similarly exposed. Medieval survivals are unknown in English silver. Recusant examples number less than a dozen. Perhaps the most interesting being that made for Sir Thomas Strickland, c. 1670, in which a chalice, upturned and with foot unscrewed, serves as the base. The earliest marked example seems to be that of 1693 (National Museum of Ireland). There are two fine monstrances of Canadian manufacture amongst the Henry Birks Collection; both date from the late 18th century.

Bibliography
J.E. Langdon, *Canadian Silversmiths, 1700–1900*. Toronto, 1966.
C.C. Oman, *English Church Plate*. Oxford University Press, 1957.

Monteith

'This year in the summer-time came up a vessel bason notched at the brim to let drinking vess hang there by the foot, so that the body or drinki place might hang into the water to cool them. Su a bason was called a Monteigh from a fantastic Scott called Monsieur Monteigh who at that ti or a little before wore the bottome of his cloake coate so notched'. This is Anthony à Wood's defi tion in his oft-quoted diary entry of Decem 1683. It should be noted that no mention is ma of the scalloped rim being detachable (**35** Raised from one piece of plate, the bowls of the vessels required fluting, not only for decoration also for strength, unless they were of a particula heavy gauge metal. One of the earliest surviv monteiths dates from 1684, and another of 168 engraved with chinoiserie figures and landscap Generally shallow with outward-curving sid these early monteiths average some 10 in. (2 cm.) in width. As time went on, they grew deep wider, and developed straighter sides until th had a definite 'tumble home'. The need for pun bowls, which required no scalloped rim, led to bowl being designed with a rim as a detacha addition, unfortunately this was easily lost. In 16 we find the Ironmongers' Company recording gift of just such a piece of plate 'a punch bowl . which rimme . . . being fixed in the said bole, becomes a monteith' (**357**). Most silversmit referred to this rim as a 'collar' and it is as such th Anthony Nelme invoiced one to the Duchess Newcastle in 1716. Generally speaking, the earli monteiths had simple, narrow, cast and appli foliage rims, as on the solitary, surviving examp made in Chester, c. 1690. This soon developed a variously shaped outline of gadrooning, scro cherubs' masks and shells, the lower border bei of similar moulding to the rim of the punch bow if it were detachable, and the join thereby bei concealed. The fluted body almost invariably i cludes one or more cartouches for the engravi of a coat of arms or crest. At an early date lion mask and drop-ring handles were also fitted to t bowl. An example by John Elston of Exeter, 170 of just this form is amongst the personal plate Her Majesty the Queen. It can be appreciated th handles were a necessity for two reasons, t sheer weight of such a bowl when filled with ic drink and glasses and, as glass was fairly expe sive, the need to prevent accidents when surfac on which the monteith was placed became sli pery due to the condensation (**359**). Tw American examples, the work of John Coney Boston, survive, one in the Garvan Collection, Ya University Art Gallery (Colour Plate **18**); the oth once belonged to Robert and Alida Schuyl There are, also, two much later American throw backs of the 1770s. By 1760 a monteith England is a definite rarity, unless a copy made special order. A brilliantly chased and engrave example of 1736 is amongst the Corporation Pla of St Albans, Hertfordshire. Scottish examples a very uncommon (**358**). A Scottish monteith su vives for each of the years 1692, 1698, 1720 ar 1727. They are equally rare from Ireland. The lad of that belonging to the Royal Company of Arche was made in 1720 from Scottish silver mined Alva. Very rare indeed is the example made Sheffield plate of c. 1790, some 10½ in. (26·7 cm in diameter, in the Victoria and Albert Museum.

Bibliography
G.B. Hughes, 'Bowls for cooling wine glasse *Country Life*, September 20th, 1962.
See also Jardinière; Ladle, Punch or Todd Punch Bowl; Verrière.

355

355 Medal and Chain
Gold.
National Maritime Museum,
Greenwich.
Given to Vice-Admiral Penn by
Parliament in 1653.

356 Monteith
Maker's mark of George Garthorne.
Hall-mark for 1684.
Diam. 12⅝ in. (32·1 cm.).

357 Monteith
Maker's mark of John Jackson.
Hall-mark for 1700.
Diam. 14 in. (35·6 cm.).

358 Monteith
Maker's mark of James Cockburn.
Hall-mark for 1702, Edinburgh.
Diam. 12½ in. (31·8 cm.).
Engraved with the Arms of
Johnstone.
It has a brass liner.

359 Monteith
Maker's mark of John Swift.
Hall-mark for 1730.
Diam. 12¾ in. (32·4 cm.).

356

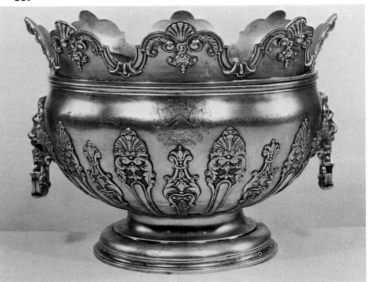

357

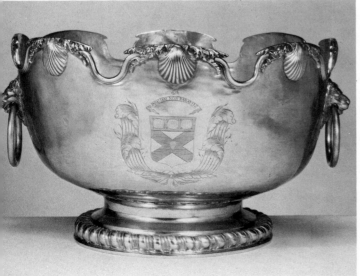

358

359

181

Monument Candlestick

A late 17th-century description, probably of column candlesticks as made at that time and reappearing in the 1750s (Figs. **Id**, **VIc** and **d**). The stem was usually formed as a fluted column, the later examples have Corinthian capitals with very rare exceptions of Doric form.

See also Candlestick.

Moresque

Also known as Arabesque moresque. Derived from Near Eastern art, this line ornament was usually of stylised scrolling and intertwining foliage.

Mortar

Only one is known to exist and this unfortunately lacks its pestle (Henry Birks Collection). Nevertheless, it is most remarkable, not least for its being Canadian, but also because of its great weight. The work of Paul Lambert of Quebec, c. 1730, it is on loan to the Canadian Museum, Toronto.

Bibliography
J.E. Langdon, *Canadian Silversmiths, 1700–1900.* Toronto, 1966.

Moser, George Michael (1704–83)

A German-Swiss chaser, born at Schaffhausen, Switzerland. He at first worked for a Soho cabinet-maker named Trotter. As early as the 1730s he ran a drawing school, and by 1736 he is recorded as a 'Gold Chaser'. He is considered to be the best chaser of his day, and it is he, together with H.F. Gravelot, who may take the credit for the introduction of the Rococo taste to England. Designs for watch cases, in which Moser specialised, survive in the Victoria and Albert Museum. He later became the first Keeper of the Royal Academy of Arts. His signature is found on a snuff box of 1741 (Wrightsman Collection) and two boxes (one made by James Hunt in 1768) given to King Christian II of Denmark on the occasion of his visit to England in 1768 (now in Rosenborg Castle, Copenhagen). By 1763 he was described as 'Chaser and Painter in Enamel Colours', and Plate **360** illustrates his prowess as a designer.

Bibliography
Mark Girouard, 'English Art and the Rococo', part III. *Country Life*, February 3rd, 1966.
A.K. Snowman, *Eighteenth Century Gold Snuff Boxes of Europe.* Faber & Faber, 1966.

Mounted-pieces

Agate, Jasper and Alabaster

During the late 18th century, the habit of using agate or jasper for the handles of knives, forks and, occasionally, spoons which were to be used for dessert dishes, became as widespread as it had been for knives during the 16th century. One such service, comprising eighteen of each and made by Eley & Fearn in 1817, was mounted for Mr Timothy Curtis using Scottish jasper supplied at a cost of eighteen guineas for the thirty-six pieces by John Sanderson of Edinburgh: 'I have selected all the variety I could procure or any stone I could make, to the size—The Green is from the Isles of Rum & Sky—The Brown Moss Agate is from Dunglass and Dunbar—The Red is from the Burn by Brechen—The Black is from Keith—The Yellow with Red is from Angus—The Spreckled is from Arthur Seat'.

Surviving pieces of mounted agate, other than those used for the lids of snuff boxes, the handles of cutlery, or as seals, appear to be rare. A goblet of agate with silver-gilt mounts of 1567 is in the Victoria and Albert Museum. Quite the most splendid, though probably made in Antwerp and marked after importation to England, c. 1580, is the ewer and basin in the collection of the Duke of Rutland. Apart from the Dyneley Casket of about 1620 (Victoria and Albert Museum) the only other recorded piece with English mounts is a small alabaster vase or caster with silver-gilt mounts by IC, c. 1665, and 6½ in. (16·5 cm.) high.

Coconut

The coconut, impervious and capable of taking a high polish, either sculpted or engraved, must have appealed from an early date. ('Cyphum de nuce Indye' is mentioned in a will of 1259.) A number of late medieval examples of coconut cups survive, some with extremely fine silver mounts, though rarely preserving their covers. Two of the finest are at New College, Oxford. In one, of truly medieval form, the coconut is enclosed in the branches of an oak tree whose trunk rises from a palisaded foot, this was originally set with small figures or animals similar to the Giant Salt at All Souls College, Oxford. The base of the other shows considerable similarity to that of known standing cups of the 1440s and has a shallow, slightly everted lip, engraved with the Angelic salutation to the Virgin. A fine, covered example of c. 1450, almost globular, is in the Lee Collection, Toronto. Two others with remarkably similar mounts are at Oriel College, Oxford, and Corpus Christi College, Cambridge. Later in the 15th century the lip grew taller. Gonville and Caius College, Cambridge, possesses an example of c. 1470 with cover (**362**). Another, the property of Lord Gisborough, is on loan to Temple Newsham House, Leeds, and is of late 15th-century date. The lobed, trumpet-shaped foot of the standing mazer appears with a coconut bowl of c. 1510 at Eton College and from this date onwards decoration and fashion is similar to other contemporary pieces. One of the most interesting is that having the stem formed as a gilt dragon (one of the supporters of the Royal Tudor Arms) and the bowl carved with the Arms of Sir Francis Drake, those of England and with a scene from Drake's voyage of circumnavigation (private collection). It was traditionally presented to him by Queen Elizabeth I on his safe return.

Very plain examples, foreshadowing the revival of such cups in the 18th century, are found dating from 1580; one marked in Norwich in 1581 is of such quality as to suggest its being of Dutch origin (Victoria and Albert Museum). A later cup from Hull is illustrated on Plate **371**a. An interesting, two-handled example made by John Plummer of York in 1667 stands on four pomegranate feet. A cup of mid 18th-century date is remarkable for the quality of the engraving on the applied silver plaques. Outstanding also are the silver mounts, engraved with the crest and Arms of Clayton, to a coconut punch ladle of about 1730. By 1790 the demand seems to have been for *tours de force* of the geometrical carver's art or pieces like the nut, with gilt mounts and inset with Wedgwood jasper-ware mounts, in the Victoria and Albert Museum. Very few examples are known of the two-handled, mid 18th-century form of cup with strapwork ornament (**371b**).

Bibliography
E.H. Pinto, 'Nut Treen', part I. *Apollo*, January 1950.

Coral

Used occasionally for decoration, frequently for teething sticks and children's rattles.

Glass

Rarely considered suitable for mounting prior to the 16th century except as jewellery, one of the finest pieces to survive is the striated, pear-shaped, milky glass tankard known as the Sudeley Tankard (**363**), with silver-gilt mounts of 15 and enamelled with the Arms of Parr (Lond Museum). Another dated 1548 is in the Brit Museum. A crackled glass example, the mou made in London in 1563, is in the Lee Collecti Toronto. Clear cut-glass with gilt or white mou returned to fashion in the 1790s in the form bowls, sometimes as parts of an epergne, la vases (a pair was made by Storr in 1808 (**361**) as liners to cream pails, sugar baskets, honey po or very rarely, as salt cellars. For salt cellars, blue red glass liners were the general rule and they f appeared about 1760. The Company of Found possesses a goblet of Venetian glass with a silv gilt foot, which was bequeathed to them in 16 The donor related the supposed history of goblet, saying that it had been 'brought fr Bullen [Boulogne] out of France, at the time wh Henry the VIII the King of England had that pla yielded unto him'. The mounts in fact may of 1527.

Horn and Ivory

Throughout the Middle Ages, ox-horns w mounted with silver (see Horn), and beakers this material, often having a silver rim, were ma during the latter part of the 18th century a probably earlier. A cylindrical horn tankard w silver mounts of 1561, is probably the inspirat for the form of the silver cylindrical tankard. One the most important pieces of mounted ivory survive is the Howard Grace Cup having mounts 1525, now in the Victoria and Albert Museum. T silver-gilt mounts are decorated with added pea and the cup is engraved round the lip 'VINV TVVM BIBE CVM GAVDIO' and the co 'ESTOTE SOBRII' with TB and a mitre tw repeated, probably for Thomas, 15th Lord Berkel though there are also claims to it having be associated with St Thomas à Becket. The ivory m indeed be of earlier date than the mounts. A cup lobed and fluted outline bearing hall-marks 1653 (though perhaps on importation fr Germany) is also known. A number of vases w carved sections of elephant ivory were mounted silver-gilt in England during the late 17th centu Perhaps the finest pair of such vases are those w mounts made by David Willaume in 1711; ag the ivory has an earlier history (Peter Wild Bequest, British Museum). Small patch a counter boxes were also silver-mounted during late 18th and early 19th centuries. As late as 18 a human skull, said to have been found in the Fi of Flodden, was mounted as a drinking cup.

Bibliography
J.F. Hayward, *Huguenot Silver in England.* Fabe Faber, 1959.

Leather

Toughened leather jugs, flasks and tankards known from the 16th to 19th centuries with silv mounts.

See also Black Jack.

Mother-of-pearl

This has always been attractive to the decorat and a number of pieces, almost certainly of Engl manufacture, have survived from the 16th and 17 centuries, but a considerable specialist trade in t material (usually small scales laid down on ground) seems to have centred upon south Germany. A salt in the Lee Collection, Toron dates from c. 1590. Of about the same date is t domed box in the Museum of Fine Arts, Boston. the Untermyer Collection, New York, is a sma silver-gilt mounted, covered cup of 1590, maker's mark, RW, with mother-of-pearl bo (**370**). In 1649 in the Jewel Tower of the Tower London, there were 'six Fruit dishes of Mother

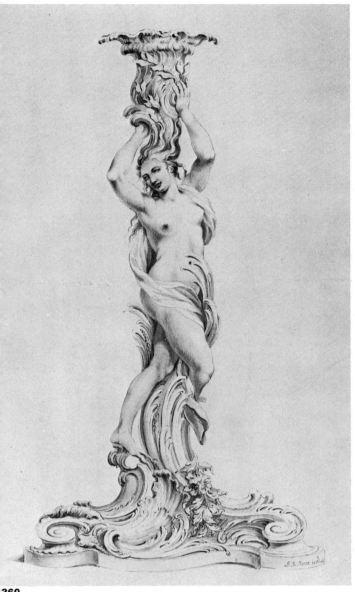

360

361

62

363

360 Design for a Candlestick
A design for a candlestick by
George Michael Moser, brown ink
drawing and light brown wash.

361 Vase
One of a pair of cut-glass vases
mounted in silver-gilt.
Maker's mark of Paul Storr.
Hall-mark for 1808.
Height $20\frac{1}{4}$ in. (57·5 cm.).

362 Coconut Cup
Silver-gilt mounts.
c. 1470.
Height $9\frac{1}{4}$ in. (23·5 cm.).
Gonville and Caius College,
Cambridge.

363 The Sudeley Tankard
Now called the Parr Pot.
Silver-gilt mounts and Venetian
glass.
Maker's mark, a fleur-de-lys.
Hall-mark for 1546, London.
Height 6 in. (15·3 cm.).
London Museum.
Enamelled with the Arms of Sir
William Parr.

Pearle garnished about with silver gilt'. A large circular basin, the rim hall-marked 1621 (Victoria and Albert Museum), fits this description exactly. A cylindrical flagon, a ewer and several basins so made, also survive. Perhaps the most attractive piece of all is the two-handled, globular cup and cover, with silver mounts, of about 1660 (Victoria and Albert Museum); it is illustrated on Colour Plate **24**).

Nautilus Shell

Comparatively well known on the Continent, not many mounted shell cups have survived with English mounts. One of the finest, probably having the shell engraved separately, is that of 1585 with the maker's mark, TR, in the Fitzwilliam Museum, Cambridge (**366**). The Glynne Cup of 1579 on loan to the Victoria and Albert Museum, has a silver body which was substituted for the original shell at a later date (**180**). A very interesting cup, quite possibly Scottish, c. 1600, 10 in. (25·4 cm.) high, with unmarked silver-gilt mounts appeared at Sotheby's in November 1967.

Bibliography

J.F. Hayward, 'The Mannerist Goldsmiths'. *Connoisseur*, January 1967.

Ostrich Egg

The fact that no English, mounted, ostrich eggs of earlier date than the last half of the 16th century have survived, must be due to their extreme fragility. 'Gryphon's Eggs' or 'Gripe's Eggs', as they were known to the medieval world were rare and worthy of richly jewelled mounts. An example made in Leipzig, c. 1590, survives, the egg finely painted with arabesques and mythical beasts, and there is no reason to suppose that similar English examples were not made, for another, similar to the latter (made in Nuremberg in 1594) is to be seen at the Minneapolis Institute of Art, Minneapolis. Late 18th-century examples formed as goblets are a short-lived revival. An unmarked ewer, having the body formed of an egg, with gilt, acanthus foliage mounts, now at the Museum of Fine Arts, Boston, is probably English, c. 1670. The Goodriche Cup (Franks Bequest, British Museum) was originally made in 1563 to hold an ostrich egg. Later broken, it was replaced by a silver bowl, c. 1610, of the same form, coarsely engraved with figures, birds and formal ornament. The Aston Tankard in the same Bequest bears hall-marks for 1609; this, however, retains its ostrich egg. The Ducie Cup, made for William Rice in 1584, has a replacement ostrich egg, but is perhaps the finest English piece of such work (**365**), while that belonging to Corpus Christi College, Cambridge (1592) retains what appears to be its original case.

Porcelain

Perhaps as early as the 14th century, pieces of Oriental porcelain may have filtered through to the European market, to be received with wonder, and then suitably mounted. The similarity between Chinese stem cups of the early 15th century and the few surviving silver standing cups from this period is worthy of remark. Probably the earliest English mounted piece of porcelain to survive is the Celadon Bowl, now at New College, Oxford, which appears to be that presented to the College by Archbishop Warham in 1516, but traditionally given to him by the Archduke Philip of Austria in 1506. The earliest piece bearing English hall-marks is, however, the silver-gilt mounted, blue and white jug, 7½ in. (19·1 cm.) high, bearing the date-letter for 1550 (Museum of Fine Arts Boston). This only came to light in 1957. Until that date the Lennard Cup (1569) in the Percival David Collection, was thought to be the earliest survivor. From the latter part of the 16th century an increasing

quantity of pieces of Chinese porcelain began to reach Europe, principally by means of the Dutch East India merchants, and a considerable number of bowls, ewers (**369**) and mugs with white or silver-gilt mounts bear witness to this. Examples may be seen in most of the principal fine art museums, in particular the Metropolitan Museum of Art, New York, and in the Lee Collection, Toronto. The mounts frequently have only the maker's mark and, bearing in mind the usual source of the object, it frequently proves upon inquiry to be that of a Dutch silversmith, rather than an Englishman. Isnik pottery from Turkey (**368**), remarkable for its brilliantly coloured decoration, miscalled 'Rhodian ware', is also found similarly mounted. An example of this pottery, known as the Rhodian Jug is illustrated on Colour Plate **31**.

Bibliography

S.W. Bushell and E.A. Jones, 'A Ming Bowl with Silver-gilt Mounts of the Tudor Period'. *Burlington Magazine*, vol. XIII, 1908.

Yvonne Hackenbroch, 'Chinese Porcelain in European Silver Mounts'. *Connoisseur*, June 1955.

N.M. Penzer, 'Tudor Font-shaped Cups', part II. *Apollo*, February 1958.

Edward Wenham, 'Silver-mounted Porcelain'. *Connoisseur*, vol. XCVII, p. 189.

Rock-crystal

This has, from the earliest times, been considered worthy of mounting, not only for its own sake, but also for its supposed power of revealing poison (**187**). It seems to have been commonly used, for obvious reasons, as the bowl of a salt cellar, being impervious to the chemical action of the salt. The Giant Salt of All Souls College, Oxford, and the Monkey Salt at New College in the same University, each own rock-crystal bowls. The Stonyhurst Salt, 1577, has considerably earlier rock-crystal parts, though the bowl is of silver-gilt. The Crystal Mace of the city of Norwich has silver-gilt mounts also. Some other pieces, such as the earliest English candlesticks of c. 1610, and the Walker Salt at Trinity College, Oxford (1549) also incorporate rock-crystal, as does the Methuen Cup (Scottish mid 16th century) now in Los Angeles County Museum (Colour Plate **26**). Numerous gold-mounted and jewelled spoons of rock-crystal are noted in the Inventories of the Royal Plate. Extremely interesting, if not to everyone's taste, is the silver-mounted, rock-crystal ewer made by George Heriot (1568–85), Edinburgh. Amongst the Burrell Collection, Glasgow, there is a rock-crystal tankard of baluster form, the engraved silver mounts having London marks for 1617 and it is 8¾ in. (22·3 cm.) high.

Bibliography

C.C. Oman, 'The Civic Plate and Insignia of the City of Norwich', part I. *Connoisseur*, April 1964.

Hugh Tait, 'The Stonyhurst Salt'. *Apollo*, April 1964.

F.C. Eeles, *Proceedings of the Society of Antiquaries of Scotland*. Vol. LV.

Serpentine

This mineral, a marble, found, amongst other places in Britain, in Cornwall, Anglesey and Banffshire, and particularly widespread on the Continent, is extremely pleasing to the eye when mounted with silver; tankards, flagons and bowls being the most suitable form (**598**). Examples from the 16th to the late 17th centuries survive. One of the finest being that of 1575 formed as a beaker-shaped tankard with silver-gilt mounts (Sherborne Collection). On occasion other marbles were also used. A tankard in the Victoria and Albert Museum has exceptionally fine, engraved cherubs and masks of the winds, on the domed cover, typical of the best work of the

1620s. A two-handled bombé cup of c. 1650, the most important known silversmith of his [...] who used the hound sejant mark, is some 6¾ [...] (17·2 cm.) high.

Silver

During the 19th century, embossed plaques [...] Continental silver were given English mounts. [...]

Stoneware (Earthenware)

'They consume great quantities of beer, double [...] single, and drink it, not out of glasses, but f[...] earthen pots, with handles and covers of sil[...] even in the houses of persons of medium wealth. [...] wrote Étienne Perlin of the English in 1558. Du[...] the 1540s, so-called 'stone-ware' jugs, more of [...] than not of mottled appearance, became fashi[...] able (**367**). These were fitted with silver-gilt a[...] more rarely, with plain silver mounts to foot and [...] and, more rarely still, with straps enclosing [...] body as the Wilbraham example of 1566 (A[...] molean Museum, Oxford). Those jugs with pe[...] shaped bodies, cylindrical necks, and having [...] handle well below the lip, were often provided v[...] a box-like structure which was necessary to ho[...] a hinge for the domed, silver cover, which m[...] have a baluster, lion or crest finial. In the earl[...] examples, which were small and bulbous becom[...] taller later, the band round the lip was only [...] graved, but later it was embossed en suite v[...] the cover and foot. Enamelled initials or coat[...] arms are sometimes incorporated. Though ca[...] jugs, these pieces are probably the origins of [...] pear-shaped Elizabethan tankard, neverthel[...] one example of 1574 with a pinched-out spou[...] the lip should be noted. The majority of this sto[...] ware (Terre de Pipe) was imported from [...] German town of Siegburg. Wrotham, Kent (**3[...]** and Nottingham wares are also known to have b[...] mounted from 1560 onwards, the latter, with si[...] mounts, is particularly rare, but in fact there [...] tall, cylindrical example of 1566. A general nam[...] all these varieties, the vast majority of which w[...] mounted in London, is 'Tigerware', as many [...] them have a brown striped appearance. The w[...] is often extremely coarse, especially on l[...] examples. One on loan to the Metropol[...] Museum of Art, New York, bearing the Royal A[...] of Queen Elizabeth I and with an unusual finia[...] the cover, is an exception, it being one of those [...] tremely well-mounted pieces, executed in the W[...] Country, the work of Peter Quick of Barnstaple. [...] in many similar cases good workmanship of [...] nature is also evident in Exeter, Plymouth [...] Norwich. About half of the surviving moun[...] stoneware 'potts' appear to be fully marked. T[...] are found bearing trite sayings, such as 'The To[...] that lieth killeth the Sovle' as on a piece of ab[...] 1540 in the London Museum. (A comprehens[...] collection of mounted stoneware is that to [...] found in the Ashmolean Museum, Oxford.)

Wood

Rarely used except for the bowls of mazers, y[...] cup of gold made by William Gilchrist of Edinbu[...] in 1752 has handles of ebony (Metropoli[...] Museum of Art, New York). Wood handles [...] finials are, of course, to be expected on [...] receptacle for hot food or liquid, such as [...] coffee or chocolate pots.

Bibliography

W.W. Watts, *Catalogue of the Lee Collection*. 19[...] *The Treasures of New College, Oxford*. (A Gui[...] N.D.)

Edward Wenham, 'Silver-mounted Pottery'. *Connoisseur*, vol. XCVIII, p. 251.

Judith Banister, 'Pottery Garnished with Silv[...] *Antique Dealer and Collectors' Guide*, June 19[...]

Eric Delieb, *Investing in Silver*, 1967.

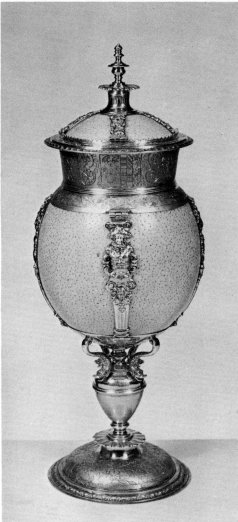

365

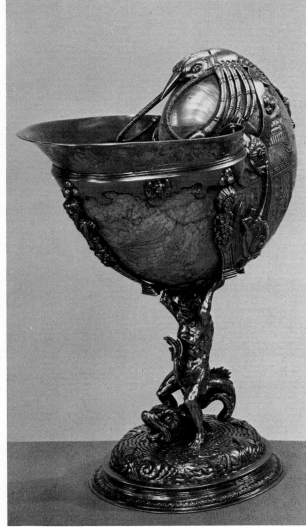

366

a b c

367

185

368 Isnik (Turkish)
Pottery Jug
Silver mounts.
Maker's mark, IH.
Hall-mark for 1592.
Height 10¼ in. (26·1 cm.).
369 Ewers (Kende)
Silver mounts and Chinese blue and
white porcelain.
Left: unmarked, *c.* 1610.
Height 9 in. (22·9 cm.).
Pricked with the initials CPL.
Right: maker's mark, EI.
c. 1610.
Height 11 in. (28·0 cm.).
370 Standing Cup
Silver-gilt and mother-of-pearl.
Maker's mark, RW.
Hall-mark for 1590, London.
Height 7¾ in. (19·7 cm.).
Untermyer Collection.
371 Coconut Cups
a. Unmarked, *c.* 1670.
Royal Scottish Museum.
b. Unmarked, *c.* 1730.
Height 6 in. (15·3 cm.).
Engraved with the Arms of
Vernon of Haslington.

368

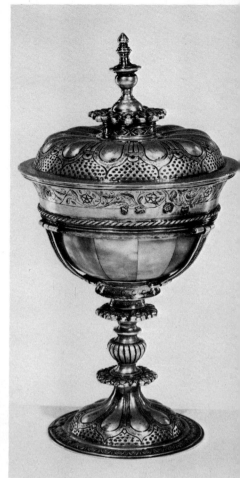

370

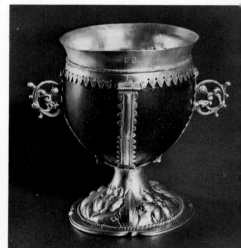

371a

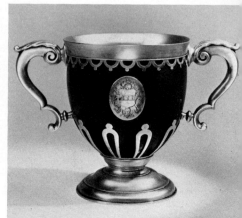

371b

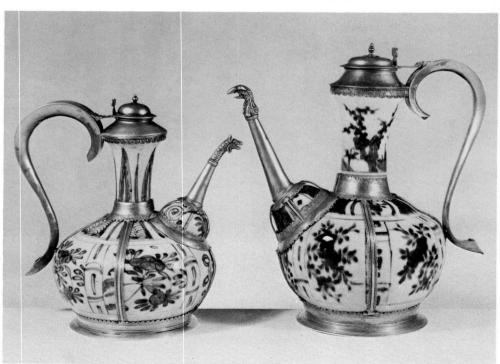

369

See also Black Jack; Cup, Standing; Cup, Two-handled; Mazer; Mug; Norwich Silver; Rattle; Tankard.

...ffineer See Caster.

...g

...rprisingly, the mug or 'cann' as we know it, with ...capacity of about half a pint, does not appear ...til the end of the reign of Charles II. A bulbous ...riety, derived from Nottingham-ware pottery, ...th tall, reeded, cylindrical lip and flat, reeded, ...oll handle, is amongst the first of this form, and is ...quently found with chinoiserie or matted ...coration. A pair of 1685, the work of Garthorne, ... at Polesden Lacey; another pair, of shaped ...tline, engraved all over with cherubs amidst ...iage (1692) are in the Carter Bequest, Ash-...olean Museum, Oxford. Besides these, there also ...nain a pair made in Boston by John Coney, c. ...95. In the Sheffield City Museum is a small mug ... everted beaker form, the strap handle riveted to ...e side, made in London in 1675. A bell (thistle) ...aped variety with small C-shaped handle and a ...ulded rib round the body, was common to both ...otland and England (**378**). The lower part of the ...wl is usually enclosed in a calyx of applied ...ped fluting. A pair of very similar form, but made ... gold, appear to date from c. 1700, having a ...ker's mark only. The splendid, gold, chinoiserie ...ample, with cover and/or saucer, in the collec-...n of Lord Derby, also has only the maker's mark, ...ssibly that of Ralph Leeke. Colonial American ...amples are usually of a somewhat later date (**377**). ... s not until the last years of the 17th century the ... cylindrical mug appears (**375**), unlike the one ...strated, this form is usually either wholly or ...rtly chased with vertical fluting and bands of ...mped ornament similar to the decoration found ... porringers of the day. This fluting, by giving ...ditional strength to the piece, also allowed for ... use of a thinner gauge metal; the handle might ... cast or made from a flat, reeded, metal strip. By ...15 the plain, cylindrical mug with everted lip and ...ck-in' foot had made its appearance and the cast ...ndle, which was at first single, later tended to ... double scroll form. Great sets of two or three ...zen of these were made for some of the Oxford ...d Cambridge Colleges. From 1725 onwards, the ...luster form with moulded foot begins to appear ...76). An example in gold, made in Newcastle, c. ...'30, was amongst the Noble Collection. It is not ...til 1770 that, with rare exceptions in which the ...dy is made of one piece with no additional foot, ...e cylindrical form returns, now decorated with ...in bands of horizontal reeding, the handle being ...metimes almost harp-shaped (stirrup) and of ...ctangular section. The two pairs of large mugs, ...spectively dated 1762 and 1763, which were ...ven by George III and Queen Charlotte to Eton ...ollege are the exceptions that prove the rule. A ...ost attractive and unusual example is that, 5¼ in. ...3·4 cm.) high, of ovoid form made by Louisa ...urtauld in 1766.

The 19th century saw a rapid progression of the ...ug through all imaginable forms, including the ...vival of a number of those noted above. Cast or ...ased examples in the Classical taste reflect the ...fluence of Greek art on designers such as ...axman and Stothard, and through them on such ...versmiths as Storr (**374**), Scott and Smith. As ...ith tankards, a number of mugs have been ...ased and decorated at a later date, with the ...ccasional addition of a lip spout to form a cream ...g, a quite illegal addition unless re-marked at the ...me time as its being added.

A very rare form is the mug with a detachable cover as illustrated on Plate **373**. One made by John le Sage in 1722 and engraved with the Arms of Manners is in the Ashmolean Museum, Oxford. Another the work of J.G. Lansing, Albany, New York, c. 1720, is in the collection of J.D. Kerman. At least one pair of Queen Anne mugs with detachable covers, made by Simon Pantin in 1710, survive. Though the covers are not marked, there seems no reason to doubt their belonging to the mugs. It is interesting to note these dates and the fact that *Bailey's Dictionary* of 1728 defines a mug as 'a Cup for warming drink etc.'. An interesting quirk is the York tumbler cup made by Thomas Mangy in 1678, with an added handle which makes it into a mug. This handle is in fact the reused stem of a Hull spoon (Munro Collection, on loan to the Huntingdon Art Gallery). Another oddity is that illustrated on Plate **372**.

Bibliography

G.B. Hughes, *Small Antique Silverware*. Batsford, 1957.

S.A. Courtauld and E.A. Jones, *Silver Wrought by the Courtauld Family*. 1940.

See also Beaker; Goblet; Tankard; Travelling Canteen; Tumbler Cup.

Mustard Pot

The earliest fully recorded purchase appears to be that made by Arthur, 1st Earl of Donegal, in 1666, though John Wycliffe was known to keep a pot of mustard ready mixed as early as 1380, and mustard was well known in Tudor times. One such pot was supplied for Prince Rupert by Alderman Blackwell on April 28th, 1670: '1 pepper box, 1 mustard pot, 2 crewetts ...'. Another inventory of December 5th, 1689 records 'Item 1 Sugar box, mustard pot & pepper box...'. So described, we must assume that the difference between the pots and boxes was obvious and it is likely that the blind casters so often found in sets of three or more (usually after 1720, mounted in a cruet frame) were for dry mustard. The unpierced, domed covers of these casters were engraved *en suite* with the piercings in those of the other two casters and are thus called 'blind'. It is likely that such a caster was originally supplied with all early sets, but the majority have been pierced at a later date when the use of dry mustard was discontinued. On occasions the blind caster was in fact pierced, but lined on the inside; again this lining was often removed later. One such example, with a spoon, dated c. 1680, the maker's mark, F.G., is in a private collection.

A curious, ovoid mustard pot showing strong Dutch influence, the work of Pieter Van Dyck of New York, is in the Garvan Collection, Yale University Art Gallery, and dates from c. 1726 (**380**). One of 1732 is cited by Commander G.E.P. How as bearing a square cut in the rim as a contemporary feature; another with a spoon, both by the same maker, serves to corroborate this, but whether for wet or dry mustard is still an open question, and perhaps not of great importance. Early mustard spoons are formed as teaspoons with elongated stems. The earliest surviving mustard pots of the form we know today appear to be those dated 1724, from the collection of the Marquess of Sligo, illustrated on Plate **379** and discussed in *Connoisseur*, vol. LXVII, pp. 158–9, 1923. Jackson cites one as being of 1737, but this is a mistake, for 1777 is the correct date. Another of French Régence form, on a high foot, with rising scroll handle is in the Farrer Collection at the Ashmolean Museum, Oxford. The work of Edward Wakelin, it must date from c. 1740, and the Garrard Ledgers do, in fact, confirm this possibility—'May 1, 1752. To a

mustard Barrele'. That, in the National Museum of Ireland, made by John Moore of Dublin in 1751 (**381**) is tankard-shaped, like most early examples. An advertisement of March 1789 refers to mustard pots as 'Mustard tankards'. Very recently there has appeared a mustard pot and cover made by Thomas Rush in 1749 (the cover is also thus marked), formed as one would expect, like the contemporary salt cellar, on three feet but with cover and rising scroll handle to one side. By 1760, the plain, cylindrical mustard pot appears (**382**), but soon pierced with 'Gothick' arcading and fitted with blue, glass liners, this form seems to have caught the public fancy, though by 1785 oval ones in sets with salt cellars were becoming more common. They are often somewhat larger than those made today, but, like casters, the form has hardly ever been bettered. As might be expected the Adam-inspired vase form was also adapted (**383**). The cover is never pierced *en suite* with the body. A particularly interesting example, of caster form, incorporates a nutmeg grater in the domed cover, the finial of which, in its turn, is detachable. Hall-marked 1724 this is in a private collection. An intriguing form is that modelled as a monkey clasping the barrel (**384**), whilst one in the collection of the Duke of Portland, made in Sheffield, has a spherical body.

Bibliography

Commander G.E.P. How, *Connoisseur*, February 1938.

G.B. Hughes, *Small Antique Silverware*. Batsford, 1957.

See also Caster; Cruet.

Mustard Spoon See Spoon (Mustard Spoon).

Myers, Myer (1723–95)

Myers was born in New York in 1723 of parents who had emigrated from Holland. The family were members of the congregation of Shearith Israel, the Sephardic and the earliest synagogue in America, and Mrs Rosenbaum suggests that Myers may well have been educated in the congregation's school. Little is known of the silversmith himself, however, till the record of his obtaining his freedom as gold-smith in 1746, his apprenticeship, as far as we know being unrecorded. Nothing is heard of him again until 1754, and in the next year he is found trading in Philadelphia as well as New York. By 1759 he had grown in stature and was President of Shearith Israel, as he was again in 1770. The Revolution drove him and his family to Connecticut. By 1782 they were to be found in Philadelphia; in that same year the Spanish-Portuguese congregation of Mikveh Israel was reorganized in that city, and Myers made substantial donations to its building fund. After the British evacuation of New York he returned there to end his days in prosperity, dying in 1795.

The five marks, here illustrated, can be attributed to this silversmith. The last (e) being of the firm of Halstead & Myers, trading as such only in 1763–4.

a b c

d e

Amongst his considerable output may be singled out a pair of cast 'bamboo' candlesticks (Yale University Art Gallery), together with a pair of snuffers and a stand; the only recorded American

372 Mug
Maker's mark, TM in monogram.
Hall-mark for 1677, London.
Engraved with the Arms of St John.

373 Mug and Cover
Maker's mark, D in script.
Hall-mark for 1688.
Height 6¼ in. (15·9 cm.).
Engraved with the Arms of
Wyndham impaling Gower.

374 Mug
Maker's mark of Paul Storr.
Hall-mark for 1801.
Height 3½ in. (8·9 cm.).
National Museum of Wales.
Inscribed underneath 'Nelson's
Grog Mug', it was used by him
on H.M.S. Victory.

375 Mug
Maker's mark of Andrew Raven.
Hall-mark for 1706.
An unusual, plain mug.

376 Mug
Maker's mark of John Edwards.
Hall-mark for 1728.
Height 4¾ in. (12·1 cm.).
Engraved with the Arms of Methold
impaling Davison.

377 Mug
Maker's mark of John Coddington
of Newport, Rhode Island.
c. 1730.
Height 3⅝ in. (9·2 cm.).

378 Mug
Maker's mark of Thomas Robinson.
Hall-mark for 1690, Chester.
Height 3⅜ in. (8·6 cm.).
Engraved with the initials I S and
Gᶜ E.

372

373

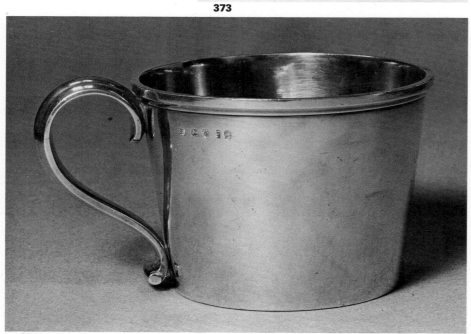

374

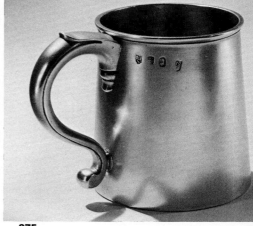

375

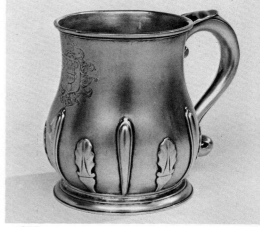

376

377

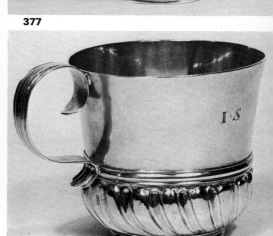

378

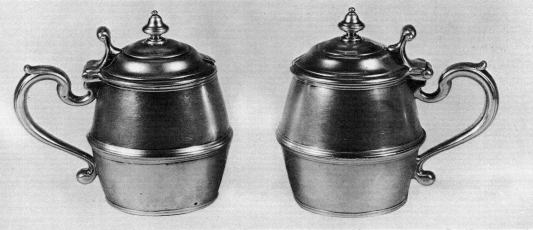

379

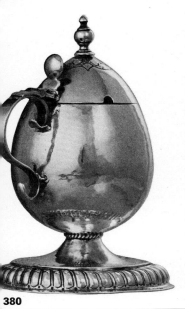

380

381

379 A Pair of Mustard Pots
Hall-mark for 1724.
380 Mustard Pot
Maker's mark of Pieter Van Dyck
of New York.
c. 1725.
Yale University Art Gallery,
Mabel Brady Garvan Collection.
381 Mustard Pot
Maker's mark of John Moore.
Hall-mark for 1751, Dublin.
National Museum of Ireland.
382 Mustard Pots
Maker's mark of Hester Bateman.
Left: hall-mark for 1779.
Height 3¾ in. (9·6 cm.).
Centre: hall-mark for 1785.
Height 4¼ in. (10·8 cm.).
Right: hall-mark for 1784.
Height 3¾ in. (9·6 cm.).
383 A Pair of Mustard Pots
Maker's mark of Abraham Peterson.
Hall-mark for 1791.
384 Mustard Pot
Maker's mark of John Bridge.
Hall-mark for 1825.

382

383

384

189

dish ring; a square waiter with incurved angles, uncommon in England and rare in America, and a tankard with a particularly elegant, recurved scroll handle. But it is for his synagogue pieces that Myers claims our attention as an important contributor to the history of American silver. These comprise five pairs of Rimonim or bells for the Torah scrolls, of which two pairs each belong to Touro Synagogue, Rhode Island, and Mikveh Israel, Philadelphia, and one pair to Shearith Israel, New York. The last is identical with one of the pairs at Rhode Island. These parallel pairs of bells in New York and Rhode Island, made about 1765, have bodies of triple-bulb form, pierced and chased with flowers and foliage. In this pierced decoration they closely resemble a pair of bells of 1719, made by the London goldsmith, Gabriel Sleath, now at Bevis Marks Synagogue, London, but formerly belonging to the Barbados congregation which had been founded in the mid 17th century. This raises the interesting question whether Myers's design for these bells originated from the Barbados examples. Sleath's bells are not unique among English examples. Others of the same form as those made by the Jewish goldsmith, Abraham de Oliveyra in 1724, are in the Jewish Museum, London, and more could be cited. On the whole one inclines to the belief that Myers must in some way have seen the Barbados bells, since connections between New York and that island were very close at the time. The other pair of bells at the Touro Synagogue is of the same general form, but these have solid bodies with engraved decoration in place of the piercing. Myers's final pair at Mikveh Israel are of quite different form, with pear-shaped bodies partly chased with fluting. Both form and decoration could be paralleled in English domestic pieces, such as coffee pots of the same period, though Mr Schoenberger has suggested German influence, comparing them with a pair of Nuremberg bells of c. 1750 in the Jewish Museum, New York.

Bibliography
J.W. Rosenbaum, *Myer Myers. Goldsmith.* The Jewish Publication Society of America, 1954.
See also Jewish Ritual Silver.

Nanny See Statuette and Model.

Napkin Holder or Hook

Amongst the fittings of a 17th-century travelling set may be found C-shaped hooks intended for the suspension of a napkin from the collar or cravat. At a later date another form made its appearance, it had a ring at one end and the other was formed as a pair of tweezers with a sliding sleeve to hold the grip. Both forms of napkin holder are rare, but the latter probably more so than the former. An example may be seen in the collection of the Birmingham Assay Office; in this case the ring is designed to fit over a waistcoat button.
See also Travelling Canteen.

Napkin Ring

Regrettably easy to fashion from a skewer; undoubted early examples, such as the four made by James Barker and William Whitwell of York in 1821 and 1830, are most uncommon.

Navette

Used as an adjective to describe something boat-shaped in outline.

Nef

A vessel formed as a ship. Relatively common on the Continent during the Middle Ages, but less than a dozen survive today. None of these are English, though a French example, made in Paris in 1482, once at Burghley House, Lincolnshire, is amongst the collection at the Victoria and Albert Museum. The larger examples served as status symbols, the lesser ones as salts. William of Wykeham bequeathed an alms dish formed as a nef in his will of 1404, and both Henry IV and Henry VI had such nefs. The boat-shaped incense vessel, such as that from Ramsey Abbey (Colour Plate 13), is perhaps the nearest that surviving English silver ever approached to the nef proper.

Bibliography
C.C. Oman, *Medieval Silver Nefs.* H.M.S.O., 1963.
See also Incense Boat.

Newcastle upon Tyne Assay Office

As early as 1248 goldsmiths are on record in Newcastle upon Tyne and by the Act of 1423 a touch was ordered, under the surveillance of the 'Mayor, Baliffs or Governor' of that town. A Company of Goldsmiths, Glaziers, Pewterers, Plumbers and Painters was incorporated in 1536, amongst its ordinances, any brother taking 'a Scots man borne in Scotland' as either apprentice or workman was fined 40*s*! The number of goldsmith members seems to have decreased during the first half of the 17th century for the Act of 1697 led in 1700 to the re-establishment of assay offices in those towns empowered to mint coin. Newcastle was not one of the towns thus empowered, hence goldsmiths had to send their work to York. Parcels of silver so dispatched took, so it was claimed, a fortnight before their return. As the result of a petition of February 1701 an Act was passed in March of the same year, re-establishing an assay office at Newcastle upon Tyne, the town mark being the Arms of Newcastle—three castles. In 1773, Sheffield and Birmingham having petitioned Parliament for similar assay offices, the opportunity was taken to examine all the provincial assay masters. Matthew Prior of Newcastle acquitted himself well and clearly. But by 1884 the office was discontinued. The copper plate on which, from 1702, makers' marks were impressed, is yet preserved. Though theoretically commenced in 1702 the date-letter system (A to T—I and J being omitted) does not seem to have been properly established until 1721.

Before c. 1680 c. 1680–1884

Bibliography
Sir C.J. Jackson, *English Goldsmiths and Their Marks.* 2nd Edition 1921, reprinted 1949.
J.R. Boyle, *The Goldsmiths of Newcastle.*
'Catalogue of Exhibition of Silver Plate of Newcastle Manufacture'. *Society of Antiquaries of Newcastle.* 1898.
J.C. Hodgson, M.A., F.S.A., 'An alphabetical Catalogue of the Goldsmiths of Newcastle'. *Archaeologia Aeliana* (3rd Series), vols. XI and XVI.
Catalogue of Newcastle Domestic Silver, Laing Art Gallery, 1966–7.

Newcastle Silver

In general it is true to say that the principal productions of Newcastle upon Tyne are pieces of cylindrical form, such as mugs, coffee pots and tankards. Early 18th-century examples of the tankard have a pronounced rat-tail extension down the side of the body and below the upper joint of the handle. A number of pieces, generally of considerable impor-

tance, have survived from the latter part of the 1[?] century. These include tankards, one made [by] William Ramsay, c. 1670, is in the Victoria [and] Albert Museum; race prizes (one of 1669) in [the] form of two-handled caudle cups or porring[ers] and covers (**206**); a chocolate pot executed [by] William Robinson, c. 1700, chased with flut[ing] and a saucepan chased with foliage, the wor[k of] John Dowthwaite, c. 1675. A fine porringer m[ade] by Francis Batty, engraved with an inscription da[ted] 1694, is amongst the collection of the Bank [of] England. The pair of standing patens given to [All] Saints Church in Newcastle in 1629 are prob[ably] also of local workmanship.

As the York Assay Office declined, the quan[tity] of silver made and assayed in Newcastle by [the] Partis, Cookson and Langland families reached c[on-]siderable proportions. A tendency to 'flood', [to] use too much solder and then turn it out by me[ans] of a lathe, distinguishes the underside of the j[oint] between the foot and body of pieces produced [in] these workshops. A single, circular sauce boa[t of] 1743; a pair of double-lipped sauce boats made [by] Wm. Partis, c. 1730; a single candlestick of 17[??] and a pair of 1747 appear to be the only survivor[s of] such objects actually made in Newcastle. It see[ms] quite usual for candlesticks and also casters [to] have been sent to Newcastle to be marked hav[ing] been made in London or Sheffield. Thus, the wh[ole] range of silversmiths' goods may be expected to [be] found bearing the Newcastle marks, amongst th[em] a complete tortoiseshell mounted on wheels a[nd] table snuff box made c. 1790. Even a wine taste[r of] 1757 is known, and rarest of all, a two-hand[led] gold cup made by James Kirkup in 1728, toget[her] with a baluster mug, c. 1730, also of gold.

Bibliography
E.A. Jones, 'Old Newcastle Silver in Mr. Thor[nton] Taylor's Collection'. *Connoisseur*, vol. LXXXI, p. 2[?]
Nickola Elphinstone, 'The Church Plate of [All] Saints, Newcastle-upon-Tyne'. *Burlington Maga-zine*, November 1967.

New Geneva (near Waterford, Ireland)

The only Irish town, other than Dublin, authoris[ed] by the Act of 1784 to assay silver. A number [of] Swiss watchmakers and jewellers were giv[en] refuge here in the 1780s, with the result that o[nly] small pieces, such as watch cases and jewelle[ry] were in fact assayed here and none after 1800.

New Year's Gifts

Until about 1680 it was the custom of the Co[urt] and nobility to present a New Year's gift to [the] sovereign, its worth varying according to the ra[nk] of the donor. By the late 16th century the fig[ure] appears to have been a definite amount; [an] Earl, for example, giving £20 in gold. A gift [of] greater worth might be offered for favours past—[or] hoped for. Originally presented in person, by [the] 17th century the whole affair was wrapped i[n a] shroud of officialdom. The king gave in retur[n a] piece of gilt plate weighing 30 ounces. Any exce[ss] over, or under, this weight was subject to [a] monetary correction. Thus we find in the Earl [of] Bedford's accounts for January 1660–61: 'P[re-] sented the 1st of January 1660–61, to the L[ord] Chamberlain in Gold for the King—£20; for [an] embroidered silk and silver purse where in t[he] gold was put, 2s. paid for the overweight of t[he] plate given by the King—11s; and to His Majest[y's] officers, which was by them demanded as a t[ip] upon their delivery of the said plate then given [to] his lordship—£2 5s. 0d. In all £22. 16. 0'. In la[ter] years the cost of gold rose and thus the 'g[ift] became even more expensive. The king's gift w[as]

quently exchanged almost immediately for a ce of plate needed by the recipient.
liography
Scott Thomson, *Life in a Noble Household* (p. 0). Jonathan Cape, 1950.
C.J. Jackson, *An Illustrated History of English te*. Vol. II, pp. 496 *et seq.* 1911.
e also Spoon.

ello

fusible black alloy of sulphur, lead, silver and pper, used to fill engraved ornament in order to ghten the contrast with silver; it has been suggested that this was one of the earliest printing hniques. Nearer in its physical characteristics to metal than to enamel; a Russian test for its ality was that once inset in metal it should be ssible to heat the whole to twice its original size thout the niello cracking. At a temperature of 00 °C the ingredients fuse and can then be wdered or granulated. Traditionally, the pre-red material was kept until required in goose ills. When used it was placed in the design to be lloed, heated until it melted and afterwards the cess was polished away. It runs best on silver and ntrasts better with this metal than with any other.

pple or Nursing Bottle

veral examples of these are known, one made by orge Tiemann of New York, *c.* 1840, is the pro-rty of the New-York Historical Society (Tiemann s a cutler and surgical-instrument maker). her examples are in the collections at Yale iversity and the Museum of Fine Arts, Boston.

pple Shield

pierced, conical shield to aid infant feeding and vent breast milk from soiling clothes.

rwich Assay Office

ough established with others in 1423, it appears, m a petition of 1565, that the system, if ever re was one, had fallen into disuse. The petition ggests the use of the 'Castell and the Lyon', ing the Arms of Norwich, as a town mark and s to be struck along with that of the maker. It ms that a date-letter system was also brought o being at the same time, probably because of e imminent need to cope with large orders for mmunion plate commencing in that year. This stem was, however, short-lived and for a great rt of the 17th century, seeded rose ms to have been allied to the Arms of Norwich, th acting as town marks. The quality of work m Norwich in the late 16th century was ex-mely high and subjected to much Dutch in-ence (the town mark of Dordrecht is also a wned, seeded rose). In 1688 yet another effort organise the office was made but again this ulted in failure in 1697, when all provincial ices were closed and, though an assayer was pointed in 1702, it appears that the Norwich say Office never reopened. One piece of plate e communion paten at Kirkstead Church, Norfolk) attributed to this last assay master, Robert rtsonge.
liography
C.J. Jackson, *English Goldsmiths and Their arks*. 2nd Edition, 1921, reprinted 1949.
dith Banister, *Old English Silver* (p. 219). ans Brothers, 1965.

rwich Silver

e high-water mark of Norwich plate appears to ve been the last half of the 16th century when an ormous quantity of Norfolk Church plate was

'new-made' in 1565, 1566 and 1567 (the date-letter system commencing in the first of those years). One of the greatest silversmiths was Peter Peterson (probably a Hollander). Current opinion is that he used as his mark a sun in splendour (Colour Plate **36**). William Cobbold, an equally capable silversmith, seems to have used an orb and cross as his mark; Thomas Buttell used a flat fish (a 'butt'). Most of the surviving pieces bearing the marks of these three are of remarkable quality. The Reade Salt made by Cobbold in 1568 (Colour Plate **36**) and the Blennerhasset Cups (1561) preserved amongst the Norwich Corporation Plate, are just such productions. During the 17th century the craft declined steadily and the Norwich silver-smiths tended towards comparative simplicity. Spoons, tankards and tumbler cups are the most usual secular survivors, often made by a long line of silversmiths, named Haslewood. Two peculiar adaptations, one at All Saints, Crostwight, Norfolk, are the jugs (tankards) made by Peterson, *c.* 1590, formed as silver-mounted 'stoneware' (of which there are several Norwich examples), but having the 'stoneware' fashioned in silver; the second of these has the Arms of Pell or Bell engraved on it. There can be no question, but that these were originally made in their present form.
Bibliography
C.C. Oman, 'Guide to the Regalia and Plate of the City of Norwich'. *Connoisseur*, April and May 1964.
C.C. Oman, 'Art of the Norwich Silversmiths'. *Country Life*, April 28th, 1966.
See also Corporation and Ceremonial Plate.

Nursery Candlestick

On May 31st, 1771, Messrs Wakelin supplied Jacob Houblon with 'a hanging/Nursery/Candle-stick

17 oz. 16 dwt. at 8/9		£7	15	8
Graving a coat [of arms]				5
		£8	0	8.'

Presumably this obvious necessity was a small, much simplified, variation of the chandelier.

Nutcracker

Silver being, on the whole, too soft a metal for such a purpose these are uncommon, and when found are generally of about 1800 in date, though two early unmarked examples, once loaned to the Victoria and Albert Museum are illustrated in *Apollo*, vol. XXIII, p. 265. Plated steel examples on the other hand are far more common.
See also Lemon Squeezer.

Nutmeg-grater

Always an expensive spice, nutmeg justified a special container, combining grater and powder box. Few, if any, of early 17th-century date have survived, while many of various 18th-century forms are extant, including those of semicircular section and those of vase form. They should, however, not be confused with large, tubular, grater boxes of the late 17th century, intended for snuff, a rapee of which was contained in them as a nutmeg is kept in its grater (**385**). Nutmeg-graters had a hinged, occasionally detachable, cover at either end, the grater being immediately beneath one cover.
Bibliography
Eric Delieb, *Bulletin*. Vol. III, nos. 3 and 4.
G.B. Hughes, 'Silver Nutmeg-graters'. *Country Life*, December 30th, 1954.
G.B. Hughes, *Small Antique Silverware*. Batsford, 1957.
Elizabeth B. Miles, *The English Silver Pocket*

Nutmeg Grater. 1966.
Guy O. Smith, 'Silver Nutmeg Graters or Spice Boxes'. *Connoisseur*, vol. XIX, p. 169.
See also Snuff Box; Spice Box.

Ogee

A moulding made up of a concave and a convex curve.
See also Cyma Recta; Cyma Reversa.

Oil and Vinegar Frame

The earliest form of cruet to survive appears to be that providing for two silver-mounted glass bottles only (**386a**). Another of this form has rings to either side of the bottles, into which the detachable stoppers may be fitted when the bottles are in use; the frame also contains a rare small caster (**386b**). An example made by George Garthorne of about 1700 has a fluted handle projecting from beneath one of these rings. But with the coming of the Warwick Cruet, which contained silver casters as well as oil and vinegar bottles, the oil and vinegar frame develops separately, usually the bottles with hinged covers and handles to each of them. How-ever, the old form of bottle with detachable cover does survive (**387**), especially on the Warwick Cruet form. Always the least common of the two varieties, the oil and vinegar frame is seldom found after the middle of the 18th century. Its place is taken by a larger variety known as the 'soy-frame' (**388**), this was intended to hold bottles of sauces or dressings.
Bibliography
J.F. Hayward, *Huguenot Silver in England*. Faber & Faber, 1959.
See also Cruet; Epergne.

Oil Lamp

There are but few of antique form and this reflects the difficulty of obtaining an odourless oil at reasonable cost. Generally, those which are extant are of about 1810–30 in date, usually of finely chased, cast silver. These lamps are, therefore, best thought of as being produced for the 'luxury trade'. Some, though by no means all, were supplied with inkstands, and are known both in white and gilt. A very rare, though not particularly beautiful, example made by Paul Crespin in 1750, stands at $11\frac{1}{2}$ in. (29·2 cm.) high; it is copiously marked and formed as a baluster stem on a broad, circular, trumpet foot, with a lamp of basically antique form at the summit.
See also Argand, Aimé; Inkstand; Lantern; Sconce.

Old English Pattern

A description of a type of table silver, which suc-ceeded the Hanoverian pattern, and whose charac-teristics are largely the down-curved ends of the stems, perhaps derived from the Onslow pattern, and the tendency for the spoons' bowls to be tapered to a point. Irish and Scottish examples emphasise this tendency to an even greater degree, having even the ends of the handles pointed. This pattern was most popular between the years 1775 and 1830.

Orange Strainer

Although the 1549 Inventory of the Royal Jewel House states: 'Item on Strayner of Gold with a roose at the ende poiz iii oz', it does not tally with the 1533 Inventory: 'A Strayner of Golde for orrenges X oz', the former being amongst the list of spoons. A 'Cullender' (colander) is also noted amongst early inventories, presumably as an alter-native description for the larger strainer. Surviving strainers of an earlier date than the reign of Queen

Anne are rare. When found they usually have a circular bowl and short tubular handle to one side (**389a, b** and **c**). From then on, the two-handled variety is frequently found (**390**), often superbly pierced, generally not larger in diameter than the average sugar bowl, except in Ireland where larger examples, which are presumably for use with a punch bowl of silver or porcelain, are not unusual during the mid 18th century. Towards 1800, similar examples became equally fashionable in Scotland. One made by John Nicholson of Cork, *c.* 1760, is no less than 11 in. (28·0 cm.) in width. They are also referred to as 'orange strainers' in the Garrard Ledgers (Victoria and Albert Museum Library) but, as with so many other pieces, their purpose may have changed with the habits of each generation. The large number of strainers dating from the reign of George I, bearing the Sterling or Britannia marks of John Albright, would indicate that he was a specialist maker. In spite of the number of surviving monteiths and punch bowls, strainers of a size to fit them are rare but, when found, often of the highest quality (**392**). A variation, perhaps designed specifically for a punch bowl, is that with a single ring handle to one side of the circular bowl (oval, if the bowl is from Exeter) and with a clip on the opposite rim to fit over the lip of the punch bowl (**391**). Sir Charles Jackson illustrated a 'tea-strainer' with cover, made at Inverness, Scotland, at the end of the 18th century; it seems more likely that it was intended for use with a basin rather than a tea urn, if indeed intended for either.
Bibliography
G.B. Hughes, 'Evolution of the Orange Strainer'. *Country Life*, May 9th, 1968.
Bernard Crewdson, 'Maker of Early Georgian Strainers'. *Country Life*, November 23rd, 1951.
Bernard Crewdson, 'Silver Strainers'. *Connoisseur*, vol. cxxv, 1950.
Francis Townshend, 'Silver for Wine in Ireland', part III. *Country Life*, September 21st, 1967.
See also Lemon Squeezer; Spoon (Strainer or Mote Spoon).

Ovolo

A half-round or curved, convex moulding derived from Classical architecture and much used on Tudor plate together with egg and dart enrichment. See also Egg and Dart, Egg and Tongue.

Ox-eye Cup See Cup, Ox-eye.

Oyster Dish

An alternative and perhaps wistful description of the escallop-shaped dish now generally used for butter, though described as 'preserve dishes' in the Strawberry Hill Sale of May 1842. The Garrard Ledgers, however, confirm this early use: 'John Trevor Esq. 1740. To 5 scallops for Oysters'. The earliest of such surviving dishes appear to be of 1675. American examples are very rare; one in the collection of Phillip Hammerslough is the work of Daniel You of Charleston, who died in 1750. See also Escallop Shell.

Oyster Gauge

A solitary example in silver, made by P. A. & W. Bateman in 1804, engraved with the Arms of Colchester, is amongst the plate of that Corporation (**393**). No oyster offered for sale from the Colchester beds was to be of a smaller size than this official gauge.
Bibliography
E. A. Blaxhill, *Colchester Borough Regalia*. 1950.
See also Corporation and Ceremonial Plate.

Paint Box

Only one, unmarked silver example is known. It measures $3\frac{1}{2} \times 1\frac{1}{2} \times \frac{1}{2}$ in. (8·9 × 3·8 × 1·3 cm.) deep, is engraved with the Arms of Sir N. B. Gresley, who succeeded as 7th Baronet in 1787, and has survived with its twelve sections for colours and a space for brushes. Probably there are others, either unrecognised or converted to other uses. That given to Queen Victoria by her mother in 1837 is not of silver, though it has a silver ruler made by Charles Rawlings in 1827.
Bibliography
E. Delieb, *Silver Boxes*. Herbert Jenkins, 1968.
Sidney C. Hutchison, 'Historic Records of Artists'. *Apollo*, January 1969.

Paktong (Tutenag)

This alloy of copper, nickel and zinc resembles silver in appearance, though it is somewhat greasy to the touch. It was imported into Europe from China during the second half of the 18th century and used in the manufacture of domestic utensils, such as candlesticks, grates, fenders and gun-barrels. The Wakelin account for William Bromfield reads: '1775 to mending a Teutonick Candk. 1776 to mending 2 Teutonage Candk.'.
Bibliography
A. Bonnin, *Tutenag and Paktong*. 1924.

Palette

At least one, presented to the artist, George Chinnery, survives. It was made by Robert Wyke of Dublin in 1801.

Pap Boat

A child's plain, shallow, feeding bowl, drawn out at one side to a lip and resembling the body of a cream boat, to which many have been converted. This form appears *c.* 1710 and fades out about one hundred and twenty years later. Originally quite plain, the later examples have reeded or moulded rims. A gold example in a private collection is the work of Phipps & Robinson, 1787, and with it is associated a gold spoon, perhaps by the same, but with the maker's mark overstruck by another, R.C. Wakelin supplied 'a thr. pap boat and a pap spoon' to James Martin in 1774. Almost invariably, they are marked on the rim opposite the lip, unless of provincial manufacture. A cream boat so marked is therefore suspect. A second gold example is of the later type having a shell and gadrooned border, and made in 1816 by John Lambe. Pap consists of bread or flour, sugar and water or milk, mixed to a tacky consistency. However, a partially covered American example made by W.H. Ewan of Charleston, *c.* 1830 (Los Angeles County Museum), implies that whatever it was intended to hold must pour. In Canada there are grounds for supposing them to have been used by a number of Catholic priests in Quebec to hold the water used in the baptismal service.
See also Spout Cup.

Parcel-gilt

Literally meaning 'gilt in part only'. (Though this description should, however, not be used of a piece wholly gilt but for the underside of its foot.) Parcel-gilding is often used to emphasise and contrast the decoration and its background.

Pastille Burner

The true pastille burner, in that the pastille, once set alight, is self-consuming and requires no continuous outside source of heat in order to give forth a pleasant scent, appears to be unknown, or at least unrecognised, in silver. One possible claimant

may be a small warming pan-like object, made [by] Robert Garrard in 1846, which appears to be a co[py] of an Oriental original and was intended to be c[ar]ried through the rooms by a servant. Anoth[er] claimant, though according to the above prov[enance] not a true pastille burner, may be that made [by] Fogelberg & Gilbert in 1786; it is urn-shaped, w[ith] a heater below and the perfume is emitted throu[gh] the stem of a flower which forms the cover (**39[]**). Matthew Boulton admired a pastille burner, po[s]sibly French, when visiting Mrs Montagu, and [] borrowed one hoping to improve upon it. It is the[re]fore a matter of great interest that an example of [this] shape on three feet and standing some 11 in. hi[gh] which was made by Boulton and Fothergill [of] Birmingham in 1779 should have re-appear[ed] recently.
See also Censer; Hookah; Perfume Burner.

Pastry Cutter

Extremely rare, these usually take the form o[f a] blade with crimped edge joined by a stem t[o a] wheel cutter. One of 1683 is known but there [are] others of a later date (**60d**).

Patch Box

Small, circular or oval boxes, also suitable for sn[uff] and about $2\frac{1}{2}$ in. (6·4 cm.) in width, were made [in] considerable quantities during the middle of [the] 18th century. Many examples in pinchbeck a[nd] Sheffield plate are found, the covers often be[ing] stamped out and afterwards chased up w[ith] Rococo subjects, trophies of arms or port[rait] medallions of the heroes (military or otherwise) [of] the day. Frederick the Great and William Pitt, Ear[l of] Chatham, being only two such favourites. [An] American gold example made by Myer Myers, [c.] 1765, has a scene from the Book of Samuel (B[ook] I, chp. 16, vv. 17–22) depicted on the lid. The t[rue] patch box enclosed a mirror within the lid, thou[gh] many boxes without, did duty as such. Proba[bly] the finest extant is that, once the property of Que[en] Mary II, made of gold with enamel and diamo[nd] enrichments, it is $2\frac{1}{8}$ in. (5·4 cm.) wide and da[tes] from about 1690.
Bibliography
Peter J. Bohan, *American Gold*. Yale University [] Gallery, 1963.
See also Snuff Box.

Paten

Only two basic designs for patens were used dur[ing] the Middle Ages. In one, the central field is sunk [in] a single, circular or multifoil depression. In [the] second, there are two depressions; the f[irst] circular, the second multifoil. The form unfor[-]tunately affords no certain clue to date; sty[le,] subject of decoration and hall-marks, if any, are [the] only guide. The Anglican form, generally speaki[ng,] is similar, but with the addition of a central fo[ot.] Elizabethan examples (that of St Michael [le] Belfrey, 1559) are usually reversible, thus th[ey] form a paten, having a spool-shaped foot, and [a] cover to the communion cup. By 1640 the surfa[ce] of the bowl is almost flat and after the Restorat[ion] completely so. This is not to say that commun[ion] cups do not exist with non-reversible covers, [or] with finials which make it impossible to do so, [or] that large patens, made as separate objects, are [by] any means unknown. The paten of St Olave's, H[art] Street, London (1617) is hexagonal, the foot a[nd] stem being identical to those found on a wine c[up] of the day. All Hallows, Barking, Essex, has a pla[in] square example on four stud feet. By 1640 some [of] the larger patens were supplied with their o[wn] covers (Kenilworth, 1638; Fulham Palace, 165[]

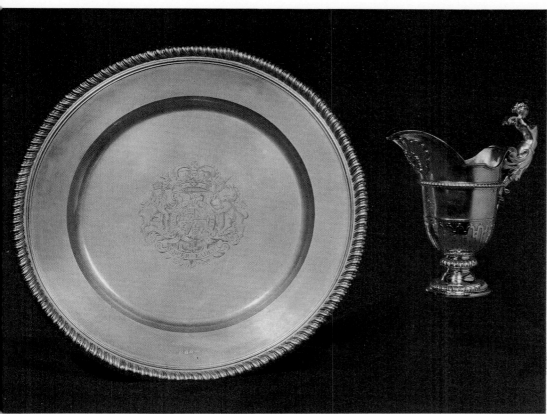

Plate 28

Plate 28 The Wentworth Ewer and Basin
Of silver-gilt with the maker's mark of Philip Rollos.
Hall-mark for 1705.
The basin is $24\frac{1}{4}$ in. (61·6 cm.) in diameter; the ewer is $13\frac{1}{2}$ in. (34·3 cm.) high.
Victoria and Albert Museum, London.

Plate 29 Ewer and Basin
Of gold with the maker's mark of Pierre Platel.
Hall-mark for 1701.
The ewer is 7 in. (17·8 cm.) high; the dish $10\frac{3}{4}$ in. (27·3 cm.) in length.
Chatsworth House, Derbyshire.

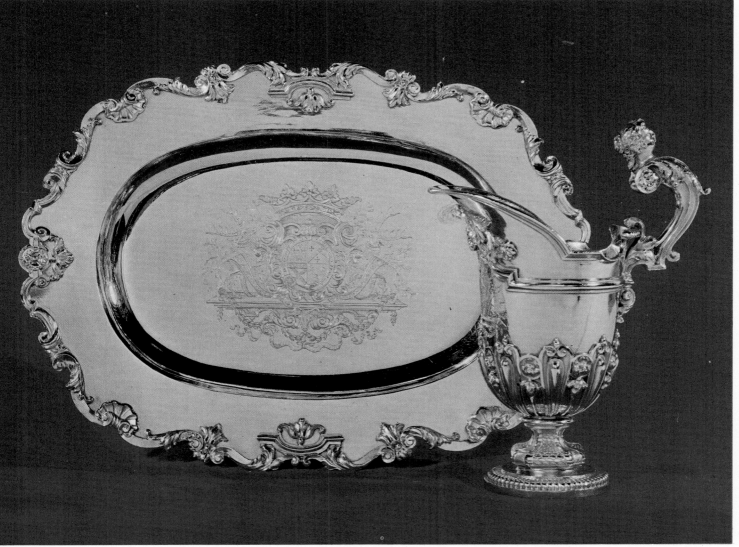

Plate 29

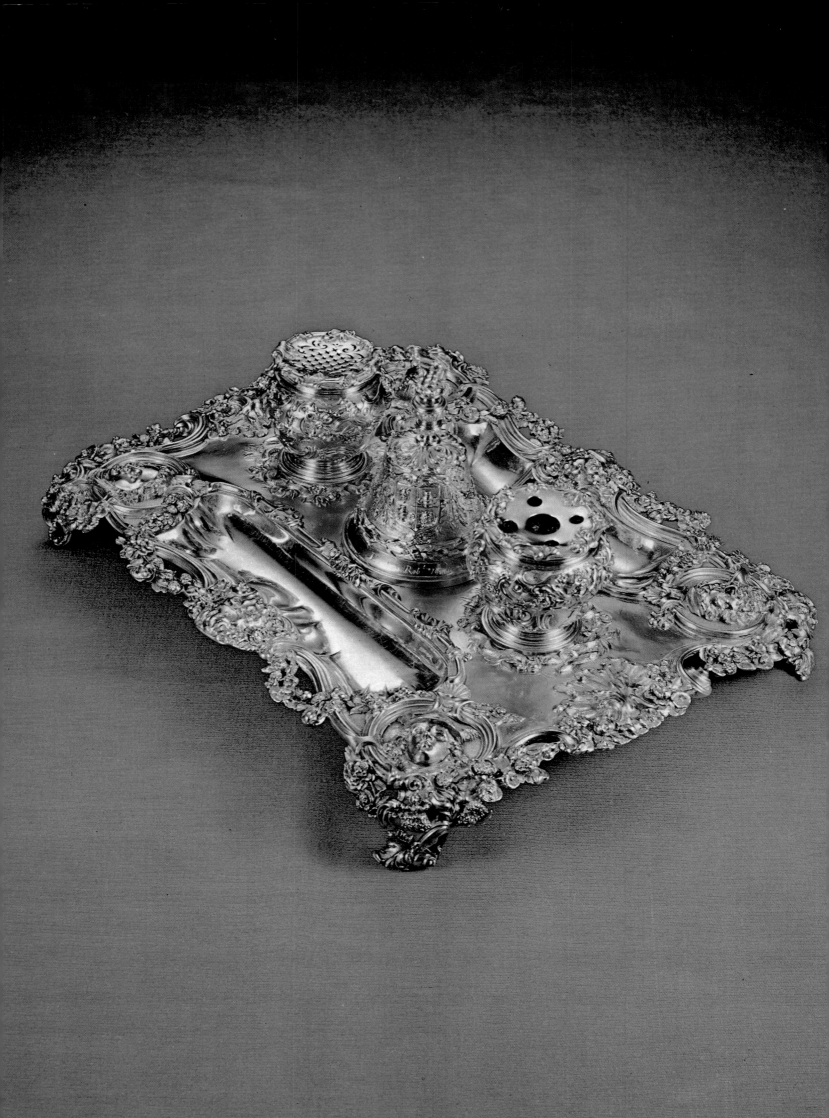

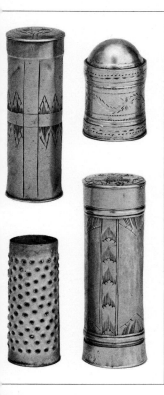

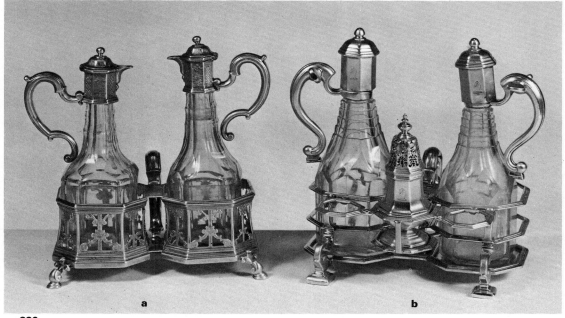

386

387

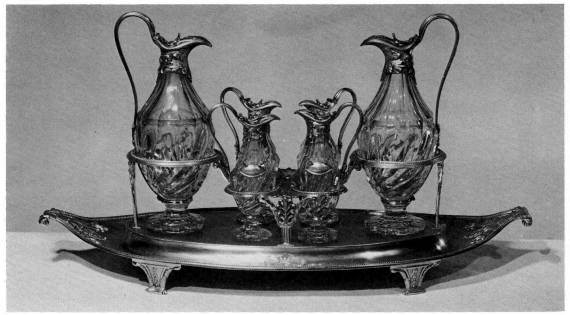

388

389 Strainers
a. Maker's mark, I C in a heart.
c. 1690.
b. Maker's mark, R B.
Hall-mark for 1686 or 1688.
c. Maker's mark illegible.
Hall-mark for 1686.
Diam. 2¾ in. (7·1 cm.).
390 Orange Strainer
Hall-mark for 1696, Dublin.
391 Orange Strainer
Maker's mark of Pentecost Symonds.
Hall-mark for 1739, Exeter.
Width 4½ in. (11·5 cm.).
A form peculiar to the West Country.
392 Strainer
One of a pair.
Maker's mark of William Plummer.
Hall-mark for 1767, London.
Width 11¼ in. (28·6 cm.).

a b c

389

390

391

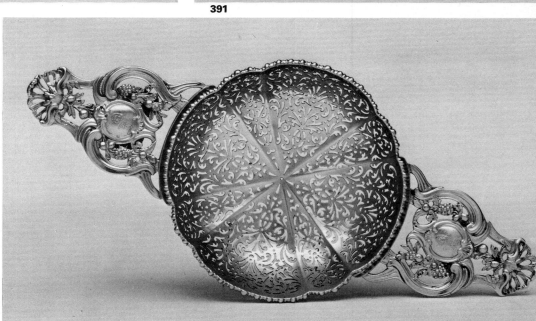

392

t these are usually of tazza form, the gifts of the
gh Anglican Church patrons, for example the
uchess Dudley at Kenilworth, or associated with
rticularly splendid arrays of altar plate. These
ger patens became necessary when the use of
usehold bread replaced the small wafer at the
ommunion service. Many churches possess a
gle dinner plate, used either as a paten or an
ns dish, and in the 18th century the standard
lver on central foot is distinguishable as a paten
lely by the inscription it may bear. Secular plate
s often been converted to ecclesiastical use at a
er date. Ripon Minster has an extremely unusual
ten cover, made by John Plummer of York, 1674,
canopy form on three claw and ball feet, it is
mispherical, with shaped sides and with an orb
d cross finial. Roman Catholic Recusant patens
e of slightly hollowed disc form, unlike any
edieval original and probably inspired by con-
mporary Continental examples.

bliography

C. Oman, *English Church Plate*. Oxford Uni-
rsity Press, 1957.

e also Chalice; Communion Cup; Tazza.

tera

rcular, fluted, Classical ornament, the design of
hich is based on the saucer used in sacrificial
ations. An ornament much used on English plate
tween the years 1770 and 1830.

tina

xide produced naturally or artificially on the
rface of metal.

tty-pan

small, circular, fluted dish with escalloped, up-
rved rim of 'Strawberry dish' type, approxi-
ately 5½ in. (14·0 cm.) in diameter. Existing
amples are listed as such by Sarah, Duchess of
arlborough, and date from 1719 to 1720.

bliography

G. Grimwade, 'Silver at Althorp', part III. *Con-
isseur*, December 1963.

x (Pax-brede)

small tablet of wood, ivory, gilt-metal or silver,
ually bearing a representation of the Crucifixion,
rely the Virgin and Child, which, having been
ssed by a priest, was also kissed by members of
e laity. A parcel-gilt example, probably English,
nmarked and of early 16th-century date, is pre-
rved at New College, Oxford. Another, probably
ade in Galway, Ireland, c. 1635, may also have
en intended for use as a reliquary (**251**). Sir
harles Jackson illustrated a parcel-gilt triptych
 central scene with two hinged leaves closing
er it), which is probably English, of 14th-
ntury date and perhaps it was originally made for
me private chapel (Victoria and Albert Museum).
ree diptyches of about the same date are in the
me Museum. A Canadian example made by Paul
mbert, c. 1790, is in the Henry Birks Collection,
ontreal.

bliography

r C.J. Jackson, *An Illustrated History of English
ate*. Vols. I and II, pp. 160 and 384. 1911.

C. Oman, *English Church Plate*. Oxford Uni-
rsity Press, 1957.

E. Langdon, *Canadian Silversmiths, 1700–1900*.
oronto, 1966.

e also Recusant Plate.

eg-tankard See Tankard.

en See Fountain Pen.

Pen Tray

Not to be confused with the much smaller, oval
spoon tray, for the pen tray came later and first
appears during the 1770s. Usually of navette shape
and having a plain, undecorated surface. The con-
temporary snuffer tray (stand) is only occasionally
distinguishable from the pen tray by the decoration
applied at either end of its flat surface, the purpose
of which was to conceal any possible scratches
made by the stud feet of the snuffers, this was par-
ticularly true during the 19th century. However, the
late examples of both these pieces return to the
hour-glass form of the early snuffer stand.

See also Navette; Snuffer Scissors; Spoon Tray.

Penner

Some 5 in. (12·7 cm.) to 6 in. (15·3 cm.) in length,
of tubular form, enlarged at one end and thus
resembling a mace. Early survivals are all of 17th-
century date, having a compartment for ink, an-
other for pens (short quills) and the finial usually
forming a seal face. They are in fact the forerunner
of the travelling inkwell. It would appear that a Mr
Coventry gave one of these to Samuel Pepys in
August 1663, he used it to make a note of the
sermon in church later that month. Penners are
seldom fully marked. One of the earliest examples
also contains a pen-knife, it appears to date from
c. 1625. King Charles I and Sir Edward Walker, his
Secretary of War, are depicted in a portrait using a
penner, with a drum as a table (unknown artist,
National Portrait Gallery, London). Of two in the
Farrer Collection (Ashmolean Museum, Oxford)
one bears the Arms of Sir William Fleetwood
(1603–74), Controller of Woodstock Park (now
Blenheim Park). This has a maker's mark only, I. H.

See also Inkstand; Seal; Seal Box.

Pepper Pot

One, of the two small casters from a set of three,
was obviously intended for pepper as it was
pierced and the other was blind. An early name for
these small casters appears in an Oxford College
plate list—'pepper cannister'. The so-called 'bun-
peppers' are only a variation of the pepper pot,
usually dating from the second quarter of the 18th
century; they have a flattened, domed cover which
cast pepper rather more easily than those with the
deeper dome. The cover is usually retained by
friction. A set of three (one larger than the others)
made by Starling Wilford in 1731 are extant.
Kitchen peppers, having a handle to one side, are
usually rather earlier in date. The muffineer is a
smaller version of the normal caster of the 1760s
and later. A very rare form are the set of twelve
engraved with the initials CW (Cayenne–White)
or B (Black), each of tapering, staved, half-
cylinder form made by Paul Storr in 1832 now in
the Henry Ford Museum, Dearborn, Michigan. One
gold pepper pot is known (**395**). The 19th century
saw many attempts to vary the form (**394**).

See also Caster; Kitchen Pepper or Spice Dredger;
Scent Flask.

Perfume Burner

The Oriental custom of perfuming a room prior to
use may be related to both necessity and pleasure.
This was also true in medieval times and later.
Probably the earliest known surviving example
is that in the Los Angeles County Museum (Colour
Plate **26**). This has a straight handle to one
side and the pierced, cylindrical body stands on
three hoof feet. Several large incense burners sur-
vive dating from the reign of Charles II. One of 1677
is in the collection of the Duke of Rutland; an-
other bears the Arms of Sir John Bankes of

Aylesford, Kent, and has a maker's mark only (**397**);
a third is in the Hermitage, Leningrad; and there is
yet another very similar in a private collection.
That of c. 1690 by Philip Rollos, in the collection
of the Duke of Devonshire, is formed more like an
andiron than the double gourd type it supersedes.
Perhaps the finest is the silver-gilt perfuming pot
and stand of 1663, 16 in. (40·7 cm.) high, the pot
with a pierced cover, given to the Tzar of Russia
by the Earl of Carlisle in 1664 and now in the
Kremlin, Moscow. By the third quarter of the 17th
century they were known as 'cassolets', whereas
in Henry VIII's 1520 Inventory the phrase used is
'fumytorie for fumigations'. Certain toilet services,
usually Continental in origin, also include small
fruit-like objects with hollow stems, which seem
to have been filled with a sweet-smelling sub-
stance whose aroma could be driven off by heat.
Celia Fiennes wrote in her diary: 'There is very fine
china and silver things and irons and jarrs and
perfume potts of silver'. If lacking their stands and
heaters they almost defy identification. A very few,
small, late 18th-century examples survive; urn-
shaped with a heater below, the perfume is
emitted through the stem of a flower springing from
the cover. Examples are known by Fogelberg &
Gilbert made in 1784 and 1786 (**396**). 'Sweet
Gale' or bog myrtle was the usual content, as
opposed to incense, which has been used by the
Roman Catholic Church throughout its history and
such ecclesiastical burners are known as 'censers'.
A small object, similar to a warming pan, with
handle to one side and a pierced lid, made by
Robert Garrard in 1846, some 4 in. (10·2 cm.) in
diameter, the whole minutely chased in the
Oriental manner, should not be forgotten. Ob-
viously made to special order, it was probably
intended to be carried through rooms immediately
after use in order to freshen the air, as is the custom
in India today.

Bibliography

Robert Rowe, *Adam Silver*. Faber & Faber, 1965.

Matthew Boulton Papers. Birmingham Assay
Office.

C.C. Oman, *The English Silver in the Kremlin*. 1961.

See also Censer; Chafing Dish; Hookah; Incense
Boat; Jewish Ritual Silver; Pastille Burner; Pipe
Lighter.

Pewter

An alloy of tin and lead used in varying proportions;
occasionally made with other metal constituents.

Pickle

A solution of acid or acids in water employed to
remove the film of oxide or sulphide from the
surface of metal.

Pickle Stand

In the Royal Collection at Windsor there are two
silver-gilt pairs of so-called 'pickle stands'; they
are of shell form and stand on a dragon base. Their
purpose is open to debate as to whether they are
more likely to have been intended for sugar or
sweetmeats rather than pickles.

Pilgrim Bottle

The traditional pilgrim bottle has always been true
to the flattened pear shape and although scent
flasks of this form have come down to us, the
earliest of eight wine bottles known to survive, are
the pair of 1579, of circular, baluster form with
pendent chain handles. These were known as
'flagons' and are today in the Kremlin, Moscow.
Another of the same date was in the German
Imperial Collection. Inventories of the mid 17th

393 Oyster Gauge
Maker's mark of P.A. & W. Bateman.
Hall-mark for 1804.
Length 2¼ in. (5·7 cm.).
Colchester Corporation.

394 Pepper or Pounce Pot
Silver-gilt.
Maker's mark, TK.
Hall-mark for 1816.
Victoria and Albert Museum.

395 Pepper Pot
Gold.
Maker's mark of Andrew Fogelberg.
Hall-mark for 1777.
Height 2⅞ in. (7·3 cm.).

396 Pastille Burner
Maker's mark of Fogelberg &
Gilbert.
Hall-mark for 1786.

397 Perfume Burner
Maker's mark, TL with an escallop
below.
c. 1680.
Height 17¾ in. (45·1 cm.).
Applied with the Arms of Sir John
Bankes of Aylesford, Kent.

393

394

395

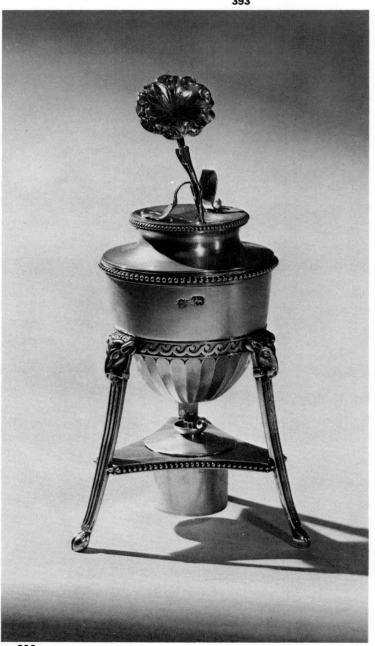

396

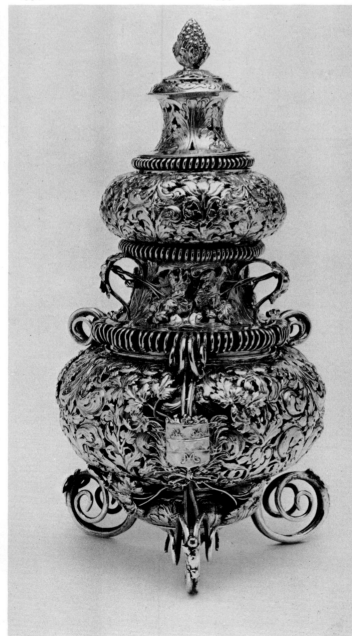

397

Plate (ii)

entury mention 'flaggons with chains', Charles I aving at least twenty-two amongst the Royal ate. The next appearance of the 'accepted' lgrim-bottle form comes after the Restoration, ometimes in leather and mounted in silver. The rliest is dated 1663, also in the Kremlin, while a air of 1683 remain at Belvoir. A pair at Eton Col- ge were made by Pierre Harache in 1699 and ave curiously fashioned chains, and the Victoria d Albert Museum has a single example made by erre Platel, c. 1710. In the Untermyer Collection an unmarked pair, engraved with acanthus liage in the English manner, together with an glish coat of arms. These must date from about 390. Those belonging to Lord Spencer are the ork of John Goode, 1701, but there is reason to ppose that they are of Huguenot origin (**398**). A agnificent pair made by Anthony Nelme in 1715, long to the Duke of Devonshire and are amongst e latest, barring of course 19th-century repro- uctions, which include the splendid example of arcel-gilt, made by C.I. & G. Fox for Lambert & awlings, to be shown at the Great Exhibition of 351. This, nearly 30 in. (76·2 cm.) high, of lobed ottle form is now in the Victoria and Albert useum. Besides these, only three other marked airs are at present recorded. In 1772 the Duke of ncaster sent a pair to Wakelin in part exchange r a dinner service just purchased and was edited with £78. Their size, the Devonshire ottles of 1715 being 33½ in. (85·1 cm.) high, ust always have meant that primarily they were nsidered as sideboard plate and only for show. deed the Prince Regent instructed Paul Storr to nvert what is perhaps the largest of all pilgrim ttles into a wine fountain. The feet of the Leigh up of 1499 (Colour Plate **25**) are formed as lgrim bottles, though threaded through the oulder loops with cords rather than chains.

bliography
A. Jones, 'The Plate of German Emperor', part I. onnoisseur, vol. XIII.
A. Jones, *The Gold and Silver of Windsor Castle.* rden Press, 1911.
C. Oman, *The English Silver in the Kremlin.* 1961.
ee also Bottle Stand; Flagon or Livery Pot; Flask.

inchbeck, Christopher (d. 1732)

watchmaker, Pinchbeck has become famous as e inventor of an alloy resembling gold in appear- ce; it contains about five parts of copper and vo of zinc. Pinchbeck was used for watch cases, uff boxes, étuis and cheap jewellery. Its first corded use as a descriptive noun was in 1734. is eldest son (Christopher, Junior, 1710–83) as clockmaker to King George III. At least one uff box, signed 'Pinchbeck' on the bezel, has rvived.

in-cushion

ne of these often formed part of a toilet service. lver-framed examples are usually oblong, though om 1720 onwards oval ones occasionally appear. e cushion was stuffed with an emery powder or me such abrasive, thus enabling the user to clean ns or needles while using the cushion. Until one undred years ago the steel, of which these pins d needles were made, quickly rusted when xposed to the air. An example of ball form, pen- nt from a chain and belt hook was made by John avid of Philadelphia and is now in the Hammer- ough Collection. A silver-gilt filigree example rmed as a miniature, lady's slipper, though un- arked, is engraved on the heel 'York Plate', d has an obituary inscription dated 1820.
e also Toilet Service.

Pin-tray See Cheese Dish; Toilet Service.

Pipe Lighter

Very similar in form to a chafing dish — and for many years so called. An example made by Adrian Bancker of New York, c. 1730, has no piercing whatsoever to its shallow bowl though the foot brackets rise above the rim. Its ascription to this purpose must, therefore, remain a matter of opinion. *A Dutch Conversation Piece* painted by J.M.Quirkhard (1749) shows a gentleman lighting his pipe from the charcoal in such a lighter; this particular example has two handles. The same pic- ture also shows a tobacco box of table size, an article so far unidentified in either English or American silver. Another American pipe lighter is that made by Shepherd & Boyd, Albany, c. 1810, now in the collection of Phillip Hammerslough.
See also Chafing Dish; Perfume Burner.

Pipe Stopper

Of baluster, downward-tapering form, often cast, they are similar to table seals. The smallness of the bowl of the 17th- and 18th-century pipe being the governing factor in their manufacture. Examples may be found with one end unscrewing to reveal a scraper of spike form. The more highly decorated stoppers chased with Rococo ornament are usually of Continental origin. They are also found fitted inside tobacco boxes or, on occasion, attached to larger examples by means of a chain, as in the case of the box (1690) belonging to Liverpool Cor- poration. A corkscrew might also incorporate such a stopper. In New England during the 18th century a favourite stopper was one formed as a gold or silver mount to a Guinea deer's foot. One of these may be seen in the Museum of Fine Arts, Boston.

Bibliography
'Pipe Stoppers. Examples from the Collection of Colonel Horace Gray'. *Connoisseur*, vol. XXIV, p. 89.

Pipe, Tobacco

In the 17th and 18th centuries, silver pipes were sometimes made, usually in the form of the con- temporary, clay, Churchwarden pipe. One is men- tioned in 1599, in the records of the Goldsmiths' Company, and as early as 1563 it was laid down that no man might practise the trade of clay tobacco pipe making without first serving a five year apprenticeship. An unmarked, silver specimen of c. 1620, 6½ in. (16·5 cm.) long, is in a private col- lection. In June 1747 George Wickes supplied 'a sucking pipe' weighing 1 ounce and 11 penny- weights at a cost of 4s 1d, but this was probably for liquid. At Colonial Williamsburg, Virginia, there is an unmarked silver pipe with a fluted bowl and in the same collection there is a mould for clay pipes, made by Cox of London, similar to the silver pipe (**399**). A silver pipe made by Joseph Wil- liams of Birmingham, in 1816, also survives. An- other, the official pipe of the 'Smoking Society' founded in 1790, now in the collection of the Birmingham Assay Office, is the work of Joseph Taylor (1811). On July 8th, 1814, to mark the occasion of the second Treaty of Greenville between the United States Government and the Indians of the Wyandotte, Delaware and Shawnee tribes, General Harrison presented the Indians with large silver pipes. That presented to the Dela- ware tribe is now in the Smithsonian Institution, Washington, It has a covered, urn-shaped bowl and an S-shaped stem, 21 in. (53·4 cm.) long. A pipe, 15 in. (38·1 cm.) long, divisible into four sections was made by Samuel Pemberton of Birmingham in 1806, it is inscribed as having been given as a second prize at 'Games' held on the Channel Island of Guernsey in 1831.

Bibliography
'A Rare James I Silver Pipe — Eclecticus'. *Apollo*, March 1955.
R.T. Pritchett, *Smokiana.*
M.B. Klapthon, 'Presentation Pieces'. *Smithsonian Institution Bulletin*, no. 241.
See also Hookah; Smoking Sets; Tobacco Stand.

Pistrucci, Benedetto (1784–1855)

A medallist and gem-engraver who came to London from Italy in 1815.

Planish

To give smooth face or level surface to a sheet of metal by beating it on an anvil with a broad-faced, polished hammer.

Plaque

Silver plaques, embossed or chased with Scrip- tural or martial subjects, are far more frequently found in Continental silver than in English. During the 17th and early 19th centuries, however, a number of these foreign plaques were mounted as parts of larger pieces, such as basins and dishes, the borders then being hall-marked. In the main no attempt is made to conceal the different origins of the workmanship, but there are exceptions. Em- bossed plaques showing topographical views, hunting or other scenes, were popular during the 19th century as decoration for snuff boxes and vinaigrettes. Small, rectangular (perhaps with one end arched) plaques were also made either for use as a pax or an inset in the ebony cabinets so popular during the 17th century.
See also Pax; Snuff Box.

Plate (i)

From the Spanish *plata*, meaning 'silver', it became a descriptive term to describe wares of both gold and silver. In 1742 a process (involving the plating of copper with silver), at first largely confined to Sheffield, produced a metal which became known as 'Sheffield plate' and by misuse the word 'plate' now implies, incorrectly, that it is the imitation of rather than the pure metal.
See also Sheffield Plate.

Plate (ii)

Sir John Fastolfe left amongst his effects in 1459 'j spice plate, well gilt like a double rose, my maister's helmet in the myddes with rede roses, of my maister's arms', this plate weighed 27 ounces. He also possessed another double gilt 'wrethen', weighing 72 ounces. The description, though not the weight, could refer to a similar plate possessed by the Church of St Mary Magdalene, Bermondsey, which is of 14th-century date, parcel-gilt, chased with swirling lobes and has a central 'print' of a lady arming her knight (**400**). This particular plate could never have been intended for use with a knife, though a sucket fork is a possibility (on loan to the Victoria and Albert Museum, 1966). Until the mid 16th century, it was the custom for food to be eaten either from pieces of bread or slabs of wood, known as 'trenchers', although the great nobles were wont, on occasion, to be served from silver or even from gold. 'Sir, I must . . . desire you to cause to be made for a friend of mine twelve drinking pots of silver, each of 6 ounces weight, and twelve round trenchers of silver, also of 6 ounces the piece; all which I pray you let be well and clean wrought, and of the best fashion. . . . The trenchers must be to lay a wooden trencher in the midst, as ye know the manner is, and about the

398 Pilgrim Bottle
One of a pair.
Maker's mark of John Goode.
Hall-mark for 1701.
Engraved with the Arms of Churchill.
As John Goode was only made a
Freeman in the year 1701 it seems
likely that these bottles were in fact
made by a Huguenot silversmith.

399 Pipe and Pipe Mould
Pipe: unmarked, but probably
English and of 18th-century date.
Overall length 30$\frac{7}{16}$ in. (77·3 cm.).
Pipe mould: cast iron.
c. 1780.
Overall length 21$\frac{1}{4}$ in. (54·0 cm.).
Colonial Williamsburg, Virginia.
Stamped 'COX LONDON' on top
of the mould stem; the initials WP
are cast in mould on the spur.

398

399

200

und edge would be some pretty print of work', us reads a passage from an undated letter of c. 550 (*Tudor Family Portrait*, Barbara Winchester, o. 146–7). Only three sets of Elizabethan plates e known to survive, the best known is a set of velve, in the Fowler Collection, Los Angeles, ngraved by Pieter Maas of Cologne with the abours of Hercules and bearing the London hall-arks for 1567 (**402**). The design for these cosmo-olitan plates is the work of Hans Aldegrever of uremberg. The quality of the engraving on these, d the two other sets, probably accounts for their eservation. One set of six made in 1573 is illus-ated on Plate **401** (Victoria and Albert Museum) d another of twelve plates made in 1569 (the uke of Buccleuch) is engraved with the story of e Prodigal Son. They were all probably spice or essert plates. Survivals even from the first half of e 17th century are rare, largely due to the melting all types of plate during the Civil War. Two, un-arked, silver-gilt plates of c. 1600 are at St John's ollege, Oxford. Part of an Elizabethan, matched nner service of 1581–1601 (including seven ates originally the property of Sir Christopher arris, buried during the Civil War and afterwards covered); half a dozen dishes bearing the Arms Twysden of slightly later date; and one piece of e English Royal Plate (1620) which reappeared ly recently, almost complete the list of plates own prior to 1625. The majority of other remain-g survivals are the twenty-two plates now in the emlin, presumably the remnants of an ambas-dorial gift, dating from between 1639 and 1643 ecause of the ravages of the Civil War on plate is is the rarest of all periods). At least two other ates of this service are known to survive outside ussia. From this period, however, a number of ld dinner plates are extant, having been used as ns basins (**403**). One dated 1625 at Hooton oberts, Yorkshire, bears the Arms of Thomas entworth, the great Earl of Strafford. Two later ts also survive, one of twenty-four (1688) and a t of a dozen of 1691. The Corporation of Oxford ossesses twelve plates (six unmarked) of 1687, hilst from the year 1700 onwards a growing mber of sets are found. The borders of the earlier ates were wide, flat and with plain, or perhaps eded, rims (**404**), but during the 17th century ns grew narrower and by the turn of the century d often acquired a heavily gadrooned border **05**). An extremely rare Canadian plate, 8½ in. 1·6 cm.) in diameter, made by Roland Paradis, 1720, is in the Royal Ontario Museum, Toronto. e coming of the Rococo style into fashion led to e desire for serpentine borders and their adop-n on plates, either moulded or with shellwork. e outline of the rim was waved and the border ew yet narrower and slightly upcurved, so xing the ingenuity of any engraver who wished apply a coat of arms (**406**). By 1760 the drooned border, of a finer type than its pre-cessor, returned to favour and a decade later the ain, circular border with reed and tie or beaded n appears (**407a**). As may be imagined a dinner ate of the 1820s following the dictum of Charles tham was supplied with a border of gadroons, ells *and* foliage (**407b**). The dinner plate is sel-m more than 10 in. (25·4 cm.) in diameter and on erage weighs about 17 to 18 ounces. 17th-ntury examples may be smaller and those few, ry small, surviving examples, some 5 in. (12·7 n.) in diameter, were used, if not designed, to ive drink at table' (a set purchased by Sarah, uchess of Marlborough, survive at Althorp). A rmal dinner service would include six dozen ates, enough for three 'removes' for twenty-four

persons, besides two dozen soup plates.
Bibliography
E.A. Jones, *The Old English Plate of the Emperor of Russia*. 1909.
See also Alms Basin and Altar Dish; Dish; Ewer and Basin; Forgery.

Plate Rack

For warming and also carrying plates to the table, they were made for silver or porcelain. In the cata-logue of the Randolph Hearst Sale in 1938, an example made by David Willaume, 1734, weighing 130 ounces 16 pennyweights, is described as being on four curved legs with hoof feet, fitted with a rack of eight divisions and having a moulded, rising handle at each end.

Plateau, Table

Although surprisingly rare in silver, plated and ormolu examples are found fairly frequently. As the word implies the table plateau is a flat base or stand with a glass surface upon which centre-pieces, candelabra, salts, tureens or casters may be placed. The most common, and latest, are cir-cular, but oblong examples are also found. The Worshipful Company of Goldsmiths has one of 1834 in silver-gilt (**409**). An American example made by I.W. Forbes, c. 1810, is now in the White House Collection and a second by the same maker is in the Metropolitan Museum of Art, New York. Another by Benjamin Halstead is in the Samuel Schwartz Collection. A plateau made by J. Bridge & W. Pitts for one of the English Royal Dukes, c. 1820, is divisible into four sections. A Portuguese service presented to the 1st Duke of Wellington by the Portuguese Government, and which reached England in 1816, contains one of the largest plateaux, which is integral to the setting of the whole service upon the table (Wellington Museum, Apsley House, London). One of the few fully hall-marked silver examples is that with the applied Arms of Starkie, made by Pitts & Preedy, 1798–1802 (**408**), this firm made at least one other in 1803, bearing the Arms of Dupree. Not sur-prisingly, there exists an example made by Paul Storr, 1820, decorated with shells and vine foliage, 36 in. (91·5 cm.) in length. Very similar, but rather smaller, 25 in. (63·5 cm.) in length, is another plateau made by Benjamin Smith in 1828.
See also Epergne.

Plique à Jour

A translucent enamel, having no metal backing, it is strengthened by strips of metal within its thickness. The effect is similar to that of stained-glass windows.

Plummit (Plummet)

A pear-shaped object, with a curved hook at the top, sometimes found with a toilet service. In 1741 a Mrs Fuller bought 'A Sett of Dressing Plate' from George Wickes amongst which was a plummit. Two survive in the toilet service made by David Willaume now at Luton Hoo, Bedfordshire. Once said to have been bell pulls, a more likely explana-tion is that plummits were button hooks for use with gloves, or for tightening stay-laces. There are other examples in the Wynne Toilet Service made by Thomas Heming in the National Museum of Wales, though probably these particular examples serve a dual purpose in that the hook unscrews and the handle may possibly have been used as a scent bottle. 'Dressing weights' were also supplied with toilet services. Their certain identification remains a problem.
See also Toilet Service.

Pomander (Pomme D'Ambre)

This is a small box, usually of silver, often gilt (Oriental examples are larger and frequently of gold filigree), intended for holding a perfume ball, or a sponge soaked in aromatic vinegar. It is also occasionally known as a 'muske' ball. These boxes were divided into as many as eight compartments filled with a variety of perfumes and/or spices and they were carried suspended from the neck, girdle or châtelaine. Shakespeare refers to one as a 'pouncet-box' in *Henry IV* and an inventory of 1542 records: 'ij long girdles of goldsmythes wrke wt pommanders at th end'. They took the form of segmented globes, dice, heads and death's heads. Produced in vast numbers in Germany and the Low Countries undoubted English examples are ex-tremely rare, a possible claimant appeared at Christie's on March 13th, 1968. A gold and black enamel example of c. 1600, on loan to the British Museum, may also be English (**410**). Their use appears to have declined by the second half of the 17th century though their successor, the vinaigrette, does not appear in such quantity until a hundred years later. Staffs and walking sticks, the head enclosing a vinaigrette are relatively uncommon. A portrait of a man by Barthel Bruyn, c. 1500, now in the collection of Baron Thyssen, Lugano, shows a filigree pomander with a short chain connecting it to a finger ring.
Bibliography
G.B. Hughes, 'Pomanders and Vinaigrettes'. *Country Life*, pp.19–44, December 1949.
W. Turner, 'Pomanders'. *Connoisseur*, vol. XXXII, p.151.
See also Pouncet Box; Vinegar Stick.

Porringer

The correct definition of a porringer, as opposed to a caudle cup, will always be debatable. The por-ringer can best be described as being a two-handled cylinder, slightly tapering and inturned at the base, with or without cover, and usually dating from about 1655 to 1720 (**196**), whilst the caudle cup is of baluster form and generally dates from 1650 to 1690. The cover was at first sometimes reversible to form a stand, having a single spool-shaped finial or, more rarely, three outward-turned scrolls at the edge. An uncommon type of decora-tion is the embossed scene of Susannah and the Elders within a cartilaginous, scroll mantling on a caudle cup of 1675 (Victoria and Albert Museum). The Yarborough Gold Porringer and Cover of 1675 is finely embossed and chased with tulips and daffodils and of decafoil, lobed form. The Win-chester Porringer also dates from this year; it was purchased (with a legacy of £40 from Anne, Dowager Countess of Pembroke and Mont-gomery) by George Morley, Bishop of Winchester (Colour Plate **33**). Another example from Hull is dated 1689. The possession of a spout entitles porringers to be called 'spout cups'; a belief at the turn of this century that all spouts were later addi-tions (disproved by examples in earthenware and glass), led to the conversion of many spout cups to porringers or caudle cups. By 1675 the porringer was pre-eminent but by 1710 it loses pride of place to the more familiar two-handled cup in which the foot is considerably more emphasised. In the Channel Islands, however, small porringers, though without covers, continued to be made as christen-ing gifts until at least 1775 (often imported from London and re-marked). An exceptionally early porringer, of perfectly cylindrical form, hall-marked 1653, was exhibited at Seaford House in 1929. In North America, the English so-called 'bleeding bowl' is referred to as a porringer—a much

400 Plate

Parcel-gilt.

c. 1325.

Diam. 10⅜ in. (26·4 cm.).

On loan to the Victoria and Albert Museum.

401 Plate

Gilt, one of a set of six.

Hall-mark for 1573.

Diam. 10 in. (25·4 cm.).

Victoria and Albert Museum.

Engraved with the Biblical scene of the meeting of Rebecca and Isaac.

402 Plates

Parcel-gilt, two of a set of twelve.

Maker's mark, probably of Thomas Bampton.

Hall-mark for 1567.

Diam. 7¾ in. (19·7 cm.).

Engraving is signed PM and attributed to Pieter Maas of Cologne.

403 Plates

a. Maker's mark, RS with a heart below.

Hall-mark for 1630.

Diam. 10 in. (25·4 cm.).

Engraved with the Arms of Thomas Darcy, Earl Rivers.

b. Maker's mark of Edward Mangy of Hull.

c. 1665.

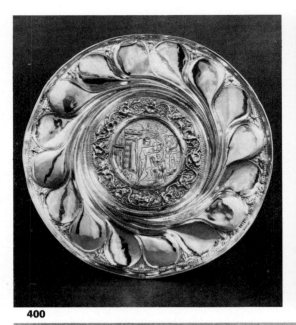

400

401

402

a b

403

202

a

b

404

a

b

405

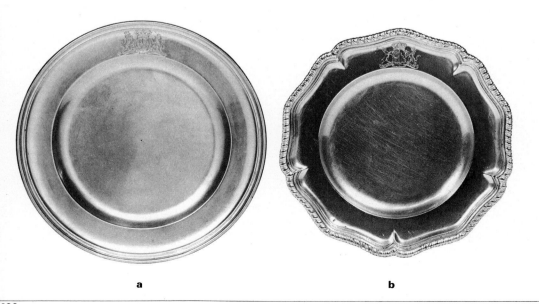

a

b

406

404 Plates
a. Maker's mark, EG.
Hall-mark for 1679.
Diam. 10 in. (25·4 cm.).
b. One of a set of four.
Maker's mark, probably of John
Jackson.
Hall-mark for 1687.
Engraved with the Arms of Turnor,
Yorkshire.

405 Plates
a. Maker's mark of Philip Rollos.
Hall-mark for 1701.
Diam. 9⅝ in. (24·5 cm.).
Engraved with the Royal Arms.
b. Silver-gilt.
Maker's mark, FG, probably of
Francis Garthorne.
Hall-mark for 1690.
Diam. 9½ in. (24·2 cm.).
Engraved with the Royal cypher.

406 Plates
a. One of a set of twelve.
Maker's mark of Nicholas Clausen.
Hall-mark for 1721.
Diam. 9⅝ in. (24·5 cm.).
Probably issued to Colonel
Stanhope as Ambassador to Spain
in 1721.
b. Maker's mark of Paul Crespin.
Hall-mark for 1732.
Diam. 9½ in. (24·2 cm.).
Engraved with the Arms of
Cavendish impaling Boyle.

407 Plates
a. Maker's mark of John Carter.
Hall-mark for 1773.
Engraved with the Arms of Sir
Watkin Williams Wynn.
b. Maker's mark of Edward Farrell.
Hall-mark for 1820.
Diam. 10½ in. (26·7 cm.).
Engraved with the Arms of Sir
Jacob Astley.

408 Table Plateau
Maker's mark of Pitts & Preedy.
Hall-mark for 1798—1802.
Width 53½ in. (135·9 cm.).
Engraved with the Arms of Starkie
of Huntroyde, Lancashire.

409 Table Plateau
(A detail.)
Silver-gilt.
Maker's mark, WB.
Hall-mark for 1834.
Length 6 ft. 9 in. (205·7 cm.).
The Goldsmiths' Company.
Retailed by Rundell, Bridge &
Rundell, it also bears their name.

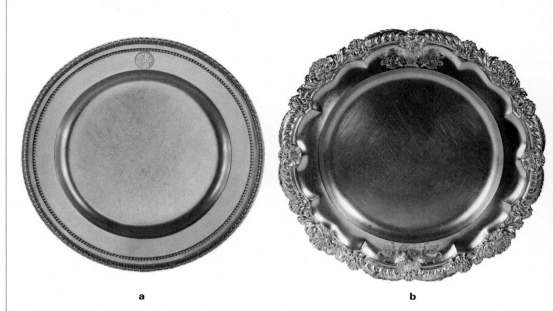

a b

407

408

409

410

more acceptable term. Large and important 17th-century examples were usually supplied with stands of presentoire form (**199**), a custom which continued with cups and covers and large tankards well into the 18th century. Charles II seems to have thought such pieces particularly suitable as presents; several given by him survive (**166**). One of the finest is illustrated by Sir Charles Jackson in *An Illustrated History of English Plate*, it was given by the city of Gloucester to 'The Lord Marquess of Worcester's Lady' on September 2nd, 1673, being to the value of 'twenty or thirty pounds'. Porringers and table silver are the principal survivals of many a provincial maker's output during the late 17th century (**198**).
See also Bleeding Bowl; Casting; Cup, Caudle; Cup, Two-handled.

Posset
A beverage made by curdling milk with ale or vinegar.
See also Posset Pot.

Posset Pot
A pot or cup, probably of caudle cup or porringer form, intended to hold posset.
See also Cup, Caudle; Porringer.

Pot
A confusing nomenclature variously used during the reigns of Elizabeth I and James I seems best unravelled as follows. The livery pot is a tall vessel of tankard form, at first pear-shaped and on trumpet foot, later of tall, cylindrical form. By 1640 this latter form was also known as a 'flagon'. 'Pottel' pots seem to have been the smaller variety of the pear-shaped form (capacity of up to two quarts), which were also used as the tankard of the day.
Bibliography
C.C. Oman, *The English Silver in the Kremlin*. 1961.
A.J. Collins, *Inventory of the Jewels and Plate of Queen Elizabeth I* (pp. 33–6).
See also Bottle; Flagon or Livery Pot.

Potato Pasty-pan
As with so many culinary utensils, examples in silver, even of such a rarity as this, are to be found. One made by John Edwards in 1801 being known (**411**). For details as to the use of the potato pasty-pan and a number of other strange kitchen wares, recourse should be made to early, illustrated, editions of Mrs Beeton's work on household management or other such books written about culinary matters.
See also Saucepan.

Potato Ring See Dish Ring.

Pounce
The powder of gum sandarach, serving to prepare the surface of parchment or paper before or after writing.
See also Inkstand.

Pounce Box
Not to be confused with the pouncet box, or pomander, of the 16th century, this is a container for pounce; generally one of two or three similar boxes were fitted to an inkstand. They were not intended to hold sand, though they could be so used as a last resort. The pounce was sprinkled over newly written letters as a general substitute for blotting paper and also as a fixative for the ink. The casting bottles of the 16th century may also have been intended for this purpose.
See also Casting Bottle; Inkstand.

Pouncet Box
Perhaps a mis-spelling for 'pounced' box, this Shakespearian description is applied to a small pomander, sometimes having the sides 'pounced' or pierced to allow the aroma contained within to escape. A particularly early example is that having six compartments (now in the Victoria and Albert Museum), square in shape with panels incorporating the Tudor Royal Arms on each of its sides. About 1¼ in. (3·2 cm.) square, this pouncet box could equally well have been used as a pocket spice box.

Pounce-work
A form of chased decoration composed of small dots, giving the impression that the surface of the piece has been sprinkled with sand. Popular in the late 16th and 17th centuries, it is sometimes referred to as 'pinking' in the United States. It is loosely used to describe both matted, chased decoration and pricked engraving—both of which resemble grains of sand.

Powder Flask
Generally made of horn, tortoiseshell or mother-of-pearl with silver mounts, examples are known from the mid 17th century. One of the few powder flasks made entirely of silver (they were more usually found in brass or copper) is hall-marked Sheffield, 1837, and was made by James Dixon & Sons, the principal makers of such pieces at that time. A silver-gilt mounted powder horn made by Phipps & Robinson in 1786, engraved with the name 'Scarlett' is just what one would expect from this particular firm who seem to have specialised in unlikely luxuries.
See also Sword Hilt and Gun Furniture.

Provincial Goldsmiths (English)
Many hundreds of makers' marks and a number of town marks are on record of which we do not know the origin. On some occasions when the town mark is heraldic, it is possible to identify it, as in the case of Lewes and King's Lynn. More usually, such marks can only be ascribed to a particular town, and this only after very considerable thought and scholarship has been bestowed on the matter. For example, the Arms of Poole, Dorset, are three escallops, thus one such escallop as a mark on a spoon is not conclusive evidence of Poole being the spoon's place of origin. It must not be thought that such ascriptions are mere guesswork, but that they are in fact learned conclusions and worthy of consideration. The late Sir Charles Jackson and Commander G.E.P. How put their respective researches on record and these works are of immense value, even though recent discoveries may, in a few cases, give cause for reassessment. Reassessment such as this—the fleur-de-lys, once ascribed to the city of Lincoln, was also once accredited to Chester. This is now considered to be incorrect and to ascribe it to the Eastern Counties of England is felt to be a safer solution.

The mark (a) has variously been ascribed to both Cork and Chester and is now also known to have been the mark of Liverpool. The mark (b) is, however, a Cork mark, occasionally used for Plymouth (see below), it has also been used extensively in the United States and Canada, both in the past and present day. Leeds has a golden fleece as the town's arms and this is known upon a number of tumbler cups, spoons and a splendid

chocolate pot of baluster form of *c.* 1690. T[he] maker's mark RW is probably that of one of [the] Williamsons, who like Arthur Mangy (hanged [for] forging coin in 1694), also worked in York as w[ell] as Leeds. Silver is known from Plymouth, who[se] arms, a saltire between four castles, are known o[n a] number of pieces. Rowe, who made the Eddysto[ne] Salt, spelled his name in full and also used a pun[ch] PLM° and PLY°. A tankard from Plymouth of abo[ut] 1700 also bears the mark (c) which stands [for] 'New Sterling' or 'New Standard'. All these Pl[y-] mouth pieces seem to be of late 17th-century da[te].

From the turn of the century Plymouth make[rs] seem to have sent their wares to Exeter, but t[he] existence of a number of mid 18th-century piec[es] made by Plymouth makers, having Exeter da[te] letters in punches of different outline to the no[rm] may indicate some irregularity in the tow[n] marking system. Taunton used a rebus of a 'T' a[nd] a 'tun' (barrel), and most of the town's produ[ce] are spoons and beakers of about 1660–90 (**198**[?]). Gateshead may have used a goat's head. Durin[g] the early 18th century, R. Hutchinson of Colches[ter] made a number of good serviceable pieces of pla[te] such as a coffee pot, and marked them with t[he] word 'Colchester' written in a complete circle.

A number of marks can without doubt [be] ascribed to the Channel Islands (**211**), but Linc[oln] (even though one of the seven assaying tow[ns] appointed by the Act of 1423), Shrewsb[ury] Rochester, Leicester, Carlisle, Sherborne, Durha[m] Poole, Salisbury and Coventry are all amongst tho[se] to which ascriptions must remain arbitrary. In Do[r-] chester, Lawrence Stratford was a prolific mak[er] but no particular town mark seems to have tak[en] his fancy (**142b**). This sounds a vague form [of] phraseology, and purposely so, in that a single m[an] working, very often on special commissions [and] (unless spoons), would see no reason to pay aw[ay] part of his earnings for the pleasure of a gre[at] metropolitan company. Local evidence, that is t[he] number of pieces made by the same maker, entri[es] in parish books 'paid Mr . . . the goldsmith for [a] flagon' and the survival of that same flagon, a[re] slow but sure ways of tracing makers of 1570 o[n-] wards. Prior to this date, the survival of paroch[ial] documentary evidence is uncommon.

Certain ancient cities, such as Bristol an[d] Coventry, have quite unaccountably almost [no] known products of earlier than 18th-century da[te] and this is hardly credible. It seems likely that sor[me] large groups of hitherto unascribed, or wrong[ly] ascribed, marks must belong to these cities. T[he] production of Exeter can hardly have sufficed f[or] Bristol yet it is not until the 18th century that, wi[th] one exception (a spoon), any pieces of Bris[tol] silver appear; they can then be numbered on t[he] fingers of both hands. These include two jugs an[d] a tankard converted to a jug (the latter in the colle[c-] tion of the New-York Historical Society).

Sir Charles Jackson lists a number of marks [as] being from Salisbury, on the grounds that a sm[all] group of spoons, from which the marks are take[n] were discovered nearby. This is completely fal[se] evidence, at least three of these spoons are no[w] known to have come from Truro, Barnstaple a[nd] elsewhere. It is one of comparatively few errors [in] a work of prime importance.

Finally, it should be noted that a large numb[er] of American and Canadian makers used marks [of] English and Scottish form, though seldom did th[ey] imitate the actual hall-marks with any degree [of]

curacy—unlike certain work from China. An unmarked wine cup, with shallow, hemispherical bowl, dated *c*. 1600, 6⅛ in. (15·6 cm.) high, and the property of Sir Ambrose Elton is engraved 'From endep I was brought * out of a leden mine * brstoll I was wrought * and now am silver fine * ' *pollo*, vol. XXXIX, p.50).

English Provincial Town Marks

Barnstaple *c*. 1370 – *c*. 1730

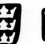 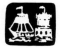

Bristol *c*. 1730 – *c*. 1800

 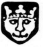

Hull *c*. 1570 – *c*. 1710

King's Lynn *c*. 1600 – *c*. 1700

Leeds *c*. 1650 – *c*. 1700

Eastern Counties *c*. 1420 – *c*. 1710

Plymouth *c*. 1600 – *c*. 1700

Taunton *c*. 1640 – *c*. 1700

Bibliography

J. Prattent, 'Mark of the Plymouth Goldsmiths'. *Country Life*, October 20th, 1960.

Sir C.J. Jackson, *English Goldsmiths and Their Marks*. 2nd Edition 1921, reprinted 1949.

Edward Wenham, 'English Provincial Silver. Its relation to American Colonial'. *Connoisseur*, vol. CVI, p.198.

See also Assay; Barnstaple; Hull, Kingston upon.

Provincial Goldsmiths (Irish)

From the late 17th century onwards, large quantities of silver were produced at Cork and, to a lesser extent, at Limerick and certain other smaller Irish towns. The quality of early Cork silver is particularly striking, especially that which dates from 1700, for example those pieces made by Goble Bekengle (National Museum of Ireland) and others in the Jackson Collection (on loan to the

National Museum of Wales). In the mid 18th century there is some evidence of direct French inspiration on Cork silver, not merely through emigrant Huguenots. There are also a number of designs peculiar to each of these silversmithing centres. None had its own assay office, and only a small part of their silver was sent to Dublin for hall-marking, the remainder usually bears a maker's mark and perhaps 'sterling'. Of all provincial Irish centres only New Geneva was, besides Dublin, appointed an assay office (1784); little but watch cases seem to have been sent to that office for marking and these by the local Swiss émigrés. At Waterford (New Geneva), Bandon, Drogheda, Newry, Kinsale, Kilkenny and Youghal, there are records indicating the existence of goldsmiths, few of whom are as yet identified with some certainty. Galway, Belfast (perhaps using a hand as its town mark) and Londonderry must also have had silversmiths earlier than the date 1784. It is also noticeable, that bright-cut table silver from Limerick, may often be differentiated from that of Cork, by the fact that the decoration at the head of the stem frequently includes a somewhat stylised group of three feathers or a fleur-de-lys.

The Parliamentary Act of 1784 ordered that all provincial goldsmiths should register their marks with Dublin, and though this gives us considerable lists of working silversmiths, there is still a great deal of research to be done before the subject of Irish provincial makers may be said to be exhausted. By 1825, all Irish-made silver bore only Dublin assay marks.

Irish Provincial Town Marks

Belfast ? 18th century – early 19th century

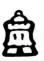 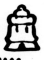

Cork *c*. 1660 – *c*. 1825

Galway *c*. 1640 – *c*. 1750

Kilkenny *c*. 1650 – *c*. 1700

 STERLING

Limerick *c*. 1700 – *c*. 1800

Youghal *c*. 1650 – *c*. 1720

Other provincial centres were Bandon, Drogheda, Kinsale, Londonderry, New Geneva, Newry and Waterford.

Bibliography

Sir C.J. Jackson, *English Goldsmiths and Their Marks*. 2nd Edition 1921, reprinted 1949.

John Hunt, 'Re-dating some important Irish Silver'. *Connoisseur*, March 1961.

J.J. Buckley, 'Some Irish Altar Plate'. *Royal Society of Antiquarians of Ireland*, 1943.

Judith Banister, *Old English Silver*. Evans Brothers, 1965.

W.J. Cripps, *Old English plate, ecclesiastical, decorative and domestic: its makers and marks*. 1878

See also Cork Goldsmiths' Guild; Dublin Assay Office; Irish Silver; Limerick; New Geneva; Trowel.

Provincial Goldsmiths (Scottish)

Until 1836 the Edinburgh Assay Office had no legal jurisdiction over the remainder of Scotland, with the result that many towns supported goldsmiths in the medieval fashion—as members of a mixed guild. There being no national direction, the marks they used and the quality of the metal, were both left to their discretion. Until 1819 the Scottish standard was 11 ounces to the Troy pound. As may be imagined it was natural for the arms of the burgh in question to be adopted as a town mark, though with a town name such as Tain or Wick, it being so short, the whole name could well be used. The fact that a maker was willing to own to the manufacture of a piece by impressing his own mark upon it, implies faith in the quality of the metal, and this was probably backed in a number of cases by the ordinances of the guilds and various burgh councils concerned. Unlike England, there is much less doubt as to the correctness of the ascriptions of the marks set out in the table on the following page.

Besides those towns listed, Old Aberdeen, Forres and Stirling are all known to have manufactured plate, and marks are ascribed to them, though the evidence is not always so conclusive. At the same time a number of travelling tinkers, working in other metals besides silver, went about the country and a number of unmarked pieces are their handiwork. On occasion, however, they marked their products. In general the quality of the products of these tinkers was somewhat lower than the products of the more settled artisan workman, whose work was seldom far behind the Edinburgh silversmith in both quality and workmanship. In early times Scottish silver appears to have been assayed at the lower, French standard, and this was so until the 19th century. The 'Tryar' using the Continental 'Zig-Zag' assay groove rather than the English straight scraping. This was probably intentional, there being far closer ties between Scotland and France than England and Scotland. One of the largest and finest pieces of Scottish provincial silver is the Fithie Communion Plate (**2**) made by Thomas Lyndsay of Dundee, 1665, 19 in. (48·3 cm.) in diameter (Albert Institute, Dundee). In most cases the provincial silver objects, made after King James VI assumed the Crown of England in 1603, were of the simpler type and the teapot made in Dundee by Alexander Johnston, *c*. 1745, is a great rarity. Small bowls, quaichs and occasional copies of larger Edinburgh or English-made pieces are the most usual products, other than spoons. No known, undoubted, Scottish spoons are extant prior to 1560. Only three pieces of silver are known from St Andrews, they are the salt cellar at St Mary's College, a cup in the town church and a two-handled coconut cup in the collection of the Marquess of Bute. All the work of Patrick Gairden, they date from the mid 17th century.

Scottish Provincial Town Marks

Aberdeen 16th century – 1860

Arbroath early 19th century

Banff 1680 – 1820

 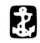

Canongate (Edinburgh) 16th century – 1836

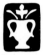

Dundee 1550 – 1834

Elgin 1680 – 1830

Greenock 1760 – 1830

Inverness 17th century – early 19th century

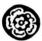 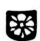

Montrose 1650 – 1820

Perth (St John's Town) 15th century – 1850

Peterhead 1720(?) – 1820

Tain 1720 – 1820

Wick 1770 – 1820

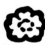

St Andrews 17th century

Bibliography
T. Burns, *Old Scottish Communion Plate*. Edinburgh, 1892.
Sir C.J. Jackson, *English Goldsmiths and Their Marks*. 2nd Edition 1921, reprinted 1949.
I. Finlay, *Scottish Gold and Silver Work*. 1958.
G.E.P. and J.P. How, *English and Scottish Silver Spoons*. Vols. I, II and III. 1952.

Pudding Dish

On November 2nd, 1815, Messrs Shepherd & Boyd of Albany, New York, invoiced Pierre Van Cortland II with a 'Silver Pudding Dish' and 'Silver Pudding Knife'. These survive, the circular dish, of shallow-bowl form, is 10¾ in. (27·3 cm.) in diameter; the knife, with a silver blade and handle, is 10 in. (25·4 cm.) in length (collection of Mrs Robert P. Browne). Deep dishes, often plain and oval in shape, are known in English silver of the late 18th century. Wakelin supplied Richard Rigby on March 22nd, 1774 with 'A plain deep oval Maccoroni dish' weighing 26 ounces.

Pudding Trowel See Fish Server.

Punch Bowl

The Restoration brought in its wake a number of foreign customs, including that of brewing punch, perhaps derived from the Hindustani word *paunch*, meaning 'five', there being five main ingredients. Brewing punch in the dining room demanded a large, plain, circular bowl, up to 12 in. (30·5 cm.) in diameter and to this end the punch bowl was invented (**412**). The Drapers' Company possesses one of 1680 and the Skinners' Company, a pair of 1685. Of this same date, is an early example of a punch bowl, now in the Untermyer Collection, but formerly the property of the Vicars Choral of Hereford. Another of 1691, with cover, some 12 in. (30·5 cm.) in height, is amongst the plate of Trinity College, Cambridge. A second, covered example, made in 1701, and one of the largest, is the work of Benjamin Pyne, now in Kansas City Museum (**414**). A third appeared recently, having a model of a horse as the handle to the cover (**415**). By the close of the 17th century, punch was already becoming fashionable in America. Jeremiah Dummer of New England made a punch bowl in 1692 (Garvan Collection, Yale University Art Gallery), this, having two scroll handles, like an enlarged porringer, is of a type that was to become very popular in the American Colonies. That of the Drapers' Company (1680) appears to be the earliest with handles, unless a large, two-handled, shallow bowl on three ball feet, dated 1677, engraved with the Arms of the Africa Company (once in the J.P. Morgan Collection) is to be included, and Sir Charles Jackson illustrates (*An Illustrated History of English Plate*, p.798) the transitional type of 1685, with notched rim, which came to be known as a 'monteith' (see Monteith). Though not an invariable rule, it is generally true to say that a bowl with a pronounced 'tumble home', even if lacking its collar, which by 1705 was becoming detachable, was probably intended as a monteith, especially if it bears hall-marks prior to the year 1725. However, there was nothing to deter one from using a monteith as a serviceable punch bowl. Proof of this, or the possible existence of an original cover, may sometimes be found by noticing a large discrepancy between the engraved weight on the underside of the bowl and the present actual weight, the former being the greater. The vast majority of early 18th-century punch bowls had handles and detachable collars to form monteiths if required. This, however, does not appear to be the case with the magnificent pair made by Philip Rollos in 1701, now in the Hanbury Tennison Collection at Cardiff, nor with the superbly engraved bowl, now in the Farrer Collection, Ashmolean Museum, Oxford, executed by Paul de Lamerie in 1723, one side depicting a dining-room scene, the other a procession of gentlemen, and engraved 'Prosperity to Hooks and Lines'. This latter was probably connected with the New-

foundland Fisheries, having been originally ma[de] for their 'Admiral' (**417**). Irish examples are b[oth] rare and exotic (**418** and **419**). Provincial pun[ch] bowls are known, several from Newcastle (**416**).

After 1730 the handles disappear. A handso[me] American bowl, on three hoof feet, as usual, sm[all] by comparison with English examples, is that ma[de] by John Burt. The Corporation of Chester made [it] practice during the latter part of the century [of] giving, as race prizes, plain, collarless punch bow[ls] of shaped outline, at least two of which were ma[de] by Hester Bateman (**420**). Two of these, dat[ed] 1769 and 1770, seem to have been melted dow[n] and refashioned as one for the winning owner [,] Thomas Heming in 1771. The result is a supe[rb] piece in the Classical manner probably design[ed] by Adam who worked for the patron concern[ed] Sir Watkin Williams Wynn, Bt. Indeed, two drawing[s] from Adam's *atelier*, for a gilt bowl, still surviv[e]. From 1775 onwards the punch bowl is uncommo[n] though a fine pair were made by Paul Storr for t[he] Corporation of Dover in 1814 (**421**). Of the sam[e] year is a most intriguing punch service; the covere[d] bowl, with two drop-ring handles, is formed as [a] mortar shell on a stand and it has a large tw[o-]handled tray, ten beakers and a punch ladle [en] *suite*. This is the work of Fletcher & Gardiner [of] Philadelphia and was presented to Lieutenan[t] Colonel Armistead by the citizens of Baltimore f[or] his spirited defence of Fort McHenry against t[he] British in 1814, now in the Smithsonian Institutio[n,] Washington (**422**). Scottish punch bowls of an[y] date are considerable rarities (**413**). That [by] Winter of Edinburgh, 1825, set with coins of t[he] first and second coinages of George IV in com[-]memoration of the first royal visit to Scotland sin[ce] 1651, preserves the excellent line for which mo[st] Scottish bowls, large or small, are renowned.

So far as is known, the gold punch bowl to [be] presented to Admiral Edward Russell, for whi[ch] subscriptions were being canvassed in the City [of] London in 1692, has not survived, if indeed it w[as] ever made.

The famous Sons of Liberty Bowl is of Orient[al] porcelain form, 11 in. (28·0 cm.) in diamete[r] made in 1768 by Paul Revere, and engraved wi[th] inscriptions commemorating the ninety-two me[m]bers of the Massachusetts Bay House of Represe[n]tatives, who voted not to rescind a letter hostile [to] the English Crown, and also indicating their su[p]port for John Wilkes and the famous 45th issue [of] his paper the *North Briton*, published in 176[3.] This perhaps, together with the Independen[ce] Inkstand made by Philip Syng are the two mo[st] historically important pieces of American silver.

Bibliography
Narcissus Luttrell, *A Brief Historicall Relation*. 169[.]
Peter Hughes, 'An Adam Punch Bowl'. *Burlingt[on] Magazine*, November 1967.

See also Bowl; Jardinière; Monteith; Race Prize[;] Sillabub Pot; Verrière.

Punch Ladle See Ladle, Punch or Toddy.

Purse Mount

Probably thanks to the non-lasting quality of t[he] purse itself, early examples are rare and many [of] those surviving are unmarked. A sporran of *c.* 17[10] made in Elgin survives and, occasionally, late 18t[h-]century purses, sometimes decorated with facet[ed] steel beadwork, are also found. 19th-century a[nd] later examples, sometimes wholly of silver chai[n]work mesh are by no means uncommon.
See also Sporran.

Puzzle Cup See Cup, Wager.

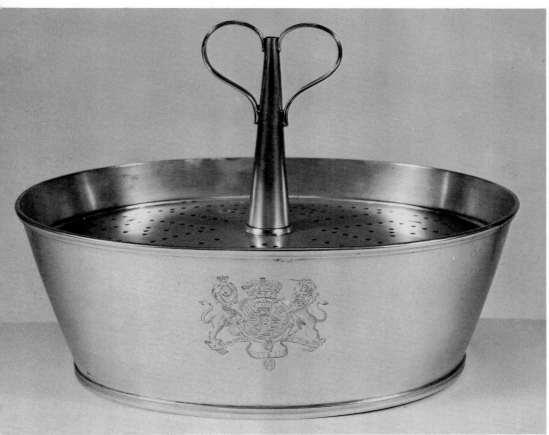

411

411 Potato Pasty-pan
Maker's mark of John Edwards.
Hall-mark for 1801.
Length 12¼ in. (31·1 cm.).
Engraved with the Arms of the Duke
of Kent, father of Queen Victoria.
It has also been known as a 'fish
kettle'.

**412 Punch Bowl,
Cover and Ladle**
Silver-gilt.
Maker's mark, PR with two pellets
above and a rose below.
c. 1685.
Diam. 15⅞ in. (40·4 cm.).
Stamford Corporation.
This huge punch bowl has a
capacity of 3½ gallons.

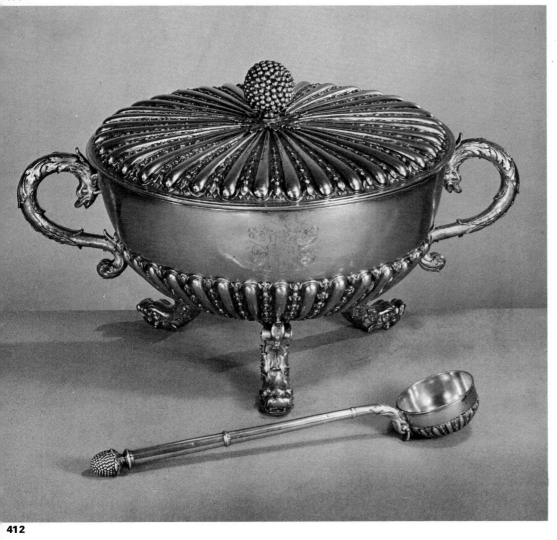

412

413 Punch Bowl
Maker's mark of Robert Bruce.
Hall-mark for 1692, Edinburgh.
Diam. 11 in. (28·0 cm.).

414 Punch Bowl and Cover
Maker's mark of Benjamin Pyne.
Hall-mark for 1701.
Diam. 17½ in. (44·5 cm.).
Height 18 in. (45·8 cm.).
Kansas City Museum.
Engraved with the Arms of
Codrington.

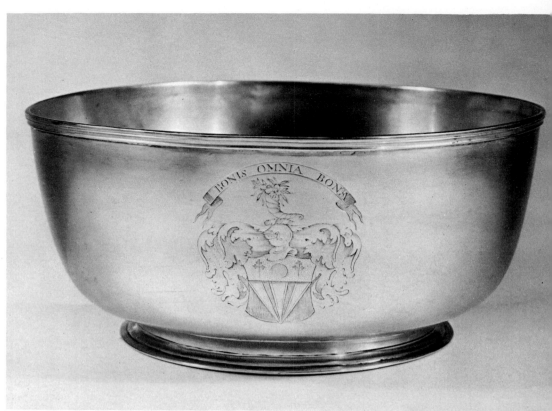

413

414

Plate 31 Rhodian Jug
An Isnik or Turkish ware pottery jug
with silver-gilt mounts, *c*. 1580.
Height 10¼ in. (26·1 cm.).
Victoria and Albert Museum,
London.

Plate 31

Plate 32 A Pair of George II Beer Jugs

Maker's mark of Phillips Garden.
Hall-mark for 1754.
Height 13½ in. (34·3 cm.).
Engraved with the Arms of Hicks.
While considering the fine quality
of these Rococo jugs it is worth
noting that Garden purchased Paul
de Lamerie's patterns and tools at
an auction on February 24th, 1751.

Plate 32

415

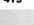

415 Punch Bowl and Cover
Maker's mark of James Fraillon.
Hall-mark for 1717.
Diam. 13 in. (33·1 cm.).
Height 17 in. (43·2 cm.).
Engraved with the Arms of
Johnstone quartering Fairholm.
The cover is unmarked and the
horse is probably a later addition

416 Punch Bowl
Maker's mark of John Carnaby.
Hall-mark for 1721, Newcastle.
Diam. 13 in. (33·1 cm.).
Engraved with the Arms of Bell.

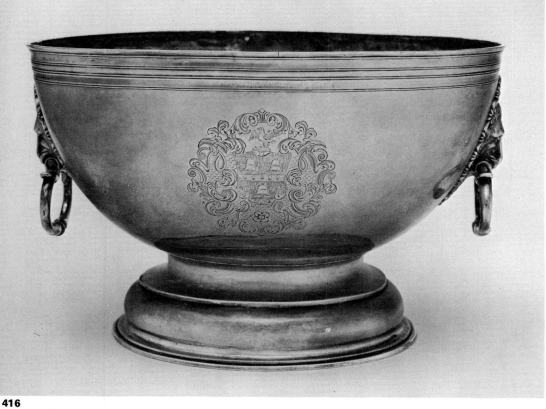

416

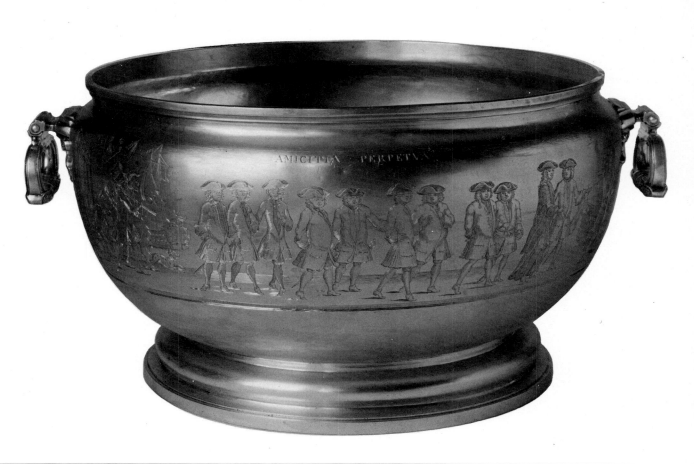

417

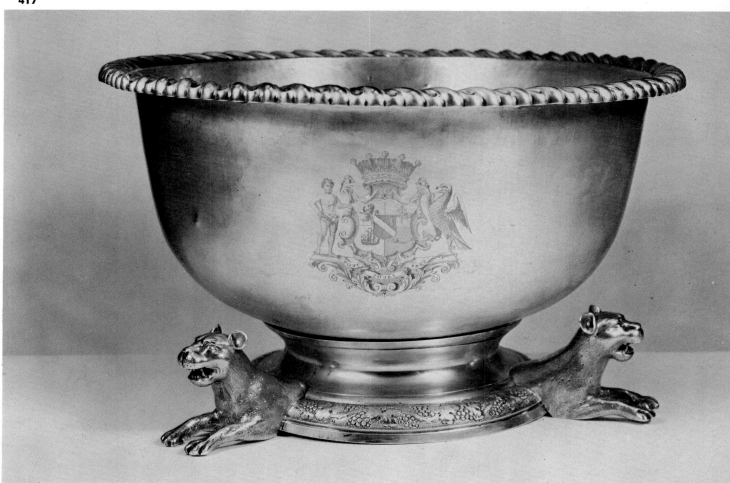

418

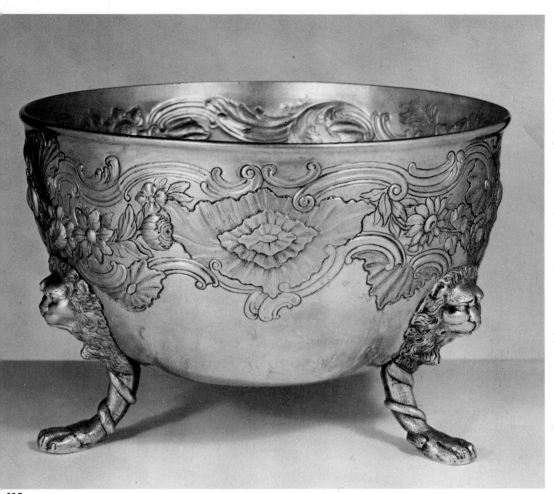

419

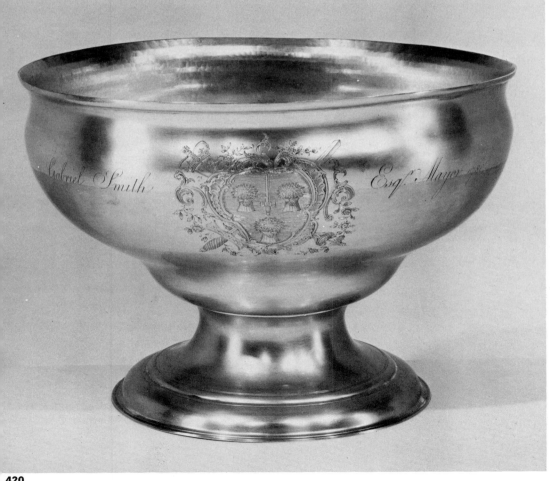

420

417 Punch Bowl
Maker's mark of Paul de Lamerie.
Hall-mark for 1723.
Farrer Collection.
It has a ladle made by Lamerie in
the same year.

418 Punch Bowl
Maker's mark of Robert Calderwood.
Hall-mark for 1737, Dublin.
Diam. 13¾ in. (35·0 cm.).
Engraved with the Arms of
McDonnel.

419 Punch Bowl
Maker's mark of John Moore.
Hall-mark for 1749, Dublin.
Diam. 10¾ in. (27·3 cm.).

420 Punch Bowl
Maker's mark of Hester Bateman.
Hall-mark for 1784.
Diam. 12¾ in. (32·4 cm.).
Height 12½ in. (31·8 cm.).
Engraved with the Arms of the
Corporation of Chester.
It was presented as a race prize.

215

421 Punch Bowl and Ladle
One of a pair.
Maker's mark of Paul Storr.
Hall-mark for 1814.
Diam. 12¼ in. (31·1 cm.).
Dover Corporation.
The bowl is also signed by Rundell,
Bridge & Rundell who
commissioned it.

422 Punch Set
Bowl and tray: maker's mark of
Thomas Fletcher & Sidney Gardiner
of Philadelphia.
c. 1814.
Bowl: diam. 12½ in. (31·8 cm.).
Tray: length 29 in. (73·7 cm.).
Cups and ladle: maker's mark of
Andrew Warner of Baltimore.
c. 1814.
Cups: diam. 3 in. (7·7 cm.).
The Smithsonian Institution.
The service was presented to
Colonel George Armistead by the
citizens of Baltimore.

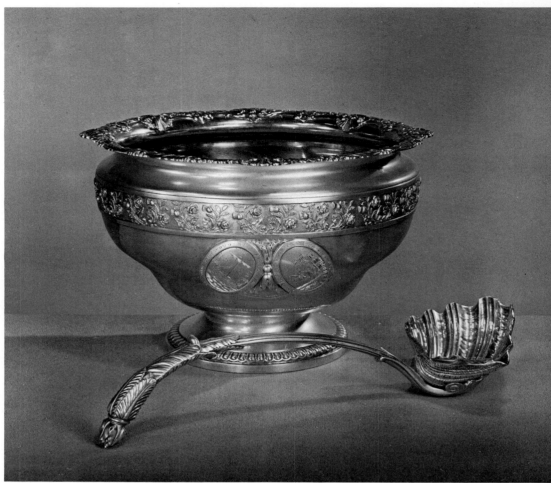

421

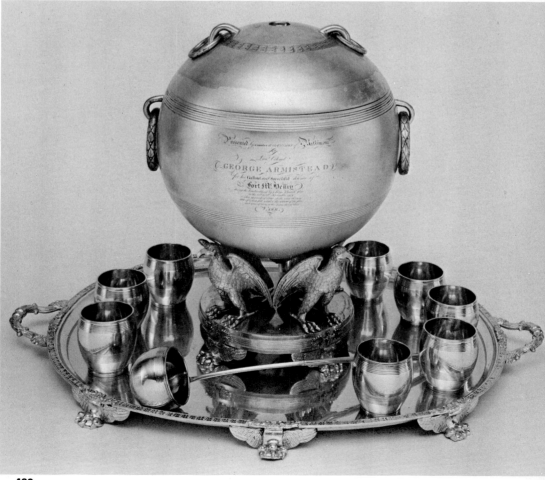

422

216

iginally the word was used of any closed box or ffer. Today, it is used to describe an ecclesias- al container for the consecrated Host, bread to used during the Communion service. Henry VII, his will, left a silver-gilt pyx to the value of 0s 0d to every church in his kingdom and eady possessed of one made in a precious metal. fortunately, it was left to his son, Henry VIII, to ry out his wishes and perhaps surprisingly, for at t he had no lack of money, Henry did nothing. those already in existence only one in silver has rvived. The Swinburne Pyx, now in the Victoria d Albert Museum; this is a cylindrical box, corated within and without with enamelled nels and with a bayonet joint to the flat cover. It tes from about 1310. The form of the pyx varied rough the centuries, that it should have a curely fastened cover, often conical, was essen- l, as it was usually suspended in some form of ntainer above the altar and, in case of an cident, it was vital that the Host should not be uched by unsanctified hands. Changing custom l to the standing pyx and so to the monstrance, nereby the Host, preserved behind panels of rock- vstal, could be exposed. The base of a standing x, of 1507, its form we shall never know, was corporated into the foot of a communion cup dered to be made for St Martin's, Ludgate, during e reign of Elizabeth I. Later pyxes are usually allow, cylindrical boxes and a number survive, cluding one of gold of c. 1620; these, of course, e all Recusant pieces. One of c. 1640 is in the llection of Mrs Munro on loan to the Huntingdon t Gallery, San Marino, California.

oliography

C. Oman, *English Church Plate*. Oxford University ss, 1957.

e also Monstrance; Recusant Plate.

x, Trial of

e trial of the pyx, no longer as picturesque as it ed to be, though still a serious ceremony, has en held since 1870, at Goldsmiths' Hall, by a y summoned from amongst the members of that mpany. It is in fact less closely connected to the nufacture of wrought gold or silver, than to the in struck at the Royal Mint. Originally, a represen- ive quantity of coins were retained from each iking, conserved in a locked strong-box or pyx, d once a year, before the Privy Council at West- nster, these coins were assayed to ensure that ey were of the required purity of metal, being sted against the official standards. Until they ere pronounced 'up to standard', the officials of e Mint 'stand upon their deliverance'. Only ently a jury called in question the fineness of an ue of coin.

bliography

H, Watson, *Ancient Trial Plates in the Pyx ronghold*. H.M.S.O., 1962.

e also Assay; Diet.

aich

obably from the Gaelic word for cup *cuach*. The aich is a two-handled, shallow bowl derived from wooden, or sometimes silver-banded original, d appears to be a purely Scottish form, though it possible that some French influence may be owed. It resembles a mazer, in as much as it too as originally carved out of solid wood. A shallow wl, of two-eared saucer form, 6¼ in. (15·9 cm.) overall width, made by A. Dennistoun, Edinburgh, 1640, has flat 'ears' of fluted, almost escallop form, uch more reminiscent of the later ecuelle than the cepted quaich, in which the handles are flat and

usually hollow. A small, two-eared, saucer-like bowl made by T. Clyghane (Cleghorn) of Edinburgh, between the years 1646 and 1648, has punched decoration of a type more commonly associated with the English 'sawcer', though it is of a size that might have been useful as a wine taster. It is much more likely to be a copy of an English original, rather than inspired by the quaich. The size of the quaich varies enormously from 3½ in. (8·9 cm.) to 7½ in. (19·1 cm.) in diameter, exclusive of the handles. Generally speaking, the largest surviving examples seem to date from the end of the 17th century (**423**). Later, quaichs are usually of the smaller variety. Their use in Scotland as communion cups is not unknown. Examples in silver are often engraved to represent the wooden staves of the more humble version from which they derive. Perhaps the finest of all, engraved with flowers and staving both inside and out, is that made by William Scott of Aberdeen, c. 1710.

Bibliography

Commander G.E.P. How, *Notes on Silver, no. 6*. 1948.

Ian Finlay, *Scottish Gold and Silver Work*. 1956.

See also Bowl; Ecuelle.

Race Prizes

Race prizes were commonly awarded in early times. Bells, usually of almost spherical form which were presented to the winning owners of race horses, survive from the late 16th century. From the reign of Charles II, and the respectability which his interest in horse racing brought to the sport, it has been the custom to present a more consider- able piece of silver or gold plate, either as the prize itself or as the container for a 'purse'. Of these early prizes few are known to have survived. The Brampton Moor Cup of 1666 is perhaps the earliest. The Ashby Maske Cup of c. 1669 is particularly interesting, as being a caudle cup made by William Ramsay of Newcastle upon Tyne. Later, but equally rare in provincial silver, is a cup made by Robert Cruikshank of Old Aberdeen, c. 1725, and presented by the Duke of Gordon to the winner of a race run at Huntly Castle in that year. Before the Civil War, the usual form of prize seems to have been a silver bell of which Carlisle Corporation possesses two, one gilt dated 1590, the other white 1599 (**34**). Lanark and Paisley have two early Stuart bells. An American porringer, refashioned from an earlier piece, bears the original inscription: '1668 wunn; att hampsted plaines march 25'; it was run for at the Rhode Island race-course (Garvan Collection, University of Yale Art Gallery). Queen Anne seems to have been as keen on racing as Charles II and presented a number of gold and silver cups, including that in gold made by Pierre Harache, Junior, in 1705, and competed for at a Yorkshire horse race meeting at Richmond in 1706; its making cost £122 14s 3d. A very rare piece of York silver, being of early 18th-century date, is the race cup made by William Busfield in 1701, en- graved 'Maggot on Kiplingcoates, 19th. March 1702' (in the East Riding of Yorkshire). Gold tea- pots made in Edinburgh in 1736 and 1737 (Colour Plate **39**), engraved with the Royal Arms, have only recently been associated with a particular race—The King's Plate, run at Leith, Midlothian. It seems, there being other extant Edinburgh gold cups (one with ebony handles is now in the Metropolitan Museum of Art, New York, and was made by William Gilchrist in 1752) that these were presented each year between 1736 and 1755. 'A Golden Cup of the Value of 50 Guineas, Given by the Corporation of Newcastle upon Tine, aforesaid is to be run for on the Town Moor'.

This cup, made by James Kirkup of Newcastle, c. 1728, some 4½ in. (11·5 cm.) in height, is still extant. Gold cups were awarded elsewhere (**209**). In Chester the head of the Grosvenor family annually presented a gold cup worth £50 (usually a large tumbler) between the years 1750 and 1791 (those of 1766, 1774 and 1791 still survive). Over the years almost every sort of silver object seems to have been presented; even a pair of double- lipped sauce boats at Royston, Hertfordshire, in 1729. Punch bowls were given in America, one made by John Inch of Annapolis is engraved 'Annapolis Subscription Plate 4 May 1743', another was given at Cambridge Heath, Boston, in 1721. Of the same date is an Irish salver (**467**). Punch bowls were also a favourite prize in England. Chester Corporation gave a series, year after year, during the latter half of the 18th century. A fine example of the standard Irish form of cup and cover is the Kildare Hunt Cup of 1757. By the 19th century, many of the so-called 'Gold Cups' were in fact made of silver-gilt. Perhaps one of the finest race prizes of all time was that designed by Robert Adam for Thomas Dundas. An example made by D. Smith & R. Sharp in 1770, and known as the Richmond Cup is now in the possession of the Marquess of Zetland; their earliest essay engraved 'Best in Ireland' is, however, of 1764. A number of otherwise standard cups of this period were rendered suitable as race prizes by the addition of a cast oval medallion, showing two or more horses at full gallop on one side and a vacant cartouche to receive the inscription on the other. In 1772, the Duke of Cumberland bespoke 'A gold Race Cup' of Messrs Wakelin. It weighed '13 ounces 15 dwt. 18 gr. at £4:3:0. per ounce'; this cost £57 4s 6d, but to this was added the 'cost of fashion £14:14: 0, engraving 14/— and 10/— for the case to hold it, £73:2:6. in all'. In 1774, the same firm supplied Lord Melbourne with 'a fine Cup and Cover. Doub. Gilt, eng. very neat /LILLY HOO/ on each side'. Several cups so engraved are known, but the significance seems to be lost. An interesting variant is the small two-handled porringer of 1767 in a pri- vate collection engraved 'SPANKER 17-FLINT- 67', presumably given as a Hound Show prize at Flint, North Wales. A snuff box formed as a horse's hoof, complete with racing 'plate', was made by W.P. Cunningham of Edinburgh, c. 1800; the lid is engraved with two horses and their jockeys at 'full stretch'. Besides the two Scottish teapots there also survives an English one of an earlier date inscribed 'Well Ridden. Miriam Wrightson. Spott. Rippon 1723' and engraved with the figure of a lady riding side saddle. This was presented, together with a 'cannister' (tea caddy), by Mrs John Aslabie and the race for which these prizes were competed was ridden between nine 'Gentlewomen riders', an event which scandalised the entire neighbour- hood.

Bibliography

E.A. Jones, *Old English Gold Plate*. 1907.

Sir Walter Gilbey, Bt., *Racing Cups 1559 to 1850*. 1910.

J. Fairfax-Blakeborough, *Northern Turf History*. Vol. II, 1949.

Robert Rowe, *Adam Silver*. Faber & Faber, 1965.

A.G. Grimwade, 'A New List of Old English Gold Plate'. *Connoisseur*, May, August and September 1951.

C.G.E. Blunt, 'An Important Souvenir of Stuart Sportsmanship'. *Apollo*, October 1960.

Peter Hughes, 'An Adam Punch Bowl'. *Burlington Magazine*, November 1967.

See also Bell; Cup, Two-handled; Punch Bowl; Teapot; Tumbler Cup.

Ramsden, Omar (1873–1939)

He registered his mark in conjunction with his partner, Alwyn Carr, in 1898 and later, in 1918, he registered a Gothic mark, when he set up in business on his own. Ramsden's work is highly individual, usually found with a Latin signature as well as his maker's mark, and with considerable emphasis on the hammer-mark finish. His work owes a great deal to Celtic art which he much admired. So far as his larger pieces are concerned the usual source of inspiration is medieval, though there is a gold tazza made by him in 1937 (Lee Collection, Royal Ontario Museum, Toronto), which is definitely in the manner of Hans Holbein.

Bibliography
E. Delieb, *Omar Ramsden—Me Fecit*. December 1961.

Rapee

A form of snuff, also a colloquial expression for a plug of tobacco for use with a snuff rasp (**385**).
See also Snuff Box.

Rattle (Coral and Bell)

Silver, silver-gilt, or even gold-mounted examples have been made down the ages, often with a piece of coral at one end, and a number of spherical bells and a whistle at the other. A portrait (National Gallery of Art, Washington) of Edward VI as Prince of Wales shows one such example. Survivals earlier than 1760 are uncommon and frequently of gold when found. One of four known American gold rattles is by D.C. Fueter of New York, c. 1760 (Yale University Art Gallery). Another by Samuel Vernon of Newport, Rhode Island, is now in the Henry Ford Museum, Dearborn, Michigan; it is of crescent form with a sphere in the middle and must date from c. 1725. Amongst the effects of Captain John Freake, killed by an explosion in Boston harbour in 1675 was 'a whissle silver chain and childe's bell' then appraised at 15s (**424**).

In the 19th century, ivory is, on occasion, substituted for the coral. From 1800, plain or chased, and sometimes gilt, rattles were apparently as usual a possession for a child as was the silver spoon of the 17th century. Unfortunately, most existing examples have suffered considerable wear and tear. Babies' dummies of the 19th century often incorporate mother-of-pearl.

Bibliography
Peter J. Bohan, *American Gold*. Yale University Art Gallery, 1963.
See also Teething Stick.

Razor Case

Other than the enamelled instrument case of the Barber-Surgeons' Company (**425**), c. 1515 (a similar example in brass survives at the Victoria and Albert Museum) now returned to that Company after a long absence, survivors seem all to be of 17th-century date and later. The figures of saints decorating this particular case are from moulds also used for the production of finials for Apostle spoons.

Until the coming of the safety razor, it was quite usual for a man to have as many as seven different cut-throat razors to hand, thus enabling him to have them professionally sharpened once a week. These, often with silver mounts and tortoiseshell scales to the handles, were contained in a case usually covered with shagreen and also enclosing a hone stone or strop, together with scissors, curling irons and other toilet instruments (**426**). One of the earliest, the case itself of tortoiseshell, has pieces engraved with the date 1644 (Victoria and Albert Museum). They are generally of the same

form as a knife box, but examples are known resembling an attaché case, containing boxes for soap, wig powder and a shaving brush; one such, contains hall-marked pieces for 1761.
See also Knife Box; Shaving Brush; Shaving Set; Toilet Service.

Recusant Plate

In spite of the penal laws against practising Catholic Recusants, it seems always to have been possible for them to retain at least a chalice and paten. At a time when so many chalices were being converted to communion cups, they could doubtless be bought on the side as second hand. 17th-century Continental fashion decreed six altar candlesticks, but few can have, as Lady Vaux, actually possessed them. James II on his accession in 1685 declared openly his Roman Catholic faith and recent research has revealed that a large part of the Recusant plate ordered for the Chapel Royal at Holyrood House in 1686 has survived in Scotland to this day. All appears to be English, but for a Sanctus Bell and an incense spoon made in Edinburgh. The thurible and the incense boat are particularly fine. Recusant plate made in England from the mid 16th century onwards includes almost all those objects which might be expected in any Roman Catholic church on the Continent, though in a number of cases only one or two examples seem to have survived. On the whole the design, however, remains stolidly English (**109**). Throughout the period, that is until 1790, there seems to have been little difficulty in getting a competent goldsmith to accept a commission for Recusant plate though the question of whether the pieces were wholly, partly or completely unmarked, probably depended on the political temperature of the day. Only one piece of Recusant gold plate is known to have survived, a circular pyx, of c. 1620, now at Westminster Cathedral, London. Recusant chalices tended to be inspired by Irish originals during the second half of the 17th century (**115**) and during the 18th century they are little different to the Anglican communion cup of the day. The Recusant paten is a slightly hollowed disc, unlike anything known in medieval times and probably of Continental inspiration. Small, oval locket reliquaries are usually engraved with the Agnus Dei and Crucifixion and are seldom marked. The majority are probably Irish.

Bibliography
J.E. Langdon, *Canadian Silversmiths, 1700–1900*. Toronto, 1966.
C.C. Oman, *English Church Plate*. Oxford University Press, 1957.
Hubert Fenwick, 'Silver for Huguenot and Catholic'. *Country Life*, April 25th, 1968.
See also Altar Cruet; Bell; Censer; Chalice; Chrismatory; Cross; Incense Boat; Monstrance; Pax; Pyx; Reliquary; Rosary.

Reeding

Ornament of thin, contiguous, parallel mouldings, a stylised form of long reed stalks.

Reliquary

Designed to hold the relics of a saint, holy person, or sacred objects, such pieces form an important part in the plate of any Continental Catholic church. Few, if any, of English manufacture seem to have survived the Reformation. The tendency to decorate these with precious stones made them obvious targets for the iconoclast and the looter. One formed as a pax, and made in Galway, Ireland, is thought to date from about 1635 (**251**). A number of rock-crystal, silver-mounted reliquary objects, generally

of 16th-century date, appear to have been ma⟨ from earlier pieces, often ecclesiastical. The Ninian Reliquary (British Museum) of c. 1200, is domed crystal with unusual gold mounts, and the one possible survivor of such an early date. number of later crystal jewels survive in Scotland. Stonyhurst College there is a cylindrical example enamelled gold and crystal enclosing a thorn a⟨ dating from about 1600; another, of about the sam date, probably by the same hand, is now at Michielskerk, Ghent. Both are comparatively sma 6 in. and 7½ in. (15·3 cm. and 19·1 cm.) hig respectively, especially when compared to silv examples, and both have a common provenanc Examples may be expected from Canada also.

Bibliography
Connoisseur, March 1961.
Hugh Tait, 'The Stonyhurst Salt'. *Apollo*, Ap 1964.
C.C. Oman, *English Church Plate*. Oxford Unive sity Press, 1957.
See also Monstrance; Pax; Pyx; Recusant Plate

Revere, Paul, Senior (1702–54)

Originally named Apollos Rivoire (1702–54), ⟨ was of French extraction and came to Boston 1715, where he was apprenticed to John Cone⟨ who unfortunately died before Revere cou complete his apprenticeship.

Revere, Paul (1735–1818)

Apprenticed to his father, Apollos Rivoire (Rever⟨ who died before the completion of his son, Paul apprenticeship. The younger Revere is well know for many reasons, not least among them h famous 'Ride' as the patriot, but also for his ou put as a prolific silversmith. He built up a co⟨ siderable business 'supplying to the trade' ar perhaps his most famous product is the Sons Liberty or Rescinders Bowl of 1768 (Museum ⟨ Fine Arts, Boston). The survival of some of h 'Day Books' has enabled the history of a numb⟨ of pieces to be traced, including the seven-pie⟨ tea set of 1792–3, made for John Templema⟨ part of another tea set made for John Blake; ⟨ elliptical salver commissioned by Elias Darby 1797 and one of the few known coffee pots stand ing on three feet (private collection). Besid⟨ silversmithing, this remarkable man founded a b⟨ and cannon factory in Boston in 1796 and by 18C this, and his other experimental interests, ha taken precedence over his silver workshop. A fir portrait of Revere, shown holding a pear-shape teapot, his engraving tools beside him, by J. Copley, his friend and patron, may be seen at th Museum of Fine Arts, Boston. His usual mark w⟨ his surname in various rectangular punches.
See also Jug.

Richardson, Joseph (1711–85)

Born into a Quaker family, who produced a num ber of goldsmiths, he worked in Philadelphia. H⟨ sons, Joseph, Junior (1752–1831) and Nathanie followed in the same trade, and were in partne⟨ ship from 1771 to 1791. The elder Josep⟨ Richardson is remembered by a number of su⟨ viving workmanlike pieces, including a coffee p⟨ together with a sugar bowl and cover of c. 175⟨ the property of the Historical Society of Pennsy vania; a pair of sauce boats in the Bortman Colle⟨ tion and the magnificent Rococo kettle in th Garvan Collection, Yale University Art Gallery. ⟨ member of the Friendly Society for Propagatin Peace with the Indians by Pacific Measures, ⟨ made a decorative gorget for this purpose in 175 By him, also, is the exceptionally large (that is, f⟨

423

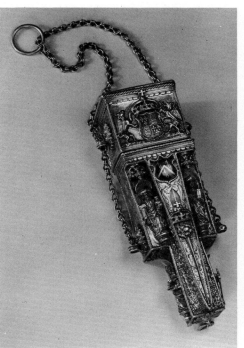

424 **425** **426**

American silver) salver, 16 in. (40·7 cm.) in diameter, in the Fowler Collection, Los Angeles, with finely chased and engraved Rococo border.

Richardson, Joseph, Junior (1752–1831)
He made an Indian Peace Medal in 1793, but his most important surviving work is probably the tea and coffee service of nineteen pieces, c. 1790, now in the Henry du Pont Museum, Winterthur. Like many other Colonial silversmiths the Richardsons imported a considerable quantity of their stock directly from England, at least until the America War of Independence. So far no connection has been established between this family of Richardsons and the Chester silversmiths of the same name.
See also Breastplate and Gorget.

Rimonim See Jewish Ritual Silver.

Ring
Rings in base and precious metals are more correctly dealt with in works upon jewellery. However, a few varieties may be mentioned, in particular heavy, plain, gold wedding or posy rings, which if of 17th-century date may be found with a suitable conjugal inscription engraved within, such as 'Hearts Content Cannot Repent' (The Joan Evans Gift, Ashmolean Museum, Oxford) and perhaps also bear a maker's mark, Sergeants-at-Law from 1117 to 1875 gave rings on their appointment, some, dating from 1736 onwards, being enamelled. They varied in size, but were always engraved, on the outside, with some suitable legal motto. In 1737, fourteen Sergeants were called and one thousand, four hundred and nine rings dispersed. Despite these large numbers, less than fifty are known to have survived of any date. From 1800 onwards they are usually fully marked. A covered jug, 8½ in. (21·6 cm.) high, made by William Fawdery in 1716, engraved 'Ex Annulis Servientium Domini Nostri Georgii Regis Anno Regni Sui Primo' is an interesting survival, as it is made from the rings of the Sergeants-at-Law, or presumably the proceeds of their sale, as the jug is of silver, and the rings were usually of gold.
Bibliography
Leslie G. Matthews, 'Rings of the Serjeants at Law'. *Connoisseur*, February 1954.
See also Claddagh Ring; Seal.

Ring Stand
Such pieces are rare and may take any form incorporating a slender cone upon which rings of varying size may be placed. One example of 1832 is 3 in. (7·7 cm.) high, and resembles a hand candlestick.

Rococo
Rock-work, shells and marine creatures seem to have caught the imagination of designers as early as the late 1730s. By the 1740s amazing *tours de force* in silver were being produced of a naturalism seldom again imitated until the appearance of Pre-Raphaelite taste in the late 19th century. Tureens, centrepieces, inkstands and candlesticks were the most usual subjects for such embellishment, but many smaller pieces were also similarly decorated. A remarkable inkstand made by Paul Crespin, 1739, whose inkwells are formed as detachable shells, is in the collection of the Duke of Devonshire. Another, the work of Paul de Lamerie, is amongst the plate at Blenheim and a truly fabulous tea kettle and stand is to be seen in the Hermitage, Leningrad. A tureen executed by Paul Crespin, 1740, was formerly in the collection

of Mr James de Rothschild. Besides these, many other pieces in the same manner, frequently of equal merit, though sometimes lacking the masterly touch of such makers as Crespin, Lamerie and Sprimont, are to be found (**263, 264** and **266**). Far later, but an astonishing *tour de force* is the tea service and kettle by I.S.Hunt made in 1849, in which each piece is formed as a shell and the kettle itself as a conch.

Rolled Gold
Rolled gold is to true gold what Sheffield plate is to silver. A layer of gold of any carat value may be applied by means of high-temperature bonding to one or both sides of a base metal, which may then be rolled to any desired thickness, the proportion of gold to backing remaining constant.

Rosary, Rosary Cross and Ring
In the Victoria and Albert Museum there is an extremely rare English medieval example, which has fifty Ave and six Paternoster beads; each one enamelled in black with a Biblical scene and the subject decorated round the side. The one large pendent bead is decorated with the Virgin and Child amongst other scenes. Other than this, most examples, if within the scope of this Dictionary, are Irish in origin inspired by Continental examples. James Moore and John Teare, both of Dublin made many crosses at the close of the 18th century. Large numbers were made in Canada from the early 18th century onwards. Small reliquary lockets are usually unmarked and probably Irish.
Bibliography
E.A.McGuire, 'Old Irish Rosaries and Rosary Crosses'. *Connoisseur*, vol. cxx, 1947.
J.E.Langdon, *Canadian Silversmiths, 1700–1900*. Toronto, 1966.

Rose Bowl
The decline in the drinking of punch and the desire to make full use of existing bowls, being decorative objects, led in the late 19th century to their being pressed into service as bowls for flowers. The demand far outstripped the supply. This led to the manufacture of vessels of similar form to the punch bowl, often without handles, which were also frequently given as prize cups. Needless to say the desire to own a genuine early example led to the creation of a number of fakes. Examples bearing hall-marks (often incomplete) of the reign of George III are, more often than not, pieces of altered plate; meat dishes or liners of soup tureens often provided the correct quantity of metal required for just such a conversion.

Rose Pattern
This, the form of decoration being self-explanatory, was used on table silver during the middle of the 19th century.

Royal Goldsmiths and Jewellers
See chart on pp. 221–4.

Rundell, Bridge & Rundell
In 1758 Messrs Thead and Pickett appear to have founded a business at the Golden Salmon, 32 Ludgate Hill in the City of London. Phillip Rundell came to London from Bath in 1769 and was engaged as 'shopman' by Mr Pickett, the firm becoming Pickett & Rundell in 1777. By 1800 they had taken into partnership Phillip Rundell's nephew, P.W.Rundell. J.W.Bridge, who came from Dorset, joined the firm as an unpaid assistant in 1804. The appointment of the firm as Court Goldsmiths and Jewellers brought them immense

business and they maintained agents as far afie as St Petersburg and Rio de Janeiro. The qual of the goods produced in their workshops (Pa Storr being one of those who worked for them) a their willingness to commission designs fr artists outside the immediate trade (such as Thom Stothard, Edward Baily and John Flaxman) add to the esteem in which they were held. The mea ing of publicity was fully appreciated by bo partners, so that any important order was sho to the public by ticket on certain days of the we resulting in yet further orders. On the retirement the two partners and their withdrawing th capital the firm was compelled to close in 1842
Paul Storr was never 'employed' by Rund Bridge & Rundell. He maintained his own wo shop, generally occupied with his own workm and his own work, and all too often strained re tions existed between the retailer and the silv smith. Rundell's therefore made it a practice stamp, as retailers, all their more important goo with the Latin signature: 'RUNDELL BRIDGE RUNDELL. AURIFICES REGIS et PRINCEP WALLIAE' (Goldsmiths to the King and Prince Wales). Plates **664** and **727** illustrate but a sm selection of their output.
Bibliography
C.C.Oman, 'A Problem of Artistic Responsibili The Firm of Rundell, Bridge & Rundell'. *Apo* March 1966.
A volume of Designs for Goldsmiths' Wo Victoria and Albert Museum (E.70. 124), 1964. E.A.Jones, 'A Forgotten English Sculptor a Silversmith [William Pitts]'. *Apollo*, vol. xix, p. 2 See also Achilles Shield; Flaxman, John; Storr, Pa

Sabbath Lamp See Jewish Ritual Silver.

Saffron Teapot See Teapot.

Salad Dish
Though known by reputation from documents su as the Garrard Ledgers, it was not until 1965 th two such gilt dishes were identified. Part of a s they are formed as circular, fluted, shallow bov with scalloped borders and each on three scr feet. They were made by George Wickes and a invoiced to Lord Montfort in the Garrard Ledg of July 18th, 1744: 'To making 8 Sallad Dishes . £53.15.2 . . . to gilding . . . £16.9.0 and Graving Crests 16.0' (**427**). The fan-shaped dish often ma today in pottery and porcelain is found in sil during the 18th century, but usually as a segme of a circular supper set. Two sets of this type known with covers. A set of four circular dish without feet, still retain their covers; they we made by Magdalene Feline in 1750, now in t Royal Collection. A further pair, *en suite*, we made by Thomas Heming and they appear prove the original association of the dishes w their covers. Thus, their use with covers c hardly have been for salad and this demonstrat the folly of too rigorous an attempt to label a pie for a set purpose.
See also Dish; Strawberry Dish.

Salt, Great or Standing
The comparative rarity and absolute need for s during the Middle Ages assured a place for it on t table, and the receptacle soon attained a soc importance, giving it a size far larger than requir in comparison to the quantity of salt it containe A considerable litarature, often contradictory, s rounds the social standing of the salt, whi became one of the most important pieces English plate. The earliest to survive appear to

Monarchs (with date of accession)	Goldsmiths and Jewellers (with dates or period of appointment)			
	Goldsmiths and Jewellers			
Henry VIII 1509	before 1509–32	Robert Amadas		
	before 1509–10	William Rede		
	1515–23	William Holland		
	1515	Henry Wheeler		
	1515	John Twistleton		
	1529–40	Cornelius Hayes (or Cornelis)		
	1532–40	Morgan Wolfe		
	1532–4	John Freeman		
	1534–40	Thomas Trappes		
	1539	Robert Trappes		
Edward VI 1547	1540–50	Morgan Wolf (alias Phelip)		
	1550–2	Morgan		
		Thomas Gardener		
		Lawrence Warren		
		William Hawtrie		
		Richard Hilles		
		John Harrison		
		Henry Castell		
		Jasper Fysshier		
	Goldsmiths		**Jewellers**	
Mary I 1553	1552–4	Jasper Fysshier		
	1554–8(?)	Robert Raynes		
Elizabeth I 1558	1558(?)–76	Affabel Partridge	1558–1603	Sir John Spilman
		Robert Brandon		
	1577–80	Robert Brandon		
		Hugh Keall (or Kayle)		
	1581–1602	Hugh Wall[1]		
		(Sir) Richard Martin		
James I 1603	1603	Hugh Keall	1603–24	Sir John Spilman
		John Williams		George Herriot
	1604–24	John Williams		Sir William Hericke
Charles I 1625	1618–42	John Acton	1618–42	Alexander Herriot
				Jacques Duart
				Francis Sympson (at Oxford)

Notes

[1] This name is spelt in many different ways. 'Wall' is no doubt a mistake for Keall, which appears subsequently.

continued on next page

Monarchs (with date of accession)	Goldsmiths (with dates or period of appointment)		
	Principal Goldsmiths	**Subordinate Goldsmiths and Plateworkers [2] (P=plateworkers)**	**Silversmith in Ordinary [6]**
Charles II [2] 1660	1660 Charles Everard 1660–88 (Sir) Robert Viner [3]	Robert Smithyer Saunder Smith Francis Cooke Thomas Harris Richard Marchant William Kirton Ralph Leek Francis Leek Jere (Jeremiah?) Lammas Smithson	1660 (?) Christian van Vianen 1661 John Cooque **Goldsmith Extraordinary** 1662 Charles Le Roux **Silversmith in Ordinary** 1669 Uldarius Marchant **Other Goldsmiths (bankers?)** 1671 Richard Stratford Henry Lewis
James II 1684/5 William and Mary 1689	1688–89/90 Robert Viner II 1689/90–1694 Bernard Eales 1694–1702 Charles Shales (of Shales and Smithin up to 1702, later Shales and Bowdler to 1715)	John Cully John Cully P. Rolles P 1690 Edward Balsom Jere (Jeremiah?) Lammas 1701–2 William Dennet (possibly William Denny P) 1701–2 William Bull P 1701–2	
Anne 1702	1702–23 Samuel Smithin (appointed Lord Chamberlain 1714)	Philip Rolles P Garthorne [4] P Francis Garthorne [4, 5] P Robor Garthorne Lammas	
George I 1714		Charles Shales William Dennett Pyne P Bates P } coronation of George I	**Goldsmith** 1716 Paul de Lamerie
	Principal Goldsmiths and Jewellers		
George II 1727	1723–30 John Tysoe	Rolles P Old Margas P Young Margas P Charles Shales Edwards P Hatfield P Farren P Allen P Tanqueray 1729	

wellers (with dates or period of appointment)				Monarchs (with date of accession)
rincipal Jewellers		**Other Jewellers (workmen?)**		
60	Francis Sympson John Sympson	1661/2 1662 1663/4	Robert Russell Henry Cokeyn Martin Dardem *(Jeweller Extraordinary for the King's Cabinet)*	**Charles II 1660**
66	Isaac le Gouch	1666 1668	John le Roy *(Jeweller Extraordinary)* John le Roy *(Jeweller in Ordinary)* Peter Belloune (Workman jeweller at Jewel House)	
		Other Jewellers (bankers?)		
		1671/2	John Portman George Portman	
		1672	Isaac Meynell Guilbert White John Grimes	
		1672	Robert Welsted Thomas Temple	
		1672	Thomas Price Bernard Turner	
		1672 1673 1673	Jeremiah Snow Pierce Reeves Thomas Rowe Thomas Pardoe Dorothea Colvill	
		1674/5 1676	Robert Ryve John Lyndsey	
rincipal Jewellers (ist probably incomplete)				
684/5	Christopher Rosse			**James II 1684/5 William and Mary 1689**
689	Sir Francis Child			
698	Sir Stephen Evence			
				Anne 1702
711	Samuel Smithin (also goldsmith)			
714	Nathaniel Green			**George I 1714**
				George II 1727

Notes

[2] From the Restoration until 1760, all goldsmiths who submitted the goldsmith's warrant (Principal Goldsmiths), with the exception of Robert Viner II, Bernard Eales, and Charles Shales, were apparently bankers or salesmen of the work of others, rather than practising goldsmiths and plateworkers who did the work themselves. In such cases, plate for repair, boiling, etc., often appears to have been delivered direct to the plateworker who was to deal with it, the plateworker signing for it on the principal goldsmith's behalf.

This system of recording in the delivery book changed in the 1720s, and subsequent lists of plate appear as 'delivered to goldsmith' for repair, boiling, etc., without signature. In some cases, however, the names of plateworkers were entered against parts of the lists; for example, names are usually given for plate from St James's Palace and later also from Kensington Palace. Plateworkers entered after 1697 are indicated in this chart by the symbol P.

From the time Thomas Heming was appointed in 1760, all principal goldsmiths were practising goldsmiths, and there is no clue to show whether the work was farmed out or not. From this date too they are known firms rather than individuals.

The lists include the names of all those who signed on behalf of the principal goldsmiths from 1684/5 to 1725, together with the names of plateworkers entered later. The first group includes names of individuals such as John Cully and Edward Balsom who were probably not goldsmiths at all.

[3] Sir Robert Viner, or Vyner, was sworn as Goldsmith September 1660, appointed by letters patent July 1661, knighted 1665 and created a baronet May 1666. He died in 1688 and was succeeded as Goldsmith by his nephew (?), also Robert Viner. Throughout this period only Sir Robert submitted to the Jewel House, and was paid on, the goldsmith's warrant.

[4] During the reign of William and Mary considerable quantities of royal plate were made by George and Francis Garthorne.

[5] Francis Garthorne's early mark, FG, appears on parts of maces dating from March 1684/5, and on the large altar dish, date letter 1691/2, in the Tower of London. His later mark, GA, appears on parts of other maces.

[6] 'Silversmith in Ordinary to His Ma[tie] for chastwork within His Ma[ties] Closett and Bedchamber, and also the Closett and Bedchamber of the Queen'.

continued on next page

Monarchs (with date of accession)	Goldsmiths and Jewellers (with dates or period of appointment)		Notes
	Principal Goldsmiths and Jewellers	**Subordinate Goldsmiths and Plateworkers (P=plateworkers)**	
George II (cont.)	1730–59 Thomas Minors (of Minors and Boldero 1742–60)	Hatfield P 1732–40 Farren P 1732–42 Edwards P 1732–43 Tanqueray P 1732 Allen P 1732–45 Margas P 1732–3 Hebart P 1736–40 Le Sage P 1741–59 Williams P 1744, 1746 Fox P 1746–59	[7] The title *Crown Jewellers* seems to have be first used as a title by Rundell and Bridge and Garrards. Apparently the title implies the responsibility the preparation of the Regalia and Crown Jew for coronations, and their maintenance general It could, on this basis, have been applied to all principal goldsmiths from 1660 to 1782 a probably to the royal goldsmiths since Morg Wolf in 1540. Since 1782 it would have been held by Willia Jones (1782–96), Philip Gilbert (1797–182 and Rundell, Bridge and Rundell (1821–43).
George III 1760	1759 John Boldero 1760–82 Thomas Heming		
	Goldsmiths and Jewellers		
	1782 Thomas Heming, *Goldsmith in Ordinary to His Majesty* (entry of appointment deleted)		
	1783–97 William Jones (of Jefferys and Jones 1779–93)		
	1797 John Wakelin (of Wakelin and Garrard)		
	1797–1826 Philip Gilbert, *Goldsmith in Ordinary* (Jefferys, Jones and Gilbert 1796)		
George IV 1820	1798–1826 Philip Gilbert, *Jeweller in Ordinary* (firm as above; later Philip Gilbert, late Jefferys and Jones)		
	1826–c.1830 Mary Gilbert, *Goldsmith and Jeweller in Ordinary*		
	1797–1819 Philip Rundell and John Bridge (firm Rundell and Bridge)		
	c.1820–30 Philip Rundell, John Bridge, Edward Walter Rundell, Thomas Bigge, John Gawler Bridge (firm Rundell, Bridge and Rundell)		
William IV 1830	1830–? William Bennett c.1830–43 John Bridge, Thomas Rundell, John Gawler Bridge (firm Rundell and Bridge)		
Victoria 1837	1830–43 Robert, James and Sebastian Garrard 1843–1952 Robert Garrard, Sebastian Garrard, Samuel Spilsbury (firm Garrards) 'to be *Crown Jewellers in Ordinary* in place of Rundell and Bridge'		
Edward VII 1901 George V 1910 Edward VIII 1936 George VI 1936			
	Crown Jewellers [7]		
Elizabeth II 1952	1952– Garrards taken over by Goldsmiths and Silversmiths Co., who later take name Garrards and are appointed *Crown Jewellers*		

ered salts of late 15th-century date (**429**), h as the Huntsman (Giant) Salt, *c.* 1470, of All ls College, Oxford (**428**); the Monkey Salt . 1500 at New College, Oxford, and those of r-glass form, for example that at Corpus isti College, Cambridge, dating from between 7 and 1492, when the donor, Richard Foxe, Bishop of Exeter. Another, equally rare, hour-ss salt is that at New College, Oxford, presented Warden Hill, *c.* 1490. This form persisted into 16th century and one dated 1507 at Christ's lege, Cambridge, still retains its cover, though air (**430**) and another two of 1518 and 1522, property of the Ironmongers' Company, have theirs. Another such salt is that hall-marked 8, formerly in the Ashburnham Collection, orated with the mermaid badge of the Berkeley ily.

destal and Drum Salts
the second quarter of the 16th century the in-nce of the Renaissance gave birth to the long-d, so-called 'pedestal' or 'drum' salt, as illus-ed on Plate **436**, often heavily embossed with los and strapwork, the cover frequently sur-unted by a standing, Classical figure. An ex-nely rare provincial example (perhaps from East glia), the cover surmounted by the figure of George and of about 1575 in date, appeared at istie's in 1967. Such salts vary in size from a few nes to sixteen or more inches in height. At least a her seven examples are square in plan, including Vyvyan Salt of 1592 at the Victoria and Albert seum (**434**), and that belonging to the Vintners' npany and dated 1569 (**431**), the former em-ished with panels of painted glass. A painting Gerrit van Houthorst (1590–1656), in the tional Gallery of Ireland, shows just such a are salt in use. Perhaps the most unusual design at the Gibbon Salt of 1576 (**432**) formed as a ssical temple, though the Stonyhurst Salt of 1577, the British Museum, incorporating as it does dieval rock-crystals certainly presents a chal-ge (**433**). Perhaps the most magnificent of the indrical type is the Reade Salt, now amongst rwich Corporation Regalia and made in that in 1568, possibly by William Cobbold (Colour te **36**). By 1575 a variation on this cylindrical me makes its appearance, the cover sometimes d, sometimes detachable, and sometimes being ported on brackets to expose the salt bowl. Of type is the so-called 'Queen Elizabeth Salt' ongst the Royal Plate in the Tower of London 572). An unmarked example of *c.* 1590 made of ther-of-pearl with silver mounts and on three ate ball feet is in the Lee Collection, Royal tario Museum, Toronto. For delicate workman-p pride of place should perhaps be accorded to a er-gilt and rock-crystal salt of about 1610. This ongs to a small group of pieces only two of ich are hall-marked (both 1611 by TYZ or TYL); property of the Duke of Bedford (Colour Plate .

ll Salt
ey are usually of three sections, two for salt and a all caster above; the caster is sometimes dis-sed with and a ring handle substituted; in her case when the upper portion is removed, the t in the lower part is revealed (**435**). Bell salts, ich may perhaps be claimed as an entirely glish form, make their appearance in the 1580s, ugh recorded as early as the 1540s, and die t by 1620. Unless plain, they are usually decor-d with conventional ornament of the period, apwork, fruit or foliage on a matted ground or h bands of strapwork and columbine foliage in earlier examples. Perhaps the earliest complete

example is hall-marked 1591. Unusual, though in-complete, is that illustrated on Plate **443**. The popular Jacobean motif of a steeple is also found surmounting the covers of earlier salts (**436**), but the lower section of the bell salt must have appealed to the popular demand and it is from this very form that the trencher salt evolves (**437**). There are naturally occasional throwbacks, as for instance the St George's Salts amongst the Coronation Regalia in the Tower of London.

In general, however, the trumpet form gradually became spool-shaped (pulley salt) and rising scrolls, attached to the upper rim, became more general by the reign of Charles I. Three American examples, one by Jeremiah Dummer, another by Allen & Edwards and one by Edward Winslow sur-vive. A salt made in St Andrews, Scotland, is one of the very rare pieces bearing the mark of that city. Napkins or a dish were now being substituted for the fitted silver cover. A particularly fine example of this type is that presented by the Corporation of Portsmouth to Queen Catherine of Braganza in 1662, which by 1693 had joined the collection of the Worshipful Company of Goldsmiths (Colour Plate **37**); known as the Seymour Salt this piece was seen by Pepys at Portsmouth in April 1662 when newly made. The famous Eddystone Salt, now the property of Plymouth Corporation, and modelled as the original lighthouse designed by Henry Winstanley, was made by one, Rowe of Plymouth, *c.* 1698 (**439**). It might, however, be equally designated as a spice box, having no less than six compartments. Last, but by no means least, there is the State Salt of the City of London made by Augustin Courtauld in 1730 (**440**). An ingenious adaptation of the Company's *raison d'être* is the salt of the Upholders' Company made in 1697 (**438**).

Bibliography
Hugh Tait, 'The Stonyhurst Salt'. *Apollo*, April 1964.
Sir C.J. Jackson, *An Illustrated History of English Plate.* 1911. (Extracts from wills and inventories pp. 571–2 and pp. 543–70.)
C.C. Oman, 'Guide to the Regalia and Plate of the City of Norwich'. *Connoisseur*, May 1964.
N.M. Penzer, 'Christ's Hospital Plate'. *Apollo*, July 1960.

Salt, Table and Trencher
The inconvenience of a central standing salt seems to have called into being a far smaller receptacle to place beside the trencher or platter, from which those at the table ate. No definite trencher salt earlier than 17th-century date is known, though the miniature standing salts may have been intended as such (**441** and **442**). Continental examples are, however, extant. A plain, circular, English example of 1603 is the earliest known and triangular trencher salts were in existence by 1607 (**444**). An example is illustrated in the catalogue of the Lee Collection, Royal Ontario Museum, Toronto. One of 1629 is engraved 'John Lane Vintner at ye mermaide neare Chearing Crosfe' (**444**). In the Burrell Collection, Glasgow, are two polygonal salts, one of 1635, the other of 1640. In a private collection are a pair of patty-pan form, hall-marked 1661. A set of six of 1667 are rare survivors (**445**). Samuel Pepys paid £6 14*s* 6*d* for 'a dozen of silver salts' on June 19th, 1665. A large set of twelve quatrefoil trencher salts, with a scroll handle in each of the indentations and bearing the London hall-marks for 1662, was formerly the property of the Painter-Stainers' Company. Six are now in the Untermyer Collection. The same Collection con-tains a set of four circular trencher salts of 1691,

with heavily knurled sides and on moulded rim feet, but a plain variety of truncated cone form survive and are illustrated on Plate **447**. Some of these have roped or knurled borders, basically a Continental form, therefore it is not surprising to find them made in Albany, New York, subject as it was to Dutch influence. Most unusual are the set of four triangular salts of 1669 date amongst the Burrell Collection, Glasgow. Octagonal salts of shaped outline, compressed, spherical (**446**) and rectangular examples with chamfered or in-curved corners, either raised or cast, were most fashionable during the first two decades of the 18th century. Double salts or spice boxes are known dating from *c.* 1700, one of the earliest being that in the Collection of Her Majesty the Queen. From 1720 to 1760 the circular or oval salt, at first on rim foot (**448** and **449**), later on three or four hoof feet, is by far the commonest (**450**). But finely cast and chased examples by leading makers, the spoons often with whip-thong handles replacing the earlier shovel-type spoons, are by no means rare (**450** and **451**). From 1760 to 1790 pierced, vase-shaped salt cellars (there are frequent references to 'Gothick' piercing in the Wakelin Ledgers) with coloured glass liners, following the Classical revival, are common, as are the two-handled boat- (**452**), basket- and tub-shaped examples. A further variety is of cut-glass with a silver stand. The late 18th and 19th centuries revived a number of designs including the more fantastic creations of silversmiths such as Nicholas Sprimont (**454**), Paul de Lamerie and Paul Storr (**453**). It is surprising that Storr was not above copying examples by his contemporary, J.B. Odiot of Paris.

Bibliography
Peter Wilding, *An Introduction to English Silver.* Art & Technic Ltd, 1950.
G.B. Hughes, *Small Antique Silverware.* Batsford, 1957.
Commander G.E.P. How, *Notes on Silver, no. 5.* 1946.
E.A. Jones, *The Gold and Silver of Windsor Castle.* Arden Press, 1911.
W.W. Watts, *Catalogue of the Lee Collection.* 1936.
See also Spice Box.

Salver and Waiter
The word 'salver' would seem to derive from the Spanish word *salva* (*salvar* meaning 'to preserve'), a reminder that it was necessaty to taste before eating or drinking, especially for the great and powerful during the Middle Ages, when fear and the real possibility of poisoning was rife. Thus, the food or drink was presented on the salver. It there-fore follows that any flat dish with or without feet or handles may be so called. The use of the word 'tazza' should, however, be restricted to the shal-low drinking bowl on a high foot, usually of 16th-century date, and wide, shallow bowls on a central foot are best described as 'dessert stands', espe-cially if pierced or decorated over most of their surface. Salvers with plain, flat surfaces are rarely found before the Restoration, but this is most probably due to the wholesale melting of plate during the Civil War rather than to their non-existence (**455**). It should be remembered when looking at early examples, that they were often associated with a cup, of porringer form, from which they may have been parted; this applies especially to those whose flanges are entirely chased with beasts and foliage. This, so-called 'stand' (a presentoire or presenter) is, nevertheless, a salver. It was considered a relative novelty in New England in 1661 (cf. Thomas Blount, *Glosso-*

427 Salad Dish
Silver-gilt, one of a pair.
Maker's mark of George Wickes.
Hall-mark for 1744.
Diam. 10 in. (25·4 cm.).

428 The Huntsman Salt
Parcel-gilt and rock-crystal,
with painted hands and face.
c. 1470.
Height 17¼ in. (43·8 cm.).
All Souls College, Oxford.

429 Standing Salt
Silver-gilt.
Unmarked, late 15th century.
Height 11¾ in. (29·9 cm.).
Corpus Christi College, Oxford.

427

428

429

430

430 A Pair of Standing Salts
Silver-gilt.
c. 1500.
Height 9¼ in. (23·5 cm.).
Christ's College, Cambridge.
Of hour-glass form. One cover is
of 19th-century manufacture.

431 Standing Salt
Re-gilt at a later date.
Maker's mark, a bird.
Hall-mark for 1569.
Height 12 in. (30·5 cm.).
Presented to the Vintners'
Company in 1702. The four sides
are embossed with the cardinal
virtues.

432 The Gibbon Salt
Maker's mark, three trefoils within
a trefoil.
Hall-mark for 1576.
Height 12 in. (30·5 cm.).
The Goldsmiths' Company.

431

432

433 The Stonyhurst Salt
Maker's mark, probably of John
Robinson (d. 1591).
Hall-mark for 1577.
British Museum.

434 The Vyvyan Salt
Painted glass panels.
Maker's mark, WH.
Hall-mark for 1592.
Height 15¾ in. (40·0 cm.).
Victoria and Albert Museum.

435 Standing Bell Salt
Hall-mark for 1594, London.
Height 9⅛ in. (23·2 cm.).
Victoria and Albert Museum.

436 The Rogers Salt
Silver-gilt and painted parchment.
Maker's mark, ID and a hart.
Hall-mark for 1601.
Height 22 in. (55·9 cm.).
The Goldsmiths' Company.

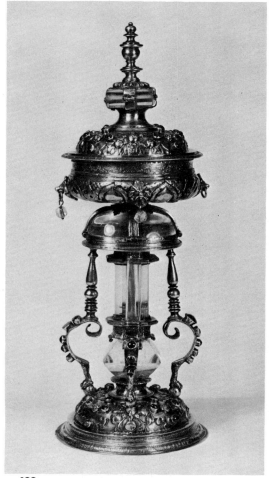

433

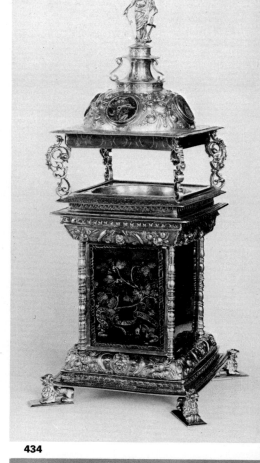

434

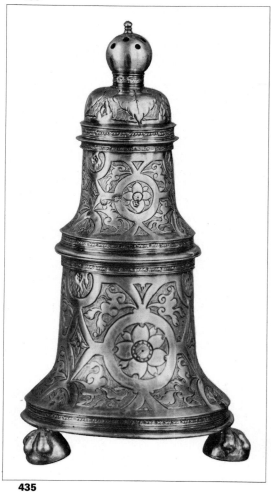

435

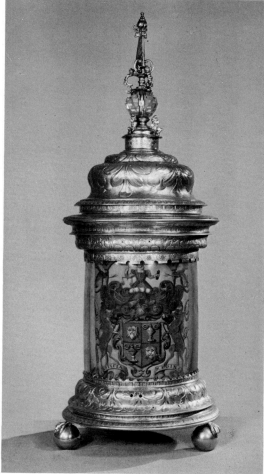

436

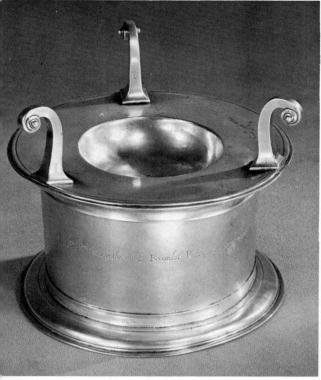

437

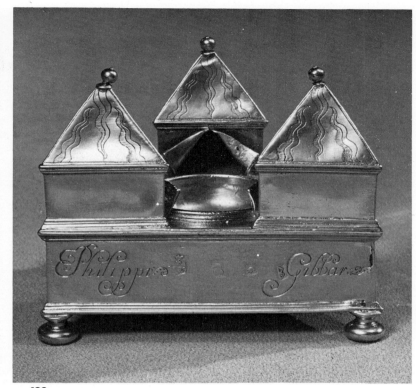

438

439

440

437 The Wrothe Salt
Maker's mark, TC in monogram.
Hall-mark for 1633.
Height 6½ in. (16·5 cm.).
Bridgwater, Somerset.
The scrolls are intended to support
a dish or napkin.

438 Salt
Silver-gilt.
Maker's mark of Louis Cuny.
Hall-mark for 1697.
Height 4⅝ in. (14·3 cm.).
The Upholders' Company.
Each corner forms a pavilion.

439 The Eddystone Salt
Maker's mark of Rowe of Plymouth.
c. 1698.
Plymouth Corporation.
Modelled on the original Eddystone
lighthouse, it might equally have
been used as a spice box as it has
no less than six compartments.

440 Salt
Maker's mark of Augustin Courtauld.
Hall-mark for 1730.
Height 10 in. (25·4 cm.).
Corporation of the City of London.
Intended 'for the Swordbearer's
table'.

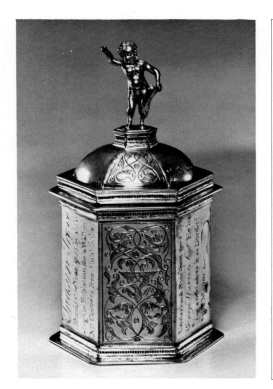

442

443

441 Hexagonal Salt
Re-gilt at a later date.
c. 1550.
Height 5½ in. (14·0 cm.).
The Goldsmiths' Company.
442 Salt
Hall-mark for 1563, London.
Height 6 in. (15·3 cm.).
Victoria and Albert Museum.
443 Bell Salt
Maker's mark, CB.
Hall-mark for 1586.
Engraved with the Arms of
Chorley, Lancashire.
444 Salt
Maker's mark, RA.
Hall-mark for 1629.
445 Set of Six Trencher Salts
Maker's mark, TK with a rosette
below.
Hall-mark for 1667.
446 A Pair of Trencher Salts
Maker's mark of R. Cooper.
Hall-mark for 1699.

444

445

446

230

phia). 17th-century examples are usually cir-
ar, on a central trumpet-shaped foot (**456** and
7), which on the better quality examples may be
t and domed, unscrewing from a calyx of cut-
d foliage (**460** and **461**). A remarkably fine
mple (though later) is the work of Paul de
merie, 1736. A plain, moulded border is usually
ociated with these latter examples. An excep-
n is that of 1660, amongst the Norwich Cathe-
l Plate, which has no border. Those with chased,
rled rims are often of thin metal. As a general
e of thumb, the word 'waiter' is today used to
scribe any salver or presenter whose diameter
width is less than 9 in. (22·9 cm.). This was not
essarily so during the 18th century, when the
rd 'waiter' was a more general term (**458**), in
t, many 18th-century waiters were also asso-
ted with toilet services and if finely engraved
most likely to derive from this source. In
rch 1773 Wakelin supplied Sir Robert Clayton
h a gadrooned waiter 16 in. (40·7 cm.) in dia-
ter.

3y 1715, the central foot was being supplanted
three, or more, feet beneath the rim and the
ge octafoil salvers begin to appear. Examples
nbining both of these styles occur, as in a pair
salvers at Pollock House, by James Kerr of
nburgh, c. 1730 (one of the detachable
tral feet is missing). With the tea and coffee
vices of that date were associated stands to
serve the surface of the table (**459**), but as late
1772 Messrs Wakelin sold 'a fine festooned
iter for a coffee pot'. The oblong salver,
erally with a border of shaped outline, appears
ut the year 1700, but is uncommon at all times,
circular, square and oval forms being most
ular and all these, when given two carrying
dles, being designated a 'tray'. In Scotland the
ly 18th century saw the production of a number
exceptional pieces of plate. A remarkable
agonal salver, with incurved 'heart' corners to
moulded border, made by William Aytoun,
nburgh, 1731, is a case in point. It is 13¾ in.
·0 cm.) in overall width. By the middle of the
ntury panels of fairly coarse chasing seem to
ve been the accepted fashion north of the
der.

The flat surface of the salver allowed ample
pe to the finest engravers of the day and it is
rth remembering that the production by hand,
m an ingot, of a large sheet of flat silver, is one
he most difficult feats of the silversmith's art.
shapes, the octafoil salver is one of the most
isfactory forms (**463**). Pieces such as the
are, Walpole Salver (**255**) were probably
ays intended for use as sideboard plate. En-
ving could be a costly business; nevertheless,
tain makers who specialised in the making of
vers and waiters, probably retained an en-
ver for the usual requirements of a client, such
his arms or crest, surrounded by a Baroque or
coco cartouche (**464**, **465** and **466**). The car-
che was often executed before the sale of the
ce and in some cases the vacant cartouche has
ver been filled. A fine 'decafoil' oval salver made
Henry Herbert in 1738 (**689**), from the Great
l of Queen Caroline and engraved with a repre-
tation of it, was presented to Kingston upon
ames by Speaker Onslow. About this date appear
earliest salvers given as race prizes (**467**).
ring the 1730s chased decoration also appears
l the varieties of cast border and ornamental
t are infinite, though generally based on the
ular Rococo motifs of shells and scrolls (**468**).
ugh some of the Huguenots, such as Lamerie
l Crespin, used pierced borders, it is not until

the early part of the reign of George III that, with
the Classical revival, this became usual; the cast
borders were made in sections and often crimped
to the main plate and usually struck with the
Sterling lion. Decoration follows the course of
fashion from now onward and with the Romantic
revival of the 1820s it was found that chased
decoration could reasonably be applied to the
whole surface. Whereas the fine engraving of the
18th century had suffered from constant use, the
coarser chasing withstood normal wear and tear
(**471**). Triangular salvers of mid 18th-century date,
competing with the circular kettle stands, were
never common. Extremely uncommon are quatre-
foil and five-sided waiters, both of which date
from the middle of the 18th century. A trefoil
example, on central foot, made by Edward Winslow
of Boston, c. 1720, is, so far, unique (**462**). The
same may also be said of the delightful fan-shaped
salver, 14 in. (35·6 cm.) radius, made by Phillips
Garden in 1756. From its first appearance, the
waiter mirrored in every respect the development
of the salver, though sets of salvers and waiters
(the latter often comprising four of the same size)
engraved with an escutcheon, often have the crest
only on the waiters. Sets of salvers and waiters
from the United States are very rare; three—one 14
in. (35·6 cm.), two 9½ in. (24.2 cm.) in diameter—
made by T. & A. Warner, Baltimore, c. 1810, are
amongst the collection of Philip Hammerslough.
Four gold circular salvers are known, one of 1821,
made by Phillip Rundell, in the Collection of Her
Majesty the Queen; one by Paul Storr, 1813, be-
longs to the Chatsworth Estates; another, again
made by Storr, 1801, was once in the collection of
the Duke of Rutland (**470**). In each case these were
made from presentation snuff boxes. A fourth on
central foot was made by Pierre Harache in 1691
and engraved with the cypher of King William III,
it may have been intended for use with a service of
Communion plate. Many, originally plain, 18th-
century salvers and waiters were given added
decoration during the 19th century and this, or the
removal of an original crest, often gives rise to a
slight 'bellying' of the flat surface, which latter may
be a guide, when in doubt, as to the later addition
or not of some part of the decoration. References
during the 18th century to 'solid silver tea-tables'
mean, with rare exceptions such as the Bowes
Kettle and Stand, circular salvers. Occasionally,
special wooden tables were made, having some-
times depressions in the wood to accept the feet
of the salver. These feet were at first of compressed
bun form, later hoof-shaped; in time they are
formed as scrolls, masks, and paws and, still later, a
claw holding a ball. Papier-mâché, japanned trays
made by Henry Clay of Birmingham are also found
with silver rims, usually bought from Matthew
Boulton during the 1780s. John Hervey, 1st Earl
of Bristol, in his book of expenses for 1696, writes:
'May 18th. Paid Mr. James Seamer ye goldsmith
for 2 table stands £15. June 23rd. Paid Mr.
Chambers and partner in full of their bill for ye silver
stand and salvers etc. £30'. A particularly fine,
American, circular salver, made by Lewis Fueter of
New York in 1772 (New-York Historical Society),
was presented to the King's Chief Engineer in
North America by Governor William Tryon and the
General Assembly of New York (**469**). There also
exists a circular salver, 15½ in. (39·4 cm.) in dia-
meter, with shell and scrollwork border, on three
scroll feet, the back is inscribed: 'Presented by
Thomas Bolsover of Whitely Wood Gent. the in-
ventor of Plating with silver, to his daughter Mary
on her marriage with Mr. Joseph Mitchell of Shef-
field, Feby.14.1760'. The front is engraved with

the cypher M.M. for Mary Mitchell. It is recorded as
in the possession of one, Samuel Mitchell, in 1840
who in a letter to the *Sheffield Mercury* on Sep-
tember 17th, 1840 says: 'he [Boulsover] at first
confined his attention to snuff boxes, and to other
small articles; but he gradually extended it to
plates and dishes, waiters, salvers etc. A beautiful
specimen of the latter article, of his own manu-
facture, the workmanship of which, especially as
to the border and the chasing, would not disgrace
any house now engaged in this branch of business,
was presented by him to his eldest daughter, on her
marriage with Mr. Joseph Mitchell merchant Feb.
14th 1760'. Mr Boulsover presented a similar
salver to his younger daughter Sarah, on her mar-
riage to Mr William Hutton.

Bibliography
G.B.Hughes, 'Silver Salvers, Waiters and Trays'.
Country Life, September 29th, 1950.
S.C.Dixon, *English Decorated Gold and Silver
Trays*. Ceramic Book Society, 1964.
G.B.Hughes, 'The Vogue for Footed Salvers'.
Country Life, October 1965.
A.G.Grimwade, 'Family Silver of three centuries'.
Apollo, December 1965.
Montague Weekley, 'Thomas Bewick and a Hunts-
man's Salver'. *Country Life*, March 7th, 1968.
See also Stand; Tazza; Teapot; Tray.

Sanctuary Lamp

A bowl-like object, suspended by chains above the
altar of a Catholic or High Anglican church, which
normally holds sufficient oil for a single light for
several days' burning. No medieval examples are
known to survive; indeed less than six are recorded
earlier than 1800. There is a worn example of
about 1670 at Broughton Hall. Two more survive
at Arundel Castle, one 1700, the other 1789. That
in the Victoria and Albert Museum of about 1725 is
particularly fine and of Continental inspiration. All
these are Recusant in origin. Not until the late 19th
century can one expect the reappearance of such
pieces in an Anglican church.

Bibliography
C.C.Oman, *English Church Plate*. Oxford Univer-
sity Press, 1957.
See also Lamp, Sabbath; Recusant Plate.

Sanderson, Robert (1608–93)

Originally apprenticed in 1623 to William Rawlins
of London for nine years, he later worked in Boston,
Massachusetts, and joined John Hull (1624–83)
as his moneyer when Hull was appointed to coin
the 'Pine Tree' shillings in 1652. The majority of
his surviving work comprises ecclesiastical plate.
A caudle cup chased with a turkey, having Sander-
son's mark only, in the Henry du Pont Museum,
Winterthur, can hardly be much earlier than 1660.
The earliest known piece showing the marks of
both Sanderson and Hull is a two-handled dram
cup of about 1651 in the Garvan Collection, Yale
University Art Gallery. Sanderson was possibly
responsible for the actual silversmithing rather
than the business side of the venture.
See also Hull, John; Hull & Sanderson.

Sauce Boat and Tureen

These, an innovation of the reign of George I, were
at first of double-lipped form with a handle at
either side and on an oval or octagonal foot. The
waved rim is frequently so made as to cause the
contents to overflow when an attempt is made to
pour from either lip, none the less early sauce
ladles are extremely rare (**472**). A pair of sauce
boats of 1719 made by Paul de Lamerie are
amongst the Widener Gift to the Metropolitan

447 Table Salts
Left: maker's mark of Simon Pantin.
Hall-mark for 1707, London.
Centre: hall-mark for 1695.
Height 2½ in. (6·4 cm.).
Right: second half of the 17th
century.
Height 1⅛ in. (2·9 cm.).
Victoria and Albert Museum.

**448 Set of Four
Trencher Salts**
Maker's mark of William Ged.
Hall-mark for 1710, Edinburgh.

449 Salt
One of a set of three.
Maker's mark of Louis Cuny.
Hall-mark for 1729.
Diam. 3½ in. (8·9 cm.).

450 Salt
One of a set of four.
Unmarked, but perhaps the work of
Nicholas Sprimont or Paul Crespin.
c. 1740.

447

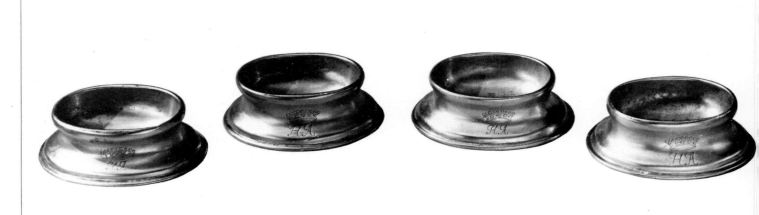

448

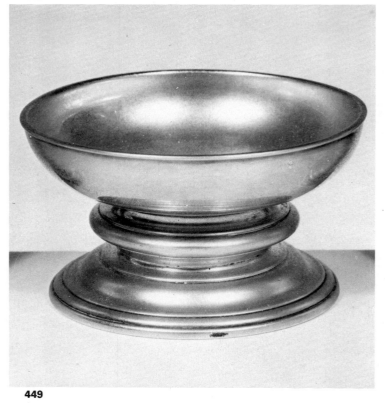

449

450

451

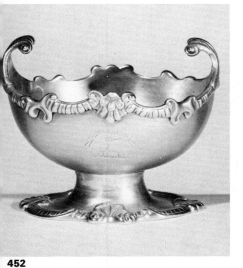

452

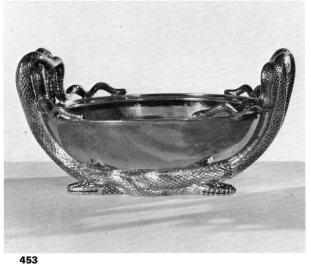

453

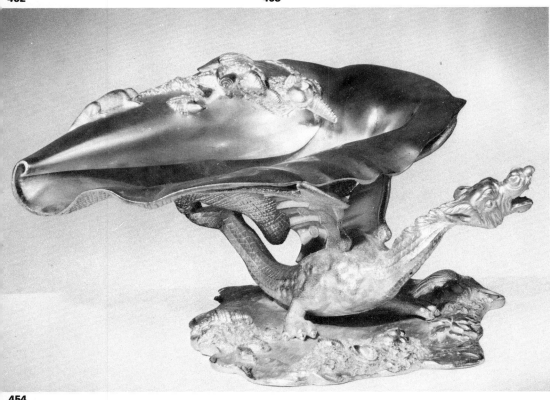

454

456

455 Salver on Central Foot
Maker's mark, AM in monogram,
possibly the mark of Andrew Moore.
Hall-mark for 1657.
Diam. 15¼ in. (38·8 cm.).
Engraved with the Arms of Chester
of Amesbury.

456 Salver on Central Foot
Maker's mark of James Penman
of Edinburgh.
c. 1675.
Diam. 13 in. (33·1 cm.).
Engraved with the Arms of Hogg
of Cammo.

457 Salver on Central Foot
(Three views.)
Maker's mark of Edward Winslow
of Boston.
c. 1700.
Diam. 9¾ in. (24·8 cm.).

458 Salver on Central Foot
Maker's mark of Philip Rollos.
Hall-mark for 1704.
Diam. 7 in. (17·8 cm.).
Engraved with the Arms of Bisse.

459 Salver or Tea Tray
Maker's mark of Joseph Walker.
Hall-mark for 1705, Dublin.
Width 17 in. (43·2 cm.).
Ashmolean Museum.
Engraved with the Arms of
Tichborne.

458

457

459

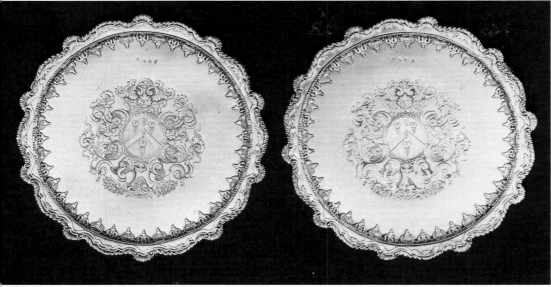

460

460 A Pair of Salvers
Each on central foot.
Maker's mark of Simon Pantin.
Hall-mark for 1713.
Diam. 14½ in. (36·9 cm.).
Engraved with the Arms of
Featherstone of Blacksware,
Hertfordshire.

461 A Pair of Salvers
Each on central foot, one showing
the underside of the salver and
the foot unscrewed.
Maker's mark of David Willaume.
Hall-mark for 1720.
Diam. 7 in. (17·8 cm.).
Engraved with the Arms of Henry
Moore, 4th Earl of Drogheda,
impaling Boscawen.

462 Trefoil Salver
Maker's mark of Edward Winslow
of Boston.
Early 18th century.
Height 2⅛ in. (5·4 cm.).
Art Institute of Chicago.

463 Octafoil Salver
On four feet.
Maker's mark of John East.
Hall-mark for 1720.
Diam. 11 in. (28·0 cm.).

461

462

463

235

464 Salver on Four Feet
Maker's mark of John Tuite.
Hall-mark for 1731.
Width 12 in. (30·5 cm.).
Engraved with the Arms of Gandy.
465 Salver
Maker's mark of John Hamilton.
Hall-mark for 1737, Dublin.
Width 15½ in. (39·4 cm.).
Engraved with the Arms of Burton
quartering Campbell, impaling
Ponsonby.
466 Lord Mayor's Dish
Maker's mark of Joseph Sanders.
Hall-mark for 1737.
Diam. 19 in. (48·3 cm.).
Presented to the Lord Mayor of
the City of London by the
Jewish Community then residing
in the City.

467 Salver
Maker's mark, probably that of
John Hamilton.
Hall-mark for 1739, Dublin.
National Museum of Ireland.
It was presented as a race prize.
468 Salver
One of a pair.
Maker's mark of Paul de Lamerie.
Hall-mark for 1745.
Diam. 10 in. (25·4 cm.).
Engraved with the Arms of Coote
impaling Newport.

464

465

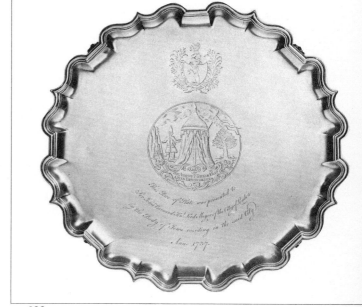

466

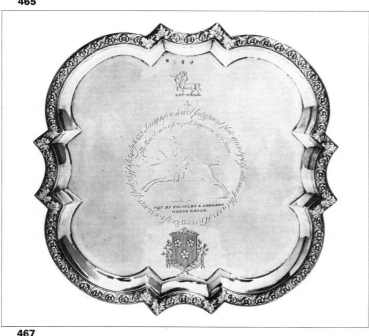

467

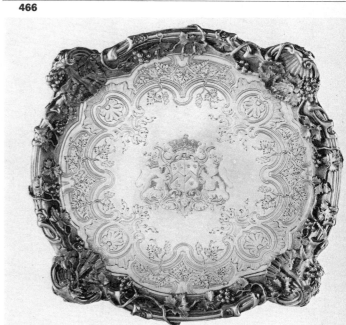

468

Plate 33

Plate 33 The Winchester Porringer

Of silver-gilt with the maker's mark, TM conjoined.
Hall-mark for 1675.
Height 10 in. (25·4 cm.).
This porringer was purchased (with a legacy of £40 given by Anne, Dowager Countess of Pembroke and Montgomery) by George Morley, Bishop of Winchester.
The Queen's College, Oxford.

Plate 34 Salts and Sauce Boat

The crab salt is of silver-gilt and one of a pair.
Maker's mark of Nicholas Sprimont.
Hall-mark for 1742, London.
Length 7⅞ in. (20·0 cm.).
The lobster salt is also of silver-gilt and one of a pair.
Hall-mark for 1742, London.
Length 5 in. (12·7 cm.).
This salt takes the form of a lobster on a base of rocks and shells.
The sauce boat is one of four.
Maker's mark of Nicholas Sprimont.
Hall-mark for 1743–4, London.
Height 9 in. (22·9 cm.).
Collection of Her Majesty the Queen.

Plate 34

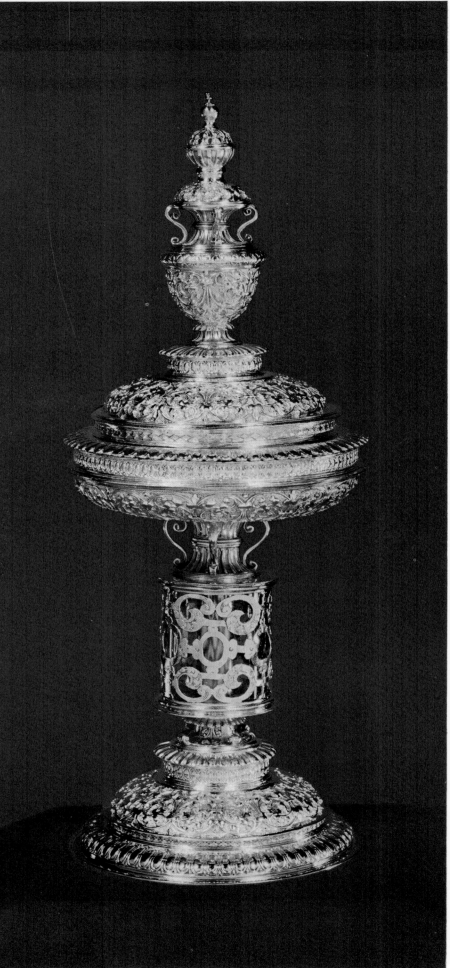

Plate 35

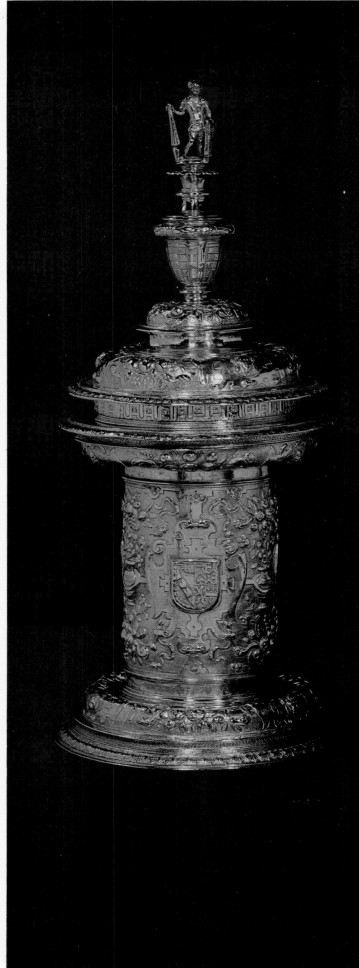

Plate 36

Plate 37

Plate 35 Silver-gilt and Rock-crystal Salt
Unmarked, *c.* 1610.
Height 10 in. (25·4 cm.).
A small group of pieces, similarly decorated, are known; two have hall-marks for 1611, the maker's mark in each case being TYL (or TYZ).
From the Woburn Abbey Collection, by kind permission of His Grace the Duke of Bedford.

Plate 36 The Peterson Cup and Reade Salt
The silver-gilt Peterson Cup bears the maker's mark, an orb and cross.
Norwich hall-mark, 1574.
Height 5¾ in. (14·6 cm.).
The Reade Salt also bears the maker's mark, an orb and cross, the mark of William Cobbold.
Hall-mark for 1568.
Height 15¼ in. (38·8 cm.).
Corporation of Norwich, Norfolk.

Plate 37 The Seymour Salt
A silver-gilt standing cup.
The maker's mark is indecipherable.
Height 10½ in. (26·7 cm.).
This piece was seen by Samuel Pepys at Portsmouth in April 1662 when newly made.
The Worshipful Company of Goldsmiths, London.

239

Plate 38 A Pair of Silver-gilt Arm Sconces
Maker's mark, I L with a coronet above.
Hall-mark for 1684.
Victoria and Albert Museum, London.

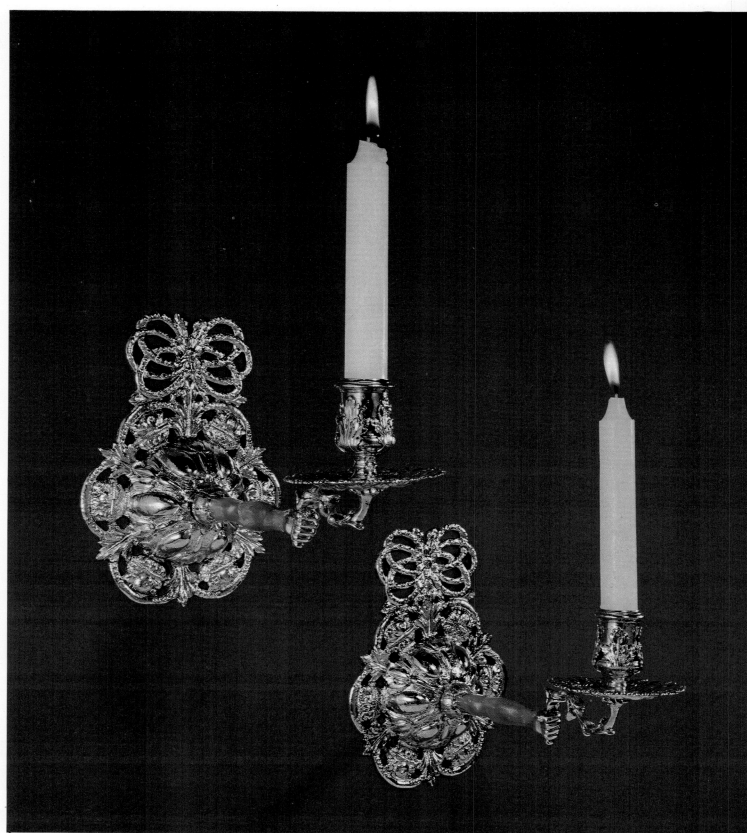

Plate 38

useum of Art, New York. A finely decorated pair
René Hudell, 1720, are in the Morrison Collec-
n, New York, and a very rare American pair, the
rk of Abraham le Roux of New York, c. 1735,
the property of the Sarah Wister Starr Estate.
e double-lipped variety survived until the 1730s.
air by William Partis of Newcastle is known as
ne from Edinburgh, but from 1726 onwards the
gle form with a scroll handle at one end be-
mes more and more usual (**475** and **476**). By
40 the bowl is supported upon three feet, the
al foot having survived until this time (**480**). The
r of 1727 by Anne Tanqueray are well in advance
their time and the dictates of fashion (**474**),
ile the set of eight, on oval feet, once in the
hburnham Collection, made by Edward Wakelin
1755, are the very opposite. Circular sauce boats
h one handle to the side are rare (**481**), at least
e survives from Newcastle, the work of Thomas
oddart, 1743, and an American example, at the
eveland Museum of Art, has only a maker's mark,
. The bowl of a sauce boat is variously decor-
d, from the quite plain variety (**478** and **479**) to
e most extravagant of Rococo forms (**482**, **483**
d **484**). Colour Plate **34** illustrates a sauce boat,
e of four, made by Nicholas Sprimont during the
ars 1743–4; the seated figure is that of Venus
d it is 9 in. (22·9 cm.) in height. A pair in the
coco style made by Edward Wakelin in 1755
re formed as nautilus shells. The occasional
ppearance of the double-lipped form is almost
ways as an enlargement of existing sets. Those
strated on Plate **473** are most unusual. A large
ner service might well include oval stands for the
ice boats (**477**). By 1765 the incoming Classical
te and the fashionable vase form brought into
ng the two-handled, vase-shaped sauce tureen,
en still referred to as 'boat-shaped'; a form
ich encouraged the creation of great matched
vices, with pairs of tureens each with sauce
ats, sometimes covered, and salt cellars en suite
85). As with the double-lipped sauce boat, so
e early sauce tureen had a moulded foot, if any
86 and **487**), and it is not until c. 1810 that the
r-footed variety generally appears (**490**). Mean-
ile, all sorts of variations on the vase or boat
ape were practised (**488**) and a number of
ations by Paul Storr, Digby Scott, Benjamin
ith and John Edwards leaves some doubt as to
ir intended purpose, whether for sauce, sugar
merely as centrepieces (**489**). Only very rarely
es the double-lipped variety reappear in the 19th
ntury, perhaps the latest being those at Windsor
1803. A pair of particularly fine Classical sauce
ats with serpent handles is that by A. Rasch
Co., Philadelphia, c. 1810, now in the Metro-
litan Museum of Art, New York.
e also Argyll; Tureen, Soup.

uce Ladle

e Ladle, Soup, Sauce, Sugar and Cream.

ucepan

any examples survive, although the vast majority
them are of 18th-century date. It cannot be
nied that a number of mid 18th-century sauce-
ns were used for heating brandy, nevertheless
call them all, or even all the smaller ones,
andy' saucepans is a misnomer. 'Pannikan'
anneken) survived as a description of a sauce-
n, even in England, until very recently. 17th-
ntury saucepans are uncommon, though a few
ep bowls with a flat handle, similar to the
eding-bowl form have survived; one such
ample made by John Douthwaite, Newcastle,
1675, has the sides chased with flowers and

foliage. The saucepan should, however, not be
confused with the skillet, which has feet.

There are two varieties of the 18th-century
saucepan. The first is circular and of baluster form
with a wooden handle at right angles to the spout;
some are very small, others considerably larger
(**491**). Frequently the marks, especially if on the
base, have been blurred by continuous heating over
a spirit flame, and the spout may be absent on the
smallest. Rarely are they found with matching
lamp and stand. Of Plymouth and Exeter manu-
facture is a particular variety, which has a silver,
double scroll handle as opposed to a wooden one.
Large examples were made with covers, those of a
later date even having a hinged flap to the spout.
Occasionally, examples of the unadorned kitchen
saucepan and cover are found entirely of silver
(**493**); even a preserving pan of 1803 is known
(**494**). A particularly attractive saucepan and cover
made by Hester Bateman in 1787 is now in the Art
Institute of Chicago (**492**).

The second main type has a relatively shallow,
cylindrical body with everted lip and stands on a
moulded foot. This is, like the first type, usually
plain and generally not found after c. 1770. Pos-
sibly the finest is a gilt example, with cast and
applied shell and scroll rim and sides, made by
Joseph Sanders in 1743. This has two interesting
additional features, the foot moulding is pierced to
allow for the easier circulation of the heat and it
has also a spoon decorated in the same manner,
though unmarked. It is of such quality as to give the
impression that it was made for a client who pro-
posed to enjoy indifferent health—and his brandy—
for some time (private collection).
See also Potato Pasty-pan; Skillet; Stewpan.

Saucer

Initially a shallow bowl or dish in which to mix a
sauce. A number of 17th-century dishes, some
of up to 6 in. (15·3 cm.) in diameter, with or with-
out handles and embossed with either fluted or
beaded decoration, or both, are probably those
referred to in contemporary writings as 'sawcers'
(**495** and **496**). An extremely rare Scottish example
made by T. Clyghane of Edinburgh, between the
years 1646 and 1648, survives, and another by
Thomas Moncrieff, Aberdeen, 1749, was noted by
Commander G.E.P. How. The Duchess of Marl-
borough's patty-pans might also have been used
as saucers when custom encouraged the use of
small side dishes for a variety of purposes. The
bowl of one of the stands (trembleuse) for six
chocolate cups of 1713 is engraved 'these six
saucers' thus showing the transfer of purpose from
the original use of the piece, above described as
being for mixing, to that of carrying. An inventory
of the goods of Sir John Fastolfe in 1459 records
thirty-six various 'Sawsers of silver'. A surtout
(epergne) supplied by Paul de Lamerie to George
Treby in the 1720s was fitted with 'saucers'.
Bibliography
Commander G.E.P. How, *Notes on Silver, no. 6*.
1948.
See also Quaich; Sweetmeat Dish; Wine Taster.

Scales

John Hervey, 1st Earl of Bristol, records in his diary
on December 16th, 1692 'Paid Mr. Robert Fowle,
in full for ... and a silver pair of scales'. Occasional
examples are found in this metal throughout the
18th and 19th centuries. They seem to have been
a fairly general article amongst the equipment of
any merchant, banker or person having cause to
deal in coin. During the period prior to the intro-
duction of milled coin, when clipping was a fre-

quent malpractice, such ready means of checking
one's change was a necessity. Generally, brass
scales were considered adequate. A pair of silver
beam scales made by Charles Freeth, Birmingham,
1796, 7 in. (17·8 cm.) high, is preserved at the
Birmingham Assay Office. Of extreme rarity is the
surviving pan of a pair of 13th-century scales, now
preserved in the library of Winchester Cathedral.
The pan is struck in its base with the figure of a
horseman, with a conical helmet and with a
sword (or perhaps falcon) in his outstretched left
hand. There is a possibility that this may be some
form of guarantee mark.

Scent Bottle

Pocket scent bottles were made in rock-crystal,
silver and gold. Usually of flattened bottle form
they are rarely marked. A fine gilt example of c.
1680, in the Victoria and Albert Museum, is en-
graved with a cherub, amidst scrolling foliage.
Glass, either mounted or wholly encased, usually
in gold, was a favourite form of the scent bottle from
1760 onwards.
See also Toilet Service.

Scent Dabber

This probable use of a small spool-shaped object
with silver mounts at one end is purely theoretical.
Only one such has ever been recognised, and this
by virtue of its association with a toilet service
made by Daniel Garnier, c. 1680, now in a private
collection.
See also Toilet Service.

Scent Flask

All surviving examples are Tudor or Jacobean and
consequently extremely rare. Those known are
often chased and embossed with strapwork, some-
times with additional fruit and foliage decoration.
They usually all have pierced covers, while those
of pilgrim-bottle form also have pendent chains.
A scent flask of 1546 is in the Victoria and Albert
Museum, as is another of vase form dated 1563. A
third of the same date is in a private collection, as is
another of 1577. They should not be confused with
spirit flasks or pocket scent bottles, such as a fine
gilt example of c. 1680 in the Victoria and Albert
Museum. Two scent flasks, one hall-marked 1581,
in the Lee Collection (Royal Ontario Museum,
Toronto) have been described as 'pepper pots' in
the catalogue of 1936. By the late 17th century
there was a considerable export trade in blue and
white glass perfume bottles, with long tubular
necks. These are also occasionally found encased
in filigree silver, but no known English example,
having hall-marks, is yet recorded.
Bibliography
Commander G.E.P. How, *Notes on Silver, no. 2*.
1942.
W.W. Watts, *Catalogue of the Lee Collection*. 1936.
See also Pilgrim Bottle; Pomander.

Scissors

At least two pairs of scissors dating from the reign
of Charles I have survived; the earlier engraved
1630; in each case the silver handles have steel
blades bearing a cutler's mark, S. The earlier
retains its tooled leather case. This form of scissors,
with silver loop handles, continued to be made until
the end of the 19th century and examples later than
1780 are not uncommon. Snuffer scissors of steel
often have similar handles.
See also Razor Case.

Scissors, Grape

Rarely found earlier than 1800, a very few of late

469

470

471

472

473

474

475

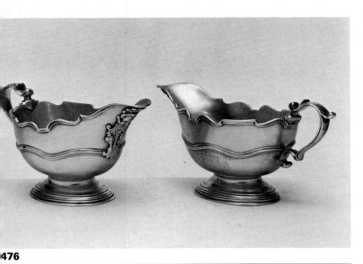

476

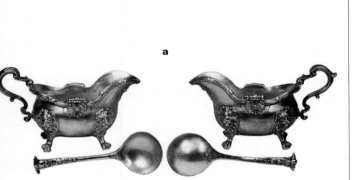

a

b

477

469 Salver
Maker's mark of Lewis Fueter of
New York.
New-York Historical Society.
It was presented to a Captain
Sowers in 1773.

470 The Rutland Salver
Gold.
Maker's mark of Paul Storr.
Hall-mark for 1801.
Diam. 12½ in. (31·8 cm.).
It was made from presentation
gold snuff boxes.

471 Salver
Silver-gilt.
Maker's mark, E B.
Hall-mark for 1825.
Diam. 25½ in. (64·8 cm.).
Engraved with the Arms of Adolphus
Frederick, Duke of Cambridge.

**472 A Pair of Double-lipped
Sauce Boats**
Maker's mark of James Fraillon.
Hall-mark for 1717.
Length 8½ in. (21·6 cm.).
Engraved with the Arms of Foster
of York impaling Whitmore of Apley,
Shropshire.

**473 Double-lipped
Sauce Boats**
Two of a set of four.
Maker's mark of Eliza Godfrey.
Hall-mark for 1764, London.

474 A Pair of Sauce Boats
Maker's mark of Anne Tanqueray.
Hall-mark for 1727.

475 A Pair of Sauce Boats
Maker's mark of Peter Archambo.
Hall-mark for 1729.

476 A Pair of Sauce Boats
Maker's mark of John Edwards.
Hall-mark for 1729.
Width 8¼ in. (21·0 cm.).

**477 A Pair of Sauce Boats,
Stands and Ladles**
Maker's mark of Paul de Lamerie.
Applied with the Arms of Yorke of
Erddig, Denbighshire.
a. Sauce boats: hall-mark for 1733.
b. Stands: hall-mark for 1739.

478 A Pair of Sauce Boats
Maker's mark of Aymé Videau.
Hall-mark for 1735.
Width 8¼ in. (21·0 cm.).

479 A Pair of Sauce Boats
Maker's mark of John Williamson.
Hall-mark for 1737, Dublin.

480 A Pair of Sauce Boats
Maker's mark of David Willaume.
Hall-mark for 1738.
Height 5¾ in. (14·6 cm.).
The Honourable Society of the
Inner Temple.

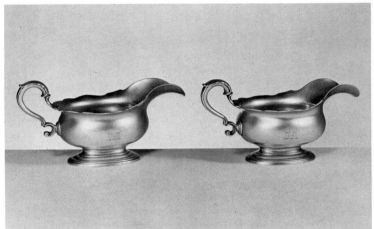

479

478

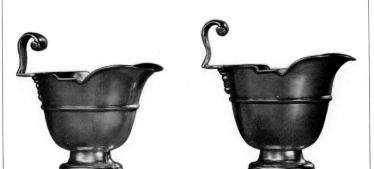

480

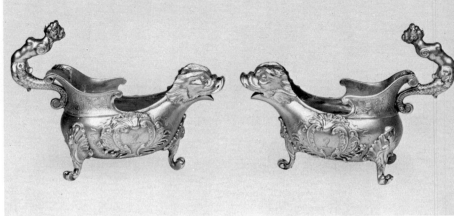

482

481 Sauce Boat
Maker's mark of Edward Feline.
Hall-mark for 1740.
Diam. 4⅝ in. (11·8 cm.).
Engraved beneath 'The Gift of Mrs
Mary Bellamy. R.C. 1740'.

482 A Pair of Sauce Boats
Maker's mark of William Kidney.
Hall-mark for 1739.

483 Sauce Boat and Ladle
One of a pair.
Maker's mark of Isaac Duke.
Hall-mark for 1747.
Width 8¾ in. (22·3 cm.).

484 Sauce Boat
One of a pair.
Maker's mark of William Cripps.
Hall-mark for 1749.
Height 9 in. (22·9 cm.).

485 A Service of Sauce Boats
Maker's mark of Robert Hennell.
Hall-mark for 1780, London.
This service was made for Charles
Manners, 4th Duke of Rutland.

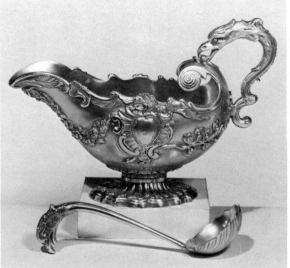

483

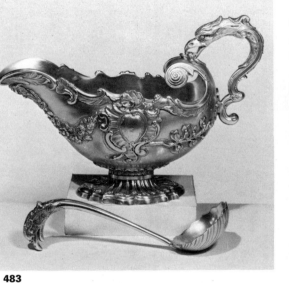

484

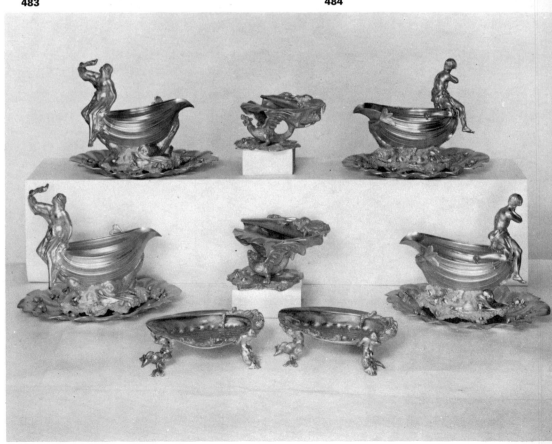

485

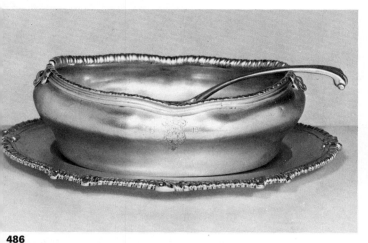

486

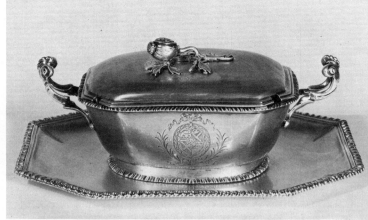

487

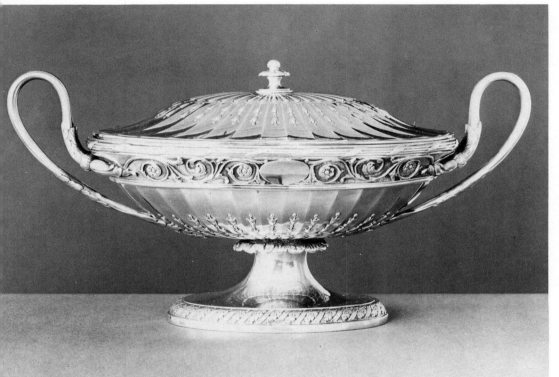

488

486 Sauce Tureen, Stand and Ladle
Maker's mark of Thomas Heming.
Hall-mark for 1761.
Part of an issue of ambassadorial plate.

487 Sauce Tureen and Stand
One of a set of four.
Maker's mark, DW in script.
Hall-mark for 1771.
Width 8¾ in. (22·3 cm.).

488 Sauce Tureen and Cover
Maker's mark of Boulton & Fothergill.
Hall-mark for 1776, Birmingham.
Overall length 10½ in. (26·7 cm.).
Victoria and Albert Museum.

489 Sauce Tureen and Cover
One of a set of four.
Maker's mark of John Robins.
Hall-mark for 1804.
Width 6¾ in. (17·2 cm.).

490 Sauce Tureen and Cover
One of a set of four.
Maker's mark of Paul Storr.
Hall-mark for 1811.
Engraved with the Arms of Richard Butler, 11th Baron Caher.

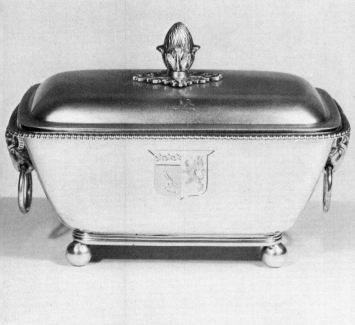

489

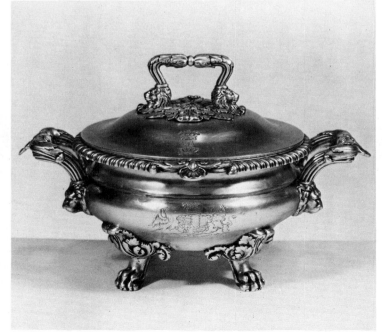

490

491 Brandy Saucepan
Maker's mark of David Willaume,
Junior.
Hall-mark for 1743.

492 Brandy Saucepan
Maker's mark of Hester Bateman.
Hall-mark for 1787, London.
Height 6½ in. (16·5 cm.).
Art Institute of Chicago.
It has a hinged cover.

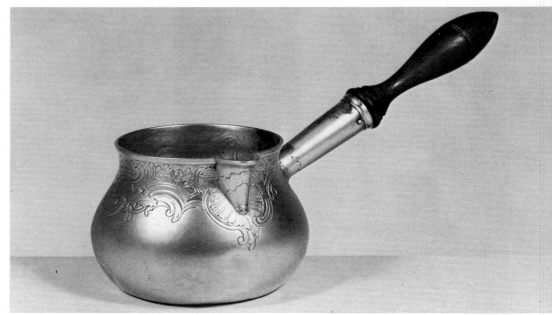

491

492

493 Chafing Dish, Stand and Lamp
Maker's mark of Peter Archambo and Peter Meuse.
Dish: hall-mark for 1754.
Cover: hall-mark for 1752.

494 Preserving Pan
Maker's mark illegible.
Hall-mark for 1803.

495 Saucer
Hall-mark for 1634.

496 Saucer
Maker's mark of William Maundy.
Hall-mark for 1634.
Diam. 5⅜ in. (13·7 cm.).

493

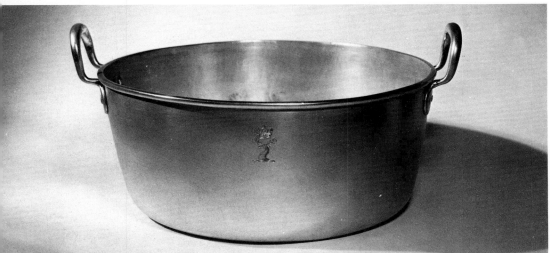

494

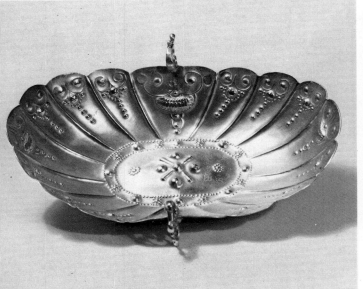

495

496

18th-century date are known. The earliest are plain with ring handles, and the blades are similar to those of sewing scissors; later the handles may be decorated with vine foliage and one blade usually engages with the other in the manner of a pair of modern secateurs. The improved design helped the relatively soft silver to retain an effective cutting edge for a longer period. Large canteens of table silver often incorporated two pairs. Plated examples are comparatively common.

See also Asparagus Tongs.

Sconce

On January 17th, 1699 'Paid David Williams for ye silver borders of 8 glass sconces for the drawing room weighing 231 oz. 13 dwts. £75.5.0'. So records the diary of John Hervey, 1st Earl of Bristol; three days later he purchased two more sconces and two 'Chimney Sconces all of silver'. Seemingly no sconces survived the Civil War, although Charles I possessed at least four at his death. The principle of the sconce was to magnify the light of one or more candles by a reflector, either of silver or glass, in front of which the candle was supported in a socket at the end of a fixed or swivel branch (**497** and **502**). Alternatively, a bowed gallery bearing the socket might be affixed at the base of the wall plate (**499**); the socket may be pierced to aid the removal of the spent candles. A small pair of silver-gilt sconces, having the branches formed as human arms, have London hall-marks for 1684 (Colour Plate **38**). These are extremely rare, although Continental examples are known. Examples of many sizes are found, some incorporating wood (**498**), tortoiseshell or silver-bordered glass. A pair by Jacob Hurd in the Henry du Pont Museum, Winterthur, have quillwork plates. A warrant for July 1st, 1691 reads 'for ye Queenes Mates service in the Gallery At Kensington twenty foure New Silver Sconces with looking-glasses in them as ye Queen has approved of'. Four such, made by John Boddington c. 1700, survive in the collection of the Duke of Devonshire. They are 16 in. (40.7 cm.) in height and gilt. Mirrors with swivelling candle branches, placed half-way up on either side, were probably intended for the dressing room; if the flame were too low down there would be little effective reflection. In general, a tall narrow back plate (**503**) is less common than the broader variety as it tended to defeat its own purpose. One of the finest of these is that of the Bank of England, made by John Bache in 1699 (**499**). Large sets of sconces were by no means uncommon in the houses of the great, a set of twelve of 1685, form part of the twenty-six surviving at Knole. Four sconces, each 23¼ in. (59.1 cm.) high and chased with the figures of Juno, Athena, Mars and Ceres are amongst the earliest known. Two are hall-marked 1668, whilst two have a maker's mark only. These were almost certainly once part of the Royal Plate, like those of the same date in the collection of the Duke of Buccleuch. In 1721, there were known to be fifty sconces at Windsor Castle. Few exist of later date than the reign of George I, although Frederick, Prince of Wales, ordered a set of eighteen from George Wickes in February 1738. A superb pair of double-branched sconces, made by Paul de Lamerie c. 1725, bearing the Arms of Thomas, 2nd Baron Foley, spent the Second World War buried in the garden of their owner's Channel Islands home. A pair of Classical form by Paul Storr (1804) are at Brodick Castle and a pair by John Emes are at the Queen's College, Oxford. In spite of the better reflecting qualities of plain silver, such as the pair made by William Scarlett in 1698, engraved with the Arms of

the 9th Earl of Derby (City of Liverpool Museum), the majority of surviving examples are richly chased with flowers, scrolling foliage and amorini (**501**). The solitary known pair from Scotland, at Hopetoun, are the work of James Penman, Edinburgh, 1698. A set of eight of c. 1700 from the Sneyd heirlooms are now at Colonial Williamsburg, Virginia, and four single examples also from the same source are illustrated on Plate **500**. Royal sconces were usually additionally decorated with applied Royal cyphers and surmounted by a crown, often changed at the beginning of a new reign, though in one case the whole back plate is pierced as a cypher. A flat strap at the reverse of the reflector allowed it to be hooked into place on the wall. A pair by John Fawdery, 1702, now in the Metropolitan Museum of Art, New York, have the nozzles formed as petals. Sconces, because of their daily use, received harsher treatment than most 'great plate'. Repairs to sconces in the Royal Palaces are frequent entries in the Jewel Office books of the late 17th and early 18th centuries. In 1735 'ten pickture sconces' were sent for repair. It may be that these were of similar form to those of 1668, referred to above, or the set of six 'Judgement of Solomon' sconces still in the Royal Collection. Both sets have been considerably altered and added to, but are basically of c. 1670 date. A pair, of Sheffield plate, now at the Henry du Pont Museum, Winterthur, are of extreme rarity. At Mount Vernon there still survive a pair of sconces burning oil on the Argand principle. They too are of Sheffield plate (**504**).

Bibliography

E. A. Jones, *The Gold and Silver at Windsor Castle*. Arden Press, 1911.

R. W. Symonds, 'Lighting the 18th century Home'. *Country Life Annual*, 1958.

N. M. Penzer, 'The Plate at Knole'. *Connoisseur*, April 1961.

E. A. Jones, 'More Old English Silver in the W. R. Hearst Collection'. *Connoisseur*, vol. LXXXVIII, p 395.

See also Argand, Aimé; Chandelier.

Scorper

A small chisel for engraving; it has blades of various shapes.

Scotia

Half-round concave moulding; reverse of astragal. See also Astragal.

Scottish Silver

Early Scottish and Irish metalwork has many features in common. The Celtic Church varied much in practice and ritual from the Church of Rome, so it is not surprising that book and bell shrines and croziers of a peculiar form are common to both the Celtic Churches of Scotland and Ireland as late as the 12th century. In the main, silver was more lavishly used in Scotland than in Ireland on the mounts of such pieces, the main frame generally being of bronze. In the case of brooches, this tendency is even more pronounced. Survivals from this early period are, however, rare and no hard and fast conclusions should be drawn from them. Perhaps the most famous of these Scottish survivals are the following three pieces. The Monymusk Reliquary, traditionally made during the 7th or 8th centuries to contain the psalter of St Columba. It was carried at the Battle of Bannockburn (1314) by the Abbot of Arbroath, when it justified its reputation as a 'Battler' (National Museum of Antiquities, Edinburgh). The second piece is the Quigrich (or crozier case) of St Fillan, also thought

to have been carried at Bannockburn. The ou case is of silver-gilt, the inner (earlier) of bron Unlike the Monymusk Reliquary, the outer case the Quigrich is undoubtedly Scottish but o' much later date, possibly 14th century (Natio Museum of Antiquities, Edinburgh). The third is Hunterston Brooch, of silver, gold and amber wholly enclosed ring type; another variety ha broken ring); it may be dated about AD 750, bu bears two Runic inscriptions of later date (Natio Museum of Antiquities, Edinburgh). Pieces fro this period of Scottish history have been found only in Great Britain but also Scandinavia. This not such a surprising fact when the nature of the disturbed times and the frequent Viking attacks borne in mind. By the 12th century those who h preserved the Celtic Church in Scotland (the l strongholds were in the east and north-ea finally surrendered to the authority of Rome duri the reign of King David I.

The coming of Norman influence to Scotla was helped by the same King's policy of granti land to men of Norman extraction, so that the end of the 12th century both the Court a Church were sympathetic only to Romanesque No goldsmith's work survives from this peri and from this we assume that much must have be imported. Edward I of England (1272–130 looted the great abbeys of Scotland. In 1296 plate of Cupar Abbey was 'delivered to Adam King's goldsmith at Westminster to be broken by order of the King to make thereof new dish for the Lady Elizabeth the King's daughter'. anything at all did survive it seems to have be irrecoverably lost at the time of the Reformation. medieval chalices of Scottish origin survive precious metal. The earliest pieces of medieval silv to survive in Scotland (not necessarily Scottis are the Iona Spoons, dated c. 1200, and of the four only one is complete. These are of silver-g having a leaf-shaped bowl; basically the stem is the same form as those from Pevensey, Taunt and that of the Coronation Spoon. Command G. E. P. How inclines to a Scottish provenance the Brechin Spoon (National Museum of An quities, Edinburgh), which dates from the la 13th century, but Finlay disagrees strongly. Th the undebated, earliest piece of Scottish mediev silver is usually allowed to be the lion boss of t Bannatyne or Bute Mazer, which perhaps dat from 1315 (**351**); some 5 in. (12.7 cm.) diameter, it is set with six, champlevé, enam coats of arms of Scottish families. Finlay conside the bowl and remaining mounts of the mazer be of 16th-century date. Certainly the boss, as it at present fitted, seems unlikely to have be originally intended for this position and perha not even for this purpose. The carved whalebo cover, like the bowl, should be dated to the ea 16th century. It is an extremely rare surviv though at least one such mazer with cover w amongst the Scottish Royal Plate of 1488 Edinburgh Castle. The 14th-century Dunvegan C is of Irish craftsmanship. Thus, besides the Bu 'print' only a few small brooches and pins surviv from this early period.

What survived the attention of the invadi English, the Reformers and the plunder of Roy Plate by either the unruly mob or the rebellio lords, was melted by Mary Queen of Scots, in 156 Even the solid gold font, which had been sent Queen Elizabeth of England to Queen Mary the christening of James VI of Scotland and I England and weighed 333 ounces, was subject to the latter treatment. That so little should surviv is none the less a mystery. It is to St Andrews th

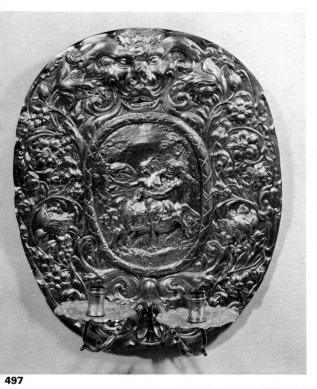

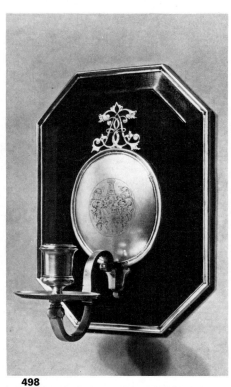

497 Sconce
Unmarked, *c.* 1660.
Height 25½ in. (64·8 cm.).
Border of chased foliage and a
Van Vianenesque mask.

498 Sconce
One of a set of four.
c. 1690.
Engraved with the Arms of Morris
and Bacon.

499 Wall Sconce
Maker's mark of John Bache.
Hall-mark for 1699.
Height 11¾ in. (29·9 cm.).
The Bank of England.

500 Sconce
One of a set of four.
Maker's mark of Philip Rollos.
Hall-mark for 1700.
Height 15¾ in. (40·0 cm.).
Colonial Williamsburg, Virginia.

497

498

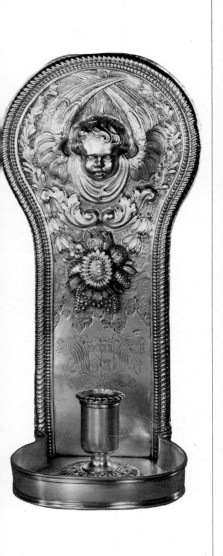

499

500

249

501 Sconce
Maker's mark of John Stokes.
Hall-mark for 1701.
Engraved with the Arms of
Catherine, widow of Sir Edward
Wyndham, Somerset.

502 Sconce
One of a pair.
Maker's mark of John Jackson.
Hall-mark for 1707.
Height 12½ in. (31·8 cm.).

503 A Pair of Sconces
Maker's mark of David Willaume.
Hall-mark for 1707.
Height 19¾ in. (50·2 cm.).
Applied with the crest and the
Arms of Douglas for James, 2nd
Duke of Queensbury.

**504 A Pair of
Argand Oil Lamps**
Sheffield plate.
c. 1775.
The Mount Vernon Ladies'
Association.

501

502

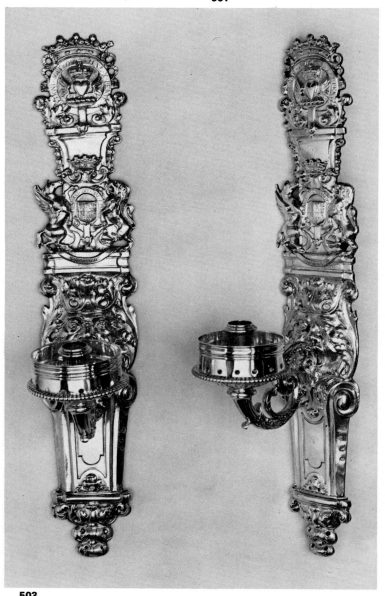

503

504

e must turn for one of the earliest, and most portant, native, Scottish pieces of silver, the rge or wand made originally for the Faculty of ommon Law at the University and of an archi-ctural (Continental) form unrelated to the true nglish) mace. This form, is also that of the mace St Andrews Faculty of Arts, as well as that of the niversity of Glasgow. Another mace, also at St ndrews (St Salvator's) bears an inscription cording its manufacture in Paris in 1461. It is of tstanding workmanship and obviously Con-ental. Brook pointed out that the majority of unders and early professors of Scottish Univer-ies were trained on the Continent and that it is st likely to be they, who would have introduced s form.

In 1457 by Act of Parliament, James II of otland formulated a policy to protect the citizen d ensure that 20 carats of fine gold became the ndard and for silver not less than eleven parts t of twelve, and 'quhat goldsmyt that giffis furth s work vtherwayis thane is befor wrettyn his dis salbe confyskyt to the Kyng and his life at the ngis will'. A maker's mark and that of the 'Dene' the craft were ordered to be struck. By 1483 a ild system was established, the 'Dene' had come a 'Dekyn' and a town mark was also dained. The guild was usually that of the ammermen, there being seldom a sufficient mber of goldsmiths to form a company of their vn. The surviving workmanship of this period nsists of the much larger and finer examples of e early, small brooch referred to above, such as e silver Kindrochit, 3½ in. (8·9 cm.) in diameter, graved with a black-letter inscription and the enlyon Brooch, 3 in. (7·7 cm.) in diameter. efore long a series of large brooches enclosing ystals, some being 'charm stones' venerated m earlier time, became popular in the Highlands. e of the most famous of these 'charm stones', in s case spherical, is the Clach-Dearg, belonging the Stewarts of Ardvorlich. It is some 1½ in. ·8 cm.) in diameter and secured to its chain (for pping in a well) by two interlaced straps of silver. ry occasionally these stones, mounted in ooches, seem to have been intended for use as iquaries. Such are the so-called 'turretted' ooches, having a number of tower-like studs set und the flange enclosing the stone. Examples of e 'turretted' brooches are the Lorne, Lossit and chbuie. The Lorne is 4½ in. (11·5 cm.) in ameter, and its 'turretts' some 1¼ in. (3·2 cm.) gh. The Lochbuie is still larger, 4¾ in. (12·1 cm.) diameter, and was made according to tradition m silver found on the Lochbuie Estate on the and of Mull (British Museum). Of late 16th-ntury date is the elegant eight-pointed Ballochyle ooch no less than 5⅔ in. (13·6 cm.) in diameter. is engraved 'DE SERVE AND HALF THE EVIN BABIF' together with the initials M C Iclver-Campbell). The silver-gilt and rock-ystal Methuen Cup has an unidentified maker's ark, VH, but there is no reason to doubt its ottish provenance of about 1550, though the scription may well be later (Colour Plate **26**).

The products of Scottish gold mines are referred elsewhere (See Mines, Gold and Silver). None e less it is worth noting here, the fact that, the wl given by the Regent Morton to the King of ance, was of 'naturall gold gotten within this ngdom of Scotland' and that this 'very fair deepe ason' was large enough to hold an English llon. More important to us, is to note that it was ade 'att Edenborough, in Cannegate Streete; it as made by a Scottsman'.

The Royal Crown of Scotland is most probably also of 'naturall gold gotten within this Kingdom of Scotland' (Colour Plate **19**). The fillet of the present crown was remodelled in 1540 by James Mossman, but retaining its earlier arches and jewels. The silver-gilt sceptre, given with the Sword of State by Pope Julius II in 1494, was remodelled by Adam Leys in 1536. The so-called 'Lord High Treasurer's Mace' of silver-gilt, 36 in. (91·5 cm.) in length, having a maker's mark, F.G., so far unidentified, would seem to be Edinburgh work of the late 16th century.

During the latter half of the 16th century the standing mazer on high foot (see Mazer) made its appearance; of those which do survive the Craigievar Tulloch and Galloway Mazers are probably the finest examples. This form can be claimed to be entirely Scottish, though probably drawing inspiration from other sources. A small rock-crystal ewer, 9½ in. (24·2 cm.) in height, made by James Cok, c. 1565, and known as the Erskine Ewer, shows another facet of the Scottish goldsmith's talent at this period. James VI endeavoured to re-establish the mining of gold in Scotland by means of an ingenious plan, which was to involve no cost to himself, only a percentage of the profits.

Vast quantities of Scottish ecclesiastical plate disappeared at the time of the Reformation, and the secular plate was also greatly depleted as a result of the civil strife between Mary Queen of Scots and John Knox, her Presbyterian adversary. As in England the communion cups that replaced the plate of the Roman Catholic Church had, at first, only two things in common. The need for greater size and to be completely different in form. An out and out Presbyterian, such as Knox, even went so far as to up end candlesticks for use as cups, but common sense seems generally to have prevailed. The general form of the standing mazer, though made entirely of silver, seems to have been most favoured for the communion cup; especially when one considers that a secular mazer could very well stand in for a communion cup. Poor country parishes could barely afford a special communion cup, and indeed if they did, the result is generally a light gauge piece. Many of the earlier communion cups noted by Burns are of London or Continental origin. The Rosneath Cups made by James Mossman, 1585–6, are amongst the earliest Scottish plate of the Reformation to survive. Both of these, and the fine and very rare Edinburgh-made (1591–4) baptismal basin, belonging to St John's, Perth, may well have an earlier secular history, though Finlay would like to think of the latter as having been made for the Kirk, in spite of the fact that the inscription is dated 1649. The lovely cup at Forgue, though made in 1563, was not presented until 1633.

In 1617 the Scottish Parliament decreed that all parishes should be provided with 'Basines and Lavoris ... and couppes' on pain of the 'minister' losing a year's stipend. Surviving examples show that this had an immediate effect. The Cawdor Cups (exceptional in having a 'print' within the bowl), made by James Moffat in 1619, are fine and particularly well documented. Gilbert Kirkwoode seems to have been a prolific and competent maker of these 'statutory' cups. The 'Basines and Lavoris' seem only rarely to have been made especially. Troubled times from 1620 to 1640 are reflected by the rarity of pieces made during this period. Indeed the Covenanters forced the sale of all plate both ecclesiastical and secular, though with a provision that it might be redeemed for ready money within a specified period if 'curious wrought worke'. The laver and basin belonging to Kingsbarn made by

Mungo Yorstoune, Edinburgh, 1705, display Scottish silver at its best.

Burns in his great work, *Old Scottish Communion Plate*, in which he also mentions many pieces other than those of Scottish manufacture, notes the earlier communion cups as having hemispherical bowls and elegant baluster stems. These gave way during the 17th century to successors with steadily deepening bowls and spreading, cylindrical stems, very rarely polygonal. By the 18th century, the multitude of forms defy reasonable classification and English influence is paramount. A number of provincial centres such as Aberdeen, Montrose and Dundee, produced particularly fine pieces such as the Strathnaver Cup by Walter Melvil of Aberdeen, presented to the Marischal College of Aberdeen in 1653 and an interesting group of particularly elegant cups made by William Lyndsay of Montrose, who was working during the last thirty years of the 17th century. These usually incorporate chased cherubs, masks and fine engraving.

Considerable quantities of beakers were used in the north-eastern coastal parishes, an area of Scotland usually in close contact with the Netherlands, and indeed some parishes possess beakers of Dutch manufacture. The majority of beakers, however, emanate from Aberdeen during the 17th century. Quaichs seem to have been infrequently used and then more often as alms basins.

Scottish secular plate of the first half of the 17th century is of extreme rarity. The few survivors form a strange miscellany: the Race Bells of Lanark (1608) and Paisley (one 1620), the gold Ampulla believed to have been used at the Coronation of Charles I at Holyrood House in 1633 and the 'siller gun' prizes given by James VI to Kirkcudbright in 1587 and to Dumfries in 1598 (a date about which there is much cause for debate). A number of silver arrows survive (prizes for archery), but early Scottish spoons are of extreme rarity and most seem to owe their survival to the fact that they had been hidden. Of great plate, the mace at Edinburgh made by George Robertson in 1617, compares favourably with any in the three Kingdoms. Others survive at Aberdeen University and in Edinburgh, at the Court of Session. The so-called 'Heriot Cup' (a silver-mounted nautilus shell) dates from c. 1612. The cup at Wemyss, is remarkable, having a baluster stem with cut-card decoration and, though engraved with the date 1673, was made c. 1665. A wine cup, the bowl engraved with flowers, by Thomas Clyghane (Cleghorn), Edinburgh, c. 1630, and a number of silver-mounted coconut cups from various centres survive, together with a mazer bowl entirely of silver made by James Denneistoune, Edinburgh, 1617.

After 1660 a golden age dawned in Scotland so far as the silversmith was concerned. From St Andrews there survives a salt cellar of spool-shape form made by Patrick Gairden. An early tankard from Aberdeen, a pair of trumpets of about 1680 from Glasgow and a comparative wealth of other fine secular plate, such as salvers, tankards, cups, casters, quaichs, 'thistle' mugs, toilet services, monteiths, punch bowls and as the 18th century progressed, a whole range of objects which might equally have been expected from London. Usually the Scottish product displays its origin in some subtle difference of design or decoration and the tendency was for the larger pieces to be made in Edinburgh. Even chinoiserie decoration was employed and a number of the most important pieces of gold surviving in Great Britain bear Edinburgh hall-marks. These include two particularly fine bullet teapots made by James Kerr in 1736 and

1737. Sword hilts, pistols, targes (shields) and other weapons were also furbished partly, or wholly, with silver mounts. Peculiar to Scotland is the ovoid tea or coffee urn of the 1730s with serpent handles. As communications improved between London and Edinburgh during the latter half of the 18th century, so obvious differences of form began to die, and Scottish silver slowly lost its individuality.

Bibliography

Thomas Burns, *Old Scottish Communion Plate*. Edinburgh, 1892.

Ian Finlay, *Scottish Gold and Silver Work*. 1956.

Proceedings of the Society of Antiquaries of Scotland.

W. Reid, 'A rare Scottish silver-hilted hanger'. *Connoisseur*, April 1963.

Screw-thread

The earliest recorded use of the screw-thread in English plate appears to be on the Leigh Cup of 1499 (Colour Plate **25**). From then onwards until the early 18th century it becomes increasingly common. After this date the screw-thread is more generally used to enable a piece to be taken apart, so that it can be cleaned or packed more easily.

Seal

The print of a coat of arms, or any other device, made in wax and set to any document, is known as a 'seal'. This also applies to the instrument or piece of metal (matrix) on which is engraved (in reverse) the device impressed in the wax. During the Middle Ages these were made in precious and base metals. Generally, a large table seal was cut with the full achievement of arms of the person or corporation for whom it was intended, together with a smaller example, often a finger ring, cut with the crest or some small personal device. The seal of Chichester Cathedral, dating from the 12th century and now in the British Museum, is a particularly fine example. The mayors of most corporations had a private seal. The larger examples might have a hinged thumbpiece (that of 1587 at Southampton) to the back or be of trumpet form. This latter, considerably shrunk, came in time to be the earliest form of fob seal, worn pendent from a chain or lady's châtelaine. Double or triple reversible examples, pivoting between two brackets, might be of silver, gold, steel or hardstone. These were equally popular as the finger seal rings. From 1738 to 1791 silver or gold examples were exempted from hall-marking, and the vast majority of surviving silver examples date from this very period. By 1810 the preference in seals was for gold-mounted hardstones. From 1750 onwards the table seal proper, with handle of ivory, worked metal or hardstone, began to reappear and examples with a number of interchangeable matrices are not uncommon. Penners were usually made with one end fashioned for the cutting of a coat of arms. A fine, early example of *c*. 1640 bears the Arms of Disney. A number of pieces of plate are also known, made from the matrices of the Great Seals of England, Scotland or Ireland, broken on the occasion of the death of a monarch, or the Lord Deputy, or for some other reason. The diary of John Hervey, 1st Earl of Bristol, recalls that on 'May 3rd 1689. Ye great Seale of England was found at ye bottom of ye Thames by a fisherman in a red bag between Lambeth and Vauxhall and presented to King William. Dropt by Queen Mary King James's Consort as she was crossing ye river to goe into France'. These Great Seals are now represented, for the most part, by standing cups or salvers engraved with a representation of the seal concerned, as the Seal had by law to be broken and defaced to prevent fraud. They were formed as two separate matrices for each side of the impression. The survival of one side of an Irish example of early 19th-century date, and incorporated in a salver, is therefore perhaps comprehensible. That of Frederick, Prince of Wales, who failed to survive his father George II, is, however, still in existence and even retains its red morocco case. The Great Seal of Scotland of *c*. 1760, that of Charles II for the Chancery of the Counties of Carmarthen, Cardigan and Pembroke and that of Edward III (1327–77) for the Office of the Receipt of the Exchequer, are all three exhibited in the Victoria and Albert Museum.

Bibliography

G.B. Hughes, 'Seals for Business and Adornment'. *Country Life*, May 22nd, 1958.

See also Penner; Ring.

Seal Box

The importance of the seal affixed to a document in the days before the majority of people could read cannot be over-emphasised. It therefore became the custom to enclose the seal of important documents in a box, in some cases of silver, especially if the document were the Freedom of a City (**506** and **507**). 17th-, 18th- and even 19th-century examples are known (**252** and **505**). Generally round, they vary in size, some of the largest have been converted to inkstands and the small ones to snuff boxes (**518**). Both the Universities of Oxford and Cambridge affixed oval seals to their documents with the result that their boxes became oval or navette-shaped, engraved on the outside with the arms of the respective University. Small table seals, the handle formed as a box for the sealing wax and with the matrix at one end, are found from the 17th century onwards. An early example in the Victoria and Albert Museum bears the Arms of Strode, Devon. Another of *c*. 1720 in the same Collection is of baluster form, square in section and has the top inset with an uncut crystal.

Bibliography

A.S.F. Gow, 'A Cambridge Seal Box'. *Cambridge Antiquarian Society*, vol. XXXIV.

See also Snuff Box; Tobacco Box.

Seal Plate

It was required by law that 'all seals of Royal Authority' should be broken and defaced upon the death of the sovereign. This together with several other possible reasons meant that from time to time the seal matrices, in many cases of silver and of considerable size, were made available after defacement for re-use by the last holder. For this reason, and perhaps to commemorate within his own family his holding of a high office it became customary to commission a piece of plate. A considerable number of seal-plate pieces survive from the reign of Elizabeth I onwards. At first a standing cup was the usual form, later a salver (**689**), cup and cover or punch bowl upon which the engraver generally traced a representation of the obverse and reverse of the seal in question. Because of the standing of the client and the complexity of the engraving such pieces are usually the work of only the best silversmiths and engravers of their day. Frequently, a considerable amount of metal, over and above that obtained by melting the matrices, must also have been used for such pieces. The great square Walpole Salver made by Paul de Lamerie in 1728 (**255**) is one such piece (Victoria and Albert Museum). In this case, it is thought to have been engraved by William Hogarth and some support for this theory may be enlisted from the painting of a tea party by this artist (once in the Cook Collection), which depicts just such a square salver. One 19th-century example seems to have flown very close to the wind in that one half of the actual matrix, only nominally defaced, is inset in the surface of a salver. Very occasionally in the 18th century, the Royal Arms are engraved between the supporters proper to the arms of the man commissioning the piece, rather than the lion and unicorn.

See also Salver; Seal.

Service

A descriptive term for pieces of different form but having identical hall-marks, maker's mark, decoration and engraving. If any piece does not conform to this rule then the description should more correctly be a 'matched service'. Very few large table services (knives, spoons and forks of table and dessert size) can truthfully be described as such, many of the pieces having been matched, perhaps even when first put up for sale. A garnish of plate can imply either a matched service or a true service. Knife handles were usually made by different makers to those who made the spoons and forks. One of the earliest complete table services to survive, once gilt, is that supplied to Sir Paul Methuen as part of his 'Indenture Plate' on being appointed Ambassador to Spain in 1714. Even this is a matched service, the joint work of such silversmiths as George Lambe, Thomas Spackman, William Franc and others. Each piece is engraved with the Royal Arms of George I. The Lord Chamberlain's Day Book of the Jewel Office (Public Record Office) contains the following entry:

'Dec. 20th 1714. Delivd unto His Excelency Paul Methwin Esq. Ambasr Extray to the King of Spain for the use of His table to Return unto His Majts Jewell Office upon Demand. The Partickulars of Plate ffollowing' followed by a list of 'White Plate' totalling 5,850 ounces and 'Gilt Plate' totalling 1,118 ounces including the following:

It: Two Doz: of large & two Doz: Small knives	
It: two Doz: of large & two Doz: small spoones	293 ozs. 15 dwt
It: two Doz: of large & two Doz: small forkes	
It. twelve teaspones & two pr. tongs'	

The Jewel Office Account Book (L. C. 9/47) lists the above followed by 'all gilt wt. 293 oz. 15d. at 5s. 6d. and gilding 12s. each all £175.11.7'. Against the Day Book entry in the margin is the note 'Discharged by Privey Seall bearing date ye 26th inst'. Amongst the Farrer Collection (Ashmolean Museum, Oxford) is an unmarked dessert service of *c*. 1725, each piece finely chased with interlaced strapwork, masks, husks and acanthus foliage. Later (early 19th century) dessert services are sometimes true services. Colour Plate **46** illustrates a dinner service, which should more correctly be called a 'matched dinner service'. Of silver-gilt the maker of all the pieces, except a two-handled tray, was Paul Storr, it was made during the years 1812–16. The tray, however, is the work of Digby Scott & Benjamin Smith and hall-marked 1805.

See also Ambassadorial and Perquisite Plate; Dish; Fork; Garnish; Knife; Spoon; Travelling Canteen.

Shagreen

A species of untanned leather, at first made from the backs and flanks of the wild asses of Persia and Turkey, whence it derives its name (Shagri). It wore well and was waterproof; initially it was soaked

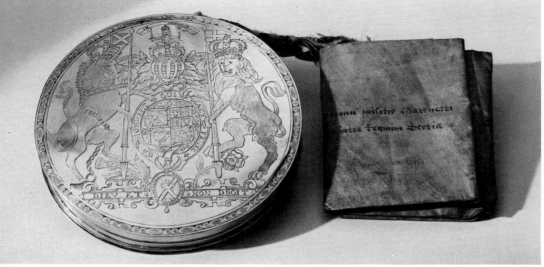

505

505 Seal Box
Maker's mark, TK, probably the
mark of Thomas Kirkwood of
Edinburgh.
c. 1667.
506 Freedom Box
Maker's mark of John Rollo.
Hall-mark for 1736, Edinburgh.
Width 10 in. (25·4 cm.).
This box was presented to Sir
John Barnard on the occasion of
his being given the Freedom of
Edinburgh. Inside the box is the
original document.
507 Freedom Box
Silver-gilt.
Maker's mark of James Keeting.
Hall-mark for 1795, Dublin.
The base is engraved with the Arms
of Drogheda and the lid with those
of Frederick Bowes. The box
contains the Freedom of Drogheda
on vellum.

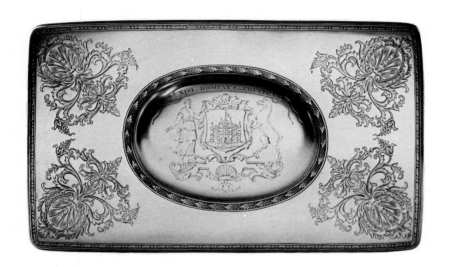

506

507

lime water and later dyed, usually green, red, black and, rarely, blue. White shagreen was obtained by bleaching with dough. The increasing demand for shagreen led to the use of the hides of horses, mules and camels. These lacked the characteristic granular texture of asses' skin, however this deficiency was supplied artificially. Even today it is easily cleaned if dull and soon returns to its original brilliance.

Shagreen was used to cover a vast number of different containers: boxes for tea caddies, knife boxes, canteens, small pocket or presentation cases, spectacle cases, magnifying glasses, knife handles, parasol handles, fan cases, miniature cases, and during the early 19th century, jewellery, thimbles and such-like trinkets were also presented in shagreen-covered boxes, often of the same contour. By 1760, nurse-shark skin (known as 'nurses skin') became the newest source, of what was soon to become the newest variety of shagreen, but a duty of 3*d* per pound encouraged the use of less expensive dog-fish skin. These fish skins are rarely found in any colour other than green. Originally, shagreen replaced leather, yet it in turn was eventually ousted by a new and improved coloured morocco leather.

Bibliography

Sylvia Groves, ' The Curious History of Shagreen'. *Country Life Annual*, 1959.
G.B. Hughes, 'The Fashion for Shagreen'. *Country Life*, November 28th, 1968.

Shaving Set

'A Shavyng basyn of sylver and an ewer' are mentioned in an inventory of 1521. No survivors are, however, known earlier than the reign of Charles II. A jug of 1687, in a private collection, being perhaps the earliest. The shaving basin is usually circular or oval with a semicircular section cut from the lip to accommodate the neck of the person being shaved. The jug is usually of flattened oval section; a fine specimen together with a basin, dated 1691, is in the Assheton-Bennett Collection (**508**). One of the most interesting basins to survive bears the cypher of William III, the perquisite of whose barber it was. In the Ashmolean Museum, Oxford, is an ingenious jug, executed by Anthony Nelme in 1710, the foot of which is detachable to form an oval bowl and which has a beaker fitting within the lip. The whole is but 6¾ in. (17·2 cm.) in height and was probably designed for a travelling shaving set. Such sets usually included a soap box (**509**). By the end of the 18th century a number of ingenious, plain, cylindrical shaving pots had been designed to accommodate the detachable wooden handle, a beaker and heater and stand. In March 1773 Edward Pauncefort purchased 'a Soap box, a Powder Do. & A Shaving brush', with a glass liner to the soap box, all fitted in a fish-skin case. During the next few years he seems to have broken and replaced the liner several times. One of the finest shaving services is illustrated on Plate **510**.

Shaving Brush

Though they do not seem to have survived before the middle of the 18th century they are, in all probability, an earlier invention. A form of travelling shaving brush in which the bristles could be unscrewed, reversed, and stowed away inside the cylindrical handle were later innovations on the same theme. Sometimes these also incorporate a second section for soap.

See also Razor Case; Soap Box; Sponge Back.

Sheffield Assay Office

Established in the face of strenuous opposition from the London Goldsmiths' Company in the same year (1773) as the assay office at Birmingham and for the same reasons. The Company (Wardens or Guardians) then incorporated, were required to stamp a crown as their mark, together with the usual standard mark and a date-letter. The first of these letters in Sheffield follow no real order and the fact that the first President of the Sheffield Goldsmiths' Company was the Earl of Effingham may well have influenced the fact that the starting letter was an E. Sheffield is the only English assay office to have used a Continental form of combined date-letter and hall-mark in one punch, generally, only on small pieces between the years 1780 and 1853 and in every case the punches may also be found of the usual separate form. At first Sheffield used twenty-five letters of the alphabet (excepting I or J), but after two cycles this system seems to have broken down. It is worth noting that, no one having satisfactorily explained the choice of a crown as the hall-mark, the committee urging the original establishment of the office used, whilst in London, to meet at the Crown and Anchor Inn. The Birmingham mark is an anchor while Sheffield took the crown.

 Sheffield mark on silver

 Sheffield mark on gold

A considerable number of Sheffield-made pieces, such as candlesticks and casters, are to be found having the original marks overstruck by those of London, Newcastle or other centres. The Worshipful Company of Cutlers have assembled a collection of pieces of silver bearing the marks for each year of the operation of the Sheffield Assay Office; a piece for 1940 proved particularly difficult to find!

Bibliography

Sir C.J. Jackson, *English Goldsmiths and Their Marks*. 2nd Edition 1921, reprinted 1949.
Frederick Bradbury, *History of Old Sheffield Plate*. Macmillan, 1912.
Robert Rowe, *Adam Silver*. Faber & Faber, 1965.
G.B. Hughes, 'Hallamshire Cutlers' Fine Silver'. *Country Life*, April 7th, 1966.

Sheffield Plate

Various attempts, such as close-plating, were made to plate base metals with silver before 1742 when a Sheffield cutler, Thomas Boulsover (1704–88), discovered the method of fusing sheets of silver to copper; it is said that he came upon the process accidentally when he was repairing a knife haft and overheated some silver and copper. One great advantage of old Sheffield plate over other methods used, and particularly over electrolytic plating, is that the layer of silver is of the Sterling standard, and therefore Sheffield plate is harder and of a better colour than electroplated silver. In addition, the rolling and hammering process involved in the making of Sheffield plate also hardens the metal, while modern electroplating methods tend to soften the core metal. The core of Sheffield plate is copper mixed with small quantities of zinc and lead, cast into ingots. These are planed, filed and scraped. A sheet of Sterling silver, about an eighth of an inch thick, and slightly smaller in area than the ingot, is similarly prepared and pressed firmly on to the copper base. The silver is embedded into the copper with hammer blows to evict air between the layers. Another copper plate, treated with a chalk solution to prevent it adhering, is then placed to protect the silver from the fire. Borax solution applied to the edges, and the whole bound together with wire. The ingot is placed in a cc furnace until the silver begins to 'weep'. Wh cooled it is dipped in acid, scoured with sand a water, and finally sent for rolling into sheets raising or stamping. Double plating, with silver either side of the copper, is made by sandwich the copper core with silver on either side, and th protecting the silver with a copper 'protect layer', making five layers in all. This latter meth was perfected between 1762 and 1770.

Once established as a commercial propositic any object, until then made in silver, could equa well be made in plate and thus the forms of 'plated' pieces follow, and even on occasion le those of the more precious metals. Men such Joseph Hancock (1711–91), once manufactur of wares, soon turned to making the sheet me for others. There is of course no reason why su pieces should not be gilded except that cop alone can be gilt with equally satisfactory resu Thus the (apparently) more expensive luxur were brought within the reach of the rising mid class. An interesting comment by Horace Walpc in a letter dated September 1st, 1760 to N Montague, reads: 'As I went to Lord Strafford passed through Sheffield, which is one of the foul towns in England, in the most charming situati where there are 22,000 inhabitants making kniv and scissors. They remit eleven thousand pound week to London. One man there has discovered art of plating copper with silver. I bought a pair candlesticks for two guineas, they are quite pret

Whenever possible parts of the object und manufacture were either spun or stamped out fr steel dies; mouldings for the borders were produc by means of a swage, a roller being later substitu for the latter. Some of the best of the early plate the work of James Dixon and Tudor and Leader major development in the history of the techniq and design of Sheffield plate was the discovery a method of producing plated wire in 1768. Fr about 1743 to 1750 only small items were ma but then saucepans, plated inside only at fi candlesticks, coffee pots, jugs and salvers beg to appear. Most plated candlesticks made betwe the years 1765 and 1840 were from Sheffie Wirework epergnes were introduced about 177 teapots with stands, about 1785, and from 1805 about 1815 there were wine coolers, trays and ta centrepieces, heavily ornamented and very akin the silver pieces of the period. Sheffield-plat spoons and forks are rare survivals, in anythi approaching good condition, though made fr 1800 onwards in considerable quantities. Duri the 19th century some of the more finely decorat sections of a piece were made of pure silver a those parts of the object most liable to wear we from an early date, given an extra covering of silv Pieces of silver were also inserted in places suitab for the engraving of crests or coats of arms, order to avoid the possibility of the copper showi through the engraving. In 1830 Samuel Robe took advantage of the introduction of a wh metal (German or nickel silver) placing a layer this between the copper and the silver, th enabling less of the latter to be employed witho the copper appearing any more quickly than w the previous, more expensive, process. By 1836 improved form of German silver known as Arge tine enabled the copper ingot to be dispensed w altogether. These improvements did not, howev mean that the steel dies became any less expens and there was, as a result, a tendency by 1840 Sheffield-plated goods (whether from Sheffield

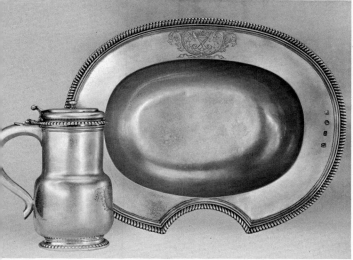

508

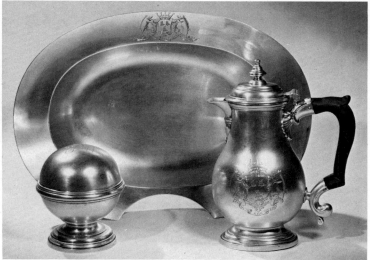

509

510

508 Shaving Dish and Ewer
Maker's mark, ID.
Hall-mark for 1691.
Ewer: height 6¾ in. (17·2 cm.).
Dish: width 13⅝ in. (34·6 cm.).
Assheton-Bennett Collection.

509 Shaving Set
Comprising a dish, ewer and
soapball box.
Maker's mark of James Shruder.
Hall-mark for 1744, London.
Engraved with the Arms of George
Booth, 2nd Earl of Warrington.

510 Dressing Case
Jug: unmarked.
Height 7¼ in. (18·4 cm.).
Shaving basin: unmarked.
Width 13 in. (33·1 cm.).
Some small pieces bear the maker's
mark of Joseph Heriot.
Hall-mark for 1788.
Each piece is engraved with the
initial E beneath a coronet for
Edward Augustus, 4th son of George
III. All the pieces are fitted into
a mahogany box.

Birmingham) to lag behind the fashion of the day. In 1840, Messrs Elkington & Co. of Birmingham patented a method of electroplating which was used under licence by a number of other manufacturers. This dealt the death blow to the Sheffield plate industry, which had seen its heyday in the 1790s before the imposition of American tariffs and the restrictions resulting from the Napoleonic Wars. By 1880, little but buttons and carriage lamps were produced by the original plating method. It should be emphasised that whereas by the older process, the plating came first, by the newer method the finished article is the subject of electrolysis which allows considerable scope to the 'improver' and, regrettably, the forger. Though a substitute for silver, Sheffield plate has today a considerable antique value.

The amount of silver used was originally reasonably high—for double plating, 12 ounces of Sterling silver to 8 pounds of core metal—though this was much reduced when 'rubbed in'; silver shields solved the problem of engraving on Sheffield plate. Some wares, such as dish covers, were single plated, and then the 'skin' of silver was about 10 to 12 ounces of Sterling silver per 8 pounds of copper, but the proportions varied a great deal at different times, being as high as 24 ounces to 8 pounds and as low as 50 pennyweights to 8 pounds (much less than on modern electroplated ware). While Sterling silver is used in the making of Sheffield plate (925 parts pure silver and 75 parts of alloy, usually copper) electroplating requires the use of pure silver. This fact therefore allows for a chemical test to be made if there is any doubt as to an object being either one or the other. Nitric acid, slightly diluted with distilled water, when applied to the surface of Sterling standard metal will change it to the colour blue. On the other hand, if no change takes place then the silver is pure and the object has been electroplated.

The process of turning the rim of a sheet of Sheffield plate was achieved by making the cut with a dull-edged tool, which served to draw the upper layer of silver out beyond the central layer of copper (a) and so allow for its being hammered out afterwards (b) to adjoin the lowest layer of silver (c).

a b

c

The Plate Assay (Sheffield and Birmingham) Act, 1772, ordered the Sheffield Assay Office to ensure that no marks on plated goods should resemble those struck on silver. Legislation in 1784 allowed for a maker's mark or device, a note of which was to be kept in a register maintained by the Sheffield Assay Office. After 1836, this seems to have been allowed to lapse, perhaps because the decline in the trade was already apparent.

Chronology
1742 Thomas Boulsover discovers the process of plating silver.
1768 Production of plated wire achieved.
1785 Applied silver edges introduced, together with die-struck, thin, silver mounts filled with lead or tin.
1790 'Let' or 'rubbed-in' pure silver shields for engraving.
1824 Silver edges discontinued.
1830 German silver substituted for copper.
1840 Invention of electroplating, which supersedes fused and Sheffield plate almost entirely by 1855.

Bibliography
Frederick Bradbury, *History of Old Sheffield Plate*. Macmillan, 1912.
Edward Wenham, *Old Sheffield Plate*. 1955.
B. Wyllie, *Sheffield Plate*. 1908.
K.C. Buhler, *Mount Vernon Silver*. 1957.
G.B. Hughes, 'Wire-work in Sheffield Plate'. *Country Life*, February 8th, 1968.
H. Raymond Singleton, *Old Sheffield Plate*. Sheffield City Museum, 1966.
G.B. Hughes, 'The Prime of Sheffield Plate'. *Country Life*, October 19th, 1967.
G.B. Hughes, 'Identifying old Sheffield Plate'. *Country Life*, April 10th, 1969.
See also Close-plate; Electroplating; Salver.

Shell See Escallop Shell; Oyster Dish.

Shoulder-belt Plate

Amongst the rare silver pieces of military equipment are shoulder- or cross-belt plates. Usually oval, these ensured that the pouch belt and sword belt—slung over opposite shoulders—should cross at the centre of the wearer's chest. Generally, they are of base metal but silver and silvered examples are known, in most cases engraved with the name or badge of a regiment. A very rare example made for Peter Gansevoort, Junior, and engraved with the Arms of New York State and the 3rd Regiment, *c.* 1780, is in the collection of the Albany Institute.
Bibliography
Major H.G. Parkyn, 'Some Shoulder Belt-Plates worn in the Regular Army'. *Connoisseur*, vol. LVIII, p. 147.
Major H.G. Parkyn, 'Shoulder Belt-Plates of the Fencible, Militia and Volunteer Regiments'. *Connoisseur*, vol LXII, p. 140.
See also Badges; Breastplate and Gorget.

Shrub

A drink compounded of spirits, fruit juice, sugar and spice. Wine labels are occasionally found so engraved.

Sick Communion Set

After the Reformation, and until the increasing availability of Church plate in the 17th century, it would seem likely that few, if any, churches were possessed of a special service of plate for the administration of Communion to the sick. At an early date, size does not give any strong clue for such use of Church plate; it may only reflect the small size of the original chalice that was converted into a communion cup. After 1660 such sets begin to appear, though often they must have been the personal property of the incumbent. Early examples consist of a cup, cover and sometimes a paten. St James', Piccadilly, has a cup and cover of 1684, $4\frac{1}{4}$ in. (10·8 cm.) high. Late 18th-century examples have a miniature flagon and perhaps a glass flask. They are generally extremely well made.

Sideboard Plate

Throughout the Middle Ages and until the end of the 17th century, a garnish or display of plate, some pieces hardly ever intended for use, was a *sine qua non* of the dining hall. Amongst these great ewers, flagons, bottles and the like were ranged smaller pieces, some being called into service as required, a dish as a 'voyder' for scraps or a cup for a particular toast. The tradition survives today in colleges and the Inns of Court, and most pieces of any size have probably been at sometime dignified by the name 'sideboard plate'. Of surviving English silver, only a few of those pieces sent to Russia in the 17th century were of such size that they could

never, whatever the circumstances, have be intended to be used, except for display. For e ample, the pair of leopards, now in the Krem Moscow, and hall-marked 1600, some $27\frac{1}{2}$ (69·9 cm.) in height, formed part of the Engl Royal Plate until sold in 1626; they are recorde having reached Russia in 1629, being purchas by, and not given to, the Tzar on this occasion. T pair of deeply scalloped, circular dishes of 16 18 in. (45·8 cm.) in diameter, once in the Brow low Collection, is not by any means uniq although they seem to have been old fashion even in their own day. Ewers and basins w probably the most consistently fashionable pie of such 'Great Plate'. During the 19th century again became fashionable to have such enormc pieces. They are most frequently from the wo shops of Rundell, Bridge & Rundell, and alm always gilt.
See also Alms Basin; Flagon; Garnish; Pilg Bottle; Water Pot; Wine Cistern.

Signatures

Only in one or two cases are pieces of plate actua signed by their designer or creator, as opposed bearing the registered maker's mark of the silv smith. In London, makers such as T. Ash and T. P having such short names used them in full; Exeter and the West Country it was far mc customary to use full names. Again in No America, this practice was quite usual, Paul Rev being a case in point. Engravers also signed th work on rare occasions. It is, however, not unusual to find the name of the retailer who su plied the piece, either stamped or engraved, rou the foot or rim. Wakelin; Rundell, Bridge & Rund Storr and Mortimer; Ellis; Hamlet and others, this frequently. It may perhaps be postulated th a piece bearing such a signature was actua commissioned by the firm named, not purchas casually within the normal trading channels. interesting two-handled cup in the Adam tas made by William Holmes, was supplied by Huds Mason of the Strand, as retailer, to the 'Friends Freedom' for presentation to their secreta Thomas Blair, in 1773. A pair of candlesticks 1800, 7 in. (17·8 cm.) in height, once in the colle tion of the Duke of Hamilton, are engraved benea 'Made for the Abbey at Fonthill, by Vulliamy & S 1800'. An oval teapot, made by Thomas Daniel 1788, is inscribed on the base 'Made at the Sil Lion. Foster Lane. London'.
See also Engraving.

Sillabub (Syllabub) Pot

A drink or dish made of milk or cream curdled the admixture of wine, cider, or other acid, a often sweetened and suitably flavoured. In M 1677, the Earl of Bedford purchased from Robert Vyner 'a sillabub pot weight 50.05.00 6.5 per ounce £15. 1. 4.', the engraving of a sing coat of arms cost a further 2s 6d. Though one c only guess at the form of the pot, it must sure have taken the form of some sort of cup or pc ringer, judging only by the very weight of the pie A piece of this form without handles survives Levens Hall and would also fit the description. 1697, Hezekiah Usher, Junior, of Boston possesse besides two tankards, 'I sillibub pot and cover'.
Bibliography
G. Scott Thomson, *Life in a Noble Househo* (p. 353). Jonathan Cape, 1950.
See also Skillet.

Silver Metal

Pure silver is, next to gold, the most malleable

metals and may be worked or beaten to almost fine proportions as gold. Pure silver, as opposed alloyed silver, may be drawn into the finest wire thout breaking and needs but little annealing; it elts at 960·5 °C. Whilst silver is resistant to a wide nge of acids and alkalis and thus suitable for linary purposes, it is, however, attacked by ost sulphur compounds, thus tarnishing (a lphide film) on exposure to fumes of coal or gas es. It dissolves in an 80 per cent solution of hot lphuric acid or more usually nitric acid, when it rms silver nitrate. Since the discovery of the New orld, much of the silver mined has come from exico. It is usually found as a sulphide in varying oportions of purity. Refining is carried out in two ages. At first the bullion is treated by cupellation, which it is melted down with lead and a stream air blown over the surface. The base metal xides dissolve in the lead oxide, which is then run f leaving the bullion about 98 per cent pure. This cast into anodes forming the positive plate of an ectrolytic cell containing a dilute solution of silver trate. Current is then passed through these to a thode upon which silver 99·9 per cent pure is eposited.

Fine silver, like gold, is too soft for normal use d is therefore alloyed, usually with copper, which tter is also electrolytically refined. When casting, eat care must be taken not to allow the oxygen in e air to come into contact with the melted silver. nould it do so, the result will be at best liable to eakness, at worst below standard.

Rolling or mechanical treatment causes the etal to become harder, more brittle and less orkable. Reheating, or 'annealing' as it is known, uses the growth of fresh crystals in the structure the metal and the recovery of its ductility. hereas the hand craftsman can allow for varia- ons in the quality of his materials, the machine ill not and extreme care is needed in the pro- uction of material suitable for mechanical hand- ng. Stains in the metal, known as 'fire-stain', are used by the formation of cuprous oxide on the rface, during annealing or soldering, and its enetration by oxygen below the surface. Each uccessive annealment increases the amount of xide formed and the extent of the stain, which ecomes extremely difficult to remove, if indeed ossible at all. The cure is to place the stained lver in a special enclosed furnace or to pickle it acid.

A wry comment on the value of silver in relation its fashioning is made by Samuel Pepys in his iary on October 19th, 1664. He is very disturbed nat the value of his flagons, at 10s per ounce, is venly divided at 5s for silver and 5s for workman- nip, 'but yet am sorry to see the fashion is worth much and the silver come to no more'.

ibliography
taton Abbey, *The Goldsmiths and Silversmiths andbook*. 1959.
ee also Assay; Hall-mark.

ilversmithing

ncient peoples were for the most part depend- nt on local sources of silver. By the end of the oman Empire, most of the European and Near astern mines seem to have been exhausted, and e ensuing Dark Ages were almost devoid of lver and gold.

About AD 900 gold and silver were found in reat quantities in the Rhineland. From then, until e discovery of new riches in the New World, ermany, Bohemia and Spain supplied the greatest art of Europe's silver. Outmoded or damaged ieces were melted down and converted into new.

Silver was inevitably restricted to the rich, and men sought everywhere for new sources of wealth. The voyages of the Spanish Conquistadores revitalised the silver trade in Europe, and for three centuries Mexico, Peru and Bolivia yielded up their rich ores, which were treated and cast into ingots and sent into the silversmiths' workshops throughout Europe. Even today, Mexican silver is among the purest in the world, although America and Australia are now the largest contributors to world markets.

The Standards of Silver

The beautiful grey lustre of the metal is unrivalled by any other material, natural or man-made. Fine silver has the skill of design and craftsmanship, the individual treatment even of pattern-book styles that is the mark of hand workmanship. Years of experience and the traditional adherence to high standards have created a hard-wearing metal that will serve well during many decades of use.

Silver alone is too soft to be durable enough for everyday use, and from earliest days silversmiths have alloyed it with other metals in order to harden it. Long ago they found that copper was the most satisfactory, a small proportion giving the silver hardness and improving its working properties without destroying its lustrous grey colour.

In Britain, the proportion of 11 ounces 2 penny- weights of pure silver to 18 pennyweights of copper per pound Troy (otherwise expressed as 925 parts per 1,000 pure) has been the standard for silver since 1300 at least, and probably since Anglo-Saxon times. The term 'Sterling' applied to this standard is plausibly derived from the Easterlings, coiners from East Germany whom Henry II brought over to improve the coinage of the realm. But it may well be that earlier silver- smiths in Britain had already established such a standard. The Anglo-Saxon kings had initiated silver coinage in Britain, some etymologists even say that Penda of Mercia gave his name to the penny. Certainly, Alfred asserted a royal preroga- tive and ordered his name to appear on the coinage, and Edgar later decreed an effigy as well as a name. In 7th-century Kent, gold and silversmithing were living crafts, and the silversmith (who was prob- ably usually a moneyer as well) no doubt co- operated with the authorities in maintaining a high quality for the silver used for pennies. Saxon and Norman silver coins are almost all of good grade silver, usually between 920 and 940 fine, with many approximating to the 925 Sterling standard.

The metallurgist today may question whether strict adherence to the Sterling standard is advan- tageous but, as one of the leading bullion dealers has put it, 'long usage has clearly demonstrated the soundness of those properties [of Sterling silver] in terms of both appearance and durability'. In the language of metallurgy, the tensile strength of standard silver is nearly twice that of pure silver, and it is more than twice as hard. Wares made of Sterling silver stand up well to everyday use and are, of course, less subject to tarnish than higher standards of pure silver, such as is used for plating.

The Working of Silver

Until modern refining methods were introduced during the 19th century, silver was extracted from the ore with nitric acid. The process was known as 'leaching'. It did not, of course, dissolve out any gold present in the ore, but all base metals were dissolved out and the resulting metal was entirely noble. Alloying with the permitted 7·5 per cent of copper brought the metal to the Sterling standard, though methods used for casting the ingots did not always ensure homogeneity, and the copper

sometimes tended to concentrate itself in the centre of the ingot. To the silversmith, such silver is known as 'fiery', and in the old days, when he had to roll his own metal, perhaps even to alloy it and cast it into ingots as well, fiery silver must have wasted much of his time, the copper on the surface being eliminated only by laborious heating and cooling processes. In 1871, extraction of the silver from the ores with hot sulphuric acid became standard commercial practice, while in the next decade electrolytic refining of silver, as used today, was patented.

In early times, the silversmith had to undertake the preparation of his metal, and until the begin- ning of the 18th century, battery (or hammering) and making silver wire were his two fundamental methods of preparing silver for plateworking. The silversmith has for centuries hammered his metal, then toughened it by heating, painstakingly and gradually working the silver until the ware is formed.

Until the 19th century, the silver ingot was hammered down into workable sheet form by battery. A series of different hammers of varying weights would be employed, laboriously flattening the metal into sheets as even as the eye and patience could make them, ready for the craftsman to raise into silver wares. This process continued even after the introduction of the rolling-mill, and the late 17th-century silversmith would often conceal the surface unevennesses of his wares by an ebullience of chased decoration. In 1697, John Houghton, who wrote a *Collection of Letters for the Improvement of Husbandry and Trade*, noted that a rolling-mill had been installed at a works on Mousley River, near Esher. Though the provincial silversmiths probably did not benefit from such industrial advances for many years, in London the silversmith was eager to take advantage of the thinner gauge metal made possible, more espe- cially as the Britannia standard silver was rather more expensive than Sterling.

The Tools of the Silversmith

A hollowed-out tree-trunk, hammers and mallets, calipers and stakes, gravers and punches have been the tools of the silversmith's trade since history was first recorded. Change comes slowly to the craft. The silver collector today watching a modern silversmith ply his tools needs little imagination to translate himself back into the workshop of a silversmith one, two, three or even four hundred years ago. The actual tools the silversmith uses may be many years old; there are silver craftsmen work- ing in London today using the tools which have been passed from master to pupil for nearly two hundred years. More than likely the block on which he holds his work is simply a piece of tree-trunk, as it was a thousand years ago. The silversmith's weights and balance look just as they did when painted by Holbein, his tools identical with those portrayed in the few design books that have sur- vived. And the silversmith's methods have changed little: his task is still an exacting one, a labour of skill and patience and precision, bringing out the beautiful reflecting surfaces of the metal to best advantage, blending form and decoration and function with beauty.

One of the most complete lists of the 17th- century silversmith's tools is that of the appraisers of the estate of Richard Conyers, a goldsmith of Boston, made in April 1709 and published by J.M. Phillips in *American Silver*, 1949.

Raising a Silver Pot

The method of making a silver coffee or teapot by hand-raising is a good illustration of the different skills that the silver craftsman has had to master

since time immemorial. First, he takes a sheet of silver, and with the shears cuts it to a circle, estimating the diameter from the drawing of the pot he is to make. He then holds the silver over one of the shallow depressions of the tree-trunk steady block. Using a ball-faced blocking hammer, he sinks the silver sheet over the hollowed-out shape in the block patiently working, hammer blow by hammer blow, round the outer edge and then, row by row, round and round until he gets near the centre. Gradually the sheet takes on a saucer shape, and is ready for raising. But the repeated hammer blows have hardened the metal, and distorted the crystallographic structure. The metal becomes brittle and may crack, so before further hammering it must be annealed.

Annealing

To anneal it, silver is placed on a special pan, known as a 'hearth', which is rotated in the flame. When the silver has been brought to a dull red heat, it is quenched in cold water. Now it is malleable again, ready for further hammering. Just as the pewterer smells his metal to see if it is hot enough for casting, so the silversmith by eye and experience judges the redness the metal must attain for annealing. Annealing is usually done in a dark corner of the workshop so that the silversmith can judge the colour properly as it glows under the flame.

Firestain

Because the copper used to make silver durable oxidises readily, great care has to be taken during annealing to avoid firestain. This staining (not to be confused with the bluish bloom caused by annealing) is due to the oxidisation of the copper just below the surface, and can only be removed by stoning down the surface with an abrasive or pickling the piece in acid to dissolve out the copper oxide.

Sinking

For bowls and saucer shapes, further shaping is done by hammering the metal over a sand-filled leather saddle, using a sinking hammer. Deeper wares must, however, be raised over a stake.

The Raising Stakes

After annealing, the silver is worked over the raising stake. This is an anvil-like, cast-iron stake which is fixed in the steady block or, for smaller work, in the bench vice. The silversmith tilts the work over the end of the stake and starts hammering it, still slowly and row by row, from the base upwards. Each time his row of hammer blows reach the top of the body, the pot must go to be annealed again, the toughening, softening ordeal of fire and water. Each time the body is raised, the silversmith tilts it a little more over the stake, and, as the sides become narrower, so he uses smaller stakes. Every time the silversmith reaches the top edge, he hammers it down to thicken it—a process known as 'caulking' or 'corking'. The exception to corking is the making of tumbler cups, where the silver is hammered back again towards the base to make it base-heavy, instead of always beginning each new course of hammer blows from the base towards the top. Great care must be taken to ensure that the silver is kept to an even thickness, and that curves are accurately formed when the body is being drawn in or swaged to shape. Most round-wares are trued up on the lathe. An average-sized coffee pot or jug body will take approximately a day to raise by the hand method.

Planishing

When the body is the required shape, it is planished with a heavy flat-faced hammer to smooth the surfaces roughened by the hammer-raising. The process also helps to even out irregularities in the thickness of the silver, flatwares such as trays being held over a surface plate, and the bodies of cups and pots over a round-headed stake. Good hammerwork, both in raising and in planishing, is an essential skill of the silversmith, for it is that which gives the ware its contours and reflections, its regularity of curve and its basic form, as well as ensuring that bases and bodies are of suitably thick metal without unevenness or patchiness.

Turning up from a Cone

A less onerous method of making hollow-wares such as tankards and coffee pots, and one used at least since the 17th century, is to turn up the body from a cone of silver. A suitably sized piece of silver is seamed to form a cylinder or cone, and then it is hammered to shape over a stake. The faint marks of the seam can often be detected inside a pot, usually along the line of the handle joints. In turning up from a cone, the process of corking cannot be used, and a mouth wire and the base or foot must both be soldered in.

The Mouth Wire

In raising the body of a pot, the silversmith leaves the top edge straight so that the strengthening mouth wire can be sprung in and soldered on. It should be noted, however, that applied mouth wires were not generally used before the mid 18th century. Any roughness of edge left by shearing the circle of silver used to make the pot must be filed down. Once the top has been finished, the top edge can then be hammered into line with the curve of the body.

Wire-making

The drawing of wires is one of the crafts of the metalworker that was introduced into England in Tudor times. The process has a ring of the medieval torture chamber about it, as the piece of wire rod is drawn through one series of holes after another in the clanking drawplate. A piece of silver rod is first tapered either by hammering or filing so that it can be drawn more easily through the holes. As with hammering, drawing hardens the metal, and after it has been reduced in gauge two or three times, it must be annealed before it can be drawn thinner. Each hole in the plate is slightly smaller than its predecessor, and wires can be drawn so fine that they can be twisted like threads for filigree work.

Casting

Spouts, handle sockets, feet and even small articles can be produced by casting. First, a pattern of the part or piece to be cast must be exactly modelled, either in wood, metal, plaster or modelling wax. Old castings were nearly always modelled in wood or metal. These are embedded in a special sand, called 'marl', or in other types of sandstone, steatite or cuttlefish bone, all of which take a good impression. The sand is held in a rectangular iron case made in two halves. The lower half is filled with sand, and the model pressed in half-way. Then the whole is dusted with charcoal or burnt brick to form a parting surface. The top half is also packed with sand and placed to take the impression of the upper half of the model. After exerting pressure on the two halves, the case is parted and the sand dried out hard. The mould is then cramped together again and molten metal poured in through the top. Gates (or 'gets') have to be cut for intricate patterns or to separate several small castings which are being made together. It is important that the metal used for casting should be of good quality and the temperature of the molten silver correct, or pitting may occur and the casting may turn out to be brittle or rough. Flash and other irregularities must be carefully cleaned off or filed down before the casting is applied to the object for which it has been designed (**512** and **513**).

Soldering

The spout, handle sockets and foot are soldered the body of the pot with silver solder. Soldering a much more skilled operation than would appe to the layman, and a neat joint is essential. Solde like the silver for the rest of the piece, must be least of Sterling standard to conform to the ha marking laws. Nowadays, silver is alloyed wi zinc to produce a hard solder, with a relatively lo melting-point; formerly brass was used for th alloy, and the work done over a charcoal flam This gives old solder a characteristic colour whic is often a useful guide in detecting forgeries.

The foot, fitted with a collar wire, is soldered the base of the body, and the spout applied. If strainer spout is required, a series of holes must t drilled in the appropriate part of the body; th ancient bow drill is still to be found in every silve smith's and jeweller's workshop. If there is r strainer required, a hole is cut to shape in the bod The handle sockets are also soldered on, ar knuckles for the hinge made of silver tube. Th bezel wire strengthening the rim of the cover sprung on and soldered, and the cover hinge fitte Now the pot parts are united, and the ware goe for assay (the testing for standard of silver) ar hall-marking before being polished.

Forging and Hand-swaging

Besides hand-raising and casting, silversmiths hav for many years employed forging and swaging f certain articles. These are both variations hammering by battery, and were formerly mo used for flatware (spoons and forks) and silv cutlery. Knife blades are hammered out of hot met over an anvil—in Sheffield the shaping of the blad is still called 'mooding', a corruption of mouldin

Swaging is a form of forging in either hot or co metal, and entails beating out the shape over groove called a 'swage'. It is a much slower proces than stamping (see below), the work being don by a series of blows in quick succession, rathe than the heavy blows of the stamping press. Th edges of the ware are finally filed level. The metho is still used for hand-forged spoons.

Stamping

Though the first patents for stamping metal int small articles were obtained during the 1760s an 1770s, it was not for another eighty years that thi mechanical method of producing silverware wa really put into wide practice. At first, men such a John Pickering, a London toymaker, and Richar Ford of Birmingham devised stamping method to ease the slow work of engraving in the butto trade. Ford used a soft-faced metal hammer t force the metal against the die, thus initiating th use of male and female dies, still widely employe in the manufacture of silver and plated hollow ware. Stamping had an immediate effect in Shef field, where stamped parts for loaded candlestick were made in the latter part of the 18th century long before the application of the process to othe wares. The labour-saving advantages of stampin are, however, overshadowed by the loss of indi viduality. The high cost of making good dies make production by this method economical only if larg numbers of like wares are made from each di (**514**).

Spinning

Another method of making silver hollow-ware is b spinning. This was known and used by the Egyp tians, but in recent years considerable progress ha been made in the production of suitable chucks fo complicated shapes. The spinner uses flat silve sheet, which is held in the lathe and rotated. Th silver is worked over a shaped wooden chuck wit a steel-headed burnisher held in a long handle. Th

ndle is used by the spinner to steady the tool der his arm. The chucks, of lignum vitae or ech, are turned by hand. Complex shapes, such those for jugs, are made in sections so that they n be removed piece by piece from inside the un body. As with all other methods of making verware, the metal must be annealed several es during the process.

lishing

ring manufacture scratches, file ridges, minor stains on the surface, and other marks may ve marred the surface of the silver, and these st be removed before final polishing. For most res, buffing with pumice and then with Trent nd mixed with oil against a felt or leather- vered wooden wheel is adequate. Very badly rked silver may, however, have to undergo nding against an abrasive wheel and bad fire- ains can often only be removed by pickling in id.

On hand-raised silver, first polishing will, fortunately, take out the planishing marks as ll as fire marks. If the fire has been broken, by ng for example, then the silver is usually nealed again to give an even surface of fire, the uish colour always associated with silver after nealing. The preliminary polishing is then itted; it could be said that in effect it has been complished by the planisher, whose smoothing mmer has taken out the rough marks of the ising hammer. Planished silver is therefore ually polished only with Tripoli powder and lico mops, or with brushes that go into the anishing marks without removing them, to leave even surface for final polishing. This is done th jeweller's rouge and swansdown mops. The lisher works the rouge into every corner of the ver, rubbing it with the fleshy part of his hand or en his forearm, to achieve the soft lustrous flections that give silver its special appeal.

e Decoration of Silver

or some, unadorned silver may be the epitome of auty. Shape, reflecting surfaces, the pattern of e hammer, the patina of age are more than satis- ing. The lustrous grey metal needs no relief. But ost people prefer some decoration, and others onsider silverware that is ornamented overall to e silver at its richest.

There are three main types of decoration used in lversmithing: that in which the surface is ecorated without loss of metal; where decoration applied; and where the decoration entails atting away the metal, as in piercing and en- raving. Often the silversmith combines two or ore of these methods.

hasing

ne term 'chasing' covers all those forms of ecoration carried out with punches. No metal is st in the process, the silver being pushed to the esired pattern, whether from behind or in front. ne chaser uses hundreds of variously shaped unches to achieve his effects, making his own ools to suit the work in hand. The punches shift ne metal under the force of hammer blows, and it the chaser's skill that ensures that the indenta- ons made are regular in depth. Badly executed hasing has a spotty, uneven effect which is pparent even if the finished ornament is intended be vigorous rather than delicate in appeal.

lat Chasing

lat chasing, which is a surface decoration in very w relief, can achieve linear patterns very like ngraving (with which the uninitiated sometimes onfuse it). It should always be remembered, how- ver, that no metal is removed by chasing, and erefore the edges are soft and undulating, not

crisp and sharp as in engraving. The work to be chased is rested on a bed of pitch or, if a bowl shape, is itself filled with pitch. The pitch, a mix- ture of pitch, resin, plaster of Paris (or brick-dust) is a resilient substance yet strong enough to sup- port the work. In chasing, as in most decorative processes, the silverware is brought to the tool rather than the tool to the work, so chasers usually rest their pitch bed in an iron bowl which in turn rests on a leather ring so that it can be tilted to the required angle. Work that has to be filled with pitch itself is rested on a sand-filled leather bag to protect and support it (**511**).

The pattern to be chased is first marked out by using a small hammer and a chisel-like tracer which pushes the silver into an outlined pattern, straight lines and curves being achieved with different tracers. The pattern is then completed with a series of different punches, the craftsman probably having to make several special punches for the job in hand. Raised parts around the impressions made by the punches can be reduced with planishing punches. Matted effects giving a textured back- ground are also a form of flat chasing.

Embossing and Repoussé Chasing

Whereas flat chasing is done from the front, em- bossing is a technique in which the silver is pushed into raised patterns from the back. Using domed punches of various sizes, relief bosses are punched into the metal, which is supported on a bed of soft wood, wax or pitch. If the ware to be embossed is an enclosed shape, however, emboss- ing must be done 'by remote control' using a snarling iron. This is a long (almost Z-shaped) piece of iron with an upturned end which is domed. The other end is fixed in the vice, and the iron is then tapped with the hammer to bump up the pattern traced on the silver from the back, the ware being turned as required.

Embossing alone gives curved or domed shapes to the silver. A further refinement of embossing is repoussé work, the bosses being further worked from the front to complete the design, giving it detail and definition. The back of the piece must, as with flat chasing, be supported on a pitch bed. The embossed pattern is worked over with a series of different punches—dozens and even hundreds may be used for a very intricate pattern—to give highlights, effects of light and shade, and grada- tions in the depth of the design. Fluted motifs are similarly worked, the refined edge of the flute being worked with a tracer.

Cast Chasing

The rather loose term 'cast chasing' is applied by silversmiths to the process of sharpening up cast- ings and adding details that cannot be perfectly reproduced in the mould. In effect, the same process applies as for all chasing from the front, and various punches are employed to push the metal into more definite patterns (**513**).

Applied Decoration

Fancy mounts and cut-card ornament might well be called double-duty decoration for not only do they decorate the silver but they serve also to strengthen rims, handle junctions and spouts (**513**).

Ornamental Wires (used as mouldings)

Simple wires of circular, square, rectangular or hemispherical sections are made in the same way as edge mount wires in the drawplate. Decorative patterns of wire are produced by swaging, that is, hammering over a block or die into which the pattern has been cut, or by stamping. From the beginning of the 18th century wires made by cast- ing were extensively used to produce the often extremely fine and beautiful mounts used to decorate silver when taste turned to the rich and

the Rococo. The cast wires had, of course, further to be chased up after casting to give them a sharp appearance.

Cut-card Work

The charming applied decoration known as 'cut- card work' came to England about 1660, and in subsequent decades the immigrant Huguenot silversmiths in Britain used the style with consum- mate skill and virtuosity. The cards are very thin sections of silver, usually cut into leaf shapes in silhouette and then soldered absolutely flat on to the body of the ware. Originally, like pierced work, the cards were pierced into even very intricate patterns by using hammer and chisel. Nowadays, however, they are cut with the fine blades of the piercing saw, which must be held absolutely vertically, eating, little by little, into the design traced on the surface of the card. The laying of the card decoration also requires great skill on the part of the craftsman, as no solder must penetrate into the spaces cut in the card, and yet the whole should appear integrated with the body of the ware. Even before the end of the 17th century, cut-card decoration was sometimes further enriched with other applied ornament, such as beading to suggest stems and veins of the leaf motifs. An elaboration that naturally suggested itself to the mannered tastes of the Huguenot silversmiths was the so- called 'strapwork', delicately pierced outline shapes applied most happily to the bodies of cups, ewers and wine coolers of the period. Slat-like sections, often very finely chased, and sometimes pierced as well, were laid in calyx-like rows round the bases of the silverwares, several styles of 'spoon handle' sometimes being used alternately on a single piece of silver, occasionally with rather overwhelming effect, despite the inevitable appeal of the craftsmanship lavished on the decoration. In the hands of the greatest silversmiths, however, intricate strapwork married with chased decora- tion, or applied layer upon layer to create a confec- tioner's dream in silver, produced some of the most subtle and exotic ornaments of the Huguenot period. But after about 1730 the style waned, and applied ornament was chiefly cast and chased to give greater relief.

Piercing and Engraving

Decoration achieved by the removal of metal in- cludes piercing and engraving. Carving is little used by the silversmith, while etching a pattern with acid, typical of much Victorian silver, is not a process often associated in England with hand- raised silverwares.

Engraving

Engraved ornament must surely be the oldest of the arts. A few scratches made with a sharp stone on the wall of a cave, the carved lines of graffito, are engraving at their most primitive. At the other end of the scale, engraving on silver can reach artistic heights in the hands of a Gribelin or a Hogarth, or of the dozens of unknown engravers of the 18th century whose impeccable draught- manship with the graver achieved the foliate car- touches and ornaments so prized by silver collectors.

As with chasing, the work is brought to the tool rather than the tool to the work, and is turned clockwise to the graver. The graver is held against the palm of the hand and pressure exerted with the thumb; every engraver's thumb soon becomes hard and spatulate where it controls the tool.

First the pattern to be engraved—lettering, coat of arms, or decorative design—must be applied to the surface of the silver. The design is drawn out black and white, and then placed face down over the silver which has been coated with a film of

511 Chasing
Maker's mark of Paul de Lamerie and the London hall-mark for 1735 struck on the underside of an inkstand, showing the reverse of chased decoration.

512 Cast Arms
The cast Arms of the Goldsmiths' Company from a basin made by Paul de Lamerie in 1741. These Arms were bolted on to the dish.

513 Casting and Chasing
The cover of a two-handled cup made by Paul de Lamerie in 1732. It illustrates casting and chasing.

514 Stamped Repoussé
A close-up of the rustic border on a teapot made by William Thomson of New York c. 1820. It illustrates stamped repoussé work. Brooklyn Museum.

511

512

513

514

swax. Rubbing firmly with a piece of bone ⬚gs the black impression out on the wax, and the ⬚ines can be drawn on to the surface with the ⬚t of a scriber. Then the film of wax is rubbed ⬚and the engraver is left with a faintly scratched-⬚design as a guide. The work is either mounted ⬚itch or is held against a sand-bag on which ⬚n be turned without damaging the surface.

⬚ngraving is essentially linear in technique, and ⬚quires considerable skill to impart suggestions ⬚ght and shade by turning the diamond-shaped ⬚ within the cut without producing a ragged ⬚e with the stroke. To achieve different effects, ⬚eral types of tool are used. A scorper, for ⬚mple, cuts two lines at a single stroke, while ⬚tools, line gravers, lozenge gravers and round-⬚ded tools can be used to give various effects.

⬚ght-cut Engraving
⬚ exceptionally clear-cut brilliance of bright-cut ⬚raving is due to the contrasting depths of the ⬚ The tool used is very highly polished, one edge ⬚king out the silver as it cuts into it, and the other ⬚ishing the cut as the metal is removed.

⬚rcing
⬚te different in technique is piercing, which has ⬚n touched upon above in its application to cut-⬚d work. Close examination of early pierced work, ⬚casters and strainers, for example, shows that ⬚as created with hammer and chisel. By the end ⬚he 18th century, however, the piercing saw ⬚e to be used. The silversmith's piercing saw is a ⬚ fine blade set in a three-sided frame, the saw ⬚lf forming the fourth side of a rectangle. A hole ⬚rilled through the metal to be ornamented, and ⬚ the saw slipped through that and clamped ⬚ the top of the frame. The piercer cuts the metal ⬚ series of upright cuts. It is important that the ⬚ is kept vertical to ensure good, clean cuts, and ⬚e again, the silver, rather than the saw, is turned. ⬚ tiny teeth of the saw grip the thickness of the ⬚er as the shape is cut, so that the finer the gauge ⬚ilver, the finer the saw needed for the work. Very ⬚cate and intricate patterns can be cut with both ⬚sel and saw, from the tiny patterns cut into the ⬚s of casters to the formal openwork designs of ⬚e baskets and the ebullient piercing of Irish ⬚ rings.

⬚hon
⬚days when bottling one's own wine, beer and ⬚rits was the rule, the need for a siphon for this ⬚pose, besides numerous other uses, was con-⬚erable. Formed as a U-shaped tube the earlier ⬚mples rely upon the lungs of the user to start the ⬚w. 19th-century distaste for so personal an ⬚ociation with the servants may be one reason ⬚ the introduction of a more refined variety, fitted ⬚h a suction pump, frequently with an ivory ⬚dle. It seems likely that siphons were also used ⬚he dining room before the assembled company. ⬚erican examples are more often found than ⬚glish ones. Spigot taps of silver, usually about ⬚00 in date, are also known, perhaps associated ⬚h the small casks of beer which, mounted on a ⬚er-wagon' trundled up and down the table in ⬚ servants' hall whilst a jolly boat or decanter ⬚gon did likewise above stairs. In 1772 John Day ⬚rchased 'a suction pipe' (probably a siphon) ⬚m Messrs Wakelin.
⬚ also Cobbler Tube; Spigot.

⬚ewer
⬚w hall-marked skewers appear to have survived ⬚or to 1745, though one of 1702 by William ⬚mble is part of the Assheton-Bennett Collection ⬚the Manchester City Art Gallery, another in the

author's collection is dated 1738 and has a cast, scallop shell finial. The earlier examples are tapering and rectangular in section; generally of considerable weight, they are found in sized sets and the finial, often of ring form, is always designed for ease of purchase when withdrawing them from a joint. By 1790 the sharp-edged skewer, now often used as a paper knife, becomes most common. The smallest sizes are known as 'game skewers' and are only very rarely fully marked. Occasional examples are found of bodkin form, presumably intended to be used as such, with meat, by the cook. Finials vary according to the whim of the designer, shells, crests, arrows all serving as inspiration. They vary in length from 6 in. (15·3 cm.) to 15 in. (38·1 cm.). Canadian examples are extremely rare. The largest sets, one of eight is known, are for no known reason, more often than not of Scottish manufacture. Both beef and 'Veal Skures' appear in the Wakelin Ledgers of the 1770s.
See also Beef Machine.

Skillet
Surviving examples are of 17th-century date. As opposed to a saucepan, a skillet has three or more feet. The sides are more or less cylindrical, the handle may either be straight as with a saucepan, or curved as with a tankard. Whereas the silver saucepan only rarely preserves a lid, the skillet was undoubtedly designed for use with one. Often the lid is of bleeding-bowl form (**515**). Usually, an applied cartouche at the front prevented any misfit when the cover was in place. At least one example with a long spout springing from its base is known (**516**). One of the earliest, 6¾ in. (17·2 cm.) in diameter and 5 in. (12·7 cm.) in height, is an example from Hull made by James Birkby, inscribed with the date 1650. This has a fitted cover as opposed to the usual overlapping lid. One American example by William Rouse, with a cover of salver form, is the sole example so far recorded (Colour Plate **10**). That in the Burrell Collection, Glasgow, is much smaller than usual being 3½ in. (8·9 cm.) in height. It lacks a cover but may date from 1648; unfortunately the marks are poor. There is no reason why such pieces should not have been used as sillabub pots.
See also Bleeding Bowl; Saucepan; Sillabub Pot; Spout Cup.

Sleeve Button
During the 17th and 18th centuries, the unstarched wrist band was held in place by linked buttons. Almost any material was used from time to time including precious metals. 17th-century examples are generally round, the shank to the button being U-shaped. At the end of the century the octagonal variety makes its appearance, but the oval link button does not appear before 1745. Studs, both sides being of equal size, came into being about 1730 and were generally used for fastening sleeves for the remainder of the century. Fully hall-marked examples are occasionally found.
Bibliography
F. Russell-Smith, *Connoisseur*. February 1957.

Smither, James
An American engraver who signed a cartouche and an engraved inscription on a tea urn, made by Richard Humphreys (1750–1832) of Philadelphia, which was presented by the Continental Congress to Charles Thomson in 1774.
Bibliography
G. Norman-Wilcox, 'The American Silversmith in the 18th century'. *Connoisseur*, February 1955.

Smoking Set
At least one such by William Pitts, 1806, of silver-gilt has survived intact; it comprises two pipe trays, a tobacco box and a spill vase. It seems unlikely that they were ever common and all are probably of about 1800 in date. What may be termed a 'Smoker's Compendium', 4½ in. (11·5 cm.) wide, made by Edward Edwards in 1836, has two compartments, one with an aperture for a pipe and pipe cleaners, and another for tobacco, with a sleeve for matches within the lid. The second, and smaller compartment, at the base may perhaps have been intended to hold snuff, or other accessories. A Victorian pipe case, measuring 5 in. (12·7 cm.) by 2½ in. (6·4 cm.), contains a space for 'Vesta' matches (invented during the 1830s), tobacco and a pipe and bears the mark of W.R. Smiley, 1855.
See also Pipe, Tobacco.

Snuff
A preparation of powdered tobacco for inhaling through the nostrils. The use of the word in this sense has been taken from the Dutch and dates from c. 1680. Many blends of snuff were and still are made. A fine table snuff box, once the property of the 1st Staffordshire Regiment and made in Dublin in 1801 held four snuffs: Rapee, Mackora, Lundy and Scotch.

Snuff Box (and other small boxes)
The snuff box derives from the tobacco box which first appears during the middle of the 17th century (a silver example is mentioned in 1643). The tobacco itself took the form of a carotte (rapee) which was to be grated and inhaled as powder. There is an example of c. 1640 decorated with stamped ornament in the Victoria and Albert Museum. A grater was a normal requirement of the box (**385**). In the Wallace Collection, London, there is a shagreen-covered, bottle-shaped snuff box (the first recorded use of the word was in 1681), decorated with brass studs, forming the monogram of Charles II. An advertisement of 1686–7 reports the loss of 'a Shagreen snuff-box in the shape of a Bottle, with gold studs'. It would seem that, amongst the gentry at any rate, the sale of ready grated snuff took such a hold that tobacco boxes are seldom found later than 1730 whilst the snuff box grew in popularity and in size. Those presented with the Freedom of a City were generally suitable for both snuff or the original scroll (**518**). By the middle of the 18th century, examples appear having compartments for two or more sorts of snuff (**517**). Both gold and silver were used in their making, the latter often as gilt, and they appear in almost all forms. An example in the Farrer Collection, Ashmolean Museum, Oxford, of c. 1745, has three compartments, each with a cover engraved with a gentleman taking snuff; another, oval, in the Museum of Science, Oxford, is engraved with a calendar for the years 1690–1717 and the Arms of Shepherd. The Skinners' Company possesses a snuff box of c. 1680 formed as a leopard. Seashells and tortoiseshell have often been mounted in silver to make snuff boxes. It seems doubtful whether the English toymakers, with the possible exception of James Cox and the chaser George Michael Moser, often produced boxes of the quality of those made on the Continent. A rare exception, in the Farrer Collection, Ashmolean Museum, Oxford, is the shell-shaped example in gold, c. 1710, chased with the busts of Queen Anne, six of her Maids of Honour and the symbols of the three Kingdoms. Of those in the Wallace Collection or Ashmolean Museum only a handful can with any certainty be called English, but it

should be remembered that the English assay offices have never, until recently, struck such small marks as those of France, having tended to grant exception on the grounds of possible damage to the smaller object—an enlightened but perplexing ruling. A four-colour, gold, rectangular snuff box inscribed on the flange 'Parker & Wakelin, Londini Fect' is probably the handiwork of Elias Russel, 1761. During the 19th century the vast majority of snuff boxes and vinaigrettes (**520a**) were produced in Birmingham. The principal makers were Nathaniel Mills (**520b**) and Joseph Willmore. The former seems to have specialised in boxes whose covers were embossed with topographical views: houses, palaces, cathedrals and public buildings were brilliantly portrayed. The popularity of such boxes (some of table size and far too large for the pocket) and almost all rectangular in shape, decorated with views of Newstead Abbey, Kenilworth Castle, Windsor Castle and Abbotsford (home of Sir Walter Scott) seems to indicate that the first souvenir collectors had appeared in this country. The figure of Harlequin or those of one of the London street criers, besides hunting scenes, were also popular (**519**); that of Lord Nelson is quite uncommon. Three gold and silver-gilt snuff boxes are illustrated on Plate **520c**, **d** and **f**. Small spoons, generally only miniatures of the teaspoon of the period, are found from the late 1680s onward and are thought to have been intended for use with these boxes, not merely as toys.

The trade card of Marie Anne Veit and Thomas Mitchell of 1742 (Heal's *London Trade Cards*, Plate LXXIV) illustrates a box of tea-caddy form but clearly engraved 'Snuff'. It should not be forgotten that enormous quantities of snuff boxes and étuis made in pinchbeck (called 'pom-pom' in France) were produced during the middle of the 18th century. A combined snuff box and folding reading-glass made for Samuel Nicholas of Leominster is hall-marked 1790. Before 1730 the hinge to the cover usually projects externally; after this date it is usually flush with the moulding of the border.

It may be appropriate to mention the existence of a number of other pocket-sized boxes, made to preserve a caul (**520e**), for pills, patches, or salve (face cream). These are of all shapes, but a number are known formed as cylinders unscrewing into several sections, sometimes engraved on the outside with the initial letters of the original contents. Most have three containers for salt, pepper and another spice. However, one of the finest, originally gilt, divides into five sections, pasted into each of which are the directions for use of the contents; two sections retain a quantity (now hardened) of the original salve, while one end is cut with the cypher of the original owner for use as a seal. The whole of the outside is finely engraved with scrolling flowers and foliage of the 1620s. Apparently unmarked, it is 3 in. (7·7 cm.) in length (**521**).
Bibliography
C. Le Corbeiller, *European and American Snuffboxes 1730–1830*. Batsford, 1966.
C. Le Corbeiller, 'A Stuart Flask Re-defined'. *Apollo*, March 1969.
A.K. Snowman, *Eighteenth Century Gold Boxes of Europe*. Faber & Faber, 1966.
E. Delieb, *Investing in Silver*. Barrie & Rockliff, 1967.
E. Delieb, 'The Quest of Silver, part II: The Snuffbox'. *Apollo*, vol. LXXII, pp. 126 *et seq.*
H.C. Dent, 'Pique', part III. *Connoisseur*, vol. LVII, p. 93.
H.C. Dent, 'Pique', part IV. *Connoisseur*, vol. LVIII, p. 28.

Edward Wenham, 'Snuff boxes by English Goldsmiths'. *Connoisseur*, vol. XCVII, p. 72.
See also Caul (Cawl) and Stone Boxes; Moser, George Michael; Nutmeg-grater; Seal Box; Spoon (Snuff Spoon); Tobacco Box.

Snuffer Scissors and Snuffer Tray or Stand
Since the second half of the 19th century the need for a pair of snuffers has diminished due to the increase in the use of a candle which entirely consumes its own wick; it was this very deficiency in early candles which made the constant use of snuffers imperative. Though the earliest surviving pair date from about 1512, and bear the Arms of Henry VIII and those of the Archbishop of York, there is no doubt that these highly developed examples must have had many predecessors, indeed 'snoffeffers' are mentioned amongst the plate of All Souls College, Oxford, as early as 1448. Another, extremely interesting pair of snuffers, now in the Victoria and Albert Museum, is inscribed 'God save Kyne Edwarde withe all his Noble Covncel' and though unmarked must date from *c.* 1550 (**522**). If any snuffers have survived between this date and the Restoration of Charles II they would appear to be unrecorded, though considering how essential they must have been, even in Puritan times, their total disappearance is something of a mystery. The post-Restoration snuffer is often found together with a stand. Prince Rupert purchased '2 snuffer pans' and two snuffers on April 29th, 1670. The general rule was that the stand followed the outline of the snuffer and had galleried sides, though there were some exceptions, such as the one, chased with fluting and having a handle at one end, of 1673, now on loan to the Jackson Collection, National Museum of Wales (**523**). The snuffer of this period was little changed from those cited above except that one flange, formed as a vertical plate, was enclosed by the other when the snuffers were closed (**524**). Though the stands became oblong or hour glass-shaped, with a handle to one side, the handle at first a shaped tongue later a rising scroll (**527a**), it was not until the third quarter of the 18th century that any great change took place in the design of the snuffers themselves, although from *c.* 1700 the cutting edges were inset with steel. From then on, a variety of ingenious devices were introduced to ensure an efficient cut and the retention of the severed wick within the snuffer box. At the same time the snuffers themselves were frequently given three stud feet in order to facilitate their being picked up. It is uncommon to find a snuffer and stand by the same maker during the first half of the 18th century. The snuffers appear to have been made by specialists, the stands often by candlestick makers. After 1770 the stand loses its handle and is frequently indistinguishable from the so-called 'pen tray' (**527b**). There is also a variety of snuffer stand formed almost as a candlestick into which the snuffers fit vertically; these are seldom found before 1680 or after 1725 (**526** and **529**). Attached to the earliest of these stands are also found conical extinguishers (**525**). These extinguishers were called 'podkins' *c.* 1800 and formed part of the usual equipment of chamber candlesticks, together with a pair of snuffers—sometimes of steel with silver handles only—which fitted the slot in the stem (see Douter). An even rarer variety, of which there are three in the Assheton-Bennett Collection (Manchester City Art Gallery), combines snuffers, extinguisher and candle socket (**525**). Probably the latest of all, is a stand made by John Cafe in 1755, the base, of table-candlestick form, with two spreading arms above upon which the

snuffers may be balanced (**528**). However, library candlestick of 1766 (Victoria and Albert Museum) also has a place for snuffers and should not be overlooked.
Bibliography
J.F. Hayward, 'English Silver in the Collection Mr. and Mrs. E. Assheton Bennett', part I. *Connoisseur*, May 1956.
H. Littlehales, 'Cardinal Bainbridge's Snuffe *Connoisseur*, vol. LXXVIII, p. 102.
G.B. Hughes, 'Snuffing of the Georgian Canc *Country Life*, March 13th, 1969.
See also Candlestick; Candlestick, Library; Tray; Spoon Tray.

Snuff Grater or Rasp See Nutmeg-grater.

Snuff Mull
Basically of vertical baluster rather than the accep horizontal form of the snuff box (**530**), the sr mull is usually of Scottish manufacture and quently made of bone, various hardwoods, semi-precious stone with silver or gold mou Examples entirely of silver are relatively uncomm (**531**), but when found they are often super chased and sometimes also engraved. In compl contrast are those made of sheep's horn wh seem in the main to be of Scottish Highland ma facture (**532**); one of these of *c.* 1790 is engra 'Belonging to the Crossgates Chicken-pye Cl larger than normal it commemorates a Fifes club founded to improve the beef stock Fife. The deer hoof is also used for snuff mu Large ceremonial mulls, usually of 19th-cent date, for use at table, take the form of a compl ram's head and horns, while the box containing snuff is inset in its forehead with a cairngorm into the lid. A spoon and a hare's foot, the one applying snuff to the nose, the other for wiping upper lip, were often attached by a chain to th large mulls.

Soap Box (Wash Ball Box)
Of spherical form, on circular moulded foot, upper half plain, these soap boxes are rare a seldom occur later than the middle of the 18 century. Generally they date from *c.* 1720 (**509** a **550**). A large toilet service of this date might w contain one, besides a sponge box of alm identical form, the one difference being th the cover of the sponge box would be pierced allow for the circulation of fresh air (**551a**). A v late example made by John Bridge in 1820 among the Lloyd Roberts Bequest, Manches City Art Gallery. *Small* examples of the soap b are more often encountered than examples of t sponge box.
See also Shaving Set; Sponge Box.

Society of Arts
Founded in 1754 'The Society for the Encourag ment of Arts, Manufacturers and Commerce' not have very much success until the 1840s, perhaps take very great interest in the last two fie of science and economics. It was not until 18 that its secretary, Thomas Whishaw, suggested exhibition of the Products of Industry, an id probably inspired by King George IV and example of the French who initiated similar on as early as 1798. In 1843 Prince Albert becar President of the Society but until 1846 the man facturers, fearing piracy of their designs, refused exhibit. However, on the active participation Henry Cole (often using the pseudonym Fe Summerly), the Society blossomed holdi competitions, awarding prizes and organisi

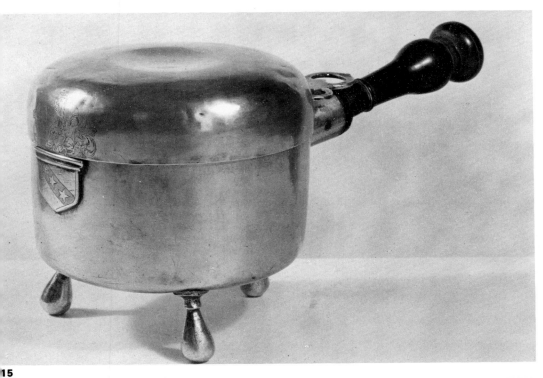

515

516

515 Skillet and Cover
Maker's mark, H B conjoined with a mullet below.
Hall-mark for 1657.
Diam. 4¾ in. (12·1 cm.).

516 Skillet
Maker's mark, IS with a cinquefoil below.
Hall-mark for 1685.
Height 6¾ in. (17·2 cm.).
Engraved with the Arms of Naylor impaling Pelham.

517 Triple Snuff Box
Maker's mark, LM.
Hall-mark for 1742.
Diam. 2¾ in. (7·0 cm.).
Engraved with the Arms of Castile-Leon, Portugal and Scotland.

518 Freedom Boxes
Gold.
a. Maker's mark, WC.
Hall-mark for 1753, Dublin.
Diam. 2¾ in. (7·0 cm.).
Freedom of Kilkenny.
b. Maker's mark, WC.
c. 1752, Dublin.
Diam. 2¾ in. (7·0 cm.).
Freedom of Waterford.
c. Maker's mark, WC.
c. 1755, Dublin.
Diam. 2¾ in. (7·0 cm.).
Freedom of Wexford.
d. Maker's mark of David King.
Hall-mark for 1733, Dublin.
Trinity College, Dublin.
All four lids are engraved with the Arms of Lionel Cranfield, Earl of Dorset and Lord-Lieutenant of Ireland, and although they are freedom boxes they tended to be used for snuff at a later date.

517

a b c d

518

519

520

521

522

523

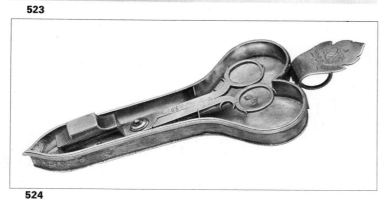

524

525

519 Snuff Boxes
Silver-gilt.
a. Maker's mark, IWG.
Hall-mark for 1828.
Width 3¼ in. (8·3 cm.).
b. Maker's mark of William Elliot.
Hall-mark for 1824.
Width 3¼ in. (8·3 cm.).
c. Maker's mark, CR.
Hall-mark for 1827.
Width 3¼ in. (8·3 cm.).
d. Hall-mark for 1830, Birmingham.
Width 3⅞ in. (9·9 cm.).

520 Snuff Boxes
a. Gold vinaigrette.
Width 1⅞ in. (4·8 cm.).
b. Silver-gilt.
Maker's mark of Nathaniel Mills.
Hall-mark for 1831, Birmingham.
Width 3⅜ in. (8·6 cm.).
c. Gold.
c. 1800.
Width 3 in. (7·7 cm.).
d. Gold.
Maker's mark of A.J. Strachan.
Hall-mark for 1812.
Width 3½ in. (8·9 cm.).
e. Gold.
c. 1750.
Width 2¼ in. (5·7 cm.).
This is a caul box and is suitably
inscribed.
f. Silver-gilt.
Maker's mark for T. & J. Phipps.
Hall-mark for 1817.
Width 3½ in. (8·9 cm.).

521 Salve or Patch Box
Silver-gilt.
c. 1625.
Length 3 in. (7·7 cm.).
It unscrews into five sections.

522 A Pair of Snuffer Scissors
Silver-gilt.
c. 1550.
Victoria and Albert Museum.

523 A Pair of Snuffer Scissors and Tray
Hall-mark for 1673, London.
Jackson Collection.

524 A Pair of Snuffer Scissors and Stand
Snuffer scissors: maker's mark, IC
with a tower.
Stand: maker's mark, WS with
rosettes and annulets.
Hall-mark for 1677.
Victoria and Albert Museum.

525 Combined Snuffer Scissors, Stand and Hand Candlestick
Maker's mark, IL with a coronet
above.
Hall-mark for 1685.
Height 7½ in. (19·1 cm.).
Assheton-Bennett Collection.

526 Snuffer Scissors and Stand
Maker's mark of Matthew Cooper.
Hall-mark for 1715, London.

527 Snuffer Scissors and Stand
a. Maker's mark of Paul de Lamerie.
Hall-mark for 1728.
Length 7⅛ in. (18·1 cm.).
Engraved with the Arms of George
Booth, 2nd Earl of Warrington.
b. Silver-gilt.
Snuffer scissors: maker's mark of
R. Emes & E. Barnard.
Hall-mark for 1816.
Stand: maker's mark of Paul Storr.
Hall-mark for 1816.
Length 11 in. (28·0 cm.).
Engraved with the coronet and
initials of Baroness Burdett-Coutts.

528 Snuffer Scissors and Stand
Snuffer scissors: maker's mark, PR.
Hall-mark for 1702.
Stand: maker's mark of John Cafe.
Hall-mark for 1755.
Height 6⅞ in. (17·5 cm.).

526

527 a

527 b

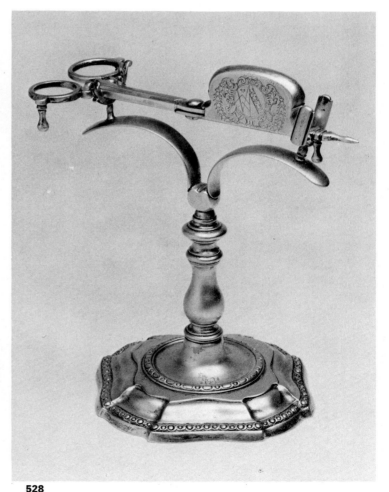

528

Snuffer Stand
Maker's mark of Cornelius Kierstede
of New York.
c. 1690.
Gift of Mr and Mrs W.A. Moore to
the Metropolitan Museum of Art.
530 Snuff Mull
Ivory, ebony and silver.
Unmarked, *c.* 1740.
National Museum of Antiquities,
Edinburgh.
531 Snuff Mull
Maker's mark, IM, probably the
mark of John Main of Edinburgh.
c. 1746.
Height 2⅜ in. (6·1 cm.).
The cover is engraved with the
Arms of Simon, Lord Lovat.
532 Ram's- horn Snuff Mull
Unmarked, *c.* 1800.
It was possibly made in the
Shetlands.

530

529

531

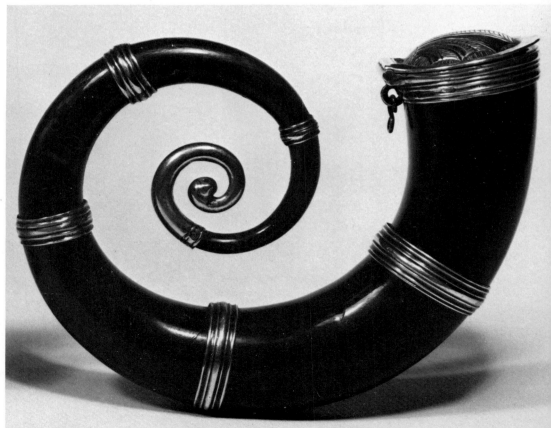

532

266

xhibitions culminating in that of 1851, which hough succeeded by others was quite the most nportant and successful ever held. A fault of mid 9th-century design was the divorce of the designer om the workman, leading to a number of unhappy sults due to a complete lack of understanding by ach of the other's requirements and capabilities. he series of exhibitions were brought to an end in 874.

oup Ladle
ee Ladle, Soup, Sauce, Sugar and Cream.

oup Plates
f similar form to the dinner plate and matching e dinner service, these are distinguished by their eeper bowl and thus are of slightly greater weight. most cases their diameter is the same as the nner plate, approximately 10 in. (25·4 cm.). urvivals earlier than 1700 are proportionately rer, there being usually but one soup to every ree dinner plates.

oup Tureen (Terreen)
hough Sir Charles Jackson refers to a tureen of 703 by Anthony Nelme as having been exhibited 1862, there is more than an even chance that is was one of the products of the most prolific ty-dodger of his day, bearing marks inserted rlier than the year of its production.

Amongst the earliest soup tureens is an example Paul de Lamerie of 1723 belonging to the Duke Bedford, this like most tureens is oval, on a rim ot with a grotesque mask at either end, and the ver has a reeded, foliate, ring handle, the whole finely chased and decorated with strapwork and edallions (Colour Plate **43**). Another similar ample in the Hermitage, Leningrad, is the ork of Simon Pantin, 1725. Yet another, of the me date by Thomas Farrer is in a Scottish collec- n. This has four scroll feet, and unlike the merie example, drop-ring handles at either end; e cover, however, is still surmounted by a ulded ring handle. An interesting small covered wl with two handles made by Lamerie in 1735 terling and Francine Clark Art Institute, Williams- wn, Massachusetts) may have been intended as a reen. Lamerie's wildest Rococo is represented by air of tureens of 1736 (one, with a later finial to e cover, is now in the Metropolitan Museum of t, New York), each decorated with every aginable fish, flesh, fowl and vegetable of which oup may be compounded. Tureens of the George eriod are still uncommon but are found imitating inese and Meissen porcelain originals with wn-turned, scroll handles at either end and uster finials (**533**), though a circular example de by Benjamin Godfrey, c. 1735 (**534**), on four n mask and paw feet has a baluster finial to the ver and two fixed ring handles. Of particularly arming bombé form are the Rococo tureens of e 1730s (one made by Charles Kandler in 1732 n the Museum of Fine Arts, Boston), the cover ually surmounted by an artichoke or vegetable ial and of waved outline (**535**). A later but similar een is illustrated on Plate 537. A decade later ilted overall decoration appears and the first doubted, as opposed to associated, stands pear (**538**). The pair of tureens by F. Kandler, 52, at Ickworth, Suffolk, are remarkable in that body is in fact a frame open at the bottom and liners are therefore an essential part of the sign not merely adjuncts. Extraordinary *tours de ce* such as the turtle tureen by Lamerie of 1750 other of Sheffield plate, c. 1800, is in the ffield City Museum) and the goat and fruit

example by Paul Crespin of 1740 (**536**), whilst not unique, must have excited comment even in their own time. The Louis XV style makes a fleeting appearance before the onslaught of the Neo-Classical revival. Approximately of this form is the very rare Canadian tureen by Laurent Amiot, but of about 1800 in date. Robert Adam, antiquary, architect and also designer planned not only his clients' houses but the silver for the tables they were to sit at. Outstanding among his designs are those for the Northumberland Dinner Plate, the tureen of which was executed by James Young in 1778. Much of this dinner service is now on view in the White House, Washington. The boat-shaped soup tureen, often *en suite* with four or more sauce tureens, dates from this period (**540**). The tendency for less and less decoration is evident by the end of the century, the body becoming quite plain save for the fluting, if any, of the lower half (**542**). Sheffield plated liners are not unknown at this date. The circular tureen, in many cases owing its approximate form to the Warwick Vase, succeeds the boat shape and is increasingly ornamented with embossed or applied foliage, seldom with any particular reference to the intended contents. The Romantic revival of the last years of the reign of George III saw the production of a number of remarkable pieces following earlier styles (**543**) and also the appearance of the oblong tureen. As a form, this latter, seems more satisfactory for entrée dishes and sauce tureens than for soup. Probably less than six Scottish tureens of earlier date than 1800 survive, one being made by Alexander Gairdner, 1763, and another is illustrated on Plate **541**. An American example made by Peter Getz of Lancaster, Pennsylvania, for Abraham Levy of that same city, c. 1780, now in the collection of Phillip Hammerslough, is extremely rare. A later (c. 1800) American soup tureen, with two sauce tureens, is the work of Hugh Wishart of New York (New-York Historical Society). In the same Collection is another of Classical form by Simon Chaudron of Philadelphia (**544**). Another by C.L. Boehme of Baltimore is boat-shaped, on an oval foot and with drop-ring handles.
Bibliography
E.A. Jones, *The Gold and Silver of Windsor Castle*. Arden Press, 1911.
J.E. Langdon, *Canadian Silversmiths, 1700–1900*. Toronto, 1966.
See also Jardinière; Verrière.

Soy
A pungent sauce popular, amongst others, during the 18th and 19th centuries and generally one of the six or more bottled sauces embraced by a soy-frame. Soy labels are of similar form to wine labels though smaller.

Soy-frame
A cruet frame for small bottles of pungent sauces, generally intended to hold at least six or more. Each bottle would have a small ticket about its neck engraved with the name of the contents. Amongst these may be noted: Kyan, Ketchup, Soy, Lemon Pickle, Anchovy, Piquante, Cherokee, Quin, Taragan, Chili, Cavice, Wood's Fish Sauce. The last on a ticket of c. 1815 encourages some enquiry as to when exactly the earliest branded names became household words. These small cruet frames are seldom found earlier than the last quarter of the 18th century.
See also Cruet; Oil and Vinegar Frame.

Spandrel
The triangular area between the curve of an arch

and a corner, made by a horizontal line from its apex and a vertical line from its springing, or between two adjacent arches.

Spectacles
Large numbers of 19th-century silver spectacle frames, both English and American, have survived, as have a considerable number of those of late 18th-century date. Earlier than 1760 they become rarer and are seldom fully marked, nor do they often retain their original cases. A remarkable survival is the folding pair of c. 1635 illustrated on Plate **545a** in Mrs Munro's Collection, on loan to the Hunting-don Art Gallery. These fold away into a silver case of pear-shaped outline engraved 'By Promise made through faith restored we be. To plefures (by Christes death) of eternitie'. A considerable collection of the later variety may be seen at the Museum of Science, Oxford. A pair of sun-glasses made by John Adams of Alexandria, Virginia, are preserved at Mount Vernon.

Spectroscopic Emission, Assay by
The possibilities of this were first suggested in print by Lockyer and Roberts in the year 1874. Roberts then being a chemist and an assayer at the Royal Mint. The process is particularly suited to the analysis of gold and silver of the highest purity, and especially that of platinum, for which no direct and simple method of assay by fire or volume is known. A total combustion technique with constant current (direct current) known as arc excitation is used for this form of analysis.

British silver wares which are over one hundred and fifty years old are made from silver alloyed with copper, and other metallic impurities which are invariably found are gold, lead, bismuth and antimony. In addition, arsenic, nickel, tin and zinc are often present. Traces of platinum are some-times found in silver made between the end of the 17th century and the late 19th century, but not in silver wares of an earlier period.
Bibliography
'Spectroscopy in the Metallurgical Industry'. *Buxton Symposium*, July 1962.
See also Assay.

Spice
So far as its application to silver is concerned the word embraces salt, pepper, mustard, ginger, mace, cinnamon, sugar and a number of other pungent flavourings essential in the days of poor quality, if not actually tainted, meat and fish.

Spice Box
The earliest table-form examples so far surviving appear to be those with escallop-shell covers, each on four feet, the interior usually divided trans-versely into two, the cover secured, either from within or with a hinged hasp. Though not quite the earliest of the score or so known to survive, perhaps the finest is that belonging to the Middle Temple of 1598 (**546**). Only recently there appeared an example of 1627, retaining what appears to be its original spoon, with leaf bowl and hoof finial, small enough to fit inside.

In the collection of the Ashmolean Museum, Oxford, may be seen an actual escallop shell mounted in this way, similar to, if not actually, the prototype. The design appears to have died out towards the end of the reign of James I and it is not until after the Restoration that a particular form of oval casket makes its appearance, generally on four feet, the flattened cover with a serpentine ring handle and the whole chased with lobes and foliage. This is known as either a 'spice' or 'sugar

533

534

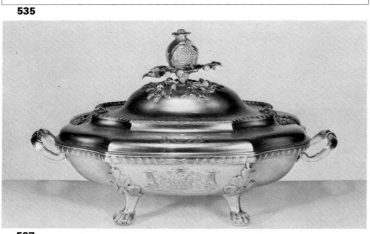

535

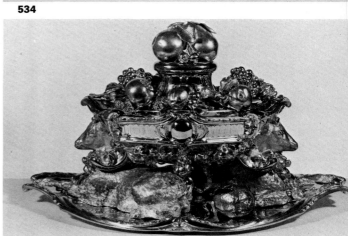

536

537

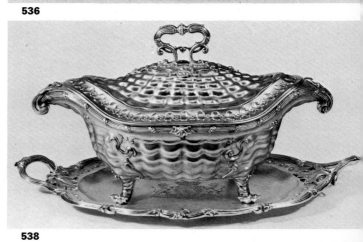

538

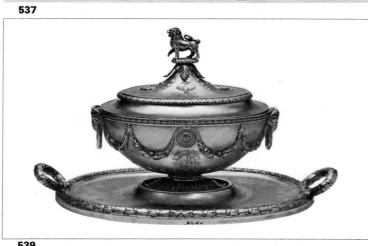

539

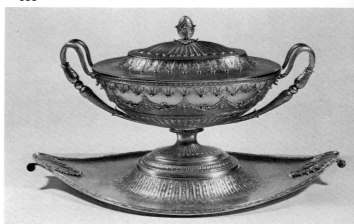

540

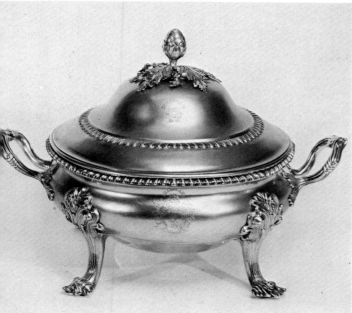

541

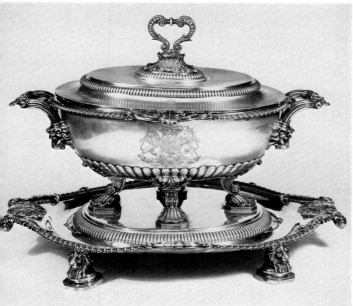

542

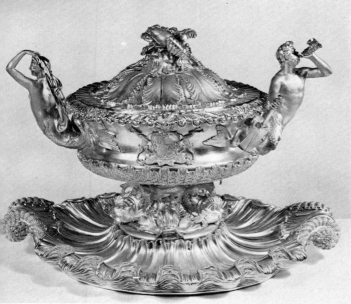

543

533 Soup Tureen
Maker's mark of Charles Kandler.
Hall-mark for 1729.
Width 9½ in. (24·2 cm.).
Engraved with the Garter motto and crest of William IV.

534 Soup Tureen
Maker's mark of Benjamin Godfrey.
c. 1735.
Width 14½ in. (36·2 cm.).

535 Soup Tureen
Maker's mark of Edward Feline.
Hall-mark for 1738.

536 Soup Tureen
Maker's mark of Paul Crespin.
Hall-mark for 1740.
Width 21¾ in. (55·3 cm.).

537 Soup Tureen
Maker's mark of William Cripps.
Hall-mark for 1752.
Width 15 in. (38·1 cm.).
Engraved with the Arms of Child quartering Wheeler.

538 Soup Tureen and Stand
Maker's mark of Edward Wakelin.
Hall-mark for 1755.
Width 18½ in. (47·0 cm.).
Engraved with the Arms of Cecil.

539 Soup Tureen and Stand
One of a pair.
Maker's mark of Andrew Fogelberg.
Hall-mark for 1770.
Tureen: 11¼ in. (28·6 cm.).
Stand: overall width 22¼ in.
(56·5 cm.).

540 Soup Tureen and Stand
Maker's mark of John Schofield.
Hall-mark for 1791.
Tureen: width 18½ in. (47·0 cm.).
Stand: width 23¼ in. (59·1 cm.).

541 Soup Tureen
Maker's mark of Patrick Robertson.
Hall-mark for 1778, Edinburgh.
Diam. 11 in. (28·0 cm.).

542 Soup Tureen and Stand
Maker's mark of Paul Storr.
Hall-mark for 1806.

543 Soup Tureen and Stand
One of a pair.
Maker's mark of Paul Storr.
Hall-mark for 1820–1.
Overall width 21 in. (53·4 cm.).
Applied with the Arms of William, 6th Duke of Devonshire.

544 Soup Tureen and Stand
Maker's mark of Simon Chaudron of Philadelphia.
c. 1813.
Width 15¼ in. (38·8 cm.).
New-York Historical Society.

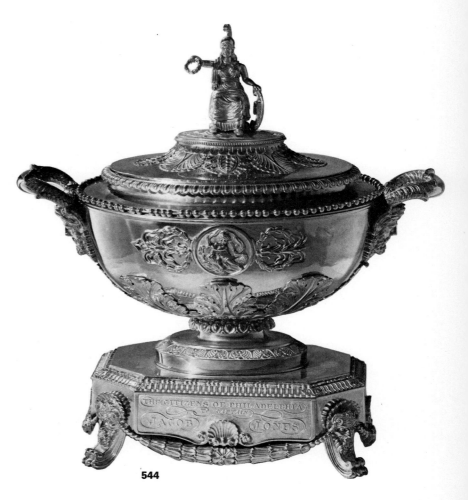

544

box' and is closely paralleled in New England where the type frequently has a much more domed cover. An Exeter example of 1705 survives (**55**). During the first decade of the 18th century these oval sugar boxes appear to have been superseded by the covered sugar bowl. The true spice box of the 18th century is either oval or oblong, with a double, centrally-hinged lid, sometimes with a central finial, which, when lifted, reveals a third compartment (**548**); they were probably referred to at this time as 'salt cellars'. Lamerie invoiced thus '2 doble salts for ye surtoute' for those illustrated on Plate **547**. These are rare and, seemingly, not found earlier than 1695. A spice box engraved with the crown and monogram of Queen Anne is in the Collection of Her Majesty the Queen; executed by Francis Garthorne, it stands on four bun feet. It could possibly be dated as early as 1697 and be re-engraved on the death of King William III. During the late 17th century one of the fittings of a personal travelling canteen was a small double spice box, usually shaped as a figure 8. One of the latest spice boxes of 1823 is formed as an ivory casket containing six boxes and two graters (**549**). Pocket spice boxes are usually of a form usable as such or as pomanders.

See also Caster; Jewish Ritual Silver; Pomander; Pouncet Box; Salt, Great or Standing; Snuff Box; Sugar Box; Travelling Canteen.

Spice Dredger

See Kitchen Pepper and Spice Dredger.

Spice Plate See Plate (ii).

Spigot

A tap, the valve being opened by means of turning it 90 degrees, was frequently fitted to tea or coffee urns of the last half of the 18th century. The tap is referred to in the Wakelin Ledgers of the 1770s as 'an ivory Cockhead'. The thumbpiece usually being of ebony, boxwood or ivory, the remainder was chased with masks and anthemion foliage. Victorian spigots often have a handle of the drop-ring variety. Detachable silver spigots for use with small kegs of beer or ale are also found and usually date from c. 1790 or later. They are unusual and when found are seldom decorated. During the 18th century the two urns, for water and knives, that stood on tall plinths on either side of the sideboard, were generally both fitted with such spigot taps though more usually of gilt or silvered metal than of pure silver. The wine fountain of an earlier date was also so fitted.

Spindle and Bead

Enrichment of scotia moulding.
See also Scotia.

Spinning

In many cases it is quicker, and cheaper, to produce an article by spinning the metal over a wooden 'chuck' or form, thus forcing the metal to the same outline, rather than raising it by hand. This has been done in England since the 14th century.
Bibliography
H.V. Johnson, *Metal Spinning*.
See also Silversmithing.

Spitting Pot (Spittoon)

Though George Wickes supplied one of gilt in 1745, weighing 9 ounces 12 pennyweights, only two examples, recognisable as such, appear to have survived. One of these is by Paul Crespin, 1742, the other, presumably a later copy, as it has remained in the same collection, is by Charles Kandler, 1786,

each is circular with leaf edges, foliated scroll handles and is 7 in. (17·8 cm.) in diameter. A pair of otherwise unexplained bowls with widely everted lips of 1723 is amongst the Corporation Plate of St Albans and may perhaps have been intended as spitting pots.
See also Bowl.

Sponge Back

An invoice of 1741 reads: 'The Duke of Roxburghe. 1741. To 2 silver silver backs for Spunges 1 oz. 3 dwts. 13/0'. They were probably small plates, fitted with a suspension ring, which were attached to sponges and other washing appliances. In November 1759, the Marquess of Winchester purchased a sponge with a silver handle for 8s 6d from Edward Wakelin and at the same time a silver-backed tooth brush for a similar sum.

Sponge Box

Usually spherical, *en suite* with the soap box but having a pierced cover (**551a**); a sponge box may also, much more rarely, be oval (**551b**). The majority must originally have been associated with shaving sets and small examples are uncommon.

Spoon

Although a number of very early spoons have been found in England, it seems unlikely that it will ever be possible to be dogmatic as to the actual provenance of such pieces, many of which must have been imported, unless, of course, marked examples come to light.

The Coronation Spoon dates from the 12th century, those from Iona, Pevensey and Taunton date from the years 1150–1250. The tiny Warwick Spoon, perhaps originally intended for use with an incense boat and having a writhen stem, is dated between the years 1150 and 1350. The extremely interesting folding spoon from Scarborough was ascribed by Commander How to the year 1300 and a spoon, with an acorn knop, from Coventry, to about the same date. It is on one of these latter that the earliest leopard's head mark so far recorded has been found. In 1329 the contents of the King's Jewel House included '36 Silver Spoons, plain white stamped with a leopard' and the will of Edith Panmer, c. 1305, mentions thirteen silver spoons marked with a star. The Royal Plate also included five spoons of gold. In 1351 John de Holegh bequeathed to Thomas Taillour 'twelve silver spoons with akernes'; c. 1355 another bequest comprises 'spoons with dragons heads' and in 1361 John Botiller bequeathed to Isabella, his wife, twelve 'best spoons' with gilt acorns. In 1549, King Edward VI was known to be the owner of many spoons, a large number of them gold, not a few of which were New Year presents to the Sovereign (a custom by which the donor generally expected a present in return of slightly greater worth than his own—see New Year's Gifts). Thus we read: 'Item a Spone of gold with a knopp [finial] six squared and the stele [stem] vj square gyven by the Ladie Marques Dorsett on New yeres daye anno XXIX° nuper H.viii'. Amongst the list of silver spoons of the same date are 'xij silver spones wt. gilt Columbynes at the endes, weing xxiij oz.' and there are many entries, such as 'Item V Spones of Cristall garnysshed wt golde enameled'. From the 14th century the stems (stele) of English spoons taper from bowl to finial (knop) and are almost invariably of hexagonal section, save a seal-top spoon of 1530 which is of diamond section. Perhaps to allow for the placing of marks the front and back facets of the stem tend to widen by 1480. The richer examples were often enamelled and gilt and

the finial frequently cast. From the 14th century the middle of the 17th century the bowls of a spoons were more or less fig-shaped and up curved, the earlier ones being more so than the later. They were thus incapable of holding 'spoonful' of liquid. Almost invariably, if marked all, one mark (in London, the king's mark of the leopard's head) was struck in the bowl near the spring of the stem. Provincial makers often place their own mark at this point. The remaining London marks were struck low down on the bottom of the back of the stem, nearest the bowl, together with the maker's mark, except in the case of slip-stump-top spoons. By 1640 it became usual for the date-letter to be struck nearest to the end of the stem and by 1650 it had become the rule. Provincial makers sometimes imitated the placing of London marks by striking their own several times in the appropriate position. Spoons from Barnstaple of 16th- and 17th-century date frequently outshine those made in London during the same period quality. By 1670, the bowl form is more rounded and often of a remarkably heavy gauge, finial becoming a flattened oval, strengthened by a r (rat-tail) extending over half-way down the out side of the bowl from the junction with the stem Of this type would have been the spoons purchase by John Hervey, 1st Earl of Bristol, 'Feb. 21 170 Paid Mr. Chambers for 12 Spoons, 12 fforks & 1 knives etc. £29.13.0.'—a not inconsiderable sum Amongst the plate of St Albans Corporation a three trefid spoons each punched with a differe unidentified crest. These are most unusual, but the may perhaps be the owners' marks, though it is ve remarkable that three such rarities should all gathered in one corporate collection.

Knives, forks and spoons made after 170 originally in services, are broadly referred to 'flatware' by the Antique trade and manufacturing silversmiths. The making of spoons was u doubtedly a specialist occupation so far as certa silversmiths were concerned. They were alway made in one piece, contrary to Continental wo practice. During the 16th century, very larg numbers of spoons are found originating from th workshop of a maker, whose mark was a fringed During the 17th century Stephen Venables was prolific maker. From 1773 many marks wer registered at the Goldsmiths' Hall by speciali 'spoon makers'. By the early 19th century, Rob son's *London Commercial Directory* (1821) lis James Beebe, J.L. Hankins and Thomas Streeth as 'Silver Spoon Manufacturers'. Paul Storr was th first maker to use the Boar Hunt, Stag Hunt an Bacchanalian patterns designed by Flaxman f Rundell, Bridge & Rundell. Contrary to norm practice these are marked on the bowls of th spoon, or the shoulders of the tines of forks, rath than deface the decoration of the stem (**562**). few 19th-century fake Apostle and seal-top spoon are known, generally of poor quality, though group of the former with superbly modelled finia are extant. In almost all cases they come to grie having been made from tablespoons of the 18 century with the date-letter defaced and as th marks are far too large and often wrongly place they cannot escape detection by any but t most gullible—or greedy. Undoubted Scotti spoons are unknown prior to 1560 and they nev seem to have been marked in the bowl. No Apost maidenhead or lion finials are known from Scotla Until the 17th century it was usual for a spoon, a set of spoons, to be given as a christening g (appropriately named Apostle finials being a obvious choice). In the Dutch-settled areas North America it was also the custom to gi

**5 Spectacles and
ok Cover**

Spectacles and case.
1640.
Book cover.
ll-mark for 1650.
th are in the Munro Collection.

6 Spice Box
ver-gilt.
aker's mark, a triangle
ersected.
ll-mark for 1598.
ight 4 in. (10·2 cm.).
e gift of Lord Rothermere to
e Honourable Society of the
ddle Temple.

547 A Pair of Spice Boxes
Maker's mark of Paul de Lamerie.
Hall-mark for 1727, London.
Engraved with the Arms of Walker,
Lancashire.

548 Spice Box
Silver-gilt.
Maker's mark of Frederick Kandler.
c. 1735. Width 5 in. (12·7 cm.).
Engraved with the initials G B,
possibly those of Georgina Bedford,
wife of the 6th Duke of Bedford.

549 Spice Box
Ivory with silver mounts.
Maker's mark, C R.
Hall-mark for 1823, London.
Fitted with silver boxes and
nutmeg graters.

550 A Pair of Soap Boxes
Maker's mark of William Holmes.
Hall-mark for 1786.

551 Toilet Boxes
a. Sponge box.
Maker's mark of William Fawdery.
Hall-mark for 1720.
b. Oval toilet box.
Maker's mark of David Willaume.
Hall-mark for 1720.
Height 2¼ in. (5·7 cm.).
Width 4½ in. (11·5 cm.).

548

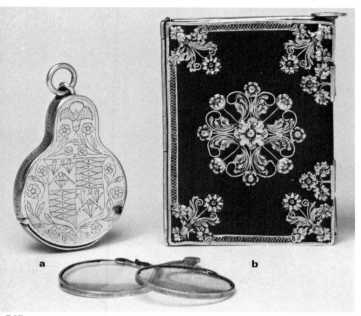

a b

545

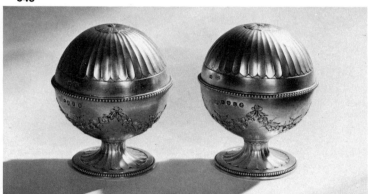

549

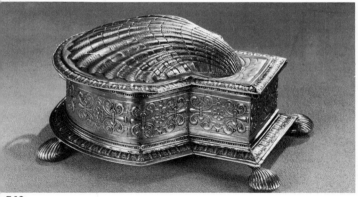

546

550

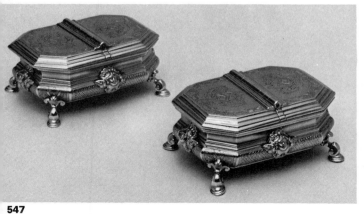

547

a b

551

memorial spoons at death, duly engraved with the deceased's name and dates. This custom continued as late as the 19th century. It was also a normal custom in England during the 16th and 17th centuries. A selection of spoons are illustrated in Fig. **XXVII**.

Bibliography

Dr Wilfrid Harris, 'The Education of a Spoon Collector'. *Connoisseur*, vol. cxxv, 1950.
American Gold. Yale University Art Gallery, 1963.
Catalogue of the Ellis Collection of Provincial Silver Spoons. Sotheby & Co., November 13th, 1935.
N. Gask, *Old Silver Spoons of England*. 1926.
C.G. Rupert, *Apostle Spoons*. Oxford University Press, 1929.
Sir C.J. Jackson, *An Illustrated History of English Plate*. 1911 (pp. 496–8 includes many relevant extracts from Royal Inventories).
Commander G.E.P. How, 'The Cult of the Teaspoon'. *Notes on Silver, no. 4*. 1945.

Acorn Head Spoon

Appearing in the early 14th century this form is one of the most popular during the Middle Ages. In a will of 1348 which was proved in 1351, John de Holegh bequeathed twelve silver spoons with 'akernes' to Thomas Taillour. Most examples made after 1550 are only replacements. That from Coventry, c. 1300, is perhaps the earliest. Another, in the Jackson Collection, National Museum of Wales, is, so far, the earliest piece of silver recorded bearing the leopard's head or the king's mark. All sorts of varieties are known; in some the acorn sprouts from a bunch of foliage, in others from a roped or twist orle. One very early spoon (c. 1350) has a baluster finial which appears to terminate in an acorn (**560a**).

Anointing Spoon

See Coronation Plate; Spoon (Coronation Spoon).

Apostle Spoon

Ideally made in sets of thirteen of the Master and His twelve Apostles (**553** and **560b**) but more frequently only one or two were given as christening gifts, with the result that full sets are extremely rare. The earliest such set dates from 1527. A will proved at York in 1494 mentions 'XIIJ cocliaria argenti cum Apostolis super eorum fines'. The earliest part set so far known are the six Beaufort Spoons of c. 1460, probably all once part of the same set. The Apostles may be distinguished by their various emblems which are held in the right hand (because these emblems were often separately cast they are liable to have been broken off). The left hand, in general, holds a book and is cast in one with the figure. The nimbus (halo) which in early examples is often solid, by 1530 is pierced and sometimes cast, surmounted with a dove as a symbol of the Holy Ghost or even an expanded Tudor rose (as on an Apostle spoon of St James the Less made in 1515). West Country examples, like seal-top spoons, are often comparatively coarse and have very large nimbi. The moulds from which the figures were cast seem to have been in use for many years and later castings were probably almost unrecognisable even when new. Spoons bearing the figures of saints other than the Apostles, such as St Nicholas (1528, in the Bute Collection), St Christopher (engraved 1518), and St Mark (1559) are also known. St Paul, replacing St Jude, is relatively common. One of the finest sets, at one time miscalled the 'Abbey Set', is that belonging to the Honourable Gavin Astor (on loan to the Victoria and Albert Museum), hall-marked 1536; each of these is engraved in the bowl with the sacred monogram. The finials are from the same moulds as those used for the figures on Bishop

Fox's Crozier; Bishop Fox died in 1528.

Bibliography

W.J. Cripps, *Old English Plate*. Various editions.
C.G. Rupert, *Apostle Spoons*. 1929. (To be read with circumspection.)
N. Gask, *Old Silver Spoons of England*. 1926. (To be read with circumspection.)
Catalogue of the Ellis Collection of Provincial Silver Spoons, Sotheby & Co., November 13th, 1935.
J.S. Sharman, 'English Apostle Spoons and their Symbols', *Connoisseur*, vol. LII, p. 138.
Commander G.E.P. How, 'The Plunkett St Christopher and Apostle Spoons'. *Connoisseur*, vol. CXII, p. 13.

See also Instrument Case.

Ball Knop Finial

Six spoons with finials of ball, or more correctly, of segmented globe form with an equatorial belt, bearing the date-letter for 1516 are amongst the plate of Corpus Christi College, Oxford.

Ball Baluster Finial

From the ball knop finial derives the ball baluster, an example of which, in the Cookson Collection, is hall-marked 1544.

Baluster Finial

This finial can take various forms and differs only from the seal-top in that the seal is surmounted by a further turned section; in one very early example (c. 1350) the baluster finial resembles an acorn. As with the seal-top, the baluster is sometimes an inch or more in length, and of this latter form is a particularly fine example made in York about 1614 (it is engraved 1615) and was originally presented to the Earl of Cumberland. The baluster knop usually dates from the late 16th or early 17th centuries. An American example (maker's mark, AC) is the only spoon of this type known from North America. It is, however, of northern Dutch form so it is reasonable to assume, though as yet unproved, that its maker had some connection with New York (John Griggs Loan, Metropolitan Museum of Art, New York). Examples of baluster finials are illustrated on Plates **560c** and **d**.

Basting or Hash Spoon (and other large forms)

The largest spoons found in the late 17th and 18th centuries are thought to have been used in the kitchen for basting, though there is no reason why they may not also have been used for serving. In their earliest surviving forms they are found as large stump-top spoons, sometimes with perforated bowls, though an example of 1679 in the National Museum of Ireland, Dublin, by E. Swan has a heart-shaped finial (**561a**). At the Bank of England is a specimen of 1691, $14\frac{5}{8}$ in. (37·2 cm.) long and with trefid finial. During the last decade of the 17th century, a type, with deep, oblong bowl and tapering, tubular handle, became fashionable and continued to be so in Ireland for some years (**561b**). In at least one Glasgow example (that made by John Luke in 1705), the finial unscrews to reveal a skewer. A number have turned wooden handles, but by 1715 the more common type was the normal spoon of the day greatly enlarged. On November 7th, 1695 John Hervey, 1st Earl of Bristol, purchased 'a porridge ladle of Edw. Waldegrave. Goldsmith in Russel Street' and on July 6th, 1700 he 'Paid Williams [David Willaume] ye french silversmith for 2 pottage and 4 ragow spoons 15.-15.-0'. An interesting punch ladle is illustrated on Plate **561c**, and engraved 'jugum jam Jollitur nobis · 1737' (private collection). Another fine example, with a baluster handle, was made by Benjamin Burt of Boston, c. 1755, now on loan to the Cleveland Museum of Art, Cleveland. A gravy spoon, with pierced bowl and lion-mask

finial is dated 1774 (**561d**). The chaser of the 19th century, as was his custom, applied himself with gusto to the decoration of such spoons, the bowl of a punch ladle illustrated on Plate **564** is one such example. Basting spoons of large size seem to have been particularly popular in Scotland and examples are known of early 18th-century date from almost every small town where a silversmith ever worked. They appear to have been known by the Scots and Irish as 'hash spoons'.

Berry Finial

One of the rarest known types of all spoon finial, an example bearing the mark of the so-called 'Arabian' head in its bowl and dating from the early 15th century, appeared at Christie's in 195_ (**560f**).

Buddha Finial

Perhaps also intended to portray Krishna, this rather ugly form of finial emanates from the West Country. Most examples seem to have been made at Barnstaple (**560e**). A possible West African origin to this finial, besides the oft-quoted Indian one, should also be considered, as should its being a distorted survival of the medieval Virgin and Child finial.

Caddy Spoon

No undoubted caddy spoon has yet come to light of a date prior to 1770. The so-called 'medicine spoons' of the 1750s could of course have been used as such, but as engraved specimens of these, leaving no doubt as to their original purpose, are extant, tea would needs be a secondary usage. Until the early years of the reign of George III the detachable cup-shaped lid of the earlier type of tea caddy was used to measure the tea into the teapot. The portrait, *The Walpole Family* by William Hogarth, c. 1735, shows just this. Perhaps from 1745 onwards the small ladles with stems near vertical to the bowl were also so used. Every form of shell and leaf shape was employed in the design of the caddy spoon, always remembering that the spoon had to be fitted into the caddy. It might be expected that Birmingham would have been one of the first centres to produce these pieces in some quantity, but no specimen marked by Chester (the assay office generally used by Birmingham before the opening of its own in 1773) has been found. The caddy spoon is generally worked up from sheet plate or die struck but cast examples are known and amongst the rarer forms may be mentioned the jockey-cap, the salmon, the eagle's wing, the mandarin and the shell and serpent types. All these latter have suffered considerably from the attentions of fraudulent imitators.

Bibliography

E. Delieb, 'The Caddy Spoon'. *Apollo*, April 1960.
E. Delieb, *Investing in Silver*. Barrie & Rockcliff, 1967.
E. Delieb, *Bulletin*. January 1963.
G.B. Hughes, 'Silver Caddy Ladles'. *Country Life*, July 13th, 1951.

Collections

Fitz-Henry Collection, Victoria and Albert Museum.
Lewer Collection, Colchester Museum.

Ceremonial Spoon

Other than the Coronation Spoon (see below) highly decorated spoons are rare, excepting trefid in either English or American silver. Outstanding are a group from Barnstaple having seal or figure finials to the stems. These are decorated over with stamped ornament and engraved with fruit and foliage. Some are the work of the Quyck family. They may be engraved with the word 'Honor God' or 'Praise God' and some have a ball knop at the centre of the stem. Unfortunately, _

Plate 39 Teapot
A gold teapot with the maker's mark of James Kerr of Edinburgh, *c.* 1736, and engraved with the Royal Arms.
It was presented as a race prize 'The King's Plate' at Leith, Midlothian.

Plate 40 A Pair of Elizabeth I Tankards
Of silver-gilt with the maker's mark, IB.
Hall-mark for 1602.
Height 8¼ in. (21·0 cm.).

Plate 39

Plate 40

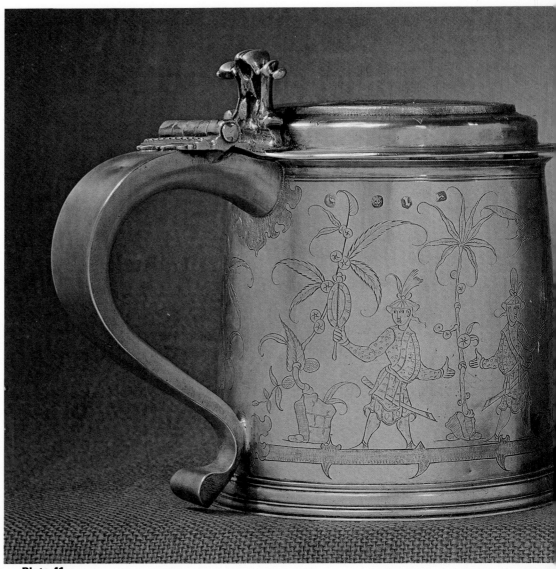

Plate 41

Plate 42

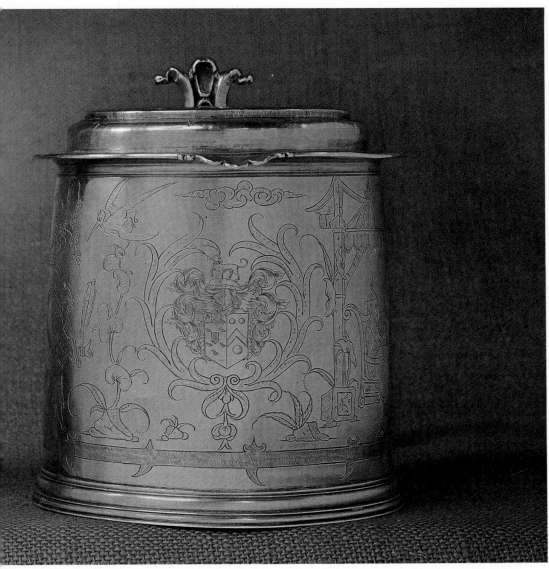

Plate 41 A Pair of Tankards
Maker's mark, a goose within a
dotted circle.
Hall-mark for 1686.
Height 8½ in. (21·6 cm.).
Decorated with the Arms of
Brownlow impaling Sherrard, and
in the chinoiserie fashion.

Plate 42 George II
Soup Tureen
A highly decorated soup tureen on
four shell feet bearing the maker's
mark of John Edwards.
Hall-mark for 1737.
Width 16¼ in. (41·3 cm.).

Plate 43 Soup Tureen
Maker's mark of Paul de Lamerie.
Hall-mark for 1723.
Width 11 in. (27·9 cm.).
This is one of the earliest known
tureens.
From the Woburn Abbey Collection
by kind permission of His Grace
the Duke of Bedford.

43

Plate 44 A Pair of Tea Caddies
A silver-gilt pair of tea caddies and
a mother-of-pearl case.
The caddies were made by Pierre
Gillois.
Hall-mark for 1763.
Engraved with the monogram of
Queen Charlotte, wife of George III.
Gibbs Collection, Nottingham Castle
Museum.

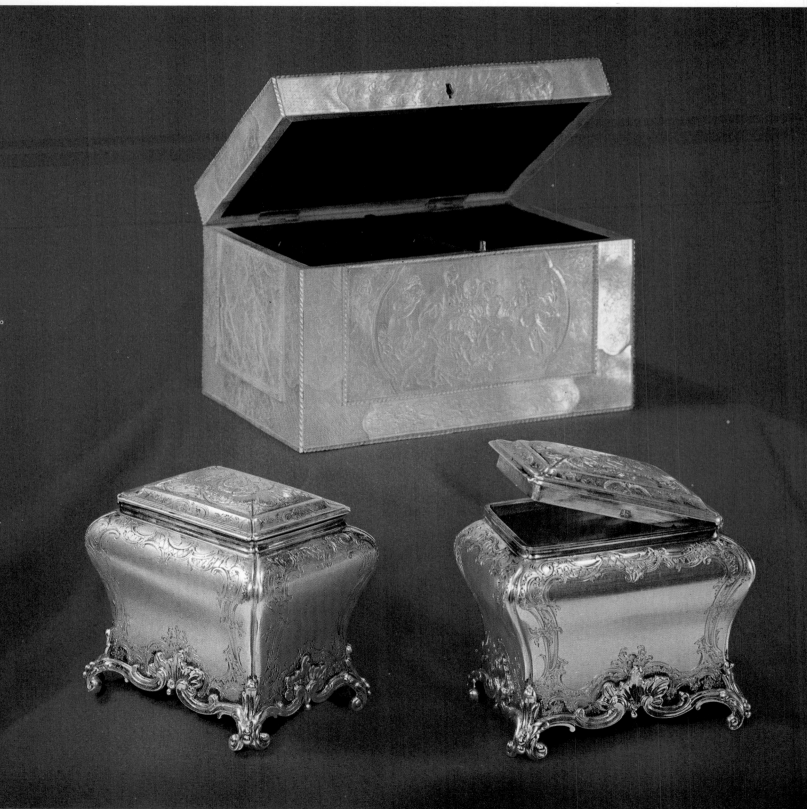

Plate 44

an a dozen of these spoons are so far recorded.

ffee Spoon

til the late 19th century, spoons made speci-
ally for coffee are indistinguishable. Normally a
aspoon would do double duty. The earliest tea-
oons were extremely small and often of silver-
t. Nicholas Blundell purchased 'six gilt Coffy
oones' for 18s in May 1703.

oliography

argaret Blundell, *Blundell's Diary and Letter
ok, 1702–28*. 1952.

e also Teaspoon.

ronation Spoon

silver-gilt, 10¼ in. (26·1 cm.) long, this spoon,
corated with four freshwater pearls at the widest
rt of the handle, is probably the only surviving
ece of the English Coronation Regalia to have
caped the melting pot of Cromwellian Par-
mentary 'reform'; excepting perhaps the body
the gold Ampulla. The bowl has a central
ge allowing the two fingers of the anointing
est to be easily dipped in the oil. It seems likely
t the spoon is indeed of 12th-century origin
ugh the bowl may have been rebuilt for the
ronation of Charles II in 1661 at the same time as
was re-gilt. Numerous reproductions have been
de in many different sizes.

e also Coronation Plate.

ssert Spoon

oons naturally varied in size during the 17th
ntury but *c.* 1700 a definite distinction set in
tween the so-called 'table spoon' and the
ssert spoon. In general, they were identical in
but size, and this also applied to the teaspoon.
wever, very occasionally special services were
de for use with dessert and these are usually of
t and extremely rare prior to 1770. One such set
twelve made by Frederick Kandler is in a Dutch
vate collection. The stems are superbly cast and
ased with shells, grapes and vine tendrils, and as
esult the marks are stamped on the backs of the
wls. Such spoons, when found, are generally
e work of the best makers of the day.

amond Point Finial

e earliest hall-marked example was made in
ndon in 1493. There are many unmarked
amples and a number with the pre-1478
pard's head mark, incorporating a letter in place
the tongue (**557a** and **b**), including one
cribed by Commander G.E.P. How to the year
66. The pointed knop is faceted like a diamond
d this form may well originate from the 14th
ntury. The Mercers' Company possesses seven
ry late survivals of 1565. In 1965 five, of 14th-
ntury date, were discovered in the wall of a
orcestershire church and are now in the British
useum.

sc-end Finial

is variety of spoon finial, peculiar to Scotland
d the northern counties of England, may have its
gin in Scandinavia. It has a shaped top, the
m lightly engraved with acanthus foliage and,
Yorkshire, a number were engraved at the top of
e front of the stem with a death's head and the
rds 'Live to Die. Die to Live'. Traditionally
ese were given as 'Memento Mori' in that county
custom presumably taken over by memorial
gs. The Scottish variety are not known earlier
an 1580, those from York date from the last half
the 17th century (**556b**, **c** and **d**). Of these
rly Scottish examples a set of seven by George
eriot, 1582, is divided between the National
useum of Antiquities, Edinburgh, and the collec-
n of the Marquess of Bute. In the latter's collec-
n are also a set of six probably from Aberdeen;
other by George Cunninghame has Canongate

marks of *c.* 1589. Plate **556e** illustrates an American
variation of the disc-end finial, the work of Hull &
Sanderson, *c.* 1665.

Dog-nose Finial (1695–1710)

These, developed from the trefid (shaped some-
what like the profile of a dog's head as viewed from
above), continued with a stem of rectangular sec-
tion until about 1700 when that part of the stem
nearest the bowl tends to become oblong in
section (**558d**). An example in gold, with two
pendent bells, presumably a child's pap spoon, by
J. Van der Spiegel is in the Garvan Collection, Yale
University Art Gallery. It appears to be the only
such spoon recorded in either gold or silver and is
probably of Dutch inspiration.

Egg Spoon

Survivors date from the late 18th century, the
earliest being of rather similar bowl form to the
mustard spoon. They are usually found as part of
the fittings of an egg frame. In May 1758, however,
Lady Raymond purchased an egg spoon from
Messrs Wakelin which required 'graving and
piercing' and weighed 2 ounces 14 pennyweights.
Perhaps it was intended to lift eggs from boiling
water (Garrard Ledgers, vol. 2). To judge from its
weight this would be of tablespoon size, similar to
those preserved as strainer spoons in a number of
churches. One of the best preserved sets con-
sists of six silver-gilt spoons with unusual flat
stems made by P.A. & W. Bateman, 1800, in the
Wilmot Collection.

Fancy-back Pattern

From 1740 until late in the century, a number of
both Hanoverian and Old English pattern spoons of
every size (the majority teaspoons) were decorated
with shells, scrolls or other decorative patterns in
place of the more conventional double drop,
below the junction of the bowl and stem. A number
were politically inspired. The many varieties of
decoration and the more usual patterns of table
silver made from 1800 onwards are illustrated in Fig.
XXVIII. Fancy-backed dessert spoons are the
least common. A set of a dozen made in Newcastle,
1749, are recorded; these have an escallop shell on
the reverse of the bowl.

Types of patterns
Shell-back (many variations)
Scroll-back (many variations)
Scroll and mask
Spray of flowers (many variations)
Basket of flowers (many variations)
Vase of flowers
Hen and chickens (several variations)
Prince of Wales feathers
A crown
Double-headed eagle crowned
Burning heart(s)
Plenty (cornsheaf, the word 'Plenty' above)
Liberty (bird on top of an open cage, 'I love Liberty'
 above)
Hearts of oak (A heart and 'British' enclosed by
 acorns)
Milkmaid with pails
Ship-back (many variations)
Harvest back (barrel and harvesters' implements,
 hat on top)
Peace (a dove and olive branch—several variations)
A swan
A parrot
A number of other birds
A squirrel (several variations)
A stag
A dolphin
A teapot
Masonic signs
A cock crowing

Feeding Spoon

These, with partly or wholly covered bowls, could
equally well be used for infant feeding or medicinal
dosing (both for human beings and animals). An
early example, probably Scottish, about 1698, is in
the collection at Pollock House, Glasgow. One of
the most interesting is that of 1827 bearing a
maker's mark, C.G., and signed 'C. Gibson,
Inventor. 71 Bishopgate St. Within'. This has a trap
to the wholly covered bowl and the tubular stem
connected with the latter has a flared washer half-
way down its length. The purpose of this is doubt-
ful, as the piece is 7¼ in. (18·4 cm.) long, and there
can hardly have been any danger of its being
swallowed, unless by a horse or other animal.
See also Spoon (Medicine Spoon).

Fiddle Pattern

As with the rat-tail, this pattern bears a name
derived purely from one of its characteristics.
However, such a simple explanation, that the top
of the stem resembles in outline that of a violin or
fiddle, seems at first unacceptable to many. In
Scotland a number of examples are extant with
rat-tail bowls and an elongated 'fiddle', especially
in the products of the provincial towns. When such
spoons have a narrow, moulded border, called
'thread', they are then referred to as 'threaded
fiddle pattern spoons'.

Finials

Because of the softness of cast silver the bowls and
stems of spoons were almost invariably hand-
forged. A few very early spoons with acorn knops,
diamond points and one or two other finials, such
as late 15th-century seal-tops, were sometimes
fashioned in one piece with the rest of the spoon
(**557**). The coming of the larger finial made this
impossible, so that these, generally cast, were
soldered on as separate entities. The method of their
joining is of the utmost importance. In London,
almost from the beginning of the 16th century a 'V'
joint from front to back of the stem became the rule.
In the provinces, however, where the finial itself
was often rather coarse, a lap joint was preferred.
This regional difference is constant until the demand
for separate finials died out with a change of
fashion. Occasionally, a slight variation of the lap
joint in the form of a long slip joint may be found.
In North America stem and spoon are always of one
piece and only in those parts of North America
where Dutch influence was strong did the Conti-
nental habit of separate stem and bowl persist for
a short time. It is also true that the moulds, from
which these finials were made, were handed down
from generation to generation, so that, other than
a slightly poorer quality and finish, there may be
little or no difference between finials attached to
spoons one hundred and twenty years apart in date.
The finials themselves were manufactured not only
for spoons, but in the case of Apostles as part of the
decoration of other silverwork (**425** and **553**), and
in all probability the making of finials was originally
a trade in itself. (The finials of the Astor Set of 1536
are from the same moulds as the figures on Bishop
Fox's Crozier.) Almost without exception finials
were gilt, whilst the rest of the spoon was of white
silver, the interior of the bowl also being of gilt on
occasion. Strangely, only a handful of spoons with
the finial formed as the crest of the owner seem to
have survived. One would much like to see the
'curious spoon of English pebble, with two gold
handles, richly worked in foliage', reputedly part of
a set of twelve made to the order of Catherine,
Lady Walpole, for presentation to Queen Caroline
(Strawberry Hill Sale. Day 15. Lot 15.)

Folding Spoon

Other than the Scarborough Spoon of *c.* 1300

(Scarborough Museum) these, which are very rare in English or American silver, are usually of late 17th-century date when found. An American example is that at the Philadelphia Museum made by Caesar Ghiselin, about 1695. Most of those surviving probably belonged to travelling services.

Fruitlet Spoon
See Spoon (Berry Finial).

Gold Spoon
A number of gold examples English, Irish and American are known but none earlier than the late 17th century. The majority are of teaspoon size. A set of twelve by John Wirgman, c. 1750, with a pair of unmarked sugar nippers, are of the plain Hanoverian pattern. Another two, one trefoil, one Old English pattern are of dessert size. Only an American example with two pendent bells is different from the contemporary run. It was obviously intended for a baby.

See also Spoon (Trefid Spoon).

Gothic Foliage Finial
A foliate finial, extremely rare, but to be expected on at least a few survivors from about 1400, or earlier. One of the most interesting is the rather 'stubby' silver-gilt example of c. 1460, stamped with the initials of five successive generations of the Postlethwayte family of Cumberland (Victoria and Albert Museum). A variety is the acorn and foliage finial of which one example, bearing the leopard's head mark, may be as early as 1350. Later examples are illustrated on Plate **557c** and d.

Hanoverian Pattern (1710–60)
The finial of the dog-nose spoon was finally rounded off by 1710 and until 1730 the majority of bowls retain the rat-tailed rib. From 1715, occasionally, but from 1730 almost invariably, the rat-tail disappears, being replaced by a single or double drop. The top of the stem turns upwards until 1760, as it always had, since varying from the straight in 1660. With the introduction of the Old English pattern in 1760 the stem began to turn downwards, this was so with spoons but not with forks. In 1774 Sir William St Quintin paid Messrs Wakelin for 'turning back ye handles of 12 gravy spoons'. Very occasionally the top of the stem is found bent sharply forwards or backwards in the manner of a hook. This is most usual with gravy or larger spoons and very often they prove upon examination to be Irish. Presumably they were hung from these hooks.

Hexagonal Finial
Perhaps the earliest surviving set of any form are the four Whittington Spoons of about 1410 belonging to the Mercers' Company. These have plain hexagonal knops and are engraved with the Arms of Richard Whittington on the backs of the bowls. A variation, having a small knob at the apex of the hexagon, are those of 1494, in the Benson Collection.

Hoof Spoon
The Royal Plate included in 1549 'a Spone of gold with a deeres foote at thend of the stele'; it weighed 2 ounces. This type of spoon, probably drawn from Italian or Swiss originals, is rare. That in the Jackson Collection on loan to the National Museum of Wales shows the original mark, which was noted by Sir Charles Jackson, the date-letter for 1567, a Gothic K with a pellet below. A much later set of six, hall-marked 1652, is exhibited at Manchester City Art Gallery, two others from the same set are in a private collection, all bear the Schuyler cryptogram. American examples, not to be confused with Dutch examples imported at the time of the Dutch settlement, are extremely rare and modelled on the latter, having oval bowls, whereas the bowls of a number of those made in

England are leaf-shaped (**554**), probably for use with spice boxes.

Bibliography
H.B. Smith, 'Four Hoof Spoons'. *Antiques*, June 1944.

Incense Spoon
Very rare, these small spoons were, and still are, associated with incense boats. A spoon with writhen stem and of very small size found at Warwick must date from 1150 to 1350. It could well have been intended as an incense spoon.

Initial Finial
A very rare finial. An example of 1494 with the initials B. & W. is illustrated on Plate **557e** and certain entries in the Royal Inventories of the 16th century may well refer to this very form.

Krishna Finial
See Spoon (Buddha Finial).

Lion Head Finial
One such of c. 1630, struck with a fleur-de-lys in the bowl, survives.

Lion Sejant Finial
'Item. twoo Spones of gold with twoo Lions holding two Scutchions with the kinges armes. enameled at the endes poiz. viii oz'. So runs King Edward VI's Inventory of 1549. This finial, one of the Royal Beasts, is an early form. A few rare examples have the lion 'sejant guardant' (sitting up and looking to one side). Most surviving examples are of 16th- and early 17th-century date. A remarkable set are the twelve of 1569 (Christie's, July 21st, 1954), the lions having shields engraved with the Arms of Campbell (**552**).

Maidenhead Finial
This type appears before the Apostle spoon. The finial is formed as the head and bust of a woman emerging from a calyx of foliage or moulded plinth. Probably this was once intended to represent the Virgin Mary (Durham Inventory 1446) but such finials are not found with a halo. One of the earliest (Victoria and Albert Museum), probably dates from the 14th century and is marked in the bowl with a coat of arms, said to be that of the See of Coventry. Christ's Hospital, Horsham, has a set of twelve of 1630. The type dies out by 1650 (**559b**).

Bibliography
Norman Gask, 'Rare Maidenhead Spoons'. *Apollo*, December 1950.

Marrow Spoon
See Marrow Scoop; Marrow Spoon.

Medicine Spoon
Three varieties are known. The earliest is similar to a normal dessert spoon but with a short stem; considering its size it is comparatively heavy. The next is a form of covered spoon with a hinged lid and tubular handle; these are also known as 'castor-oil spoons' and one example of 1827 is signed 'C. Gibson, Inventor'. Another of this form is in the Wellcome Historical Medical Museum. Last, is a double-ended form, the bowls of different sizes. These were also used with travelling canteens and were part of most 19th-century toilet services.

See also Spoon (Feeding Spoon).

Memorial Spoon
Perhaps the finest memorial spoons are a pair of 1629, the seal-tops engraved 'Butts Bradbury' and 'Wentworth Bradbury', respectively, the stems 'Martha Pope, memoriae ergo, 1629'. 'Memento mori' spoons, of Scottish disc-end type, are also found from York during the middle of the 17th century. In America, particularly that part settled by the Dutch, the custom of giving or leaving suitably inscribed spoons at death survived for an even longer period than in England.

Mermaid Finial
This finial, more correctly a female caryatid figure,

of rather flattened section, is extremely rare; alm invariably found in the West Country—usu Barnstaple. They date from about 1580 to 16 (**558c**).

Moor Finial
A rare finial, sometimes known as the Moor's he finial, found during the 16th century and, perha of an earlier origin. Existing examples are usu worn and on extremely small spoons, the finia probably intended rather as the head of the inf Christ (**559a**) than the head of a Moor. Howev the rendering of the features was at the mercy whim of the chaser.

Mote or Strainer Spoon (1700-90)
Early in the 18th century there appeared a spo with the bowl, most frequently of teaspoon si but also of the larger variety, being pierced and long stem tapering to a point. Often described 'olive spoons' these appear to have been design to remove the floating debris from a cup of tea a the spike to clear the strainer in the teapot wh the leaves, unbroken unlike those today, unfur and thus blocked the exit (**641**). Cases for spoo or tea caddies often make allowance for just suc spoon (**618**). During the 1750s sets of six o dozen teaspoons, a pair of sugar tongs and 'strainer' are frequently supplied to clients acco ing to the entries of the Garrard Ledgers (vol. That for Lady Raymond of May 29th, 1758 interesting 'To an egg spoon 16/9 To making a piercing 8/— To graving a cypher and cort. 1. The spoon weighed 2 ounces 14 pennyweig implying that it was quite a large spoon perhaps removing the egg from the egg boiler. A p ticularly finely pierced, unmarked example, (pro ably American) in the Cleveland Museum of A Cleveland, has a moulded rib half-way do the tapering stem. 17th-century spoons w pierced bowls and 18th-century tablespoons similar form are uncommon, but when fou (more often than not, still in use with Church pl and most probably intended to remove floati debris from the Communion wine) are all often of rather inferior quality. In the Hermita Leningrad, is an unusual variety with a fine strai detachable by means of a bayonet joint from normal pierced bowl of a ladle of about 1780. list of Kind Edward VI's spoons, made in 15 includes 'one strayner of gold with a roose at ther poiz iij oz.'. Its very weight implies that in probability it was a straining spoon.

Mounted Spoon
Rock-crystal, coconut, whelk-shell, mother-pearl, serpentine, agate and a host of otl precious or semi-precious materials were used various times to form the bowls and/or stems silver- and gold-mounted spoons (**555e** and Considerable lists of this form survive in Inventories of the Royal Jewel House during 16th century. The Founder's Spoon at Winche College, of about 1375, has a large knop whe crown-like circlet border may have been intend to hold a jewel.

See also Mounted-pieces.

Mustard Spoon
Small spoons, slightly larger than a teaspoon longer (**555d**) must have been used with mustard in casters. Undoubted mustard spoo appear during the third quarter of the 18th centu the bowl is almost fig-shaped and the stem follo the current style at the date of manufacture. In ti connection it should be noted that wet-musta pots earlier than 1765 are extremely rare. Egg spoo of 1800 onwards should not be confused w large mustard spoons, though sometimes alm identical.

d English Pattern (1760–1820)

vious to the fiddle pattern this is probably the st-known pattern of all, deriving from the noverian (Fig. **XXVIII**). Quite plain, the ends of spoons turn down (while those of the forks n upward); on March 28th, 1760, T. Ryves Esq. s invoiced 'To 12 Turned back teaspoons' arrard Ledgers, vol. 2). Scottish and Irish mples tend to have elongated, pointed stems. e coffin-like terminal is a New England variant. ring the 1770s, at a time when the feather- ed pattern was becoming fashionable a nber of Old English pattern spoons and forks eared having a 'shoulder' at the junction of the vl and stem. This seems to have no purpose er than decoration. From about 1780 all flatware arked at the top of the stem rather than 'bottom rked' near the bowl.

slow Pattern (1745–75)

remarkable variation from the normal path of al development for it is a terminal both scrolled d deeply fluted. The pattern apparently taking its ne from Speaker Onslow of the House of mmons. Never particularly common it tends to somewhat uncomfortable in use; it is most quently found used on gravy spoons and ladles.

l Finial

ch finials, either crests or as a rebus, as in this e, on the owner or donor's name, must have n relatively common. Six of 1506 belong to rpus Christi College, Oxford, probably given by hop Oldham rather than, as tradition asserts, the nder (a poor pun on Owldham).

ritan Spoon

pearing in the 1650s this is probably a develop- nt from the slip-top spoon, the stem of plank- form, often unusually heavy, with the end cut a right angle (**559c**). (The stump-top spoon is sely allied to this form but its stem is octagonal section and the end rounded or angled.) The er of development probably was as follows: -top, stump-top, Puritan; and from the notched ls of these latter grew the trefid spoons and nce spoons as we know them today. Only e such spoons are known in Scottish silver, e by G. Cleghorne of Edinburgh in 1651 is in the collection of the Marquess of Bute. Of two ers of 1665 and 1667, one is in the National seum of Antiquities, Edinburgh. The same nber survive from Colonial America, one each Hull & Sanderson, Jeremiah Dummer and n Coney.

lt Spoon

earlier times salt was taken with the blade of the fe, but salt spoons appear during the first cades of the 18th century. Generally, the bowl the spoon is of shovel form, though by the 40s a circular bowl, with slightly decorated ip-thong handle, made its appearance—usually ociated with salt cellars by the best makers, such Lamerie and Sprimont. In the main the stem ows the trend of current fashion. An unmarked mple with a shallow, circular bowl and a stem ribbon-scroll form, in the Exeter Museum, pro- ly dates from the first decade of the 18th tury. One set of ten salt cellars of 1731 is wn, having retained its original spoons (simi- y engraved though by a different maker). y are similar to teaspoons but have a slightly aller and more ovoid bowl, besides being of avy gauge metal. Four shovel salt spoons with ned baluster finials to the stems, of about 1730, in the Farrer Collection, Ashmolean Museum, ford.

Catherine Finial

spoons with such a finial are known, though

this Saint, from a suitable mould, appears on the instrument case of the Barber-Surgeons' Company.

St Christopher Finial

One such finial is known, amongst the Plunkett Set, it is engraved 1518.

SS Cosmo and Damian Finials

No spoons with such finials are known, though figures of these Saints from suitable moulds form part of the instrument case of the Barber-Surgeons' Company.

St John the Baptist Finial

No spoons with this Saint as finial are yet known in spite of the fact that the Merchant Taylors' Company, whose patron saint he was, are known to have possessed no less than one hundred and fifty-two examples in 1512.

St Julian Finial

The Patron Saint of the Innholders' Company, which possesses a number of spoons, the finials of which appear to represent St Julian holding a sword. One of these is hall-marked 1539.

St Nicholas (of Myra or Bari) Finial

One example only, and that extremely fine, now in the Bute Collection is yet known. It is marked 1528 and shows the Saint with a tub at his feet con- taining the three boys whom he miraculously restored to life.

Seal-top Spoon

Appearing during the reign of Henry VII, early examples usually have a short 'stubby' finial with an hexagonal seal (**559f**), often pricked or engraved with some initials and a date. The earliest hall- marked example is the Pudsey Spoon of 1525 (Liverpool City Museum). During the course of the 16th and 17th centuries the baluster elongates and the seal becomes oval and finally round. The bowl follows the same pattern as that of the Apostle spoon, that is fig-shaped, gradually becoming less elongated. Later in date than 1680, except for replacements made to order, a seal-top spoon is suspect. A rare form comes from Edinburgh in the late 16th century; in this, the seal is of tapering, rectangular section. There is an example in the Jackson Collection in the National Museum of Wales by James Cok, Edinburgh, 1577–9. Only two other such spoons are known. One in the National Museum of Antiquities, Edinburgh, of about 1573, also of Edinburgh manufacture, the other in the collection of the Marquess of Bute, made in Dundee c. 1576, by a member of the Gairdine family.

Slip-top Spoon

Thomas Rotherham, Archbishop of York, died in 1498, leaving a dozen silver spoons 'slipped in lez stalkes'. These have a stem, whose finial is slipped or cut at an acute angle, often leaving space for the engraving of one or more initials. The type is seldom found after 1650 (**559d**), the nearest approximation to it being the so-called 'Puritan' finial in which the cut is at right angles to the plank- like stem. The earliest recorded slip-top spoon is of 1487 in the Benson Collection. A set of twelve of 1640 is amongst the plate of Christ's Hospital, Horsham. An extremely rare Scottish example, probably made by G. Kirkwood of Edinburgh in 1609, is in the collection of the Marquess of Bute. Two American examples made by Hull & Sanderson, besides another made by their apprentice, Jeremiah Dummer, survive.

Snuff Spoon

Sometimes still associated with their original snuff boxes, such very small toy-sized spoons seem to have been an affectation of the period 1690–1730. They are usually miniatures of the contemporary tablespoon. At the same time, extremely rare sets of toy spoons and forks were also made for dolls'

houses and from 1740 onwards a small spoon was also supplied amongst the fittings of a lady's étui. Very rarely a snuff box contains a special compart- ment or clip inside the lid to retain the spoon.

Stump-top Spoon

Having a heavy stem of octagonal section (some- times almost rounded by wear), the finial is angled in pyramid form (**559e**). A fine set of six stump- top spoons of 1660 is at Colonial Williamsburg, Virginia.

Sucket Spoon and Fork

These, formed as a small rat-tailed teaspoon bowl at one end, with a two-pronged fork at the head of the usually rectangular-sectioned stem, survive from the 17th century (**60c**). An example, unusual in that it is fully marked, by IK. in 1670, is in the Exeter Museum. American examples are uncommon, but less so than English ones, although a set of four of the latter (c. 1685) is known, with the maker's mark, IS. crowned, perhaps the mark of John Shepherd. Such spoons were known at a much earlier date. The Inventory of King Edward VI (1549) notes the following 'Item one Suckett Spone wt a forke Joyned together of silver gilte. weing iij oz. Item one Spone wt a suckett forke upon one stele [stem] gilt. poz. iij oz.'. In time the spoon and the fork were made separately, but examples of this form still continued to take the names 'sucket spoon' and 'sucket fork' (**555b**).

Teaspoon

Early examples date from the last quarter of the 17th century. They have trefid finials, are usually very small, and often gilt. More often than not they bear the maker's marks only and little difference is to be found between English, French, or even Dutch examples at this date, especially when finely engraved with scrolling foliage (**555a** and **c**). During this period teaspoons and 'Coffy' spoons are completely interchangeable. By the end of the century such spoons are a little more frequently found, nevertheless until 1740 a surviving set of a dozen teaspoons, always of the same form as the current fashion in tablespoons, is of great rarity. They are particularly liable to forgery, especially if two or three of a set are missing. The fashion for decorative fancy-backs to the bowl was par- ticularly in evidence amongst those teaspoons made during the first two decades of the reign of George III. In the Garvan Collection, Yale University Art Gallery, are a set of seven together with a mote spoon of gold made by Simeon Soumain of New York, c. 1725. Five more, also gold, by John Ladyman, c. 1710, a sixth made to match; a mote spoon and pair of sugar nippers by Francis Williamson, Dublin, 1765, are in the Metropolitan Museum of Art, New York. A set of twelve gold teaspoons by John Wirgman, c. 1750, and an unmarked pair of sugar nippers were once in the Noble Collection.

Trefid Spoon (1660–95)

These developed, by flattening the upper part of the stem and cutting two notches downwards to- wards the bowl, from the Puritan spoon. They were later either stamped or engraved on both stem and bowl with traceried foliage and the stem swollen at the top to become pear-shaped. A rib, the rat-tail, was used to strengthen the back of the bowl at the junction with the stem, and this appearing in the 1660s, may be beaded. By 1690 the notches may be omitted thus leading one on to the so-called 'dog-nose' or 'wavy-end' finials. The earliest recorded are 1662 from London, and 1663 (without rat-tail) from Dublin. Scottish examples are uncommon. At least three are known in gold (**558a**). A basting spoon, 1691, of this form is in the collection of the Bank of England.

552 Spoons

Three of a set of twelve.
Maker's mark, C enclosing R.
Hall-mark for 1569.

553 Apostle Spoons

The Master and the finials of the
rest of the set. Hall-mark for 1592.
The emblems on Apostle
spoons (usually held in the right
hand) including the Master, are
usually symbolic of their martyrdom
or allusive to some outstanding
event in their lives.

a. St John. A cup, sometimes with
a serpent issuing from it—an
allusion to an attempt to poison
him.

b. St Matthew the Evangelist. If
not as an Apostle with a purse,
with a book and pen.

c. The Master. Representing the
Saviour. Holds in His left hand an
orb and cross, the right hand
uplifted in Benediction.

d. St Thomas. A spear, alternatively
a carpenter's or builder's square—
an allusion to his constructing a
palace in Paradise. Easily mistaken
for a broken cross.

e. St Jude (Thaddeus). A halberd
or a cross.

f. St Philip. A staff with a cross on
the end.

g. St Bartholomew. A flaying knife.

h. St Paul. A sword.

i. St James the Greater. A pilgrim's
staff, sometimes a pilgrim's cap
suspended over his back or from
his girdle.

j. St Peter. A key.

k. St James the Less. A fuller's bat.

l. St Simon the Zealot. A saw.

m. St Andrew. A cross saltire (X).

Sets might also include:
St Matthew the Disciple. A purse
or money-bag.
St Matthias the Disciple. A spear
or an axe.
St John the Evangelist. If not with
a cup, an eagle.
St Mark the Evangelist. A lion.
St Luke the Evangelist. A bull or
the head thereof.

554 Hoof Spoons

Left: maker's mark, D enclosing C.
Hall-mark for 1622.
Centre: maker's mark, A F.
Hall-mark for 1652.
Right: maker's mark, a crescent
enclosing W.
Hall-mark for 1612.

555 Spoons and a Fork

a. 'Coffy' spoon. c. 1685.
b. Sucket fork. c. 1690.
c. 'Coffy' spoon. c. 1690.
d. Salt or mustard spoon. c. 1720.
Length 6½ in. (16·5 cm.).
e. Spoon with coconut bowl. c. 1700.
f. Spoon with mother-of-pearl bowl.
Maker's mark, SW. c. 1700.
Length 7⅞ in. (20·0 cm.).

Fig. XXVII

A group of spoons, 1692–1815.
Approximately 6½–7½ in. (16·5–
19·1 cm.) long.

552

553

1692 1769 1789 1815

Fig. XXVII

554

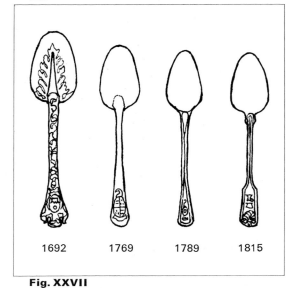

a

b

c

d

e

f

555

liography

rman Gask, 'A Gold Charles II pocket Cutlery and three Gold Trefid Spoons'. *Apollo*, August 49.

also a note in *Apollo*, vol. XVII, p. 280.

gin and Child Finial

extremely rare survival, being associated with Roman Catholic Church. However 16th-century perhaps earlier examples are known. An inven- y of 1525 refers to spoons 'knopped with the ige of our Lady'. A fine example of 1577 is in the toria and Albert Museum. The Astor Set of 1536 ludes one spoon with the figure of the Virgin.

liography

talogue of the Holburne of Menstrie Museum, th. Vol. II, 1929.

gin and Heart Finial

earliest example, *c.* 1490, is, like all the rest of rare form, of small size (but beware of later tations).

dewose Finial

e (formerly in the Ellis Collection) dating from ut 1460 (London) having its finial formed as a d man is now in the Victoria and Albert Museum. s possible that St John the Baptist may have en modelled as the finial on some of these ons, but the 'Green Man', or wild man of the ods, was a favourite medieval legend. Two other ch spoons are known (Benson and Walter llections).

rthy Spoon

e Tichborne Set of twelve by Christopher Wace, 92, has finials including the figures of those e men, either legendary or factual, considered rthy in the estimation of informed opinion of ir day. The nine classical 'Worthies' were added or subtracted from at the craftsman's will. 16th- d 17th-century contestants for such eminence en fell by the wayside in the opinion of the 18th tury. None, other than this set are, however, known. Besides the nine, Queen Elizabeth, St er and Our Saviour Christ are included in the set. orthies' of the 16th century may be listed as ows, in the popular estimation of the day.

shua *
g David * } Biblical Heroes
das Maccabeus *

ctor of Troy *
xander the Great * } Classical Heroes
rcules
ius Caesar Pompey *

g Arthur *
arlemagne * } Romantic Heroes
dfrey of Bouillon
y, Earl of Warwick *

enotes those included in the Tichborne Set.

ythen Knop Finial

s finial is formed as a ball engraved with rally twisted fluting. Examples do not seem to earlier in date than the early 15th century. mmander G.E.P. How ascribes one to 1463; two ers fully marked of 1480 and 1488 are known. ir popularity seems to have ebbed by the middle he next century (**558b**).

oon Tray

e need for a small dish upon which to place the cessary spoons while 'taking of a dish of tay' was vious, especially when we consider that our dern-day saucer was the item from which the nker sipped his or her tea. From the very begin- g of the 18th century an oval dish was usually vided, or the upturned lid of a sugar bowl, and s at first plain, later with fluted, scalloped or saw- thed borders, was subjected to all the vagaries fashionable ornamentation. The basic form,

however, seems never to have altered although on occasion the trays were placed upon four feet or might be oblong (**563**). By 1760 they were apparently no longer useful, thus reflecting perhaps a change in the method of tea drinking. The late Irish examples of this date are, generally, very slight and with cheap punched bead decoration. See also Pen Tray; Snuffer Scissors and Snuffer Tray or Stand.

Sporran

At least one example with silver mounts, these being derived from the medieval purse, has sur- vived, it was made in Elgin by William Scott. Traditionally it was worn by the then Marquess of Huntly at the Battle of Sheriffmuir in 1715 (**565**). Another, of velvet and braid with chased silver mounts is said to have been the gift of Prince Charles to a Mrs Ross after the Battle of Culloden. See also Purse Mount.

Spout Cup

Of 17th- and 18th-century date, these may be said to most resemble a bulbous, cylindrical tankard, the cover sometimes detachable. Some, however, have two handles as the American example by Jeremiah Dummer, *c.* 1715 (Museum of Fine Arts, Boston). A narrow, curved spout springs from the base of the spout cup, and Gerald Taylor suggests their possible use as coffee pots up to 1670 (**567**, **568** and **569**) or more likely for the imbibing of whey or curdled milk. John Coney supplied a spout cup to Judge Sewall in 1710 (**570**). They were usually assumed to be for the use of invalids. The later form more nearly resembles a two-handled porringer. In the past, large numbers have been converted to mugs and porringers by the removal of the spout which was considered to be a later addition. A particularly large example made in Edinburgh in 1707, originally formed part of Edinburgh Corporation Plate; documentation implies that it was used as a 'Loving Cup' for a drink, the ingredients of which would otherwise have tended to float upon the surface and impede the lips of the drinker—certainly no invalid in this case (**572**). An example of 1642 is attributed to Timothy Skottowe of Norwich (**566**); this may be the earliest English spout cup. An example from Plymouth about 1690 is illustrated on Plate **571**. American pieces are somewhat more often encountered, though still very rare. An extremely rare example in London Delftware of about 1680 is in the Manchester City Art Gallery and a number in glass are also known; probably less than a dozen in all. A silver spout cup, with a single wickerbound handle, at right angles to the spout and having half the top covered nearest the spout, is hall-marked 1689 (private collection). Amongst the latest variations are those (including an American example by Joseph Richardson, Senior) with the handle opposite the spout. See also Skillet.

Sprimont, Nicholas (1716–70)

Born in Liège, Belgium in 1716, he was apprenticed in 1730. In 1742 he married Anne Protin, having entered his mark at the Goldsmiths' Hall earlier in that same year, as of Compton Street, Soho. He appears to have made little, if any, silver after 1746. Besides being a silversmith of note he was also proprietor of the Chelsea Porcelain Factory from at least 1749. He secured Royal Patronage, and retired from the factory, due to ill-health, in 1769. He died in 1770.

He was greatly influenced by the *Rocaille* designs of Meissonnier (1675–1750). Twelve

pieces by Sprimont are amongst the Royal Collection at Windsor (Colour Plate **34**). A design for a soup tureen, the decoration incor- porating the Arms of Thomas Coke, Earl of Leicester, now in the Victoria and Albert Museum, is signed 'N. Sprimont in : & del.'. Perhaps the most imagina- tive of his flights of fancy, in the Rococo manner, is the kettle and stand of 1745, now in the Hermitage, Leningrad. Amongst pieces made in silver by Sprimont and copied at the Chelsea Factory in porcelain may be mentioned four shell and dolphin sauce boats (1743–5); several crayfish salt cellars (1742) and a set of four sauce boats decorated with applied swags of fruit and flowers, masks and scrolls (1745).

Bibliography

E.A. Jones, *The Old English Plate of the Emperor of Russia*. 1909.

Richard Ormond, 'Silver Shapes in Chelsea Porcelain'. *Country Life*, February 1st, 1968.

Springing

The level at which an arch curves away from its vertical supports.

Spur

These, of silver or gold (the latter the privilege of a knight) have been made from early times, but in general surviving examples are of late 18th- and 19th-century date. The smaller ones are usually for ladies. Considerable numbers of American examples are to be found. A 'Box-spur' of 1845 is perhaps one of the earliest of this type in silver. The gold spurs amongst the Coronation Regalia, though unmarked, date from about 1661. See also Cockfighting Spur.

Staff Head

See Cane and Staff; Corporation and Ceremonial Plate.

Stand

In order to protect the table or cloth from either heat or damp, a stand of some form was obviously necessary from an early date. Probably small waiters were often called into use as such, but for the grander services or pieces of plate, special stands were provided, at first, *c.* 1720, without feet and usually circular or octagonal. As may be imagined, few wooden trays have survived from the 18th century; their disappearance may have been hastened by the heat and drips to which they were subject. Silver plinths were provided for some of the vases awarded by the Lloyd's Patriotic Fund of 1805–6; and other cups and vases thereafter.

Teapot Stand

Stands for teapots, as opposed to the heaters and frames, were supplied, in all probability, from as early as the reign of George I and usually reflect the form and pattern of the pot; normally the work of the same maker, and today even rarer than the teapot itself (**648**). The apparent eclipse of the silver teapot *c.* 1745 by that in porcelain, until *c.* 1770, has a similar effect on the stand, which only reappears at the same time. Generally speaking, the teapot thereafter is oval and the stand likewise, but on four feet. Shaped teapots had shaped stands, frequently the work of different makers, though similarly engraved and of the same date. On the other hand, large services by the best makers, for example Paul Storr and Benjamin Smith, were usually exceptions and entirely the work of one maker. By 1810, the teapot is generally oblong or circular and so is the stand. Some stands have a wooden base, wood being particularly effective as an insulator, and no feet, while the teapot itself

556 Spoons

a. Unmarked.
Early 17th century.
Royal Scottish Museum.
b. Maker's mark of Thomas Mangy.
Hall-mark for 1682, York.
c. Maker's mark of Thomas Mangy.
Hall-mark for 1677, York.
d. Maker's mark of John Plummer.
Hall-mark for 1661, York.
e. Maker's mark of Hull & Sanderson
of Boston.
c. 1665.
Gift of Hollis French to the
Cleveland Museum of Art.

557 Spoons

a. Spoon with diamond-point finial.
b. Spoon with diamond-point finial.
c. 1466.
c. Spoon with Gothic finial.
c. 1500.
d. Spoon with Gothic finial.
Maker's mark, a pheon.
Hall-mark for 1538.
e. Spoon with initial finial.
Maker's mark, a leaf.
Hall-mark for 1494.

558 Spoons

a. Gold spoon with trifid finial.
Maker's mark, R B or R R.
Hall-mark for 1681.
Length 5¾ in. (14·6 cm.).
Engraved with the Arms of Rumsey
impaling Ashburnham.
b. Spoon with wrythen knop finial.
Hall-mark for 1514.
c. Front and back views of a spoon
with mermaid finial.
d. Spoon with dog-nose finial.
Maker's mark of Henry Aubin.
Hall-mark for 1709.
Engraved with the Arms of
Oxenham.

559 Spoons

a. Spoon with Moor's head finial.
b. Spoon with maidenhead finial.
One of a pair. Early 16th century.
c. Puritan spoon. One of a set of four.
Hall-mark of 1665.
Pricked with the initials RY above EF.
d. Spoon with slip-top finial.
One of a pair.
Maker's mark, D crossed with a bow.
Hall-mark for 1629.
e. Spoon with stump-top finial.
Maker's mark, RC with three
pellets above.
Hall-mark for 1638.
e. Spoon with seal-top finial.
Maker's mark, an estoile of six
points. c. 1500.

556

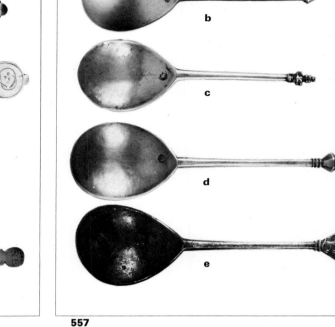

557

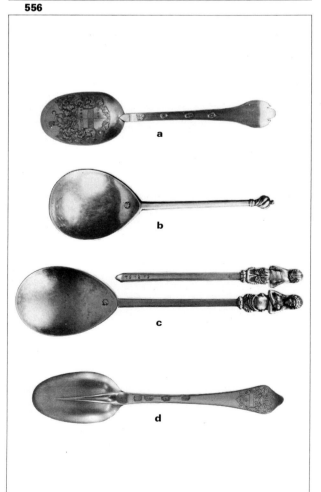

558

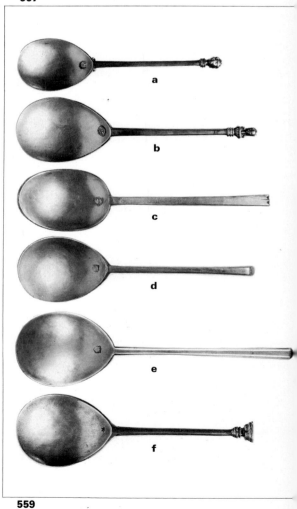

559

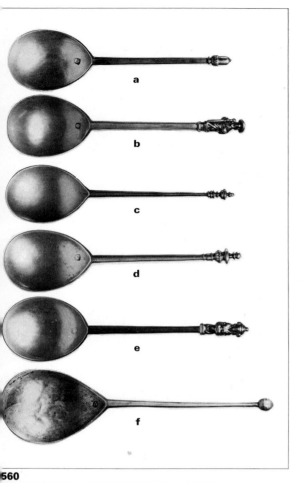

560

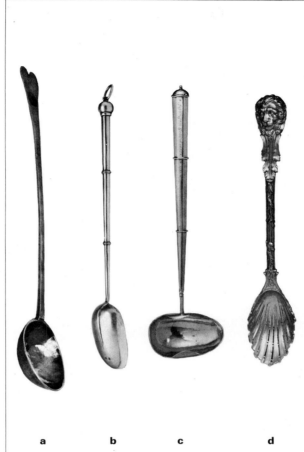

a b c d

561

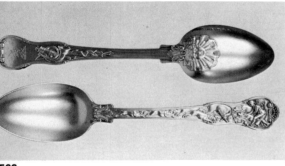

562

563

564

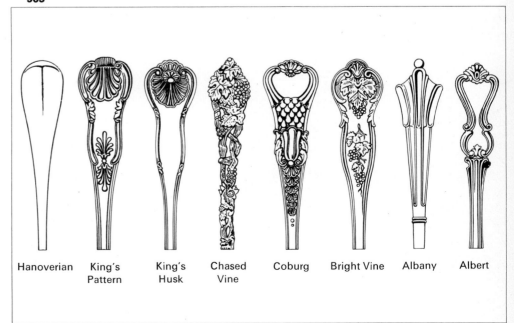

Hanoverian King's King's Chased Coburg Bright Vine Albany Albert
 Pattern Husk Vine

Fig. XXVIII

560 Spoons
a. Spoon with acorn-top finial.
Maker's mark, mullet and annulet.
Hall-mark for 1585.
b. Spoon with the Apostle finial
of St James the Great.
Maker's mark, C enclosing W.
Hall-mark for 1612.
c. Spoon with baluster-top finial.
Early 14th century.
d. Spoon with baluster-top finial.
Hall-mark for 1554.
e. Spoon with Buddha-top finial.
c. 1635.
f. Spoon with berry finial.
Early 15th century.

561 Long-handled Spoons
a. Ladle.
Maker's mark of Edward Swan.
Hall-mark for 1679, Dublin.
National Museum of Ireland.
b. Hash spoon.
Hall-mark for 1724, Dublin.
Length 21½ in. (54·6 cm.).
c. Punch ladle. Engraved 1737.
d. Pierced gravy spoon.
Maker's mark illegible.
Hall-mark for 1774.
Length 12½ in. (31·8 cm.).

562 Tablespoons
Maker's mark of Paul Storr.
Hall-mark for 1816.
Designed by Thomas Stoddart and
modelled by Francis Chantry.

563 Spoon Tray
Silver-gilt.
Maker's mark of Paul de Lamerie.
Hall-mark for 1719.
Width 7⅜ in. (19·7 cm.).

564 Punch Ladle
Silver-gilt.
Maker's mark of Rawlins & Sumner.
Hall-mark for 1832.
A *tour de force* of the chaser's art.

Fig. XXVIII
Patterns of 18th- and 19th-century
spoon finials.

565 Sporran
Doeskin and silver mounts.
Maker's mark of William Scott.
c. 1706, Elgin.
Engraved with the Arms of
Alexander, 2nd Duke of Gordon.

566 Spout Cup
Maker's mark of Timothy Skottowe.
Hall-mark for 1642, Norwich.
Victoria and Albert Museum.
Engraved with the Arms of
Servington Savery.

567 Spout Cup with Lid
Unmarked, c. 1660.
Probably made in Norwich.

568 Spout Tankard
Maker's mark, TI, probably the
mark of Thomas Issod. c. 1670.
Height 4½ in. (11·5 cm.).

**569 Spout Cup with
Fixed Lid**
Maker's mark, TM.
Hall-mark for 1680.
Height 2¾ in. (7·0 cm.).

570 Spout Cup
Maker's mark of John Coney
of Boston. c. 1690.
Height 5 in. (12·7 cm.).

571 Spout Cup
Maker's mark of Henry Mutton
of Plymouth. c. 1690.
Height 4¼ in. (10·8 cm.).
There is a strainer within the cup at
the base of the spout.

572 Spout Cup
Maker's mark of Walter Scott.
Hall-mark for 1707, Edinburgh.
Height 11¾ in. (29·9 cm.).

566

565

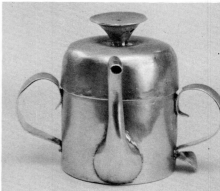
567

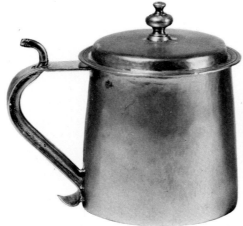
568

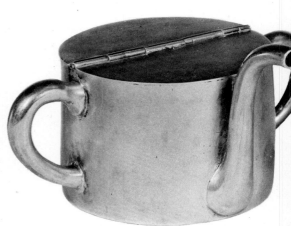
569

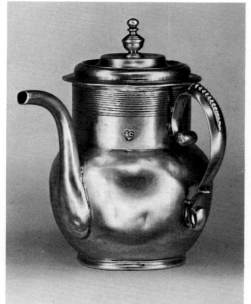
570

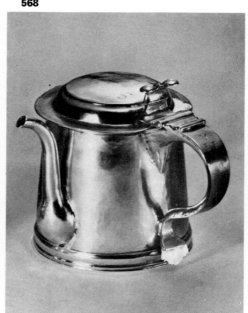
571

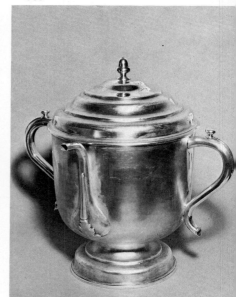
572

relops feet. (Wood-based trays also occur at this
[tim]e.) At all times, these stands probably did
[dou]ble duty, both as spoon trays and waiters.

[Ch]ocolate-pot and Coffee-pot Stands
[Sp]ecific stands for these pots are only very rarely
[fou]nd in the early 18th century. The reason is not
[the]ir rarity, but that any small waiter served this
[pur]pose.

[En]trée-dish Stand
[The]se stands contained hot water, a spirit lamp, or a
[hea]ted bar of iron. They are usually of Sheffield
[pla]te, but examples in silver are not unknown,
[tho]ugh it would seem that the majority of patrons
[con]sidered their indulgence in silver stands an
[unr]ewarding form of exhibitionism. They are the
[prede]cessor to the dish ring and dish cross.

[Ke]ttle Stand
[A] special triangular salver appeared during the
[sec]ond quarter of the 18th century, intended to
[acc]ommodate the three feet of the openwork
[fram]e supporting the kettle lamp. These are un-
[com]mon and usually only associated with kettles
[exe]cuted by the best makers. A circular stand of
[bett]er than average quality of decoration was
[som]etimes also supplied with such a kettle. The
[extr]emely rare tripod, table-like stands are in no
[wa]y comparable, being to all intents and purposes
[furn]iture.

[Tur]een Stand
[Bo]th soup and sauce tureens were, on occasion,
[equi]pped with detachable stands, usually en suite
[wit]h the rest of the dinner service. Those for
[tur]eens are generally a little more decorative than
[mer]e oval dishes; this, however, did not prevent
[the]m from being used as such, when necessary.
[Fro]m the 1770s special stands with a raised centre,
[use]less for anything else, do indeed appear.

[Wi]ne-funnel Stand
[Un]til it was washed after being used, the funnel
[wa]s naturally liable to leave marks wherever it was
[pla]ced. Thus, small circular silver dishes, of very
[sligh]tly larger diameter than the funnel, were made
[to] accommodate it or, alternatively, the bottle.
[Ap]pearing in the second half of the 18th century,
[the] centre is often convex by the early 19th cen-
[tur]y. The vast majority of surviving examples prior
[to] 1800 are Irish or Scottish, though why this
[sho]uld be so is a mystery, unless preference for
[cla]ret rather than port in those countries is any
[rea]son, as the latter was not often, apparently,
[dec]anted before use. English wine funnels are not,
[how]ever, nearly as uncommon as the stands.
[Se]e also Dish Cross.

[St]andard See Assay.

[St]and and Heater See Chafing Dish.

[St]andish See Inkstand.

[Sta]tuette and Model
[Du]ring the Middle Ages vast quantities of silver
[an]d gold were employed for the making of
[reli]gious images, either of solid or plated metal
[ov]er a wooden core. Figure models for spoon or
[othe]r finials provide the majority of survivors (**573a**
[an]d **b**). It is also likely that the fine animal models
[pro]duced in Germany and elsewhere on the
[con]tinent, from at least the 15th to the 17th cen-
[tur]ies, influenced the products of English silver-
[sm]iths. None of these early pieces, however, are
[kn]own to survive, unless the Monkey Salt (c.
[15]00) of New College, Oxford, or the Huntsman
[Sa]lt at All Souls College, Oxford, with small
[figu]res at the base (**428**), be included. A set of
[thir]teen miniature figures of the Master and twelve

Apostles of early 16th-century date are in the
Victoria and Albert Museum (**575**). A pair of
magnificent silver-gilt seated leopards of 1601,
36 in. (91·5 cm.) high, remain in the Kremlin, pur-
chased by the Tsar of Russia after their sale by
Charles I in 1626. Five silver-gilt cups formed as
cockerels (a pun on the name of the donor—
William Cockayne), the property of the Skinners'
Company, are hall-marked 1605. Belonging to the
same Company is another based on a pun, the
Peahen Cup, given by the widow of one, Peacock
(**574**). Other than the heads of staves, such as that
with the bust of a woman (Mercers' Company,
1679), the stems of candlesticks, or finials to
andirons, only occasional wager cups of c. 1680
formed as a broad-skirted woman survive. The
figure of a milkmaid engraved 'Nanny' formerly in
the collection of the Earl of Ducie is the work of
Frederick Kandler, 1777 (**576**); one of Charles II by
William Pitts, 1790, and 20 in. (50·8 cm.) high, is in
the Royal Collection. A very rare cup and cover
formed as an owl, 6½ in. (16·5 cm.) high, by
Samuel Siervent, 1755, probably copies a German
original. Paul Storr produced a number of figures,
among them that of George III in Garter robes of
1812. From this date onward free-standing
figures are not uncommon especially as part of a
large centrepiece. Plate **415** illustrates the unusual
handle, modelled as a horse, on the cover of a
punch bowl. The handles of four sauce boats, by
Nicholas Sprimont 1743–5, are formed as the
seated figures of Venus and Adonis and are in the
Collection of Her Majesty the Queen (Colour
Plate **34**). A fine model of Queen Victoria on
horseback by Robert Garrard, 1840, is amongst the
personal Collection of Her Majesty the Queen.
That, by the same maker, of the Duke of Wellington
is two years earlier (**577**). During the late 17th and
18th centuries one or two silversmiths produced
candlesticks and tapersticks of Harlequin form,
with figure stems. At least one pair with the stems
formed as knights in full armour survive from the
1830s—the second Gothic revival. The large
parcel-gilt scale model of Eton College Chapel by
John Thompson, 1834, is an early example of a
form which became very popular for caskets later
in the century.

Sterling Standard
Henry II (1154–89), in an effort to improve the
quality of the English currency, imported coiners
from eastern Germany into England. They were
known as 'Easterlings', and it would seem that this
is the most likely explanation of the origin of the
word 'Sterling'; though the belief that the trial of
the pyx took place at Easter and was known as the
'Eastering' is another, less likely, origin. The
standard of purity has been 925 parts pure silver
out of 1000 since Henry II's reign except for a
period from 1697 to 1719 when, to prevent the
wholesale melting of the coinage, the standard
was raised to 958·3. After this latter date the pro-
duction of work in either standard was permitted.
The normal standard in other European countries
is not necessarily as high as the Sterling standard.
The Sterling mark (a lion passant) does not of
course indicate a maximum but only a minimum
quality. The standard for gold was once $19\frac{1}{5}$ carats
out of 24 but this was later lowered to 18 carats;
in 1575 it was raised to 22 carats remaining at this
level until 1798 when both 18 and 22 carats were
permitted. In 1854, 15, 12 and 9 carat standards
were added. Because there was no special mark
for gold during most of this period the lion passant
was struck in lieu.
See also Assay.

Stewpan
As with saucepans, many standard kitchen and
domestic utensils are found in silver from the 18th
century onwards and are often referred to in inven-
tories of the period (**494**). John Hervey, 1st Earl
of Bristol, refers to his purchase in August 1716
of 'a silver stew-pan weighing 67 oz. 14 dwt. & for
a silver chamber-pott weighing 30 oz.' (the stew-
pan mentioned may be in fact the one made by
Simon Pantin in 1716, and engraved 'No. 2', which
still survives at Ickworth House, Suffolk). They
received hard wear and only a very few, generally
of later date, have survived. In 1774 the Duke of
Grafton bought of Wakelin '4 round gadrooned
stewing dishes and covers'. The following entry is
'to wickering the handles and 4 buttons', whilst
Humphrey Morrice had purchased 'an oval gad-
rooned stewing dish and cover 2 ivory handles
and a button' in 1771.
See also Casserole; Griddle; Potato Pasty-pan;
Saucepan; Skillet; Toasting Fork.

Stick, Walking See Cane and Staff.

Stirrup
An example of 1746, chased with shells and foliage
is amongst the personal plate of Her Majesty the
Queen. The upper section of the bow curves
forward to allow for a heavy riding boot.
Bibliography
A.G. Grimwade, *The Queen's Silver*. 1953.

Stirrup Cup
The stirrup cup in the form of a fox's mask appears
about 1765 and, other than the inscription round
the rim, differs but slightly from that of sixty years
later. The tendency for an ever more realistic por-
trait is apparent as time goes on (**578a**). Similar
cups formed as greyhounds' heads are also fairly
common (**578b**), but those as foxhounds are rare,
presumably an unpopular association of ideas.
The hare is even rarer, one of 1776 by Aldridge &
Green is known. Tapering, cylindrical bottles were
made from the early 19th century to fit a 'saddle
bucket', which sometimes incorporates an extra
compartment, presumably for 'hard tack'. The
inscription 'To all friends around the Wrekin' (in
Shropshire) is found on a large number of stirrup
cups and may recall a particular hunt custom. An-
other inscription is 'Success to Fox-hunting and
the joys of a Tally'. Examples are known of actual
foxes masks, mounted with silver liners and rims,
generally of early 19th-century date and, on
occasion, a stand was supplied with the mask. The
description of a number of small cups—about 2 in.
(5·1 cm.) in height, of baluster form, dating from
between the years 1700 and 1750, sometimes with
a single handle to one side—as stirrup cups is
difficult either to justify or to prove incorrect. One
of 1730 is engraved with the young Bacchus
astride a barrel and below, with the words 'Good
Fellowship' (Victoria and Albert Museum). A
large number of small shallow bowls, about 2 in.
(5·1 cm.) in diameter, and having S-scroll, wire
handles survive from the 17th century in both
America and Great Britain. These appear to be the
'Dram-Cups' of contemporary inventories and wills
and if so are the ancestor of the stirrup cup.
Bibliography
G.B. Hughes, *Small Antique Silverware*. Batsford,
1957.
See also Cup, Julep.

Stock See Holy Water Stoup.

Stone Box See Caul (Cawl) and Stone Boxes.

573 Finials
a. The finial of a horn.
Unmarked, *c.* 1345.
Corpus Christi College, Cambridge.
b. The finial of the Howard Grace
Cup.
Silver-gilt and pearls.
Unidentified maker's mark.
Hall-mark for 1525.
Victoria and Albert Museum.

574 Cup and Cover
Unmarked but inscribed with the
date 1642.
Height 16½ in. (41·9 cm.).
The Skinners' Company.
'The Gifte of Mary ye daughter
of Richard Robinson, and wife of
Thomas Smith and James Peacock
Skinners 1642'.

**575 The Master
and Twelve Apostles**
Parcel-gilt.
Early 16th century.
Victoria and Albert Museum.

576 'Nanny'
Maker's mark of Frederick Kandler.
Hall-mark for 1777.
Height 11¾ in. (29·9 cm.).

577 Statuette
The Duke of Wellington on his
horse, 'Copenhagen'.
Maker's mark of Robert Garrard.
Hall-mark for 1838.
Height 26½ in. (67·3 cm.).

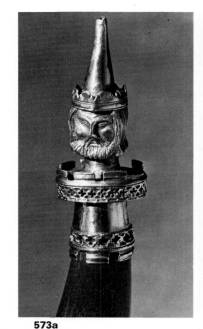

573a

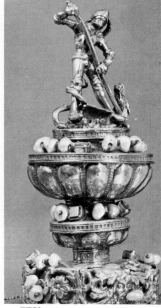

573b

575

574

576

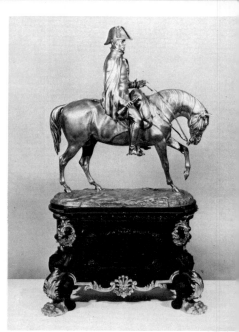

577

oneware See Mounted-pieces (Stoneware).

orr, Paul (1771–1844)
nsidered by some to have been second only to
merie as a silversmith, both for quality and the
antity of his products. He was apprenticed c.
85 to Andrew Fogelberg in Soho, and was made
Freeman of the Goldsmiths' Company in 1792,
en he joined William Frisbee in partnership.
wever, by 1793 he was working on his own,
d on January 12th of that year he registered his
st mark (a); by April 27th he had a second
ark (b). His third mark (c) he registered on
gust 8th, 1794. From 1796 to 1807, he was
sed in Air Street, Piccadilly, moving to Dean
reet, Soho, in 1807, when he registered his
urth mark (d) on August 21st. Here, as Storr &
. he was employed almost exclusively by
indell, Bridge & Rundell, the Royal Goldsmiths.

a b c

d e

1811, Storr & Co. included the Rundells, John
idge and William Theed, besides Storr himself.
September 12th, 1817 he registered a further
ark (e). In 1819, Storr severed his connection
th Phillip Rundell and moved to Harrison Street,
erkenwell, but it was not until 1822 that he took
share with John Mortimer in 13 New Bond
reet (later moving to No. 156). They remained in
rtnership until 1838. Pieces bearing the mark
torr & Mortimer' incuse, in full, date from this
riod. Storr retired in 1839.
The following Plates indicate both the quality
d quantity of Paul Storr's work: **19, 21, 48, 77,
, 132, 163, 218, 233, 238, 250, 260, 271, 315,
4, 421, 453, 470, 490, 527b, 542, 543, 562,
9, 655, 717, 721** and Colour Plates **6** and **7**.
bliography
M. Penzer, *Paul Storr, the last of the Goldsmiths*.
54.
e also Rundell, Bridge & Rundell.

tout, J. D.
n engraver, who was known to be working in
w York during the first half of the 18th century.
tankard, the armorial engraving signed by Stout,
in the Henry Ford Museum, Dearborn, Michigan.

trainer
e Coffee Biggin; Lemon Squeezer; Orange
rainer; Spoon (Mote or Strainer Spoon).

trainer, Dish See Mazarine.

trainer, Spoon
e Spoon (Mote or Strainer Spoon).

trawberry Dish
is, a convenient name and now generally
cepted, serves to describe a whole family of
rcular or, occasionally, oval shallow dessert
shes with fluted upcurved sides, flat bottoms and
calloped rims. They vary in size but are generally
 to 10 in. (25·4 cm.) in width. The spoon tray
 this form, often Irish, is distinguishable only
ecause it is oval and much smaller, and those of
 in. (10·2 cm.) to 5 in. (12·7 cm.) in diameter are

referred to as 'Patty Pans' by Sarah, Duchess of
Marlborough, and ten of 1719–20 survive at
Althorp. Equally small are the detachable side
dishes from epergnes of the period. The 'sallad
dishes' in 18th-century inventories refer to another
use for these same pieces. Two such 'sallad dishes'
appeared at Christie's in 1965 and were identified
as being part of a set of eight made by George
Wickes and detailed in the Garrard Ledgers for
July 11th, 1744, as supplied to Lord Montfort.
These are each on three scroll feet and gilt. Six
dishes, in this case with covers (four by Magdalene
Feline, 1750, two by Thomas Heming, 1771)
survive in the Royal Collection.
See also Dessert Stand; Epergne; Salad Dish.

Sucket Fork
See Spoon (Sucket Spoon and Fork).

Sugar Basin
The sugar basin, unless a reproduction of a sugar
bowl which has lost its cover, is usually of two-
handled form, generally either oval or oblong and
sometimes on feet. Essentially, it is the product of
the 1790s and later, deriving from the oval boat-
shaped sugar basket. The fact that at this date the
tea service, as the product of one workshop, began
to appear, means that in many cases a sugar basin
can often be matched to other pieces of the same
design if a collector has sufficient patience.
Bibliography
G.B. Hughes, 'Silver Baskets for Fine Sugar'.
Country Life, July 16th, 1964.

Sugar Basket
The varied forms of the sugar bowl and cover,
finally becoming vase-shaped, led to the intro-
duction of a basket, of similar form, with swing
handle, sometimes pierced and provided with a
coloured glass liner. The quality of the piercing and,
during the 1780s, the bright-cut engraving is of the
highest workmanship. The vase form is gradually
overtaken by the boat-shaped basket (**584**) and
this, in its turn, gives way to the oblong sugar basin
of 1800. Robert Hennell and Henry Chawner pro-
duced prodigious quantities of such pieces, their
standards being almost invariably high. The smaller
examples, of pail or bucket form, were probably
intended for cream and survive *en suite* with the
sugar baskets.
Bibliography
G.B. Hughes, 'Silver Baskets for Fine Sugar'.
Country Life, July 16th, 1964.
See also Cream Pail.

Sugar Bowl
The sugar bowl and cover, the latter often now
missing, appears in a specialised form about 1690;
one by Francis Garthorne of 1691 is in the Assheton-
Bennett Collection (**579**). At first the cover had a
turned finial (**580**) and presumably the idea of its
serving a dual purpose was a mere happy in-
spiration. Certainly by 1715 many covers are
reversible and may also have been used as spoon
trays (**583b** and **c**). This innovation almost coin-
cided with a taste for the octagonal form but it is
true to say that most octagonal bowls have non-
reversible covers. Between the years 1715 and
1730 the bowl tends to deepen (**582** and **583a**)
and later to take a shaped outline. Few sets of
caddies *and* sugar bowls prior to 1735 appear to
have survived. In fact, such sets are probably only
assembled rather than specifically made as such.
This was particularly true in the mid 1740s. At
least two Channel Island examples, with cover and
base of the same size, are known (**581**). By 1750

the reversible cover is replaced by one with a cone
or baluster finial until the 1760s, when the bowl
becomes vase-shaped, acquiring a swing handle
and perhaps a glass liner also, and the sugar
basket is born (**584**). A pair of the most unusual
bowls and covers are those made by Thomas
Heming, 1760, now amongst the Royal Collection;
they are of the same form as two of 1676 and 1677,
both by the same maker, PM in monogram (the
collection of the Duke of Portland). These post-
Restoration examples, having two handles, seem
rather too large for use with a toilet service from
which most shallow bowls of this early type
usually stem. One such two-handled bowl and
cover is in fact engraved with a presentation
inscription calling it a sugar bowl.
See also Bowl.

Sugar Box
The sugar box, like the bowl, is obviously com-
plementary to the caster and the naming of this
form of casket as such is obviously a matter of
choice, though hallowed by contemporary usage c.
1700. Amongst the plate of the Rev. J. Glover who
sailed for America in 1638 was 'a great silver
trunke, with 4 knop to sta[n]d on the table and
with sugar'. A large number of such surviving
pieces are American and usually oval in shape (**586**).
However, it should be noted that as late as 1760
John Heath of Boston refers to a 'Sugar Boox wt.
13 oz. 9 dwt.' which, as the same bill also mentions
a 'boole', may well refer to what we today would
call a sugar bowl and cover of the form illustrated
on Plate **587**. There is a fine example, on four scroll
feet, with the usual entwined serpent handle to
the cover, at the National Museum of Wales,
hall-marked 1678 (**585**), and a very rare, plain,
sugar box from Exeter (1705) was formerly in the
collection of Lord Clifford (**55**). Others of 1664,
1666, 1671, 1672 (**51**), 1673 and 1676 are
extant. A plain, oval example belonging to the
Goldsmiths' Company (1651) is probably the
earliest of all. In the museums at Boston and
Winterthur are two such boxes by John Coney and
Edward Winslow (Colour Plate **4**). About 1760,
though quite different in form, the sugar box is
found *en suite* with pairs of tea caddies; this is its
latest appearance (**588**) for it soon became vase-
shaped, finally dying out in the 1780s.
See also Spice Box.

Sugar Caster See Caster.

Sugar Crusher
A flat circular disc, having affixed to one side one
end of a rod about 5 in. (12·7 cm.) long, at the
furthest end of which is a finger ring. Usually of
Sheffield plate and dating from the early 19th
century. So late a date is surprising since the loaf
was the normal form in which sugar was purchased
until the early years of the present century.

Sugar Nippers and Sugar Tongs
The earliest form, c. 1685, seems to be that of a
pair of fire tongs. Perhaps a pair of toy fire tongs
were indeed adapted for this very purpose. The
arms, usually baluster turned, were straight, ter-
minating in concave oval pans. Later, c. 1700, the
spring bow was supplanted by a spring hinge
incorporated into the bow, the grips became shell-
shaped and finally by about 1715 a nipper of
scissor form was evolved. Examples of about 1740–
50 are often spring loaded at the cross of the
scissors. From that time onwards the arms of the
scissors followed all the twists of Rococo fashion,
until this form was finally supplanted, about 1775,

578a

578b

579

580

581

582

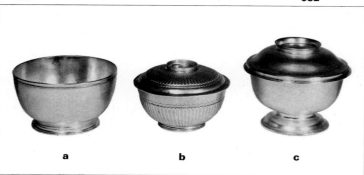

a b c

583

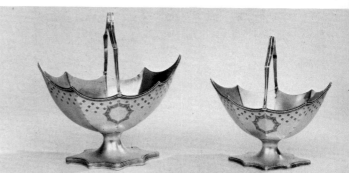

584

578 Stirrup Cups
a. Fox mask.
Maker's mark of Thomas Pitts.
Hall-mark for 1769.
Inscribed 'Success to Fox Hunting
and all friends around the Wrekin'.
b. Greyhound mask.
Maker's mark of E. Thomason.
Hall-mark for 1828, Birmingham.

579 Sugar Bowl and Cover
Maker's mark of Francis Garthorne
Hall-mark for 1691.
Diam. 4⅞ in. (12·4 cm.).
Assheton-Bennett Collection.
The arms were engraved c. 1725.

580 Sugar Bowl and Cover
Maker's mark of Pierre Harache.
Hall-mark for 1704.

581 Sugar Bowl and Cover
Maker's mark of George Hardy of
Guernsey.
c. 1735.
Diam. 4 in. (10·2 cm.).

582 Sugar Bowl
Maker's mark of John Moore of
Dublin.
c. 1750.
National Museum of Ireland.

583 Sugar Bowls
a. Maker's mark of William Fleming
Hall-mark for 1716.
Diam. 4⅜ in. (11·1 cm.).
b. Maker's mark of William Fleming
Hall-mark for 1708.
Diam. 4¼ in. (10·8 cm.).
c. Hall-mark for 1737.
Diam. 4⅝ in. (11·8 cm.).

584 A Pair of Sugar Bowls
Maker's mark of Hester Bateman.
Hall-mark for 1789.
Width 6¾ and 5¾ in. (17·2 and
14·6 cm.).

ugar tongs which first appear in the late 1760s.
earliest of these 'second generation' tongs
e usually made in three pieces with cast and
ced arms and a plain bow, later they were
le entirely from one piece of metal, the
being slightly curved in section to give it
sile strength. All forms of chasing and engraving
known on these pieces. The early nippers are
om fully marked, but we do know that I. Gray
London seems to have been a prolific maker.
ut 1750 fully marked examples occur (usually
he finger rings); the more delicate examples of
ced tongs are often only partially marked. Sets
welve spoons and a pair of sugar nippers must
e been popular, and are found incorporated
tea caddies in one box (**618**), as well as in
arate boxes of their own, though survivors are
A pair of gold tongs, associated with twelve
poons, by John Wirgman, c. 1750, is known;
bout the same date is an attractive variety of
scissor type formed as storks.

also Douter.

ar Vase

erally speaking the sugar vase is similar in
to the tea caddy, with which it was often
ded in a set of tea equipment. As the sugar
l and cover slowly disappear from fashion so
form and its cover appear c. 1745. The more
eme Rococo forms are often provided with a
r, pendent from the scroll handles, and are
uently identical in size to the tea caddies they
ompanied—this reflecting the fall in the price of
Examples with pierced covers are known but
often impossible to determine whether this is a
temporary or a later conversion. A particularly
survival, or revival, is the product of Benjamin
James Smith. These, on circular foot, are
-handled and finely cast and chased with
lling foliage; they are occasionally referred to
honey' jars or pots (**589**). Of this form is a set
eight now in the Royal Collection. This same
ign was also manufactured by Paul Storr. Cut-
ss sugar vases of the 18th century are uncom-
. That in the Victoria and Albert Museum,
ut 7 in. (17·8 cm.) in height, having an un-
ced silver cover with a strawberry finial, though
arked, must date from about 1765; it probably
e had a ladle pendent from the handles.

pper Service

ne doubt exists as to whether or not certain fan-
ped dishes were intended as part of supper
ices or, if gilt, only for use with a dessert.
bably theirs was a dual purpose (**590**). Cer-
ly, by the early years of the 19th century, large
ular trays (sometimes forming hot-water stands)
ame fashionable and these were recessed to
ive dishes of various shapes, surrounding a
tral tureen and interspersed with salt cellars.
st of those surviving are of Sheffield plate,
ertheless, there is a particularly fine gilt ser-
e by Daniel Pontifex, 1794, comprising twenty-
r plates and fourteen dishes amongst the plate
he White House, Washington. A supper set by
n Emes, 1805, engraved with the Arms of
vost is 29½ in. (75·0 cm.) long by 20 in. (50·8
) wide, fitted with four oval dishes and covers
a fifth central dish. It has handles at either end
weighs 406 ounces.

also Entrée Dish.

rtout de Table See Epergne; Plateau, Table.

ag

estoon of fruit, cloth or flowers.

Sweetmeat Dish

These, also known as 'saucers', were well known
in the 16th and 17th centuries, but in general few
survive before the reign of Charles I. They may
either be oval or round, usually having two shell
handles, and are seldom more than 8 in. (20·4 cm.)
in diameter. Their decoration often consists of
coarsely punched fluting, pellets and flowers.
Later examples of the 1650s favour more geo-
metrical ornament but seem to die out after the
Restoration. During the same period a large
number of small, approximately 3½ in. (8·9 cm.) in
diameter, shallow, two-handled bowls appear.
These, said to have been wine tasters, could indeed
be such, but could equally well have been used as
sweetmeat dishes and for a multitude of other pur-
poses. Various sauces were mixed at the table by
the individual and this is probably the most likely
original use of these dishes, as well as the most
obvious. Lamerie in one of his invoices to George
Treby in the 1720s refers to saucers as being part
of a 'surtoute' (epergne); these one would expect
to have been used for sweetmeats. Very recently a
petal-shaped sweetmeat stand by Aldridge &
Green, 1782, having a central ring handle, some
10¼ in. (26·1 cm.) high, made its appearance. This
has six, pierced, scallop-shaped compartments
and the six feet are joined by a plain wire ring.
Were it not for the hall-mark, one would be
tempted to ascribe to it a date 100 years later.
See also Saucer.

Sword Hilt and Gun Furniture

There has always been a tendency for men to
decorate their weapons, especially sword hilts
and scabbard mounts. Just such examples are
the sword of c. 1325, dredged from the River
Thames, now in the London Museum, and the
Pearl and Lent Swords (**593**) of the city of Bristol.
They were often embellished with silver and gold or
a combination of both. Swords, as symbols of
temporal power, are amongst the regalia of a
number of corporations (**592** and **593**). Both
Dumfries and Kirkcudbright possess scale-model
'Siller' guns (only the barrels surviving), presented
by James I with the express purpose of en-
couraging marksmanship amongst his subjects;
these were pistols not miniature cannon. English
cut-steel and silver-encrusted sword hilts were
one of the more expensive forms of sword
decoration during the first half of the 17th
century. A silver hilt of about 1645, in the Victoria
and Albert Museum, has a maker's mark, TH in
monogram. In Scotland, especially in the 18th
century, there was a tendency, on occasion, to
make the whole hilt of silver; one was made by
Harry Beathune, Edinburgh, c. 1715 (**591**). On the
other hand this had been a fairly common practice
in England from the Restoration onwards. The
Scots also inlaid steel basket hilts and the stocks
of nearly all steel pistols with silver knotwork. The
fashion for dress swords (small swords) from 1670
to 1820 gave vast scope to the hilt-makers. These
are generally fully hall-marked, as are the trigger
guards of pistols from 1740 onwards. There is a
silver hilt of 1676 in the Victoria and Albert
Museum; a 'plug' bayonet with fully marked
silver mounts of 1685, in the National Museum of
Wales, and a hunting sword with hilt made by
Philip Rainaud, 1705, is in the Farrer Collection,
Ashmolean Museum, Oxford. Amongst silver-
mounted gun furniture (counter plates, butt
plates, escutcheon plates, trigger guards and fore-
ends) may be mentioned a pair of holster pistols,
which are extremely early English examples, made
by William Watson (in the Tower of London) with

unmarked silver mounts; a fowling piece in the
W.K. Neale Collection has mounts with the maker's
mark, SV, of 1711, and another of 1716 has a
maker's mark, apparently HE. Identified maker's
marks are JA for Jeremiah Ashley (mark registered
in 1740); J.K. in cursive letters for Jeremiah King
(from 1739) and JK probably for John King (free
in 1757). All the above are London makers and
from Birmingham we find the maker's mark, CF,
for Charles Freeth. Somewhat later at the turn of
the century the mark, MB, is usually attributed to
Moses Brent. Maker's marks on American gun
furniture are rare, not so on sword hilts. In 1704
Richard Conyers of Boston, a London-trained
goldsmith, died, having fifteen sword blades
amongst his stock. The mounts to a sabre, pre-
sented to the 1st Duke of Wellington by the City of
London in 1812, are of gold. The trade card of
John Carman 'Working Goldsmith and Sword
Cutler' advertises hilts and sword slings. In
general, gold hilts, by virtue of their intrinsic value
had lavished upon them the workmanship of
enamellers and jewellers as well as the goldsmith
(**594**). Shepherd & Boyd of Albany, New York,
charged $314 in May 1814 'for making a gold
mounted sword for Com. Perry'. In the Victoria and
Albert Museum are two fine enamelled gold hilts,
one of 1781 by James Morisset, the other by
Ray & Montague, 1814; another by the latter firm
was supplied to the donors by Goodbehere, Wigan
& Bult in 1807. Only rarely was the standard
military issue hilt reproduced without embellish-
ment, as on a sword of 1801 presented by the
Colony of St Lucia to Brigadier-General Prevost. A
short, Enfield rifle with fine silver mounts of
1861 is exhibited at the City of Nottingham
Museum. Silver studs and mounts to Scottish,
circular, leather targes should not be forgotten,
the four survivors are of 18th-century date.

Bibliography
C.R. Beard, 'The Westminster Bridge Sword'. *Con-
noisseur*, vol. xci, p.104.
Wm. Reid, 'A Rare Scottish silver-hilted Hanger'.
Connoisseur, April 1963.
J.D. Aylward, *The Small Sword in England*.
H.T. Bosanquet, *The Naval Officer's Sword*.
American Silver Mounted Swords—1700–1815.
Corcoran Gallery of Art, 1955.
J.F. Hayward, 'Silver Mounts on Firearms'. *Pro-
ceedings of Society of Silver Collectors*, January
21st, 1963.
Ian Finlay, *Scottish Gold and Silver Work*. 1956.
'Scottish Weapons'. *The Scottish Art Review*.
Special number, vol. ix, no. 1, 1963.
A.V.B. Norman, 'British Presentation Swords in the
Scottish United Services Museum'. *Connoisseur*,
December 1967.
See also Lloyd's Patriotic Fund.

Sympson, Joseph

An engraver, who was working between the years
1690 and 1715. One of the very few engravers who
signed their work, though it was seldom dated.
Father of another Joseph Sympson, also an
engraver, though not known to have worked on
plate. Perhaps he was some relation to S. Sympson,
author of *A New Book of Cyphers* . . . (1726).
Horace Walpole records his being allowed to sign
a Newmarket race prize. He also signed a salver
made from the Exchequer Seal of George I for Sir
Robert Walpole; another by Lukin, 1717, he en-
graved with the Arms of Richard, 5th Viscount
Ingram (Victoria and Albert Museum). A ewer and
basin also by William Lukin, 1715, at Chatsworth,
Derbyshire, were engraved by him. A steadily
growing corpus of other pieces of his work are

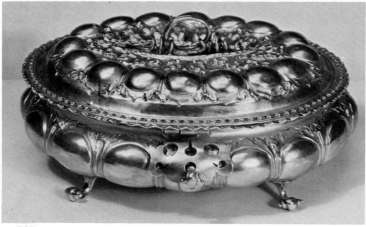

585

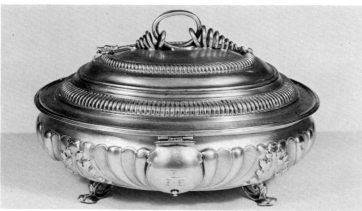

586

587

588

585 Sugar Box
Maker's mark, A H.
Hall-mark for 1678, London.
Length 7½ in. (19·1 cm.).
Jackson Collection.

586 Sugar Box
Maker's mark of John Coney of
Boston.
c. 1702.
Width 7½ in. (18·4 cm.).

587 Sugar Box
Maker's mark of Joseph Ward.
Hall-mark for 1700, London.
Diam. 4½ in. (11·5 cm.).
The inscription describes this box
as 'A Sugar dish' and is dated 1742.

588 Shell-shaped Sugar Box
Maker's mark of Christian Hilland.
Hall-mark for 1739.
It was probably associated with a
pair of tea caddies.

589 Sugar Vase
Silver-gilt, one of a set of four.
Maker's mark of Paul Storr.
Hall-mark for 1814.
Height 8 in. (20·4 cm.).

590 Supper Service
Maker's mark of J. Parker &
E. Wakelin.
Dishes: hall-mark for 1766.
Tray, cross and vase: hall-mark
1809.
Width 12¾ in. (32·4 cm.).
Engraved with the Royal Arms c
George III.

591 Sword Hilt
Maker's mark of Harry Beathune
Edinburgh.
c. 1715.
National Museum of Antiquities,
Edinburgh.

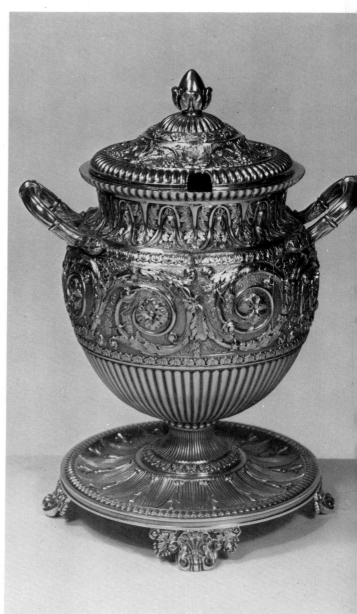

589

590

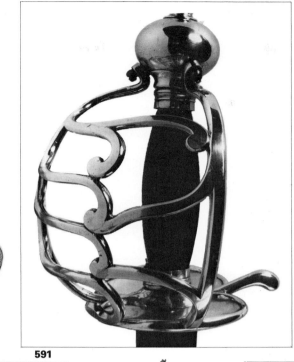

591

592 Exeter Corporation Insignia
Cap of Maintenance: 17th century, it encloses an earlier example.
The Great Sword: hall-mark for 1497; the scabbard is dated 1634.
Four Sergeants-at-Mace Chains: c. 1620.
Four Sergeants' Maces: maker's mark of George Wickes.
Hall-mark for 1730.
Mayor's Chain: hall-mark for 1874.
Sheriff's Chain: hall-mark for 1878.
593 The Lent Sword
Silver-gilt mounts.
Early 15th century.
The scabbard mounts are dated 1594.
Bristol Corporation.
So called because it was borne before the judges at the Lent Assizes.
594 Presentation Sword
Gold hilt.
Maker's mark of John Ray & James Montague.
Hall-mark for 1802.

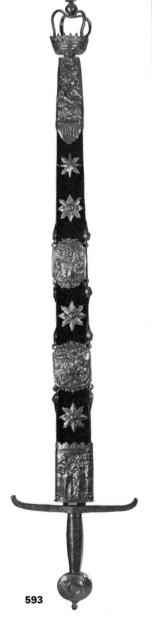

593

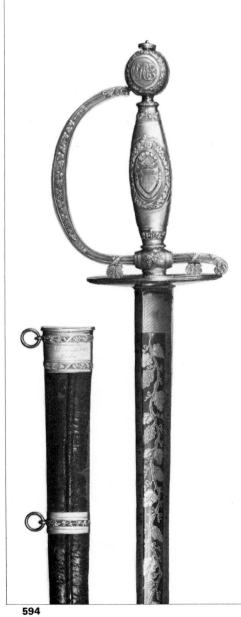

594

known, including a cup and cover from the Strawberry Hill Sale, again by Lukin, though in fact a duty-dodger.

Bibliography

C.C. Oman, 'English Engravers on Plate. Joseph Sympson and Wm. Hogarth'. *Apollo*, July 1957.
J.F. Hayward, *Huguenot Silver in England*. Faber & Faber, 1959.

Sympson, Samuel

Author of *A New Book of Cyphers more compleat and regular than any yet extant. . . .* 1726.

Syng, Philip, Junior (1703–89)

He is thought to have been born in Cork, Ireland, where his father was a goldsmith. He settled in the United States and worked in Philadelphia. A member of Franklin's Junta and co-founder of the Library Company of Philadelphia. Maker, in 1752, for the Philadelphia Assembly, of the inkstand later used at the signing of the Declaration of Independence, also a magnificent tankard with domed cover of about 1755 in the Garvan Collection, Yale University Art Gallery.

Table Plateau See Plateau, Table.

Tankard

Though referred to in accounts of the first half of the 14th century, the earliest surviving form of silver tankard is pear-shaped and, as distinct from a mug, lidded (**595**). The earliest known, entirely of silver, is that of 1556, mistakenly dated 1548 by Sir Charles Jackson in his *An Illustrated History of English Plate*. About fifteen examples of this pear-shaped, lidded form are known, generally plain but for a moulded foot and engraved bands of arabesques about the body. They are probably derived from medieval pottery originals. This form reappears during the mid 18th century, but was first superseded by the cylindrical tankard (Fig. **XXIXa**), probably deriving from examples mounted in horn (1561) or with banded staves (one such example of 1597 was once in the Lockett Collection). They usually have tapering sides sometimes slightly convex, with raised band (**596**) and only rarely, as in that of 1597 at Christ's College, Cambridge, have vertical sides. At least two pairs of Elizabethan tankards exist of 1589 and 1602 (Colour Plate **40**). This form of tankard with stepped, domed cover and finial, was made into the reign of James I and reappears occasionally in Scotland during the reign of Queen Anne. N.M. Penzer noted the lack of surviving tankards from the period 1610 to 1630. A single bulbous example of 1614 survives at Winchester but this may only reflect the wholesale melting of, comparatively speaking, modern silver at the time of the Civil War; especially as most of those surviving are mounted serpentine (**598**) and were perhaps adjudged of insufficient worth. We can almost hear it being said, 'We must keep something to use ourselves'. The Charles I tankard is usually plain, cylindrical (none the less there are still very rare globular exceptions), without a foot, the flat cover pointed to the front and with forward-curving wave-like thumbpiece (**605** and Fig. **XXIXb**). One of 1619 survives, but perhaps the finest of these rare survivals is the 1635 Eden Tankard belonging to Trinity Hall, Cambridge (**597**). This cylindrical type was replaced by the Cromwellian form, with broad 'skirt' foot, the straight sides only very rarely decorated (**600**), with kidney thumbpiece and flat domed cover. A rare small variant is illustrated on Plate **599**. An unusual silver-gilt example of 1649 belongs to Winchester

College and is engraved to represent hoops and staves, a form which reappears in the 1770s. With the advent of the Restoration came the enormous impetus for the production of new plate. This led to the making, one might almost say building, of a number of vast tankards (**601**). Particularly splendid is that of 1676, on three couchant lion feet with cherubs' masks and wing centre to the cover, at St John's College, Oxford, weighing 94 ounces. Corporate bodies frequently acquired pairs, such as those, made in York in 1670, for the Corporation of Hull. Sir Edmund Berry Godfrey, knighted for his services during the Great Plague of 1665 and Fire of London, 1666, presented a number of finely engraved tankards to his friends with appropriate decoration. These vary in date from 1673 to 1675, and are exceptional (five of these are known to survive). The majority of this period are plain (Fig. **XXIXd**), but a number have the lower part of the body chased with acanthus foliage (Fig. **XXIXc**) and, later, have cut-card work (**603**). From 1680 to 1690 the entire surface may be chased with chinoiserie figures and landscapes (**602** and Colour Plate **41**). More important examples were supported upon heraldic feet (usually couchant lions), with similar thumbpieces (Fig. **XXIXc**). One such example is the vast tankard made by George Garthorne in 1692 (capacity over one gallon); though it has no feet, it is 12 in. (30·5 cm.) high (now amongst the collection of the Bank of England). Also footed is the pair of tankards made by Thomas Issod in 1671, each 9½ in. (24·2 cm.) high, standing on three eagle or hawk feet, with similar thumbpieces. The Cumberland Tankard, 1746, one of the largest of all, runs on castors and has a dolphin beneath the handle to help it maintain its balance. Especially in York, and to a lesser extent in Newcastle, Hull, London and even Dublin and Edinburgh, copies of Scandinavian examples incorporating the pomegranate as feet and thumbpieces were made (Fig. **XXXa**). Peg-tankards are usually of this Scandinavian form. The pegs are applied to the inside and are intended to measure the amount of liquid consumed. There is at least one quart-sized exception of 1669 which has four detachable pegs to one side of the exterior, presumably as final proof in the event of a dispute during a drinking bout. It should be remembered that not only beer and ale but vast quantities of cider were also consumed. The phrase 'to take one down a peg' most probably originates from the raising and lowering of ships' colours, peg by peg, according to the rank of the person to whom the salute was being accorded, rather than to these, always uncommon, tankards. Examples are known marked from most of the assay offices, including Edinburgh (1709) and Hull, but John Plummer of York seems to have made the greatest number between the years 1657 and 1675. In New England the Dutch influence must be accounted responsible for tankard covers inset with coins. From 1695 a number of quart or larger tankards made in Edinburgh (Fig. **XXXId**), London, and a little later, in North America, have baluster or crest finials to the centres of the covers (**606**), a revival of the early Jacobean type. At the same time a moulded band begins to make its appearance round the lower part of the body (Fig. **XXXIa**). Southampton Corporation possesses a fine example of 1702, with a crest finial. The finial to the cover survived to the end of the 18th century in North America. One of the finest American tankards is that by Jacobus Van der Spiegel, *c.* 1700, in the Garvan Collection, Yale University Art Gallery (**604** and Colour Plate **11**). It was also not uncommon by the very end of the century to chase the lower

part of the body with a band of vertical or s[...] fluting and enclose the engraved coat of arms [...] chased cartouche, the cover might be simil[...] fluted (Fig. **XXXc** and **d**) and the handle joine[...] the body by a finely cut rosette of cut-card v[...] (Fig. **XXXb**). Nevertheless, the plain cylinder[...] continued to be made (**607**). Only on tankard[...] exceptional size or quality are the handles [...] (Fig. **XXXIb** and **c**), whereas from 1715, [...] handles are the general rule on mugs, until a[...] 1740. An exceptionally graceful and fulsome s[...] handle is that on the American tankard made[...] Myer Myers, *c.* 1755, once owned by the Beek[...] family. As early as 1699 tankards may be fo[...] with shallow domed covers which grew n[...] pronounced as the next century progressed; th[...] illustrated in Fig. **XXX** date from the close of [...] 17th century while those in Fig. **XXXI** date f[...] the early 18th century. Frequently, an origin[...] flat cover of an earlier date was domed late[...] make it more fashionable, but this usually disto[...] the marks, which were generously struck i[...] straight line across a flat domed cover. As [...] baluster-shaped tankard became fashionable in[...] 1720s, so the straight-sided variety died out [...] for a short revival, principally made in Newca[...] in the late 1750s and 1760s. As with the cy[...] drical form so the baluster, at first short and dur[...] because taller and more attenuated (**608**). A[...] from a few exceptional revivals (**609**) the incre[...] ing consumption of wines and spirits, as oppo[...] to beer and ale, spelt the end of any fur[...] development of the tankard after 1790. This [...] reflected, even during the reign of Queen Anne[...] the steadily decreasing capacity of tanka[...] though seldom less than one pint. Quite exc[...] tional is that presented to George Stephenson, [...] engineer, made by Robertson & Walton [...] Newcastle in 1817, it is some 9½ in. (24·2 c[...] high and weighs more than 83 ounces. [...] Victorian desire to improve and 'beautify' p[...] silver led to the addition of all sorts of chased [...] engraved decoration to many early, plain tanka[...] mugs and coffee pots. There seems, however, to[...] an exception to this in America, especially in th[...] cases where the tankard was to be used in a chu[...] as for instance the set of six made by Paul Rever[...] 1768 for Brookfield Church, now at the Henry [...] Pont Museum, Winterthur. Tankards were [...] converted to jugs by the addition of a sp[...] (illegal in England unless marked) and cutting [...] handles to insert ivory or wooden insulat[...] washers. Large examples made for presenta[...] continued to be produced. The considerable we[...] of a large tankard when full causes great st[...] upon its body at the point of junction with [...] handle and repairs, together with reinforcing pla[...] (often original), are frequent at these points. [...] so-called 'whistle-slot' is in fact made to allow [...] the escape of air when soldering the handle to [...] body and its noise-making characteristics [...] purely fortuitous.

Bibliography

Catalogue of Silversmiths Work. Burlington F[...] Arts Club, 1901.
G.B. Hughes, 'Old English Silver Tankards'. *Cour[...] Life*, September 14th, 1951.
A.G. Grimwade, 'English Silver Tankards'. *Apo[...] December 1953.
Exhibition of the Corporation Plate of England [...] Wales. Goldsmiths' Hall, 1952. (Catalogue.)
Douglas Ash, *How to Identify English Si[...] Drinking Vessels.* 1964.
Judith Banister, 'Fire of London Tankar[...] *Burlington Magazine*, June 1967.

See also Mounted-pieces; Mug.

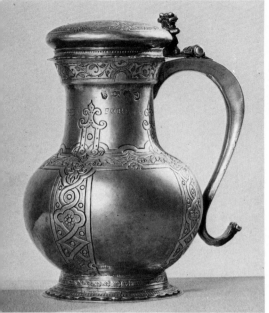

595

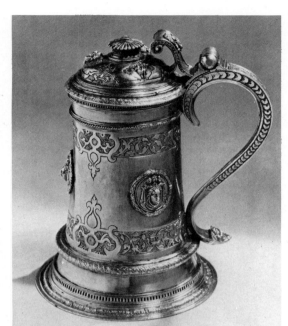

596

595 Tankard
Parcel-gilt.
Maker's mark, R D in monogram, probably the mark of Robert Danbe.
Hall-mark for 1567.
Height 7 in. (17·8 cm.).
The Armourers' and Braziers' Company.

596 Tankard
Silver-gilt.
Maker's mark, a bird, probably the mark of John Bird.
Hall-mark for 1571.
Height 6½ in. (16·5 cm.).
The gift of Matthew Parker to Corpus Christi College, Cambridge.

597 The Eden Tankard
Silver-gilt.
Maker's mark, an orb and star.
Hall-mark for 1635.
Height 7 in. (17·8 cm.).
Trinity Hall, Cambridge.
The gift of Thomas Eden, Master of the College, who bequeathed a sum of £10 'for a piece of plate on which I desire my name and arms to be set'.

598 Tankard
Serpentine with silver mounts.
Maker's mark, TP.
Hall-mark for 1637.

599 Tankard
Maker's mark, a bird with an olive branch.
Hall-mark for 1646.

600 Tankard
Maker's mark, WR.
Hall-mark for 1655.
Height 7 in. (17·8 cm.).

597

598

599

600

601 Tankard
Silver-gilt.
Maker's mark, D R crowned.
Hall-mark for 1661.
Height 11 in. (28·0 cm.).
The Drapers' Company.

602 The Dodding Tankard
Maker's mark, I H over a fleur-de-lys.
Hall-mark for 1671.
Height 7¾ in. (19·7 cm.).
The chinoiserie decoration was
probably added some ten years
later.

Fig. XXIX
A group of tankards, 1572–1670.
a. A cylindrical tankard. b. A plain,
cylindrical tankard without a foot,
with a forward wave-like thumb-
piece. c. The lower part of the body
of this tankard is chased with
acanthus foliage. d. A plain tankard.

Fig. XXX
A group of tankards, 1678–1701.
a. A tankard with pomegranate feet
and thumbpiece, a copy of a
Scandinavian example. b. A tankard
with cut-card decoration. c. A
tankard with a lion couchant
thumbpiece. d. A tankard with a
pronounced thumbpiece with
gadrooned decoration.

Fig. XXXI
A group of large tankards, c. 1710–
28. a. A tankard with a moulded
band round the lower part of the
body. b. and c. Two large tankards
with cast handles. d. A quart
tankard made in Edinburgh.

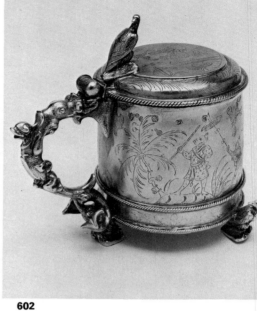

601

602

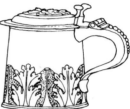

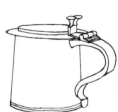

| a. 1572. Ht. 6½ in. (16.5 cm.) | b. 1633. Ht. 5⅞ in. (15.0 cm.) | c. 1663. Ht. 7⅛ in. (18.1 cm.) | d. 1670. Ht. 6¼ in. (15.9 cm.) |

Fig. XXIX

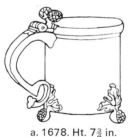
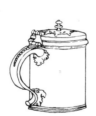
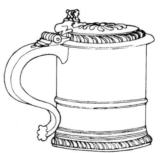

| a. 1678. Ht. 7¾ in. (19.7 cm.) | b. c. 1690. Ht. 6¼ in. (15.9 cm.) | c. 1691. Ht. 9¾ in. (24.8 cm.) | d. 1701. Ht 8¼ in. (21.0 cm.) |

Fig. XXX

| a. c. 1710. Ht. 8 in. (20.4 cm.) | b. 1723. Ht. 9½ in. (24.2 cm.) | c. 1727. Ht. 9½ in. (24.2 cm.) | d. 1728. Ht. 7¾ in. (19.7 cm.) |

Fig. XXXI

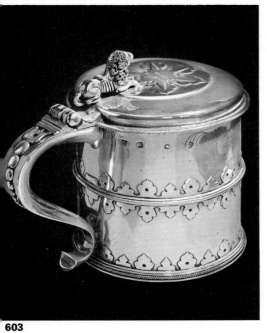

603

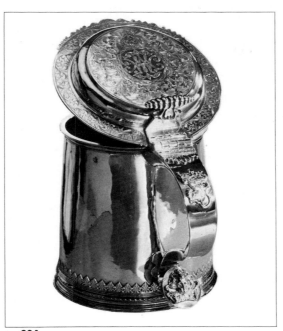

604

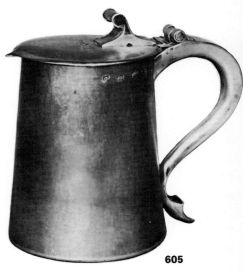

605

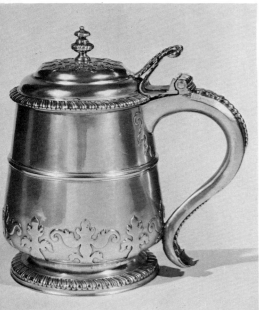

606

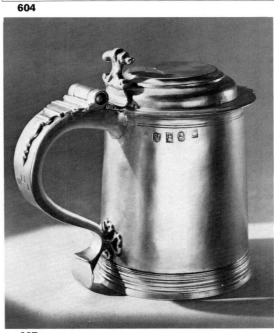

607

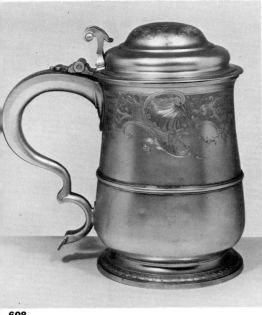

608

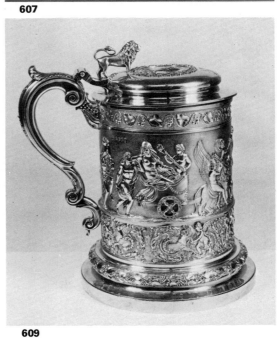

609

603 Tankard
Maker's mark, A M in monogram
with a crown above, probably the
mark of Andrew Moore.
Hall-mark for 1672.
Height 7¼ in. (18·4 cm.).
The Queen's College, Oxford.

604 Tankard
Maker's mark of Jacobus Van der
Spiegel of New York.
c. 1700.
Height 7¾ in. (19·7 cm.).
Yale University Art Gallery,
Mabel Brady Garvan Collection.
The lid is engraved with the
initials HWM.

605 Tankard
Maker's mark of Benjamin Francis.
Hall-mark for 1633.
Height 6 in. (15·3 cm.).
Assheton-Bennett Collection.

606 Tankard
Maker's mark of Robert Bruce.
Hall-mark for 1697, Edinburgh.
Height 8½ in. (21·6 cm.).

607 Tankard
Maker's mark of Peter Pemberton.
Hall-mark for 1703, Chester.
Height 7 in. (17·8 cm.).

608 Tankard
Maker's mark of Charles Kandler.
Hall-mark for 1731.
Height 9½ in. (24·2 cm.).
Engraved with the Arms of Clifford
impaling Weld.

609 Tankard
Silver-gilt.
Maker's mark of John Bridge.
Hall-mark for 1827.
Height 13½ in. (34·3 cm.).
Supplied by Rundell, Bridge &
Rundell.

295

Taper Stand (Wax-jack)

They are found in two forms. One type has the reel of turpentine-waxed taper coiled round a horizontal or vertical pillar; the other is a variation, in which the taper is coiled inside a cylinder (bougie box), at times wrongly identified as a string box.

The winch form is first found *c.* 1680 (one example is in the Museum of Fine Arts, Boston) and two other examples (there is also one in brass at the Victoria and Albert Museum) are of much larger size than their successors. The upper (the burning) end of the taper was held by a pair of spring, scissor-like grips (**610**) and these are still present in the next type with its vertical pillar standing on a circular base of dish form, occasionally with pierced gallery. It is not, however, until about 1775 that such pieces become common, by which time the form is an open wirework frame, sometimes formed as a globe, with a horizontal spindle, often with an extinguisher attached by chain.

At the same time the cylindrical form is also found and this is the type associated with travelling writing cases, being seldom over 2 in. (5·1 cm.) in diameter. The wax taper, treated with turpentine, burned clearly and did not crack or scale when bent. The general lack of such pieces during the first half of the century is probably due to the increasing use of the taperstick of miniature candlestick form. A particularly large example of the bougie box is that made by Samuel Wood, 1744, now at Colonial Williamsburg, Virginia. One of the earliest must be that of about 1690 by Benjamin Bathurst once in the May Collection.

Bibliography
C.R. Beard, 'Taper Sticks: The Wright Bemrose Collection'. *Connoisseur*, vol. LXXXVIII, p. 302.
See also Candlestick, Taper; Inkstand.

Taperstick See Candlestick, Taper.

Tassie, James (1735–99)

Born in Glasgow, he devised a method of reproducing gems, both cameos and intaglios, from an easily fused glass by which means moulds from originals and compressions from the moulds might be manufactured. On his death his business in Leicester Fields, London, was carried on into the 19th century by his nephew, William. Among his publications is the *Descriptive Catalogue of a General Collection on Antient and Modern Engraved Gems, Cameos as well as Intaglios taken from the most celebrated Cabinets in Europe*, published in 1775. Tassie's gems served as models for a number of medallions, forming part of the decoration of Classical silverwork, during the latter part of the 18th century, particularly in the work of Andrew Fogelberg and Stephen Gilbert.

Bibliography
C.C. Oman, 'Andrew Fogelberg, and the English Influence on Swedish Silver'. *Apollo*, June 1947.

Tatham, Charles Heathcote (1772–1842)

A pioneer in outmoding the Adam style. He published in 1799, *Ancient Ornamental Architecture at Rome and in Italy* and in 1806, *Designs for Ornamental Plate*. The desired effect he demanded was one of massiveness, allied with finely finished ornament. A gilt candelabrum of 1800 at Althorp is engraved 'Tatham Archt'. He was indeed a dictator of fashion who set the silversmiths such a task that few, besides Storr, Scott and Smith, could carry out with any degree of success. But it was his taste, and that of the Prince Regent (later George IV, 1820–30), that carried the day, and many others such as architects, Henry Holland and Wyatt, fully agreed and followed its dictates.

Tazza

A form of 16th-century shallow drinking bowl on a high central foot, which is rarely found retaining its cover (**611**). As a form, perhaps, it was never so popular in England as in the Low Countries, and it is sometimes difficult to distinguish it from a standing cup of mazer form (**612** and **613**). Often the interior of the bowl is engraved or chased, as in the case of that (1532) used as an alms dish since the 19th century at the Church of Arlington, Devon. The Arlington Cup is decorated with circular depressions across the whole bowl and engraved with the inscription 'BENEDICTVS. DEVS. DONIS. SVIS. ET. SANCTIS. IN. OMNIBVS'. Another, being amongst the finest, formerly belonged to St Michael's Church, Southampton, hall-marked 1567; this is embossed with a scene from the Biblical story of Isaac and Rebecca. Generally, only examples from the Low Countries have such detail as these mentioned above, Classical busts and strapwork being the usual English treatment. The standing dish or salver of the 17th century would seem also to derive from the tazza proper (**456** and **457**) and it may well be that the shallow-bowl form is really a derivation from the font cup and thence from the earlier wooden mazer bowl. After the Restoration the standing dish returns as the stand for a porringer. For the rest of the 17th century, and indeed for the early part of the 18th century, it remains in use as a circular salver. The best-quality examples usually have a cast foot which unscrews and a rosette of cut-card work strengthens the underside at the point of junction. A number of Scottish communion cups are of tazza form; so too are the reversible covered patens which appear in England from about 1630 onwards (for example the standing patens at Kenilworth, Warwickshire). The two Rochester tazze of 1528 and 1531, though with one cover of 1532, are secular in origin. The Goldsmiths' Company possesses a tazza and cover of 1584. A particularly fine pair of 1582 now in the Museum of Fine Arts, Boston, once formed part of the Corporation Plate of Boston, England. Another of 1577, parcel-gilt, is in the Art Institute of Chicago. An unmarked set of four of about 1570 is illustrated in the catalogue of the Lee Collection, Toronto.

See also Cup; Paten; Salver.

Tea Caddy

The word 'caddy' derives from the Malay *kati*, meaning approximately $1\frac{1}{5}$ pounds. The cost of tea during the late 17th century was high (40*s* per pound in 1664, between 16*s* and 50*s* from Thomas Garway in 1665), but by no means so high as it became when heavily taxed in the 18th century.

The first form of the caddy (or 'cannister' as it was called in the 17th century) was either copied from or emulated by the Chinese porcelain examples. It was rectangular or octagonal with a cap cover suitable for use as a measure (**615**). Perhaps the earliest surviving caddies are a pair of 1682, formerly in the Noble Collection, chased with chinoiserie decoration, though it is possible that these were in fact designed as part of a toilet service. Prior to 1700 they are extremely rare but a square 'Tea-Cannister' with matted sides, in the Carter Bequest, Ashmolean Museum, Oxford, may be dated about 1690. A pair made by William Scarlett in 1698 are also known. It is, however, worth noting that the trade card of Marie Anne Veit and Tho. Mitchell of 1742 (Heal's *London Trade Cards*, Plate LXXIV), illustrates this exact form, though it is clearly engraved 'S N U F F'. To facilitate

the insertion of a lead liner, the base or cov[er] is sometimes formed as a slide. Early caddies a[re] often of thin sheet metal and it is those of the fi[rst] decades of the 18th century, being of heav[y] metal, which are fitted with sliding bases or top[s,] John Newton being a specialist maker of th[at] particular form (**616**). Usually they are found [in] pairs, for black (Bohea) and green (Viridis) tea a[nd] though some of triangular section are known m[ost] are of oblong or rectangular shape. The habit [of] taking sugar with tea encouraged the silversmi[th] to produce a so-called 'set' of tea caddies (**617**) [in] a fitted case. Plate **619** illustrates a pair of caddi[es] and a covered sugar bowl, the cover sometim[es] reversible to form a spoon tray or stand. The case[,] fitted with lock and key, often finely made of ra[re] woods or covered in shagreen and silver mounte[d] or perhaps of ivory or mother of pearl (Colo[ur] Plate **44**), may be just as attractive as their con[?]tents. Some also contained teaspoons, tea knive[s,] a pair of sugar nippers and a mote spoon (**618**)[.]

The caddies, which were lined with lead were [at] first rectangular, then oblong (**620**), became vas[e-]shaped (**621** and **622**) and were finely chased an[d] engraved. One variety is formed as a slatte[d] wooden, square tea-chest inscribed with pseud[o-]Chinese characters. Recorded in the Wake[?] Ledgers, vol. IV, is the following entry: '1772 Jo[?] Wayne Esq. to two square tea-tubs, to gravin[g] mosaics and 2 cyphers'. Perhaps the most ful[ly] decorated caddy is that made by Andrew Foge[l]berg, 1772. At first glance it appears to be fine[ly] engraved, but in all probability it has been bri[l]liantly acid-etched. The etching covers the enti[re] surface of the caddy with a roadside tavern scen[e] which implies the merits of tea-drinking over th[at] of stronger waters. This, like the teapot made [by] Francis Crump, 1772, in the Sterling and Franci[ne] Clark Art Institute, Williamstown (**644**), is assume[d] to be the handiwork of Phillip Jacques [de] Loutherbourg, who came to London in 177[?.] By 1750 the tea caddies were often almost a[s] large as, and identical in shape to, the sugar bow[l] or box which rested between them in the case. [In] the eyes of the maker the high cost of tea justifie[d] the workmanship he generously lavished upon th[e] caddy (**624**) and almost every form known wa[s] pressed into service; nevertheless only one Coloni[al] American example survives, and Scottish caddie[s] are most uncommon. When the design of earli[er] years, which provided a combined measure an[d] cap cover, was superseded it was deemed nece[s]sary to produce a spoon suitable for inclusio[n] within the caddy itself. By 1770 the cost of te[a] had dropped to 6*s* per pound. During the 177[0s] the all-pervading oval form was adopted (**623** an[d] **625**), the caddy often being divided internally an[d] with its own lock to the cover—a feature appearin[g] about 1750—as it no longer came to the table in [its] case. Apparently unique is the pair of about 177[?] the sides pierced with scenes from well-know[n] plays with famous actors and with blue glass liner[s.] Of clear glass is the fine set of three balust[er] caddies with silver mounts in a fitted case that als[o] contains six spoons, a pair of sugar scissors and [a] mote spoon, now the property of the Roy[al] Academy. The case is engraved with the date 176[?] and some initials and was once thought to hav[e] been connected with Sir Joshua Reynolds. A[n] unusual form is the boat-shaped example [in] Sheffield plate of about 1790, in which the con[?]tainer rises like a temple amidships (Victoria an[d] Albert Museum). A pair of caddies by Isaac Liger [of] 1713 have a peculiar slotted device at one end [of] the covers which, in conjunction with the lock [at] the opposite end, prevents their unauthorised us[e]

612

610 Taper Stand
With coiled wax taper.
Maker's mark of Benjamin Godfrey.
Hall-mark for 1739.
Height 5¼ in. (13·4 cm.).

611 Tazza and Cover
Maker's mark, I G.
Hall-mark for 1584.
Height 13½ in. (34·3 cm.).
The Goldsmiths' Company.

612 A Cup of Tazza Form
Maker's mark, G and Cross Raguly.
Hall-mark for 1559.
Height 4½ in. (11·5 cm.).
Charsfield Church, Suffolk.
This cup was possibly made in
Ipswich.

613 The Middle Temple Tazza
Maker's mark, H S in monogram.
Hall-mark for 1573.
Height 5 in. (12·7 cm.).
The Honourable Society of the
Middle Temple.
In the centre there is an embossed
medallion with a bust of a female.

614 The Arlington Cup
Parcel-gilt.
Maker's mark, a cup in a shaped
shield.
Hall-mark for 1532.
Diam. 9 in. (22·9 cm.).
The Goldsmiths' Company.

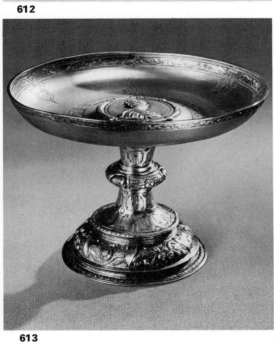

613

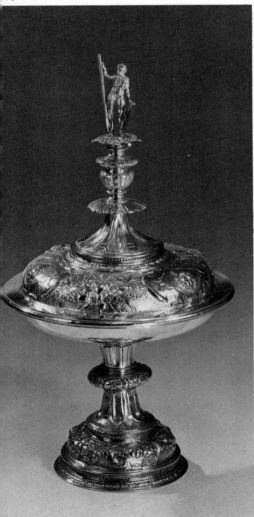

611

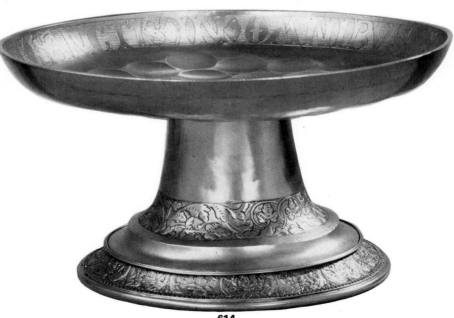

614

297

615 Tea Caddy
Unmarked, c. 1700.
Victoria and Albert Museum.
616 A Pair of Tea Caddies
Maker's mark of John Newton.
Hall-mark for 1728.
617 Set of Tea Caddies
Maker's mark of James Smith.
Hall-mark for 1730.
Height 5 in. (12·7 cm.).
Engraved with the Arms of Carew
of Carew.
618 Caddy Box
Maker's mark of Paul de Lamerie.
Hall-mark for 1735.
Pair of caddies: height 5¼ in.
(13·4 cm.).
Engraved with the Arms of Boissier
impaling Berchére.
The box contains a set of three
caddies, a milk jug, tea knives,
a set of spoons, a mote spoon and
sugar tongs.

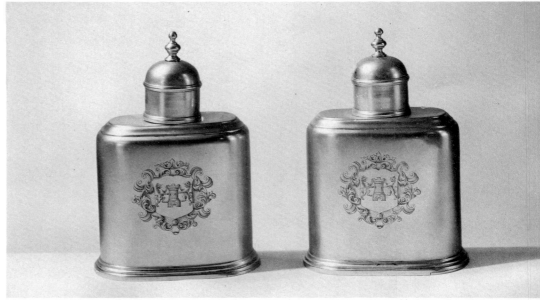

616

617

615

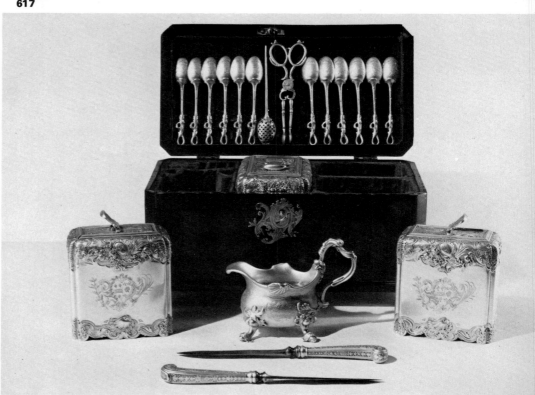

618

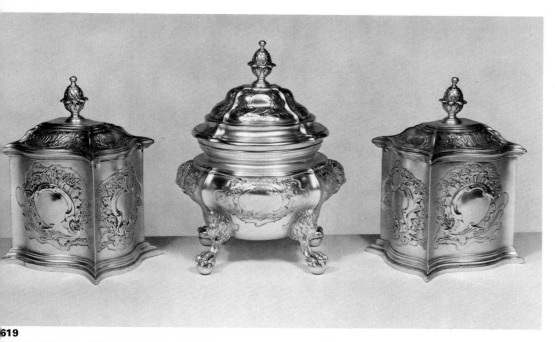

619

619 A Pair of Tea Caddies and Sugar Bowl
Maker's mark of William Kidney.
Hall-mark for 1739.

620 Set of Caddies
Unmarked, c. 1740.
Height 3 in. (7·7 cm.).
The tops are applied with the names 'Souchon', 'Pecco' and 'Hysson, all different varieties of tea.

621 A Pair of Vase-shaped Caddies
Maker's mark of William Hunter.
Hall-mark for 1743, London.
Height 5½ in. (14·0 cm.).
Jackson Collection.

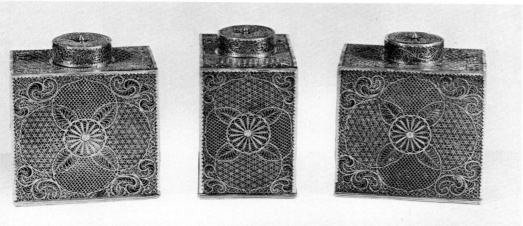

620

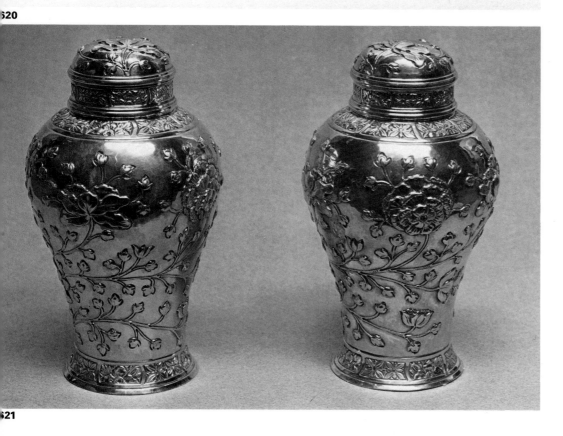

621

622　Set of Tea Vases
Maker's mark of Samuel Taylor.
Hall-mark for 1755.
Height 9 in. and 7½ in. (22·9 and
19·1 cm.).
Engraved with the Arms of Vyvyan.
The larger vase was intended for
sugar.

623　Tea Caddy
Maker's mark of John Lutwich &
William Vere.
Hall-mark for 1763.
Engraved with a Chinese character.

624　A 'Pagoda' Tea Caddy
Maker's mark, CM.
Hall-mark for 1764.
Height 6 in. (15·3 cm.).

625　Tea Caddies
a. Maker's mark of Henry Chawner.
Hall-mark for 1791.
b. Maker's mark of Hester Bateman.
Hall-mark for 1791.
c. Maker's mark of Henry
Greenaway.
Hall-mark for 1790.

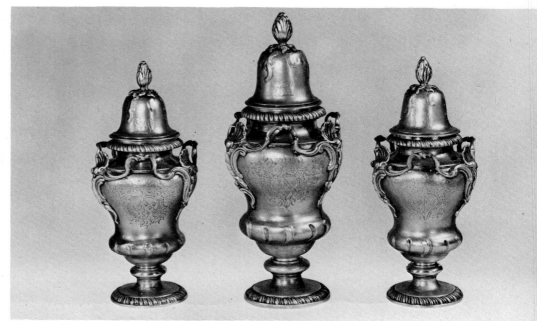

622

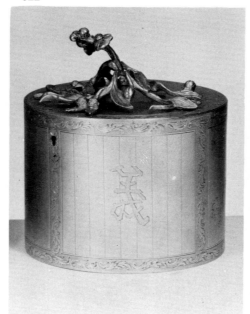

623

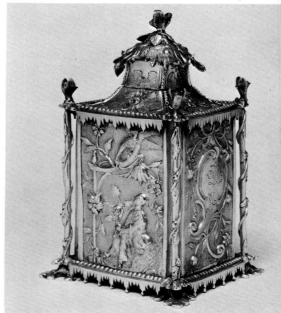

624

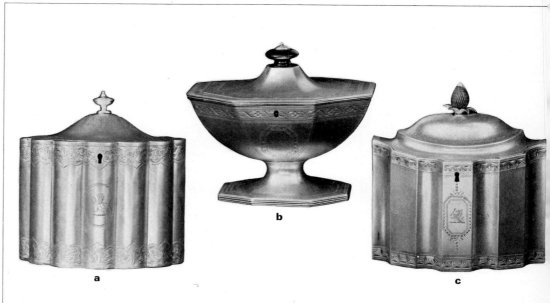

a

b

c

625

eir having a lock is exceptional at such an early
te.

liography

.Oman, 'Plate and Prestige'. *Apollo*, January
69.

.Oman, 'English 18th century Silver Tea
ddies'. *Apollo*, vol. xiv, 1931.

t G.Spendlove, 'Tee (A China Drink) and its
ect upon the English Scene'. *Connoisseur*,
cember 1953.

e also Box.

a Cup and Stand or Saucer

e earliest tea cups of European manufacture seem
have been of silver and follow the Oriental
m (**627a**). In England, perhaps, they are a
vival of the Restoration taste for fashioning a
ge of rather impracticable objects in silver.
e impossibility of holding a hot, handleless metal
p called for a saucer, often with a retaining ring,
t the impracticability of such an arrangement
ant the rapid extinction of the silver cup, with
casional survivals whose purpose is debatable
28). Though it must, however, be noted that in
probability scalding tea was not at first fashion-
e. The frame and saucer sometimes survived,
t with a substitute porcelain cup which was
re generally used for chocolate than tea. The
nds or frames are known as 'trembleuse'. Silver
os are seldom earlier in date than 1680 or later
n 1715; chinoiserie engraved examples of 1683
d 1686 are known, and Hayward illustrates a
r of two-handled, shallow bowls and stands of
88, by FS, as such. A silver-gilt example of
34 is in the Lipton Collection and a pair of 1688
Pierre Harache survive. A pair having only a
ker's mark, IP crowned, c. 1685, once in the
rewood Collection, are illustrated on Plate **626**.
s by no means impossible that the very small
o-handled bowls, common during the mid 17th
ntury (probably as stirrup or dram cups), were
o pressed into service as tea cups (**627b**). A
r of trembleuses made by Lamerie (1728) is not
latest, for in the Royal Collection are four of
34–5. Continental toilet services included such
mes until later in the century, often for use with
taller chocolate beaker of Meissen or another
rcelain.

liography

e *Lipton Collection of Antique English Silver*.
ntington Art Gallery, Exhibition Catalogue,
56.

.Hayward, *Huguenot Silver in England*. Faber
d Faber, 1959.

e also Cup, Chocolate.

a Kettle and Stand

hough an inventory of 1679 records 'one Indian
nace for tee garnished with silver' as then being
Ham House, Surrey, its form is not known. It is
ught that the tea kettle probably made its
ut c. 1690. It must be obvious that a stand and
p are necessities with a kettle. In 1697 the
l of Bristol notes his purchase of one weighing
ounces 11 pennyweights at 6s 2d an ounce;
s was enormously heavy, though one in the
rer Collection, Ashmolean Museum, Oxford, by
ul de Lamerie, 1713, weighs no less than 113
ices. Early kettles are usually pear-shaped,
her plain or octagonal, the stands with carrying
ndles and on four feet. This feature was soon
erseded by pinning the kettle and stand to-
her and carrying the whole by the kettle handle.
e feet (soon only three) are usually hollow
eres or if hemispheres originally designed to
close wooden studs to keep the heat from the

table upon which the kettle stood (**629**). In a few
rare cases, the stand itself was formed as a tripod
table and made entirely of silver, as depicted by
Hogarth in *The Marriage Contract*. The Bowes
Kettle and Stand of 1724 by Simon Pantin now in
the Untermyer Collection (**633** and **634**) and that
of c. 1725 with the crest of the Earl of Exeter, now
in the Victoria and Albert Museum, are two
examples of variations on this same theme, of which
perhaps six are known. Both tea kettles and teapots
followed the same form, so that the former are also
found bullet-shaped (**631**) and later of inverted
pear form (**632**). Only rarely is the stand of
chafing-dish form (one survives by Lamerie), 'A
silver tea-kettle stood on a silver-chafing-dish.
Coal might be placed in the Chafing-dish and that
kept the water hot,' so wrote Mrs Anistis Lee in a
narrative published in Connecticut in 1791.

Naturally, the decoration of the tea kettle was
no different from other pieces of the same period
and they were made in the most florid styles as
occasion demanded, that by Charles Kandler in the
Victoria and Albert Museum, 1727–37, exempli-
fying the Rococo (**630**). The coming of the tea
urn in the 1760s caused a general displacement
of the kettle (with exceptions, such as those
illustrated on Plates **653** and **654**) but it returned
to favour, usually with very little change except in
outline, with the discovery in the 19th century of
camphorine, an odourless and inexpensive fuel as
opposed to spirits of wine formerly used.

Surviving American examples may almost be
numbered on the fingers of one hand, but among
their number is one, made by Joseph Richard-
son, Senior, c. 1755, which may be classed as
perhaps the nearest any American silversmith ever
approached to the Rococo. It is also the only one
to retain its stand and lamp, unlike that by
Cornelius Kierstede, New York, c. 1710, now in the
Metropolitan Museum of Art, New York.

During the second quarter of the 18th century,
kettles, usually by the better makers (who might
be understood to have richer clients), are some-
times found with triangular as opposed to circular
salvers (**635** and **636**), in addition to the openwork
stand, and occasionally referred to in contemporary
documents as 'tables'. Early Scottish kettles are
rare (**650**). The ovoid Scottish tea urn of the 1730s
(**660**) is perhaps a variation on the kettle rather
than the prototype of the accepted tea urn.

Bibliography

G.B.Hughes, 'Old English Silver Tea-Kettles'.
Country Life, December 28th, 1951.

'An Unique Ensemble'. *Connoisseur*, August 1955.

See also Stand (Kettle Stand) ; Tea Table.

Teapot

Tea was on sale in London before the Restoration,
though costing as much as 40s per pound in 1664.
By 1669 it was available almost anywhere. The
earliest known teapot (**637**), a tapering cylinder
with conical cover, would, but for its inscription,
be mistaken for a coffee pot (1670, maker's mark,
TL, now in the Victoria and Albert Museum).
Perhaps, because its form was unsuitable, it is
also comparatively large, being 13½ in. (34·3 cm.)
high. The silversmith seems to have turned next to
the Chinese wine pot for his inspiration and the
teapot, which is dated prior to 1679, owing to the
fact that it bears the Arms of Archbishop Sharp
of St Andrews, is of this form. Another of c. 1685
(which could possibly have been intended to hold
cordial), superbly engraved with a boar and lion
hunt by one, F.S.S., is in the Museum of Fine Arts,
Boston. Two others exist, both gilt, one possibly by
Richard Hoare in the Victoria and Albert Museum

and one by Benjamin Pyne, in the Ashmolean
Museum, Oxford; both are partly matted and have
detachable spout caps affixed by a chain. This
seems to have been usual. The Lord Chamberlain's
Books record the cost on September 19th, 1679 of
'1 teapot 24-1-0 at 8/– (the oz.) £9-14-0'. A
very early American example, illustrated on Plate
638, of c. 1705 came from the Schuyler family
(New-York Historical Society). During the reign of
Queen Anne teapots are less of a rarity and have
become one of two forms. The first, which appears
in 1705, is pear-shaped (**639** and **640**); a York
example of 1708 and two from Exeter, one 1712
and the other 1714, survive, the last at Colonial
Williamsburg, Virginia. The second form is globular
(bullet) appearing about 1710. In each case
polygonal examples are known though six- and
particularly seven-sided ones are very rare. A fine
octagonal teapot and stand made by David King
of Dublin in 1712 is in a private collection. The
pear-shaped variety was generally supplied with
a heater and stand which had a baluster handle
to one side. This form dies out by about 1725 (a
'changeover' form peculiar to Scotland is illus-
trated on Plate **642**), reappearing as an inverted
pear during the 1740s. The globular teapot, often
with flush, hinged lid stands on a narrow, moulded
rim foot, and generally has a straight, tapering
spout. A seven-sided example by Isaac Ribouleau,
1724, is the only known such example, technic-
ally much more time consuming to produce (**641**).
An octagonal example in the Farrer Collection,
Ashmolean Museum, Oxford, by James Seabrook,
1718, is remarkable for the eagle-headed spout.
A teapot by George Robertson, Aberdeen, c. 1725
(City of Dundee Museum) is remarkable both for
its size, 6 in. (15·3 cm.) in height, and also its place
of manufacture. The bodies of these globular
examples were raised from one piece of metal in
the manner of an inverted tumbler cup. Two
spherical examples in gold, made in Edinburgh in
1736 (Colour Plate **39**) and 1737, were given as
race prizes. The teapot by Alexander Johnston of
Dundee, c. 1745, formed of two hemispheres must
be almost unique, now in the City of Dundee
Museum, though an example by Mettayer, 1712,
has a body formed from four segments. A rare
example is that in Sheffield plate of about 1760.
The pure sphere form survived later in Scotland
than elsewhere. Exceptions to the general rule
occasionally occur as those emulating European or
Oriental design (**643**). Other than a band of en-
graving round the shoulder, it is not until about
1740 that scrollwork and chased shells begin to be
applied by way of decoration.

Between the years 1755 and 1770 silver teapots
are uncommon, perhaps reflecting a change in the
drinking habits or a taste for porcelain. An interest-
ing contradiction, is the Leeds cream-ware pottery
'teapot' of globular form, c. 1765, inscribed
'Punch'. With their return and a drop in the price
of tea to about 6s per pound, all manner of forms
of teapot, including the small cylinder with
straight spout (the bachelor teapot), make their
appearance. One of the finest of these (now in the
Sterling and Francine Clark Art Institute, Williams-
town) is by Francis Crump, 1772 and is illustrated
on Plate **644**. This is brilliantly engraved (acid-
etched?) with Cimon and Iphigenia as described
by Giovanni Boccaccio in his *Decamerone*, and
with a second scene from La Fontaine, perhaps
the work of P.J.de Loutherbourg (see Tea Caddy).
A rare variety, on an openwork, detachable frame,
is occasionally found; those known are of about
1780 (**645**) and probably owe much to the designs
of Robert Adam. An example from the C.D. Rotch

626 A Pair of Tea Cups and Saucers
Silver-gilt.
Maker's mark, IP crowned.
c. 1685.

627 Tea Cups
a. Hall-mark for 1683.
b. Silver-gilt.
Maker's mark, RL.
Hall-mark probably for 1682.
Height 1⅞ in. (4·8 cm.).

628 Tea Cup and Saucer
Maker's mark of James Goodwin.
Hall-mark for 1719.
Tea cup: height 2 in. (5·1 cm.).
Saucer: diam. 4⅝ in. (11·8 cm.).

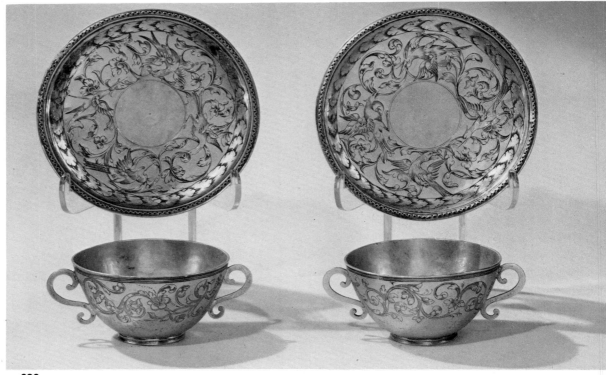

626

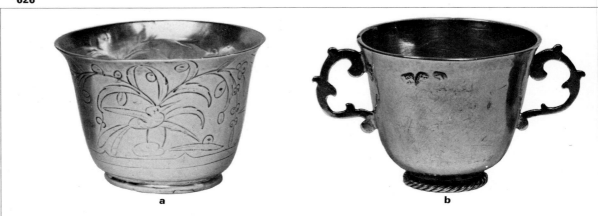

a b

627

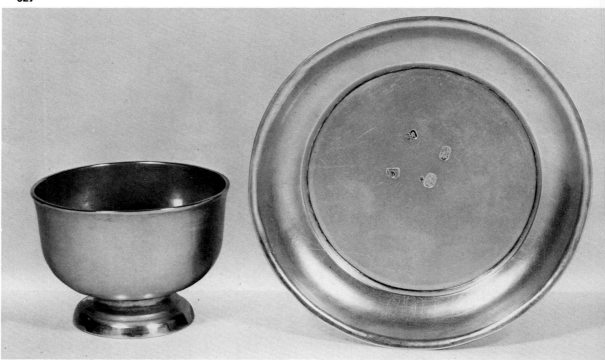

628

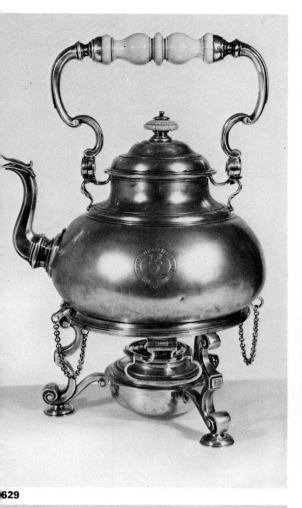

629

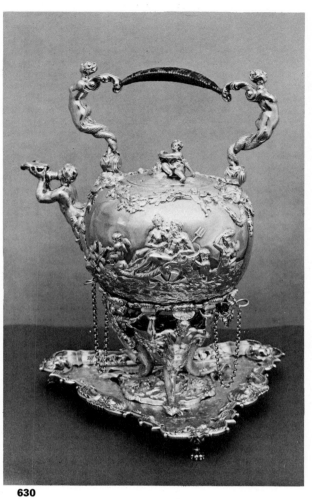

630

629 **Tea Kettle, Stand
and Lamp**
Maker's mark of Humphrey Payne.
Hall-mark for 1719.

630 **Tea Kettle, Stand
and Salver**
Maker's mark of Charles Kandler.
Hall-marks for 1727—37.
Height 13¼ in. (33·7 cm.).
Victoria and Albert Museum.

631 **Tea Kettle and Stand**
Maker's mark of Paul de Lamerie.
Hall-mark for 1740.

632 **Tea Kettle, Stand
and Lamp**
Maker's mark of William Partis.
Hall-mark for 1743, Newcastle.
Lamp: hall-mark for 1742.

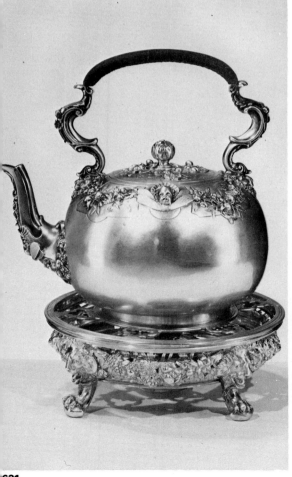

631

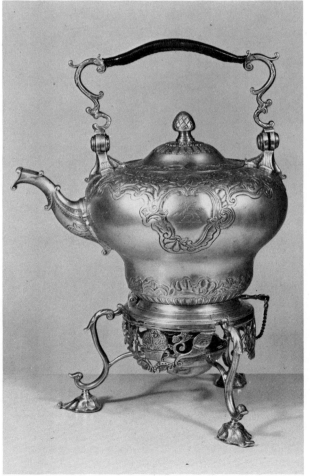

632

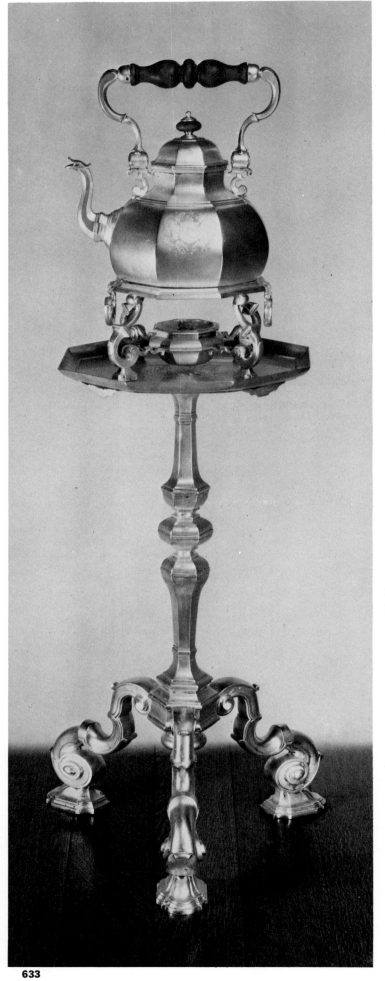

633

634

635

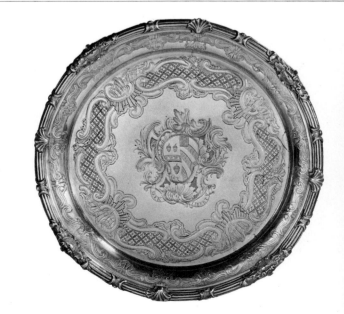

636

633 **The Bowes Kettle and Stand**
Maker's mark of Simon Pantin.
Hall-mark for 1724.
Stand: height 25½ in. (64·8 cm.).
Untermyer Collection.
Engraved with the Arms of Bowes with Varty (Cumberland) in pretence.

634 **The Bowes Kettle Stand**
(View of the stand top.)
Maker's mark of Simon Pantin.
Hall-mark for 1724.
Diam. 12 in. (30·5 cm.).
Untermyer Collection.
Engraved with the Arms of Bowes with Varty (Cumberland) in pretence.

635 **Tea Kettle Stand**
Maker's mark of Robert Abercromby.
Hall-mark for 1735.
Engraved with the Arms of Tracy impaling Hudson.

636 **Tea Kettle Stand**
Maker's mark of Paul de Lamerie.
Hall-mark for 1736.
Diam. 10 in. (25·4 cm.).

637 **Teapot**
Maker's mark, TL.
Hall-mark for 1670.
Height 13½ in. (34·3 cm.).
Victoria and Albert Museum.
Engraved with the Arms of the East India Company and those of Lord Berkley. Inscribed 'this Silver tea pott was presented to ye Com[tte] of ye East India Company . . . 1670'.

638 **Teapot**
Possibly made by Kiliaen Van Renssclaer III (1663–1719).
c. 1705.
New-York Historical Society.
It probably belonged to Johannes and Elizabeth (née Staats) Schuyler, who were married in 1695.

639 **Teapot**
Maker's mark of David Willaume.
Hall-mark for 1706.
Height 6⅝ in. (16·9 cm.).
Assheton-Bennett Collection.

638

639

640 Teapot
Maker's mark probably of Benjamin
Branker of Liverpool.
c. 1720.
Height 6¼ in. (15·9 cm.).
641 Teapot
Maker's mark of Isaac Ribouleau.
Hall-mark for 1724.
Height 4¾ in. (12·1 cm.).
642 Teapot
Maker's mark of James Kerr.
Hall-mark for 1725, Edinburgh.
Height 5½ in. (14·0 cm.).

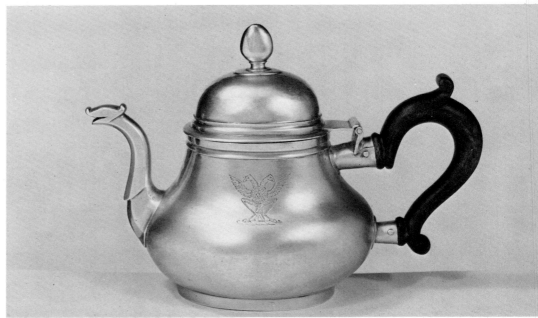

640

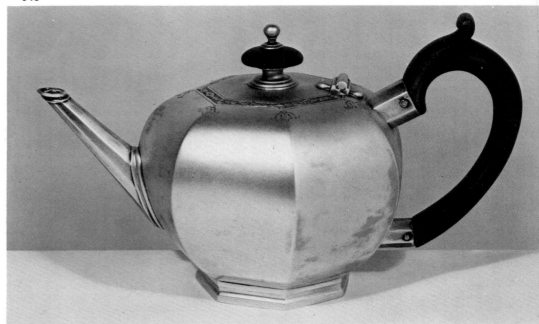

641

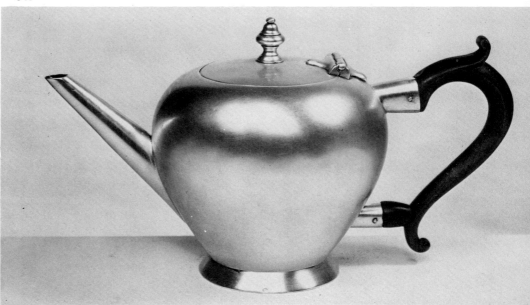

642

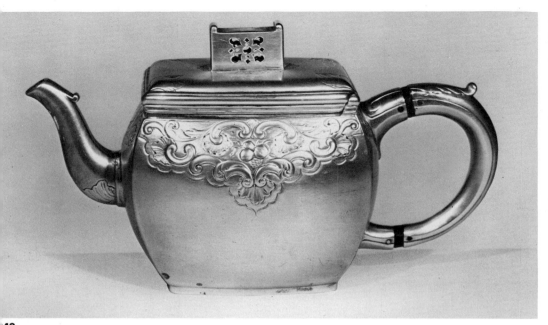

643 Teapot
Maker's mark of C. Dickson.
Hall-mark for 1740, Edinburgh.
644 Teapot
Maker's mark of Francis Crump.
Hall-mark for 1772, London.
Height 4½ in. (11·5 cm.).
Sterling and Francine Clark Art
Institute.
645 Teapot and Stand
Maker's mark of William Davie.
Hall-mark for 1784, Edinburgh.
The openwork stand is detachable.
646 Teapot and Stand
Hall-mark for 1831, London.

43

44

645 646

Collection, now in the Victoria and Albert Museum, is gilt and was made by A. Fogelberg & S. Gilbert, 1784. A plain, oval teapot with stand was most popular in the 1780s and 1790s and from 1790 tea services became more common. The gold teapot and stand made for William Beckford by Smith & Sharp in 1785 is of this form. At this date also appears the 'Wedgwood' teapot of compressed, spherical form, sometimes wholly or partly fluted and referred to as such in inventories and ledgers of the period until the 1820s. The last years of the reign of George III saw a revival of the taste for chasing and embossing with flowers and foliage and the circular, partly fluted, teapot with Classical decoration of 1800, often cast, if by the very best makers, was gradually superseded by the oblong variety on four ball feet, and that in turn by a number of variations upon the melon shape. It is at this time that the comparatively small capacity of the teapot is greatly increased and handles of silver, with ivory insulating washers, often replace those completely of wood or ivory. From now on the quality of design suffers, with few exceptions (**646**), from a tendency to overdecorate. An intriguing essay in copying another medium is the bullet-shaped teapot by Robert Garrard, 1826, with handle, spout and finial to the cover formed as rustic woodwork, perhaps after a Staffordshire pottery original (White House, Washington). During the whole course of the 18th century a number of very small (but otherwise identical to their full-sized brethren) teapots are found, particularly from 1725 to 1775. These are thought to have been used for saffron tea, a medicinal drink taken in the 18th century. During the early 19th century, a number of teapots are found with raised collars about the junction of cover and body; these collars are highest towards the front. An example antedating these by forty years was made in Edinburgh by William Davie in 1783. The presence of this feature seems to be dictated only by fashion, unless to prevent it overflowing when newly filled.

Bibliography
N.M. Penzer, 'The Early Silver Teapot and its Origin'. *Apollo*, December 1956.
E. Wenham, 'Later American Silver Teapots and Tea-services'. *Apollo*, vol. XXX, p. 16.
C.C. Oman, 'The English Silver Teapot, 1670–1800'. *Apollo*, vol. XIII.
The Lipton Collection of Antique English Silver. Huntington Art Gallery, Exhibition Catalogue, 1956.
D.C. Towner, *English Cream-coloured Earthenware*. Faber & Faber, 1957.
A.G. Grimwade, 'A New list of Old English Gold Plate'. *Connoisseur*, May, August and October 1951.
See also Cordial Pot; Race Prize; Stand (Teapot Stand); Tea Service.

Tea Service

There can be no doubt that tea services, sometimes with a coffee pot added, were made from at least the reign of Queen Anne. Of two known, both of 1712, one is illustrated on Plate **647**, the other of five pieces, each fluted, is by Lewis Mettayer (collection of the Duke of Buccleuch). Another of 1713 is of seven pieces; yet another of 1721 by Philip Rollos, was a christening present from George I to George, later 3rd Marquess of Annandale, and is in a private collection (**649**). A part service of 1719 by Joseph Ward (**648**) belongs to the Goldsmiths' Company. Another, also octagonal, made by Peter Archambo in 1720 is at the Pennsylvania Museum of Art, Philadelphia. A

fine and very complete service by Pezé Pilleau, Junior, of 1731 has a teapot, coffee pot, sugar bowl, a pair of caddies, tray, cream jug, spoon tray, teaspoons, etc.; one or two Scottish services of the 1730s and 1740s also survive (**650** and **651**). By the last quarter of the century such services become less infrequent (**652**, **653** and **654**) and a superb American example by Joseph Richardson, Junior, of Philadelphia, now in the Henry du Pont Museum, Winterthur, must date from about 1790. This has two teapots, one presumably for black and the other for green tea. A fine bright-cut example by Paul Revere, 1797, belongs to the Minneapolis Institute of Arts. 19th-century tea services are often of considerable size and enormous weight (**655**), particularly American examples. One service, of nine pieces made between 1800 and 1801, of parcel-gilt, is in the Museum of Fine Arts, Boston. It should be remembered that as a general rule the tea kettle stood beside the hostess on a separate table; no tray was designed to carry the weight of a whole service when actually in use. By 1820 large numbers of such services were being made, but few were of the quality of those illustrated on Plates **656** and **657**. An oft-reproduced picture of such a service in use is that painted by Richard Collins, entitled *Family taking tea*, now in the Victoria and Albert Museum. It seems likely that during the late 18th century a tea service was frequently purchased piecemeal. As a result the individual pieces, though matching and similarly engraved, may vary slightly in date and even bear different makers' marks. An American service by W. Thomson of New York, c. 1820, has an engaging border of windmills, cottages, beehives, scythes, harrows and sheaves of corn (Brooklyn Museum, New York). As the 19th century progressed more and more ornament was required by the customer.

Bibliography
J. Tudor-Craig, 'Christening Presents of George I'. *Connoisseur*, May 1960.
A.G. Grimwade, 'Three Centuries of British Silver'. *Apollo*, August 1950.
'Notes on Furniture. The Tea Equipage'. *Apollo*, October 1956.

Teasdale, J.

An engraver, who signed a Rococo cartouche for a triple coat of arms on a salver of 1763 by Samuel Courtauld, now amongst the Courtauld Loan to the National Gallery of Rhodesia.
See Engraving.

Teaspoon See Spoon (Teaspoon).

Tea Strainer

A small, oval, basket-like object with pierced body the size of a sugar sifter bowl, made by one, CR, 1822, also marked on the handle, appears to be the forerunner of a type that was suspended from the spout of a tea cup by a spring pin.
See also Orange Strainer.

Tea Table

Other than silver kettle stands, only two silver tea tables are known. One is in the collection of the Duke of Portland, this has a wooden frame enclosed in sheet silver and dated 1742. The whole top lifts off for use as a tray (four stud feet are supplied for this purpose) and is engraved with all the quarterings of Harley. In style it appears to be of an earlier date than the hall-mark. The other, also 1742 and now in the Kremlin, Moscow, is by Augustin Courtauld. During the 18th century,

silver salvers and trays were frequently referred as 'tables'.

Bibliography
E.A. Jones, *Catalogue of Plate belonging to Duke of Portland at Welbeck Abbey*. 1935.

Tea (or Coffee) Urn

Although there survives an urn with spigot made by Thomas Bolton of Dublin in 1696, makes no provision for heating the contents. the other hand it is far smaller, being 15¾ in. (4 cm.) in height, than most wine fountains (**65** Possibly due to the unpleasant burning quali of most fuels available in the 1760s, other t the rather expensive spirits of wine, the tea ke went rapidly out of fashion upon the appearanc the charcoal-burning tea urn, which, fitted wit central flue and a tap, heated the water and pensed it much more efficiently. Early tea urn c. 1765, not of Sheffield plate until about 17 standing upon a square plinth with four feet allow a draught of air, are generally ovoid or u shaped. The first piece of plate assayed at t newly opened office in Birmingham in 1773 a tea urn by Boulton & Fothergill. The discov patented by John Wadham in 1774, that a hea bar of cast iron, inserted in a tube within the b round which the water flowed, acted almos efficiently and allowed for a more elegant des meant that the heater could be dispensed v (**661**). However, this did not permit the water t kept hot indefinitely and by 1790 spirit la begin to reappear, usually as a miniature vers of the urn above them. Tea urns could take m forms; a very early example with two spigot t may well be an adaptation of a piece designed tea kettle. A pear-shaped coffee urn with t taps by Ephraim Brasher, New York, c. 1770 (**6** is in the Art Institute of Chicago. Others of var sizes survive, made in Dublin in 1702, Londo 1703, Edinburgh in 1746 and at least three slightly later date also from London. As no vision was made for keeping the contents ho must be assumed that these urns were also u for cold beverages or even just for water. It sh perhaps be stated that more often than not tea made either in the cup or a teapot, not in the itself, which contained only the necessary water. As the tap usually failed to cut off the w instantly, some sort of drip-tray was necess The finial of the tap was generally of ivory or wo for it would otherwise have been far too ho touch (**664**). On Saturday, December 10th, 1 'Hamilton arrived . . . brought . . . a very handsc *joint cadeau* to us of a Silver Tea-Urn', so re the *Wynne Diaries*. Sets or 'machines' compris one large (capacity six quarts) and two sm urns (one for tea, one for coffee) together wit waste bowl, are not unknown. Though they generally of Sheffield plate, such a set of th made by R. & S. Hennell, 1808 is at Colo Williamsburg, Virginia, whilst St John's Colle Oxford, possesses an urn with two tea caddies suite, of 1777. The Scottish variety of ovoid f (**660**) on three cabriole legs is usually of ea date (c. 1735) and perhaps more correctly thou of as a tea kettle (**662**). Perhaps the earliest is by Hugh Gordon of Edinburgh, 1729, in the N Collection. Scottish or Irish tea urns proper are common. During the second half of the century, special tables were provided for th urns as for tea kettles, they generally had a leried top and a pull-out slide to the front and v made of mahogany. The tea and coffee 'machi referred to above were probably intended breakfast use; the central urn swivelled to a

647

647 Tea Service
Maker's mark of Richard Watts.
Hall-mark for 1712.
Engraved with the Arms of Staunton impaling Lynch.
648 Tea and Coffee Service
Maker's mark of Joseph Ward.
Hall-mark for 1719.
Engraved with the Arms of Ilbert, Devon.
649 Tea Service
Silver-gilt.
Maker's mark of Philip Rollos.
Hall-mark for 1721.
Engraved with the Royal Arms.

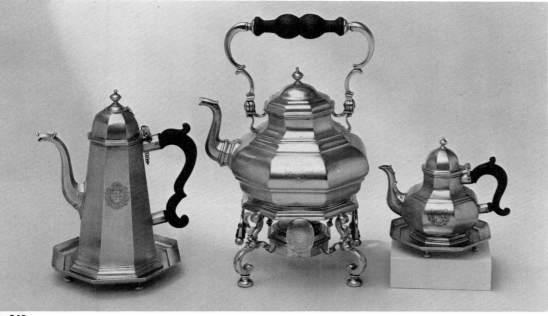

648

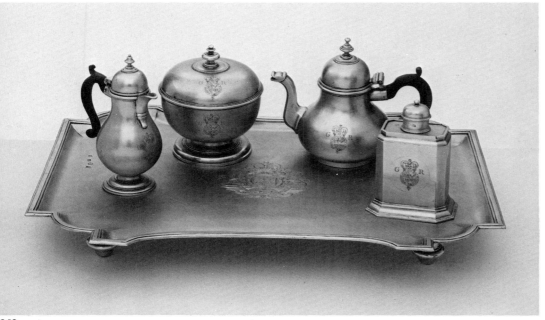

649

650 Tea Service
Maker's mark of James Kerr.
Hall-mark for 1734, Edinburgh.
Salver: width 9¾ in. (23·8 cm.).
Sugar basin: length 6 in. (15·3 cm.).
Spoon tray: length 8 in. (20·4 cm.).
Hot-milk jug: height 5⅝ in. (14·3 cm.).

651 Tea Service
Maker's mark of James Kerr.
Hall-mark for 1743–4, Edinburgh.
Each piece is engraved with the initials A E.

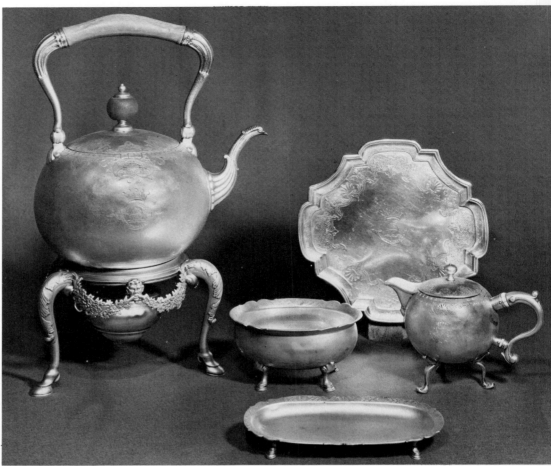

650

651

652 **Tea and Coffee Service**
Maker's mark of Orlando Jackson
& James Young.
Hall-mark for 1774.
This service was once the property
of David Garrick.
653 **Tea Service**
Maker's mark of John Schofield.
Hall-mark for 1790.

652

653

654 Tea Service
Maker's mark of John Robins.
Hall-mark for 1798–9.
655 Tea and Coffee Service
Maker's mark of Paul Storr.
Hall-mark for 1814.
656 Tea Service
Silver-gilt.
Maker's mark of William Bateman.
Hall-mark for 1817.
657 Tea and Coffee Service
Maker's mark of John Bridge.
Hall-mark for 1828, London.
658 Tea and Coffee Service
Maker's mark of G. Rait.
Hall-mark for 1897, Glasgow.
Tea tray: maker's mark, C F.
Hall-mark for 1880, Sheffield.
Length 28 in. (71·2 cm.).

654

655

656

657

658

the refilling of the two lesser urns. Not infrequently the engraved 'garters' and other mounts to the plated bodies were of Sterling silver.

Bibliography
G.B. Hughes, 'The Georgian Vogue of the Tea Urn'. *Country Life*, October 25th, 1962.
G.B. Hughes, 'Dual purpose elegance at Breakfast'. *Country Life*, April 4th, 1968.
See also Wine Fountain.

Teething Stick or Coral

Survivors frequently appear to be of earlier date than they are in fact. Most are of silver-gilt or gold, few having more than a maker's mark; their decoration is confined to stylised acanthus foliage with a ring at one end, the single stick of coral projecting from the other. The 1st Earl of Bristol records that on 'Mar 14th 1690. Paid Abraham Chambers. for a corrail sett in gold £1. 10. 0'. By 1740 the tendency was to combine the coral with a whistle and bells. A rare American example, c. 1750, by George Ridout illustrates this stage; slightly earlier is the example by Henricus Boelen of New York and rather later, the splendid Rococo fully developed example, c. 1760, by D.C. Fueter of New York.

Bibliography
Peter J. Bohan, *American Gold*. Yale University Art Gallery. 1963.
See also Rattle.

Ten Eyck Family

Koenraet Ten Eyck (1678–1753)

Of his ten children, two sons, Jacob (1705–93) and Barent (1714–95) became silversmiths. Born in Albany, New York, Koenraet kept an account book from the year 1729 which has survived, and from which we learn that, like many other silversmiths, he was also a general merchant. A pair of mugs, of about 1710, made by him are in the Metropolitan Museum of Art, New York. A fine tankard in a private collection also shows the same waved wirework border which is typical of such early New York silver.

Jacob Ten Eyck (1705–93)

Was responsible for at least two bowls of the type peculiar to American silver, each about 8 in. (20·4 cm.) in diameter, and having two handles with chased panels of foliage round the sides. One is in the Henry du Pont Museum at Winterthur, the other on loan to the Museum of Fine Arts, Boston. A very small version, 3⅝ in. (9·2 cm.) in diameter, is in the Garvan Collection, Yale University Art Gallery (Colour Plate **5**).

Barent Ten Eyck (1714–95)

Is remembered for a number of pieces of homely form, pear-shaped teapots and plain beakers of normal Dutch inspiration. More remarkable is the military gorget (excavated from an Indian burial) the property of the Museum of the American Indian, Heye Foundation. A number of funeral spoons are known by both brothers.

Theatre Ticket

Owners or grantees of leases for the building of theatres or other places of entertainment did on occasion retain the right to one or more free places. The Borough of Colchester did so in 1764 on the building of a theatre and a circular silver disc, unmarked, but suitably engraved, is preserved amongst the Corporation Plate. Bury St Edmunds also has two engraved 'The Alderman. 1800'. A number of tickets for Vauxhall Gardens (dating from about 1732–51) are preserved at the British Museum. These were, perhaps, season tickets. One, of gold, was given by Jonathan Tyers to William Hogarth.

Bibliography
E.A. Blaxhill, *Colchester Borough Regalia*. 1950.
See also Medal.

Theed, William (1764–1817)

After studying at the Royal Academy Schools and a visit to Rome, he worked for Josiah Wedgwood and from 1803 for Rundell, Bridge & Rundell. He exhibited two models at the Royal Academy in 1814.

Theocritus Cup

A design by John Flaxman, R.A., for a two-handled cup, adopted by Paul Storr in 1812. The subjects, chased round the bowl, are taken from the first Idyll of Theocritus, the handles are formed as entwined stems of vines. An example with square pedestal is known of 1811.
See also Cup, Two-handled; Wine Cooler.

Thimble

Examples are known from the 16th century, but generally the earliest found are of about 1700. These are usually incorporated in a needle case and some also include a spool for thread. A fine silver-gilt example of c. 1710 in the Victoria and Albert Museum, has a suspension ring for use with a châtelaine. Large numbers were made in pinchbeck during the 18th century. A very rare combination is a thimble and vinaigrette of about 1790. Gold examples, sometimes enamelled, were usually supplied in separate shagreen or leather cases. Thimbles are seldom marked, being items exempted by law owing to their small size.
See Hall-marking, Exemptions from.

Thistle Cup See Cup, Thistle; Mug.

Thurible See Censer.

Tinder Box

Seldom do these seem to have been made in the precious metals and thus the example in the Museum of Fine Arts, Boston, probably the work of one of the Richardsons of Philadelphia, is extremely rare. It has a hinged steel of handle form and compartments for flint and tinder.

Tine

The prong of a fork. The earliest examples are of rectangular section but by the early part of the 18th century they become round, and not until the 1780s does the square form reassert itself (Fig. **XXIV**).

Tipstaff

A term used both of a sheriff's officer, bailiff or constable, and also of their staff of authority. As a staff of authority this usually has a top or cap of metal, often formed as a crown, which developed during the 19th century into the colourfully painted truncheons, of which perhaps the largest collection is the Dixon, now housed at the Police College, Bramshill. Copper, sometimes silvered, rather than pure silver, is the more usual material for the head. In certain cases where the local authority's jurisdiction extended to the waterfront, an oar might be incorporated in the design (**665**) the most usual method being to encase it in the shaft of the truncheon, whence it might be withdrawn and displayed at will. At least one example incorporating a pistol is known (**666**).
See also Corporation and Ceremonial Plate.

Toasted-cheese Dish

An oblong dish, usually with hinged (detachable), shallow-domed cover, sometimes incorporating hot-water compartment beneath. The turned wo[od] handle is usually at the back. The finest is that [of] John Moore, 1804, with a finial formed as [a] mouse-trap added at a later date, and with a mou[se] at each corner (**667**). They are also, on occasi[on] fitted with a shallow two-handled tray besides [a] series of six or more small individual squa[re] saucers, which could be used separately. Th[e] belonging to Brasenose College, Oxford, and ma[de] by Paul Storr in 1815, has twelve such sauce[rs]. The tray was defined by at least one diction[ary] in 1700 as a 'ramekin'. Sometimes one cheese di[sh] was supplied with two trays; examples of the[se] trays, on their own, are found from the reign [of] George II and are often called 'Chop-Dishe[s]' whether in error or correctly is hard to say. Th[ey] are also used as pin trays on dressing tables; [in] larger toilet services of the 1750s onwards bei[ng] so provided, whereas they seem to be absent [in] earlier ones. Messrs Wakelin supplied Lord Mol[d]eaux in 1772 with 'a Cheese toaster wth wa[rm] plate and reflector' weighing 61 ounces 7 penn[y] weights. The reflector was the cover which, h[eld] open by a short length of chain, protected the ha[nd] from the fire and also reflected its heat on to [the] cheese which was grilled on small pieces of toa[st] sometimes soaked in wine, with which each of t[he] small individual dishes was filled. Lancash[ire] cheese was considered one of the best [for] toasting.

Bibliography
G.B. Hughes, 'The Georgian Way with Toast[ed] Cheese'. *Country Life*, May 30th, 1968.

Toasting Fork

Probably the earliest to survive is that made fo[r a] member of the Railton family of Norfolk and e[n]graved with the date 1561 between the two pron[gs] (**668**). The silver of this example is finely engrav[ed] the shaft being of hardwood (possibly campeach[y]) Thomas, Lord Wharton, possessed one at his dea[th] in 1568: 'a tostinge forke iii quarters iii s. vi [d]' From the Jewel House Inventories of Henry V[III] it would seem that the King's Plate Room co[n]tained one in 1550 described as 'an instrumente [of] silver and gilte supposed to be to roste pudding[s] with a steel of silver and gilte having a Roose [at] thende'. In the Victoria and Albert Museum is [an] example engraved with the date 1669, which, li[ke] the Railton example, has a backward hook besid[e] the two prongs. Another, c. 1690, has a rack as w[ell] as prongs. Another variety is the hinged rack an[d] most intriguing of all, a type which works on t[he] principle of a gimbal to ensure that the bre[ad] remains vertical.

A fair number of toasting forks with lo[ng] wooden handles, some with hinged prongs, s[ur]vive from 1700 and later, and an interesting, thou[gh] not unique, example of 1729 formed as a studd[ed] reflector plate (possible also a toast tray) wa[s in] the collection of Nevill Hamwee, Esq. (**669**). Th[is] however, was probably made in answer to [the] whim of a particular client, and may even ha[ve] been designed for grilling meat also. In most cas[es] the handle is of wood, up to 40 in. (101·7 cm[.]) long, the exception being those with telesco[pic] handles, either of silver or Sheffield plate (perha[ps] for travelling) and usually dating from about 180[0]. One of Sheffield plate in the collection of [the] Birmingham Assay Office is engraved 'Thomaso[n] Patent'.

Bibliography
C.C. Oman, 'English Silver Toasting Forks'. *Antiq[ue] Collector*, vol. xxxiv, pp. 24–5.
See also Fork; Griddle.

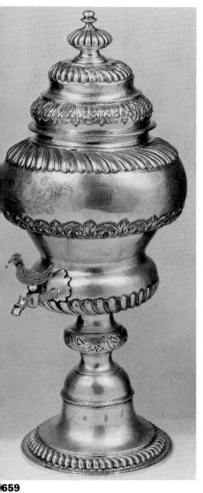

659 Urn
Maker's mark of Thomas Bolton.
Hall-mark for 1696, Dublin.
Height 15¾ in. (40·0 cm.).

660 Urn
Maker's mark of William Davie.
Hall-mark for 1746, Edinburgh.

661 Tea Urn
Maker's mark of Daniel Smith &
Robert Sharp.
Hall-mark for 1783.
Height 20 in. (50·8 cm.).
It has three lion-mask spouts.

662 Tea or Coffee Urn
Maker's mark of George Fenwick.
Hall-mark for 1806, Edinburgh.
Height 21½ in. (54·6 cm.).

659 660

661 662

663 Coffee Urn
Maker's mark of Ephraim Brasher.
of New York.
c. 1770.
Height 17¼ in. (43·8 cm.).
Art Institute of Chicago.

664 Urn
Maker's mark of Digby Scott &
Benjamin Smith.
Hall-mark for 1806.
Height 14¼ in. (36·2 cm.).
Engraved with the Royal Arms and
those of the 2nd Earl Spencer.
In the Egyptian taste inspired by
Thomas Hope and supplied by
Rundell. Bridge & Co.

665 Oar Tipstaff
Maker's mark of E. Morley.
Hall-mark for 1817.
Length 9½ in. (24·2 cm.).

666 A Group of Tipstaffs
Hall-marks for 1793 and later.
The Goldsmiths' Company.

667 Toasted-cheese Dish
Maker's mark of John Moore.
Hall-mark for 1804.
Width 9½ in. (24·2 cm.).
The mousetrap is a later addition.

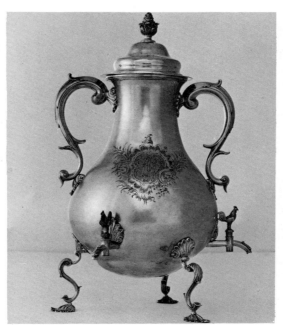

663

664

665

666

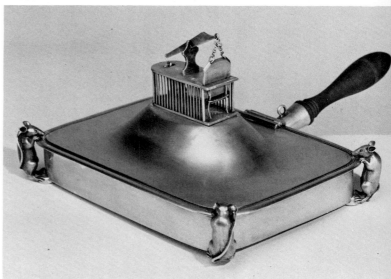

667

Toast Rack

Known during the late 18th century as a 'toast tray', the toast rack of the 1770s is usually of wire-work on an oval or oblong 'tray' base with four feet, the ring handle surmounting the centre rib often incorporates a plate suitable for engraving. They do not appear to have been made in Sheffield either in silver or plate prior to 1775. By 1800 reeded borders make their appearance and an infinite variety succeeds thereafter, some of considerable size and weight. The 'tray' base is now obsolete. In Scotland a variety for bannocks had up to three parallel rows of ribs. Prior to the introduction of the rack, toast must have been served in a dish. Folding toast racks are relatively uncommon and when found are often by Roberts and Cadman, who were working in Sheffield during the first two decades of the 19th century; a variety of this form was patented by Samuel Roberts in 1807. They fold either lengthwise or across their width on the 'lazy tongs' principle. It is likely that certain of the more cage-like racks were intended for letters.

See also Bannock Rack; Letter Frame or Rack.

Toast Water

Made by steeping toast in water and considered a suitable drink for invalids on account of the carbon content, for such invalids were generally suffering as a result of over-indulgence. A gilt jug engraved 'TOAST-WATER' survives amongst the collection of the Marquess of Exeter.

Tobacco Box

Throughout the period of silversmithing under discussion in this book, thousands of small boxes of every shape, size and material have been made. Few can be assigned a particular use. The letter from Thomas Knyvett to his wife written on January 17th, 1640 is therefore pertinent '. . . I desire him to send me by this bearer towe of Illingsworths Tobaccoe boxes with the Kings picture of silver, & a silver stopper. Thay cost ...-6d a peece' (*Knyvett Letters*, Constable, 1949). Although tobacco was introduced into England during the late 16th century, we have no certain survivals, so far as containers for it are concerned, prior to 1660. The chances are that earthenware was used and it may be that only during the reign of Charles I (1625–49) did it become fashionable to carry a supply upon the person of the smoker. Tobacco used as snuff was carried in the form of a plug with a rasp upon which to grate prior to use. Whatever the cause, a considerable number of more or less plain, oval boxes with detachable covers survive from 1660 to 1730 and occasionally later (**671**). Towards the end of this period many of these boxes have hinged lids. Usually they are engraved with the arms and even the name of the owner. A few are known engraved with candles, pipes, bottles and the paper roll in which tobacco was purchased. A suitable saying, such as 'Ne Quid Nimis' (nothing in excess), might also be added. One such box has incorporated in the engraving the initials T K, which may be those of the engraver, though more likely of the owner. These boxes usually measure 4 in. × 3 in. × 1 in. (10·2 cm. × 7·7 cm. × 2·5 cm.). Though bearing maker's mark, Sterling or Britannia, lion or lion's head erased, on the cover, they usually carry the full hall-mark only on the side. There is of course absolutely no reason why they should not have been used for snuff, especially those with a hinged lid. Gold examples are very rare and when found are generally of early 18th-century date, and more probably intended for snuff, being usually rather smaller and shallower. Tobacco boxes of box-wood, tortoiseshell and indeed almost every other substance are known, often with silver mounts and perhaps with added decoration in silver or gold piqué. These are seldom fully marked. In the author's collection is a horseshoe-shaped tobacco box engraved with the date 1717. So far it appears to be the only one of its kind known.

A few much larger boxes for use at the table are known, but unless these are possessed of a stopper, as very occasionally found with the pocket variety (see above), there is no way of telling their original purpose. The stopper, if present, may be an integral part of the box or attached by a chain. Such table boxes were the usual adjunct of a corporation or great city Livery Company and were circulated at meetings of the Court, of the Company or at dinner. Liverpool Corporation has a table box, with stopper, of 1690 (**670**). Ludlow Corporation has a splendid pair of large, oval boxes made by Humphrey Payne in 1721; one could have been used for tobacco and the other for snuff (**672**). Generally speaking, the boxes from a lady's toilet service are too deep to be confused, but some circular boxes from a gentleman's service may well be masquerading as tobacco boxes, even today. An oval box seems to be unknown in a toilet service prior to 1750. Unfortunately this is not so with circular tobacco boxes, though uncommon, so that no hard and fast rule can be given. Tobacco boxes are known from almost all the silversmithing centres. Two, rare, silver-mounted shell boxes in the Victoria and Albert Museum, each with a scroll handle at one end, are called 'nut-meg graters', but their possessing a protuberance at the opposite end to the handle, of pipe-stopper form, seems to point to their being intended for tobacco. Unmarked, they appear to date from about 1650.

Bibliography

Eric Delieb, *Investing in Silver.* Barrie & Rockliff, 1967.

Eric Delieb, *Silver Boxes.* Herbert Jenkins, 1968.

A.K. Snowman, *18th Century Gold Boxes* Faber & Faber, 1966.

See also Box; Seal Box; Snuff Box.

Tobacco Candlestick

During the winter a spill from the fire was a feasible 18th-century method of lighting one's pipe. In summer, however, it is likely that a small taper-stick was kept burning for this purpose until it was superseded by the wax-jack in about 1770. This, in its turn, giving way to a whole variety of instant-fire contrivances and eventually, about 1830, to the friction match.

See also Candlestick, Taper; Taper Stand.

Tobacco Stand

Such stands were most suitable for public rooms, such as those of the Universities', and are therefore unlikely to have often been found in a private house. The tobacco was kept in the central container and the bowls could be used for ash, resting the long churchwarden pipes, or even for charcoal. One of the finest, probably largely Continental in inspiration, is that at Clare College, Cambridge, by Phillips Garden, 1757. This has a central cask between two shallow bowls and is 18 in. (45·8 cm.) long.

Bibliography

E.A. Jones, *Catalogue of the Plate of Clare College, Cambridge.* 1939.

See also Pipe, Tobacco; Smoking Set.

Toddy

Generally whisky, or rum, and water mixed with lemon juice and sugar and served hot. Grated nutmeg might be added to taste. Originally arrack, a primitive Far Eastern spirit distilled from the sap of the coconut or date palm, was imported as 'palm toddy'.

Toddy Ladle

A small edition of the punch ladle appears about 1800, generally with a whalebone handle. In the main, those which are extant bear Scottish hallmarks.

Bibliography

G.B. Hughes, 'Silver Punch Ladles'. *Country Life*, November 17th, 1950.

See also Ladle, Punch or Toddy.

Toddy Lifter

Dumb-bell-shaped with an aperture at both ends; when dipped in liquid and a finger placed over the upper end the liquid might be withdrawn from the bowl. An innovation of the early 19th century on the pipette principle.

See also Cobbler Tube.

Toilet Service

The toilet service can hardly have been an invention of 1660, indeed pieces from French services of earlier date survive. However, in England it is not until after the Restoration that reasonably complete survivals are known. John Evelyn records in 1673 that Catherine of Braganza had a set 'all of massie gold, presented to her by the King, valued at £4000'. Most of these early examples owe a good deal to French inspiration and a number of unmarked services are still of doubtful provenance. At Knole in Kent that of 1673 is one of the earliest. The Calverley Toilet Set, now in the Victoria and Albert Museum, is hall-marked 1683 (**674**). Another at Chequers, Buckinghamshire, from the Lee of Fareham Collection, dates from about 1690. One of those at Chatsworth, Derbyshire, having cut-card decoration, is hall-marked 1694. That in the Metropolitan Museum of Art, New York, engraved with chinoiserie decoration, can mostly be dated at 1683 (**675**). In the National Museum of Ireland, Dublin, is a service of eleven pieces by John Phillips of Dublin, 1680 (**673**). An extremely rare Scottish service by Colin McKenzie, 1703, was once in the Stirling of Keir Collection. A considerable number of such services dating between 1695 and 1725 and in varying states of completeness are known. At Luton Hoo the toilet service is the work of David Willaume, who made it for the Marchioness of Kildare between 1698 and 1722. One of the finest from almost any point of view is the Treby Service of twenty-nine pieces made by Paul de Lamerie in 1724 for which the original accounts survive (Ashmolean Museum, Oxford). Another of similar quality, made for Count Biron by Lamerie and others, between the years 1720 and 1737, is now in the Hermitage, Leningrad. Part of a toilet service made for Queen Anne by Isaac Liger survives, and so does that made at a later date for Queen Charlotte by Thomas Heming in 1771. Possibly the finest of this last maker's toilet services is that made for Sir Watkin Williams Wynn in 1768 and comprising twenty-nine pieces, some six being illustrated on Plates **676**, **677**, **678**, **680** and **681** (National Museum of Wales). Similar to these last two mentioned services is one of thirty pieces made in 1766 for Caroline Matilda (sister of George III) and now in the Kunstindustrie Museum, Copenhagen. One of the last of these great services, in the Adam style, is that by Daniel Smith & Robert Sharp, 1779, now in the National Museum of Stockholm.

668 Toasting Fork
(Three detailed views.)
Wooden staff and silver mounts.
Unmarked but engraved with the
date 1561.
Overall length 34½ in. (87·7 cm.).
The initials and rebus are probably
those of the Railton family of
Norfolk.

669 Toaster
With wooden handle.
Maker's mark of John White.
Hall-mark for 1729.
Length 22¾ in. (57·8 cm.).
Pan: width 8¼ in. (21·0 cm.).

670 Tobacco Box
Maker's mark, PR in monogram.
Hall-mark for 1690.
Length 6½ in. (16·5 cm.).
Liverpool Corporation.
There was originally a pipe stopper
attached by a chain to the inside,
this is now lost.

**671 Cover and Base
of a Tobacco Box**
Maker's mark of Matthew Pickering.
Hall-mark for 1705.
Width 3⅝ in. (9·2 cm.).
Assheton-Bennett Collection.
Engraved with the initials WH and
the Arms of Hawes and a portrait
of John Churchill, 1st Duke of
Marlborough.

672 Tobacco Box
Maker's mark of Humphrey Payne.
Hall-mark for 1721.
Width 5 in. (12·7 cm.).
Ludlow Corporation.

673 Toilet Service
Maker's mark of John Phillips.
Hall-mark for 1680, Dublin.
National Museum of Ireland.

668

669

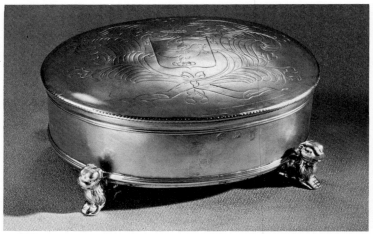

670

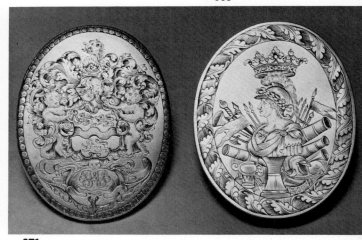

671

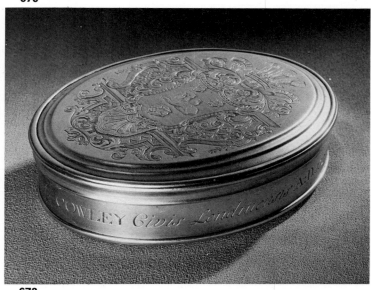

672

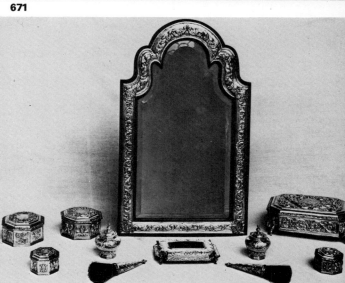

673

nother by the same firm was made in 1783 (**682**). om this date onwards, most of those surviving e considerably smaller, both physically and umerically, and are usually supplied with a fitted se, from which they need not be removed when eir owner was travelling. Of the earlier services umerated above, only the Wynn Toilet Set eserves its original case. The Lennoxlove Toilet ervice, now in the Victoria and Albert Museum, hich also has its 17th-century travelling case, is ench. At the same time as these great services ere being supplied for the wives of the rich, the entlemen also felt the need for toilet cases conining razors and boxes for pomatum, soap and ent. Examples for razors alone are not so unmmon, but cases for further pieces are far more re. One of the earliest being as late in date as 761.

Mention should be made of the various pieces mprising a toilet service. A mirror (**679**), a pair large rectangular boxes (known as 'comb xes), a smaller pair, two scent bottles, hair ushes and a box with pin-cushion top, seem to ve been the basic essentials. Further pieces ch as a ewer and basin, candlesticks (often by a fferent maker and smaller than the table variety), uffers and stand, square scent flasks, a tray, ap bowls (covered or open) and a pair of hisks and any number of extra boxes might be ded at will. Not until the services made by eming in the 1760s do the glass scent bottles ith silver mounts appear. Surprisingly, pin trays ldom survive with earlier services, perhaps having en removed from the set for use on their own or some other purpose. The exact purpose of those jects (sometimes formed as pear-shaped scent ttles), whose tops are hooks, has not yet been certained. They could be the 'Dressing weights' d 'Plummits' which are known to have been supied by silversmiths. Their use is debatable, but ghtening stay laces is one possibility. Hogarth's cture *The Countess's Dressing Room* (1744) and ffany's *Queen Charlotte at Her Dressing Table* 765) both show toilet services in use. The rarest ece of all, of which only one is known to survive robably made by Daniel Garnier, *c.* 1680) is a ent dabber. In 1773 Peter Burrell paid Wakelin for 'new hair to a beard brush'. Two years pre-ously Sir William Draper had paid £234 6*s* 3*d* r a new service including 'two Comb brushes, 2 oaths Brushes, 2 patch boxes, 2 essence bottles, patch boxes, 2 powder boxes, 2 comb boxes a wel box with blue velvet covered pin cushion lid d a looking glass frame'.

ibliography
Starkie Gardner, 'Silver Toilet Services'. *Con-isseur*, vol. XII, p. 95.
G. Grimwade, 'Royal Toilet Services in Scan-navia'. *Connoisseur*, April 1956.
M. Penzer, 'The Plate at Knole', part II. *Connois-ur*, April 1961.
C. Dauterman, 'Dream-Pictures of Cathay'. *etropolitan Museum of Art Bulletin*, Summer 964.
ee also Ewer and Basin; Pastille Burner; Pin ushion; Plummit; Razor Case; Scent Dabber; oth Brush.

ongs, Sugar
ee Sugar Tongs and Sugar Nippers.

ongue Scraper
bow of plain springy silver, generally with a oulded finial at either end, formed part of the ccessories to a toilet service. Most examples, if arked, date from about 1800 or later. These were

also found associated with a tooth powder box and tooth brush in pocket travelling cases.

Tooth Brush
Originally a silver handle with a number of spare ivory-set bristles, interchangeable at will, forming part of a toilet service. Examples earlier than 1780 are very rare. Edward Finch obtained six from George Wickes in 1748. Pezé Pilleau, Junior, advertised himself in the 1730s as 'Goldsmith and Maker of Artificial Teeth'.

Tooth-pick
During the late 17th and early 18th century these are often found combined with ear-picks, some-times folding as a pen-knife.

Tooth Powder Box
Formed as a long, narrow, shallow box with a centrally hinged double lid, these are found in small fitted cases with a tooth brush and some-times a tongue scraper. They date from the last quarter of the 18th century.

Tontine
Taking its name from a Neapolitan banker, Lorenzo Tonti, who initiated the scheme in France in 1653. By it, the subscribers to a loan or common fund each receive an annuity during their lives which increases as the number of subscribers is diminished by death, till the last survivor enjoys the whole income. The term is also applied to the share or rights of each survivor. A gold tumbler cup made by Pierre Harache in 1702 (Museum of Fine Arts, Boston) has the base engraved with an inscription relative to such a tontine. A number of other tontine pieces survive, amongst them a plain circular waiter of 1782; two other waiters, one of 1737, the other 1817; an inkstand with a central obelisk and a two-handled cup and cover by Parker & Wakelin of about 1770.

Torus
A large half-round convex moulding.

Touchstone
Originally used in the assaying of gold and silver, any hard, black, silicious stone or earthenware may suffice. Josiah Wedgwood supplied them of black basalt ware during the 18th century. Used in con-junction with sets of twenty-four needles of each of the three different gold varieties and carats found, the streak of gold left by the object and that by the needles, side by side on the stone, could, by an expert, be accurately compared. For silver a similar method was at one time used, but as so much copper may be added to silver without visual effect, this was never satisfactory. In each case the alloy was dissolved by washing with acid before comparing the touch.

The standard work of the 17th century on the subject of metalwork was *A New Touchstone for Gold and Silver* (1679) written by one, W.B. Running through several editions, the frontispiece is engraved with a representation of the interior of a silversmith's workshop.

Toys
A considerable number of toys, as opposed to small-sized objects, are still to be found. It seems that they first made their appearance during the late 16th century (both Louis XIII and XIV of France having toy soldiers in the precious metals), but the manufacture of miniature copies of every-day objects for use by children seems to have commenced in earnest during the mid 17th

century, from which date a very few dolls' houses also survive. English examples are always utensils, seemingly never miniature suites of furniture or stage-coaches; these, when found are usually Dutch.

The earliest 'Toymaker' in England (the word came to have an additional meaning during the 18th century) of whose handiwork we have sur-viving specimens, seems to be George Middleton (or Manjoy) who was working during the reign of Charles II, and pieces from his hand exist hall-marked during the 1680s. Other makers were J. Daniel, J. Steward and, most prolific of all, David Clayton, who entered a mark in 1697 at Goldsmiths' Hall, but most of whose work is of the period 1710–30. For many years his Sterling mark, D C, in Gothic letters, was wrongly ascribed to Augustin Courtauld, having been read inadvertently as a Britannia standard mark. Among the range of toys that he produced were beakers, tankards, candlesticks, tea cups, tea kettles, coffee pots, chocolate pots, salvers and warming pans. How-ever, the most unexpected toy of any produced is probably the whisky still of 1685 by Middleton (Manjoy). Many toy spoons were of course made, but should not be confused with the small spoons usually about $1\frac{1}{2}$ in. (3·9 cm.) long used with snuff boxes. A toy knife box, fitted with knives, forks and spoons, is known of about 1735. Generally, the quality of these toys is high, but there are, of course, poorly made exceptions. By 1750, the fashion for such toys seems to have passed, or perhaps the rising cost of silversmithing dissuaded all but the fondest parents. In all events after this date only a very few toys by such makers as Thomas Heming and Samuel Massey are known. Very uncommon is the set of two tea caddies and a sugar box, each with sliding cover by Ambrose Boxwell, Dublin, *c.* 1770. A fine representative collection is that of the Pennsylvania Museum of Art, Philadelphia.

Bibliography
Commander G.E.P. How, 'Some Early Silver Toys'. *Connoisseur*, vol XCIX, p.197.
J.D. Kernan, 'American Miniature Silver'. *Antiques*, December 1961.
G.B. Hughes, 'Old Silver Toys'. *Country Life*, March 31st, 1950.
Eric Delieb, *Investing in Silver*. Barrie & Rockliff, 1967.

Transposed Hall-mark
See Duty-dodgers; Forgery.

Travelling Canteen
The usual form of the 1680s travelling set was a beaker, generally oval and sometimes engraved (two of gold survive, one hall-marked 1719, in the collection of the Duke of Portland), fitting within a leather-covered case, and enclosing a plug fitted with a double spice box, knife, fork and spoon, napkin hooks, corkscrew and occasionally an apple corer (**684**). The beaker of the travelling canteen can probably be identified as 'a field cup'; very rarely indeed were these made with a cover, although an example supplied to the 2nd Earl of Peterborough, *c.* 1685, still retains one. A rare form of the 'palm beaker' is the rounded, boat-shaped silver-gilt example engraved with the Owl of Savile (the collection of the Duke of Portland), the sides folding over towards the centre. This can be paralleled by an example in red glass from Germany of about 1680 (Victoria and Albert Museum) painted with ribald allusions, some to drinking; it could easily have served as a wine taster. A very similar German example is known.

**674 The Calverley
Toilet Service**
Hall-mark for 1683.
Victoria and Albert Museum.
675 Toilet Service
Maker's mark, WE with a knot of
ribbon above.
Hall-mark for 1683.
Mirror: height $22\frac{1}{4}$ in. (61·6 cm.).
Metropolitan Museum of Art.
Decorated with chinoiserie
ornament.
676 Chap Bowl
Part of the Watkin Williams Wynn
Toilet Service.
Maker's mark of Thomas Heming.
Hall-mark for 1768, London.
677 Mirror
Part of the Watkin Williams Wynn
Toilet Service.
Maker's mark of Thomas Heming.
Hall-mark for 1768, London.
678 Whisk
Part of the Watkin Williams Wynn
Toilet Service.
Maker's mark of Thomas Heming.
Hall-mark for 1768, London.

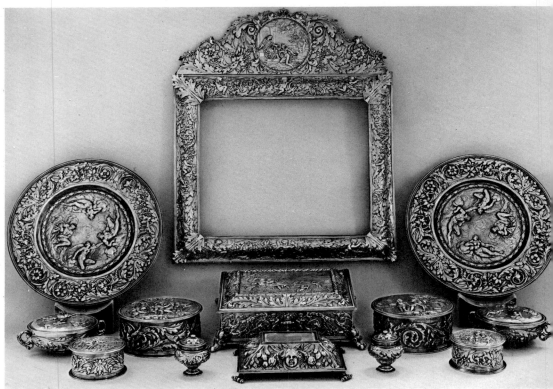

674

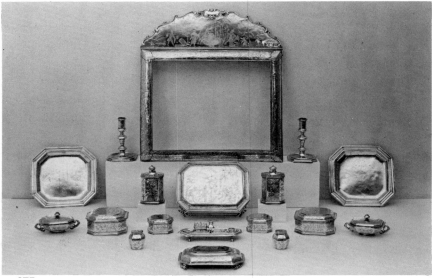

675

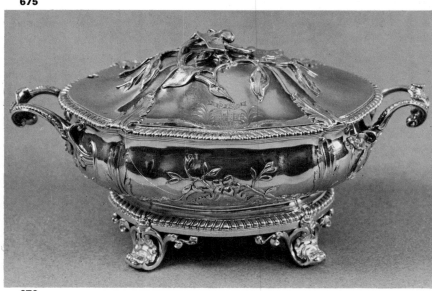

676

677

678

679

679 Mirror
Part of a toilet service.
Maker's mark of Frederick Kandler.
Hall-mark for 1777.
Height 22 in. (55·9 cm.).
Width 17¾ in. (45·1 cm.).
Engraved with the Arms of Augustus
John Hervey, 3rd Earl of Bristol.

680 A Pair of Bottle Holders
Silver-gilt with blue glass scent
bottles. Part of the Watkin
Williams Wynn Toilet Service.
Maker's mark of Thomas Heming.
Hall-mark for 1768, London.

681 Bottle with Hook Finial
Part of the Watkin Williams Wynn
Toilet Service.
Maker's mark of Thomas Heming.
Hall-mark for 1768, London.

682 Part of a Toilet Service
Silver-gilt.
Maker's mark of Daniel Smith &
Robert Sharp.
Hall-mark for 1783.
Large boxes: width 11½ in. (29·2
cm.).

680

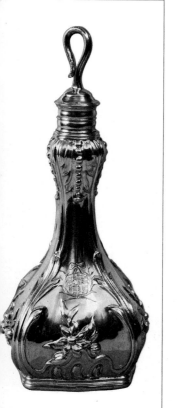

681

682

321

Besides these usual travelling beakers and accessories of the late 17th century, a number of travelling services survive of the last half of the 18th century. These services contain a teapot, sugar basin and cream jug, the one nesting within the other; one such example of 1814 is at Apsley House.

Most splendid of all are the travelling tea and chocolate service, the case engraved 'Her Grace's Service' and the travelling dinner service engraved 'His Grace's Service', both made by John Schofield in 1786–7 for the 4th Duke of Bedford. The latter includes four hash dishes and covers, a heater, a pair of candlesticks, six beakers, salt cellars, a caster, twelve knives, spoons and forks, etc. The need for such services reflects the 18th-century discomforts of travel.

Similar shaving-water equipages, with silver-handled brushes, were also made. Early in the 19th century large travelling toilet sets became fashionable and remained so until the decreasing availability of servants rendered these cumbersome objects—magnificent though they were—obsolete. A particularly early example of 1676, probably the work of Andrew Moore, perhaps a campaign canteen, includes two oval dishes, both a round bowl and an oval bowl, a fiddle-shaped spice box, together with a knife, fork and spoon (**683**). A gold set of knife, fork, spoon, tooth-pick, ear-pick and two other small pieces of *c.* 1680 also survives. Of later date is an American travelling set consisting of a cylindrical bowl, two plates measuring 5¾ in. (14·6 cm.) and 6¼ in. (15·9 cm.) in diameter and a ladle made by Joseph Foster of Boston, *c.* 1790. A set of eight camp cups (six by Joseph Richardson, Senior, of Philadelphia, two by Richard Humphries of Wilmington) of beaker form once belonged to General Nathaniel Green, Second-in-Command to George Washington, and are now in the collection of Phillip Hammerslough. Particularly fine are two pairs of beakers by Aymé Videau, 1743 (**685**) and a most intriguing pair of bombé beakers, maker's mark, P I F, 1818, whose covers prove upon examination to be the undersides of a pair of small chamber or hand candlesticks.

Bibliography
Norman Gask, 'A Gold Charles II Pocket Cutlery Set'. *Apollo*, August 1949.
M.A.Q., 'Traveller's Plate'. *Apollo*, April 1952.
A.G. Grimwade, 'Family Silver of three centuries'. *Apollo*, December 1965.
See also Bartholomew Fair; Beaker; Napkin Holder.

Travelling Cutlery

A combination spoon and fork found in a grave at Scarborough, with a sliding sleeve to hold the hinged stem rigid and with a diamond-point finial, appears to date from about 1350. The majority of surviving examples in which the bowl of the spoon can be slid over the tines of the fork are Continental in origin and of a later date. A combined knife and fork in gold, maker's mark only, EA, was made for Nelson and is now preserved at Lloyd's. An unmarked gold set of *c.* 1680, consisting of knife, spoon and fork, with trefid finials, also survives. Another such set by Whipham & Wright, 1769, made for the Blount family retains its fish skin case, but numbers of these survive in silver and may be more correctly thought of as personal dessert services or perhaps as christening presents.

Bibliography
Norman Gask, 'A Gold Charles II Pocket Cutlery Set'. *Apollo*, August 1949.

Tray

The tray as we know it today is seldom found without handles, and this is the sole difference between it and the oblong salver of Queen Anne's reign (**686**, **687**, **688**, **689**, **690**, **691**, **692** and **693**). A number of pictures of family groups show that salvers were in constant use throughout the 18th century and quite a number of this date survive (**694**). By 1755 the oval salver appears, with handles at either end, usually as a stand for a soup tureen, and from 1775 the tray proper is by no means uncommon, the handles being sometimes incorporated in the gallery border. An interesting American transitional example of 1797 by Paul Revere, which is referred to in his accounts as a 'Silver Waiter', appears to have been given handles almost as an afterthought. Some examples are of relatively thin silver on a wooden base. The growth in the size of the individual pieces of a tea service led to the demand for larger and larger trays (**695**, **696**, **697**, **698**, **699** and **700**). During the 18th century and well into the 19th century, the tea kettle, however, occupied a separate table, though this was not always so with the tea urn. Individual preference with regard to trays for such pieces cannot be over-emphasised, and to attempt any hard and fast classification is foolhardy. It is worth noting that the annual 'douceur' presented by the London Jewish Community to the Lord Mayor from 1679 to 1779 included, on a number of occasions, a two-handled oval or oblong tray, probably loaded with sweetmeats or a purse of £50 or even both (**466**). Of this form is the four-handled, basket-like tray of 1660 at Knole House, Kent. Another such transitional piece is that bearing the Arms of Capel made by Pierre Harache in 1686; one theory is that this was a layette basket. A gold tray by Phillip Rundell, 1821, decorated with many of the Orders of Chivalry is in the Collection of Her Majesty the Queen.

Bibliography
S.C. Dixon, *English decorated Gold and Silver Trays*. Ceramic Book Co., 1964.
See also Basket; Cheese Dish; Pen Tray; Salver; Spoon Tray.

Treen

A descriptive word for something made of tree—or wooden. From early times wooden platters were used as a form of plate, and in the 16th century wooden trenchers were placed within the silver plates to protect them from the cutting edge of the user's knife. Mazer bowls and cups of wood were given silver mounts. Of the former, some of the earliest belong to the Harbledown Hospital, Kent. Of the latter, is a splendid silver-mounted standing cup and cover of *c.* 1620, some 17 in. (43·2 cm.) high (Victoria and Albert Museum). It once belonged to the Mucklow family of Areley Hall, Worcestershire; the present mounts may be of a slightly later date. A wassail bowl with the Royal Arms of James II is also known.

See also Mazer; Plate (ii); Wassail Bowl.

Trefoil

Composed of three leaves, from the French *trois feuilles*. Thus one also has quatrefoil, cinquefoil, etc.

Trembleuse

See Cup, Chocolate; Tea Cup and Stand or Saucer.

Trencher See Plate (ii).

Trowel

The custom of using a silver or gold trowel at the

ceremonial laying of a foundation stone came in being at the beginning of the 19th century, an suitably engraved, they, like keys and spades, w afterwards retained by the user. Some of t earliest known survive at Woburn Abbey. Super engraved with a view of the projected harbo works at Donaghadee (1821), the blade of t trowel used at this ceremony is also signed 'Her Gardner Watchmaker. Belfast. fecit et scripsit'. would thus appear to be the only self-authentica piece of Belfast silver (the handle bears Dub marks).

See also Fish Server.

Troy Weight See Carat; Weight.

Trumpet

Silver for trumpets must generally have been us for the larger variety, for the metal has alwa been said to produce a sweeter note. More ea silver examples, in comparison to base metal on survive, probably as a result of their intrinsic val rather than there having been originally more number. One of the earliest recorded makers such pieces was William Bull; an example of bra with silver garnishes signed and dated by him 1651 survives. One entirely of silver, by the sa maker, dating from about 1665 and including t words 'fecit Londoni' is in the Ashmolean Museu Oxford. An extremely rare pair by Thomas Mon (McCuir) and Robert Brock of Glasgow (*c.* 1670 in the collection of the Marquess of Bute. T London Museum possesses, besides that of 16 cited above, an example signed by Augusti Dudley, 1666. The 'Luck' of Woodsome Hall i silver-mounted brass trumpet, 30¾ in. (78·1 cn long, and signed 'Simon Beale Londini Fecit 166 Beale (1615–82) was State Trumpeter under b Cromwell and Charles II. The Dayrell Horn, loan to the Victoria and Albert Museum, is straightened ox-horn, tipped with silver and dat 1692. A trumpet at St James' Palace is the work William Shaw, 1787, and ten others by this fi are known, besides that by Thomas Heming, 17 amongst the fifteen State trumpets preserved w the Coronation Regalia. Other than these latt one of the latest trumpets is that by Edmu Johnson, 1834, in a private collection. During last hundred years, a number of instruments ha been made in silver, plated examples are even mc common. Silver hunting horns are, surprising not perhaps as common as might be expecte Many of the earlier trumpets were used ceremonia either for State occasions, or in the case of t Queen's College, Oxford (engraved 1666), summon the Fellows to the dining hall. Messrs K of Pall Mall, London, supplied a silver bugle ma by William Tant in 1811 to Major Drummond of t 104th Regiment; it is 14¾ in. (37·5 cm.) long.

Bibliography
Major-General H.D.W. Sitwell, *The Crown Jewe* 1953.
Eric Halfpenny, *Galpin Society Journal*. Vols. x XVI and XX. (Various articles by F.S.A.)
See also Ear Trumpet; Horn; Wassail Horn.

Trunk

A general used term for plate chests in 18th-cent invoices.

Tumbler Cup

One of our earliest records of tumbler cups is th written by Pepys on October 20th, 1664: 'Ther home, by the way of taking two silver tumbl home, which I have bought . . .'. Known also 'Cocking Bowls' in the north-west of Engla

683

683 **The Greville Canteen**
Spoon and fork: maker's mark, IK.
Hall-mark for 1674, London.
Knife: maker's mark of a London
cutler, B with a coronet above.
Bowls and dishes: maker's mark,
probably that of Andrew Moore.
Hall-mark for 1676, London.
Spice box: maker's mark, AM in
monogram.

684 **Prince Charles Edward's
Camp Canteen**
Maker's mark of Ebenezer Oliphant.
Hall-mark for 1740, Edinburgh.
Presented by the Duke of
Cumberland to Viscount Bury, later
the 3rd Earl of Albermarle, after the
battle of Culloden.

685 **Two Pairs of
Oval Beakers**
a. Silver-gilt.
Maker's mark of Aymé Videau.
Hall-mark for 1743.
Height 3¾ in. (9·6 cm.).
b. Silver-gilt, *en suite* with
the larger pair.
Maker's mark of Aymé Videau.
Hall-mark for 1743.
Height 1¾ in. (4·5 cm.).

684

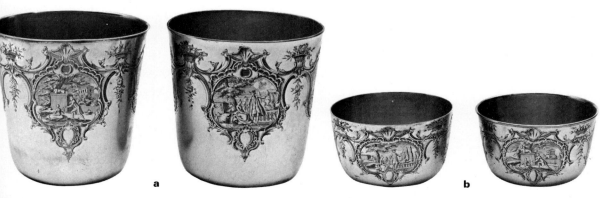

a b

685

686

687

688

689

690

691

Tray

Maker's mark of John Tuite.
[Hall]-mark for 1726.
[Wid]th 16¾ in. (42·6 cm.).
[Eng]raved with the Arms of
[Jac]kson.

The Walpole Salver

[Ma]ker's mark of Paul de Lamerie.
[Hall]-mark for 1728.

Tray

[Silv]er-gilt.
[Ma]ker's mark of Thomas Farrar.
[1]730.
[Wid]th 9¼ in. (23·5 cm.).
[Col]onial Williamsburg, Virginia.
[Eng]raved with the Royal Arms.

689 Tray

Maker's mark of Henry Herbert.
Hall-mark for 1738.
Length 16 in. (40·7 cm.).
Kingston-upon-Thames Corporation.
This tray was made from the Great
Seal of Queen Caroline, wife of
George II.

690 Tray

Maker's mark of John Barbe.
Hall-mark for 1741.
Width 21 in. (53·4 cm.).
Engraved with the Arms of
Cholmley Turner impaling
Marwood.

691 Tray

Maker's mark of John le Sage.
Hall-mark for 1742.
Width 23¾ in. (60·4 cm.).
Engraved with the Royal Arms of
George II.

Plate 45 Toilet Service

Maker's mark of Daniel Garnier,
c. 1680.
There are seventeen silver-gilt
pieces in all.
The mirror is 31¼ in. (79·4 cm.) high.
Ilchester Loan, Birmingham City
Museum and Art Gallery.

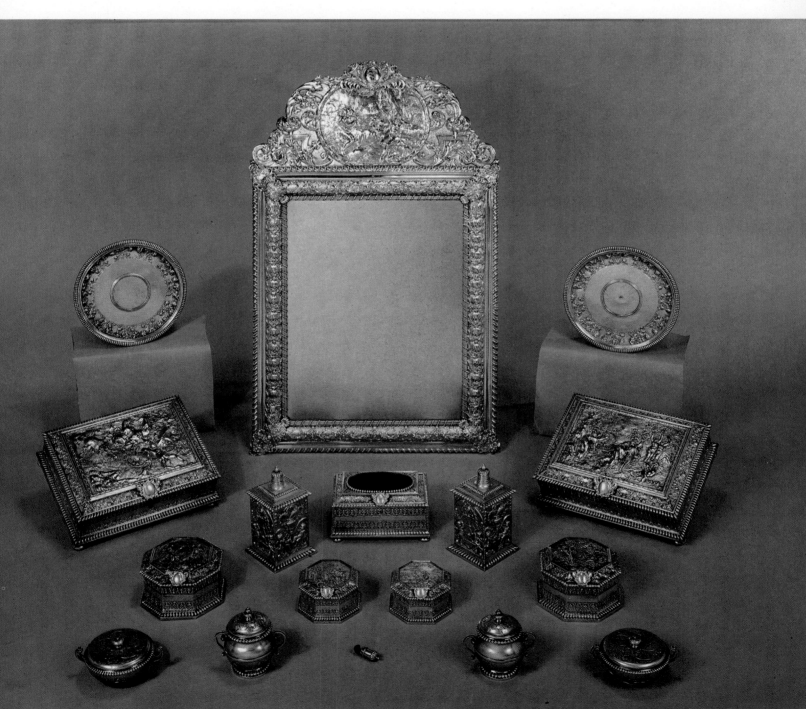

Plate 45

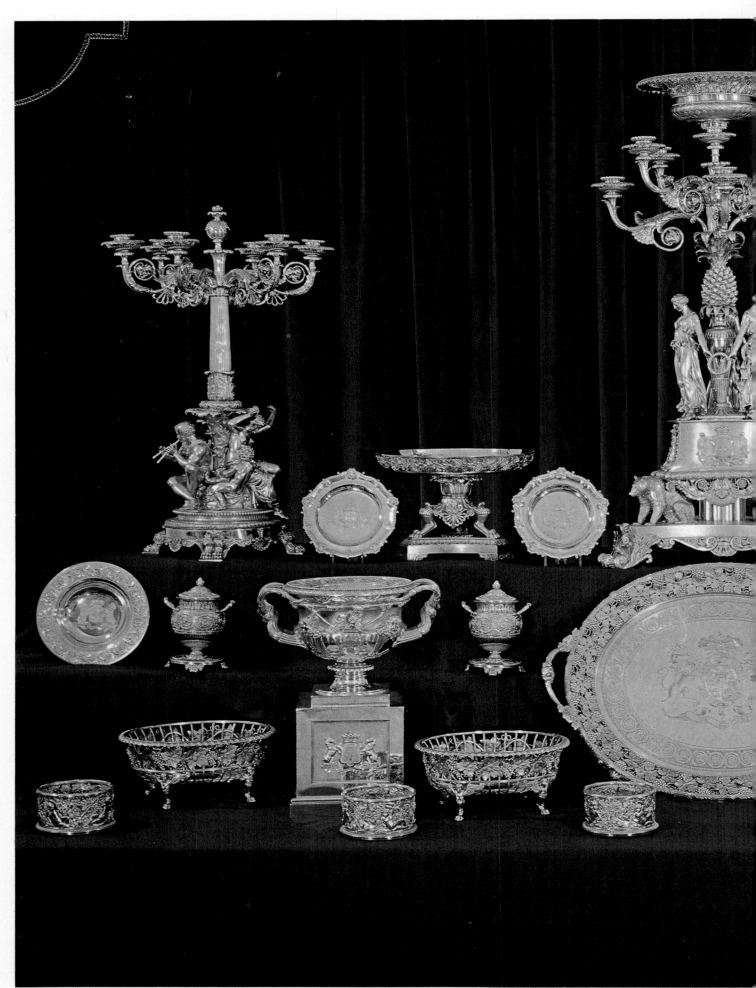

Plate 46

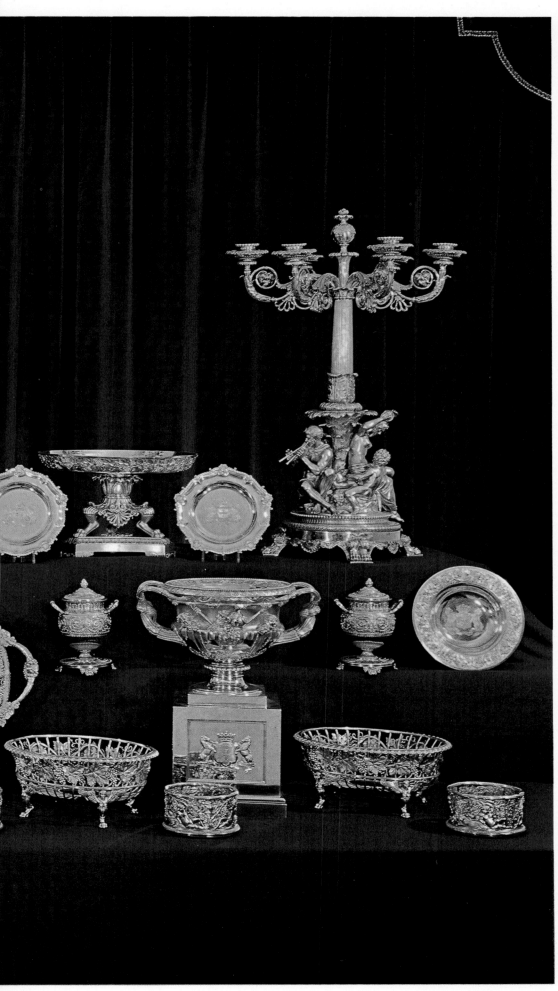

Plate 46 Dinner Service
A group of silver-gilt Regency plate.
Maker's mark of Paul Storr.
Hall-mark for 1812–16.
The two-handled tray was made by
Digby Scott and Benjamin Smith in
1805; it is 23¾ in. (60·4 cm.) wide.

Plate 47 Two-handled Vase
Of parcel-gilt with the maker's mark
of John Bridge.
Hall-mark for 1826.
Height 5¾ in. (14·6 cm.).
It was designed by John Flaxman.
Collection of Her Majesty the Queen.
**Plate 48 A Pair of
Wine Coolers**
Maker's mark of Philip Rollos
c. 1720.
Height 10½ in. (26·7 cm.).
Engraved with the Arms of John,
1st Earl of Bristol.
Ickworth House, Suffolk.
Courtesy of the National Trust.

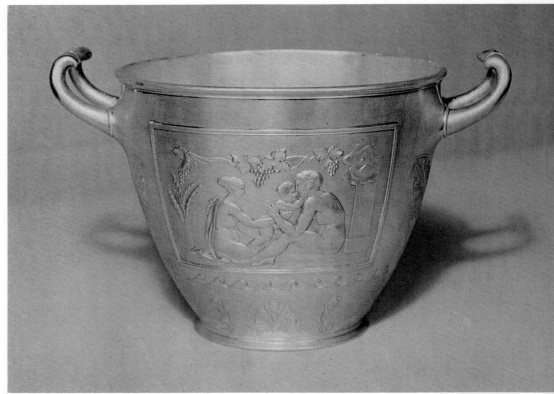

Plate 47

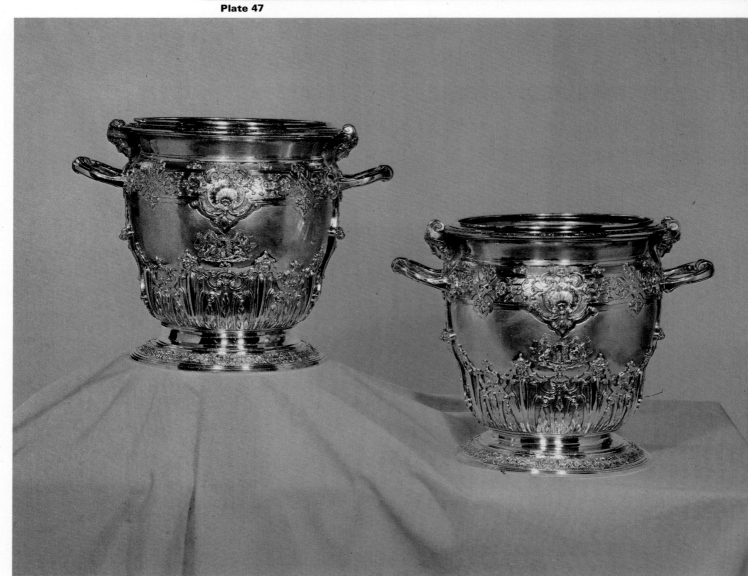

Plate 48

2 Tray
ood backed.
aker's mark of John Carter.
all-mark for 1769.
idth 23 in. (58·5 cm.).
graved with the Arms of
ovelace Bigg.

3 Tray
aker's mark of Richard Rugg or
Rew.
all-mark for 1782.
idth 30½ in. (77·5 cm.).
graved with the Arms of
thschild (c. 1815).

694 Salver and Chandelier
Conversation piece by
William Hogarth (1697–1764),
an oil painting of 1730–40
showing a contemporary salver
and chandelier.

692

693

694

695 Two-handled Tray
Maker's mark of Smith & Hayter.
Hall-mark for 1794.
Width 25 in. (63·5 cm.).

696 Two-handled Tray
Maker's mark of Crouch & Hannan.
Hall-mark for 1802, London.

697 Two-handled Tray
Silver-gilt.
Maker's mark of Joseph Preedy.
c. 1806.
Length 29 in. (73·7 cm.).

698 Two-handled Tray
Maker's mark of James Barber &
William Whitwell.
Hall-mark for 1813, York.
Width 26½ in. (67·3 cm.).

699 Two-handled Tray
Maker's mark of R. Gainsford.
Hall-mark for 1818, Sheffield.
Overall length 29 in. (73·7 cm.).

700 Two-handled Tray
Silver-gilt.
Maker's mark of Phillip Rundell.
Hall-mark for 1822.
Overall length 24½ in. (62·3 cm.).

695

696

697

698

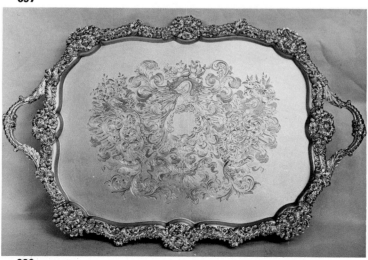

699

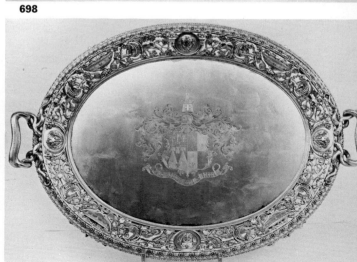

700

here they were given in cockfighting contests as [pri]zes, these can vary hugely in size, but have one [th]ing in common in that tipped to one side they [m]ust 'tumble' back to an upright position. Early [ex]amples tend to be broader than their depth and [wi]th near-vertical rather than flared sides. The [m]ajority are plain or engraved with a coat of arms [or] crest (**703**). Some, however, may be fluted, [fl]atted, engraved with chinoiserie decoration or [ev]en embossed. One early variety, probably copied [fro]m a Continental example, clips over the rim of its [pa]ir to form a dumb-bell-shaped piece (**702**). One [of] the finest is dated 1672 from the collection of [Ea]rl Howe, now in the Munro Collection, Pasadena. [Nes]ts, fitting one within another, are rare, but must [ha]ve existed in some numbers. Such a 'nest' of six [sal]t tumbler cups and cover, maker's mark, RH, [da]ted c. 1685, is at Colonial Williamsburg, Virginia [(7]04). Another nest of six with the maker's mark, [R]H, 1688, also survives. A very late set of five made [by] Emes & Barnard in 1819 is also on record. It is [lik]ely that many travelling and toilet services in[clu]ded at least one. A gold one, valued at £100, [w]as advertised in the *London Gazette* in 1689. John [H]ervey, 1st Earl of Bristol, records in his diary of [16]91, April 22nd, 'I won ye Newmarkett Gold [T]umbler with my horse called Davers, riding him [m]yself at 12 stone weight'. Another was made for [Si]r Richard Hoare in 1726, but the earliest sur[vi]ving, hall-marked, gold one appears to be that by [Pi]erre Harache of 1702 engraved with a tontine [in]scription, now in the Museum of Fine Arts, [B]oston. Others were given by the Grosvenor family [as] race prizes at Chester from the year 1765 until [th]e turn of the 18th century (**705**). The earliest [sil]ver tumbler cups now in existence are probably [th]ose of 1671 at All Souls, Oxford; this College [al]so possesses a number of other early examples. [A]s with ox-eye cups, the Cambridge Colleges, [un]til recently, possessed none. A set of eight [tu]mbler cups made by George Methuen in 1750 [is] in the Manchester City Art Gallery, another set [of] four of 1707 also survives. One of the largest, [3¾] in. (9·6 cm.) high and 4½ in. (11·5 cm.) in [di]ameter, made by John White in 1720 is engraved [V]INE CERERE. FRIGET VENUS. ET BACCHO'.

Bibliography
[Fe]stival Exhibition of Ecclesiastical and Secular
[S]ilver. Chester, 1951.
[G].B. Hughes, *Small Antique Silverware*. Batsford,
[19]57.
[G].B. Hughes, 'Silver Tumblers and Travelling
[S]ets'. *Country Life*, November 10th, 1955.
[S]ee also Bartholomew Fair; Beaker; Cockfighting
[Sp]our; Hawking and Cockfighting; Race Prizes;
[T]ontine.

[T]umbler Cup Frame
[Fo]rmed as a multi-branched tree, each branch with
[a] ring terminal fitted with a glass, whose foot is
[gl]obular and thus cannot stand upright. Perhaps
[un]ique in silver, a known example by Edward
[A]ldridge & Co. of 1760 holds thirty-one tumbler
[gl]asses (**701**). Turned, wooden punch bowls are
[al]so known having a series of upright balusters
[ro]und the base upon which wood, metal or china
[tu]mbler cups might be placed upside down.
[A]mongst the Preston Corporation Plate is a glass
[tu]mbler cup with silver foot manually adjusted to
[g]rip the knop base, given to the town about 1708.

[T]un, Trinity Hall, Cambridge
[Pl]ain silver beakers, owing much, if not all, to the
[in]spiration afforded by the 'Founder's Cup' of
[ea]rly 14th-century date. This Cambridge College is
[n]ow possessed of a considerable number dating

from 1690; always referred to as 'Tuns' in inventories of the College Plate. On the other hand at Magdalen College, Oxford, the word 'tun' is used to describe ox-eye cups.

Tureen, Sauce See Sauce Boat and Tureen.

Tureen, Soup See Soup Tureen.

Urn, Memorial See Memorial Urn and Casket.

Urn, Tea See Tea (or Coffee) Urn.

Van der Spiegel, Jacobus (1668–1708)
The maker of a number of outstanding pieces of Colonial silver, especially with regard to the engraving and decoration of the object. He worked in New York. A tankard in the Garvan Collection (Colour Plate **11**), is perhaps his finest product to survive, and remarkable is the fine, rare, 'lighthouse' caster in the Goelet Collection. But the most intriguing is the strange little caster on three scroll and pad feet which one is tempted to call a 'kitchen pepper', the property of the North Carolina Department of Archives and History.

Van Vianen, Christian (1598–1666 or later)
Born in Utrecht in the Netherlands in 1598, the eldest son of Adam Van Vianen, and nephew of Paul Van Vianen, who worked at the Court of the Emperor Rudolph II. In the early days of his career Christian followed in his father's footsteps, but his particular claim to fame is his use of the so-called 'auricular' or 'cartilaginous' style. Christian became a master goldsmith in 1628. In 1650 he published his father's book of designs, the latter having died in 1627. Summoned to England, probably by King Charles I, he was ordered a Royal Pension in April 1630, but returned to Utrecht in 1631. (Pieces bearing the Utrecht hall-marks of this date survive.) He was back in England in late 1633 and the expense of his move to London, together with the sum of £50 for a single candlestick, were ordered to be paid him on March 5th, 1633. The candlestick entered the King's Cabinet of Curios. In 1634 he was ordered an advance of £600 towards the cost of the new plate for the Chapel of the Knights of the Order of the Garter, St George's, Windsor. This was not finally delivered until July 1637. Another payment was made to him on June 29th, 1636, which included £156 for a ewer and basin weighing 313 ounces, the bullion alone costing 5s 6d an ounce, the remainder of the sum being for 'fashion'. Surviving pieces of his work are excessively rare, probably being amongst the first victims of the financial crisis into which the King was plunged by the Civil War. The two-handled bowl and cover with an associated salver made for the 10th Earl of Northumberland are remarkable as still being in the possession of the same family. His work in England seems to have been exempted from assay at the Goldsmiths' Hall, and when found usually bears his signature in full. The dolphin-bordered basin in the Victoria and Albert Museum is engraved 'C.V. Vianen fecit 1635'. The seventeen pieces of the Windsor Altar Plate all decorated with High Anglican scenes were soon melted, but Walpole records the survival of a number of other pieces into the 18th century. Vertue also mentions two portrait medallions (included in the sale of Benjamin West's possessions in 1773). On May 12th, 1637, his wife and family returned to Holland, but Christian was still in England in December 1640. He finally settled in Utrecht once again in 1647. The influence of his style survived him in England. The Evelyn Cup and a small gold cup,

both unmarked (both at the Museum of Fine Arts, Boston) and a pair of jugs now in the Rijksmuseum, Amsterdam, together with a two-handled cup and cover of 1668 (Jackson Collection, National Museum of Wales) are evidence of this, as also the fine gilt covered bowl by the hound sejant maker at Chatsworth, Derbyshire.

Bibliography
R.W. Lightbown, 'Christian van Vianen at the Court of Charles I'. *Apollo*, June 1968.

Vase
The Restoration period has been sometimes called 'The Age of Silver', for silver was used during this period for almost any purpose that might possibly be imagined. Even public houses possessed considerable quantities of silver. Symbols of this growing wealth were evident in the furniture and garnitures of vases (**707**), 'jars' as they were also known. Also included in a garniture were bowls, bottles (**706**) and ginger jars, their form inspired by Chinese porcelain or Dutch pottery originals. These relied on their form and size, 15 in. (38·1 cm.) to 18 in. (45·8 cm.) high, and the superbly embossed acanthus and mask decoration for their effect. A garniture would consist of at least two vases of beaker form, occasionally with covers, and one covered bombé vase (ginger jar), but any number might be added. Excellent examples may be seen at Knole, where there is also a bowl *en suite* (perhaps for pot-pourri), and another at the Victoria and Albert Museum (1675). Others remain in private houses, often with the families for whom they were first made. They are frequently only imperfectly marked and a number of poor imitations or even forgeries were made in the 19th century. The type lingers on towards the end of the 1680s, so that examples with chinoiserie decoration are also found. A pair of vases and a pair of covered jars so decorated (1688 and 1685), of unashamedly Oriental form, are amongst the collection of the Duke of Rutland. Vases next appear in the form of an immense pair, 36 in. (91·5 cm.) high, of the Classical form, made by Andrew Fogelberg in 1770, now in the Hermitage, Leningrad. The Warwick Vase, when copied in silver, was generally intended for the dual use of decoration or as a wine cooler, a purpose for which the Carolean examples could never have been used, nor the 'Portland Vases' illustrated on Plate **708**. Finally, mention should be made of the pair of great vases and covers, having a maker's mark only of about 1665, in the collection of the Duke of Portland, which, 17½ in. (44·5 cm.) high and of considerable weight, are wholly French in inspiration though of English manufacture. Colour Plate **47** illustrates a two-handled vase made by John Bridge from the designs of John Flaxman, R.A., in 1826 (Collection of Her Majesty the Queen).

Bibliography
N.M. Penzer, 'English Plate at the Hermitage', part II. *Connoisseur*, February 1959.
N.M. Penzer, 'The Plate at Knole', part I. *Connoisseur*, March 1961.
N.M. Penzer, 'The Warwick Vase', parts I and II. *Apollo*, December 1955 and January 1956.
See also Altar Vase; Furniture; Ginger Jar; Sugar Vase.

Vegetable Dish
Generally an entrée dish did duty as such, but a few shallow, circular, two-handled dishes and covers, sometimes with spirit heaters and stands, may be allowed to have been used at times for vegetables. A particularly interesting example, once the

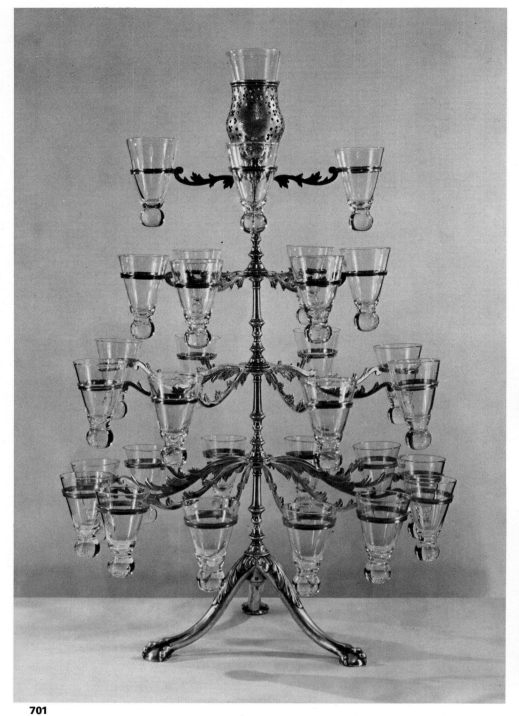

701

701 Tumbler Cup Frame
With thirty-one glass cups.
Maker's mark of Edward Aldridge
& Co.
Hall-mark for 1760.
Height 23 in. (58·5 cm.).

702 Tumbler Cup
Maker's mark, D G.
Hall-mark for 1683.
Height 3 in. (7·7 cm.).

703 Tumbler Cup
Maker's mark of John Luke.
Hall-mark for 1694, Glasgow.
Height 2½ in. (6·4 cm.).

**704 Nest of Six Tumbler Cups
and Cover**
Silver-gilt.
Maker's mark, R H.
c. 1680.
Tumblers: diam. 2⅞ to 3⅛ in.
(7·3 to 8·0 cm.).
Colonial Williamsburg, Virginia.

705 The Chester Gold Cup
Hall-mark for 1792, London.

702

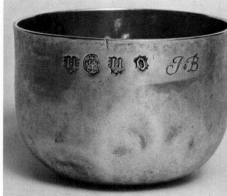

703

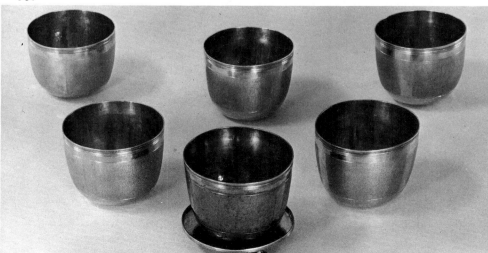

704

705

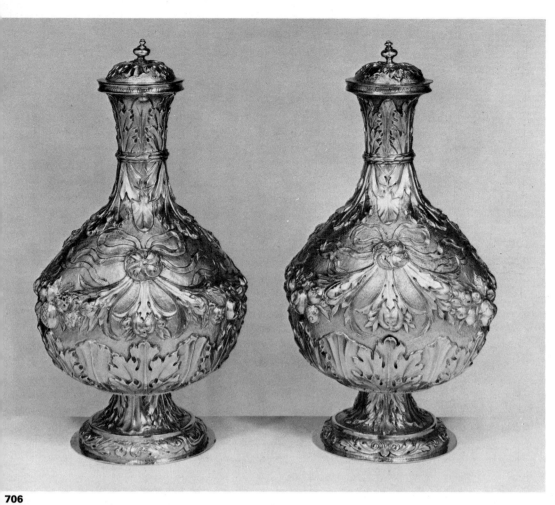

706

706 A Pair of Vases and Covers
Silver-gilt.
Maker's mark, probably for Thomas Issod.
c. 1670.
Height 13¼ in. (33·7 cm.).

707 Set of Vases
Silver-gilt.
Tallest vase: unmarked, *c.* 1670.
Height 18¾ in. (47·7 cm.).
Pair of vases: maker's mark, TI, probably the mark of Thomas Issod.
c. 1670.
Height 17¾ in. (45·1 cm.).

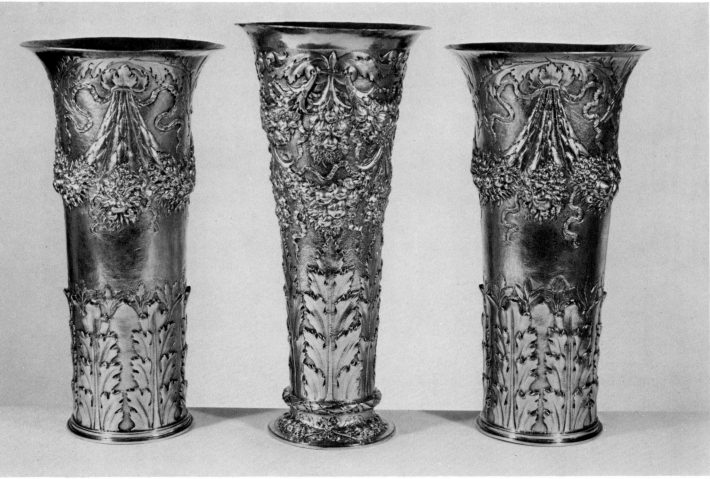

707

property of the late Sir Winston Churchill, made by J. Wakelin & R. Garrard in 1793, would otherwise be called a 'casserole dish', were it not fitted with a detachable divider, held vertical by a wire rim of the same diameter, 9 in. (22·9 cm.), as the inside of the dish.
See also Casserole; Entrée Dish and Stand.

Venison Dish
Perhaps out of a desire to be different, or perhaps stemming from a real need, the venison dish is the brain-child of the early 19th century. Oval, 18 in. (45·8 cm.) to 20 in. (50·8 cm.) wide, often on two stud feet, the underside of the gravy reservoir forming the third, and with raised fluted base, this was made as often in silver as Sheffield plate and frequently with a built-in hot-water compartment (**232** top).

Vermeil
The French term for silver-gilt.

Verrière
A bowl, often with mask and ring handle at either end, filled with ice or water to cool the bowls of inverted glasses. This word was applied to both the monteith and the rare, tapering, cylindrical wine glass coolers—more often made in glass—of a much later date. There are at Windsor a number of these later examples described by Rundell Bridge & Co. in 1832 as 'Verriers' and made by Digby Scott & Benjamin Smith in 1805.

During the late 18th century, an oval two-handled bowl, similar to a jardinière, but with scalloped rim, made its appearance, probably copied from a porcelain original. A still-life by Madame Vallayer-Coster, dated 1787, shows such a verrière with waved rim from which project the stems and feet of glasses. Such bowls were generally supplied in pairs, as those by Henry Greenaway in 1774, now in private hands.
See also Monteith.

Vinaigrette (Vinegarette)
A container only rarely of gold (**528a**), varying in length from half an inch to four or five inches, generally of box, locket, purse, nut, fish, shell or animal form, it is designed to hold a small piece of 'turkey' sponge soaked in some aromatic substance, this concealed by a variously pierced and gilded inner lid or grill. Such pieces were worn either as pendants or carried in the manner of a snuff box and though earlier examples are known, the vast majority, usually of Birmingham manufacture, date from 1775 to the end of the 19th century. They directly derive from the vinegar stick and pomander of an earlier date, all of which were used as an antidote to numerous unpleasant smells. As with snuff boxes of the early 19th century, great numbers were decorated with topographical scenes, the rarest being perhaps Lichfield Cathedral.
Bibliography
E. Ellenbogen, *English Vinaigrettes*. Golden Head Press, 1956.
L.J. Middleton, 'The Vinaigrette'. *Connoisseur*, vol. xc, p. 308.
G.B. Hughes, 'Pomanders and Vinaigrettes'. *Country Life*, December 1949.
G.B. Hughes, 'Silver Vinaigrettes'. *Country Life*, October 12th, 1961.
See also Pomander; Pouncet Box.

Vinegar Stick
Possibly more correctly called a 'physician's cane', these 17th-century sticks have a pierced box forming the head, which could be used to contain an aromatic substance in order to improve the atmosphere, if not the patient!
Bibliography
Sir C.J. Jackson, *An Illustrated History of English Plate*. Vol. II, p. 919. 1911.
See also Cane and Staff.

Voider
A receptacle into which something is voided or emptied, particularly in relation to the clearing of a table. A quotation of 1620 reads: 'I sent my old silver voider . . . to be exchanged for a new'. The Drapers' Company possesses a circular dish, 23 in. (58·5 cm.) in diameter, of 1658, made to replace that given by Sir Edward Barkham in about 1634.

Voiding Knife
One only in silver, though there are a few of steel, seems to have survived. Like the voider of 1658, it is a replacement of that given in 1634, though in this case not made until 1678 (**709**). Originally the form may have been intended as a serving knife or a presentoire.

Volunteer (1777–92), Militia (1792–1811) and Yeomanry (1796–1815) Medals
Usually oval or circular, these date from the last quarter of the 18th century. Occasionally found in gold they are generally engraved with the name of the recipient together with that of the regiment or association. Unlike cross-belt plates they usually have a suspension ring. There is a fine collection of Irish examples in the National Museum of Ireland, Dublin.
See also Badges; Medal.

Volute
A scroll, especially that used in an Ionic capital.

Wafer
In the context of this book it has one of two meanings. A thin disc of unleavened bread for use at the Eucharist in the Roman Catholic Church, or a small disc of flour mixed with gum or gelatine used for sealing letters or receiving the impression of a seal.

Wafer Box
A box or compartment in an inkstand or standish to hold wafers.
See Inkstand.

Wafer Press
A rare object formed as a pair of pincers. When pressed together between finger and thumb, the ends of the arms, with ribbed plates, give an impression to the wafer before using it to seal a letter, or even in the act of sealing it.

Wager Cup See Cup, Wager; Puzzle Cup.

Waiter See Salver.

Wakelin Ledgers See Garrard Ledgers.

Wall Light See Sconce.

Warming Pan
A number survive in brass, some with turned, wooden, baluster handles and some with steel. On January 1st, 1669 Pepys records his being given by Captain Beckford 'a noble silver warming pan'. At least three in silver still exist, the earliest known was made by Charles Petit in 1661, closely followed by one of 1662, bearing the Arms of the Long family

and once in the Farrer Collection. The pierced co[ver] of that by Seth Lofthouse, 1715 (**710**), is 11 [in.] (28·0 cm.) in diameter, now engraved with [the] initials and crown of Queen Charlotte (wife [of] George III) but an inscription beneath the b[ase] records its having belonged originally to Caroli[ne] Queen of George I (in the Collection of [Her] Majesty the Queen). Henry Howard was posse[ssed] of one in 1614 and in the following year the Du[ke] of Lennox was robbed of one worth £5, while [Nell] Gwynn was known to own one in 1674.
Bibliography
C.R. Beard, 'English Warming Pans of the 1[7th] Century'. *Connoisseur*, vol. xci, p. 4.
G.B. Hughes, 'Silver Warming Pans'. *Country L[ife]*, August 6th, 1953.
E.A. Jones, *Old Plate of William Francis Far[rer]*, 1924.

Warwick Cruet
This seems to be a 'trade-name' of the 19th centu[ry] having originated when the belief was curr[ent] that the earliest cruet frame was that in the poss[es]sion of the Earl of Warwick. This particular cr[uet] made by Anthony Nelme in 1715, has five si[lver] casters, whereas the name itself is applied [in]discriminately to all cruets having three cast[ers] and two oil and vinegar bottles. Earlier examp[les] usually Irish, are known.
See also Cruet.

Warwick Vase
'I built a noble greenhouse and filled it with bea[uti]ful plants. I placed in it a Vase, considered as [the] finest remains of Grecian Art extant for size [and] beauty', so wrote George Greville, Earl of Warw[ick]. This vase was discovered in fragments on [the] draining of a pool in the grounds of Hadrian's V[illa] by Gavin Hamilton in 1770, and was repaired [and] considerably restored by his partner, Nollekens [at] a cost of £300 for Sir William Hamilton (17[30–] 1803). The latter, failing to sell it to the Bri[tish] Museum, then succeeded in persuading [his] nephew, the Earl of Warwick, to purchase it and [in] 1744 it had been set up in the grounds at Warw[ick]. An attempt in 1813 to make a full-scale copy [in] silver for Lord Lonsdale (at a cost of betwe[en] £30,000 and £35,000) fell through, but two bro[nze] copies were made in Paris from the moulds [of] William Theed) in 1821–2, one of which is no[w at] Windsor. Reduced copies in silver and bron[ze,] the former by Paul Storr, were made from 18[20] onwards, probably based on the 1778 engravi[ngs] of Piranesi; the form was found eminently suita[ble] for wine coolers.
Bibliography
N.M. Penzer, 'The Warwick Vase', parts I, II, [III,] *Connoisseur*, December 1955, January, March 19[56].

Wash Ball Box See Soap Box.

Wassail (Wacceyl)
From the Old Danish *Waas Hael* meaning to [be] whole or be well—a toast.

Wassail Bowl
Traditionally used only of a turned, wooden (tre[en]) bowl, sometimes with silver mounts, there see[ms] no reason why a punch bowl of any material sho[uld] not be so called. A fine example bears only [the] maker's mark, IR, on the silver mount, but [is] engraved with the Royal Arms of James II. T[he] 'print' in the interior is a Tudor rose.
Bibliography
C.R. Beard, 'A Royal Wassail Bowl'. *Connoisse[ur]*, vol. c, p. 316.

ssail Horn

Founder's Horn of the Queen's College, Oxford,
ed c. 1340, is engraved round its gilt lip mounts
on one of the other encircling bands with the
rd 'WACCEYL' thrice repeated; the later cover
imilarly engraved.
also Horn.

tch See Clock and Watch.

tch Loop

the suspension of a fob watch from a button-
e, formed as two recurved metal loops, one
htly smaller than the other and both at right
les to a button-like finial. They generally date
n the second quarter of the 19th century.

ter Leaf

tylised motif taken from a large, broad, un-
ed, tapering or rounded leaf. A motif much
d on plate during the years 1770–1830.

ter Pot

o splendid pairs of silver-gilt covered jugs in
Kremlin (1604 and 1615) are the only examples
wn to survive. The earlier pair was sold to John
on in 1626 from the Royal Plate, as part of
011 ounces realised in order to provide Charles I
n ready money; they are 23¾ in. (60·4 cm.) high.
a type they are otherwise unknown, even in
entories of the larger houses. German examples,
haps the source of inspiration for these, are
wn, including some in the Kremlin, Moscow.
liography
. Oman, *The English Silver in the Kremlin*. 1961.
asures in the Kremlin. Hamlyn, London, 1964.

x-jack See Taper Stand.

dge (for Dishes)

ver dish wedges are found from the mid 18th
tury onwards. They were designed to tilt the
t of a dish as an aid to gathering the liquid,
rein contained, to one side. Sometimes found
h ring handles, stepped ridges, and studded or
ated borders. An example is illustrated by David
re in his book *Hester Bateman*.

ight

e Tower pound (or Saxon moneyers' pound) of
00 grains Troy was abolished in 1527 and
laced by the slightly heavier Troy pound which
already been in use for more than a century.
e mark of 3,600 grains, was the equivalent of
-thirds of a Tower pound. The Troy pound was
lished by the Weights and Measures Act of
'8, except for weighing precious metals and
nes, and its place was taken by the older
irdupois pound for ordinary commercial use. A
imal subdivision of the ounce is legal, but in
ctice goods are weighed only in ounces and
nyweights, however heavy they may be.

les of Weight
ver Weight
=1½ marks=20s=240 dwt=5,400 grains Troy
1 mark=13⅓s=160 dwt=3,600 grains Troy
1s= 12 dwt= 270 grains Troy
1 dwt= 22½ grains Troy
y Weight
=12 oz=240 dwt=5,760 grains Troy
1 oz= 20 dwt= 480 grains Troy
1 dwt= 24 grains Troy
irdupois Weight
=16 oz=256 drams=7,000 grains Troy
1 oz= 16 drams=437·5 grains Troy
1 dram = 27·3 grains Troy

Carat Weight for Gold
1 oz Troy=24 carats (gold)=96 carat grains
1 carat (gold)= 4 carat grains

The Conversion of Troy Weight to Grammes
1 dwt Troy = 1·555 grammes
5 dwt (¼ oz) Troy= 7·775 grammes
10 dwt (½ oz) Troy= 15·551 grammes
15 dwt (¾ oz) Troy= 23·327 grammes
20 dwt (1 oz) Troy= 31·103 grammes
2 oz Troy = 62·207 grammes
3 oz Troy = 93·310 grammes
4 oz Troy =124·414 grammes
5 oz Troy =155·517 grammes
6 oz Troy =186·621 grammes
7 oz Troy =217·724 grammes
8 oz Troy =248·828 grammes
9 oz Troy =279·931 grammes
10 oz Troy =311·035 grammes
11 oz Troy =324·138 grammes
12 oz (1 lb) Troy =373·242 grammes
lb=pound; oz=ounce; dwt=pennyweight;
s=shilling.

Wellington Shield
Made by Benjamin Smith for Green, Ward & Green,
c. 1822, after a design by Thomas Stothard, R.A.
(1755–1834) which was executed in 1814. The
Shield was presented to the 1st Duke of Welling-
ton by the merchants and bankers of the City of
London.

Whalebone Handle
Punch or toddy ladles, especially from 1740
onwards, frequently have whalebone handles.
Previous to this date they were of wood, and
earlier still of silver. To give these whalebone
handles strength, as well as pliability, they were
made of twisted section, generally with a silver
ferrule.

Whisk
A pair of these, the silver handles of tapering,
conical form, are found with most toilet services of
the 17th and early 18th centuries. The bristles may
be of any length.
See also Toilet Service.

Whistle Tankard
The fact that the 'blow-hole' in the base of the
handle of a tankard, or a communion flagon, may
have perhaps been made to act also as a whistle,
merely proves, in the author's opinion, that the
silversmith made a virtue of the necessity he was
under, to allow for the escape of superheated air
when soldering the handle to the body of a piece.
Bibliography
Country Life, p.786, April 2nd, 1964.

Wickes, George
A silversmith who was appointed (that is, he was
licensed to advertise that he 'made for') to
Frederick, Prince of Wales (eldest son of George
II). His importance to such a book as this, is the
survival of many of his ledgers and accounts
(Victoria and Albert Museum Library, Case 72)
and those of the several firms who continued his
business, not to mention a vast quantity of fine
plate of which they were the makers.
See also Garrard Ledgers.

Wig Hook
An aid to the dressing of the hair; three were
supplied by George Wickes to Mrs Mann in 1742
for 4s 6d. So far none have been identified with
any certainty.

Wig Powderer
Formed as a tapering cylinder, from the cover of
which rises a tube with a mouth of spherical form,
these are rare, usually of about 1800 in date and
undecorated. There is yet extant one earlier piece,
by Thomas Heming, probably from a toilet service;
it is made as a small gilt caster of baluster shape
and was probably intended for use with hair
powder. This may well be the original purpose of
many of the pepper pots now known colloquially
as 'kitchen' or 'bun peppers'. A silver-gilt mounted
alabaster vase 6½ in. (16·5 cm.) high of c. 1665
may perhaps have fulfilled this function.

Wine (or Water) Cistern
From the late Middle Ages onwards, paintings of
wine cisterns can be seen in use, that is with
bottles placed in them to cool, beside almost any
feasting group. A splendid pottery example in the
manner of Bernard Palissy (c. 1585) with dolphin
mask and drop-ring handle is in the Victoria and
Albert Museum. It can hardly be doubted that they
existed in precious metals besides brass and
copper. However, not until the 1660s (the Rose-
bery Cistern on four dolphin feet is hall-marked
1667) do the large, oval, shallow basins on four
feet with flat everted rim, appear. A Royal Warrant
for a cistern of 1,000 ounces, amongst other
pieces, was issued to 'Mademoiselle Kroualle'
(Louise de Querouaille) on October 8th, 1672.
Though known in all sizes, there was a tendency
to make these pieces ever larger, the handles often
allusive to the owner's crest or armorial sup-
porters. The rim was soon found to be more
suitable than four separate ones (**711** and **712**).
On those occasions when the four-footed arrange-
ment was retained it is generally found to be un-
satisfactory. Such are two of the four cisterns in the
Hermitage, Leningrad (one of 1726 by Lamerie)
and the largest of all, 5½ ft. (167·8 cm.) long,
made by Charles Kandler in 1734, but designed for
Henry Jerningham by George Vertue—electro-
type copies in the Victoria and Albert Museum
and Metropolitan Museum of Art, New York.
The success of the design of another cistern by
Lamerie, 1719 (**714**), may also be questioned. It
is worthy of note that not until the middle of the
18th century were satisfactory feet given to the
wine cistern as opposed to a base originally
designed for larger objects (**715** and **716**). The
later tendency of the bowls to increase in depth
and their being referred to colloquially as 'baths'
from the early 18th century onwards, gives weight
to the theory that, whilst still used as coolers, they
were also used on a side table for rinsing glasses
during the course of a meal. There can be no doubt
that the possession of such a piece, only furniture
and perhaps chandeliers having larger dimensions,
served as a status symbol, in the eyes of the owner
at any rate. Such pieces were still occasionally
made as late as the early 19th century. The sole
recorded Irish example, having handles formed as
swans' heads and necks, is 32½ in. (82·6 cm.) in
overall width and was made by John Hamilton of
Dublin in 1715. As might be expected, the arms on
such an object were often cast and applied in the
same way as the handles, which might also be heral-
dic (**713**). This on occasion proved awkward when
the piece changed hands, which was not so infre-
quent an occurrence. With the cistern was fre-
quently, but not invariably found, a wine fountain
(**712**) though seldom in the case of the small
variety. The weight of these cisterns varies from
several hundred ounces to some 8,000 ounces for
that made by Kandler of 1734, and equally heavy
is that made by John Bridge of 1829 in the

**708 A Pair of
Two-handled Tray Vases**
Silver-gilt.
Maker's mark of Phillip Rundell.
Hall-marks for 1820 and 1823.
Based on the Portland Vase, copies
of which were popular at the time
in Wedgwood jasperware.

709 Voiding Knife
Maker's mark, FG, probably the
mark of Francis Garthorne.
Hall-mark for 1678.
Length 25¾ in. (65·4 cm.).
The Drapers' Company.

710 Warming Pan
Maker's mark of Seth Lofthouse.
Hall-mark for 1715.

711 Wine Cistern
Maker's mark of George Garthorne.
Hall-mark for 1694.
Height 13 in. (33·1 cm.).
The Bank of England.

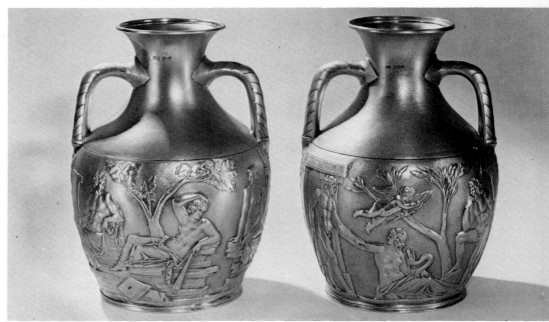

708

709

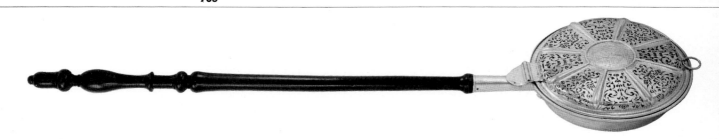

710

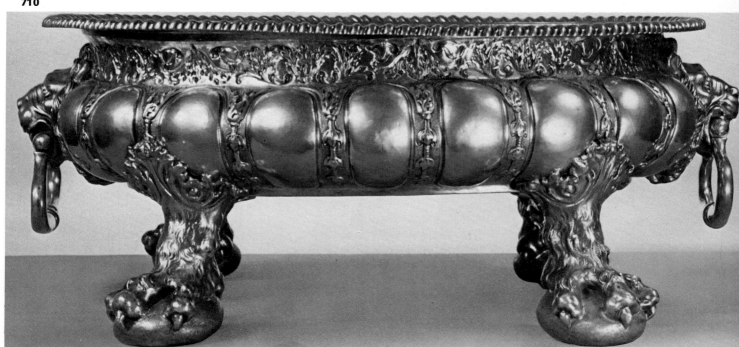

711

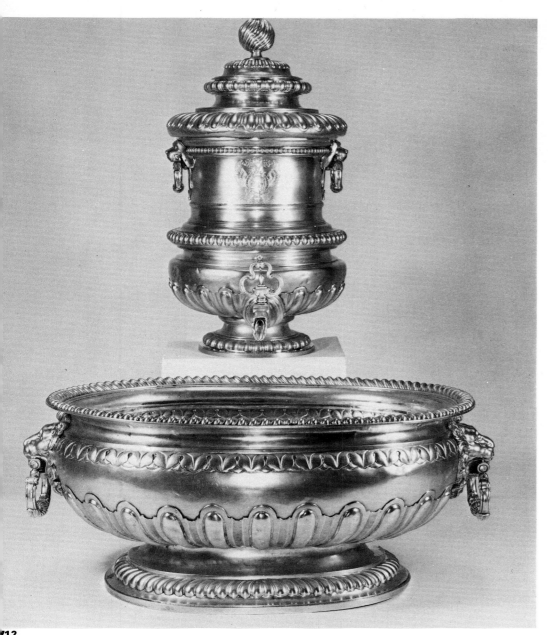

**712 Wine Cistern
and Fountain**
Maker's mark of Pierre Harache,
Junior.
Hall-mark for 1700–1.
Engraved with the Arms of
John Churchill, 1st Duke of
Marlborough.
713 Wine Cistern
Maker's mark of Philip Rollos.
Hall-mark for 1712.
Width 27 in. (68·6 cm.).

712

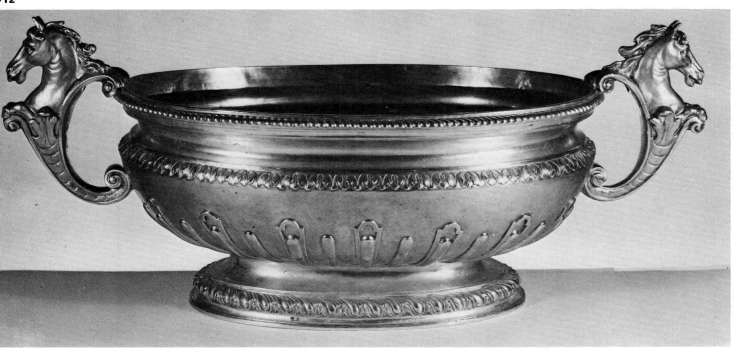

713

714 Wine Cistern
Maker's mark of Paul de Lamerie.
Hall-mark for 1719.
Engraved with the Arms of Gower.
715 Wine Cistern
Maker's mark of Thomas Heming.
Hall-mark for 1770.
Width 54 in. (132·2 cm.).
716 Wine Cistern
Maker's mark of James & Elizabeth
Bland.
Hall-mark for 1794.
Height 26¼ in. (66·7 cm.).
Width 35 in. (88·9 cm.).
Applied with the Arms of Augustus
Frederick, Duke of Sussex, on one
side and the Arms of Packe on the
other.

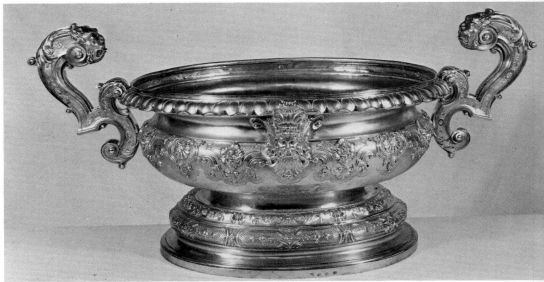

714

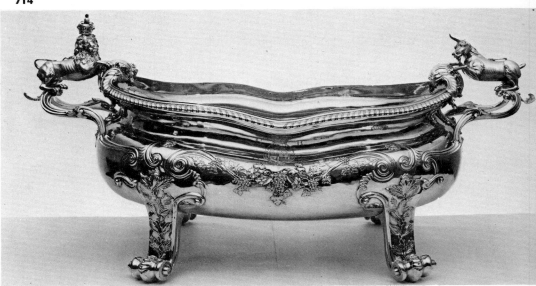

715

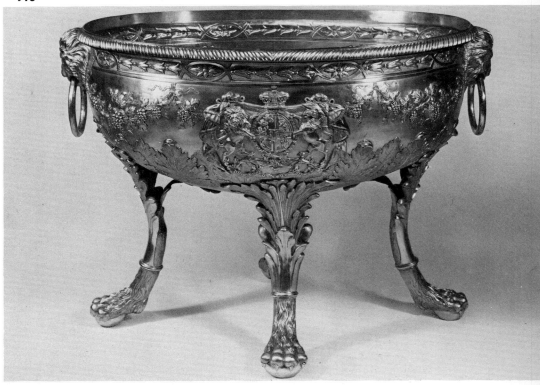

716

ollection of Her Majesty the Queen at Windsor. he latter is gilt, as is that by David Tanqueray at hatsworth, Derbyshire. The following almost rtainly refers to the great cistern made by harles Kandler now in Leningrad—*The Bee* (no. 5, p. 405) May 10th–17th, 1735: 'This Day Mr. rringham is to carry the fine Cistern which he s lately finished for Mr. Menill, into St. James's arden where the Royal Family are to see it. It is id to be the finest Piece of Plate in all Europe, th for Size and Workmanship. Its Weight is 0lb. and its Value reckon'd to be 8000L'. King hn of Portugal ordered an English wine stern, or bath (now vanished) in 1724. A plate t of October 1752 notes 'A large Cistern for ttles' and *The British Journal*, May 4th, 1723 (no. XIII): 'A very fine Silver Cistern, made by Mr. ints, is just finish'd, being the usual Present from s Majesty to the Speaker: It weighs 1790 nces. The former weigh'd 2000 Ounces; but ch inferior to this in the Workmanship'. The st of all is probably that made by Robert Gar- d, 1873, and presented by Her Majesty's vernment to the Secretary of the Arbitration bunal for the Alabama Question; the U.S. vernment also presented silver (Geneva useum).

bliography
M. Penzer, 'English Plate at the Hermitage', rt I. *Connoisseur*, December 1958.
M. Penzer, 'The Royal Wine Cooler'. *Apollo*, vember 1955.
M. Penzer, 'The Jerningham-Kandler Wine- oler', parts I and II. *Apollo*, September and tober 1956.
M. Penzer, 'The Great Wine Coolers', parts I and *Apollo*, August and September 1957. (With a t of surviving 18th-century examples.)
A. Jones, 'One of Paul de Lamerie's chefs euvre in the Winter Palace'. *Connoisseur*, vol. III, p. 53.
e also Bath; Wine Cooler.

ine Coaster

e wine coaster was also known as a 'wine de', 'decanter stand' and 'bottle stand'. Early amples are rare, although the shallow saucer- dishes made by George Garthorne at various tes from 1688 to 1705, amongst the Collection Her Majesty the Queen, may have been in- nded as such. They are 4¾ in. (12·1 cm.) in ameter. Other than these, such objects seem to almost unknown until the 1760s when, with the smissal of servants from a room, the gentlemen emselves were left to handle the bottles and the w-fangled decanters; this seems to have called ch pieces into being (**719**). Lacquered examples th silver mounts are occasionally found, though e majority of coasters have wooden bases with ver sides and an inset plaque for the desired en- aving, if any. During the 1780s these coasters are st frequently made by Robert Hennell. The better ality coaster was supplied with a wholly silver erior (**718** and **720**). The finest, and heaviest, en of openwork with applied vine foliage, are ually the handiwork of Digby Scott & Benjamin ith or Paul Storr (**717**) and date from the ening years of the 19th century. Double asters often of jolly-boat form, are usually of out 1795 in date, those on wheels (wagons) are ghtly later and often more cumbersome (**721**). agons should be fully marked, although it was t difficult to make them from a pair of ordinary, rked coasters, supplying an unmarked chassis! pair of 1793 by John Schofield are of navette rm (Adair Collection). Coasters were usually

supplied in pairs or multiples of two, up to six or eight. Scottish examples are rare, perhaps because for a long while the Scots drank claret with their meals rather than decanted port. Very much in the flamboyant taste of their day (1829) are the pair of gilt wagons by Emes & Barnard stamped 'D. Ellis. London. Fecit. London.', the retailer. Wine tables, of horseshoe form, with a moving slide on a rail and bracket within the semicircle, do not appear to be known with silver fittings. Plated coasters, still with central silver plaques for engraving, are found from about 1790 onwards. Sarah, Duchess of Marlborough, records as in her possession a set of small plates, 5 in. (12·7 cm.) in diameter, which were, in her own hand, 'to give drink at table'. Fitted cases for up to a dozen spirit decanters, sometimes with silver caps also, are known to have survived from the early part of the 18th century though the silver is generally un- marked.

In November 1790, George Washington wrote to Tobias Lear propounding a new idea: 'Enclosed I send you a letter from Mr. Gouvr. Morris with the Bill of cost of the articles he was requested to send me. The prices of the plate ware exceeds, far exceeds the utmost bounds of my calculation . . . As these Coolers are designed for warm weather, and will be, I presume, useless in cold, or in that which the liquors does not require Cooling; quere, would not a stand like that for Castors, with four appertures for as many different kinds of liquors, just sufficient (each apperture) to hold one of the Cut decanters sent by Mr. Morris, be more convenient for passing the Bottles from one to another, than handling each bottle separately; by wch. it often happens that *one* bottle moves, *another* stops, and *all* are in confusion? Two of these, one for each end of the Table, with a flat Bottom with, or without feet, (to prevent tilting), open at the sides, but with a raised Rim as Castors have, and an upright by way of handle in the middle, could not cost a great deal were they made wholly of Silver. Talk to a Silver Smith and know the cost, and whether they could be *immediately* made, if required in a handsome fashion . . . Four dble. flint glasses (such as I expect Mr. Morris has sent) will weigh, I conjecture, 4 lb; the Wine in them when full, will be 8 lb. more; these *added* to the weight of the Coolers, will, I fear, make these latter too unwieldy to pass; especially by Ladies, which induced me to think of a frame in the form of Castors; wch. by being open at bottom wd. save Silver'. It does not appear that these, if indeed they were ever made, have survived, although a sketch for them exists and an advance of $220 to Joseph Cook was in fact proposed.

Bibliography
G.B. Hughes, *Small Antique Silverware*. Batsford, 1957.
E.M. Elville, *Dictionary of Glass*. Country Life, 1961.
G.B. Hughes, 'Old English Wine Coasters'. *Country Life*, May 10th, 1956.
K.C. Buhler, *Mount Vernon Silver*. 1957.
See also Bottle Stand; Jolly Boat.

Wine Cooler (Ice Pail)

About 1700 (the earliest being those of 1698 in the collection of the Duke of Devonshire), the need for a single bottle cooler was felt, probably at first on those rare occasions when the master of a great house was dining alone. These were two-handled and vase-shaped having a detachable collar and liner to hold back the ice and allow the free inser- tion of the bottle. John, 1st Duke of Marlborough, had an unmarked pair of solid gold (**722**), both still survive. Eton College possesses a pair (origin-

ally Speaker Hanmer's) made by Louis Mettayer in 1713; another pair of 1714 by the same maker is illustrated on Plate **723**, whilst a fine octagonal pair of 1716, now in the Untermyer Collection, was once the property of Sir Robert Walpole (**724**); there is a superb pair by Philip Rollos, about 1720, at Ickworth, Suffolk (Colour Plate **48**). Excepting a pair of about 1740 by Crespin (collection of the Duke of Marlborough), there now seems to be a gap until the 1760s, from which date every variation on the vase form was used (**725**) including the rather satisfying reeded or staved bucket (**726**). As is often the case, this gap may represent a change of fashion (a somewhat similar one exists in the case of teapots from 1750 to 1770); the use of porcelain, or the production of wine in jugs rather than in bottle are two possibili- ties. Some of the later examples (**728**), especially those of an otherwise somewhat top-heavy ap- pearance, were supplied with stands (**727**). Wine coolers without handles are uncommon, the body usually being slippery with condensation. Other- wise almost unknown in American silver, one pair of plain, cylindrical form by Shepherd & Boyd of Albany, c. 1820 are in an American private collection. Her Majesty the Queen possesses an extremely rare pair of double wine coolers made in 1805 by Digby Scott & Benjamin Smith for William, 1st Earl of Lonsdale. A plated double cooler, once General Washington's, survives at Mount Vernon; he was also possessed of two four-bottle plated coolers. Enormous numbers were also made, based either exactly or approximately on the Warwick Vase; the finest of these are usually by Digby Scott or Paul Storr, and made for Rundell, Bridge & Run- dell. It is worthy of remark that when the pair of gold wine coolers referred to above, were pre- sented to John Churchill, they seem to have been accepted with no very clear idea of their purpose and are referred to as late as 1712 as 'two very large gold ewers'. Their maker can only be guessed at, but the pair at Chatsworth, referred to above, are by David Willaume.

Bibliography
K.C. Buhler, *Mount Vernon Silver*. 1957.
See also Cup, Two-handled; Theocritus Cup; Warwick Vase.

Wine Cup See Cup, Wine.

Wine Fountain

As with wine cisterns, there were predecessors to those surviving, if medieval examples from the Con- tinent are any criterion. The earliest English fountain, though unmarked, is claimed to be that of about 1660 presented to Charles II by the Corporation of Plymouth and now amongst the Coronation Plate. This is formed as a circular dish, 28½ in. (72·4 cm.) in diameter, having a square, central column, each side having a niche set with marine figures. Oman, however, advances the theory that it is so closely akin to the work of Peter Oehr I of Hamburg as to be more probably German. Certainly the produc- tion of a piece such as this, so soon after the Res- toration, by an English silversmith would have been a remarkable feat. About 1680 the fountain of vase shape or baluster form appears, though a fountain more in name than fact being really a reservoir with a tap to one side (**712**). A splendid pair, entirely French in inspiration, be- longing to the Duke of Portland, each have a drop-ring handle low down on the reverse side to the spout and a scrolling carrying handle above, so that in spite of their being 34 in. (86·4 cm.) high, the maker at least must have considered the possibility of their use as portable objects! Until

718

719

720

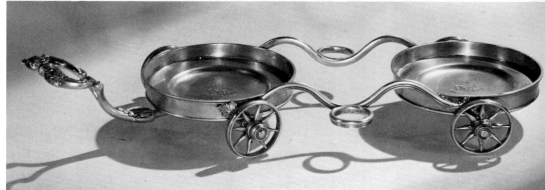

721

717 Wine Coasters
Silver-gilt, two of a set of four.
Maker's mark of Paul Storr.
Hall-mark for 1815.
Diam. 6 in. (15·3 cm.).
Engraved with the Arms of
Lascelles.

718 Set of Four
Wine Coasters
Maker's mark of William Plummer.
Hall-mark for 1792, London.

719 Wine Coasters
Left: maker's mark of William
Plummer.
Hall-mark for 1774.
Right: maker's mark, N L.
Hall-mark for 1768.

720 Wine Coasters
Silver-gilt, two of a set of four.
Maker's mark of Phillip Rundell.
Hall-mark for 1822.

721 Decanter Trolley
Maker's mark of Paul Storr.
Hall-mark for 1836.
Length 16 in. (40·7 cm.).

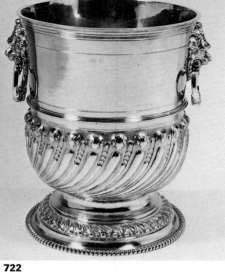

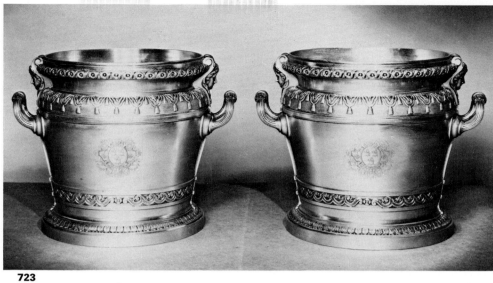

722 **723**

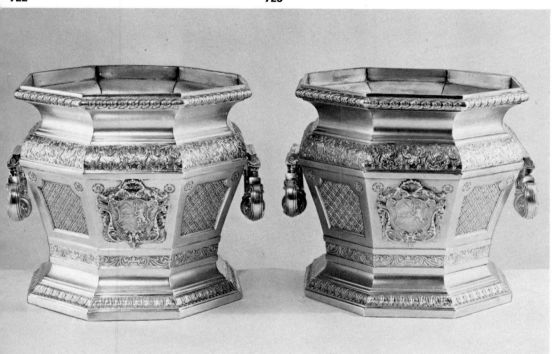

722 **Wine Cooler**
Gold.
Unmarked, *c.* 1700.
Height 10½ in. (26·7 cm.).

723 **A Pair of Wine Coolers**
Maker's mark of Louis Mettayer.
Hall-mark for 1714.
Height 9 in. (22·9 cm.).
Engraved with the Arms of
Methuen.

724 **A Pair of Wine Coolers**
Maker's mark of William Lukin.
Hall-mark for 1716.
Height 8¼ in. (21·0 cm.).
Untermyer Collection.
Applied with the Arms of Walpole.

725 **A Pair of Wine Coolers**
Maker's mark, R G, probably the
mark of Robert Garrard.
Hall-mark for 1788.
Height 9½ in. (24·2 cm.).

724

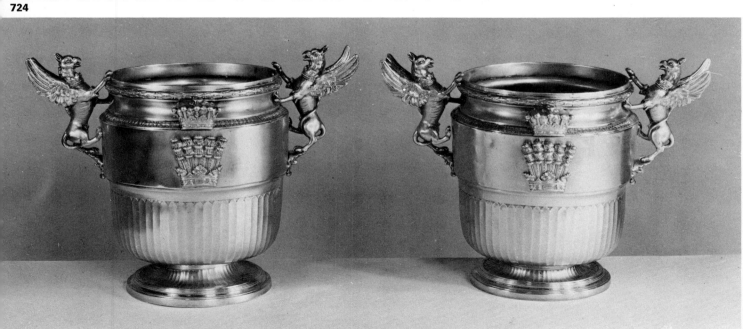

725

1740, when they start to die out, it is unlikely that many were made without a cistern *en suite*, though this is not the case with the latter. They are certainly far outnumbered by the surviving cisterns. These pieces are amongst the largest wrought-silver objects ever made—with the exception of furniture and chandeliers. Not infrequently they seem to have represented the status symbol of their day. Amongst the Marlborough Plate in the collection of Earl Spencer, there survive a wine fountain (1700) and wine cistern (1701) both by Pierre Harache, Junior (**712**). For these the original Jewel Office account has been traced in which they are referred to as 'One large ffountaine' and 'One small cesterne'. Seen together, the former placed above the latter, they balance admirably. Separately the fountain, as is often the case, seems clumsy. The fountain made for the Duke of Newcastle by J. Ward in 1702 displays the baluster form at its best. It stands 24½ in. (62·3 cm.) high and is wholly decorated with fluting, relieved only by two splendid lion mask and drop-ring handles. On the other hand, that made by Peter Archambo in 1728 to the order of that greatest of plate collectors, George Booth, 2nd Earl of Warrington, stands 27 in. (68·6 cm.) high and though of the finest workmanship is both ungainly and vulgar. However, as it has been divorced from the cistern supplied by the same maker in the following year, though in quite a different style, it may originally have appeared only vulgar.

The best of both worlds has been attained by Thomas Farrer who made the wine fountain, now in the Folger Collection, for Archibald, 1st Earl Rosebery, in 1720, although this is even taller, 28 in. (71·2 cm.) high. Probably the largest surviving is that in the collection of the Duke of Brunswick made originally by David Willaume in 1708 for Chamber, 5th Earl of Meath. It stands 42½ in. (108·0 cm.) high. One of the latest specimens is that by Robert Calderwood, made in Dublin in 1754 for the Duke of Leinster.

A peculiar item of this form by Thomas Bolton, Dublin, 1696, is only 15¾ in. (40·1 cm.) high and seems too small, as compared with the remainder, to be intended for use with a wine cistern (**659**). All the foregoing are fitted with one spigot tap, but there exists a group of similar vessels with two, three or even four such taps, similar to the Dutch coffee urns of the mid 18th century. Some, such as that by Thomas Bolton, Dublin, 1702, are quite small—13½ in. (34·3 cm.) high. It has two handles, stands on three 'dog-leg' feet and is wholly decorated with cut-card lambrequins and acanthus foliage (Folger Collection). An American example of later date by Ephraim Brasher of New York, c. 1770, is in the Art Institute of Chicago. Another was made in Edinburgh in 1746, but that by John Cory, 1703, originally having four taps, stands 25½ in. (64·8 cm.) high and this was surely never intended for any hot liquid. Indeed none of these have any provision for heating their contents.

Bibliography
Francis Townshend, 'Silver for Wine in Ireland', part III. *Country Life*, September 21st, 1967.
A.G. Grimwade, 'Silver at Althorp'. *Connoisseur*, October 1962.
C.C. Oman, 'The Civic Gifts of Charles II'. *Apollo*, November 1968.
J.F. Hayward, *Huguenot Silver in England*. Faber & Faber, 1959.
See also Tea (or Coffee) Urn.

Wine Funnel
Used for decanting wine or other liquids, these were almost invariably plain and functional. The earliest recorded appears to be that in the Victoria and Albert Museum of 1661. Few bear more decoration than a reeded or foliage lip. The small ring sometimes found within the collar is for the retention of an additional muslin strainer. An example, some 7 in. (17·8 cm.) long, probably Irish, is engraved 'Invented by Captain Brent Smith, July 1722 and called by him a Protestant and by others a Brent' (*Connoisseur*, vol. XV, p.126). The collection of the Bank of England contains two, both 1694. Strangely, examples of the first half of the 18th century are very rare. Not until 1770 do they appear in quantity, often with associated stands—'to a funnell salver' (Wakelin Ledgers, John Whalley Esq., 1773). The stem is sometimes provided with ribs to allow the air to escape from the container while it is being replenished. These later examples have the tip of the stem turned to one side, this prevents the aeration of the wine while it is being decanted.
See also Stand.

Wine Label or Bottle Ticket
The variety of wines and liquors available in the late 18th century, and the increasing tendency to offer as much choice as possible, may be the explanation of the sudden appearance of bottle tickets in large numbers about 1760, though certainly they are known from as early as 1753 and referred to at Goldsmiths' Hall in 1723. At first cartouche-shaped and flat chased, they tended to become more Classical in form following the taste of the day, until, in the second quarter of the 19th century, a tendency for realism was exploited to the full, when they are cast, chased or hand-raised. From 1784 onwards the label is generally fully hall-marked. Enormous quantities were also made in Battersea enamel and porcelain.

In general, the ticket was suspended round the neck of the bottle or decanter by a chain, but some are found as plain collars to slip over the neck, though seldom much earlier than 1760. Another variety, a plain rectangle, is hinged from a wire ring and appears about 1800. Vine-leaf labels are uncommon prior to 1820. Toilet-water labels are very similar in form and almost every liquid seems at one time or another to have been dignified by a label, even gin, though this latter being a 'low' drink often masquerades under another name. Madeira, port, sherry and claret appear to be the commonest names, the letters at first engraved and later pierced. Bushby and Argostola are among the rarest. A specialist collection of wine labels may be seen in the Ashmolean Museum, Oxford (H.R. Marshall Collection).

Bibliography
N.M. Penzer, *The Book of the Wine Label*. Home and Van Thal, 1948.
John Sturt, 'Dating Silver Wine labels'. *Connoisseur*, May 1952.
G.B. Hughes, *Small Antique Silverware*. Batsford, 1957.
B.W. Robinson, 'Bottle Tickets in the Collection of the Hon. Sir Eric Sachs'. *Connoisseur*, June 1958.
N.M. Penzer, 'Wine labels at Buckingham Palace and Windsor'. *Connoisseur*, June 1962.
Cyril Cook, 'Battersea Wine labels'. *Connoisseur*, December 1952.
'Collection of Wine Labels formed by R.B.C. Ryall'. *Christie, Manson & Woods Sale Catalogue*, June 14th, 1968.

Wine Taster
It seems that no undoubted wine tasters of earlier than 17th-century date have survived in England. One of 1636 remains in its original home in the north of England, but the earliest appears to be that of 1631, in the Jackson Collection, engraved 'John Hine'. Their standard form is a shallow bowl about 4 in. (10·2 cm.) in diameter with raised centre against which the colour of the wine may be viewed (**730**). The temptation to call the small, shallow, two-handled, sweetmeat dishes of the 17th century wine tasters is great but difficult to prove correct. Enormous numbers of these latter were made by William or Thomas Maundy. Certainly wine tasters existed much earlier, appearing in a Norwich tavern inventory of 1383, whilst in 1477 they were expressly exempted from an embargo placed upon the export of plate as 'a taster ou shewer pur vine' if taken abroad by a wine merchant as part of his business equipment. The placing of the hall-marks on an English wine taster indicates the way in which it is to be held, and the central dome is generally proud of the rim thus proving its not being intended for use, reversed as a trencher salt. One of 1646 has an inscription dated 1670 'Michaell Robinson his taster', and a late example by John Langlands, Newcastle, 1757, also survives as does another by Thomas Daniel, 1788, in Britannia standard silver. English examples, as opposed to Continental, are more uncommon. That by Pierre Harache, 1684, is of the Continental form—a shallow bowl with escallop shell handle to one side. It has been engraved at a later date with the Arms of Aylmer. A Canadian example by Paul Lambert is in the Canadian Gallery, Royal Ontario Museum. The wine taster seems to die out at the very end of the 18th century. As quite often seems to happen with rarities, a provincial wine taster of about 1765, made in Cork by Michael McDermott, is known. This is engraved with a typical inscription: 'Edmond Meagher Wine Cooper'. An exception to the general rule is a boat-shaped example with a handle at one end. Hall-marked 1632, some 4 in. (10·2 cm.) long, it is now in a private collection. What is thought to be the earliest surviving piece of American silver is in fact one of the small two-handled bowls referred to above (**729**). If the attribution of the initials it bears to a girl who married in 1651 is correct, it would seem unlikely to be a wine taster. It bears the mark of Hull & Sanderson. The Inventory of the Royal Jewel House of 1649 records three tasters, each of gold, one being 'a golden taster with a lyon in the middle 5 oz. at £3. 6s. 8. £16. 13. 4.'.

Bibliography
G.B. Hughes, 'Silver Wine Tasters'. *Country Life*, June 28th, 1951.
See also Quaich; Travelling Canteen.

Winslow, Edward (1669–1753)
He was, perhaps, apprenticed to Jeremiah Dummer who worked in Boston, Massachusetts. His portrait was painted by John Smibert. Appointed Judge of the Inferior Court of Common Pleas 1743, which place he held until his death. The maker of a considerable quantity of Massachusetts ecclesiastical plate besides numerous secular pieces, such as a sugar box in the Ford Collection, Dearborn, Michigan; another in the Henry du Pont Museum, Winterthur (Colour Plate **4**), and a third in the Garvan Collection, Yale University Art Gallery; spout cups; chafing dishes and a standing salt (one of three known) in the Museum of Fine Arts, Boston; a fluted chocolate pot at Yale and the only known example, in either English or American silver, of a trilobate salver on a central foot in the Art Institute of Chicago. A chocolate pot made by Winslow, c. 1720, is in the Metropolitan Museum of Art (Colour Plate **17**).

726

726 **Wine Cooler**
One of a set of four.
Maker's mark of William Hall.
Hall-mark for 1794.
Height 7¼ in. (18·4 cm.).
Engraved with the Arms of Parker.

727 **Wine Cooler**
Silver-gilt.
Supplied by Rundell, Bridge &
Rundell.

728 **Wine Cooler**
One of a set of four.
Maker's mark of Robert Garrard.
Hall-mark for 1824.
Height 12¼ in. (31·1 cm.).

729 **Wine Taster**
Maker's mark of Hull & Sanderson
of Boston.
c. 1670.
Overall width 3 in. (7·7 cm.).
Yale University Art Gallery,
Mabel Brady Garvan Collection.

730 **Wine Taster**
Hall-mark for 1689.
Victoria and Albert Museum.

727

728

729

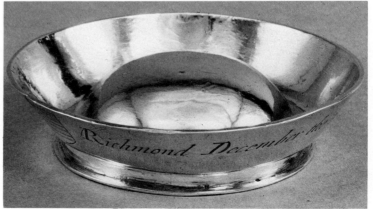

730

Women Silversmiths

With the exception of Ann Tanqueray, Eliza Buteaux-Godfrey, Louisa Courtauld and Hester Bateman, most collectors must be unaware of the large number of other women, who, if they did not necessarily flourish, were apprenticed and later entered a maker's mark at the Goldsmiths' Hall. E.J.G.Smith has tracked down no less than one hundred and sixty makers, starting with Agnes Harding in 1513. These do not include women retailers or another one hundred and forty-two who were apprenticed, but of whom only nineteen appear to have actually completed their apprenticeship yet registered no mark.

There is no doubt that a number of such 'makers' were in fact widows carrying on their late husbands' businesses. That is not to say that they gave to it only their name. Perhaps the earliest of these women silversmiths whose work has survived is Alice Sheen, her mark, registered in 1700, is to be found on the Beadles' Staves made for the Company of St George in 1704. Ann Tanqueray (mark registered 1720), widow of David Tanqueray, was the daughter of David Willaume and had thus been in 'silver-smithing' all her life. Eliza Godfrey was the widow of Benjamin Godfrey, but had previously been married to Abraham Buteaux. Between her marriages, 1731–4(?) and after her second husband's death (1741) she in each case registered a mark and carried on a business so considerable, producing objects of such high quality to suit the taste of the greatest families, that she, rather than Hester Bateman, should be regarded as the pre-eminent woman silversmith of the 18th century. The products of the Bateman family business (first mark registered April 1761) during the second half of the 18th century are almost always adequate and often pretty, but very rarely exceptional and usually do not deserve to carry the premium they do. The range of goods they produced is, however, worthy of remark. The latter may also be said of John Emes' widow, Rebecca, who in 1808 took into partnership her late husband's workshop foreman Edward Barnard.

Bibliography
E.J.G.Smith, 'Woman Silversmiths', parts I and II. *Antique Dealer & Collectors Guide*, May 1969 and September 1969.
David S.Shure, *Hester Bateman*. W.H.Allen, 1959.
See also Bateman, Hester; Courtauld Family.

Wristband

One of many types of simple jewellery intended for presentation by the United States Government to the Indians, in the late 18th century; they were offered as a gesture of peace, as were the Presidential Medals. Such wristbands were of plain silver, some $1\frac{1}{2}$ in. (3·8 cm.) wide, with moulded borders and engraved with the Arms of the United States. Among the English Coronation Regalia are a pair of gold bracelets made about 1661.
See also Gauntlet.

York Assay Office

York, the most important provincial city of the Middle Ages, was the first named of seven towns appointed in 1423 to have touches. There are, however, earlier records of goldsmiths striking such marks in the city, there having been a local touch as early as 1410. In 1560 the 'pounce of this citie, called the halfe leopard head and halfe flowre-de-luyce' is referred to in detail. Besides this mark there was, or ought to have been struck, that of the maker and from about 1560 onwards a date-letter was introduced. Sir Charles Jackson

calls attention to the fact that from 1632 onwards the representation of the demi-leopard head is such as to be doubtful whether it is not intended to be in fact a demi-rose. Differences of this sort can easily arise from the maker of the punch not having been fully instructed as to what he was required to make (or, though unlikely, from an unrecorded yet intentional change). In 1698 the office was closed with other provincial assay offices and re-established in 1701 with the Arms of the York (a cross charged with five lions passant) as the new mark. By 1717 the practice of assaying at York had died out, the remaining goldsmiths sending their wares to Newcastle. The office reopened in 1779 finally closing in 1858 after the discovery of many irregularities. It may be noted that much 19th-century York plate bears no town mark, but can usually be readily distinguished by the square form of the punch containing the crowned leopard's head.

1560 – 1698 1701 – 17

c. 1780 – 7 1787 – 1858

Bibliography
Sir C.J.Jackson, *English Goldsmiths and Their Marks*. 2nd Edition 1921, reprinted 1949.
See also Hull, Kingston upon; Newcastle upon Tyne Assay Office.

York Silver

Little York-made silver has survived from the 16th century, though a spoon of about 1500 is known. By the 17th century, however, such quantities were being produced that even a few secular pieces prior to the Civil War are known, including a number of silver-mounted coconuts. Several generations of the Mangy family made silver in York, and other members of the clan set up in Leeds and, more successfully, in Hull. After the execution of King Charles I (1649), a number of tankards were made in York of a particular form, largely inspired by Scandinavian originals. These, usually the produce of John Plummer or Marmaduke Best, stand upon three ball or pomegranate feet, have a flat, domed cover and, generally, a pomegranate thumbpiece. The latter silversmith was responsible for the gold wine cup (1672) and also the chamber pot of 1670, both amongst the York Corporation Plate. A form of spoon made in York with flattened stem, the finial of disc form on a plane with the remainder, and engraved 'Live to Die. Die to Live' are paralleled only in Scotland and a very rare American example by Robert Sanderson.

After the reopening of the assay office in 1779 most of its employment was upon the work of Messrs Hampston & Prince, later trading under the name of Cattle & Barber.
Catalogue of Rare York Silver, Property of W. Riley Smith. Christie, Manson and Woods, April 22nd, 1953.
See also York Assay Office; Newcastle upon Tyne Silver.

Zegadine See Cup, Ox-eye.

The bibliography is confined to works about English, American and Dominion plate in English, and with only a few exceptions to printed books. Numerous articles, long and short, of varying interest but usually well illustrated, on a wide variety of specialised topics, for example, small collections, individual makers, interesting pieces of plate and the development of particular types, can be found in many periodicals, international and local, and especially in *Antiques, Apollo, Archaeologia, Burlington Magazine, Connoisseur, Country Life,* etc. The bibliography has been divided into the sections seen below.

I PLATE OF THE BRITISH ISLES
General History Studies
Special Topics
Hall-marks
Biographies and Biographical Sources
Metallurgy and Manufacturing Techniques
Catalogues of Public Collections
Picture Books of Public Collections
Catalogues of Private Collections
Catalogues of Corporate Collections
Catalogues of Important Exhibitions
Monographs on Church Plate
Magazines

II PLATE OF THE UNITED STATES OF AMERICA
Historical Studies
Catalogues of Collections and Exhibitions
List of Principal Public Collections

III PLATE OF CANADA

IV VARIA

V DESIGN SOURCES

In each section the books are in an alphabetical arrangement based either on the surnames of authors or owners of collections, or on place-names, but in certain sections the order is chronological. Unless otherwise stated, the place of publication is London.

I PLATE OF THE BRITISH ISLES
General Historical Studies
Judith Banister, *An Introduction to Old English Silver*. Evans Brothers, 1965.
Judith Banister, *English Silver*. Paul Hamlyn, 1969.
Isa Belli Barsali, *Medieval Goldsmith's Work*. Paul Hamlyn, 1969.
R.P.T. Came, *Silver (Pleasures and Treasures)*. Weidenfeld & Nicolson, 1961.
W. Chaffers, *Gilda Aurifabrorum*. (A history of London goldsmiths and plateworkers and their marks stamped on plate, containing a considerable amount of biographical data.) 1863 (1899 Edition).
The Inventory of Jewels and Plate of Queen Elizabeth I—1574. British Museum, 1955.
W.J. Cripps, *Old English plate, ecclesiastical, decorative and domestic: its makers and marks*. 1878.
Stephen Ensko & Wenham, *English Silver 1675–1825*.
I. Finlay, *Scottish Gold and Silver Work*. 1958.

A.G. Grimwade (General Editor), *Faber Monographs on Silver*.
A. Hayden, *Chats on Old Silver*. Ernest Benn Ltd. 1915.
J.F. Hayward, *Huguenot Silver in England, 1688–1727*. Faber & Faber, 1959.
Commander G.E.P. How, *Notes on Antique Silver*. Various publications from 1941–53.
G.B. Hughes, *Small Antique Silverware*. Batsford, 1957.
Sir C.J. Jackson, *An Illustrated History of English Plate, Ecclesiastical and Secular*. Vols. I and II, 1911.
E.A. Jones, *Old Silver of Europe and America*. 1928.
H.P. Okie, *Old Silver and Old Sheffield Plate*. 1952.
C.C. Oman, *English Domestic Silver*. 1934, 4th Edition 1959.
W.S. Prideaux, *Memorials of the Goldsmiths' Company, 1335–1815*. Vols. I and II, 1896–7.
M. Ridgeway, *Chester Silver*. 1969.
R. Rowe, *Adam Silver*. Faber & Faber, 1965.
Gerald Taylor, *Silver*. Penguin Books, 1956.
W.W. Watts, *Old English Silver*. 1924.
E. Wenham, *Old Silver for Modern Settings*. 1950.
P. Wilding, *Silver*. 1950.
S.B. Wyler, *The book of old silver: English, American, Foreign*. New York. 9th Edition.

Special Topics
Caroline Silver
C.C. Oman, *Caroline Silver*. Faber & Faber, 1970.
Channel Islands
Richard H. Mayne, *Old Channel Islands Silver*. 1969.
Drinking Vessels
Douglas Ash, *How to Identify English Silver Drinking Vessels 600–1830*. 1964.
The Nelme Cup. Cambridge University Press, privately printed, 1957.
Judaica
A.G. Grimwade, *Anglo-Jewish Silver*.
Transactions of the Jewish Historical Society of England. Vol. XVIII.
The Michael Zagayski Collection of Rare Judaica. Parke-Bernet Sale Catalogue, March 18th–19th, New York, 1964.
Gold Plate
E.A. Jones, *Old English Gold Plate*. 1907.
Knives and Forks
C.T.P. Bailey, *Knives and Forks*. Medici Society, 1927.
J.F. Hayward, *English Cutlery*. H.M.S.O., 1956.
Prices
J.W. Caldicott, *The Values of old English Silver and Sheffield plate*. 1906. (An invaluable record of past prices, but entirely misleading as a guide to current prices.)
Racing Cups
Sir Walter Gilbey, Bt., *Racing Cups 1559 to 1850*. 1910. (A useful corpus but the text contains numerous inaccuracies.)
Sheffield Plate
F. Bradbury, *History of old Sheffield Plate*. 1912.
H.N. Veitch, *Sheffield Plate*. 1908.
E. Wenham. *Old Sheffield Plate*. 1955.
B. Wyllie, *Sheffield Plate*. 1908.
Snuff Boxes
C. Le Corbeiller, *European and American Snuff Boxes, 1730–1830*. Batsford, 1966.
H.D. Hill, *Antique Gold Boxes, their Lore and their Lure*. New York, 1953.
R. and M. Norton, *A History of Gold Snuff Boxes*. 1938.

A.K. Snowman, *18th Century Gold Boxes of Europe*. Faber & Faber, 1966.

Spoons

F.G. Hilton Price, *Old Base Metal Spoons*. 1908.

N. Gask, *Old Silver Spoons of England*. 1926.

G.E.P. and J.P. How, *English and Scottish Silver Spoons*. Vols. I, II and III, 1952.

C.G. Rupert, *Apostle Spoons*. Oxford, 1929. (This book contains their evolution from earlier types, and the emblems used by the silversmiths for the Apostles.)

Trays

Stanley C. Dixon, *English Gold and Silver Trays*. Ceramic Book Co., 1964.

Wine-labels

H.C. Dent, *Wine, spirit and sauce labels of the 18th and 19th centuries*. Norwich, 1933.

N.M. Penzer, *The Book of the Wine-label*. 1947.

Hall-marks

Report of Departmental Committee on Hallmarking. Board of Trade, 1959.

F. Bradbury, *Guide to Marks of Origin on British and Irish Silver plate from mid 16th century to the year 1959*. 10th Edition (Pocket Edition) 1959.

J.P. de Castro, *The Law and Practice of Marking Gold and Silver Wares*. 1926. 2nd Edition 1935.

W. Chaffers, *Hall-marks on Plate*. 5th Edition 1874.

Sir C.J. Jackson, *English Goldsmiths and Their Marks*. 2nd Edition 1921, reprinted 1949.

D.T.W., *Hall Marks on Gold and Silver Plate*. J.M. Dent & Sons Ltd., 1925.

Biographies and Biographical Sources

H.W. Dickinson, *Matthew Boulton*. Cambridge, 1937.

Joan Evans, *Huguenot Goldsmiths of London*. 1936.

Joan Evans, *Huguenot Goldsmiths in England and Ireland*. 1933. (Both reprinted from the Proceedings of the Huguenot Society, vols. XIV and XV.)

Garrard's, 1721–1911. (Crown jewellers and goldsmiths during six reigns and in three centuries.) Garrard's, 1912.

A. Heal, *The London Goldsmiths, 1200–1800*. (A record of the names and addresses of the craftsmen, their shop-signs and trade cards.) Cambridge, 1935.

E.A. Jones, *Silver wrought by the Courtauld Family*. Oxford, 1940.

R.W. Lightbown, 'Christian Van Vianen at the Court of Charles I'. *Apollo*, June 1968.

N.M. Penzer, *Paul Storr, the last of the goldsmiths*. 1954.

P.A.S. Phillips, *Paul de Lamerie: citizen and goldsmith of London 1688–1751*. 1935.

D. Shure, *Hester Bateman*. W.H. Allen, 1959.

Metallurgy and Manufacturing Techniques

S. Abbey, *The Goldsmith's and Silversmith's Handbook*. (A practical manual for all workers in gold, silver, platinum, and palladium, based on handbooks by G.E. Gee.) 1952.

B. Cellini, *The treatises of Benvenuto Cellini on Goldsmithing and Sculpture* (translated by C.R. Ashbee). 1898.

B. Cuzner, *A Silversmith's Manual: treating of the designing and making of the simpler pieces of domestic silverware*. 1935.

M. Eissler, *The Metallurgy of Silver*. 1891.

M. Eissler, *The Metallurgy of Gold*. 1900.

Joan Evans, *Pattern: a study of ornament in Western Europe, 1180–1900*. Vols. I and II, 1931.

R.J. Forbes, *Metallurgy in Antiquity*. Leiden, 1950.

G.E. Gee, *The Goldsmith's handbook*. 1881.

G.E. Gee, *The Silversmith's handbook*. 1885. (See also above, S. Abbey.)

The scientific and technical factors of production of gold and silverwork. Worshipful Company of Goldsmiths, 1936.

H. Maryon, *Metalwork and enamelling: a practical treatise on gold and silversmiths' work and their allied crafts*. 1912, 3rd Edition 1954.

H.J. Plender Prith, *The Conservation of Antiquities and Works of Art*. Oxford, 1956.

T.K. Rose, *The metallurgy of gold*. 1898.

A. Selwyn, *The retail silversmith's handbook*. 1954.

J.H. Watson, *Ancient Trial Plates in the Pyx Stronghold*. H.M.S.O., 1962.

H. Wilson, *Silverwork and Jewellery: a textbook*. 1903.

Catalogues of Public Collections

Bath, Holburne of Menstrie Museum

Anonymous, *Catalogue. Part II: Silver*.

London, British Museum

H. Read and A.B. Tonnochy, *Catalogue of the Silver Plate . . . bequeathed . . . by Sir Augustus Wollaston Franks*. 1928.

London, Tower of

E.A. Jones, *Old Royal Plate in the Tower of London*. Oxford, 1908.

H.D.W. Sitwell, *The Crown Jewels and other Regalia in the Tower of London*. 1953.

London, Victoria and Albert Museum

W.W. Watts and H.P. Mitchell, *Catalogue of English Silversmiths' work (with Irish and Scottish); civil and domestic*. 1920.

W.W. Watts, *Catalogue of Chalices and Other Communion Vessels*. 1922.

Moscow, Kremlin

E.A. Jones, *Old English Plate of the Emperor of Russia*. 1909.

C.C. Oman, *The English Silver in the Kremlin*. 1961.

The State Armoury Museum of the Moscow Kremlin. Moscow, 1958.

Treasures in the Kremlin, Moscow. Paul Hamlyn, 2nd Edition 1964.

Picture Books of Public Collections

Birmingham, City Museum and Art Gallery

R. Rowe (Editor), *Silver in the City Museum and Art Gallery, Birmingham*.

Glasgow, Art Gallery

A.H. (Editor), *The Burrell Collection: Silver*.

London, London Museum

The Cheapside Hoard. 1928.

London, Victoria and Albert Museum

English Medieval Silver (Small picture book. No. 27). 1952.

Tudor Domestic Silver (No. 6). 1948.

Early Stuart Silver (No. 24). 1950.

Charles II Domestic Silver (No. 17). 1949.

Queen Anne Domestic Silver (No. 25). 1951.

Mid-Georgian Domestic Silver (No. 28). 1952.

Adam Silver (No. 35). 1953.

Regency Domestic Silver (No. 33). 1952.

Royal Plate from Buckingham Palace and Windsor Castle (No. 37). 1954.

Sheffield Plate (No. 39). 1955.

Irish Silver (No. 46). 1959.

The Gloucester Candlestick. 1959.

Manchester, City Art Gallery

Silver. 1957.

Oxford, Ashmolean Museum

British Plate. 1961.

Royal Scottish Museum, Edinburgh

English and Scottish Silver. H.M.S.O.

Catalogues of Private Collections

H.M. The Queen

A.G. Grimwade, *The Queen's Silver*. 1953.

E.A. Jones, *The Gold and Silver of Windsor Castl*[e] Arden Press, 1911.

J.R. Abbey

J.F. Hayward, *Silver bindings from the collectio*[n] *of J.R. Abbey*.

Ashmolean Museum

Collection of Plate in the Ashmolean Museu[m] *Oxford* (in preparation).

Duke of Bedford

A.G. Grimwade, *Woburn Abbey and Its Collec*[t]ions: The Silver. (Reprint from *Apollo Magazin*[e] December 1965.)

Benett-Stanford (Ellis)

G.E.P. How, *Catalogue: of entire collection left b*[y] the late H.D. Ellis, Esq., the property of Lieut[.] Col. J. Benett-Stanford. (Sotheby Sale, 13th–14th November, 1935.)

Farrer

E.A. Jones, *Catalogue of the Collection of old plat*[e] *of William Francis Farrer*. 1924.

Folger

C.C. Dauterman, *Antique English Silver Coffe*[e] *pots*. Folger Coffee Co. Collection. 1959.

Lee of Fareham

W.W. Watts, *Works of Art in Silver and othe*[r] *Metals belonging to Viscount Lee of Fareha*[m] (Section 1, British Silver.) 1936.

Lipton

Parrish and Bowen, *Antique English Silver in th*[e] *Lipton Collection*. 1956.

Portland

E.A. Jones, *Catalogue of Plate belonging to th*[e] *Duke of Portland at Welbeck Abbey*. 1935.

Spencer

A.G. Grimwade, *Silver at Althorp*.

Miles

Elizabeth B. Miles, *The English Silver Pock*[et] *Nutmeg Grater*. 1966.

Munro

G. Norman-Wilcox, *English Silver Cream-jugs o*[f] *the 18th century*. 1952.

Ridpath

Knives, forks and spoons. (Sotheby Sale, 18th[–] 19th February, 1942.)

Untermyer

Y. Hackenbroch, *English and Other Silver in th*[e] *Irwin Untermyer Collection*. 1963.

Catalogues of Corporate Collections

L.L. Jewitt and W.H. St J. Hope, *The Corporatio*[n] *Plate and Insignia of Office of the Cities and Cor*porate Towns of England and Wales. Vols. I and I[I] 1895.

Abingdon

A.E. Preston, *The Abingdon Corporation Plate*. 195[?]

Bank of England

C.C. Oman, *A Catalogue of Plate belonging to th*[e] *Bank of England*. Privately printed, 1967.

Cambridge

E.A. Jones, *The Old Plate of the Cambridge Co*[l]leges, Cambridge, 1910.

E.A. Jones, *Catalogue of the Plate of Clare Co*[llege]

...e, Cambridge. Cambridge, 1939.

...on
...A. Jones and Others, *The Plate of Eton College*.
...38.

...ndon, Livery Companies, etc.
...mourers' and Braziers'
...D. Ellis, *Description of some of the Ancient Sil-*
...r Plate belonging to the Worshipful Company of
...mourers' and Braziers'. 1892. (Supplementary
...scription . . . 1910.)
...rber-Surgeons'
...T. Young, *Annals of the Barber-Surgeons'*. 1890.
...oderer's
...Holford, *A chat about the Broderer's Company*.
...10.
...apers'
...A. Greenwood, *Ancient plate of the Drapers'*
...mpany, with some account of its origin, history
...d vicissitudes. Oxford, 1930.
...shmongers'
...W. Towse, *Portraits, Pictures and Plate in the*
...ssession of the Worshipful Company of Fish-
...ngers. 1907.
...unders'
...M. Williams, *Annals of the Founders' Company*.
...67.
...oldsmiths'
...B. Carrington and G.R. Hughes, *The Plate of the*
...orshipful Company of Goldsmiths. 1926.
...ercers'
...onymous, *Mercers' Company Plate*. 1941.
...erchant Taylors'
...M. Fry and R.S. Tewson, *Illustrated catalogue*
...the silver plate of the Worshipful Company of
...erchant Taylors. 1929.
...iddle Temple
...B. Williamson, *Catalogue of silver plate, the pro-*
...rty of the Honourable Society of the Middle
...mple. 1930.
...addlers'
...e History of the Guild of Saddlers. 1889.
...xford
...C. Moffatt, *Old Oxford Plate*. 1906.
...hrist Church
...A. Jones, *Catalogue of the Plate of Christ*
...urch, Oxford. Oxford, 1939.
...agdalen
...A. Jones, *Catalogue of the Plate of Magdalen*
...llege, Oxford. Oxford, 1940.
...erton
...A. Jones, *Catalogue of the Plate of Merton Col-*
...ge, Oxford. Oxford, 1938.
...riel
...A. Jones, *Catalogue of the Plate of Oriel Col-*
...ge, Oxford. Oxford, 1944.
...ueen's
...A. Jones, *Catalogue of the Plate of the Queen's*
...llege, Oxford. Oxford, 1938.
...ew College
...easures of New College, Oxford. Oxford Univer-
...ty Press.

...atalogues of Important Exhibitions
...95. Cambridge, Fitzwilliam Museum
...E. Foster and T.D. Atkinson, *An illustrated cata-*
...gue of the loan collection of plate exhibited at
...e Fitzwilliam Museum, Cambridge. 1896.
...97. Newcastle, Blackgate Museum
...ver Plate of Newcastle Manufacture. 1897.
...01. London, Burlington Fine Arts Club
...S. Gardner (Editor), *Exhibition of a collection*
...silversmiths' work of European origin. 1901.

1902. London, St James's Court
J.S. Gardner, *Old silver work*: chiefly English from
the 16th to 18th centuries; a catalogue of the
unique loan collection exhibited in 1902 at St
James' Court, London. 1903.
1928. Oxford, Ashmolean Museum
W.W. Watts, *Catalogue of a Loan Exhibition
of Silver Plate belonging to the Colleges of the
University of Oxford*. Oxford, 1928.
1929. London, 25 Park Lane
Catalogue of a Loan Exhibition of Old English plate
(in aid of the Royal Northern Hospital). 1929.
1929. London, Seaford House
G.R. Hughes and Others (Editors), *Queen Char-
lotte's Loan Exhibition of Old Silver*. 1929.
1931. Cambridge, Fitzwilliam Museum
*Catalogue of an Exhibition of Silver belonging
to the University and Colleges of Cambridge*.
Cambridge, 1931.
1933. London, Vintners' Hall
Wine trade Loan Exhibition of Drinking Vessels.
1938. London, Goldsmiths' Hall
Exhibition of Modern Silverwork. 1938.
1950. Los Angeles, County Museum
Three Centuries of English Silver.
1951. Cambridge, Fitzwilliam Museum
*Silver Plate belonging to the University, the Col-
leges and the City of Cambridge*. 1951.
1951. London, Goldsmiths' Hall
*British Silverwork, including Ceremonial Plate
by Contemporary Craftsmen*. 1951.
1951. London, Goldsmiths' Hall
Historic Plate of the City of London. Vols. I and II,
1951.
1951. Chester
*Ecclesiastical and Secular Silver in Cheshire Col-
lections – Festival Exhibition*.
1952. London, Goldsmiths' Hall
C.C. Oman, J.F. Hayward and A.G. Grimwade
(Editors). *Catalogue of Corporation Plate of Eng-
land and Wales*. Vols. I and II, 1952.
1953. London, Goldsmiths' Hall
Treasures of Oxford. Vols. I and II 1953.
1954. London, Victoria and Albert Museum
C.C. Oman and J.F. Hayward (Editors), *Exhibition
of Royal Plate from Buckingham Palace and
Windsor Castle*. 1954. (See – **Picture Books of
Public Collections**.)
**1955. London, Christie, Manson & Woods,
Ltd.**
A.G. Grimwade, *Silver treasures from English
Churches; an exhibition of Ecclesiastical Plate of
Domestic Origin*. 1955.
1958. Toronto, Royal Ontario Museum
Seven Centuries of English Silver. 1958.
1959. London, Goldsmiths' Hall
Treasures of Cambridge. Vols. I and II.
1962. London, Victoria and Albert Museum
*International Art Treasures Exhibition of English
Silver*.
1965. Manchester, City Art Gallery
The Assheton-Bennett Collection. 1965.
1966. Oxford, Ashmolean Museum
Oxfordshire Church Plate.
**1966. London, National Maritime Museum,
Greenwich**
C.C. Oman and K.C. McGuffie, *Oar Maces of
Admiralty*. 1966.

Monographs on Church Plate
General
W.H. St J. Hope and T.M. Fallowe, 'English Medie-
val Chalices and Patens'. *Archaeological Journal*,
vol. XLIII, 1866.
J. Gilchrist, *Anglican Church Plate*. Connoisseur/
Michael Joseph, 1967.
E.A. Jones, *The old Silver Sacramental Vessels
of Foreign Protestant Churches in England*. 1908.
C.C. Oman, *English Church Plate, 597–1830*.
1957.
Bangor
E.A. Jones, *The Church Plate of the Diocese of
Bangor*. 1906.
Berkshire
J.W. and M.I. Walker, *The Church Plate of Berk-
shire*. 1927.
Breconshire
J.T. Evans, *The Church Plate of Breconshire*. Stow-
on-the-Wold, 1912.
Cardiganshire
J.T. Evans, *The Church Plate of Cardiganshire*.
Stow-on-the-Wold, 1914.
Carlisle
R.S. Ferguson, *Old Church Plate in the Diocese
of Carlisle*. Carlisle, 1882.
Carmarthenshire
J.T. Evans, *The Church Plate of Carmarthenshire*.
1907.
Chester
T.S. Ball, *Church Plate of the City of Chester*.
Manchester, 1907.
Cork, Cloyne and Ross
C.A. Webster, *The Church Plate of the Diocese
of Cork, Cloyne and Ross*. Cork, 1909.
Derbyshire
S.A. Jeavons, *The Church Plate of Derbyshire*.
1961.
Dorsetshire
J.E. Nightingale, *The Church Plate of the County
of Dorset*. Salisbury, 1889.
Essex
W.J. Pressey (Editor), *The Church Plate of the
County of Essex*. Colchester, 1926.
Gloucestershire
J.T. Evans, *The Church Plate of Gloucestershire*.
1906.
Gowerland
J.T. Evans, *The Church Plate of Gowerland*: with
an exhaustive summary of the church plate in the
diocese of St David's. Stow-on-the-Wold, 1921.
Hampshire
P.R.P. Braithwaite, *The Church Plate of Hamp-
shire*. 1909
Herefordshire
B.S. Stanhope and H.C. Moffatt, *The Church Plate
of the County of Hereford*. 1903.
Ireland
J.J. Buckley, 'Some Irish Altar Plate'. *Royal
Society of Antiquaries of Ireland*, 1943.
John Hunt, *The Limerick Mitre and Crozier*.
Dublin, 1962.
Leicestershire
A. Trollope, *An Inventory of the Church Plate of
Leicestershire*. Vols. I and II, 1890.
Llandaff
G.E. Halliday, *Llandaff Church Plate*. 1901.
London
E. Freshfield, *The Communion Plate of the
Churches in the City of London*. 1894.
E. Freshfield, *The Communion Plate of the Parish
Churches in the County of London*. 1895.
Man, Isle of
E.A. Jones, *The Old Church Plate of the Isle of
Man*. 1907.

Middlesex
E. Freshfield, *The Communion Plate of the Parish Churches in the County of Middlesex*. 1897.
Northamptonshire
C.A. Markham, *The Church Plate of the County of Northampton*. 1894.
Nottinghamshire
S.A. Jeavons, *Church Plate of Nottinghamshire*. Thoroton Society of Nottinghamshire, 1965.
Oxfordshire
J.T. Evans, *The Church Plate of Oxfordshire*. Oxford, 1928.
Pembrokeshire
J.T. Evans, *The Church Plate of Pembrokeshire*. 1905.
Radnorshire
J.T. Evans, *The Church Plate of Radnorshire*. Stow-on-the-Wold, 1910.
Rutland
R.C. Hope, 'An Inventory of the Church Plate of Rutland'. *The Reliquary*. N.S., 1887.
Scotland
T. Burns, *Old Scottish Communion Plate*. Edinburgh, 1892.
Shropshire
S.A. Jeavons, 'Church Plate of the Archdeaconry of Salop'. *Transactions of Shropshire Archaeological Society*, supplement to vol. LVII, 1962–3.
Awkright and Bourne, *The Church Plate of the Archdeaconry of Ludlow*. 1961.
Somersetshire
E.H. Bates and Others, 'An inventory of Church plate in Somerset'. *Somersetshire Archaeological Society's Proceedings*, vols. XLIII–XLIX, 1897–1903 and vol. LIX, 1914.
Staffordshire
S.A. Jeavons, *Church Plate in the Archdeaconry of Stafford*. 1957.
Suffolk
E.C. Hopper and Others, 'Church Plate in Suffolk'. *Proceedings Suffolk Institute of Archaeology*, vol. IX, 1897.
Surrey
T.S. Cooper, 'The Church Plate of Surrey'. *Surrey Archaeological Collections*, vols. X–XVI, 1891–1901.
Sussex
J.E. Couchman, *Sussex Church Plate*. 1913.
Warwickshire
S.A. Jeavons, *Church Plate of Warwickshire*. 1963.
Wiltshire
J.E. Nightingale, *The Church Plate of the County of Wilts*. Salisbury, 1891.
Windsor Castle
E.A. Jones, *The Plate of St. George's Chapel, Windsor Castle*. 1939.
Worcestershire
W. Lea, *Church Plate in the Archdeaconry of Worcester*. 1884.
Yorkshire
T.M. Fallowe and H.B. McCall, *Yorkshire Church Plate*. Vol. I, 1912 and vol. II, 1915.
Royal Commission on Ancient Monuments
Reports on various counties make some mention of plate in the possession of some of the churches surveyed.

Magazines
Antiques, Antique Collectors' Guide, Apollo, Archaeologia, Country Life, Burlington Magazine, Connoisseur.

II PLATE OF THE UNITED STATES OF AMERICA
Historical Studies
C.L. Avery, *Early American Silver*. New York, 1930.
F.H. Bigelow, *Historic silver of the Colonies and its Makers*. New York, 1917.
C.K. Bolton, *An American Armory*. Boston, 1927.
M. Brix, *List of Philadelphia Silversmiths and Allied Artificers from 1682–1850*. Philadelphia, 1920.
J.H. Buck, *Old Plate: its Makers and Marks*. New York, 1903.
Kathryn C. Buhler, *American Silver*. Ohio, 1950.
E.M. Burton, *South Carolina Silversmiths 1690–1860*. Charleston, 1942.
R.A. Christie, *Silver Cups of Colonial Middleton*.
H.F. Clarke, *John Coney, Silversmith, 1655–1722*. Boston, Massachusetts, 1932.
E.M. Currier, *Marks of Early American Silversmiths* (with notes on silver spoon types and list of New York City Silversmiths, 1815–41). Portland, Maine, 1938.
G.M. Curtis, *Early Silver of Connecticut and its Makers*. Meriden, Connecticut, 1913.
G.B. Cutten, *The Silversmiths of North Carolina*. Raleigh, 1948.
G.B. Cutten, *Silversmiths of the State of New York*. Hamilton, New York, 1946.
G.B. and Mrs. G.B. Cutten, *Silversmiths of Utica*. 1930.
G.B. Cutten, *The Silversmiths of Virginia, together with watchmakers and jewelers from 1694–1850*. Richmond, Virginia, 1952.
S.G.C. Ensko, *American Silversmiths and their Marks, 1650–1850*. Parts I, II and III, New York, 1927, 1937 and 1948.
17th and 18th century American Silver. Robert Ensko Inc., New York, 1915.
Hollis French, *List of early American Silversmiths and their Marks with Silver Collectors' Glossary*. New York, 1917.
Hollis French, *Jacob Hurd and his sons, Nathaniel and Benjamin, Silversmiths 1702–81*. Cambridge, Massachusetts, 1939.
Hugh J. Gourley III, *The New England Silversmith*. Museum of Art, Rhode Island, 1965.
J. Graham, *Early American Silver Marks*. New York, 1936.
J. Harrington, *Silversmiths of Delaware, 1700–1850*. Camden, New Jersey, 1939.
N.W. and L.F. Hiatt, *The Silversmiths of Kentucky, together with some watchmakers and jewelers, 1785–1850*. Louisville, Kentucky, 1954.
E.A. Jones, *The old Silver of American Churches*. Letchworth, 1913.
J.M. Phillips, *American Silver*. New York, 1949.
J.H. Pleasants and H. Sill, *Maryland Silversmiths, 1715–1830: with illustrations of their Silver and their Marks*. Baltimore, Maryland, 1930.
Mrs. A.C. Prime, *Three Centuries of Historic Silver*. Philadelphia, 1938.
J.W. Rosenbaum, *Myer Myers, Goldsmiths 1723–95*. Philadelphia, 1954.
E. Wenham, *The Practical Book of American Silver*. 1949.

Catalogues of Collections and Exhibitions
Albany Institute of History and Art 1964
Albany Silver 1652–1825 (a particularly comprehensive bibliography).
Boston, Museum of Fine Arts
J.H. Buck (Editor), *American silver, the work of seventeenth and eighteenth century Silversmiths*. Boston, Massachusetts, 1906.
G.M. Curtis, *American Church Silver of the seventeenth and eighteenth centuries*. Boston, 1911.
K.C. Buhler, *Colonial Silversmiths, Masters and Apprentices*. Boston, 1956.
Chicago, Art Institute of
From Colony to Nation. Chicago, 1949.
Detroit, The Detroit Institute of Arts
The French in America 1520–1880. Detroit, 1951.
The Arts of French Canada 1870–1913. Detroit, 1946.
Harrington Collection
Mrs. Y.H. Buhler, *Massachusetts Silver in the Frank and Louis Harrington Collection*. 1965.
Hammerslough Collection
American silver collected by Phillip H. Hammerslough, Hertford, Connecticut. Vol. I, 1958, vol. II 1960 and vol. III, 1964.
London, Christie Manson & Woods
Mrs. Y.H. Buhler, *American Silver*. 1960.
Museum of the American Indian (Heye Foundation)
H.E. Gillingham, *Indian Ornaments made by Philadelphia Silversmiths*. New York, 1930.
New York, Metropolitan Museum of Art
The Collection of Spoons made by S.P. Avery. New York, 1899.
R.T.H. Halsey, *Catalogue of an Exhibition of Silver used in New York, New Jersey and the South*. New York, 1911.
C.L. Avery, *An Exhibition of early New York Silver*. New York, 1931.
New York, Museum of the City of
Silver by New York Makers. 1937.
Philadelphia, Pennsylvania Museum of Art
Exhibition of old American and English silver. Philadelphia, 1917.
Richmond, Virginia, Museum of Fine Arts
Mrs. Y.H. Buhler, *Masterpieces of American Silver*. 1960.
Washington D.C., Mount Vernon
Mrs. Y.H. Buhler, *Mount Vernon Silver*. 1957.
Washington, The White House
The White House, an historic guide. (Numerous photographs of silver and ormolu.)
Williamsburg, Virginia (Colonial Williamsburg)
The Silversmith in 18th century Williamsburg. 1956.
Williamstown, Sterling and Francine Clark Art Institute
Catalogues of Silver Exhibition. 1953, 1958, 1960, 1962, 1964, 1965, etc.
Wilmington, Winterthur Museum
M.G. Fales, *American Silver in the Henry Francis Du Pont Winterthur Museum*. 1958.
Yale University, Gallery of Fine Arts
Early Connecticut Silver. New Haven, 1935.
Art in New England: Masterpieces of New England Silver. New Haven, 1939.
Early American Silver (The Mabel Brady Garvan Collection). 1960.
P.J. Bohan, *American Gold, 1780–1860*. 1963.

List of Principal Public Collections
Albany, New York
Albany Institute of History and Art.
Andover, Massachusetts
Addison Gallery of American Art.
Phillips Academy.

Baltimore, Maryland
Baltimore Museum of Art.
Boston, Massachusetts
Museum of Fine Arts.
Cambridge, Massachusetts
Fogg Art Museum (Harvard University).
Chicago, Illinois
Art Institute of Chicago.
Cincinnatti, Ohio
Cincinnatti Art Museum.
Cleveland, Ohio
Cleveland Museum of Art.
Detroit, Michigan
Detroit Institute of Arts.
Minneapolis, Minnesota
Minneapolis Institute of Arts.
New Haven, Connecticut
Yale University Art Gallery
Philadelphia, Pennsylvania
Philadelphia Museum of Art.
Historical Society of Pennsylvania.
Providence, Rhode Island
Rhode Island School of Design.
St. Louis, Mississippi
City Art Museum.
Williamsburg, Virginia
Colonial Williamsburg.
Williamstown, Massachusetts
Sterling and Francine Clark Art Institute.
Wilmington, Delaware
Winterthur Museum.
Worcester, Massachusetts
Worcester Art Museum.

this firm since 1766 are preserved by them.)
Sotheby & Co., London
Catalogues of Silver (by annual subscription).
Parke-Bernet, New York
Catalogues of Silver (by annual subscription).

Books
H.Alan Lloyd, *The Collector's Dictionary of Clocks*. Country Life, 1964.
The Shorter Dictionary of English Furniture. Country Life, 1964.
J.D.Aylward, *The Small Sword in England*. Hutchinson, 1945.
J.F.Hayward, *The Art of the Gunmaker*. Vols. I and II. Barrie & Rockliff, 1963.
Garrard (Wakelin) Ledgers (on loan to the Victoria and Albert Museum).
C.C.Oman, *The Gloucester Candlestick*. H.M.S.O., 1958.
D.E.Strong, *Greek and Roman Gold and Silver Plate*. 1966.
Sutton Hoo Ship Burial. Trustees of British Museum, 1947 and later.
Joan Evans, *A History of Jewellery*. 1953.
J. Fairfax-Blakeborough, *Northern Turf History*. Vol. II, 1949.

V DESIGN SOURCES
Sir William Hamilton, *Collection of Etruscan Greek and Roman Antiquities*. Vol. I, Naples, 1766.

PLATE OF CANADA
Marius Barbeau, 'Deux Cents Ans D'Orfèvrerie Chez Nous'. *Transactions of the Royal Society of Canada*, Sec. I and Sec. II, 1939.
Marius Barbeau, *Indian Silversmiths on the Pacific Coast*.
A.Jones, *Old Church Silver in Canada*. Transactions of the Royal Society of Canada, 3rd series.
E.Langdon, *Canadian Silversmiths and their Marks (1667–1867)*. 1960.
E.Langdon, *Canadian Silversmiths, 1700–1900*. Toronto, 1966.
Piers and D.C.MacKay, *Master Goldsmiths and Silversmiths of Scotia and their Marks*. Halifax, Nova Scotia, 1948.
Smith, *Canada, Past, Present and Future*. Toronto, 1852.
Traquair, 'Montreal and Indian Trade Silver.' *Canadian Historical Review*, March 1938.
Traquair, *The Old Silver of Quebec*. Toronto, 1940. (Public Collection: Montreal, Museum of Fine Arts.)
Wenham, 'Old Canadian Silver.' *Canadian Homes and Gardens*, 1927.

V VARIA
Catalogues
Christie Manson & Woods, Ltd., London
Catalogues of Silver (by annual subscription). (A complete series of all sale catalogues issued by

Acknowledgments

Colour Plates

N. Bloom & Son Ltd., London: 23. British Museum, London: 1, 27. The Trustees of the Chatsworth Settlement: 29. Christie, Manson and Woods Ltd., London: 39, 40, 41, 42, 46. Copyright reserved: 7, 20, 34, 47. Corporation of Congleton, Cheshire: 21. Corpus Christi College, Oxford: 15, 16. Lady Galway (on loan to the Birmingham City Museum and Art Gallery): 45. The Rector and Churchwardens of Harthill Church, Yorkshire: 9. Henry Francis du Pont Museum, Winterthur, Delaware: 4, 5. The Controller of Her Majesty's Stationery Office (Crown copyright): 19. Corporation of King's Lynn, Norfolk: 22. Los Angeles County Museum of Art, California: 26. The Master and Wardens of the Mercers' Company, London: 25. Metropolitan Museum of Art, New York, bequest of A. T. Clearwater, 1933: 17. The National Trust, London: 8, 48. The Warden and Fellows of New College, Oxford: 14. Corporation of Newark-upon-Trent, Nottinghamshire: 3. The City and County of Norwich: 36. Nottingham Castle Museum, Gibbs Collection: 6, 44. Prestons Limited, Bolton, London and Toronto: 12 (photograph reproduced by permission of D. S. Lavender Antiques, London). The Queen's College, Oxford: 33. Sotheby & Co., London: 32. Victoria and Albert Museum, London: 13, 24, 28, 31, 38. The Woburn Abbey Collection, by kind permission of His Grace the Duke of Bedford: 2, 35, 43. The Worshipful Company of Goldsmiths, London: 30, 37 (photograph reproduced by permission of Fratelli Fabbri Editori, Milan). Yale University Art Gallery: 10 (skillet photographed by permission of Messrs Gager, Henry and Narkis, Waterbury, Connecticut), 11, 18.

Monochrome Plates

Art Institute of Chicago, Illinois: 164, 265, 424, 462, 492, 663. Ashmolean Museum, Oxford: 28, 36, 39, 92, 102, 256, 301, 309, 339, 417, 459. Asprey & Co. Ltd., London: 300. His Grace the Duke of Atholl: 277. The Governor and Company of the Bank of England: 310, 319a, 499, 711. Bermondsey Parochial Church Council, London: 400. Birmingham City Museum and Art Gallery: 185. N. Bloom & Son Ltd., London: 7. A. & B. Bloomstein, London: 541. J.H. Bourdon-Smith Ltd., London: 107, 521, 719. Bracher & Sydenham Ltd., Reading: 47, 234, 272, 535. Brooklyn Museum, New York: 514. The Most Honourable the Marquess of Bute (on loan to the National Museum of Antiquities, Edinburgh): 351. Christie, Manson and Woods Ltd., London: plate on p. 10, nos 5, 6, 8, 11, 12, 14, 16, 19, 20, 21, 27, 29, 32, 44, 46, 48, 49, 53, 54, 55, 56, 57, 58, 59, 67, 68, 70, 72, 78, 81, 85, 87, 93, 96, 103, 106, 108, 109, 110, 114, 115, 121, 122, 127, 133, 137, 140, 141, 142, 144, 154, 155a, 155c, 156a, 158a, 158b, 163, 166, 167, 168, 170, 171, 181, 183, 184, 186, 195, 196, 200, 201, 210, 211, 213, 214, 216, 218, 219, 220, 223, 227, 228, 229, 233, 235, 237, 238, 240, 241, 248, 250, 251, 253, 254, 255, 260, 261, 262, 264, 266, 267, 268, 269, 270, 271, 279, 280, 282, 288, 296, 297a, 306, 312, 313, 316, 320, 322, 323, 325, 326, 327b, 330, 331, 332, 333, 335, 336, 340, 342, 344a, 348, 356, 358, 359, 360, 361, 364, 365, 367, 368, 369, 373, 377, 379, 389, 395, 404a, 405a, 406, 407b, 413, 414, 415, 418, 419, 423, 427, 433, 449, 450, 451, 457, 463, 471, 472, 475, 477, 479, 482, 486, 487, 489, 490, 491, 493, 496, 497, 502, 503, 513, 515, 519, 520, 527, 531, 532, 533, 534, 536, 537, 538, 539, 540, 542, 543, 551b, 552, 553, 555, 556b, 556c, 556d, 557, 558a, 558b, 559, 560, 561b, 561c, 561d, 563, 564, 568, 569, 576, 577, 578a, 583, 586, 589, 590, 594, 598, 599, 600, 608, 609, 618, 619, 620, 623, 627b, 628, 629, 631, 632, 633, 634, 635, 636, 640, 641, 645, 649, 651, 65 654, 655, 656, 659, 661, 662, 684, 691, 693, 69 698, 702, 703, 705, 706, 707, 714, 715, 716, 71 720, 725, 727, 728. Cleveland Museum of A Ohio: 556e. Colonial Williamsburg, Williamsbur Virginia: 88, 118, 399, 500, 688, 704. Copyrig reserved: 35, 247, 287, 289, 290, 710. Corp Christi College, Cambridge: 354, 596. Corp Christi College, Oxford: 1, 429. Delieb Antiqu Ltd., London: 347, 371b. The Drapers' Compan London: 601. Corporation Art Galleries a Museums, Dundee: 2. The Fishmongers' Con pany, London: 119. Fogg Art Museum, Harva University, Cambridge, Massachusetts: 26, 20 Mr Francis E. Fowler, Los Angeles: 402. Garrard Co., London: 384. Harbledown Hospital, Cante bury, Kent: 349, 350. Henry Francis du Po Museum, Winterthur, Delaware: 30. Histo Churches Preservation Trust, London: 73, 83, 13 172, 176, 177, 187, 199, 202, 221, 226, 285, 61 Holmes (Jewellers) Ltd., London: 314. How Edinburgh: 18, 43, 98, 138, 145, 307a, 372, 38 426, 444, 446, 452, 495, 565, 567, 606, 616, 627 660. H.R. Jessop Ltd., London: 120, 257, 26 696. Simon Kaye Ltd., London: 62, 63, 232, 31 334, 390, 570, 658, 699, 700. Knight, Frank Rutley, London: 169. R.A. Lee Ltd: 363. The Rig Honourable the Lord Leigh: 304. Lewis & Ka Ltd.: 578b. The Most Honourable the Marquess Linlithgow: 75, 206, 572, 650. Thomas Luml Ltd., London: 13, 61, 64, 105, 156b, 156c, 159 205, 208, 242, 246, 249, 258, 284, 304, 319b, 34 375, 383, 387, 388, 403b, 404b, 407a, 443, 44 454, 485, 494, 498, 501, 505, 509, 526, 549, 55 551a, 580, 626, 646, 648, 708, 718, 723. Ma chester City Art Gallery, Assheton-Bennett Colle tion (photography Royal Academy of Arts): 12 182, 207, 308, 508, 525, 579, 605, 639, 671. Metr politan Museum of Art, New York: 76, 529, 67 The Mount Vernon Ladies' Association, Virgin 504. Mrs William B. Munro, Pasadena, Californi 157, 158c, 158d, 158e, 545. National Gallery Scotland, Edinburgh: 165. National Maritim Museum, Greenwich, London: 324, 355. Natio Museum of Antiquities, Edinburgh: 4, 530, 59 National Museum of Ireland, Dublin: 113, 155 204, 244, 381, 467, 561a, 582, 673. Natio Museum of Wales, Cardiff: 374, 676, 677, 67 680, 681. National Museum of Wales, Cardi Jackson Collection: 523, 585, 621. The Natio Trust, London: 15, 71. The New-York Historic Society, New York: 469, 544, 638. Henry Oliver Co. (London) Ltd.: 643. Philadelphia Museum Art, Pennsylvania: 65. S.J. Phillips Ltd., Londo 547. Plymouth Corporation: 438. Michael Poynd (Antiques) Ltd., London: 391. Private collection 33b, 60, 80, 89, 91, 124, 135, 198, 212, 281, 33 528, 571, 624, 683, 713. The Queen's Colleg Oxford: 603. Royal Scottish Museum, Edinburg 252, 371a, 556a. St John's Hospital, Canterbur Kent: 349. Eric Shrubsole, Esq.: 588. Sir Joh Soane Museum, London: 79. The Smithsonia Institution, Washington, D.C.: 422. Sotheby & C London: 9, 17, 24, 25, 38, 50, 51, 69, 77, 82, 84, 9 104, 116, 117, 123, 125, 126, 129, 130, 131, 13 136, 153, 160, 189, 197, 209, 217, 222, 224, 23 231, 236, 275, 286, 291, 295, 296b, 299, 302, 30 307b, 311, 315, 327a, 328, 329, 338, 344b, 35 357, 370, 376, 382, 392, 397, 403a, 405b, 40 410, 416, 420, 445, 455, 456, 461, 464, 465, 46 468, 470, 473, 474, 476, 478, 483, 484, 506, 51 516, 517, 518, 548, 554, 558d, 581, 587, 602, 61 622, 647, 652, 657, 665, 667, 668, 669, 679, 68 685, 686, 690, 692, 695, 701, 724, 726. The Rig Honourable the Earl Spencer: 45, 90, 386, 39 411, 664, 697, 712, 722. Spink & Son Ltd

ndon: 146, 259, 343, 396, 482, 558c, 607, 610, 21. Sterling and Francine Clark Art Institute, illiamstown, Massachusetts: 86, 239, 346, 644. ouncil of the Stock Exchange, London: 10. essiers Ltd., London: 37, 460, 507. C.J. Vander Antiques) Ltd., London: 562. Victoria and Albert useum, London: 3, 33a, 33c, 33d, 40, 94, 95, 97, 34, 143, 147, 159a, 159b, 180, 188, 243, 283, 02, 297c, 345, 394, 401, 434, 435, 442, 447, 453, 88, 522, 524, 566, 573b, 575, 615, 630, 637, 674, 80. Walker Art Gallery, Liverpool: 215. West & on, Dublin: 378. Wilberforce House, Hull Mus- um, Hull: 52. Walter H. Willson Ltd., London: 42, 58. The Worshipful Company of Goldsmiths, ndon: 22, 23, 31, 34, 41, 100, 111, 112, 148, 49, 150, 151, 152, 162, 173, 175, 178, 190, 191, 92, 193, 194, 225, 273, 278, 293, 294, 298, 352, 62, 366, 393, 409, 412, 421, 425, 428, 430, 431, 32, 436, 437, 438, 440, 441, 480, 512, 546, 573a, '4, 593, 595, 611, 613, 614, 666, 670, 672, 689, 09. Yale University Art Gallery, Connecticut, abel Brady Garvan Collection: 74, 101, 317, 380, 04, 729.

ne Drawings

ne following figures were reproduced by kind ermission of the Trustees of the estate of the late r Charles Jackson: XVII, XVIII, XIX, XXVI.

larks

elp in the preparation of the hall-marks was nerously given by the Worshipful Company of oldsmiths, Goldsmiths' Hall, London.